The Best of Popular Photography

Edited by Harvey V. Fondiller

Ziff-Davis Publishing Company · New York

Library of Congress Catalog Card Number: 79-66279
ISBN: 0-87165-037-1

Printed in the United States of America
First Printing 1979

The Best
of
Popular
Photography

Dear "Uncle" Paul
(alias Old Prune")
This is not exactly original, but I
hope you enjoy it.
Brenda
(Sparky)

December/83

Contents

Techniques

Photojournalism

Moving Images

Viewpoints

Editor's Preface

Editing an anthology of articles and pictures from *Popular Photography* yielded expected pleasures mingled with unforeseen problems. Having been a reader of the magazine since its inception, I found that reviewing the issues of years past was a pleasant task. What could be more enjoyable than again encountering thousands of articles by perceptive writers and countless pictures by noted photographers?

To me, photography has provided a lifetime of enjoyment. Having been an amateur and professional as well as an editor, writer, and teacher, I've been able to appreciate it in many ways. Much of my education and inspiration came from the pages of *Popular Photography.*

Consider the state of photography four decades ago. There were no cameras with exposure automation, no pictures-in-a-minute, no self-loading cameras. Amateur color photography was in its infancy . . . photo galleries and academic courses in photography were virtually non-existent. How better to learn about photography than by reading?

From the beginning, artistic and technological developments in photography have been synergistic, for equipment, images, and photographic literature are inextricably interrelated. The popularity of 35-mm cameras eventually led to the appearance of *Popular Photography,* which espoused "candid" shooting in its many manifestations. The widespread publication of images liberated from large-camera limitations helped to foster the production of advanced cameras, lenses, and emulsions. More recently, the popularity of the single-lens reflex and of wide-angle and telephoto lenses have brought forth new esthetic approaches. Each development, chronicled in the pages of *Popular Photography,* heralded further advances in imagery and technology. And the cycle continues.

Selecting articles and pictures to represent more than forty years of an art and craft forces the anthologist to make difficult decisions. What should be included from a wealth of available material? My criterion was that the selections have lasting interest within the chosen subject areas.

Picture retrieval was complicated by the fact that the magazine's files prior to 1969 were nonexistent. It was difficult to obtain some of the early photographs and impossible to get others, although efforts were made to track down the photographers, their heirs or assignees on three continents.

On behalf of the contributors, I invite you to enjoy a look at contemporary photography and some of its personalities, techniques, and viewpoints. A sage has written: "To see more is to live more fully". If *The Best of Popular Photography* succeeds in showing the reader how to do this, our efforts will be well rewarded.

HARVEY V. FONDILLER

Foreword

Many magazines, whatever their merit, don't match their names. The *Saturday Evening Post,* for instance, in its latter years of splendor, was not published on Saturday evening, *Esquire* these days has little or nothing to do, even ironically, with the life style of country gentlemen, and *Cosmopolitan* is not the publication where one would seek a wordly view of international culture. *Popular Photography,* however, has lived up to its logo from Volume 1, Number 1 (May, 1937) to the present. The first issue was a sell-out on the newsstand, and with a circulation in 1979 of 865,000 it is the largest photographic publication in the world.

The adjective, "popular" not only has been well earned but has proven to be indestructible. Once, under the editorship of Bruce Downes, we dropped it. Bruce's feeling, which a number of us junior editors shared, was that the magazine was comprehensive and successful enough to simply call itself "Photography." We were wrong, not necessarily conceptually, but in underestimating the way that an affectionate nickname sticks, even after the recipient feels he has outgrown it. We were "Popular Photography", "Pop Photo," or just "Pop," and nobody would go along with our move. Quietly, we put the adjective back in.

Popularity is one thing; lasting value is another. Inevitably, the editorial content has been uneven with its share of ups and downs over more than forty years and hundreds of thousands of pages. In any enterprise as broad-based and topical as this magazine, much that is ephemeral and repetitive is bound to be included, which indeed has been the case. Photography both as art and technology tends to become obsolete rapidly.

However, the magazine always has maintained a direct, vital contact with its readers, supplying nourishment that many kinds and levels of photographers responded to warmly. From its beginning to the present day, *Popular Photography* has been an informal teaching institution, a paperback university for anybody interested in the craft of photography. It has taught many people, including some who went on to achieve considerable success, the basics of their medium. Also from the beginning it has been a showcase of photographic images, sometimes eclectic and uncritical but generally responsive to what was vital and exciting in the evolution of image-making. Also, *Popular Photography* has been an open forum, a sounding board for a diversity of opinions about photography and photographers. Rebels and reactionaries, pictorialists and photojournalists, intellectuals and primitives, amateurs and artists all have had their say.

The remarkable thing is how much of enduring value and interest was caught in the magazine's journalistic net, even while it was serving the practical, day-to-day needs of its readers. To browse through back issues of *Popular Photography* from 1937 on is a serendipitous experience, of which this book is a distillation.

Actually, the title's a misnomer. What is contained here is not necessarily the "Best" of *Popular Photography*. Other editors might cull those quarter of a million or more editorial pages and emerge with a totally different but perhaps equally interesting anthology. So what we have is only some of the best. I hope you find the selection well worth the looking and the reading.

ARTHUR GOLDSMITH
Editorial Director
Popular Photography

Introduction

by Beaumont Newhall

When *Popular Photography* first appeared in 1937 there were six other photographic magazines currently circulated in the United States. One was directed to the professional; the others were mainly concerned with what was then known as "pictorial photography" and the activities of the camera clubs that sponsored the many annual salons. Plates of prizewinners at these exhibitions were inserted in these magazines in a haphazard way, interspersed with technical articles of the "how-to-do-it" kind. Only rarely did the editors seek out the truly creative photograph: to find a print by Steichen or Weston or Adams was rare. The work of Stieglitz or Strand, of Brassaï or Cartier-Bresson was not to be found in any of them.

Popular Photography brought us a new kind of magazine, broader in coverage than the others, directed to an audience wider than camera club members. We came to meet, through lively interviews, the pioneer photojournalists Alfred Eisenstaedt and Margaret Bourke-White and the masters of the view camera Edward Steichen and Edward Weston. We learned of new products, new techniques, new approaches. We were given inspiration to experiment, shown the mirror distortions of Kertész, the photograms of Moholy-Nagy. We were encouraged to throw off the shackles of convention, of "composition," which led to the sterility of latter-day pictorialism. At first we were disappointed at the quality of production: the halftone plates were coarse, the paper pulpy, the layout somewhat confused and contrived. But as the years wore on the magazine improved; personality articles were more lively, technical data more precise, news coverage more complete, concern with the process of picturemaking more perceptive.

A magazine lies part way between a newspaper and a book. Seldom do we keep a newspaper, rarely do we discard a book. A magazine, by the very periodicity of its publication becomes obsolete every month. Complete files of *Popular Photography* exist in most public libraries. Properly bound in volumes the 500 or more issues that have thus far appeared take up twenty feet of shelf space. Between their covers lies a living history of photography for the past forty-two years—a mine of information and inspiration. I know from experience that mining that great resource is laborious: my notes merely abstracting the contents are voluminous. The selection of articles here presented is a distillation of that richness.

Retrospect: Four Decades

This Was 1937

Beaumont Newhall

Looking back, it is now obvious that the end of 1937 marked the end of one era of photography and the beginning of another. Traditional "pictorialism" was on the wane; "pure photography," which only a few years earlier was considered "modernistic" when Group *f*/64 waged its valiant fight in California, was accepted; the new photojournalism was being practiced by the photographers and editors of the new picture magazines, *Life* and *Look;* the documentary approach was forged by film makers and the Farm Security Administration's photographic team. Technically, the invention of dye-coupling multilayer color films was revolutionizing color photography; semi-automatic cameras were amazing the photographic world; film speeds were reaching new heights; and "strobe light, the lively light" was in the laboratory of its inventor, Harold Edgerton, in the Massachusetts Institute of Technology in Cambridge, Mass. And a brash, lively new magazine, at once stimulating and infuriating, appeared upon the scene, named POPULAR PHOTOGRAPHY.

Those of us who were immersed in the photographic world hardly realized that we were on the brink of a revolution as staggering as any that photography in its hundred years of existence had experienced; certainly I did not when I was asked by the Museum of Modern Art to assemble the retrospective exhibition "Photography 1839–1937," which was on display in the 53rd St. Gallery in the spring of 1937. To me, the assignment to direct the Museum's first major photographic exhibition was a challenge, and I sought out in America and Europe what I considered to be the best examples of the art of photography.

Quite rightly I began with Alfred Stieglitz, whose brilliant career as a photographer spanned two centuries. I extended to him an invitation to be the chairman of the advisory committee for the exhibition. This, to my disappointment, he declined. I was even more disappointed when he not only refused to lend photographs, but denied us access to any of his photographs in public collections, specifically the Metropolitan Museum of Art in New York and the Museum of Fine Arts in Boston. Other photographers were more cooperative. Paul Strand, although skeptical at first of my plan to show the entire spectrum of photography—he thought I should limit the selection to David Octavius Hill, Stieglitz, Atget, and himself—agreed to show if the choice of prints as well as the hanging of them on the museum walls, was left to him. Edward Steichen, who was then photographing for *Vanity Fair* and *Vogue,* joined the advisory committee and was most helpful; for the catalog of the exhibition I chose his fine portrait of Carl Sandburg. I would have preferred one of his color photographs, but the budget for the production of the catalog did not allow for color.

I knew, by reproductions, the work of Edward Weston and Ansel Adams. They responded promptly to my invitations. Weston sent six pictures of sand dunes. Later in the year he received the first Fellowship of the John Simon Guggenheim Memorial Foundation ever given for photography; this for him was the beginning of a new period, in which he expanded his vision to encompass the great landscapes of the West. Adams had published his *Making a Photograph,* the first of his technical manuals, brought out with superb repro-

ductions by the London Studio: he had been given a one-man show by Stieglitz at An American Place in New York. He replied to my invitation with enthusiasm. Not only did he send his own photographs, but he brought to my attention the photographs of the Southwest by a 19th century photographer known to me only by his Civil War photographs: Timothy H. O'Sullivan.

The state of photography in 1937 cannot be understood without an understanding of the social and political scene. The nation was in the midst of the Great Depression; Europe was cruelly rehearsing for World War II by the intervention of Nazi Germany and Fascist Italy in the Spanish Civil War; and Hitler's rise in Germany drove progressive artists of all media and persuasion to asylum in England and the United States.

DOWN WITH SHARPNESS!

To Frank Roy Fraprie, editor and publisher of *The American Annual of Photography,* these political events meant nothing; he continued to publish the same greased nudes, vapid landscapes, and obvious patterned compositions which had been seen in the Annual year in and year out. In the issue dated 1938, but published the year before, he proudly proclaimed that the 100 prints he had selected for reproduction from the more than 7,-000 that had been submitted "show that the photographic world as a whole has departed from the ideals of excessive sharpness, of all forms of modernism, and of too rigorous reliance on purely photographic technique . . . away from sheer literalism to more sentimental and human forms of representation." Photographers were rated by Fraprie not by the significance of their pictures, but by a statistical formula based on the number of prints accepted by "recognized salons" throughout the world. If you had one or more prints accepted by any two of these salons, your name was printed in the "Who's Who in Pictorial Photography." If you "made" the 1938 *Annual,* you were one of 2,292 out of 4,745 competitors. You might have envied Leonard Misonne, who topped the list: he showed in no fewer than 184 salons in 1937.

OUR OWN GREASED NUDES

Popular Photography brought new life to the photographic press. True, it reproduced nudes as greased as the *American Annual's* and vapid landscapes too; but it also showed life—sometimes crudely (topless burlesque queens shot by stage lighting), but sincerely as well (how can the President of the United States be photographed with the dignity befitting his position). The magazine had frequent biographical articles: on Margaret Bourke-White, on Alfred Eisenstaedt, on the press photographer Arthur Fellig who later took the pseudonym Weegee—names which never figured in the "Who's Who in Pictorial Photography" though at least one was to be found in *Who's Who in America.*

To combat the depression in America, Franklin Delano Roosevelt formed by Presidential order the Resettlement Administration, and its director, Rexford Guy Tugwell, invited Roy E. Stryker, his former colleague at Columbia University, to direct a photographic team to show the American public the plight of those Americans who through no fault of their own were driven from their farms into dire poverty. In 1937, Tugwell's group became the Farm Security Administration under the Department of Agriculture. Stryker's photographers included Walker Evans, Dorothea Lange, and Arthur Rothstein; they produced a moving record and established a new photographic style. In New York, Berenice Abbott photographed the city for the Works Progress Administration, in a style which was inspired by Eugène Atget, the French photographer of Paris whose negatives she courageously and somewhat miraculously preserved for posterity.

In England the documentary spirit found its greatest outlet in film making. Splendid films were being produced in the tradition of John Grierson and Robert Flaherty (who was then in India filming *Elephant Boy*), distinguished not only by their photography, but also by their scripts and music. Harry Watt's *Night Mail* (1936) had a poetic commentary by W. H. Auden and music by Benjamin Britten. In America, *The Plow That Broke the Plains,* produced in 1935 for the Resettlement Administration by Pare Lorenz, with Paul Strand and Ralph Steiner, was followed in 1937 by *The River,* a brilliant and beautiful explanation of the taming of the Mississippi by the Tennessee Valley Authority. The sound track was a poem by Lorenz and original music by Virgil Thomson.

Both Henri Cartier-Bresson and Paul Strand had put aside their still cameras to make films 30 years ago. Strand headed a production organization called Frontier Films; Cartier-Bresson was assistant director for Jean Renoir. In 1937 they both

made films about the Spanish Civil War: Cartier-Bresson, *Return to Life;* Strand, *The Heart of Spain.* A third film on the same subject, *Spanish Earth,* was made by Joris Ivens with commentary written and spoken by Ernest Hemingway and music by Virgil Thomson and Marc Blitzstein.

PHOTOJOURNALISM IMMIGRATES

The French picture magazine *Vu* devoted an entire issue to photographs of the Spanish War—and lost all its advertisers because of it. The art director, Alexander Liberman, came to America to work for *Vogue.* Alexey Brodovitch, as art director of *Harper's Bazaar,* was encouraging young photographers to develop new approaches to fashion illustration. A new form of photojournalism, born in pre-Nazi Germany with "available-light" photographs made possible by the miniature camera, found outlet in America in two new magazines: *Life,* which appeared in the fall of 1936, and *Look,* which came to the newsstands a few months later. Alfred Eisenstaedt brought to *Life* his experience as a magazine photographer in Germany, Margaret Bourke-White, photographer for *Fortune* magazine, came on the staff with a background of industrial photography, but quickly developed skill in reportage. *Popular Photography* sent Jack Price "to take a look at *Life";* his story in the September issue was richly illustrated and is in retrospect a unique document, for no other publication bothered to report on the new trend which was to be so influential.

The dreadful tragedy of the explosion of the airship *Hindenburg* at Lakehurst, N.J. in May, 1937 produced some of the most remarkable news photographs. Practically all news photographers used 4×5 Speed Graphic cameras which they handled with amazing rapidity and skill. *Popular Photography* had vividly written monthly features on news photography.

BAUHAUS COMES TO CHICAGO

The Nazi conquest of Germany brought to this country many of Europe's best artists. Laszlo Moholy-Nagy came to Chicago in 1937 to head up an art school, the New Bauhaus, which was intended to continue the traditions of the progressive Bauhaus founded in Germany by Walter Gropius, where Moholy had taught. The experiment was a failure, but Moholy persisted and founded the Institute of Design, now part of Illinois Institute of Technology. He brought with him a new approach to photography, the experimental: cameraless pictures made by exposing photographic materials beneath objects of all kinds, similar to the "rayographs" of Man Ray, the American painter then living in Paris.

To collect for the Museum of Modern Art Exhibition, I went to Paris and London. Charles Peignot, the publisher of *Photographie,* the liveliest of all the photographic annuals of the 1930's, was a member of the advisory committee, and he arranged for me to meet the leading photographers of France. I did not meet Cartier-Bresson—he was film-making then—but Brassai lent some of his series of "Paris by Night" and an unusual mountain climbing scene. From André Kertész I selected some of his mirror distortions and Paris scenes. I found little in London. Because of the political situation I did not visit Germany; had I known of the work of Albert Renger-Patzsch and August Sander, I would certainly have had representative collections in the exhibition.

The impact of the introduction of Kodachrome color film by the Eastman Kodak Company in 1935 was revolutionizing photography, and did much to make the 35-mm camera universally acceptable. But in 1937 the principal users were amateurs. The professionals worked the carbro process. They used special "one-shot" cameras to expose three plates or sheets of film simultaneously through red, green, and blue filters. These separation negatives, each developed so that gray scales on the edge of the scene showed uniform densities for each corresponding step in all three, were printed on bromide paper. The silver was bleached away, and the gelatin images were transferred to carbro tissue—cyan for the red printer, magenta for the green printer, and yellow for the blue printer. These colored images were then superimposed on a final support. Great craftsmanship was required, and each studio had its lab and skilled technicians. Steichen excelled in carbro printing. There were specialists in food (Nick Muray), in illustration (Anton Bruehl, Valentino Sarra, Victor Keppler). Dye-coupling, multilayer films were to make carbro printing and the one-shot camera obsolete, but in 1937 the film was available only in 35-mm transparencies, and most photoengravers in those days wanted larger images to work from and art directors wanted big pictures to show their clients. There was one exception: *Leica Photography* printed three four-color reproductions from 35-mm Kodachrome transpa-

rencies by Ivan Dmitri in its June, 1937 issue.

The fastest black-and-white film on the 1937 market was Kodak Super-X, rated at Weston 32 (the approximate equivalent of ASA speeds, which were introduced later). To increase the speed, hypersensitizing techniques were devised: the film was exposed to the fumes of ammonia, or sealed up with mercury overnight. These techniques soon became obsolete when, in 1938, research laboratories released films four times faster than anything photographers had used.

SIX SHOTS A SECOND

With remarkable foresight, *Popular Photography* gave an extensive review of a new 35-mm camera,

the Robot—so named because the shutter was cocked and film wound on automatically by a spring-driven mechanism actuated by the shutter release; it was claimed that as many as six exposures could be made in a second. The reviewer wrote that the Robot "probably will be the prototype of new cameras to come within the next few years." Zeiss brought out the Contax III, a new model of their popular 35-mm camera, which had a built-in exposure meter, "direct reading, no tables." *Photo Art Monthly* despaired: "When the inventive genius of man succeeds in eliminating the photographer from photography, we shall go out of business." Leitz introduced an *f*/1.5 lens, the Xenon, and a rapid winder for the Leica G. Another step toward the automatic camera was the

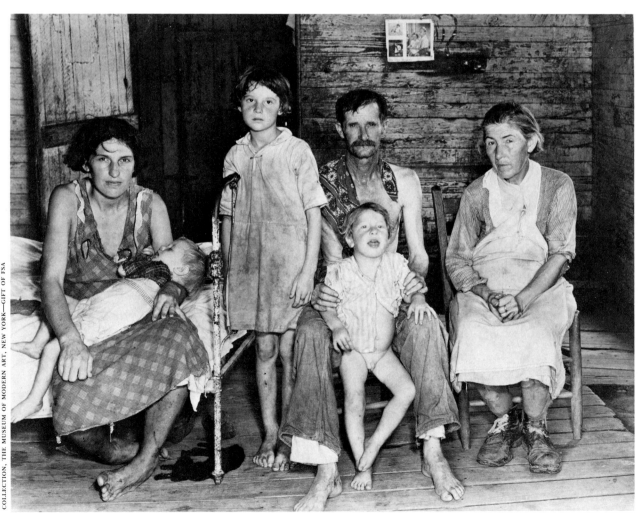

SHARECROPPER'S FAMILY, ALABAMA—1936 WALKER EVANS

new model of the Rolleiflex, which automatically counted exposures, doing away with the red window entirely, and which had the film wind coupled with the shutter cocking mechanism. Still on the drawing board was the most advanced camera of the decade, Kodak's Super Six-20, announced in July, 1938; the lens diaphragm was automatically indexed by current produced by a photoelectric cell.

MINIATURIZATION ARRIVES

Two cameras demonstrated brilliantly that miniaturization could be achieved with no loss of precision: the Compass camera built by the Swiss watchmakers Le Coultre, and the Minox, patented in Latvia in 1935. The Compass camera quickly became obsolete because of the unfortunate choice of glass plates as the sensitive material; although a roll film back for Bantam-size film was made available, its bulk—almost that of the camera itself—defeated the virtue of the camera, its small size. The original Minox was precisely identical to the current model III-S (except for a heavier body and the lack of synchronization); it did not become at all popular, however, until its value had been proved in espionage work during World War II.

Despite the popularity of these miniature cameras, there were still endless discussions pro and con. Fritz Henle, fresh from an extensive trip through China and Japan, spoke up strongly in the favor of the Rolleiflex ("Small Cameras Can and Do," *Photo Arts Monthly,* May, 1937), and Ansel Adams showed, in a series of articles in *Camera Craft,* that prints of extraordinary sharpness and clarity could be secured with Contax cameras and lenses.

When I accepted the assignment to assemble a retrospective exhibition for the Museum of Modern Art, I did not know that there were other historians of photography in the United States. Had I met the late Edward Epstean, who was translating Potonniée's *History of the Discovery of Photography,* and the late Robert Taft, whose monumental *Photography and the American Scene* was then in manuscript, I would have been saved much effort, and much research in the libraries of the French Society of Photography in Paris and the Royal Photographic Society in London. Each of the Museum's exhibitions was traditionally accompanied by a book-length, hard-bound catalog, containing a critical essay by way of explanation and introduction to the display. In the case of this exhibition, the book was of equal importance to the show. The reception of both exceeded our expectations. The *New York Herald Tribune* wrote an editorial about the show: "One sees the camera as the technically triumphant instrument of exact depiction, as a sensitive medium of artistic record, as a device creating new imaginative worlds out of its own limitations and possibilities, going on to exploit its deliberate distortions of light and form for their own sake until finally even the camera itself disappears, leaving the abstract 'shadowgraphs' of Man Ray and others.

"Simultaneously, one sees it reaching out to report the whole of experience, developing motion, penetrating to the structure of the atom and of the giant star cluster. One sees it spreading in another sense, first to books, then to current magazines and newspapers and advertisements and its own pictorial theaters until it makes the daily world of modern man a pictorial world to a degree beyond anything in human experience."

DESCHIN WROTE THE REVIEW

Strangely, the photographic press was less impressed than the newspapers and such magazines as *The New Yorker* and *Time.* With one exception. In its second issue *Popular Photography* published a thorough, well-illustrated feature article about the exhibition written by Jacob Deschin, then photography editor of *Scientific American.* There was a sequel: beginning in the January, 1938 issue, *Popular Photography* ran each month a cartoon depicting one moment in the history of photography. The strip was based upon the text of the Museum catalog. I was a budding scholar then, and I was infuriated almost to the point of protest to see my words associated with make-believe images. I am glad that I held back my protest, for the cartoons were proof that the exhibition was not a scholarly exercise, but had meaning to photographers.

6

Forty Years of Evolution and Revolution

Charles Reynolds

Looking back on significant trends in the art and business of photography . . . and looking ahead to what the future may hold

Forty years old! That age, not quite young to be young any longer and not quite old enough to really be considered old, is, the venerable saying tells us, when life begins.

If 40 is a respectable age for a magazine which, in that time, has grown to be the most widely read in its specialized field, it is a mere moment in the life span of any of the traditional art forms whose ages are uncounted thousands of years. When *Popular Photography* was born, however, the art of photography was only an infant, barely a century old.

The 40 years of photography's infancy spanned by our magazine have been lively ones both in terms of its technology and in the development of the images themselves.

When *Popular Photography* was born, the art of photography was in a major period of transition. It involved, not surprisingly, photography's relation to the much older, more established, visual art of painting. To the artistic establishment, photography was an upstart and, in fact, was not generally accepted as a legitimate art at all. Nevertheless, painters of the previous century had looked carefully at the new medium and had, to a greater degree than was generally acknowledged, been influenced by the camera's unique way of rendering the visual world. By 1937, the "art photography"

promoted by Stieglitz and his associates (Steichen among them) in the Photo Secession movement which deliberately imitated the effects of Impressionist and Expressionist painting, had been watered down into the codified banalities of the pictorialist salons. The pictorialists, whose photographs were frequently deliberately staged depictions of literary or popular sentimental scenes and were printed using techniques of manipulation which made them *look* like paintings, were occasionally printed in early issues of *Popular Photography*.

Before long, however, the general editorial bias of the magazine was against the "decadence" of pictorialism and for a new, more spontaneous approach to the medium that during the magazine's first decade was to be spurred on by the advent of World War II and the rise of the big picture magazines such as *Life* and *Look* with their emphasis on photojournalism. These magazines drew upon a body of highly skilled documentary photographers who were about as far as it was possible to get from the literary-romantic pictorialist mold. Many of them had worked under Roy Stryker in his Farm Security Administration project documenting America during the great depression. Among those who were not absorbed by the magazines but exerted a strong influence were

May 1937: As for the pay: a good model will earn $40 to $60 a week, plus expenses. The minimum rate is $5 for the first two hours, $2.50 for each additional hour, or $15 a day. These rates are for clothed poses. In the nude or even in seminude such as lingerie or bathing-suit shots, the fee is higher: $5 the first hour and $3 each additional hour. A good week is 10 pictures a week. Ten percent of this is paid to the Models' Registration Bureau as its commission.

May, 1937: When asked to define the term, "candid shot," Rogers *(a picture editor—Ed.)* replied: "The candid shot, which originated in England some years ago, has come to mean a photograph—usually a close-up, taken when the subject is unaware. And should show the individual in a clear and vital pose.

"It need not be humorous," he continued. "In fact it is frequently tragic."

May 1937: Photographers seeking greater speed than found in modern emulsions will be interested in the new and practical method of dry hypersensitizing with mercury vapor as developed through the experiments of Drs. Dersch and Duerr of the Agfa Ansco Research Laboratories. The technique is extremely simple and sur- prisingly effective, giving from 50- to 150-percent increase in emulsion sensitivity.

June 1937: A new flashbulb has been developed with a hydrolanium wire light-producing medium which maintains peak intensity three times as long as in the foil type, its makers inform us. The Wabash Superflash is therefore reported to yield 50 percent more illumination, and to give the fullest coverage and evenest exposure of the negative when used with Leica, Contax, and other candid cameras with focal-plane shutters.

June 1937: A new, faster roll film is Agfa Ansco's offering this month. Called Agfa Super Plenachrome, it has greater speed coupled with higher color sensitivity in an orthochromatic emulsion, more brilliance, and extreme latitude. The new film is antihalation coated and has a special surface coating to prevent scratches during handling.

July 1937: The coupled rangefinder now being a fact as an aid in focusing cameras, it is just possible that coupled exposure meters may also be a possibility in the future. Just as a suggestion as to the design of such an instrument, the future exposure meter will, by the assistance of an interlocking cam, control the possible combinations of aperture and shutter speeds for every given light intensity. This is something for our inventive readers to take into their dreams.

July 1937: There is a rule at the White House now forbidding the use of the candid camera at all. It seems that a certain photographer who shall remain nameless caught the President while he was pinching the bridge of his nose, after removing his glasses. Something we all do. A magazine published this picture with a misleading caption. As a consequence of this and other photographic misdemeanors, all cameramen are forced to use big press instruments, such as the 4x5 Speed Graphic. The idea being that it is impossible to take candid shots with this camera.

August 1937: Wonder how far this automatic film shifter idea is going? It would seem after all these years that at least one camera manufacturer would have solved the problem and placed the developed self-cocking camera in his standard line, but unfortunately this phase of camera development has been ignored.

To our way of thinking, an automatic film transporter is far more essential to camera efficiency than many of the gadgets that have recently been hung on the cameras...we predict that the successful camera of the near future will click over the film as quickly as you can push the old button.

Minox—1937

August 1937: The miniature camera, I believe, has evolved from urgent necessities felt first in motion-picture studios. It has made an important and interesting contribution to the modern art of photography. But I believe that much of its present popularity is due to its being merely the current craze. It must, I suppose, have its day. Right now you will hear its stoutest devotees say in unguarded moments that they at times yearn to have in their hands "something a little larger and easier to handle."—Journalist *Thomas H. Uzzell*

October 1937: Eisenstaedt goes nowhere without his camera. If he is on vacation, he can't enjoy himself unless

he has his Leica in his hand. Without his camera he feels as if he were blind— as if he had pads over his eyes.

Many jokes are told about the short, powerfully built, thirty-nine-year-old photographer. One of the best concerns his first trip to Paris. Mr. Daniel asked him, "Eisenstaedt, what did you do at night in Paris?"

He answered: "Why at night in Paris, I had to expose longer."

SOURCES OF PICTURES SENT TO LIFE

In round numbers, the pictures received by *Life* every week are as follows:

U.S. pictures from 4 major syndicates	3,000
Foreign and original prints from 4 syndicates	1,000
File pictures from the major syndicates	1,000
Smaller agencies and free lances	1,200
Movies and newsreel stills	300
Life staff photographers	800
Correspondents	500
Amateurs, and offerings to Contributions Editor	5,000
—or an approximate total of	12,800

Sept. 1937

September 1940: The Brooklyn Museum has started a collection of outstanding photographs which are to be preserved and handled in the same manner as fine prints of non-photographic origin. While we feel that masterpieces of photography are worthy to hang in any museum or gallery, we hate to see the burden put once more on the shoulders of photographers. True, it is an honor to be hung—or even to be kept on file—in a museum. But museums and galleries purchase their paintings and sculptures, and we see no reason why they should not do the same with photographs.

Argus C3—1939

September 1942: Every camera user who is a loyal American wants to abide by the wartime regulations for photographers. These rules have been set up to safeguard our great war effort, and are as much a part of it as precautions taken by the men on the firing line.

On the other hand, there has been some confusion among amateurs and local authorities as to just what pictures can be taken, and what ones are prohibited. To clarify this situation POPU-

LAR PHOTOGRAPHY has prepared a card summarizing the wartime regulations. This card...gives a list of restricted and unrestricted subjects, and a digest of rules governing photographers.

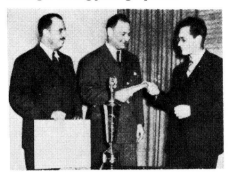

W. Eugene Smith (r.), about to join the Navy, was presented the First Prize in our 1942 Contest ahead of time.

January 1946: The new process, called the Kodak Dye Transfer Color Process, utilizes the principle of dye transfer from matrices made from color-separation negatives. However, every step in the process—from the making of the color-separation negatives to the transfer of the dye from the matrix to the paper—has been improved over former matrix color printing methods so that the entire process takes only a fraction of the time heretofore required.

January 1946: Photographic progress in 1945 was still practically entirely a matter of the war. The use of photography grew as the end approached, and its importance was clearly recognized by the military staffs. It was stated that toward the end, some 20 million prints a month were made by the U.S. forces. By far the greatest part of our knowledge of the enemy was obtained from photographs made from the air.

In his report on the winning of the war, General Marshall said that in the case of the assault on Normandy, complete intelligence gathered up to the final moment provided detailed knowledge of enemy dispositions and enabled the troops to breach the defenses. Continuous reconnaissance photography by day and night gave detailed information of enemy defenses and movements.

February 1946: POPULAR PHOTOGRA-PHY's Traveling Salons, which are made up of the prize-winning pictures from our annual Picture Contests, are available free of charge for exhibit at libraries, museums, department stores, banks, Army camps, USO Centers, or any other organization or institution open to the public.

March 1946: Another photographer with something to say is Margaret

Bourke-White. Her saying: "It is important for the photographer to know much more about his subject than appears in the finished picture. Good photography is a pruning process; a matter of fastidious selection."

May 1946: Plastics lenses are here, and they are here to stay and to benefit photography in a variety of ways. Yet they are different in many respects from what the average photographer expected plastics lenses to be.

To begin with, plastics lenses probably will not replace optical glass lenses in the smaller cameras. They become really economical only in the larger sizes—lenses of 2½ inches or more in diameter. In such sizes, and especially in the form of single-element lenses used in optical viewfinders, they are considerably cheaper than glass lenses but they are not "cheap" either in price or in the sense that they could be "stamped out" in quantity in a single operation.

June 1946

June 1946: Salons as they are now conducted are not exhibitions of genuine art, although the exhibitors too often present them to the public as such. Occasionally a work of art gets into an international salon, but by and large, hemmed in as it is by a jury system that has long since become atrophied, salons are made up of technically excellent mediocrity.

Dorothea Lange and Walker Evans, while Gordon Parks, Arthur Rothstein, and others joined the magazine staffs. It is interesting that the pictorialist and documentary trends effectively merged in the romantic photojournalism of perhaps the greatest photographer of the *Life* magazine era, W. Eugene Smith, who, in turn, exercised a strong influence on some of the best young photojournalists of the 1950s and '60s, among them Bill Pierce, Jim Karales, Charles Harbutt, and Bruce Davidson.

A distinction may be made between photographers who work strictly to please themselves and photographers who work to meet the demands of a particular client (critic Gene Thornton has identified the first of these approaches with Stieglitz and the second with Steichen). While photographers continued to do their personal work during the first decade of *Popular Photography,* the great theme was World War II and life in a wartime America, and many photographers were working either for the armed forces or for publications reporting the conflict. After the war, the rise of advertising photography was an important trend in addition to the continuing success of photojournalism in the large-circulation picture magazines.

During the 1930s and early 1940s, the towering figure in commercial photography was Edward Steichen, whose work during the '20s and '30s on the pages of the Condé Nast publications *Vanity Fair* and *Vogue* as well as his advertising work showed an unfailing sense of showmanship. He was a master of studio photography with a highly theatrical lighting style (utilizing spotlights and minimal backgrounds) that made the Steichen portraits of important celebrities of the day (as well as his fashion illustrations) instantly identifiable. Another very important fashion photographer of the first decade was Martin Munkácsi, who shot with a small camera and deserted the studio to take his models to outdoor locations where he caught them in action (frequently jumping over puddles and other obstacles) rather than in static poses. He was an important influence on later fashion photography, particularly on the fashion work of Richard Avedon. In 1941, Munkácsi was said to be America's highest-paid photographer.

During the first decade of *Popular Photography* the museums and galleries that later were to supply an important part of the audience of non-commercial photographers were only beginning to appear. Alfred Steiglitz, then in the last years of his life, had stopped photographing but continued to run the American Place Gallery which exhibited both photographers and other contemporary artists until his death in 1946.

In the spring of 1937, Beaumont Newhall, then director of photography at New York's Museum of Modern Art, organized the first of many major photographic exhibitions that were to follow at that museum. It was a retrospective titled "Photography 1839–1937." Eight years later, Steichen, who had retired from commercial work and succeeded Newhall at the helm of the Museum's photographic department, presented his monumental "Family of Man," which remains to this day a high water mark in photographic exhibitions, having been viewed by over nine million people in 69 countries and selling millions of copies in book form. The influence of Steichen's "Family of Man" was to be great, not only in opening the doors of major museums to photographic activities, but in influencing the way photographers saw the world and its people. It was a major photojournalistic event of the 1947–1957 decade.

If Steichen was the kingmaker on the humanist-photojournalism front as photography moved into the 1950s, surely his counterpart in the areas of fashion and commercial photography was an imperious Russian-born art director of *Harper's Bazaar* named Alexey Brodovitch. A man of superb taste with an unerring eye for what was original in photographic imagery, Brodovitch taught photographic workshops through which passed most of the major commercial photographers and many of the best editorial photographers of the times. The fine photographers he encouraged and first introduced to the printed page in his superbly designed issues of *Harper's Bazaar* are legion.

The 1950s were an era of great photographic ferment and creativity. Irving Penn (who had been an assistant to Brodovitch) and Richard Avedon (a Brodovitch discovery) were moving to the forefront of fashion photography, the elegant fashion and nudes of John Rawlings were setting new standards, and the work of a new commercial photographer named Wingate Paine, who later was to be one of the most innovative and successful advertising illustrators, was beginning to be seen. *Life* and *Look* and other major picture magazines were in their heyday with the work of Margaret Bourke-White, Gordon Parks, Alfred Eisenstaedt, W. Eugene Smith, and literally hundreds of other top photojournalists being published each week.

In 1947, three top photojournalists, Robert Capa, Henri Cartier-Bresson, and David Seymour, started Magnum Photos, an international cooperative picture agency which was to exert great influence over the photojournalism of the '50s and '60s by assembling many of the top talents under one roof and then getting its members the assignments which best utilized their particular abilities.

In 1954, New York's first gallery devoted entirely to photography, the Limelight Gallery, opened in the back of a Greenwich Village coffee house. It was under the directorship of Helen Gee and lasted until 1961. During its seven-year history, more than 150 photographers exhibited at the Limelight, many of the major talents of today having been shown there for the first time. The Limelight was followed by Larry Siegel's Image Gallery and Norbert Kleber's Underground Gallery. Most of these were marginal operations at best, the Limelight mostly being supported by the coffee-house aspect of the operation.

Throughout the 1950s, pictorialism was on the decline and personal photojournalism was on the upswing. Fortunes were being made in advertising photography. *Popular Photography, U.S. Camera,* and *Modern Photography*—the three major specialized publications in the field—and the *Photography Annual,* the *U.S. Camera Annual,* and many smaller publications, offered important and much-needed showcases for new talent. Photography was moving from just a popular hobby, with a few top commercial photographers and even fewer dedicating themselves exclusively to it as an art, to a wide-ranging and serious means of expression. A few were making big money at it, and many more were pursuing it with a seriousness and dedication that was unheard of little more than a few years before.

In the 1950s two books of photographs were published that were to have a profound influence on personal photojournalism. The first, in 1952, was *The Decisive Moment* by the great French photographer Henri Cartier-Bresson, and the second was *The Americans* by the Swiss-born American photographer, Robert Frank.

During the 1950s, a new popular art was on the rise which, though few realized it then, was to transform the world of still photography in the years to come. It was, of course, television.

An important part of the photographic ferment of those years was due to the technology that was being developed which allowed photographers greater flexibility and made it easier to take pictures. The growing acceptance of the 35-mm camera in professional use and the faster films that allowed the photographer to take pictures in "available light" (a term that moved into standard usage through the pages of *Popular Photography*) greatly changed the seeing of photographers and the images they produced.

If *Popular Photography*'s second decade was marked by excitement and discovery in the ways of seeing and making pictures, the third decade (1957–1967) could be said to be one of adjustment. By the late 1960s, it was becoming obvious that television was becoming the major journalistic imagemaker of our society. By the time that *Life* or *Look* could report on a news event it was already history. Everyone had seen it happen with greater immediacy and impact on the TV screen nearly a week before. The handwriting was clearly on the wall, and the great days of big magazine photojournalism were drawing to a close.

The motion-picture industry was even more transformed by the rise of television, and within a few years the old world of Hollywood filmmaking was virtually extinct. With this came a change in motion-picture technology (lighter, easier-to-work cameras, faster films, more portable lights, more manageable sound-recording techniques) that began to attract the still photographer. Many major still photographers flirted with filmmaking, usually with mediocre results. While the still photographer's eye could be useful to a filmmaker (some earlier still photographers such as Paul Strand and Cartier-Bresson had been successful as film cameramen), the photojournalist's way of thinking about the final result was diametrically opposed to the filmmakers'. Some talented still photographers like Robert Frank and William Klein entered movies only to vanish almost entirely, while others who tried moviemaking found it incompatible to their creative approach and quickly got out.

Print advertising, if not drying up, was at least being sharply curtailed by television. Some of the successful advertising photographers found work as visual consultants on TV commercials, while others became commercial producers. Some advertising photographers (like Howard Zieff, Jerry Schatzberg, and Dick Richards) became successful movie directors because, unlike the photojournalists, they were trained in creating action in front of the camera rather than capturing and distilling it as does the photojournalist. Many photojournalists went into corporate work (annual reports and

⟦ 1947-56 ⟧

September 1949: Joe Rosenthal, the photographer who made the famous picture of the U.S. Marines planting the American flag on Iwo Jima, will play a part and act as technical adviser for Republic's new film "Sands of Iwo Jima." Joe was borrowed from the *San Francisco Chronicle* through Paul Smith, managing editor, himself an ex-Marine. Only two of the six Marines who planted the flag are still living; they will be in the picture, too.

Hasselblad—1948

November 1949: The perennial argument concerning the superiority of one type of camera over another will, of course, never be settled to the satisfaction of anyone other than the partisans, but I am inclined of late to suspect that the 35-mm type—for quite a while outrun in popularity by the twin-lens reflex—is gaining ground rapidly.

The reasons for this change lie, I think, in a reviving appreciation of photography's unique principles, which distinguish it from all other means of graphic expression. I refer to the camera's distinctive ability to hold the mirror up to nature as no other medium has ever been able to do. This ability is common to all cameras, of course, but the compact miniature has an advantage over all larger ones as Erich Salomon proved 20 years ago when he introduced the Leica camera so spectacularly to open a new era in the field of European photojournalism.—*Bruce Downes*

December 1949: The means for making color photographs having been with us in one form or another for more than 40 years, I should like now to raise a pertinent question, to wit: What's the matter with color photography? I am not being facetious for, although the technical materials now widely available have improved considerably, I have seen some Lumière Autochrome transparencies made early in this century which compared favorably with modern Kodachromes. The point is that progress during four decades of extraordinary scientific advance has been surprisingly slow. Esthetically the progress has been nil.—*Bruce Downes*

July 1949: There's nothing like a little humor to brighten the day. Recently in our morning mail came a letter from Mrs. Gladys Ray of Dallas, Tx., who sent us some amusing excerpts from mail she has received in connection with her work. For several years Mrs. Ray tinted mail-order photographs; here are some of the instructions that accompanied orders for colored enlargements:

From Arkansas—"Make me one 8x10 photo of my soldier husband. His eyes are squinched closed. Will you please open his eyes and paint them blue. Also my underskirt is showing. Can you fix this?"

January 1950: An important event in the world of photography took place on November 9th at Rochester, N.Y., with the opening of The George Eastman

House, a public institute which has been set up to educate and serve everyone interested in pictures and picture making—amateur and professional photographers, and writers, editors, and historians as well. In order to further photography's means, accomplishments, and potentialities in all fields, the institute has been provided with facilities for lectures, demonstrations, exhibitions, and collections of photographs, motion pictures, and apparatus. Eastman House will be a national and international center for conferences on photography; for meetings of camera clubs and photographic organizations; for the education of school children by guided tours; for the screening of both historical and modern movies; and for other related purposes. It is a living memorial to George Eastman, and is housed in the home he built in Rochester.

Micro Myracle — 1948

April 1950: More than eight million pictures have been turned out by the Polaroid-Land (pictures-in-a-minute) process in the 13 months since the Land camera made its debut in Boston in November, 1948.

Jan. 1952: Did you notice our cover this month? Yes, after 15 years as POPULAR PHOTOGRAPHY we've streamlined our facade, simplified our name, dropped the word POPULAR from our logotype.

We published our first issue in May, 1937, and instantly became THE popular leader in the field of photographic magazines...

Such popularity, we reasoned long ago, hardly needs an adjective to de-

scribe it any more than gold need be called "genuine"...

Henceforth your favorite camera magazine will be known simply as PHOTOGRAPHY. (After some months of having almost everyone still refer to the magazine as "Popular Photography," "Popular" was officially restored to the title...*Ed.*)

January 1952: (Letter from a soldier/reader) I'm making this request in answer to many pleas. We'd like to get pictures from your readers—pinups—and an appreciative audience is assured. We are in the Korean area and

Fifteen years of covers: top to bottom—May 1937, November 1941, July 1942, February 1944, March 1946 and January 1952.

"I can't understand it, Martha...I've always made the best tintypes to be had."

have little chance to augment our tiny supply of reminders that such lovely creatures as the American female do exist; we have been out here for 10 of the past 13 months and are scheduled for at least another half year. A bumper crop of femme photos would make it easy to supply every division aboard ship. Thanks in advance to anyone who can send pictures.

May 1954: A new and rather unexpected solution to the wide-angle lens problem recently turned up in Japan—the Panon camera. This is a compact instrument of unusual design which combines the wide sweep and even illumination of the old-fashioned panoramic camera and the instantaneous action-stopping features of a portable camera with a fast wide-angle lens.

September 1956: Sometimes our contributors express understandable ds-appointment that we can't give them detailed criticism on pictures and stories that we return to them. One ingenious fellow in the armed forces attempted to pin us down; with a selection of color slides, he enclosed a card headed, "Check one or more and return, please." There was a row of boxes down one side, with these alternatives:

Good, but not good enough
Fair, try again in 5 years
Superb; sorry we can't use them
Whooee—go back to black-and-white
Perhaps you should take up the yo-yo
Nice mounting job, very neat
Check enclosed for $_____

Trouble was, none of the lines exactly fit his pictures; we wouldn't decide which box to check. But we kept the card, anyway. ○

such) and continued to work on book projects and on the many smaller publications that continued to flourish and regularly used photographers.

As the '60s drew to a close and *Popular Photography* entered its fourth decade, the world of photography was rapidly changing in terms of outlets for creative work. The big magazines were gasping their last (*Life* was to expire in 1972, and *Look* was soon to follow), and much of the advertising dollars had switched from print to television. Many major museums had photographic collections, and such institutions as New York's Museum of Modern Art, which once had been in the vanguard of photography with new and exciting exhibitions, were absorbed into the establishment mainstream, offering an important research facility and an occasional exhibit of interest, but with little vitality either as makers or reflectors of what was happening in the medium. Photographic galleries were on the upsurge in the early 1970s marked by the opening of the Witkin Gallery in 1969, followed by innumerable others. At least for a few gallery operators the sale of photographic prints (frequently of historical value by photographers long dead) was becoming big business, and for the first time a select group of living photographers was able to make a decent living out of the sale of prints.

A major phenomenon of the '60s and '70s affecting both the art and the business of photography has been the meteoric rise of photographic academia. Just at a time when the commercial outlets for photographs are either shrinking or radically changing, the schools are producing competent photographers at an unprecedented rate. During the first three decades of *Popular Photography*, there had always been some major teachers of photography and stories about them had regularly appeared on the pages of the magazine. The Brodovitch course was legendary. Lisette Model had, for many years, taught a deservedly renowned course at New York's New School for Social Research (among her students was Diane Arbus). Ralph Hattersley's courses at the Rochester Institute of Technology had graduated many of the top photographers of today. Many photographers such as David Vestal, Ray Shorr, Berenice Abbott, and Harold Feinstein, had taught private classes in their studios. But by the mid-60s, almost every college, university, and art school in the country was moving rapidly into photography. Photography was contemporary "instant art." It did not require the long training of the other graphic arts to come up with at least a recognizable image that *someone* might like.

Where were all these new photographers to go? Many (or probably most) were not interested in commercial work, and even if they had been, the immediate market for their work seemed smaller than 20 years previously. In their academic environment they were encouraged to express themselves (a perfectly legitimate academic pursuit), and many of them had become proficient at this. The only problem was (for those unfortunate enough not to be independently wealthy or have spouses who worked) how to make a living when the school years were over. The answer was simple. They would become teachers of photography and then, in their nonteaching hours, be able to "do their own thing" in the medium they loved, while teaching others to be photographers who, presumably, would also someday become teachers so that they could pursue their artistic goals unhampered by commercial demands.

This approach which, so far, has worked for many, would seem to be limited only by a slowdown in the rapid expansion of photographic teaching in the last few years. I suspect that signs of this inevitable slowdown have already begun to appear.

What does all of this mean, at the beginning of *Popular Photography*'s fifth decade, in terms of the quality of photographers and their images?

First, it means that the overall quality of photographers will be higher. This, I believe, is becoming increasingly obvious to anyone who, as I do, deals with many photographers and their pictures on a day-to-day basis. With all the high-quality work of new photographers (particularly young photographers), there seems to me to be fewer who stand out as having a unique vision. One reason for this may be that young photographers are seeing more pictures than ever before. The influences of certain contemporary photographers upon them seem obvious—Ralph Gibson, Duane Michals, the late Diane Arbus (who even seems to have influenced an old-timer like Avedon, I fear, not for the better) come immediately to mind. All of these photographers have powerful personal vision in their work, and it should not be too surprising that young photographers are, at least in the early stages of their creative life, more influenced by what they have seen (alas even in the pages of *Popular Photography*) than by what they see. The fact that many of these photographers have had an academic training under teachers with a strong

personal style (Jerry N. Uelsmann, Harry Callahan, Arnold Newman, etc.) often means that they will emulate the seeing of their teachers even if, as in many cases, the teacher has tried hard to avoid this. Emulating a master in the early stages has a long and honorable tradition in the teaching of art, and there is nothing wrong with this as long as the academically trained photographer eventually finds his own way of perceiving and photographing the world.

Also, because of their academic training, many of these young photographers are more concerned with defining (or redefining) the medium in terms of what it can do most effectively than were their nonacademically trained predecessors. They are also concerned with expanding the medium through the use of any expressive technique at their disposal, in order to communicate their images with the maximum impact. This, happily, is happening without the artist having to modify those images to the particular demands of the marketplace.

There will be always, of course, those who play their photographic skills strictly for their editorial or advertising clients and those who have mastered the creatively schizophrenic trick of producing work for their clients on one hand and work for themselves on the other (some excellent photographers like Elliot Erwitt have been masters of this for many years). Still others will support themselves by teaching and still be able to do their personal creative work. Even fewer will live by the sale of their prints in galleries or from the revenue from their photographic books. More photographers in the next decade will, I suspect, make their living entirely out of photography and still be creative photographers in their spare time. This is not easy, but it also is not impossible; we must remember that William Carlos Williams was a doctor and T.S. Eliot a publishing executive.

If photography as an art, and perhaps even as a business, is healthier for all of the radical changes that have taken place over the last four decades, I can only hope that it will be reflected in the images photographers produce in the years to come. If it is so, the jobs of those of us who search for those images, and even occasionally publish them, will be happier and more rewarding for it.

⦃ 1957-66 ⦄

POPULAR PHOTOGRAPHY

Apr. 1957: It wasn't too many years ago that the world knew next to nothing of the Japanese camera industry. Today, Japanese cameras and photo products not only are exported in substantial quantities to the United States, Europe, South America, and other world markets but have made a tremendous impression on photographers all over the world...

There are several reasons why and how all this came about, but none so fundamental as the fact—often underestimated—that the Japanese for decades have been among the most avid camera enthusiasts in the world....

Most photo fans by now know the meteoric rise to international prominence of Nippon Kogaku's Nikkor lenses, following their outstanding performance in the hands of photographers covering the Korean war. POPULAR PHOTOGRAPHY was the first of the American photographic magazines to break this story. Norman C. Lipton reported on these lenses in *Tools & Techniques* (February, 1951) and in his article on David Douglas Duncan in the March, 1951, issue, Bruce Downes described that *Life* photographer's experiences with the up-to-then unknown Japanese lenses.

Apr. 1958: Two responses to the question, "Do you think photography is getting easier or harder?" were:
Louis Stettner—"Easier and harder," to me, depend on enthusiasm for meaning. With enthusiasm the hardest job becomes easy. Technically, photography is easier, since better cameras and films are available. Also, stimulating photographic climate—typical of today with more fine photographers around and good work more readily acceptable—makes work easier.
Arthur Rothstein, Look magazine—It is

becoming easier to obtain a visual record. However, with the progress in photography, the techniques that must be mastered for exceptional success have become increasingly complex. The public's more perceptive visual mindedness means that the creative aspects of photography require increasingly higher standards making outstanding photography difficult.

May 1958: A poll of 243 critics, editors, professional photographers, and other experts had produced the following names on a list of The World's 10 Greatest Photographers: Ansel Adams, Richard Avedon, Henri Cartier-Bresson, Alfred Eisenstaedt, Ernst Haas, Philippe Halsman, Yousuf Karsh, Gjon Mili, Irving Penn, W. Eugene Smith.

Aug. 1958: In the eyes of editors in close touch with the photographic output of amateurs and professionals over the last decade there has been a conspicuously steady decline in photographic quality. Too much work today betrays a kind of feverish haste as if photographers had been actually shooting on the run in mass disregard for all the inherited technical niceties of the craft. One has only to take a look at some of Dr. Erich Salomon's fine available-light pictures made in the '20s to realize that too many photographers not only have

not kept pace with the vast improvements in cameras, lenses, and emulsions made since that time but have actually fallen behind.

New from Russia: the Leningrad, Oct. 1958

Oct. 1958: An article titled "Is This Tomorrow's Camera?" predicted the following features for cameras of the next 10-15 years: 35-90-mm zoom lens, solar battery-plus-printed circuit for automatic diaphragm control, meter-photocell angle to vary automatically with that of zoom lens, electric-motor drive for either sequential or individual exposures and automatic rewind, drop-in loading, built-in electronic-flash ring lighting. On the coming cameras, said the seers, one press of the exposure button would produce: exposure, automatic film advance, film-counter advance, and shutter cocking. Also expected: a universal color-negative film—fast and with tremendous latitude; it would produce both color and black-and-white prints and color transparencies.

Feb. 1959: Asked whether the 35-mm camera would replace the (4x5-in.) "press" camera in newspaper work, two photographers said:

Dick Sarno—Most papers have 35-mm cameras for special features and for use when they have sufficient working time, but for the quickie, the fast-breaking news story, the 4x5 is a workhorse

which will be around for a long time because of the ease of editing and the speed with which the picture can be processed. Thirty-five millimeter is, however, a growing trend because it lends itself to shooting sequences and to working for dramatic candid results under existing-lighting conditions. This trend is the result of major modifications in small cameras which have made them almost foolproof.

Ernie Sisto—The 35-mm is ideal for certain assignments, but it will be a long time before it replaces the press camera entirely. For architectural assignments, where perspective and distortion must be controlled, there is no substitute for the big camera. I also prefer it for sports because I can see and follow action more freely than with a 35's optical finder, and the large negative makes it easy to blow up a small section. Finally, for one- or two-shot assignments, the 4x5 is best because of the ease of selecting the proper negatives to print.

Olympus Pen—1959

Feb. 1959: Photography is afflicted with more than its share of mumbo-jumbo, a fact that has kept as many people out of the hobby as it has lured in... And in recent years the manufacturers themselves have contributed to the confusion by designating their products with a numerical and alphabetical cryptography that is awesome, to say the least.

One wonders how many potential hobbyists never get past the hurdle of this formidable letters-and-numbers game. The following, for instance, are a few culled at random from advertisements in a recent issue of POPULAR PHOTOGRAPHY:

Keystone 511, Yashica LM and Yashica 635, Praktica FX3, M5 flashbulbs, Leica M3, Leica M2, and Leica 3g, Canon VI-T, Revere 888D, Revere 555 and Revere CA-3, Nikon SP and Nikon S3, Bolex 20/20, Bolex C-8S and Bolex H-8T, Exakta VX-IIa, Ilford HP3, and the Samoca L28.—*Bruce Downes*

March 1959: The world's tiniest flashbulb, an all-glass, pellet-sized package of power that delivers as much light as lamps four times its liliputian dimensions, was recently previewed before a group of photo editors and technical writers air-lifted to General Electric Company's fabled Lighting Institute at Nela Park, Cleveland. Called the "All Glass" flashbulb, the new zirconium-filament lamp does away with the conventional metal base, having instead a flat-ended glass base through which two contact-wires protrude.

Oct. 1964: After several postponements, Beaumont Newhall's revised edition of *History of Photography* will be published in mid-October by the Mu-

seum of Modern Art in collaboration with George Eastman House of Rochester, N.Y. Many new photographs in it have never been published in the U.S.

Dec. 1964: Agfa Rapid System or Kodapak cartridges?: Japan's 12 leading manufacturers are said to be leaping on Agfa Rapid System bandwagon, because of easier camera-production process, and no royalty payments or charges for use of patents. Kodak patent use involves $2,500 initiation fee and 5 percent royalty, but patents cannot be used until 1966. (High-royalty approval for remittance of dollars is difficult to obtain.) Trade expects many newcomers to photography because of these easy-to-use systems.

Kodak Instamatic 100—1963

Apr. 1965: Wilson Hicks, former *Life* picture editor, had several observations about photography and photographers:

I sometimes feel that today's photographer should be more a writer than a painter. More than in painting, he should find his creative stimulus in literature—in the quick image of poetry or the narrative and descriptive meaningfulness of prose.

Much of the thinking on newspapers and magazines is done by word men. The photographer has not become a real part of the editorial family.

Taking a picture is an emotional act. Judging a picture, essentially, is an intellectual act. A photographer is a victim of his own emotions.

I remember one man telling me, "You raised the prestige of the photographer one notch above the job of the professional wrestler."

A photographer doesn't know his best pictures. Taking pictures is primarily an emotional experience. He's involved with the difficulty of shooting—sometimes hanging by his heels to get a picture. Later when he looks at the picture, he brings all that went into the situation to the picture. ○

The Way We Were in 1937

Bob Schwalberg

A nostalgic look at the cameras, lenses, films, and flash that Popular Photography readers used to use— and how they evolved into what we have today

Popular Photography was born in Chicago in 1937, at the dizzy heights of the Great Candid Camera Craze. These were exciting times in which photographers had to struggle against technical limitations that have been almost forgotten today.

Films were slow and grainy, exposures long and hazardous. Fast lenses were few, costly, and charmingly imperfect. Cameras were only beginning to embody the refinements and conveniences that we now take for granted.

In 1937, amateur and professional photographers worth their hypo were pioneering a future that we enjoy today. They were improvisors and experimenters who forced the medium forward into the turbulence of the 20th century, against the dark skies of European fascism and American depression. They made of it an informing, crusading, analytical, and sometimes even amusing witness to the human condition.

Led by little 35s like the Leica, the Contax, and Retina, and relatively compact roll-film designs like the Rolleiflex, Korelle Reflex, and Super Ikontas, "miniature cameras" were becoming more numerous, and their adherents more daring.

Lenses were plentiful even then, with focal lengths from 28- to over 500-mm, and some were a lot faster than one might imagine today. For the Leica there were 50-mm f/1.5 Xenons and Summars, plus a 73-mm Hektor f/1.9. Its prestigious Zeiss Ikon rival, the Contax, flaunted its sensational Sonnars, including a 50-mm f/1.5 and an f/2, plus a magnificent 85-mm f/2.

The legendary Bentzin Primarflex, a 2¼-square roll-film ancestor of the modern Hasselblad, could be had with a 125-mm Astro (Berlin) Tachar f/1.8. High-aperture lenses were as exciting as the then new superheterodyne radio receivers, and just as necessary. However, the majority plugged along at f/4.5 and f/3.5, and the 28-mm wide-angles from Leitz and Zeiss were a mere f/6.3 and f/8, full out.

The fastest film made in 1937 was Kodak's Super-X, Weston-rated at 32, and yellow-boxed only in 35-mm and No. 828 rolls, the old 28x40-mm Kodak Bantam format. ASA ratings didn't come until 1947, and have twice been revised. In our modern system, Weston 32 translates as ASA 40, meaning that the 1937 "miniaturist" had to give *10* times your unpushed 1977 ASA 400 Tri-X exposure!

Other formats had to settle for film of a bit less speed, but they had great names like Kodak Super-Sensitive Panchromatic, Agfa Superpan, and that model of diffident British understatement, Ilford Hypersensitive Panchromatic. Shakespeare was doubtlessly right about roses, but I'm not sure

that his principle applies to naming films.

Color was acoming. The first genuine "integral tripack," with three color layers sandwiched together, was Bela Gaspar's Gasparcolor, produced with only moderate success in Berlin in the mid-1930s. Then came Kodachrome and Agfacolor, both available in 35-mm format the year *Popular Photography* was born, and the race was on.

"Shooting Our Cover in Color" was a monthly *Popular Photography* feature, always with the page reference printed prominently beside the illustration. The first, for May, 1937, was made by Stanley Young, using a 3¼×4¼-in. "one-shot" color camera of his own design, which he valued at $1,200, a lot of money for those depression days.

Cameras of this special type were loaded with three sheets of black-and-white film (Young used Ilford Hypersensitive Panchromatic) to produce three black-and-white "separation negatives" from the same exposure. Semitransparent mirror beam-splitters divided the light to each of the three negatives, and three filters separated images from the blue, green, and red regions of the spectrum. The system was cumbersome, but very good, and it persisted until the late '50s, or perhaps even longer.

Our second cover, for June, 1937, was a 35-mm Kodachrome shot by an amateur, W.S. Seegers, on a sunny Florida beach. Seegers used a Leica "G" (the USA-only designation for the then-new Model IIIa) with a 50-mm Summar f/2 lens, exposing in very bright sunlight for 1/100 sec at f/5.6.

Seegers' shot was actually a retake. His first pictures were made on Dufaycolor, a British material that used a single-layer, geometrical, three-color mosaic produced by a mechanical printing process. This additive color film was responsible for a lot of good pictures, but wasn't really sharp, which was the reason why our 1937 editors had to reject Seegers' first try, and why the process finally died.

Kodachrome and Dufaycolor were both rated at Weston 8/(now ASA 10) for daylight exposures. A "night filter" for tungsten illumination chopped this to Weston 3, a bit less than ASA 4.

As experience with color films of the day, and a lot more with black-and-white materials, accumulated, two things became clear. Fast lenses weren't much help if they needed to be stopped down to small apertures for increased depth of field, with slow films dictating very long exposures. And fast films were worth little unless backed by fast lenses, because the object wasn't to make some kind of a picture possible with 1/4-sec exposures, but to permit practically hand-holdable shutter speeds with at least moderate action-stopping potential.

Like the naval race then running between gun power and armor plating, an impractical imbalance occurred whenever one of the two became very much stronger than the other. And in 1937 the lens was ahead of the films in speed, although the resolving power of the best films of the day—slow, contrasty black-and-white materials of about Weston 12 to 16 (ASA 15 to 20)—were better than many of the lenses.

In 35-mm, the lens wars were fought largely by Leitz and Zeiss. Leitz took the position that high-speed optics for the small 24×36-mm format must be very well corrected, with only small amounts of residual aberration. This meant the use of the so-called Gauss type of construction including many air-glass interfaces. They therefore built the six-glass Summar f/2 with eight interfaces, and the seven-glass Xenon f/1.5 with 10 interfaces.

Carl Zeiss took an almost opposite view. They felt that high-speed lenses for a small film format intended for high enlargement ratios must, above all else, have a very high image contrast. And because the lack of contrast was due largely to reflections from the air-glass interfaces, their lenses would be designed to have the smallest number of surfaces possible.

The high-speed Zeiss Sonnar lenses, 50-mm f/2 and f/1.5, and 85-mm f/2, were complex triplets, six glasses for f/2, seven for f/1.5, but with only six air-glass interfaces.

The Zeiss lenses soon won a reputation for extreme brilliance, the Leitz optics for exquisite resolution of small details. It appeared that photographic optics had reached a point of either/or, and things might have stayed this way except for one thin little invention: lens coating.

Coating changed the picture. Thin metallic films applied to lens surfaces by Smakula of Zeiss, and Chamberlain and Strong in the U.S., suppressed air-glass reflections to a small fraction of their original strength. Now the coated surfaces of a complex lens design gave less image-degrading reflection than simpler uncoated optics.

More surfaces could therefore be tolerated, and the path of optical design led clearly to the highly correctable Gauss types. The Sonnar became a type for longer focus lenses only, sometimes with

((1967~77))

Mar. 1967: This is the essence of a work of art: that you never touch bottom. If a picture has for everybody exactly the same meaning, it is a platitude, and it is meaningless as a work of art. The same is true for a portrait: if it is not rich in character and meaning, it is a poor portrait.

Another essential quality of a portrait is its honesty. You falsify reality by imposing your ideas. Even by putting your subjects into unfamiliar poses, changing the tilt of their heads or by arranging their hands, you lose some part of the truth. I, however, want the people I photograph to be as they are.—Photographer *Philippe Halsman*

June 1967: Cadmium-sulfide (CdS) has all but replaced selenium (Se) in photocells for photographic light meters. Though the CdS cells require an external power supply in the way of a battery, they are capable of a sensitivity about 1,000 times that of the selenium cell. A thousand-fold increase is hard to beat.

Sept. 1967: If we lose the meaning of an expanding reference point, one which does not attempt to define the existence of things, but tends to establish a greater interrelatedness of things, then understanding might exist on less temporal terms.—Photographer *Nathan Lyons*

Oct. 1967: An article on spirit photography said: From England, spirit photography spread to France where it was first popularized by a Paris medium called Buguet. His profitable trade ended in 1875 with his arrest. Buguet

Rollei 35—1966

made a full confession and was sentenced to a year in prison. During the trial he explained in detail how he had first used assistants to produce spirit faces, but his business had grown so fast that he could not keep using the same faces over and over again. He rigged up a mannikin which he would drape in various ways and on which he placed various heads. *Scores of his clients flatly refused to believe him.* They insisted in court that the blurred spirit faces on their portraits were actual photographs of departed relatives. Spiritualists of the day branded the trial a Jesuit conspiracy in which a genuine sensitive had been bribed to make a false confession.

Jan. 1971: Society gives culture award: Beaumont Newhall, director of George Eastman House, and L. Fritz Gruber, head of the cultural section of *photokina,* have been awarded the 1970 Culture Prize of the German Society of Photography.

July 1972: If the rangefinder camera is supposed to be dead, or on the way out, then perhaps someone ought to be told about it. But, as you see, that would indeed be a fabrication. From top classic 35-mm models such as the Leica M4 and M5, rangefinder cameras range through the new breed of relatively inexpensive compacts, to rugged and versatile press cameras, to specialized stereo and sequence models. As you can see, they're alive and kicking hard.

July 1973: At 90, Edward Steichen was quoted as saying: When I first became interested in photography, I thought it was the whole cheese. My idea was to have it recognized as one of the fine arts. Today I don't give a hoot in hell about that. The mission of photography is to

explain man to man and each man to himself. And that is no mean function.

Dec. 1973: The tintype—a species of photograph as American as the Gettysburg Address—has returned to the old campgrounds more than a century after its heyday....

The process has recently been revived by several latter-day practitioners of the tintypist's art. Among them is Doug Elbinger ... dedicated to the rebirth of the process....

Last July 4 weekend, at Little Round Top Farm on the Gettysburg battlefield, he set up his darktent and tintyped scores of boys and men in Civil War uniforms.

Polaroid SX-70—1972

April 1975: At an opening preview of New York's International Center of Photography November 14, 1974, a giant arc searchlight beamed at the imposing facade of a Fifth Avenue mansion. Celebrities poured into the marble halls— an elite assemblage of photographers, critics, and personalities renowned in society and finance. An event of the first magnitude in the world of photography, it was Cornell Capa's moment of triumph—for his "impossible dream," dimly perceived a generation before, had become a reality.

Canon AE-1—1976

April 1976: In the United States upwards of 90 percent of all film used is color emulsion: print film, slide film, or "instant" color. (When did you last see a family snapshot or home movie in black-and-white?) ●

Nixon by Halsman — Aug. 1973

apertures as high as f/2, but more usually f/2.8 or f/4.

As far as really high-speed objectives were concerned, the Sonnar was doomed by the new freedoms afforded by lens coating, and Zeiss now turned back to the Gaussian concept with the high-speed Biotar for 35-mm cameras at about the same time *Popular Photography* first appeared.

But the precision miniature that received the Biotar wasn't Zeiss Ikon's redoubtable Contax, but an outsider. Beginning in 1935, the Dresden firm of Ihagee produced a small single-lens reflex called the V.P. Exakta. It wasn't a 35; V.P. was the internationally recognized abbreviation for "vest pocket," and in photospeak this meant eight 3× 4-cm exposures on No. 127 paperbacked roll film.

The first 35-mm, or "Kine" Exakta, appeared in 1937, and the first ad for this pioneer SLR appeared in our July issue of that year. This asked the reader to "Check the important features of the Exakta":

Regular speeds from 12 seconds to 1/1000 part of a second.

Delayed-action shutter from 1/1000 part of a second to 6 seconds.

Interchangeable lenses.

Film transporting lever for changing film quickly.

Shows image right side up.

NO PARALLAX.

Except for the last point, and because it was put last, this ad shows that the Exakta's makers never realized that they had taken a bold step toward revolutionizing 35-mm photography. But nobody else did either.

This was hard to see in 1937 because there were many single- and twin-lens reflex cameras, and almost all had better viewfinders than the Exakta —simply because they were bigger. Looking down into a waist-level hood at a groundglass screen measuring only 24×36-mm wasn't much fun. Today, some modern SLR systems offer accessories for doing this, but only as optional problem-solvers for special applications. If the 35-mm SLR had stayed with its original waist-level viewing system it would probably have survived only as a minority camera for technical and macro photography.

But it didn't. Just before the second world war, Carl Zeiss devised a new kind of "pentaprism" with a roof to reverse the image from right-to-left. This brought the image up to eye level, erect, unreversed, and of course, parallax-free. However, the first of the truly modern eye-level 35-mm

SLRs didn't appear until after the war, as the Contax S, Exakta V, and the Praktina.

A new and innovative voice began to be heard in the late '50s, when Japan entered the SLR lists. Asahi Pentax—then Asahiflex—introduced the instant-return mirror; now there was no black-out after each SLR exposure. Mamiya coupled this with an instantly returning aperture, eliminating the need to close down before each exposure and reopen for further viewing. Nippon Kogaku, whose rangefinder Nikon models ran a tight race with the Leica and the Contax, put all these things together in an incredibly interchangeable design, the Nikon F, which made it possible to personally tailor almost every aspect of the camera to the photographer's needs of the moment.

Because of the triumph of 35-mm, the little postage-stamp format that came to dominate so much of still photography, we tend to think of the developments of the '30s and afterward too much in terms of the Leica-Contax and later rangefinder-reflex rivalries. But it wasn't that way at all.

These were years of rapid development in every branch of photography, and none was more important than the paper-backed roll-film formats from 3×4- to 6×9-cm. Greatest of all were the Rolleiflex and Rolleicord twin-lens reflexes, and the former is still being made, and widely used today. But even here, the Rollei wasn't alone. Magnificent twin-lens 2¼-square cameras were built by many other firms including Voigtländer, in whose Superb the upper viewing camera actually tilted downward as one focused to nearer distances, in order to compensate for parallax.

And there were many wonderful single-lens roll-film reflex cameras as well, offering batteries of interchangeable lenses that rival those of a contemporary 2¼ × 2¼-in. SLR. Both camera types, 35-mm and 2¼-square, were rich on the optical long side, poor in short-focus lenses.

Because the reversed telephoto, or "retro-focus" lens hadn't yet been invented—this had to wait for Angenieux, Paris, in the early '50s—the only wide-angles were 28- and 35-mm lenses for Leica and Contax and, of course, the great classical large-format designs like the wide-angle Dagors and Protars, to say naught of the incredible Hypergon, which gave a rectilinearly corrected field of almost 140 degrees when stopped down to f/22.

The main thrusts of the '30s was toward more speed and greater focal length. "Reaching Out with the Miniature," by our still very active con-

tributing editor, Jacob Deschin, appeared in the very first issue of *Popular Photography* listing longer-than-normal lenses then available for the Leica, Contax, V.P. Exakta, Plaubel Makina, National Graflex Series II, Bentzin Primarflex and Korelle Reflex.

This is a three-to-one ratio against 35-mm, four of the six interchangeable lens cameras in Deschin's 1937 story being roll-film (or roll- and sheet-film) models, with formats from 3×4- to 6 ×9-cm. These were the relatively compact cameras that fought the last-ditch battle against the flood of 35s that was building. Not the "real" cameras whose formats began at 3¼×4¼ and 4×5 inches.

The roll-film camera, and the 2¼-square type in particular, offered a widely acclaimed "sensible alternative" to the perils of 35. Then as now, because the roll-film camera is still very much among us, the argument was better utilization of film quality through reduced enlargement ratios. It is still a potent anti-35 argument (witness the current popularity of the 4.5×6-cm format), but not nearly so devastating today as yesterday.

Even when I became a photographer, in 1947, everything was compared to the Rollei. No matter how good your 35-mm technique was, your enlargements never had that "Rollei quality." This was simply the painful difference between getting up to 8×10 in. by stretching the 24×36-mm negative nearly eight times, the 2¼×2¼ only four times. In this sense there is still no argument against format.

But the people who worked in previous decades had a much tougher fight. Films with any pretensions to speed were incredibly grainier than those we have today, or even those we had in the late '40s and early '50s.

There were two principal approaches to the grain and glop of the '30s and '40s. Most followed the leadership of such pioneers as Dr. Paul Wolff in Germany and Harry Champlin in the U.S., who advocated overexposure and underdevelopment, using a formula laden with silver solvents, such as Champlin 15 and Sease No. 3. Secret recipes and patented panaceas were often based on the combination of paraphenelenediamine with glycin, sometimes augmented by a bit of metol, and loaded with pure solvents, like the thyocyanates.

All this accomplished a blurring of the grain, by dissolving away the sharp edges of silver clumps, leaving little sharpness and less speed. But people believed in this as a religion, and famous books like Champlin's *Brilliance, Gradation and Sharpness* were read as tracts, although notable for not demonstrating any of these attributes.

The other group of 35-mm fanatics took their stand for image sharpness, and were willing to accept the inherent graininess of their films. This meant using one of the slower, finer-grained materials, giving an adequate minimum dose of exposure for shadow density, and processing in soft-working developers free from any silver solvents, save sodium sulfite. These were the D-76 people.

In the end it was the photo-chemists who paved the way for 35 by getting the speed up and the grain down. In the very beginning almost all the film companies opposed 35, but once the ice was broken by Perutz, who agreed to spool their high-resolution, fine-grain *Fliegerfilm* (aerial film) in 35-mm, and Agfa introduced a commercial cartridge to fit all but the very earliest Leica cameras (these had to have a smidgeon of protruding metal removed, much to the contemporary dismay of collecting maniacs), the big companies showed an amazing partiality to the little format.

Eastman Kodak, for example, introduced their fine line of folding Retina 35s beginning in 1934, and later packaged the perforated fodder in yellow boxes marked "For Retina, Contax, and Leica cameras." Super-X, the first of the mighty line we now know with three Xs, was initially spooled only in 35-mm cartridges and No. 828 rolls. Kodachrome went the same way, except for large-format sheet sizes (until 1951), and was never offered in any of the "sensible" roll-film formats.

They even pioneered in fine-grain development an obvious offshoot of their interest in the professional movie-film market. Kodak D-76, first announced as an unpackaged formula in my own natal year, 1927, was followed by DK-25, D-23, DK-20, Microdol, and Microdol-X, all in this line.

The early issues of *Popular Photography* constantly published achievements in 35-mm available-light work, beginning with Pat Terry's "Shooting the Burlesque From the Center of Baldhead Row," in May, and "Our Candid Cameraman (M. Robert Rogers) Goes to the Circus," in June (both 1937).

Pat Terry went to Minsky's armed with "a Contax camera, list price $399" to shoot Agfa Superpan (Weston 24/now ASA 32) with his 50-mm Sonnar f/1.5 full out, at 1/50 and 1/100 sec. He used a Weston light meter, but not for theatrical work, warning his readers: "Don't ever use an ex-

posure meter in the theatre. You have no time for it. You have to learn the *feel* of timing if you want to develop into a real candid theatre photographer."

M. Robert Rogers took a Leica to the circus, using "the new Xenon f/1.5, latest and speediest of the 50-mm lenses." Using the fastest film then available, Kodak Super-X (Weston 32/now ASA 40), he shot under the spotlights at f/2 and 1/20 sec. Today's ASA 400 standard would bring this to a comfortable 1/100 sec at f/2.8.

Terry and Rogers were photocreatures of their times, and both used secret developing formulas that could not be confided to our readers, or their competitors. Terry apologized for the secrecy of his concoction "which I cannot make public," and Rogers was willing to say only that his recipe was "a metol-paraphenelenediamine-glycin formula, but "truthfully a slight refinement of the widely used Edwal-12." He then goes on to say that his preference had changed to Champlin-15, "which provides an ideal combination of a fine grain and superspeed developer." This is the stuff of which darkroom legends are made.

Another kind of light that became widely available in the '30s was the flashbulb. Previously, photographers had risked losing fingers with flash powder fired in open pans. The magnesium-filled flashbulb stuffed full of shredded foil, and ignited by battery current (if your flash cord functioned), ended this risk. With it came reflectors placed behind the lamp to increase the throw about eight times, or three f-stops more than the naked lamp.

A flashbulb doesn't reach its peak light output instantaneously, as Dr. Edgerton's xenon-filled electronic-flash tubes almost do. Instead, it introduces a delay, measurable in milliseconds, before it peaks. In the '30s, '40s and '50s, there wasn't a photographer worth his hypo who couldn't quote peaking delays for the GE, Wabash, and Sylvania lamps.

To make these peaks coincide with the fully open aperture of an interlens shutter required the genius of such as Heiland, Mendelsohn, Kalart, Burvin, and many other inventors of patent flash synchronizers. Between-the-lens shutters could be synchronized by one of these electro-magnetic devices that fired the lamp first, and then, just at the right millisecond, the shutter.

The focal-plane shutter created great difficulties, however, because its flying slit might give short effective shutter speeds, but always took too long to complete its edge-to-edge travel. Thus, for a very long time the magic of flash synchronization belonged to the interlens camera, and the champions of 35 with their curtain shutters were sadly disadvantaged, although a small museum would be needed to house all of the incredible Rube Goldberg contrivances invented in attempts to solve this problem.

Particularly in the United States, photography moved into the era of multiple-extension flash in which it was considered almost rude, and clearly unprofessional, to blast a subject with less than at least three flashbulbs. The flashbulb had a profound effect on the technics and aesthetics of photography that were not to be changed until the closing phases of World War II.

Most of all, the flashbulb created a new image of the press photographer, with his gunned-up Speed Graphic, back-angled headgear, and dangling cigarette. Newspaper people held onto their mighty 4×5-in. Speed Graphics far longer than the admirals were able to retain their battleships, or the generals their cavalry regiments.

Some claimed that this was because of the superior image quality of a big 4×5-in. negative. Others thought that only the Graphic was strong enough for the rough and tumble of press photography. But the truth was apparently different: with a big, fat flashbulb in a wide reflector, camera focus set to about 12 ft., lens stopped down to f/16, and shutter at 1/100 sec, the press photographer had a really fool-proof professional box-camera that could hardly miss. No matter that few pictures showed any background, or that most victims appeared as facing the third degree, the Speed Graphic plus flash gave a kind of security that went back to the womb.

A new image of the press, and now the "magazine photographer," was born of the advanced 35-mm cameras with wide-eyed optics and improved high-speed films. By the end of the '50s, available-light photography was rapidly receding into terminological meaninglessness, and all that was left was the photography with which it all started. To paraphrase Sir Isaac Newton's famous statement, "If we see far today, it is because we stand upon the shoulders of giants."

Personalities

Secrets? I Have None– Says Eisenstaedt

Florence S. Meetze

From button salesman to world-famous photographer is a long road, but Eisenstaedt found a shortcut—he saw everything as a picture

Small, friendly, frank—Alfred Eisenstaedt is a man who lives in his eyes.

This brilliant German photographer, thrice wounded and thrice decorated in the World War, sees pictures in his brain. When he starts out to take a series of photographs, he can actually visualize them as they will appear when they are published in a magazine. That is why he is considered by many to be the ablest cameraman of the day.

Mr. Eisenstaedt, whose pictures have become tremendously popular in the United States during the past eighteen months, was interviewed at his studio at the Pix Publishing Company, New York, of which he is a partner. Eisenstaedt is also a staff cameraman for *Life* magazine.

"I have taken many pictures," the minute but mighty photographer began shyly. "I have had the good fortune to make photographs of many prominent people," he continued. "Kings, premiers, dictators, film stars, radio singers, Eastern potentates, and," he smiled, "of course, Shirley Temple, and Mickey Mouse.

"I go many places. I photograph many people. And they so kindly write their names in my autograph book. See!"

He opened a book expensively bound in hand-tooled Italian leather. "Here is the signature of King Gustave of Sweden," he exclaimed. "And here are the names of the Crown Prince of Sweden and his wife and daughter. And Anthony Eden, the Englishman. Here are William Dodd, American Ambassador to Germany, and Rudy Vallee, Robert Young, Joan Crawford . . ." and Eisenstaedt rolled off famous names without catching his breath. His shyness had vanished. "This book goes with me everywhere. I treasure it more than anything I ever had. I let nobody touch it but those who write in it—and me. It is a record of the best things I have done." He fingered the book lovingly.

It was with real difficulty that he was brought back to the subject of photography. He likes talking of others—not of himself.

"Pictures?" he asked. "I always took pictures—since my thirteenth year. But I never sold any until 1929. I was a button salesman in Germany. After the war I took what work I could get—selling buttons and belts for ladies' dresses."

Eisenstaedt's friends considered him a curious fellow. He would never go with them to drink coffee and hear music in the cafes. He loves music but even on Sunday he would not go. They did not understand. They thought he was "tight."

"But I am not stingy," the little photographer explained. "I just saved every cent I could get to buy photographic equipment.

"On Sundays I would take my camera and go out in the forest. I would photograph swans on the lake, maybe. Or two old women going to the railroad station at four o'clock in the morning.

"Yes, I sold buttons to earn a living. But I took pictures to keep on living. Pictures are my life—as necessary as eating or breathing."

"But how about your technique?" this correspondent queried.

"Technique is not the most important," he stated frankly. "I am acquainted with men who know all the technicalities of photography, and they cannot sell a picture. Their prints are not alive. They don't breathe. You can't see a man's heart beat in their sports pictures. They are records only. Black-and-white records. Nothing more.

"I have no special technique—no secrets—not from you nor anybody. I'll tell you exactly how I get my photographs.

"First of all, and most emphatically, I am a lone camera chap. I must take my pictures by myself. Oh, perhaps I have a boy around to carry my tripod and other equipment, but he must not speak. I must arrange my composition in quietude, and the person I am photographing must trust me,

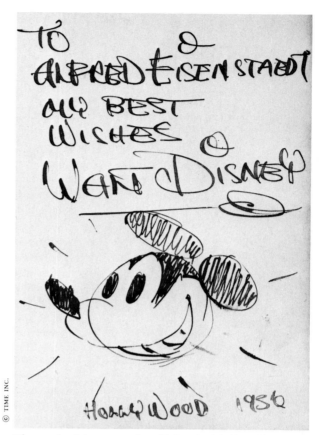

Thousands of signatures of world-famed celebrities fill Eisenstaedt's autograph albums.

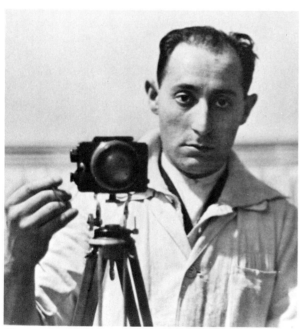

Eisenstaedt with his Ermanox in 1928, before he switched to Leica cameras and lenses.

have faith in me, must feel that I know my job. Yes," he laughed, "maybe I am a little autocratic. But I know what results I must accomplish. My subjects do not—it is not their responsibility.

"Second, I can't say what kind of pictures I am going to take until I get to the spot. My editors never tell me what to take. That is the difference between an editor and a photographer.

"Photographers take the right pictures but once they are developed they don't know which are the proper ones to publish. I always select the wrong ones. If I take a hundred pictures, and say to Mr. Daniel, who is my partner here at Pix: 'These twenty are nice,' he always throws them aside and takes the eighty I think are not so good. 'These are the best,' he says. And he is right. Therefore, when you take pictures, don't trust your own judgment as to the best ones for sale. Let somebody help you out.

"Third, I don't use an exposure meter. My personal advice is: Spend the money you would put into such an instrument for film. Buy yards of film, miles of it. Buy all the film you can get your hands on. And then experiment with it.

"That is the only way to be successful in photography. Test, try, experiment, feel your way along. It is the experience, not the technique, which counts in camera work first of all. If you get the feel of photography, you can take fifteen pictures while one of your opponents is trying out his exposure meter. Naturally, some photographers feel the need of such an instrument, but I do not.

"Fourth, as I have mentioned before, technique is not as important as the angle at which you take a picture!

"A simple way to illustrate this is the manner in which an amateur will squat down on the ground and shoot up. Or he will climb up on a ladder and shoot down.

"The people of this world are so weary of routine—the same job, the same house, the same

Feet of Ethiopian soldier, photographed by Eisenstaedt in 1935, is among his most widely published pictures.

food. They must have something different. Give it to them in pictures. Provide them with originality of angle—and your work will be sold.

"In ninety-nine cases out of a hundred I use a Leica. I was one of the first Leica owners. Telling a story in pictures—we call it *reportage*—was my speciality in Europe. To show people as they are —working, playing, laughing, weeping—striving to live with some measure of peace and content, that was my purpose.

"Truthfully I am a pictorial photographer. But in my business I can take only one pictorial to ninety-nine descriptive photographs."

Mr. Eisenstaedt was asked to define a pictorial.

"That is difficult to answer," he replied. "The way I would describe a pictorial is that it is a picture that makes everybody say 'Aaaaah,' with five vowels when they see it. It is something you would like to hang on the wall. The French word *'photogenique'* defines it better than anything in English. It is a picture which must have quality, drama, and it must, in addition, be as good technically as you can possibly make it."

In every set of pictures Eisenstaedt takes, there must be at least one pictorial. One pictorial which sums up for him the whole set.

"For instance," he explained, "take the shot I made of a girl playing tennis at Vassar. You may remember it was used as a cover for *Life.* That is a pictorial. Many photographers would not be satisfied with it. They would want to see the girl's face clearly. They would wonder why all that big expanse of wall."

He was asked why he did take it that way.

"That is how I see Vassar," was his answer. "That picture sums up Vassar to me. It is something I feel. Something I cannot express.

"So many people ask me how I came to change buttons for cameras. This I can explain. As I told you, from my thirteenth year, I have been taking pictures for pleasure. My uncle gave me a very old and very cheap Eastman box. I got developing tank, paper, everything. I saved up my money and bought more equipment. After the war came peace and no jobs. And so I went into the button business. But always I began to live when my business hours were over and I could take my camera and make pictures.

"And so life continued until the third day of December 1929, when I met Mr. Daniel. He was manager for the photographic department of the Associated Press in Europe. He said: 'If I were you, Eisenstaedt, I would give up the button busi-

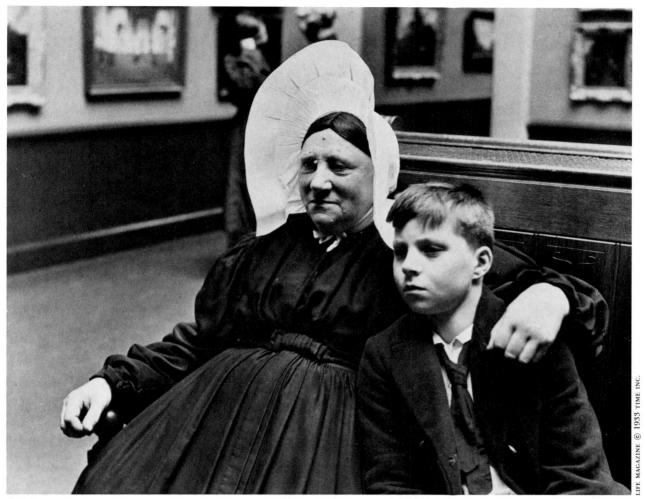

Dutch grandmother and her grandson were photographed in the Rijksmuseum, Amsterdam, in 1933.

ness and would start to work as a photographer.'

"I did, and I never have regretted it. I worked for six years with the Associated Press, having my headquarters in Berlin and travelling all over the world. In December 1935, I left Europe with Mr. Daniel. We settled in New York. And again—I don't regret it.

"I have lots of fun making pictures and lots of headaches," Mr. Eisenstaedt stated. "Take that time not so long ago in McKeesport, Pa., when I was arrested with Paul Peters, Associate Editor of *Life*. We weren't doing anything wrong, just standing in front of a steel mill, taking pictures of the outside. We were told: 'You cannot make photographs in this town except with the *written* permission of the Mayor,' and they arrested us."

Eisenstaedt goes nowhere without his camera.

If he is on vacation, he can't enjoy himself unless he has his Leica in his hand. Without his camera he feels as if he were blind—as if he had pads over his eyes.

Many jokes are told about the short, powerfully built, thirty-nine year old photographer. One of the best concerns his first trip to Paris. Mr. Daniel asked him, "Eisenstaedt, what did you do at night in Paris?"

He answered: "Why at night in Paris, I had to expose longer."

It never occurred to the former button salesman that Mr. Daniel was asking what he did for amusement in Paris. Other visitors to the Gallic city may go to the Ritz Bar or to the Folies Bergere or to the Opera. But Eisenstaedt—at night in Paris he takes pictures. And exposes longer!

Steichen–The Living Legend

Rosa Reilly

*He explains the rumor of his retirement, tells of his
plans for the future, and gives advice to amateurs*

Forty years agrowing—as a photographer. Fifty-eight years agrowing—as a man. Then came the rumor that he was planning to retire.

Edward Steichen, already a legend in the photographic world, is not retiring. He is transplanting himself, for a while, to Yucatan, where, under warm and luminous tropical skies, he will study the ancient Maya civilization and continue the pursuit of his life-long mistress—*light*.

When the rumor about Steichen reached the ears of *Popular Photography*'s editor in Chicago, he wired me:

"Understand Steichen is retiring. Please interview him —get statement . . ."

Steichen—his name is pronounced as if it were spelled *Stike-en*—has little time for the press. He had consistently refused to talk to me for six months. The legend was that he gave reporters short shrift. That he was out-and-out crusty.

I telephoned his secretary, asked for an appointment, and received another graceful refusal.

Then I went to the Public Library and read Carl Sandburg's book about Steichen. I said to myself: "This man is human. Not the crabbed, barbed-wire crank he is represented to be. Sit down and write him a simple letter. Tell him what your orders are. Ask him to help you."

The letter was sent up by messenger at four o'clock in the afternoon. At six my phone rang.

It was Steichen's secretary. Almost immediately the photographer was speaking to me:

"Hello girl," his voice was warm and full of laughter. "I got your letter. Come on up here to see me."

I went!

Steichen received me in the ground floor office of the three story building in which he has his New York studio, his laboratories, and his home.

His innate courtesy was immediately revealed by the fact that he placed me in a chair with my *back* to the light, while he faced it. Nearly every other person I have interviewed always has seated me facing a window as if to say, "Let me see what kind of creature *you* are."

"Are you really retiring?" was my first question.

"I am closing this studio on January First," Steichen answered. "I am not going to do any more advertising photographs and precious little commercial work. But say . . ."

He jumped from his chair, stood there, six feet tall, slender. "It's a bad plan to make plans," he explained. "Right now my schedule is to go south into Yucatan and up through Mexico, studying the Maya civilization for some months. After that I hope to experiment with color photography—not colored photography—which is all we have at present."

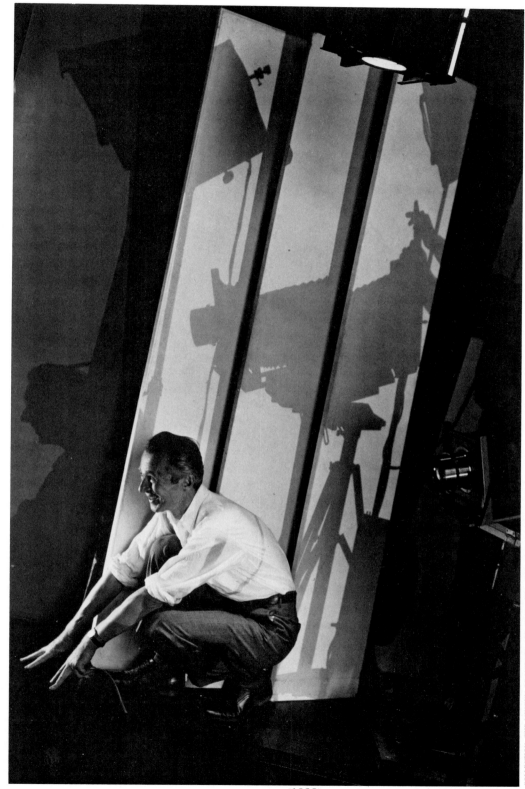

SELF-PORTRAIT WITH PHOTOGRAPHIC PARAPHERNALIA (1929) EDWARD STEICHEN

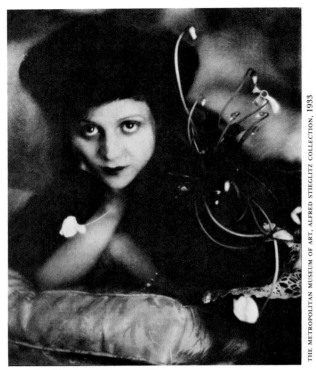

CYCLAMEN—MRS. PHILIP LYDIG

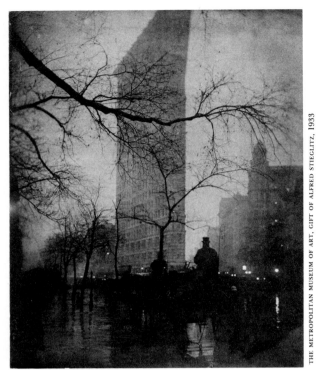

THE FLATIRON BUILDING

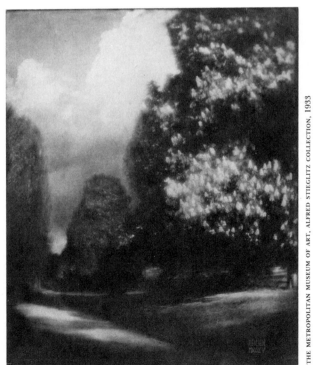

CHESTNUT BLOSSOMS

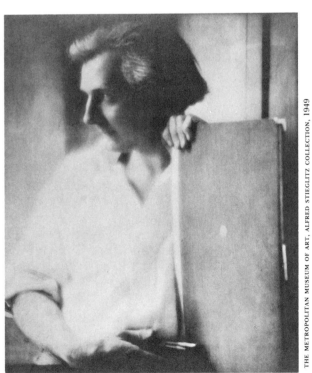

PORTRAIT OF EDWARD GORDON CRAIG

In Steichen's opinion modern color photographs are little better than hand-tinted prints. He maintains that they do not present a true color conception.

"What about your delphiniums?" I questioned.

"I want to carry on and enlarge my plant breeding," his face softened, grew young, as he spoke of his flowers.

I looked at Steichen, who is generally conceded to be the foremost photographer in the world. I knew in one cycle he had been a painter with his pictures in the Metropolitan, Toledo, and Luxemburg Museums. I was aware that for the past thirty years he has been a plant hybridizer in a class, some authorities consider, with the late Luther Burbank.

My immediate reaction was that this man is more violently alive than any personality I have ever encountered. His eyes are blue. Brittle blue. One second full of humor. The next flashing heat lightning at some stupidity of the world—or himself. His hair is sandy gray. His nose is a good nose. But it is his mouth that photographs him. On its curves are etched those things he will never speak about: hunger, misunderstanding, hopelessness; dissatisfaction with his work, his world, himself.

"Why are you giving up this studio?" I asked.

Mr. Steichen walked towards the light—"that old charlatan" light, as he has termed it. The element which he has tried to subdue for forty years.

"I recently saw a play called *The Star Wagon*," he said. "There was an old inventor in it who was finally getting the breaks—making a little money. He decided to give up his job. But his boss came to him and asked, 'How'd you like to stay on here as general advisor?'

"The old fellow hesitated. 'Would I have to take any orders?'

" 'Not a single order.'

" 'All right then—I'll stay.'

"That's why I'm closing my studio. I'm tired of taking orders," Steichen's voice was firm. "Besides, the production problems are tremendous in a studio like this. I find myself working on production eighty percent of the time and photographing only twenty percent. The only way I can do the things I want to do is by forgetting everything else but the job in hand. Which reminds me—that got me into trouble once.

"I had been working for the Condé Nast publications for about ten years. One day I was photographing a model who had everything. I was just getting the reaction out of her that I wanted when the door opened and a man walked in.

"On my soul I couldn't remember his name. Although I knew him as well as I know my secretary. I could see he wanted to be presented to the girl. I mumbled some sort of an introduction.

"It was only when he had left the room that I could remember his name.

"It was—Condé Nast!"

Steichen is unlike many other artists and thinkers. He does not live in isolation, absorbed in specialties and "indifferent to the main stream," as Charles and Mary Beard say in their book, *The Rise of American Civilization.* It is because he does not "fall short of that universality which gives full stature to genius" that I asked him to say a few words for the people who are just beginning their photographic activities.

"I can't say anything that would help them," Steichen exploded, when I placed the question before him. "What do you think I am—some god sitting up on Olympian heights talking down to people? I'm not. I'm just a plain photographer—like the rest—still trying to learn. I've been trying to learn for forty years. Besides, every cameraman's problem is an individual one. I can think of nothing in the abstract which would be of any use."

"But can't you tell them something?" I kept at him.

"There are only two problems in photography," he spoke slowly. "One is how to conquer light. The other is how to capture a moment of reality just as you release the shutter. By reality, I mean provoking an emotional reaction in your subject. Making him spark into life. Every man must learn to work out those two problems for himself.

"Now take a commercial photographer. He differs from the pictorialist and the amateur. They can work when they feel like it, when conditions suit them. But the commercial man has to get himself in a lather of emotion at a given time—say two-thirty in the afternoon. Any afternoon.

"But don't get me wrong. Commercial pressure is an amazing, productive force. Artists, with rare exceptions, are poor producers. That was particularly true of Rubens and others. Rubens' best work was done under pressure of the church or of aggressive clients. Few painters would create any living art if they didn't have pressure blowing down on the backs of their necks."

Steichen was rifling through his files to find me

some prints to illustrate this article, also a photograph of himself.

"May I have the self-portrait of you that I saw in the *Gebrauchs-Graphik?*" I asked.

He handed me the portrait which had appeared in this German illustrated journal. As I studied it, I realized how well it sums up Steichen. It shows him at work, electric with vitality. It shows his humor, his lithe body which the years seem unable to affect, his lusty laugh, his strong, magnetic hands. Sandburg writes that the photographer is "melancholy, brooding." You could never guess it from the picture—nor from the man.

The two other prints reflect him more than any written words. One is a photograph titled *The Clinic.* The other is of Paul Robeson—Steichen calls it *Black Boy.*

These pictures interpret Steichen's sympathy for the tragedies of the world. He understands, hunger, fear, illness, race oppression, death.

"I went to an eye, ear, and throat dispensary to make a picture," Steichen explained. "I saw all those people sitting in the waiting room. Blind, half-blind, fearful of blindness. I asked the clinic director to request them to go up the stairs when I gave the signal.

"Then I massed every light I owned at the top of the stairs. There was additional light too—sunlight coming through a skylight at the head of the steps. The only change I made in the grouping was to place the mother with the baby in the middle of the composition—as the central figure. I had arranged with my electrician for the light to be turned on when I made a certain gesture. I was sure that would make the people on the stairs look up. I hid my camera in the corner.

"When the people had grouped themselves on the steps, I said 'Look at the light,' signalling the electrician at the same time. He flashed on all his power.

"They looked. I got the picture."

Simplicity—that's Steichen. Simplicity plus an understanding of the human heart. H. K. Frenzel said in an article he wrote for the *Gebrauchs-Graphik:* "Steichen has his pictorial conception complete before he opens the lens. . . . He never attempts to achieve his effect by subsequent cutting and interesting enlargements."

Steichen's interpretation of a phase of American social history is evident in a picture which he calls the Hoover Era. It shows a long line of homeless, and hopeless, women—old, middle-aged, young, and scarcely adolescent girls—lined up before a lodging house during the depression, waiting for a slice of bread and a cup of coffee.

Although Steichen has earned, and is earning, enormous sums of money and is conceivably beyond every form of privation, he has a real understanding of the man who doesn't know where food is coming from for his children's next meal.

"One thing which struck me about the depression," the photographer said, "was the amazing quality of kindness which came out in the American people. We have also learned something else from that terrible period. We are not children playing at life any more. We are not taken in by political platitudes as we formerly were. And another good point about us is, we don't think and live as tragically as the European nations."

It is evident from Steichen's picture *Black Boy,* that the photographer does not confine his sympathy and understanding to the white race. His print of Paul Robeson embodies the soul of the Negro race. He put it there for anybody to read: the talent, the tragedy, the fear, the strength, the weakness, the inextinguishable joy, the torture— all are there in Robeson's eyes.

Edward Steichen has a 240-acre farm at Umpawaug, Connecticut. Where Indian teepees once rose along the fields of Indian corn, Steichen grows delphiniums. Where the medicine man beat the tom-tom for rain, Steichen pipes water for the thirsty soil. Ten acres of prize delphiniums—delphinium aristocrats—bred from the sweat of thirty years' toil in crossing, discarding, sowing, reaping. There his flowers stand in the full midsummer sun, row after matchless row, tapering gently into bursts of bloom; blue, purple, mauve, white— spotlessly, immortally beautiful.

Steichen grows from fifty- to one hundred thousand plants a year. From each thousand he saves one or two as seedlings for his experiments. Recently he had a one-man delphinium show at the Museum of Modern Art.

"I have always been interested in genetics—in the heredity of organisms," Steichen told me. "I acquired this interest from breeding plants. All growing things—and that includes people—respond basically to the same stimuli and environment. What you learn about flowers you can apply to people. The only thing we can do is to breed the foolishness out of human beings. There is no real hope for what we call a change in our race until we start breeding them properly. But the tragedy is, nobody knows how to go about it, for nobody

34

knows what to breed for—what to aim at. That's why I am eager to carry on my hybridizing experiments.

"I haven't achieved, by a long shot, what I'm after in delphiniums. I was surprised when I saw my flowers at the Modern gallery. Up until that time they had been to me units—figures on a ledger. At the show they became real. What I want now is to breed a delphinium with stamina—with resistance to disease."

The press of nearly every country in the world has written fulsomely about Steichen the photographer. But nobody has troubled to penetrate through Steichen's achievements to the man himself. That is why I have tried to avoid writing what everybody knows. I prefer to stick to the legends about this living legend.

His parents were peasants. His father a miner, his mother a housewife who later became a milliner.

"Whatever I am comes from my mother," Steichen's tone was earnest. "I don't know what she had. But I wish I possessed a fraction of it."

His mother was strong. Her day might include putting out a week's wash, hoeing in the garden, making and selling hats, coming home at night and cooking a big meal for son, daughter, and husband. And then finding energy enough over her mending basket to stop and listen to her son's problems. The son whom she warmed, filled, comforted, and inspired.

Edward Steichen says he got all he had from his mother. But I believe he received his love of light from his father. His peasant father who worked down in the copper mines all day—who descended into the pit when it was dark—and came out only when night covered the earth.

One of Steichen's most expressive pictures was made for a Jergen hand lotion advertisement. We see a woman's work-worn hands peeling potatoes. I like to believe that woman represents Steichen's mother.

He is the only man in America today who can make women look real in advertising photographs. His girls don't seem to be Venetian glass countesses. You can imagine them having a toothache or cussing over a run in their last pair of sheer stockings.

Women—models—are the medium through which Steichen works. But it is my belief that his true mistress is *light*.

This man has been married twice. He is divorced from the mother of his two daughters.

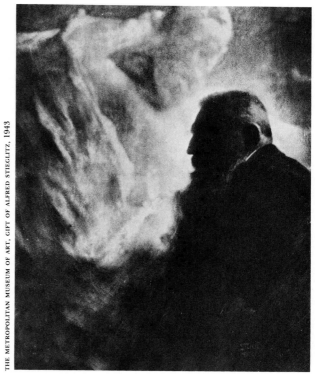

RODIN

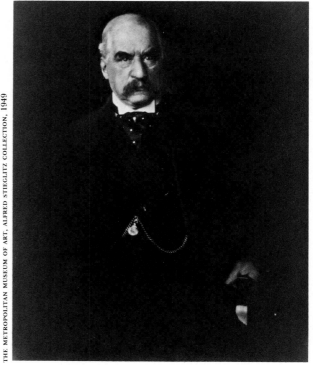

J.P. MORGAN

35

Whatever woman he has loved, I am sure has been created in his mother's pattern—one who warms, fills, comforts, and inspires a man.

Perhaps the girl he loved most of all was his grand-daughter, who died a short while ago at the age of ten.

"She was a genius—if there ever was one," Steichen told me. "And, of course, a genius is somewhat of a problem child. But her mother was just getting everything worked out for her when the child contracted pneumonia, and," he fumbled for a word, "and went away from us. I learned another lesson in human endurance from that child. The doctors gave her up three times. And three times she rallied. She fought for her life superbly. But . . ."

His hands dropped. "The girl's mother is now at the Rochester Medical School, studying to be a doctor."

Fortunately, both for the child's mother and Steichen himself, the little girl who went away from them has a sister who is talented and lovable.

In the book which Carl Sandburg, who married Steichen's sister, has written about the photographer, you can find his summation: "Steichen throws a long shadow and ranks close to Ben Franklin and Leonardo da Vinci when it comes to versatility."

The first we learn of Steichen is when he was four years old, residing at Hancock, Michigan, with his parents and his sister. As a lad, he sold vegetables from door to door, peddled newspapers, was apprenticed to a firm of lithographers and quit the job while earning fifty dollars a week, to come to New York.

All through his adolescence two facts stand out: he photographed and painted water colors equally well; he saved his money—enough to get to New York.

In New York he sold a few photographs, but purchases had long gaps between. And here is another legend. He was dispossessed. All his possessions were thrown out in the street on a gusty March day. The wind blew the sketches of his lovely nudes into the gutter.

Alfred Stieglitz, famous photographer, befriended Steichen after a while. He paid him from fifty to one hundred dollars for one reproduction of his photographs.

They were *arty* prints. Steichen had learned that by joggling his camera and spitting on his lens, he could achieve *artistic* effects. Several of these were published in *Camera Notes,* which Stieglitz edited.

The young man must have been good for he photographed the financier, J. P. Morgan, Sr., and the famous actress, Eleonora Duse—both in one day.

Somehow, Steichen got enough money together to get to Europe. He photographed Bernard Shaw in England, "who was as easy to take as a big dog." From England he went to France and made friends with Rodin, the sculptor. He photographed Auguste Rodin seated between two of his most famous sculptures—his black marble statue of Victor Hugo and his white marble figure of *Le Penseur* (The Thinker).

Steichen broke down and cried in Rodin's studio. He felt he was not accomplishing what he wanted, either in painting or in photography.

Rodin put his arms around the boy's neck and with tears standing in his own eyes said, "That is the test of the true artist—always being dissatisfied and always doubting one's own ability."

Steichen settled on a little three-acre farm at Voulangis, not far from Paris. Here, while photographing and painting, he began breeding plants. And here it was he made his famous statement: "I am as determined as the tides of the sea and as patient as the Roman Catholic Church."

During this period Steichen photographed endless varieties of flowers as well as famous personalities: Maeterlink, Anatole France, Matisse, Gordan Craig, and others. He married, and started to rear a family.

At intervals he returned to America. Remarkable success was coming to him. As far back as 1908 he sold two two-color photographs to the old Century magazine and received five hundred dollars each. "Stieglitz helped me to get that price," Steichen said.

He was at Voulangis when the war broke out. Steichen returned to America. When the United States entered the conflict, he enlisted in the U.S. Army Air Service. He was made technical adviser of the entire Aerial Photographic Section.

It was while the second battle of the Marne was raging that Steichen was placed in command of all photographic operations in France. He was made a captain.

Three-fourths of all information on which the Army operated was obtained, or verified, by actual photographs. Steichen commanded fifty-five officers, one thousand troops, and five planes.

Gone were the days of shaking his camera, or spitting on his lens, to make *arty* photographs. Absolutely meticulous definition of line was re-

quired. That training helps to account for Steichen's being considered the world's greatest photographer.

For relaxation during those war days, Steichen and General Billy Mitchell would occasionally take time off to go out to a cafe and split a bottle of *vin rouge.* Their favorite song, when the wine warmed them, was one of their own composition: "Where'll we be a hundred years from now?"

When the war was over Steichen was a lieutenant-colonel, with the ribbon of the Legion of Honor in his button hole, a ribbon which he always wears. He painted two portraits for five thousand dollars each but would do no commercial photography. For one solid year he experimented with prints, striving to maintain the meticulous definition he had acquired in aerial photographs. He shot one white cup and saucer a thousand times. "He was seeking the photographer's control," Sandburg says, "as between the blackest black velvet and the whitest white paint."

After the year's experiment, he began to work for *Vogue* and *Vanity Fair,* where he remained until his retirement. He signed a contract with the J. Walter Thompson Agency to do advertising photographs exclusively for them.

He began to make portraits of everybody in America: society women, industrial magnates, stage and screen artists, debutantes, dowagers, singers. It reached the point where one could not actually claim to be a celebrity unless photographed by Steichen.

Steichen's technique was changing. It was sharper. More highly lighted. He began to earn phenomenal sums of money, receiving as high as a thousand dollars for a single advertising photograph.

The photographer was divorced by his first wife, and remarried. He bought his farm in Connecticut. Studied Chinese art. Commuted back and forth to Europe.

About this time he went to Venice. In a gondola on the Grand Canal, he saw Isadora Duncan, the talented, temperamental dancer, in another boat. "I'm going to Greece," she shouted. "Come on along."

Steichen went with Isadora, more than amply chaperoned by five of her pupils. He photographed the great dancer under the arch of the Parthenon, one of his most famous pictures.

At Voulangis, he continued his plant breeding, developing a new class and type of pure blue petunia. Also a perennial delphinium. He was having remarkable results with begonias, iris, and rambler roses. So much so that the French Horticultural Society presented him with a gold medal.

It was during this period that Steichen began to be dissatisfied with his painting. One morning he was sitting at breakfast. His gardener brought in a water color, a copy of one of his own pictures.

"Who did that?" he shot at the gardener.

"I did," the man answered.

"It's better than mine. I'll never paint again." He never did.

A few days later Steichen and his gardener made a fifty thousand dollar bonfire in the Voulangis garden, burning up the work of many years.

In America, Steichen had climbed to the height of his photographic career and has maintained his success to this day. His definition of art is the "taking of the essence of an object, or experience, and giving it a new form, so that it has an existence of its own."

Having traced the man through the various cycles of his life, let's have a few day by day facts about him.

Steichen eats rapidly, sleeps without any clothing, and is as healthy as one of the pups that romp over his farm.

"As I grow older I try to become more tolerant, but my temper grows shorter," he told me. "I still get as excited about a photograph as I did when I was eighteen years old. But the absorbing thing is *taking* it. When I have finished, I am disgusted with it—don't even want to look at it again.

"One thing I have learned is this. Every human being has some fear which keeps him from accomplishing the things he should. And this is true of me—of you—of everybody. In proportion as we find that thing and control it, we become successful, civilized human beings."

Unquestionably, Steichen has conquered his fear, for he still stands at the top of his profession.

"My only advice," he concluded, "is this: We don't know where we are going, but we should give life all the gas we've got."

Does that sound like the valedictory of a man who is retiring?

Steichen is simply going on to his next cycle of fulfillment. He will never retire. When they carry him out, feet first, he will be clutching a recently developed and beautiful color—not colored—photograph in one hand, and a strong, disease-resistant delphinium in the other.

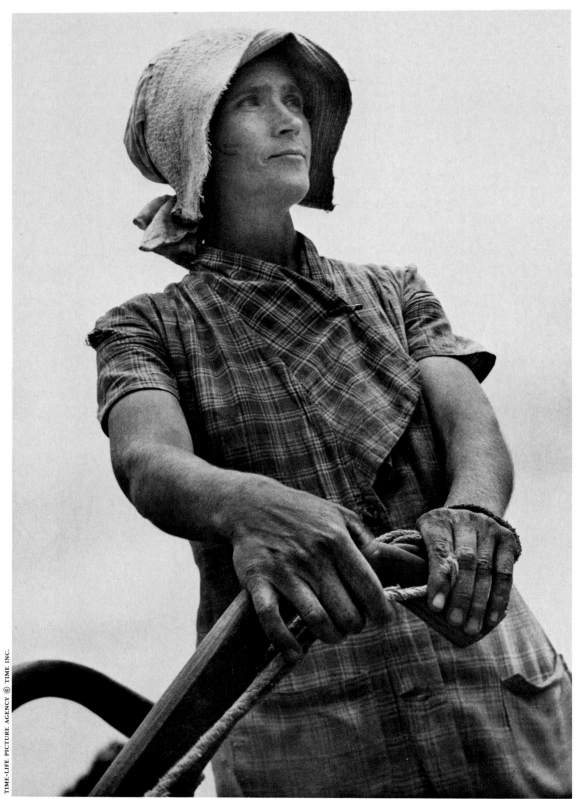

SHARECROPPER—HAMILTON, ALABAMA MARGARET BOURKE-WHITE

"You Have Seen Their Faces" Why I Wanted To Do This Story

Erskine Caldwell

EDITOR'S NOTE:—Margaret Bourke-White, famous photographer, and Erskine Caldwell, noted writer, have collaborated on a startling book, "You Have Seen Their Faces," which presents the challenging, pitiful story of the southern sharecropper. Seventy-five photographs by Bourke-White document the written word of Erskine Caldwell in this "best seller." How these photographs were taken and used to help tell the story is in itself a story of interest to every camera owner. Only photography and the written word in the hands of experts could have presented this message in such a forceful, heartrending manner. We are proud to present the story behind their remarkable achievement.

For many years I have wanted to do a book which would lay a foundation for opening up the whole pitiable subject of the southern sharecropper.

There have been studies of sharecroppers in the South before. But they were mostly statistics—economics. I wanted to try something different. To try to humanize the sociological and economic problems of the South where I was born.

The need for a pictorial as well as a word record was obvious from the start. For four years I looked for a photographer who could capture in pictures what I was seeking to express in words. But I couldn't find anybody sympathetic with what I had in mind or with the skill that was so vital a need.

Finally my agent suggested Miss Bourke-White. I looked through a bunch of her photographs. Frankly, I didn't feel she had my viewpoint. Then I saw a print she had made of three peasant women eating from the same bowl of food: a grandmother, a daughter, and a granddaughter. I knew from that picture that she was the one person I could work with.

Miss Bourke-White agreed to help me. The book has been an entirely collaborative effort from the start. We didn't know what we wanted to do or how we would fuse our media of pictures and words. We started out motoring through the South at various seasons of the year—whenever we had the leisure.

I wanted her to see—and photograph—what I had seen ever since I was born—ten million people trying to raise cotton on eroded, depleted, unprofitable land, under a system of absentee landlordism.

I do not wish to intrude upon the social creed of any of the readers of *Popular Photography*. But before I tell you about pictures, of whatever social significance, I must tell you what inspired their making.

My father was a minister—in constant contact with the poor. I had grown up among the sharecropper families—families numbering from eight to sixteen struggling souls, living on tenant farms which are only clay deposits and sand dunes. Getting up before day, bedding down after dark, living or dying on a steady diet of cornmeal and molasses, plus a little snuff to deaden hunger and ease pain. There are a million and a half families like that being bred and crushed in a land without hope—the sharecropping South.

I have written about this South, dramatizing not individuals but the system that made *Tobacco Road,* for example, possible. Now I wanted the camera to help tell the story to a camera-conscious world. I was fortunate in being able to persuade Miss

Bourke-White to bring her fine, prejudice-free camera into the South.

As she and I motored along, the whole business began to take shape. We would stop and speak with people we met on the road—talk with them about their crops, their families, themselves.

We might, for instance, see a cotton gin. We would go over and watch the men at their jobs, see the cotton come in, see it go out. Miss Bourke-White would make a few preliminary shots and I would take some notes. About the fourth day when we got the feel of what we wanted, we began to work. Separately, of course. The thing that constantly surprised me was that after she had finished her photographs and I had written up my notes, our ideas had usually coincided, our media had merged.

Miss Bourke-White will tell you about her field, her technical equipment, the special problems she had to work out, and the experiences which happened along the road. I'll confine myself to a case which seems to me to sum up the whole idea I had been trying for years to get down into words—*and pictures.*

And let me say here, as we say in our book, that we do not intend to criticize any individuals who are part of the system we portray.

At Sweetfern, Arkansas, we met three people. A middle-aged man who was blind; his wife, suffering from goitre; and their illegitimate grandchild, the son of their mentally defective daughter.

The man, an unheroic figure, had begun life as the average sharecropper does, with hope and the will to succeed. When he came of age, his life followed the pattern of other sharecroppers. He left his father's farm and worked for day wages on another place. After a few years he married.

Like most of his kind, this man didn't have money to buy land of his own, so he rented a place. His first need, after food, was fertilizer. Without it he could not grow enough cotton to earn a living. That took the few dollars he had in reserve. A poor season put him in debt. He couldn't pay his rent.

Like many another, he was forced to move to a farm where he could sharecrop. He promised to pay his rent on the first place when he gathered his crop the following year. But in the meantime he and his wife had to eat. Because they were sharecroppers, they got credit at the company store.

The wife helped him in the fields. After five years of sharecropping, he had made no progress. There were three children then with another on the way. Food had to be provided. Their diet was cornmeal and molasses three times a day. Their debt at the company store had grown proportionately with the years.

At the end of fifteen years, this man began to realize that something was wrong but he didn't know what. He only knew that despite his unending work his children first began to beg, then to cry, for food which he was unable to provide for them.

As time passed, he learned something else. Erosion had washed away the topsoil of the farm. There was no money for fertilizer. Bitterness and resentment, hopelessness and despair, can't take the place of fertilizer.

No matter how long nor how hard he and his wife and his children worked—the result was the same: increasing debt, no food but cornmeal, no education for his twelve children, no medicine when illness struck.

To failing health and the consequent inability to work, which is the lot of the average sharecropper after twenty years' constant toil and inadequate food, were added blindness. The absentee landlord had been watching this tenant's slow demoralization and had been making plans to put a younger man, preferably a Negro, in his place. That's what happened.

So there they were at Sweetfern, Arkansas, when Miss Bourke-White and I came along. How to get their story and how to tell it in pictures? We got it, after days of listening, asking, verifying, and we tell it—in five words and one picture. You have only to see Miss Bourke-White's doorway portrait of the grandfather, the grandmother, and the grandchild, to see that her camera has really painted a lifetime in its split-second exposure. The grandfather with gnarled hands clasping the whittled stick that guides him in his blindness; the barefooted grandmother with her terrible goitre; the child, bare-shanked, disconsolate, awkwardly poking dirt from his eye.

That's the photograph. Its caption: *Poor people get passed by.*

This case history from Sweetfern, Arkansas, is one of thousands I could cite. We put only a few of these cases into the book.

What it all adds up to is that cotton sharecropping has ruined *ten million people* and its's going to ruin a lot more. The camera has known great achievements. It adds another achievement of heroic stature in the photographs Margaret Bourke-White made for *You Have Seen Their Faces.*

How the Pictures Were Made

Margaret Bourke-White

You have felt the same way; the need to get away from the things you have been doing, the urge to create something new—something different.

That was the state of mind I was in when Mr. Caldwell's agent suggested that I collaborate on a book with him.

I didn't know Mr. Caldwell at the time but the idea of going into the South and photographing the people of the land just as we found them, appealed to me. But I wondered how my technique—taking picture after picture to get a satisfying photographic sequence—would fit in with his writing scheme.

I was nervous, as I always am on a job. But then I consoled myself. We had decided to try to create something entirely different. We had no precedents, so whatever we did was that much more interesting. But I also realized it was up to me to make good on an exacting assignment.

We took along five cameras. I wanted to be ready for anything. I'll tell you about my equipment later.

Our first trip was difficult. We didn't know each other very well. Our techniques were entirely different but by the time we were on the second lap of our work we began to see daylight.

We finished the job in two years.

Imagine yourself on that photographic assignment. Riding along, you might say, with nothing to do but take pictures. A photographer's paradise!

But was it a paradise? Remember the subjects: hungry, ragged, crippled, or imbecilic children; haggard, under-nourished, snuff-dipping mothers; bitter, frustrated, "body-sick" fathers—all living in flimsy shacks, the walls of which were covered with sheets of newspaper.

How would you photograph this: From eight to eighteen people living in from three to five rooms with perhaps only two beds in the house? Insufficient warm clothing to go around so that only three or four of the children attended school in winter? No money for medicine or dentists or hair cuts? A patent medicine as the doctor—the same medicine for every ailment?

In two years' camera wandering in the share-cropping South I learned that those people have some of the purest blood of any stock in America. Many of them have as much background as those who came over on the Mayflower. There is one family in Georgia which spells its name *Amoson*. It is a branch of the original family of *Emerson* which produced Ralph Waldo Emerson as a member.

Pitiable, heartbreaking, but that's the manner in which the sharecroppers and their families exist. It was up to me to photograph them that way. I took hundreds of pictures under every possible condition. A photographer's paradise, perhaps. But a photographer's hell, too.

I think the picture we made in Hamilton, Alabama, of a woman with her hands on a plow, touched me most of all. The caption is *We manage to get along.*

As you look at the picture you see that the woman's features are strong—noble. So is she. Her husband is bedridden. The family was put off the tenant farm they lived on. They had no income and no compensation. This woman went out and got land and farmed it herself. She has five children. The oldest is eight, the youngest two. She

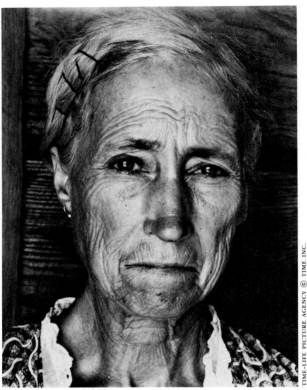

FARMWIFE, GEORGIA

plows and farms her cotton alone. The baby follows along beside her in the furrow. She takes time out to nurse and dry him. The older children keep the cotton weeded but they are not able yet to do any of the heavy work.

I'm proud of having found such a subject—and of having met such a woman.

One of the most terrible photographs was shot in McDaniel, Georgia.

A woman holding a baby; she was suffering from toothache and had taken a little snuff to help her bear the pain.

Her face was drawn with agony, her eyes held the misery of every sharecropper. Suffering, degraded, hopeless—she stood there while the child reached out his hands and tried to comfort her by patting her face.

The woman we found at Locket, Georgia, had a story—in her bobby pins. She and her husband were walking along the road, begging. Yet this woman hadn't lost her pride. Her dress had a white collar on it—and the collar was clean. She had little earrings in her ears—and bobby pins in her hair.

Those bobby pins told the story. She still had pride in her personal appearance. Her level hadn't gotten her entirely down.

Before she would pose for us, she asked to be given two kinds of snuff—she specified the kinds, *Banjo* and *Rooster*—and two kinds of chewing tobacco. Though she was sick and hungry, snuff was more essential than food.

Snuff, as you perhaps know, is finely ground tobacco. The sharecroppers rub it on their gums. It has a stimulating effect on the stomach and soothes pain.

Another woman I shall remember photographing was one from Maiden Lane, Georgia. Living in unspeakable poverty, she had somehow managed to keep her hair peroxided to a blonde shade.

Ordinarily I despise blondined hair but here I respected it. I realized that this woman, despite her terrific handicaps of poverty, ill health, and under-nourishment, still wanted to look lovely.

She was quite concerned about my own hair. I am prematurely gray and love it. But she thought it was terrible—such a young woman with gray hair! She took me aside and told me what kind of dye I should buy to restore the color of my hair and just how I should apply it.

Remember, I was on these expeditions as a photographer but I had to take pictures for an editorial pattern that was weaving itself as it went along. My lens had to be a mirror, a net, a sieve—all in one.

Before it passed women, men, children, ministers, chain gangs, religious fanatics, fecund colored mothers, pickaninnies, houn' dogs, old automobiles, strange road signs. There passed, too, examples of stamina and nobility.

You will perhaps be interested in how we took our photographs and how we narrowed them down to the seventy-five used in our book.

Of the five cameras I took along, I used my Linhof, a small view camera, most frequently of all. This flexible instrument, with tilting and rising front, and tilting and revolving back, takes 3¼ × 4¼ pictures. With it I used lenses of varying focal lengths, from wide-angle to telephoto. Some of the crowded, one-room homes we worked in were so small I was glad I had the 9 cm. Angulon wide-angle lens. However, I seldom use a wide-angle lens if I can help it because of the danger of distortion. I employed mainly Zeiss Tessar lenses with focal lengths of 13.5 cm., 15 cm., 18 cm., and 27 cm.

I also brought with me a Soho camera which is

of English construction. It possesses a front which twists and tilts, an adjunct to the reflex which we do not find included in our American built cameras. Since this feature is necessary for precise focusing I can't understand why all our reflex models, with the exception of the very small ones, are made without it.

My lenses for the Soho included varying focal lengths of which a Cooke Anastigmat Series X, 6⅜″ f 2.5, and a Zeiss Tessar, 13.5 cm. f 3.5, proved most helpful.

This Soho was useful for outside work, particularly for picturing the land and the people at work on it. The Soho's flexible frontboard allows you to follow action excellently. The stopping-down necessary to keep depth of focus is reduced to a minimum, thus permitting high exposure speeds.

I also carried a Contax Model II, with Sonnar f 1.5, 5 cm. lens, because a miniature camera can shoot pictures where nothing else will.

As my standby, I packed my old 3¼ × 4¼ Revolving Back Auto Graflex with 7″ Kodak Anastigmat f 4.5 lens. You can count on mishaps on every job. This old Graflex has pulled me out of many a photographic hole when more delicate apparatus has failed.

I also used a Super Ikonta A, with Zeiss Tessar f 3.5 lens. This was the fifth and last camera I carried. It has some of the advantages of a miniature camera and also provides a somewhat larger negative.

Because electricity was not available in many of the places we photographed, lighting was a serious problem. Flash bulbs became a necessity for shooting all interiors. I didn't have much respect for flash bulbs when I started out on the assignment. But I was using them all the time before it was finished. I got to regard them with downright affection.

When shooting interiors I usually moved some distance away from my camera, as if it were of no importance. I would sit as natural, composed, and as interested as I could with a remote control in my hand. I would watch our people as Mr. Caldwell talked with them about their everyday lives. I had to be interested, too, or they wouldn't talk. But I had to watch also for that fraction of a second when a hand was lifted in a gesture, or a face was mobile, or the characters were arranged in that intangible something that is composition—and a picture was made.

I had an arrangement built with extensions to avoid the flat lighting which results from the usual

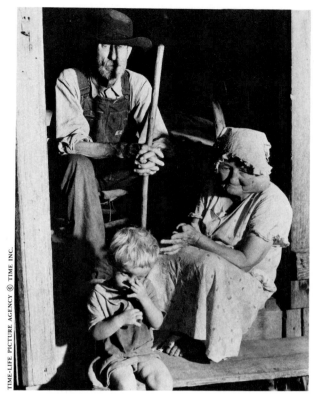

FAMILY, ARKANSAS

synchronizing device where the reflector is attached directly to the camera. A two-way or three-way plug from the synchronizer could be used with this. If more outlets were needed, a spider box, with cords plugged in, and fitted with reflectors of the clamp-on type, solved the problem.

I used Panchro-Press film for most interiors. Sometimes I employed Super Sensitive Panchromatic for indoor jobs because it is satisfactory for use with flash bulbs. I stuck to Super Sensitive Panchromatic throughout the trip for outside work.

During the two years we were intermittently at work, I took, I should say, several hundred photographs, good and bad. Mr. Caldwell and I brought that number down to a hundred and fifty, all of which we liked. But it took three months to edit those down to the seventy-five required for the book.

Last of all we had the captions to write. The titles we put under the pictures were not what the people actually said but what we imagined they would have said in their own language.

We both wrote the captions. We would each put down what the picture meant to us, in as simple language as possible. We would then show the captions to each other. Whichever was better we chose, though sometimes we would combine what both had written.

Those captions were all rooted in the soil with King Cotton: "What my menfolks have a powerful gnawing for right now is a slab of sow-belly to eat with this cornbread" . . . "It never felt like Sunday to me until I plucked the guitar some" . . . "Blackie ain't good for nothing, he's just an old hound dog."

The written word and the photograph are welded in *You Have Seen Their Faces.* Working with a writer taught me a lot about photography.

Edward Weston– Master of Simplicity

Nestor Barrett

Edward Weston, a giant among photographers, in actual life is a quiet, unassuming man. Unlike some of his famous contemporaries, he affects no long hair, pointed beard, or eccentric clothes. And unlike many another great man, he is easily approachable, willing to explain his art to the rankest beginner.

Indeed, so unconscious of his greatness is Weston that when you ask him about his work he can think of nothing important enough to be recorded. Only through specific questions can you discover his way of doing things.

Weston's equipment is made up of a very few items. His camera is an 8 × 10 Century Universal View, to which he has added a device of his own. This is an adjustable metal rod which connects the front board of the camera with the rear, in order to hold it absolutely rigid. This rod is necessary because of the high winds in which he sometimes works. For further stability, Weston mounts his camera on a Paul Rees tripod with tilting head.

An unusual item in Weston's equipment is his focusing cloth, which is white on the outside, black on the inside.

"It is made this way," he told me, "because much of my work is done in the desert where the heat would be unbearable if the conventional type of cloth were used. The white exterior reflects the hot sun's rays instead of absorbing them."

Regarding lens equipment, Weston uses both a 19″ Zeiss Protar and a 12″ Turner Reich triple convertible. For a lens shade he employs a Wörsching Counter Light Cap. In the way of filters he carries only a few, using a K-2 and a G most often, and a K-1 and an A occasionally.

"Clouds will show up satisfactorily without the use of filters, if they are exposed for properly," says Weston.

"This equipment of mine may seem bulky in these days of miniature cameras," he continued. "Altogether it weighs about sixty pounds, and I carry it with me at all times. But despite its bulk I can set it up as quickly as many of the smaller cameras are set up by their owners who use gadgets.

"I had myself timed the other day, and discovered it took me exactly two minutes and thirty-one seconds to make the complete setup, from opening the case to making the exposure."

Having described the equipment, let's get acquainted with the man who uses it so well. Edward Weston is a man of medium height and has just passed the half-century mark. He was born in 1886 in Highland Park, Ill., spent his youth in Chicago, and made his first photographs in Chicago's parks, when he was sixteen. He moved to Los Angeles when he was nineteen. Since that time he has traveled widely in pursuit of his profession.

For a while he punched stakes for the old Salt Lake Railroad in Nevada; he worked in several Los Angeles studios, and canvassed from house to house with a postcard camera.

Finally, in 1911, he built and opened his own studio in Tropico (now part of Glendale, Calif.). At about this time he began exhibiting, and was elected to membership in several photographic salons.

In 1923 Weston sailed for Mexico. For three years he maintained a portrait studio in Mexico

Edward Weston, photographed by Chandler Weston

exposures are as long as from one to three seconds. When I'm making pictures in the redwoods, exposures of ten minutes or more are not uncommon.

"For 30 years I judged exposures entirely by looking on the groundglass. Now I use a Weston meter. [There is no connection between the meter's name and that of the photographer.—ED.] I take the normal meter reading as a base, augmenting it with my own judgment.

"The old-time rule was to expose for the shadows and let the highlights take care of themselves. I often expose for the highlights and let the shadows take care of themselves." This method must be effective, because the richness of the shadows in Weston's prints is one of the features of his work.

Professor George Stone, head of the photographic department at San Jose State College in California, is the authority for the following interesting anecdote regarding his friend Weston's working methods. A wealthy Eastern camera enthusiast believed he might attain considerable suc-

City. Then he returned to San Francisco, and since has lived and worked in Carmel, Santa Monica, Los Angeles, and San Francisco, Calif. During the past ten years he has exhibited one-man collections in this country and Europe.

Long experience has developed such skill in Weston that he never makes more than one negative of a subject. He claims that there is no guesswork in his methods, since his more than 35 years of work assure his getting what he wishes on the negative when he exposes it. As an example of this accuracy he points out that among 1,100 negatives he made last year 90 per cent printed satisfactorily on the grade of paper he originally intended to print them on.

Weston's work is known everywhere for its brilliant, almost brittle, sharpness. Here is how he achieves this effect.

"Generally," he says, "I use only the smallest stops and give longer exposures to compensate for them. My camera's diaphragm is especially constructed so that it will stop down to f 256. Of course my exposures are lengthy. In the desert, for instance, even in bright sunlight many of my

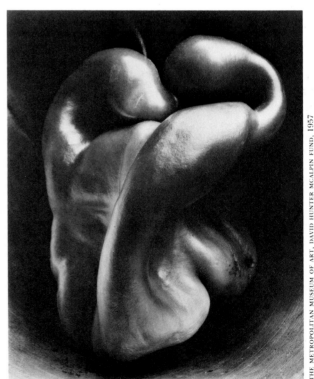

GREEN PEPPER, CA. 1930 EDWARD WESTON

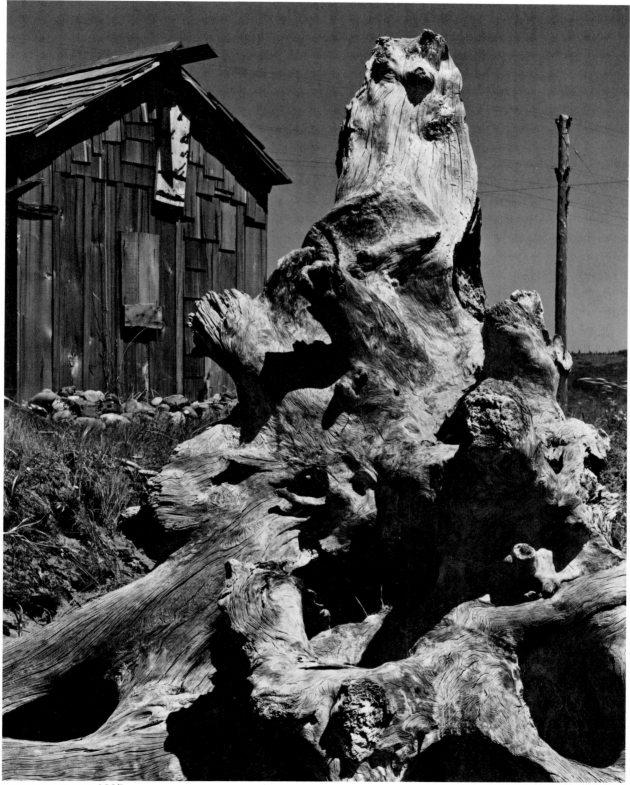

CRESCENT BEACH, 1937

EDWARD WESTON

cess in his own work if he might see how Weston developed his films. So he made the trip across the continent and called on Weston in his home, only to be astounded by the fact that the master's methods were the simplest and his equipment almost elementary.

Weston's preference among films is for the slower panchromatic emulsions, more specifically Agfa Isopan. He develops all his negatives in a tray by inspection, using the A. B. C. Pyro developer. (This consists of three stock solutions which are mixed at the time of actual use.)

"Personally, I like the warm black of the pyro negative," he says. "I make only one modification in my developer, and that is to cut down the carbonate as much as 60 per cent. This prevents the highlights from blocking up and gives the shad-

ows plenty of time to register. The resulting negatives are in no sense thin, being medium dense if anything.

"I make all my prints by contact. I never enlarge. The contact print is still supreme, which is evident from the very manner in which enlargements are judged. The highest praise we can give an enlargement is to say that it has *contact quality*.

"My paper is a chloride type, Convira, which I develop in an amidol solution. I have no special printing apparatus, using merely an ordinary printing frame which is placed below an uncovered light bulb. Glossy paper is to be preferred to matte surfaces because it has twice the scale from black to white. You know how much better your matte prints look in the wash water. A glossy paper has the same effect."

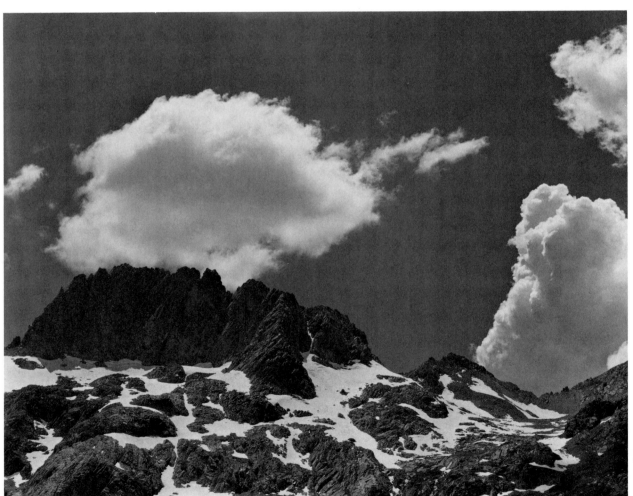

LAKE EDIZA, 1937 EDWARD WESTON

As might be imagined, Weston is an exponent of straight printing with no retouching of negatives.

"I do not favor spotting and retouching," he says. "These words bring to my mind a picture of *changing* a negative, of 'working it over.' Such processes destroy the photographic quality of the image.

"On the other hand, I am not pedantic about the matter, nor so 'pure' that I would not spot out pinholes caused by dust, or accidental scratches."

His opinions regarding retouching are somewhat remarkable in view of the fact that for 30 years Weston earned his living as a portrait photographer. It is interesting to note that for this work he used a 4 × 5 Graflex, equipped with a 10¾ ″ Meyer Plasmat lens.

Upon being asked for his opinion of the miniature camera, Weston had this to say: "Minicams are fine instruments, but are not good cameras for beginners. They should be used only by experienced workers, and then only when necessary.

"So far as good photography is concerned they have a very limited field, in which, of course, they are invaluable. But you cannot get perfect photographic quality in your prints with a miniature camera. Personally, I like to study and see the 'finished print' on the groundglass before I trip the shutter."

In 1937 Edward Weston was awarded a $2000 fellowship by the John Simon Guggenheim Memorial Foundation. He is the first photographer ever to receive this honor; and the fact that it was recently extended another year is fitting tribute to

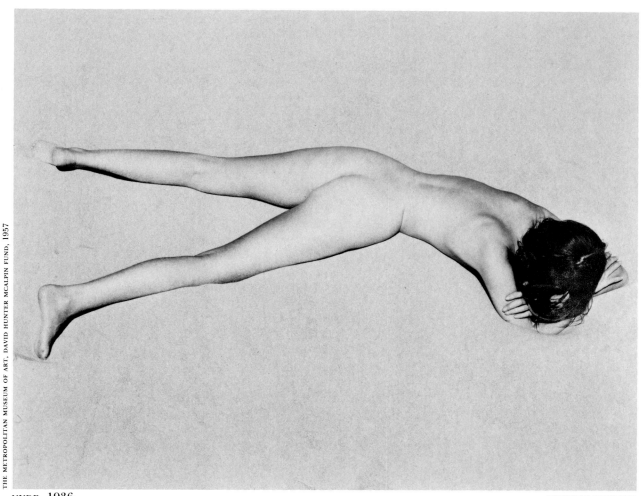

THE METROPOLITAN MUSEUM OF ART, DAVID HUNTER MCALPIN FUND, 1957

NUDE, 1936 EDWARD WESTON

his careful work. The grant was made to enable him to photograph the West. I asked him what he considered his objective in this undertaking.

"The objective of my work has been erroneously reported in the press as being the making of a photographic cross-section of the West, particularly as regards agriculture," he said. "My true program is summed up in one word: *life.* I expect to photograph anything suggested by that word which appeals to me during my fellowship."

Now let's hear what Edward Weston has to say on the controversial subject of composition.

"There must be broad symbolism in every artist's work. My own work has sometimes been spoken of because of its pattern and texture. If I thought my work only meant pattern and texture I would quit photography tomorrow. Form is more important to me.

"Many photographers are irked by the so-called limitations of the camera, and try to imitate painting and other art forms. To me the limitations of the camera are as important as its advantages. In the same way, the limitations of the poet's sonnet are what make it.

"I don't know a thing about the rules of composition. I make my own. The subject is very difficult to write about, and perhaps can never be explained in words, since it is so involved in personal experience and growth. Words, 'art criticism,' and explanations are the curse of today so far as art is concerned. To me, composition is the clearest and strongest way of seeing a subject."

Weston's advice to the beginner is characteristically simple and unpretentious. "Start out with a simple outfit, and learn all there is to know about it," he counsels. "You can do this adequately with an inexpensive $3\frac{1}{4} \times 4\frac{1}{4}$ view camera on a sturdy tripod, fitted with a five dollar rectilinear lens.

"If I have any 'message' worth giving to a beginner it is that there are no short cuts in photography (or in anything else, for that matter). I can give a student every bit of information I possess to no avail unless he has real love for his medium and is willing to sacrifice years of his life to it. I have worked 35 years, yet this year I feel that I have made definite progress."

Such is Edward Weston's creed, which has made him one of the leading photographers of our time. Throughout his entire philosophy and method of working runs one single thread, the undeviating line of *simplicity.* He has shown that careful attention to detail, not elaborate equipment, is the secret of good photography. It's a valuable message to the amateur photographer.

The Kid Who Lives Photography

Peter Martin

W. Eugene Smith's life is the kind of existence that everyone dreams of. At 24, he ranks as one of the nation's ace photographers

On August 4, 1942, a Fort Devens ammunition officer stood before a photographer slowly shaking his head. The photographer was saying, "All I need to finish my story is a picture of several soldiers crawling out of a dugout, under a cloud of smoke and flying debris. We can make the explosions with dynamite."

The officer said, "The army can't offer soldiers as props for such a picture. They might be blown to bits!" The man with the camera then asked if the War Department objected to his borrowing two empty uniforms. There was no objection, so he did, putting one on himself and stuffing his reporter-writer in the other. On a tripod deeply buried in the ground, an Ikoflex was mounted. In front of this camera, the photographer and writer crawled and crouched next to a stone and gravel covered stump—undermined with *55 pounds of dynamite!*

The fuse was lit and when the charge went off, the shock-blinded photographer tripped the camera shutter with an extension release. The picture was published in the newspaper supplement *Parade,* erroneously titled "Advance Patrol." The caption should have read "Photographer W. Eugene Smith, self portrait." The picture won first prize in the black-and-white class of the 1942 *Popular Photography* Picture Contest.

The Devens incident is not unusual in the history of 24-year-old photographer Smith. It is no more important than the occasion when he was almost washed down a Manhattan sewer; or any more significant than the moment when he spilled into the path of two crashing automobiles at the Freeport speedway; or the time his single-armed grasp was jolted from the top rung of a 140-foot rotary oil rig in Illinois; or the day his airplane "conked out" over the flooded Arkansas river. The folly of risking his neck is to W. Eugene Smith as much a part of photographic technique as shutters and filters are to other photographers.

Eugene, who was a newspaper photographer at the age of fifteen, on the photographic staff of *Newsweek* at eighteen, and with *Life* on his nineteenth birthday, has come a long way since the people back in Wichita complained about the wild boy who raced his bicycle around town and too frequently smashed into some citizen's automobile. It must have been this passion for velocity that convinced him in his fourteenth year that he must design aeroplanes. He filled his room with sixty model planes and began to collect pictures of "every type of plane ever built." For a Christmas gift, he gave his mother a sheet film back for her 3A Kodak—so that he might make just the kind of

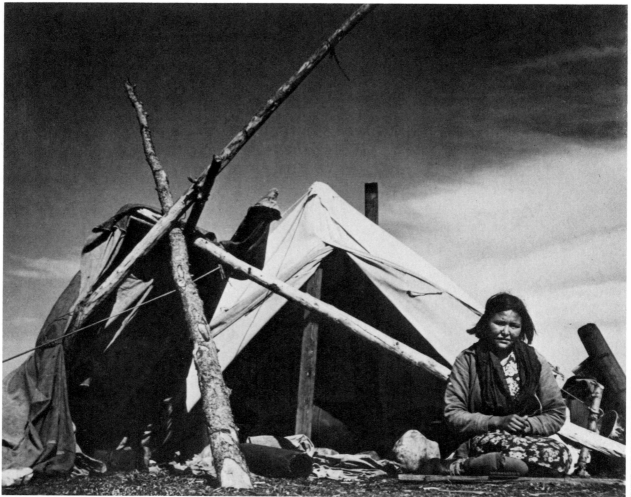

HUDSON BAY INDIAN NEAR ARCTIC CIRCLE

aeroplane pictures a young aeronautical engineer needed.

Soon the ingenuity of the camera began to interest the young boy, so much so that Eugene bought a Graflex and a Speed Graphic within the next four months. By June, he had decided to become a newspaper photographer for life, so he bought a green and white Chevrolet and painted the words "Eugene Smith, Photographer" on the trunk in back.

Newspaper photographers found adventure, thought Gene, and that was what he wanted. He never drove his Chevrolet away from his home without having his Graphic open beside him, loaded and with a flashbulb in place. In true theatrical fashion, he popped in and out of sports events followed by six or seven assistants, who were always anxious to help—and see a free game. Once to impress other newsmen with his nonchalance, he covered an entire boxing bout while slumped down in a ringside seat with his feet on the railing. All of the sixteen negatives he made that night showed his feet.

Despite his foolish theatrical behavior, Smith was developing good camera technique. Long before Kalart synchro-sunlight publicity, he was experimenting with flashbulbs to kill the knotty holes the Kansas sun made in the faces of his subjects. Editors of the Wichita *Beacon* and the Wichita *Eagle* used his pictures to the discomfort of the old staff men who were still living in the flashlight powder era.

When the drought hit Kansas in the summer of 1934, Gene and his green and white Chevrolet

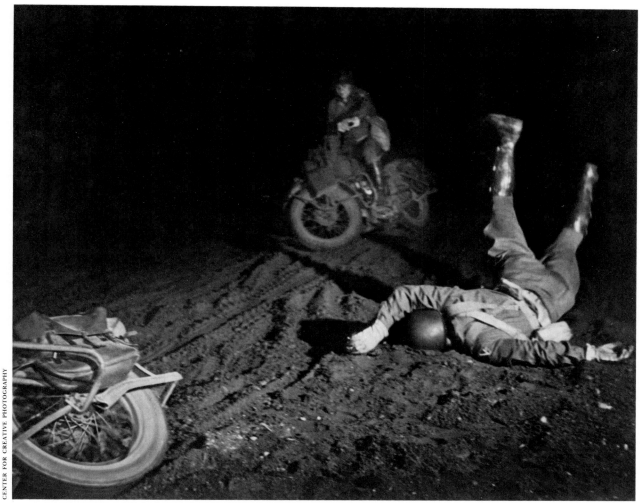

MOTORCYCLE ACCIDENT

covered the event. Stopping only to refill a steaming radiator, he drove from one devastated county to another recording the stark, wind-flattened fields and an occasional cow skull. His filters melted under the Kansas sun but *The New York Times* bought his pictures.

In 1935, Eugene Smith was paddling a rowboat in the torrent of a great Kansas flood. One day's shooting detail took him in the air above a wide, windswept area. While flying there, the plane's engine sputtered and died. While the pilot fought to save the falling ship, Smith leaned out the window and continued to shoot until the plane landed.

Gene managed to meet enough classes at Wichita High school during these years to be called a student. In the spring of 1936, his reputation as a sports photographer reached the officials of Notre Dame. They offered him a camera scholarship for the coming fall. The only event that dampened his spirits that spring was his father's serious illness.

About graduation time, his father's condition reached such a state that Gene submitted to two transfusions within six hours; but his father died anyway. The same afternoon of this day, young Gene went out with his camera trying to forget his sadness. He stood atop his automobile and made two shots of Wichita High School for the frontispiece of the school's yearbook, then fell on his face in a dead faint.

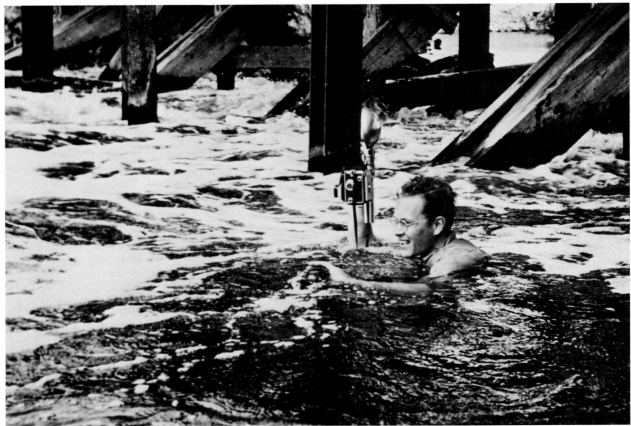

Smith's assignments take him everywhere. He spent 45 minutes in the snake-infested canal shown above.

FROM NOTRE DAME TO "BIG TIME"

Notre Dame had great plans for Eugene Smith. He was to be their sports, yearbook, and publicity photographer. By Christmas, he had 1,400 negatives but had found little time to study. From then until midterm examinations, he stayed in his darkroom. When he came out, he said, "I'm getting a fine liberal education!" But his history professor did not agree and handed him a report card marked 66.

This was a crushing blow to Eugene, because history had always been his favorite subject. By sheer instinct, he had made top grades all through high school. He walked out of the Notre Dame history class, took the negatives he had shot that day, wrapped them up with complete directions for development and then caught the first train to New York. When he reached the city, a friend's letter was awaiting. The history professor had made an error; he had mistaken Gene for another

Smith in the class.

He enrolled at the New York Institute of Photography but could not confine himself to the school's assignments. He chose to experiment with his new small camera. When summer came, he packed his equipment and started home, stopping at newspaper offices in Buffalo, Akron, Cleveland, South Bend, and Kansas City long enough to get a positive *no* from each editor. Today, he is grateful that none of these newseditors hired him.

By fall, Gene was in New York again—this time as a staff photographer for *Newsweek.* He started using a small camera most of the time and began to battle with his editor in behalf of rapid, miniature camera technique. In the heat of argument, his editor positively forbade him to use the small camera. After Smith was fired, he swore never to take a staff job again. He soon had a free-lance contract with *Life.*

LIFE AND NEAR DEATH

Eugene Smith's incredible pace was established on *Life* assignments. It was generally understood by *Life* editors and researchers that the W. prefixing his name stands for "Wacky."

In May, 1939, *Life* sent Smith to Centralia, Ill., to document an oil boom town. In one working night, he came within the reach of death three times. First, while eating a "boomerang" sandwich in a beer parlor, he noticed a peculiar relationship between the owner and a police officer. He pulled out his camera and shot a picture of under-the-counter bribery, then made for the back door.

At the next cafe, Smith was approached by a happy oil worker with a giggly female wrapped around his neck. He asked Smith to take their picture. Gene took some simple shots of the two. While all this was going on, a huffy drunk was raising a disturbance in the background. The flashbulbs soon attracted him and he came stumbling over, swatting with a beer bottle, shouting, "You can't take my pitcher." Gene ducked and the bottle broke on a post above his head. Then, the drunk made for him with the jagged broken bottle top.

After dodging the drunk, Smith went outside and his eye caught an expanse of derricks lighted by the flames of gas spouts. He found a newly-rich farmer who owned a Taylor Cub plane and bar-

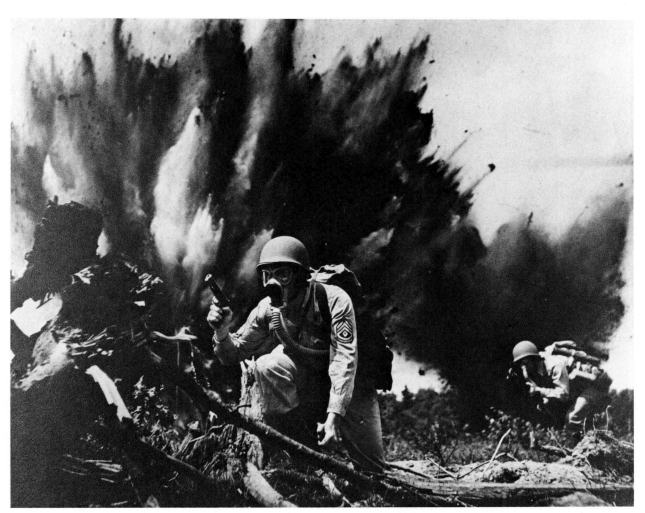

Smith donned a sergeant's uniform and pressed cable release with his left hand to make this picture.

gained with him to fly over the fields. The farmer took off by the light of Gene's automobile. However, the trip ended in a swift crosswind that angled the plane into a fence at the end of the cow pasture.

Still thinking he had no picture, Smith climbed up the rigging of a 140-foot rotary rig in the darkness. Just as his hand reached for the last cross bar at the top of the structure, the folding tripod on his back sprung out and jerked both hands loose. He fell backward and caught his neck in the crotch of two cross beams. There he hung until he regained his hand hold. The few ounces of energy left in the Smith torso propelled him to the flat top of the tower where he lay limp and half-conscious. He made several exposures holding the camera in his hand and opening the shutter for ½ and 1/10 second. He got what he wanted: two good negatives.

ONE LOVE LETTER TRANSLATED: $3

Eugene Smith had kept his face buried so far down in the hood of his Ikoflex those years that ordinary matters, such as women, had bothered him very little. That is, until *Life* sent him over on Broadway to do a story on twenty-two dancing girls from Mexico.

For the entire sixty-three performances of the show, Eugene sat in the front row and watched Marissa Flores dance to Goyescas' *Intermezzo.* He thought she was the most beautiful object he had ever seen. He showed Marissa and her singer girl friend New York—but the show left without him once mentioning his love.

Apparently, the singer friend had fallen for Eugene in the shuffle for when the show returned to Mexico City, he began to get long mushy letters in Spanish. A translator was charging him $3 a letter for translation until someone at the Black Star agency offered to have a Spanish girl acquaintance do them for nothing. The letters began to come more often so Smith, feeling obligated to a translator he had not even met, offered to take her to dinner.

He married the polite and pretty translator and named his daughter after the dancer who held him transfixed for sixty-three consecutive nights. Even after he was married, Gene still had a hangover from his enchantment. He bought a phonograph record of Goyescas' *Intermezzo* and played it every night.

For him, photography had always been a hyper-

emotional experience. The walls of his darkroom were gutted as a result of his pounding with his fists when he failed to make a perfect print. There was something in the Goyescas' *Intermezzo* that calmed him. "Music," he said, "saved my life."

Today, the four walls of his living room are shelved with 10,000 phonograph records. There is a speaker in his dining room and one in his darkroom. His record-changing phonograph is equipped with special oil gadgets to keep the machine from going to pieces under hour-after-hour punishment and a "permanent needle" is changed every three weeks. The index of his records list Beethoven, Wagner, "boogy-woogy" piano, and chain gang ballads. "One of the happiest weeks of my life was the one I attended six concerts in a row and played music at home in between," Smith says.

SMITH'S PHOTOGRAPHIC TECHNIQUE

The photographs that Eugene Smith makes today for his clients—*Colliers,* the *American,* and *Parade,* the weekly picture-news supplement, are a compound of technical magic. Their brilliancy and dimensional feeling have prompted *Parade* editors Fred Sparks and Charles Kraft to bow, throw incense, and call him *God with an Ikoflex.*

He visited Brooklyn recently to lecture before a camera group known as the "Tripod Club." First words spoken by Smith that night were: "Gentlemen, *I hate* tripods!" Without a tripod, W. Eugene still manages to expose most of his negatives at *f* 16 and *f* 22—apertures that often call for speeds of 1/5, 1/10, and 1/25 second. He usually overexposes three times normal and brings detail out with long printing. He uses the small camera on all jobs except aerial, and his chemicals, film, and papers are the ones prescribed by the manufacturers. However, his cameras include a Rolleiflex, Speed Graphic, Graflex, and Contax, besides his five Ikoflexes.

A couple of years ago Smith, in a desperate mood, pulled all his prints out and covered the walls and floor space of his house. He looked at them all and thought there was definitely something wrong. His conclusion was that the pictures all were too darned perfect. They were exposed at the *climax of action;* compositions were too balanced. Today he brings into his compositions a healthy kind of imperfection. Motion is stopped before it reaches the obvious point; people are caught doing what you don't expect them to do.

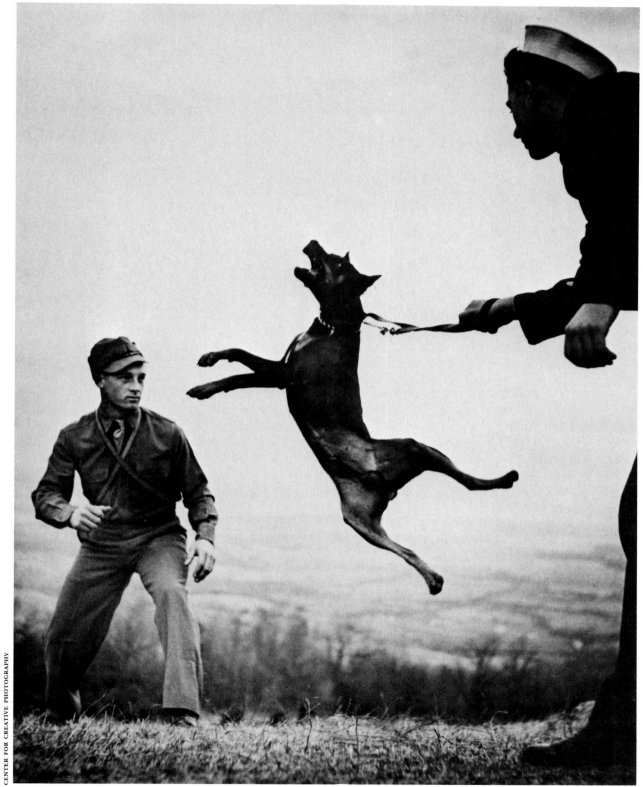

K-9 TRAINING, 1940

W. EUGENE SMITH

57

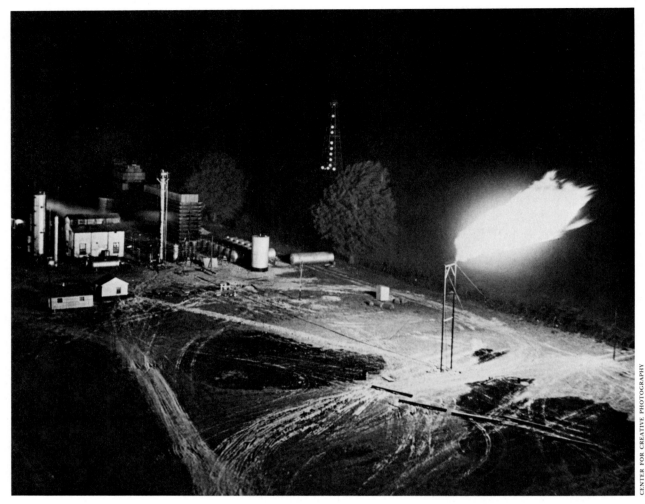

OIL FIELD

Smith hates to work with reporters and writers. He names only three reporters with whom he has willingly traveled. They are Ed Motyka of *Parade,* who humors him by finding unusual characters for personality stories; red-headed Bernice Shrifte of *Life;* and Allen Sloane, an ex-*Parade* reporter whose non-compromising nature put Smith in a fighting mood the first hour they were together. However, this hate turned to admiration when, later that day, Sloane met with the law of Fayetteville, N.C., got sassy, and they were kicked out of town.

Today, the W. Eugene Smith technique continues to change. He is trying to get a more "out of this world" spirit into his pictures. At times, he has even chosen soft negatives in preference to wire-sharp ones—to get more mood. His army stories are always preferably shot on cloudy days for a grim effect.

Smith repeats an idea expressed by Edward Steichen: "Most photographers seem to operate with a pane of glass between themselves and their subjects. They just can't get inside and know the subject."

Alfred Stieglitz 1864-1946: A Tribute

Georgia Engelhard

It was indeed a remarkable face, a face that looked at life with piercing keenness for more than eight decades, had seen brownstone New York metamorphosed into a city of soaring skyscrapers, had seen Europe torn by two world wars, had seen the easy going ways of the Victorian era transformed into the roar and bustle of an over-mechanized world. A vital face with penetrating dark eyes that looked honestly and trenchantly not only at you but at life. A face that could be grim and sad with the sorrows of the universe, a face that could flame to challenge or rouse to anger at injustice, a face that could smile at you with all the sweetness and directness of a child, that could twinkle with fun and humour as well. For all its eighty-two years it was a young face with smooth skin, rich with life and an inner fire. It was a face of universal moods, mirroring all of existence—the face of the Great God Pan, the face of the Grand Old Man of Photography, Alfred Stieglitz.

It was the face of a great photographer, but it was also more than that: it was the face of an historical figure, an American institution. Although born in Hoboken in 1864, Stieglitz was made of the same stuff as the men of Plymouth Rock or of the pioneers who trudged westward with their oxcarts, mile after mile, year after year, across wild and hostile country, their eyes fixed on a goal in far places. A pioneer, in the true sense of the word, Stieglitz had never been content to rest, had always striven to go higher and higher in his work, to make each phase of it a step forward, had never allowed himself to rust in the rut of success. He himself said: "My teachers have been life, work, and constant experiment."

Life was a challenge to him; photography had always been a challenge to him from his earliest student days when he questioned the dictum of his teacher who said: "You can't photograph white on white although you can paint it." "Why not?" queried Alfred, and went out and proved that he could in one of his early prize-winning pictures, "The Letter." He was told that you can only photograph in daylight, so he shut himself in a dark cellar and photographed an old dynamo. The exposure lasted twenty-four hours, but the result was a perfect negative of the machine. In later years, when photographing varied aspects of New York, he heard someone say that you could not take pictures from a moving train. He promptly met this challenge with "The Hand of Man," a subject still popular with contemporary photographers. He was not only able and willing to meet challenges, but he derived enormous and elemental joy and satisfaction from accepting them. It was through this ability and willingness, through his desire to experiment, to try with all his heart for what he wanted to achieve that he succeeded, many years ago, in lifting photography from the status of a purely documentary craft to the level of creative art, to a means of interpreting the essence of life through the camera.

Photography was not only his career, but the love of his life, which he pursued with intense singleness of purpose. He demanded this singleness of purpose, this integrity from others too. Sloppy work and sloppy living were intolerable to him. He didn't care what you did or how you did it, provided you did it with conviction and 100% sincerity. When you met him, this intense sincer-

59

ity, expressed not only in his eyes, but in all of his features, was one of the things that you first noted. His was not just an interesting face—it was an enormously real face, the face of a man who had lived his life according to his own lights, regardless of convention and the world's opinion.

Always a perfectionist, he was his own sternest critic. Time after time I have seen him ruthlessly tear up prints of excellent quality because they were not exactly what he wanted. Time after time I have seen him discard negatives because they did not fully express what he was after. He had always believed primarily in artistic and personal integrity rather than in worldly success and self promotion. And from himself he had always demanded the utmost. I visited him (just before he died) in his gallery at 509 Madison Avenue. He told me one of his whimsically profound stories which reveals much of his essential attitude toward himself and his work. Smiling, he said: "You know, some years ago, a man said to me, 'Mr. Stieglitz, look at all that you have done in your life,' to which I replied: 'My God, I have done nothing, the quintessence of nothing—but at least it was the *quintessence.*'" His message to you, the photographer: "Don't be satisfied with something that you think will get by—be only content with it when you know that it is good—and then don't just sit back and gloat over it—go out again with your camera and try to create something better."

His lens has been pointed at every detail of life around him. He did not have to go to exotic, far off places to find subject matter. He did not need glamorous models to pose for him. He made pictures of what he saw around him, and his photographs glow with trenchant feeling and humanity that make them works of art. Steaming horsecar nags shivering in the wintry dusk, crowded ferry boats, the dignity of country lanes, swirling mists of a blizzard in New York, a tree, dew laden grass, hands, the placidity of an old Victorian lady, clouds—he had seen pictures in all of them, and instinctively he transfigured these everyday scenes and subjects into masterpieces. He was no specialist, his eye saw pictures in everything, for he loved and had feeling for what he was taking rather than thinking about making "effective" pictures to intrigue the public eye. Recently he was asked: "How does a photographer learn?" to which he answered without even a second's hesitation: "By looking."

He was well grounded in the science of chemistry and photography; his technical background was probably much sounder than most of us have today. Although a champion of the arts, he claimed that he didn't know what Art is, and the other day when he was showing me some of his early prints, he smiled roguishly, remarking: "You know, I never learned anything about that thing called composition." Maybe he never learned about composition in a formal, academic way, maybe he never heard about S curves and X compositions, but he did learn about it, as many of us do, by looking at the works of others, at paintings and etchings, and subconsciously absorbing the basic principles until the feeling for them became instinctive.

When you talked with him, his keen, dark eyes were piercing, seeking to penetrate your very soul, to see the real *you.* He was always pursuing reality in his work, not surface reality, but the essence of things, the pulse of existence. Simplicity was his working keynote. A simple man, wearing simple clothes, with simple tastes, he lived quietly and unpretentiously. He never felt that he had to beautify a person or a scene in his pictures. Where other photographers would have "dubbed in"

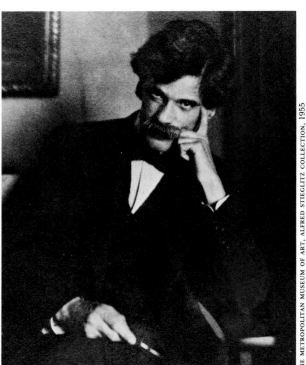

THE METROPOLITAN MUSEUM OF ART, ALFRED STIEGLITZ COLLECTION, 1955

Alfred Stieglitz—photograph by Heinrich Kuehn, 1904.

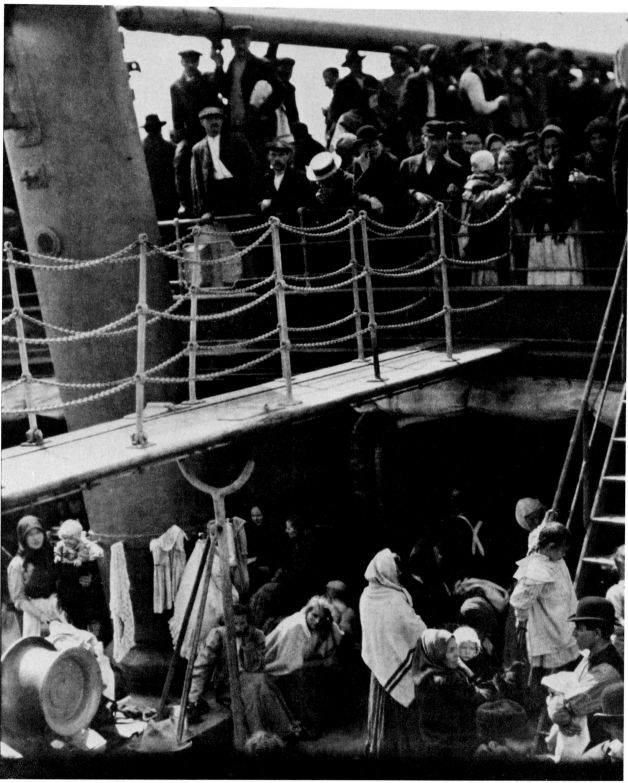

THE STEERAGE, 1907

ALFRED STIEGLITZ

clouds to make a shot of a dirt road flanked by towering trees more dramatic, he avoided such trickery, and therefore achieved a picture whose impact is terrific just because of its stark simplicity. His portraits are honest, straightforward; not always flattering to the sitter, but always true. He never went in for glamour lighting with enormous blocked up shadows sweeping half across the face, or for hair "burned" to death with top lighting. He never used floods and spots, but depended only on natural light, sometimes augmented by a white parasol for a reflector or the illumination from a skylight. Stieglitz's portraits are living, breathing human beings, maybe not the sitter's wish fulfillment, but they are intensely real. You can feel the firmness of flesh, the roundness of cheek and arm, the bone structure of hands, you can almost sense skin color, and above all, you know the character of the person in the photograph. You may not like his photographs, but you cannot fail to recognize that they have something to say, with their glowing vitality and inner strength. They are always interesting and dynamic, always supremely alive.

His technique was so fine that you are utterly unconscious of it. When you look at his photographs you never question how they were done, on which film or with which filter, for you are looking at conceptions which are works of art in which photographic technique was just a means to an end. Many of his early prints, unfamiliar to most of us, illustrate the great technical mastery that he already had in the days when fast film did not exist, when cameras were cumbersome and less versatile than they are today, when enlarging papers did not range from number 0 to 5 to enable you to correct errors in exposure or development. Pictures of houses in Germany and Switzerland, scenes of Venice reveal perfect shadow as well as highlight detail, a thing that was looked upon as impossible by the then experts.

His was an honest and open face, and his pictures are not only honest in portrayal, but also in the photographic sense: they never try to ape another medium, they never look like etchings or paintings—they look like photographs. And why not? We condemn a painting with photographic qualities, so why not produce photographs which are true to the medium? Stieglitz has told me that as a child, he never had any desire or talent for drawing, would never make naive sketches with colored crayons as other children did, but when, at the age of three, he posed for a photographer,

he insisted on going into the darkroom to see how the processing was done. His mind and his heart had always been given solely to photography, and his craftsmanship lay in that he knew best how to use camera, lens, film, paper—how to make them work for him and sing for him, just as the painter uses brush and canvas, just as Beethoven used a symphony orchestra. The camera was his means of expression, and he always remained true to it, just as he had always remained true to anything that he believed in.

I think that one of the basic reasons for the greatness of his pictures lies in the fact that he made them to please himself and nobody else. He never worked commercially, never would accept money for photography, and thus left himself free to take what he chose, and to take it the way he wanted, rather than having to satisfy a client. Many well-known persons wanted their portraits made by him, but if he did not like them or felt them unsympathetic, he always refused. Nor would he make portraits until he knew his subjects, and that more than casually. How else, except through talking to them, getting to know their mental as well as physical characteristics, could he give a portrayal which would be an interpretation of personality?

There had never been anything ostentatious about him or his photography. He himself was unostentatious, liking simple people and the white walls of *An American Place,* where quietude reigns and the noises of New York are shut out, save for the sound of the Cathedral chimes. His photographs are equally simple and direct, not only in what they portray and in composition, but also in the way that they are presented. The prints, many of them done on platinum papers, are small: $4 \times 5, 5 \times 7, 8 \times 10$. You will never find any flamboyant 16×20s tricked up with submounts. Such is the power of his pictures that they do not need size to make them sing: even a 4×5 on an 8×10 mount has terrific impact, due to the purity of the feeling, the elemental vision, the perfect juxtaposition of masses and tones.

Don't think that he just went out with his camera and made pictures with his innately artistic eye without working over it. He worked harder than any photographer that I have ever seen; he worked not only physically, but with his whole soul. He put so much intense emotion into picture taking that it would exhaust him, drain him. I have seen him wait days, Graflex in hand, for cloud formations to assume the patterns that he wished

for his magnificent sky symphonies, "Equivalents." For years before his death, he took no pictures, and many persons thought he had renounced his camera. Actually, he suffered from a heart ailment (which caused his death July 13, 1946). Thus excitement was banned, and to him photography was excitement. Years ago, while at his Lake George farm, I showed him my reflex camera with a Cooke lens. "Let me hold that camera for just a minute," he said. I handed the machine to him; he looked in the groundglass, manipulating the focusing knob. His whole person seemed to flame to life, years fell away from him, and he was no longer an old man in a black Loden cape but the master photographer. But this transformation was only momentary; sighing, he handed the camera back to me: "No, I can't do it any more, it's too exciting."

He not only worked hard, but when you posed for him, as I often did as a child, he made *you* work —hard. Light, camera angle, focus, pose, above all, expression; everything had to be exactly as he wished it. He worked on you until he got that, cajoling, teasing, bellowing with impatience because he could not always get what he wanted. His patience and persistence were endless and forceful; he often wore me down to tears. But when he got the result, it was not just a pleasing picture of a blonde child, but the very essence of childhood itself. His work was not merely pictorial representation, it was his vision of people and of life.

I shall not go into the facts of all that he has done for the advancement of photography. You can find that out for yourself by studying *Camera Notes, Camera Work* and Lewis Mumford's "America and Alfred Stieglitz." His influence is strongly to be seen in the work of Paul Strand, whose photography is marked by the same honest intensity of vision as that of Stieglitz, in that of Edward Weston whose studies of trees, rocks and other natural details are done with a stark and striking simplicity that must have been partially derived from an appreciation of Stieglitz's work. Weegee, with his brutally forceful news pictures, carries on in a spirit that was Alfred's too. Weegee derives his material from life around him, faces facts frankly, and tries to present an honest record of what he sees and feels. So did Stieglitz except that

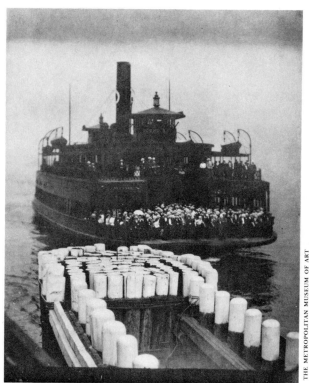

THE FERRYBOAT

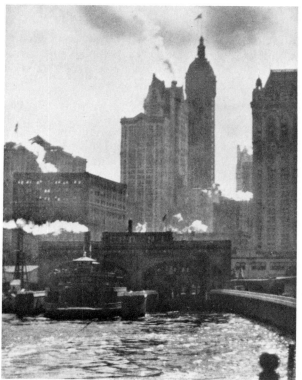

METROPOLIS

his world was a much less violent, bitter and satirical one.

Stieglitz was remarkable in that, although photography was the ruling passion of his life, he nevertheless had many, many other interests. He was at one time amateur billiard champion of Germany, he loved the theater, not only Duse, but Weber and Fields as well, he loved to walk, not only in the Alps in his student days, but also over the rambling hills of Lake George. I remember him well, in his late sixties on many a hike and picnic in the Adirondacks: he was not only one of the swiftest and most vigorous of walkers, but also the fun maker on those expeditions, and his often sombre face was always gay and happy, sparkling with exuberance. He had always loved horse racing, and Man O'War was one of his idols; the chestnut stallion was to him not only the symbol of the perfect horse, but also the personification of physical perfection coupled with a great heart. In his younger days, Stieglitz not only hiked but rowed and played tennis, not just casual tennis, but tennis into which he put all his energy and his will to win. He was interested in music and in literature, particularly in modern literature, in the works of Sherwood Anderson and D. H. Lawrence, in the work of men trying to do in their medium what he strove to do in his. Whatever he did, he did wholeheartedly; had he not been a photographer, he would have made an equally successful doctor, lawyer, or business man, provided that he loved any of these professions as deeply as the career he chose.

He would have made a superb actor. As a raconteur he was unsurpassed. His stories were ironical, amusing, dramatic, always profoundly interesting, and as he told them, you could sense that he was really living them. Not only did he throw himself completely into the tale he was telling, but such was his power that he made you, his listener, live them with him, and see them in your mind's eye as if the experiences had been your own. Due to his heart ailment, he did not indulge in talking or story telling as much as he did earlier, but if he liked you, he would talk to you as much as his strength permitted.

If he didn't like you, he could be cuttingly rude, silent and sarcastic. When people came to his gallery, where he exhibited paintings by John Marin, Georgia O'Keefe and Arthur Dove (for he had always championed painters and sculptors as well as photographers), I have often heard his reply to the question of what the price of a painting was.

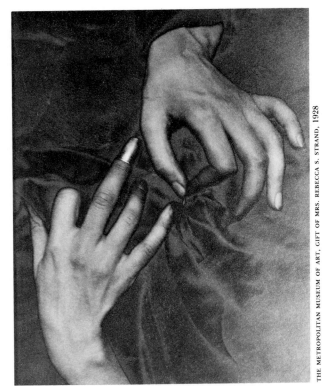

HANDS—GEORGIA O'KEEFFE—1919 SERIES

NEW YORK CENTRAL YARDS

"How much is it worth to *you?*" he would query belligerently, dark eyes snapping. And I know that he has refused high prices if he felt that the buyer did not truly appreciate the painting, giving it for much less to someone whom he thought would truly love that picture.

Although it was not always obvious when you first met him, he loved people and he loved to talk to people. Many thought him haughty, eccentric, aloof, almost superhuman. To me, he was essentially a kind man, full of sympathy and warm feeling for others. I think that he was not apt to judge your character so much by what you said about yourself and your views, but more by the way that you listened to him, by your reactions to stories, and to the paintings and photographs he showed you. Some years ago he liked to show prints of his cloud pictures, "Equivalents." He would show them to you right side up, upside down, held sideways and then ask: "Which way do you like this picture *best?*" Your answer provided him with a key to your character, though he would never tell you which way *HE* liked the pictures or had meant them to be presented.

Although he no longer photographed, he was interested in the work of contemporary photographers: his favorite was Ansel Adams, the only one, incidentally, for whom he had given a show at *An American Place.* He liked Adams because he is simple and straight-forward. Furthermore, Alfred was fascinated by newer cameras and technical advancements. When I went to photograph him I was using both synchro-flash and open flash, and he wanted to know exactly how the mechanism worked, why the lights were set up in a certain way, what my exposures were. And incidentally, he was one of my favorite models.

Not only was his face a photographic "natural," whether he smiled or scowled, but he took direction like a veteran model, and gave you just the pose, the expression you wanted from him. And how he could hold that pose! He never moved; when five flashbulbs went off he never blinked. He was never static before the camera, always dynamic, always intensely alive even in repose, and it was, I think, difficult to miss making effective pictures of him.

To meet Stieglitz was a thrilling experience. You liked or disliked him, but he was always interesting, always a dynamic force. There were those who adored him, those who hated him; he inspired genuine emotion just as he himself had genuine emotions. You may love or hate mountains, you may love or hate the sea but you can never forget them—and this is equally true of Stieglitz and his photographs. There was in him a tremendous power, like the power of Nature itself; an elemental impact which hit you through his appearance, through his gestures, through the quality of his voice, and above all, through the luminous expression of his austere yet mobile face.

In this slight little man with his black, Byronic

THE METROPOLITAN MUSEUM OF ART, ALFRED STIEGLITZ COLLECTION, 1933

FLATIRON BUILDING

65

eyes, his thinning grey hair, his quaintly faun-like, tufted ears and ever present black Loden cape, you found the living example of the trenchant truth of Shakespeare's adage:

"To thine own self be true, and it must follow
 As the night the day, thou canst not then be false to any man."

It is this quality which made Stieglitz not only a great photographer, whose work will live on as surely as that of Shakespeare, Beethoven and Rembrandt, but also an unforgettable and great personality whom it was a supreme privilege to know.

Feininger as I Know Him

Wilson Hicks

To no other man I know is photography a more exciting job than it is to Andreas Feininger. Slight and dark, soft of voice and somewhat shy, he gives one the impression that there is a great suspense within him, that he is living almost breathlessly until the next time he can train his camera on some new picture and some new picture problem. Unless it is a special problem in light and shade, form and space, pattern and texture or motion and mood it is not a picture for Feininger.

In Feininger converge important factors of birth and background which help make him what he is. Born an American of German ancestry, son of an artist, he seems to have inherited both the virtuosity in science for which his European forbears are noted and, I think I am correct in saying, a considerable talent in art. This is a happy combination for a man who chooses to make a career of photography, product that it is of the strange marriage between art and science.

Before I tell you more about Andreas Feininger I think I should let you know why I tell you about him at all. It is because he has written and is to see published on November 1 a quite remarkable book, "Feininger on Photography." My guess is that across more than one reviewer's mind will flash the word "monumental" in writing of this work, even though they may not actually use the term. For Feininger has produced a complete text on (1) use of the camera and (2) processing procedures. Both are explained in terms of the control of light, space, motion, contrast and color. The book constitutes a full course of instruction for amateur or advanced practitioner. It is painstakingly up-to-date in its exposition of techniques. If

monumental is too large a word, the book can be said to be unique in the sense that its author is a working journalist (a *Life* staff photographer), schooled likewise in the techniques of the communication of facts and ideas. He never lets one forget that a good photograph is invariably the product of those two inseparable coefficients, C—camera and B—brain.

Let's have a look at this photographer-author. Andreas Bernhard Lyonel Feininger was born in Paris, France, December 27, 1906. His paternal grandfather came to the United States in 1848 from Durlach, Baden, Germany. His father, Lyonel Feininger, the abstract painter, was born in this country. At the age of 16 he went to Europe to study art, first in Belgium then in Hamburg and Berlin. In this last named city he married and decided to establish himself as an artist. In the lean beginning years of his career Lyonel Feininger drew a comic strip, the "Kinder Kids," for the *Chicago Tribune.* Thus printer's ink entered the family bloodstream. Later Lyonel Feininger became closely associated with Walter Gropius in the founding days of the Bauhaus. He taught painting there for several years, then became artist-in-residence and adviser.

Andreas Feininger attended technical high schools in the German cities of Weimar and Zerbst. From the latter's school he was graduated *summa cum laude* in architecture March 16, 1928. The German economy was suffering from various maladies which even a Schacht could not cure. One of them was unemployment. The state rigidly controlled the job market, and the basic tenet of that control was jobs for Germans first. To Fein-

TRAFFIC JAM, NEW YORK ANDREAS FEININGER

inger, a United States citizen, this meant that he could work only by special permission, which was next to impossible to obtain. The drafting boards were crowded but somehow he managed to find an occasional seat at one of them. From the fall of his graduation to the winter of 1931 he lived precariously on odd assignments.

Today Feininger describes with bitterness those trying pre-Hitlerian days. But he recalls that in them there was a reward, the significance of which he did not realize at the time. In 1928, for reference purposes in working out his building designs, he took his first photographs. They were simple exercises in line and form but they introduced him to a new profession and the taking of them proved to have been a valuable experience when later he undertook his transition from architecture to photography.

In 1931 Feininger concluded that his frustration was too acute to endure longer so he scraped together what marks he could and invested most of them in an Opel roadster, the German near-equivalent of a Stutz Bearcat. For six months he toured the provinces of Germany and France. Architecture was still his overpowering aim and ambition and Le Corbusier was one of his gods. At Le Corbusier's atelier in France his Opel finally stopped. He stayed a year, worked as a designer on a volunteer basis and as a student. Meals were not always regular but the name Le Corbusier was magic. Sometimes that magic had to substitute for meat and drink, for France too was racked with economic pains and there was no regular paid job for United States Citizen Andreas Feininger.

On his motor tour the Opel had taken him to visit his father at the Bauhaus in Dessau, Germany. There he had met Wysse Hägg at Christmastime in 1931. Once again a plan for his life was being shaped. By some romantic quirk he and Miss Hägg met the second time in Paris in the fall of 1932. A year later Feininger decided to try his luck in Stockholm. Construction was on the upgrade there and in his pocket he had some notes on prefabricated houses, his own original ideas. Miss Hägg also went to Stockholm. She had been a student at the Bauhaus. In the Swedish capital she readily obtained a job as a pottery designer.

Feininger proudly hung out his shingle as an architect while his wife kept the home fires burning with her weekly pay envelope from the factory. He was a married man now. He just had to make a go of it. Sure, he was an alien. He spoke only German. But the Swedes would like his ideas for prefabs once he could present them to the right people. . . .

Exactly nothing happened. And so, seventeen years ago, Feininger decided that he was not cut out to be an architect. He remembered having once held a camera in his hands, having tripped the shutter, having created something. House plans he couldn't sell. But photographs? He would try.

His first salable pictures were of Stockholm itself,—"architectural shots." Some of them were eventually published in book form. Feininger says today that he never really "learned" photography. Apparently it came naturally to him. He was never an amateur. Instead of settling down to master the techniques through study he began in 1934 to write about them, a form of study which he shared with others. In five years he turned out at least half a dozen books, one or two of which were translated into several European languages.

One summer night not long ago I visited Mr. and Mrs. Feininger and their 13-year-old son, Thomas, in their apartment in downtown Manhattan. He showed me those earlier photographic books. In particular I remember one, sprinkled with pictures by German and Swedish photographers of the early Thirties, most of them strongly under the influence of Dr. Paul Wolff. Feininger laughed as he laid them out on a table. They were modest little volumes in paper backs, but for me they had a special meaning. All written in German, they were the precursors of the husky work which Feininger now has written in such excellent English. Those little books represented the unusual feat of a man who simultaneously mastered a craft and, in a very effective way, became articulate about it.

As I sat in the Feininger home he and I talked of his philosophy of photography.

"Realism and super-realism," he said, "are what I'm after. This world is full of things the eye doesn't see. I mean even the eye of a sensitive person. The camera can see more, and oftentimes better."

I recalled the words of the great W. H. Fox Talbot: "A painter's eye will often be arrested where ordinary people see nothing remarkable."

"The painter," I added, "can outsee the layman. The camera can outsee the photographer."

Feininger held up a picture of a poppy taken from the under side. I reflected that I had never viewed a flower from exactly that angle.

"See those little hairs on the stem?" he asked.

"The eye misses them altogether. As well as recorder the camera is investigator and researcher. It emphasizes the characteristics of an object. It makes one more keenly aware of one's surroundings. It gives human beings a deeper understanding of the world's form and content. It increases knowledge. It is a versatile instrument, too. With a short lens one can reveal the hidden things near at hand, with a long lens the hidden things far away. To me the telephoto provides a new visual sensation for people. It widens their horizons."

As we talked his son Thomas called in occasionally from his own workroom where he was building a telescope. Before we had sat down I had a brief glimpse of Thomas' sanctum. On its walls were maps and charts of the skies and all about were books, tools and instruments. This room, with its optical workbench, adjoins his father's combination laboratory and study where he writes, makes enlargements or rigs a new telephoto camera.

"Thomas and I both like astronomy," Feininger said. "He's pretty good at it. I don't care about knowing the names of the stars, but the sweep and grandeur of the universe fascinate me."

I could see Feininger was about to take up the phase of photography he likes best, that of spaces and forms which are wide, high and deep: city views and landscapes, mountains and bridges, streets and rivers, almost anything that is built,

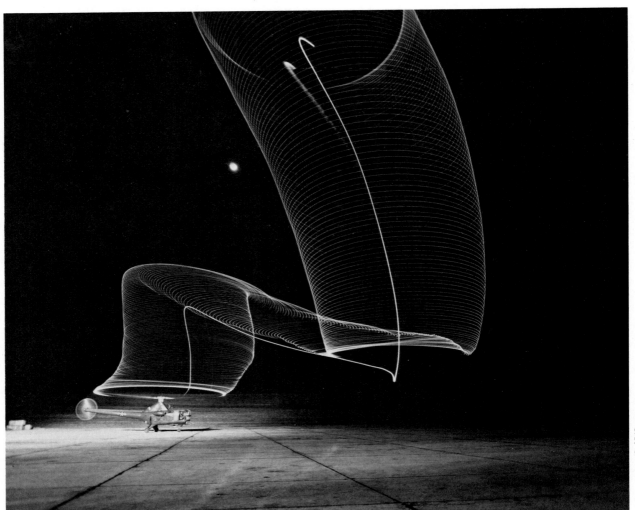

HELICOPTER TAKE-OFF

whether it is built by man or by nature. The urge to deal with space and form which once made him long to be an architect has been carried over into, is one of the driving forces of, his photography. He began to hand me, one at a time, some of his pictures, those he liked particularly well. His real favorites without exception were adventures into the world of pure design in which he had dealt with the elements of space and form with "sweep and grandeur."

"Space he loves first in his pictures," observed Mrs. Feininger. "It decides everything else."

"Do you ever wish you had become a painter?" I asked Feininger.

"No," he replied. "The photographer has almost as much control over his subject matter as a painter. He can control light and shade, form and space, pattern and texture, motion and mood, everything except composition."

I said I believed that photographers more and more were learning to control composition better, too. At times the camera is inclined to show too much. I said I thought the technique of concentrating on the essentials was being improved. Feininger agreed.

His living room where we sat had two of his photographs on its walls. They were of heroic proportions. One, a view of Shasta dam from below, must have measured at least five by ten feet. The other, a view of the desert near Tucson, Arizona, was a good four by five—feet, that is. For years *Life* has found it difficult to use many of Feininger's

LIFE MAGAZINE © 1945 TIME, INC.

STEEL MILL, PITTSBURGH

pictures in less than two pages each. He has come to be known to some of his friends as "Double Truck Feininger." Now here was sweep and grandeur on the very walls of his home. Perhaps he was really a muralist. If the camera's invention had been delayed a century and he had become a painter, he would have painted murals. I told him what I was thinking.

"That's true, I guess," he said.

"I'm stumped a little," I said, "in formulating my theory about what kind of photographer you are. How do I reconcile your camera myopia, that is, your interest in the things in your immediate environment, with your interest in the far away things, whether telephotos or—well, murals."

"Those things right under my nose," he smiled, "also look good when blown up real big."

"I'm not sure my theory is entirely accurate," I said. "You are a muralist but you do other things too."

"That's right," he said. "I guess it all comes down to this: I'm just interested in the beauty of design and the complexity of things."

A thing of complexity other than his pictorial subject matter which Feininger mastered with quickness and ease was the color camera. In this medium too his background in art, built up of his study of the related subject architecture, his infor-mal pursuit of art studies since and his close association with artists and their work, serves him particularly well. He shares my view that for the color photographer nothing is more valuable than a study of the painter's art.

"Through such knowledge," I said, "the camera is able most effectively to press the scientific color film medium to its limits and beyond. It is there—the 'beyond'—where the color photographer begins to compete with the imaginative painter."

"Naturally," Feininger added, "a thorough self-training in the mechanical techniques should closely approach, if not actually become, second nature to the photographer if the phenomenon of pushing the medium is to produce unusual results."

I was afraid our discussion was getting a little esoteric.

"At least we're learning," I said, "that a good color photograph is not a colored black-and-white."

"Yes, and we no longer drag in props—a red umbrella or green bathing suit—to make a scene chromatic. That's some progress."

In 1939 Feininger brought his family to New York where his father also lives now. In 1943 he joined *Life*'s photographic staff on which he has been "double trucking" ever since.

Assignment: Korea

Bruce Downes

David Douglas Duncan and his dramatic camera coverage of the Korean War

When *Life* magazine assigned David Douglas Duncan to cover the Korean war last June it was opening another violent chapter in the biography of a genuine photo-journalist—not as that hyphenated word usually implies, just a press or magazine photographer, but a rare one who, like his colleague, Carl Mydans, can handle a typewriter as deftly as a camera.

Though he is listed on *Life*'s masthead as a photographer, young Duncan is the ideal all-around war correspondent, who can cover armed conflict —especially the Far East variety—both ways. What the photographs can't communicate his written dispatches can, and vice versa, as all who have followed *Life*'s outstanding Korean coverage must know.

Beyond this journalistic ambidexterity, by means of which the perceptive mind functions through his images as well as word symbols, David Douglas Duncan arrived in Korea fully conditioned to the exigencies and agonies of war. He had gone through the years of World War II as a photo officer (1st Lieutenant) with the U.S. Marines in the South Pacific and before that had led a rough, tough life deep sea diving off the Florida coast, and photographing hunting and fishing expeditions half way 'round the world.

"In fact," says Duncan, "those years of freelance on expeditions were so tough physically that when I got into the Marines life seemed softer than it had been in years!" To note resemblances to Hemingway, both as writer and man, is perhaps to recognize a conspicuous product of this century of violence.

Though it came as a new kind of adventure to a young man who had pursued excitement as a career, Duncan found war a much grimmer business than he might have expected it to be. When Korea ignited he was thirty-four, sobered by World War II and the events he had since covered. He was in Tokyo doing a peace-time story on the highlights of Japanese art and culture when the Red tanks began rolling south across the 38th parallel.

Duncan knew what this kind of oriental war meant. He knew the suffering and agonies of the foot soldier. He had been one of them, and now he would be with them again, lying in foxholes beside them, flying with them in combat. Although no longer one of them, he would still be wearing his ball cap bearing the Marine insignia. Now he was a correspondent there to share the hardships and tragedies, the triumphs and defeats so that the people back home could see and know and perhaps understand a little of what went on in this strange new war that might bring, in Duncan's words, "the final answer to the one question of our world today."

73

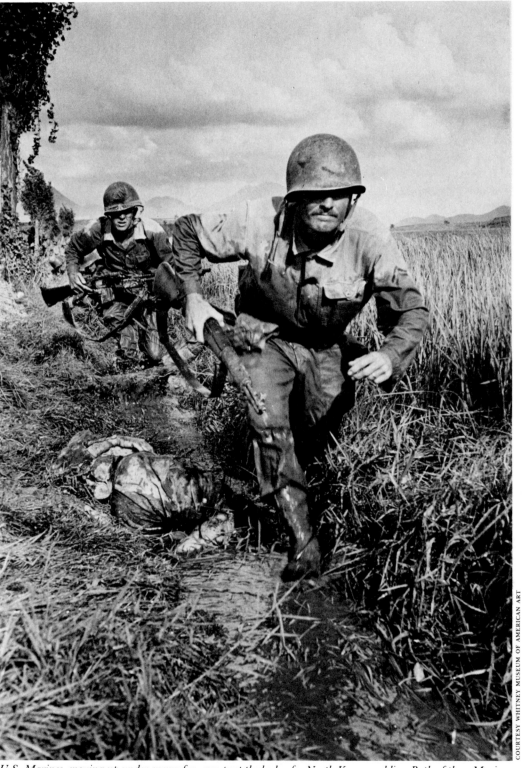

U.S. Marines, moving up under enemy fire, run past the body of a North Korean soldier. Both of these Marines later died in action, like thousands of their comrades.

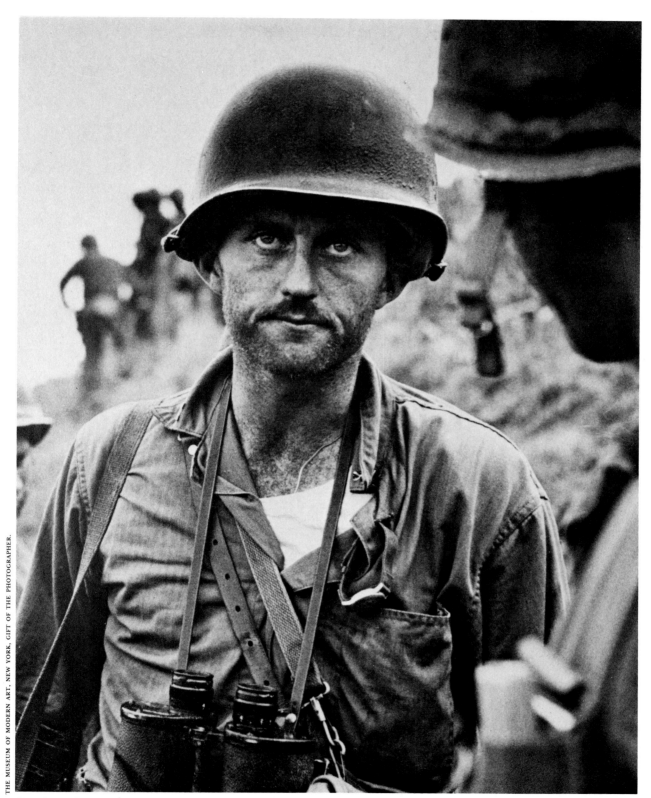

Man in combat: Capt. Ike Fenton of the U.S. Marines was photographed by Duncan at No Name Ridge, Korea in 1950.

For almost four months Duncan covered one or another phase of the Korean struggle. And most of the time he got up close, reducing the fighting, as he put it, "to the perimeter of the guy in the line."

"My objective always," says Duncan, "is to stay as close as possible and shoot the pictures as if through the eyes of the infantryman, the Marine, or the pilot. I wanted to give the reader something of the visual perspective and feeling of the guy under fire, his apprehensions and sufferings, his tensions and releases, his behavior in the presence of threatening death."

To stay close to the men meant staying close to bullets, but up to November when he returned home for a respite, he escaped injury. The closest he came to it was when he was hit in the chest with a spent 30-calibre slug, which just dropped to the ground.

By getting close up Duncan got pictures that are clear, simple straight-forward statements into which he has succeeded in injecting his own compassionate understanding of the guy under fire. In fact he got up so close at times that machine-gun vibrations blurred his pictures. With his World War II background Duncan's spiritual oneness with the fighting man shows in pictures that bring the reader into sometimes shockingly intimate contact with the sufferings and tensions of war, which are nowhere so evident as on the faces of the men themselves.

This sense of intimacy was enhanced by Duncan's preference for the 35-mm camera, which, used at eye level, he felt enabled him to communicate the true perspective of what he saw in whatever position he was when he saw it. Although in World War II he made most of his pictures with the Rolleiflex, Duncan took two 3C Leicas, equipped with Tewe Polyfocus finders, into the Korean battlefront. Strapped around his neck he

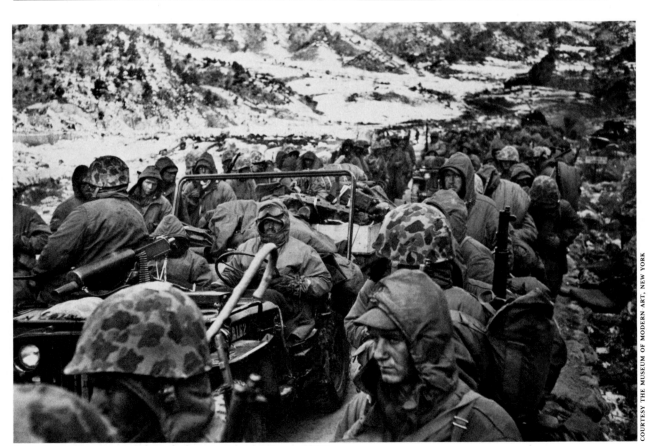

Long line of troops moves through the mountains in Korea, 1950.

found these the most practical combat cameras. They were light, compact and could stand a beating. The Leicas, he said, stood up beautifully under sometimes terrifically adverse conditions of rain, mud, and sand. He found the cameras could take abuse when it was necessary to drop abruptly to the ground under fire.

Curiously, except for a Summaron wide angle, he did not use Leitz lenses. For most of his work he used a 50-mm $f/1.5$ Japanese Nikkor lens, but carried with him and used also 85-mm $f/2$ and 135-mm $f/3.5$ Nikkor lenses. They were recommended to him by photographer Horace Bristol in Tokyo, and tests showed their superior resolving power. When the negatives began arriving in New York, according to Frank Scherschel, *Life's* assistant picture editor, they turned out to be the sharpest 35-mm negatives the lab ever processed.

The Nikkor lenses are made for the Nikon camera, Nipponese version of the German Zeiss Contax incorporating a Leica-type shutter, and are manufactured by the Japan Optical Co., Ltd. The plant, according to Duncan, employs 1,700 men and is geared, at this writing, to produce 400 cameras a month.

Duncan went to the front with only absolutely essential equipment: a poncho blanket, spoon, toothbrush, bar of soap, mosquito lotion, two rubber liferaft water bags for use as camera raincoats, wrist compass, Marine backpack, 2 canteens, steel helmet, the two cameras, a pistol belt, and enough film in two pockets to last about two weeks. Interestingly enough, he considered his old Weston Master meter, which went with him through World War II, essential equipment. He hooked it to his Marine pistol belt and used it whenever the light was off-normal.

As a result of this careful concern with correct exposure Duncan went to the head of the class in the eyes of *Life's* lab men. His negatives, they reported, were the best and most consistent to have come through. Despite varying light conditions the negatives were of uniform density.

The life of a war correspondent, however, is not just a simple matter of shooting pictures while ducking enemy fire. You've got your camera loaded with 35-mm film—36 exposures. All hell breaks loose and you start shooting pictures. In your pocket there's a little brown loose-leaf notebook with pages bearing numbers from one to 36. You've got to make notes opposite the numbers corresponding with the exposures you've made in

the camera for captions. Your pictures not only have to have captions, but they've got to be accurate. You've got to get names whenever possible, and they have to be spelled correctly. Yes, and you've got to do this with bullets screaming and shrapnel falling all around you. You wait, of course, until the peak of action is over before you start scrounging around for names. But however you do it, you've got to get complete and accurate captions that must correspond with the latent images inside the undeveloped rolls. The films are going back to New York, remember, so you can't wait and see what's on the negative before writing the captions.

Not only that but you've got to worry about getting your exposed rolls and captions cleared by Friday of each week and on their way to New York by Pan American or Northwest Airways.

"Carl Mydans and I worked together beautifully," Duncan recalls. "He covered one phase, I another and we always got our films through on time. We were really very lucky as a result of which there never has been a war story run continuously for so long in *Life* without a break and without losing a major angle. Because of the time difference between Tokyo and New York our Friday shipments arrived in New York on Saturday morning and appeared in the following week's issue of *Life*".

David Douglas Duncan early in life had his heart set on exploration and prepared himself for a life of adventure by studying archeology at the University of Arizona and marine zoology and Spanish at the University of Miami. His deflection, if indeed deflection it was, may be attributed to the fact that on his seventeenth birthday his sister gave him a 39-cent Univex camera, which absorbed his attention long enough to have made him a convert to·photography. From the Univex he transferred his affections to a Vollenda, then to a 620 folding Kodak, and so on up the customary ladder of amateur photographic equipment.

If photography never became his prime objective it certainly was an important tool aiding and abetting and ultimately changing Duncan's professional direction. Excitement and adventure seem to have been his dominant interest from the beginning. Archeology provided a dignified excuse to dash off on trips to Mexico and Central America during and between university years in Arizona, and marine zoology lent academic authority to his penchant for big game fishing. All of this sharpened his zest for the Hemingway kind of

life and developed his picture-taking ability and his sinewy prose style.

In Miami Duncan's zoological studies led him to deep sea diving and needless to say he experimented with undersea photography. For Duncan 1937 was a red-letter year. He won second prize ($250) in the National Newspaper Snapshots Awards, graduated from the University of Miami, and embarked on a career of adventure and excitement in dead earnest. With the prize money he bought a Speed Graphic and then gave himself his first speculative assignment—an expedition aboard a hundred-foot schooner plying from Key West to the Cayman Islands in the West Indies and down the coast of Central America in search of giant sea turtles. It was a success. He sold features to the *National Geographic Magazine* and newspapers all over the country. He was definitely on his way as a freelance photographer and writer.

Soon other expeditions followed, notably four

with fabulous Michael Lerner, businessman and sportsman, to Peru, Ecuador, Chile, Nova Scotia, and Alberta for broadbill swordfish, striped marlin, and big-game hunting. This was a wonderful life for a handsome young man who craved excitement. But it was a tough life, too, and it prepared him well for what was to come. And when it did come—Pearl Harbor—Duncan was well trained. As a photographic officer with the U.S. Marines, he had territorial *carte blanche.* He could go anywhere west of Pearl Harbor, and he did. By now his talents as both writer and photographer had matured. While with the Marines he wrote and illustrated many articles for a number of national magazines.

The wonderful thing is that men like David Douglas Duncan and Carl Mydans, both writers, are proud of their status and function as photographers because they have as much respect for photography as they have for writing—which is sel-

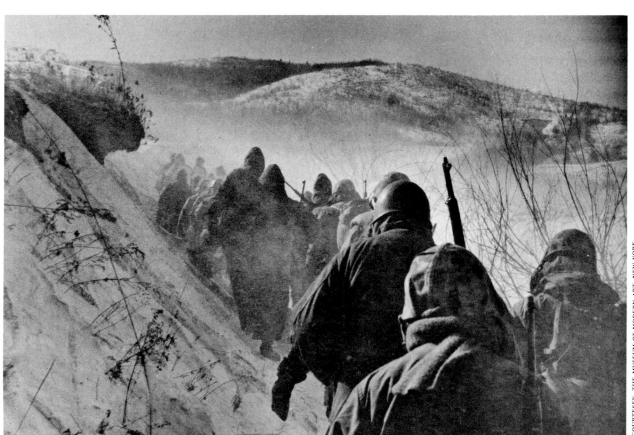

Marines hike in bitter cold along a path through rugged terrain.

dom the case with writers who are not photographers.

One would suppose that the language of photography could not convey emotions and subjective experiences as completely and effectively as the language of words. Yet any number of Duncan's shots of fighting men's faces are in themselves emotional dynamite. But one cannot make rules so readily, for in one of his dispatches Duncan describes the burning intensity in the eyes of General MacArthur, but photographs of MacArthur seem unable fully to convey this apparently objective fact. There is, of course, no substitute for words when it comes to the subjective experiences of the observer, and when that man is also a photographer then his exceptional ability as a writer illuminates and makes his pictures more meaningful.

Duncan's description of what he experienced aboard Lieut. Col. Bill Samway's jet fighter while it and other jet planes were diving at a North Korean target is an outstanding piece of writing. Here, extracted from his *Life* dispatch, is Duncan describing what happened after the jet had made its first dive at 600 miles an hour:

"The earth and sky, life and death, all that is and ever had been was crushing me lower and lower toward the floor of the cockpit, and showering thunderbolts over my head and shoulders and down along my spine. Sweat burst out all over my body, not as sweat usually is, but in rushing rivers which drenched my clothes, soaked the parachute and filled my eyes with burning tears . . . then as the plane leveled off and the vise began to release me, I managed to slightly raise my head and saw that glittering gems of canary-colored liquid were splashing down upon my knees and safety belt, where they lay shimmering. Others escaped through my clenched teeth and from my nose, and I thought to myself 'but these are priceless and

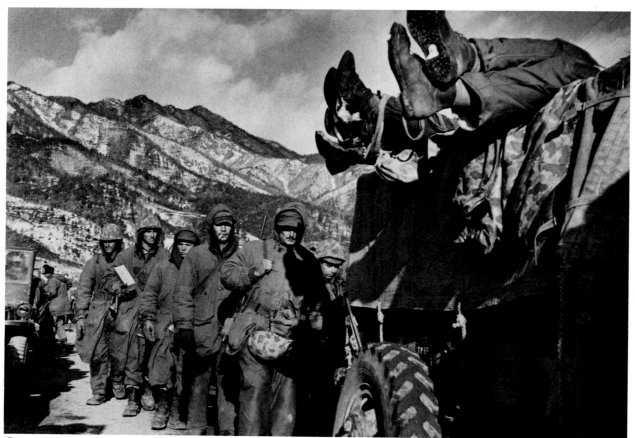

Return from Chosin Reservoir, North Korea, December 1950. Dead marines were brought out in trucks.

79

very beautiful but should stay deep inside of me for they are what makes me tick. Something secret must have broken and these are its melted parts.' I wasn't ill, nor were these gems priceless. In its agony and protest my body had simply reacted within the limits of human agitation and had driven its juices back along my system. No, they weren't gems but globules of bile.

". . . the second attack was just like the first except that we had bad luck. Samways had our jet so close I couldn't even see the other plane's wingtips in the camera viewfinder (Duncan used a Japanese aerial camera re-built with Zeiss shutter, equipped with an $f/3.5$ Hexar lens and using No. 120 rollfilm) . . . Just before going again onto the floor of the cockpit on the last attack, I had glanced into the little mirror to see what Samways was doing but instead saw a face I couldn't recognize. Eyelids pulled down from the bottoms, so that the eyes were protruding, cheeks creased with long vertical lines, all sodden and formless like gunny sacking dragged from the river. It was myself and I thought 'Good God, what a picture!' but then the vise held my hands again and I couldn't raise my camera."

Thus Duncan's words tell what a jet attack felt like, his photographs (the first ever made by a magazine photographer aboard a jet plane in actual combat) what it looked like from the cockpit.

What is the chief significance of the Duncan story? Probably this: That in Duncan the word and picture languages merge to remove the misnomer from *photo-journalism* and to hint at what the future will demand of its working photo-journalists. For words and pictures never complement each other so happily as when they spring from the same observer. It is an exciting and a heartening story.

Meanwhile, on the chance you might find yourself covering a war one of these days either in or out of the armed services, here is how Duncan would brief you for the task:

1. Keep your head down.
2. Get some understanding of military tactics so you'll know what to do to protect yourself. It's like boxing; your chances of getting hit are less if you know defensive tactics.
3. Know your equipment so that you can use it automatically. Use lightest possible camera and shoot from eye level.
4. Then move in close, close, close, and keep the picture simple.

Robert Capa

John Steinbeck

*A famed novelist's tribute to a fabulous
photojournalist who died in action
at the front line in Indochina*

I know nothing about photography. What I have to say about Capa's work is strictly from the point of view of a layman, and the specialists must bear with me. It does seem to me that Capa has proved beyond all doubt that the camera need not be a cold mechanical device. Like the pen, it is as good as the man who uses it. It can be the extension of mind and heart.

Capa's pictures were made in his brain—the camera only completed them. You can no more mistake his work than you can the canvas of a fine painter. Capa knew what to look for and what to do with it when he found it. He knew, for example, that you cannot photograph war because it is largely an emotion. But he did photograph that emotion by shooting beside it. He could show the horror of a whole people in the face of a child. His camera caught and held emotion.

Capa's work is itself the picture of a great heart and an overwhelming compassion. No one can take his place. No one can take the place of any fine artist, but we are fortunate to have in his pictures the quality of the man.

I worked and traveled with Capa a great deal. He may have had closer friends but he had none who loved him more. It was his pleasure to seem casual and careless about his work. He was not. His pictures are not accidents. The emotion in them did not come by chance. He could photograph motion and gaiety and heartbreak. He could photograph thought. He made a world and it was Capa's world. Note how he captures the endlessness of the Russian landscape with one long road and one single human. See how his lens could peer through the eyes into the mind of a man.

Capa for all his casualness was a worrier. In Russia he had to send his film to be developed by the Soviet Government. He fidgeted and fried until the negatives came back. And then nothing was right. They were over- or underdeveloped. The grain was wrong. He would clasp his brow and yell with anguish. He cared all right. He cared very much.

The greatness of Capa is twofold. We have his pictures, a true and vital record of our time—ugly and beautiful, set down by the mind of an artist. But Capa had another work which may be even more important. He gathered young men about him, encouraged, instructed, even fed and clothed them, but best he taught them respect for their art and integrity in its performance. He proved to them that a man can live by this medium and still be true to himself. And never once did he try to get them to take his kind of picture. Thus the effect of Capa will be found in the men who

worked with him. They will carry a little part of Capa all their lives and perhaps hand him on to their young men.

It is very hard to think of being without Capa. I don't think I have accepted that fact yet. But I suppose we should be thankful that there is so much of him with us still.

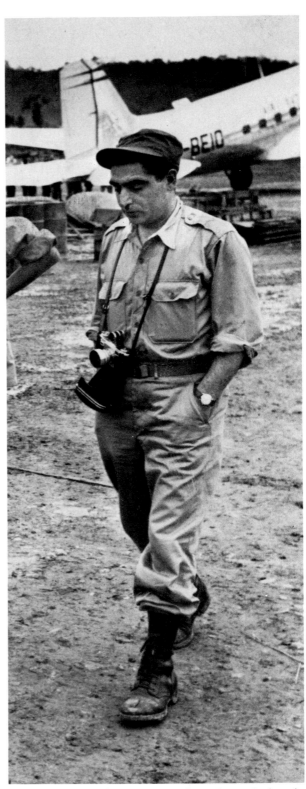

Last picture ever made of Capa was taken at Luang Prabang by Michel Descamps.

Capa–A Memorial Portfolio

H.M. Kinzer

For eighteen years, Bob Capa was a war photographer. The two restless decades gave him little rest from his grim and challenging occupation. Though he longed to become "unemployed" as a war cameraman, he felt always instinctively that as long as there were front lines and beachheads and assault waves anywhere in the world, he belonged in them. When he took pictures of peace, as he did in Israel and Russia, there was always war—or the threat of it—in the background.

This spring found Capa in Indochina, reporting for *Life* on the world's only hot war. It was a Tuesday like any other, late in May, when he left his battle-stalled jeep to walk ahead in search of the war that wouldn't come to him. "I'm going up the road a little bit," he said. "Look for me when you get started." Up the road a little bit, Bob Capa stepped on a Vietminh land mine, and a great war reporter's career was ended.

Robert Capa, who never really existed, was a product of the imagination of André Friedmann, born in Budapest in 1913. This Friedmann, bored with the life of a darkroom assistant and unknown free-lancer, presented some of his pictures to French newspapers as the work of "Capa, a talented visitor from America." Editors were intrigued first by the new name, then by the fine pictures. A career was born, and Friedmann-Capa left shortly for his first war, in Spain. There he made his first (and probably most spectacular) war picture, of a Loyalist infantryman in casual short-sleeved white shirt, falling with a Falangist machine-gun bullet through his head.

In Spain he lost his lovely wife Gerda, in the meaningless confusion of Loyalist retreat. From there he went to China, where another war was being fought against formidable odds. These were deadly dress rehearsals for World War II, and by now Capa was a seasoned combat photographer. He was still a Hungarian national (though he renounced citizenship in a nation overrun by Hitler), and not until the summer of 1942 did he get clearance to leave the country as an accredited correspondent. *Colliers* sent him to London, and from there he went to North Africa. When the Sicilian operation began, he had a front-row seat —with the 82nd Airborne Division, hanging under a parachute.

Throughout the war, Capa kept himself in the front lines. He went ashore at Salerno 72 hours after the earliest landings; he crossed the English Channel in the first assault wave to land at Omaha Beach; he was among the first planeload of American soldiers to parachute into Germany. His camera was with him all the way—or perhaps more properly, he was with his camera. The photographs he sent out of Europe in the war years rank with the greatest documents of man's folly and courage and greatness.

In 1947, Capa publicly declared his aspiration to "stay unemployed as a war photographer till the end of my life." He managed to ignore the "police action" in Korea, but with the heightening of activity and world involvement in Indochina, he accepted what was to be his last assignment. From this, his last war, came more memorable Capa pictures, bringing that far-off battlefront closer to Americans who were becoming daily more concerned with it.

As he stepped from his jeep that late-May after-

noon, a cablegram was on its way to him; he never got it. It reported the death of his friend, Werner Bischof, in an automobile accident in Peru.

Capa spoke five languages, and they helped him move more swiftly through the world, and opened military and diplomatic doors more easily to him. But he spoke a sixth language better than all the others, one that needed no words, one that speaks and will speak for man everywhere—the language of pictures.

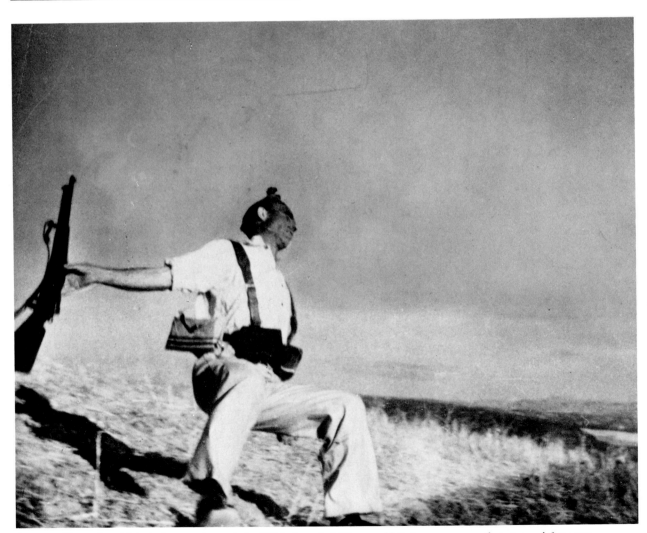

SPAIN: This much-published photograph, made in 1936, launched 22-year-old Capa on a career that spanned five wars.

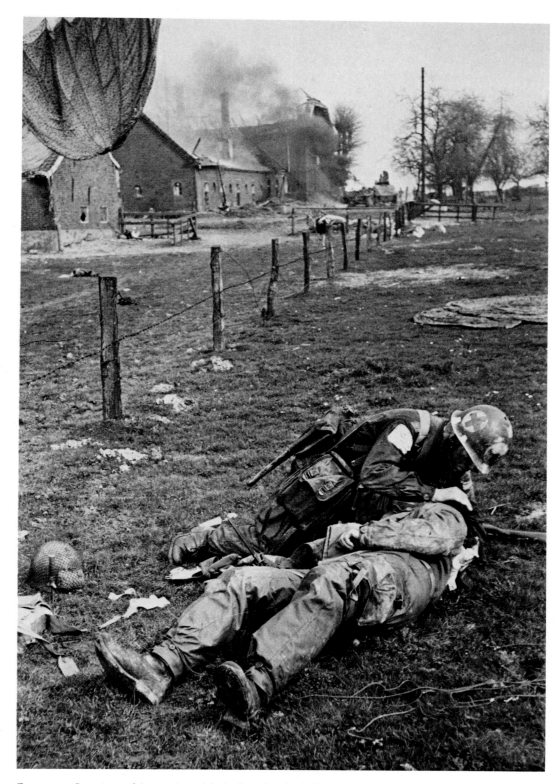

GERMANY: Capa jumped into action with the first planeload of paratroops across the Rhine.

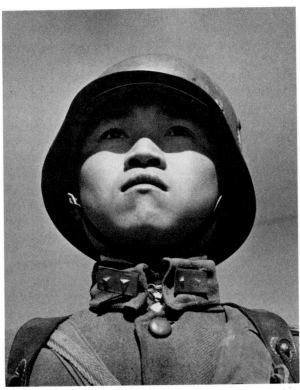

CHINA: *Capa's second war was on the Asiatic mainland, where he photographed this 15-year-old soldier.*

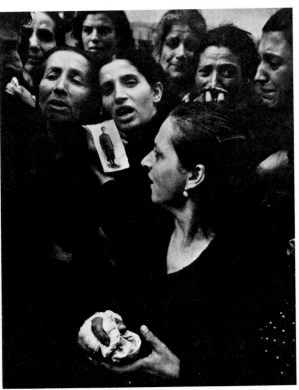

ITALY: *Women weep for massacred last-ditch defenders of Naples. Capa said: "Those were my truest pictures of victory."*

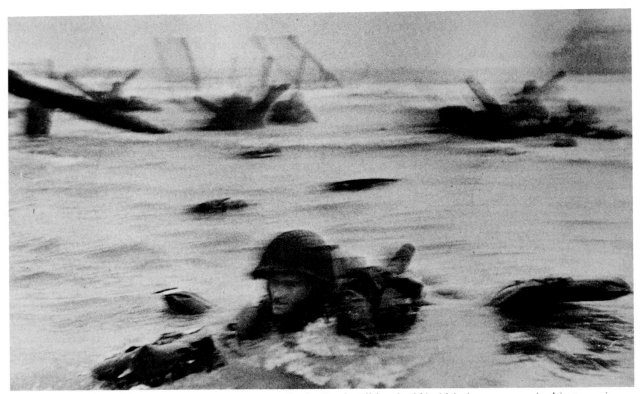

NORMANDY: *D-Day found Capa with assault troops on Omaha Beach. All but 8 of his 106 pictures were ruined in processing.*

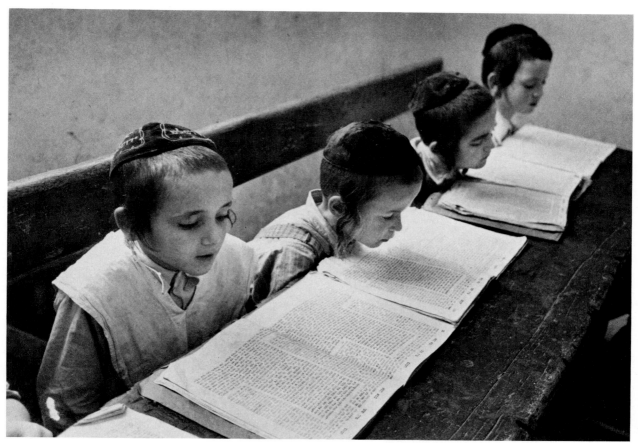

ISRAEL: In the backwash of their country's war for independence, skull-capped children bend over schoolbooks.

RUSSIA: Capa and Steinbeck toured the Soviet Union, collaborated on "A Russian Journal" in 1948.

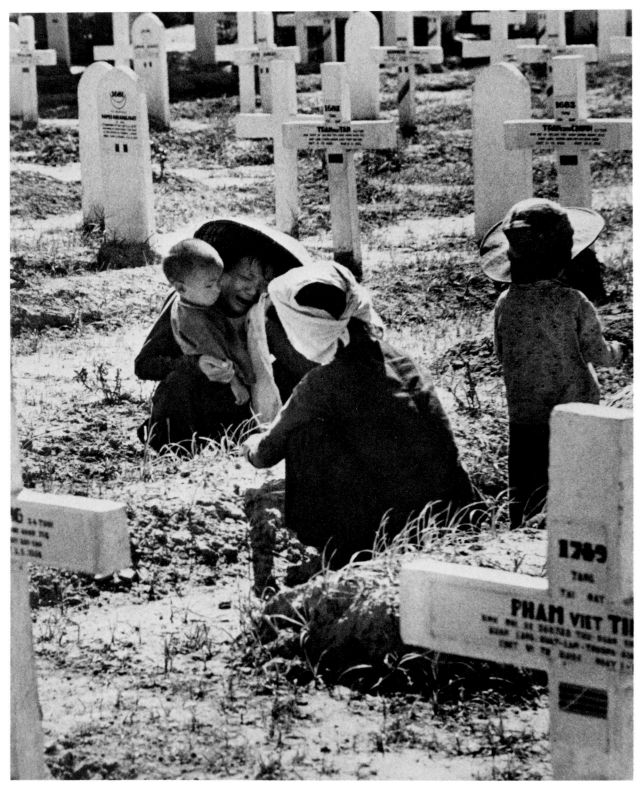

INDOCHINA: On his last assignment, Capa photographed Vietnamese mourners at a soldier's grave in Nam Dinh.

I Was an Amateur

Victor Keppler

When I was nine years old and nagging my father, as usual, for a camera he handed me an empty cigar box and said, "Make out it's a camera." I didn't do it right then and there but when I was in high school I drilled a hole in a cigar box, fitted it with a photographic plate and made out it was a camera. The picture I took showed the Woolworth building at an alarming slant. "Looks like the building is falling backwards" was the majority opinion. Today it might be called a modern architectural photograph.

But I acquired a real camera before my tenth birthday by saving my pennies and haunting the Third Avenue pawnshops. My firstborn was old—but professional. It required plates when other cameras were using film but it had a good lens and even my first attempts were sort of professional. At least the critics said so when a recent museum exhibit compared a photograph taken of my mother and sister at that time with one of my newest advertising illustrations.

My camera was always my most precious possession. It followed me to school and when a teacher tried to confiscate it just because I was playing when I should have been studying I had a man-size tantrum. In high school I joined the camera club and for the first time discovered the stimulation that comes from sharing your hobby. Finally I managed to effect a merger between the camera club in my school and the other high school clubs and found myself elected president of the first interscholastic camera club.

Our first interscholastic exhibition, shown anonymously at the Metropolitan Museum of Art, brought me first and third prizes. I began to won-der if photography might be a profession for me. But when I told my father he didn't joke. I would be a doctor or lawyer or—. Rather than learn what the "or" stood for I enrolled at N.Y.U. as a law student. Medicine was washed out the day a friend of mine, a pre-med student, asked if he could do his homework in my room because his sister was having a party and the noise disturbed him. The homework turned out to be a half-dissected cat. Even before my stomach returned home I had a great insight—no M.D. me.

After two years I found that my law studies interfered with my darkroom work so I quit and took a job as assistant to a Japanese still-life genius. He gave me sukiyaki instead of money and I left to photograph fingerprints at police headquarters. My father's "I told you pictures would be the ruination of you" was ringing in my ears instead of wedding bells when I got married. To earn an extra dollar I began hand painting felt hats at night. My wife liked the photographs so much she said I should open my own studio.

Rather than eat her words she sold her jewelry and I was in business. Within a day I had a studio in a mansion built by Stanford White on 50th St., a real studio camera, professional lights—but no clients. I thought the advertising illustrations in the magazines were exciting so I went to the biggest advertising agency—certainly it had the longest name—Batten, Barton, Durstine & Osborn—and asked to see an art director.

"You can't see an art director without an appointment and samples," the receptionist told me. I showed her pictures, but, unlike my wife, she didn't call me "genius." Nevertheless

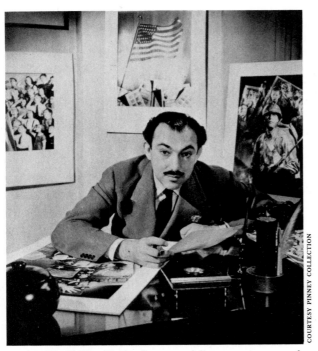

During World War II, Keppler was a dollar-a-year man, made posters for U.S. Savings Bond drives.

I camped in the reception room day after day.

The art directors not only noticed me, I learned later, but they amused themselves by wagering on my persistence and age. I wore a big black mustache to hide the fact that I was 21 and smoked a big black cigar because I liked big black cigars. One day an art director was bored and thought he'd have some fun. He called me into his office.

"I want a picture," he began, "of canned spinach on a white plate on a white tablecloth and I want it to make flies drool."

"Is that all?" I asked.

"No," he said. "I want it tomorrow!"

I bought a dozen cans of spinach and borrowed a white plate and cloth. After all, even in 1927, $300 doesn't last forever. I worked all day and all night. Next morning at nine I was occupying my usual seat in the reception room. At 9:30 the art director appeared and I grabbed him. He looked startled but he took me into his office and looked at my photographs. He swallowed a couple of times then grinned weakly.

"It was only a gag," he said. "You know, like sending a new boy out to buy a sky hook. Nobody can photograph canned spinach on a white plate against a white background." He looked again, jumped up, and pumped my hand up and down. "But you DID it!" he exclaimed. He showed my pictures to the entire art department and I would have blushed at the compliments I was given except that I weighed less than 135 pounds and didn't have enough blood.

I never sold that picture, but B.B.D.&O. gave me real assignments from then on and they still do, 30 years later.

I liked advertising photography then and I like it now. It's challenging, exciting, and progressive. When color photography was little more than a dream I scrapped my studio, moved to larger quarters, and built one of the first all-air-conditioned darkrooms in this country. I made my own carbro prints and watched color photography change from primitive posterish shouting to a subtle whisper. Clients' demands have switched from "needle-like sharpness over-all" to "kick-the-tripod softness" throughout. Yet I have pictures from my first year as a pro in which the featured subject is sharp while the rest is soft just as it is in natural human vision.

A trend that I find a bit amusing is the new (?) technique, available light. I can't help wondering what people would have said if I had called my technique "available light" when I photographed my family near a window with sheets bouncing light into the shadow side. And in 1930 I photographed a Victorian table, chair, and kerosene lamp using only the actual light from the kerosene lamp. That photograph won a major prize and was widely used as an ad.

The tendency to cut down on camera size and weight is new. I often substitute a 2¼ × 2¼ twin-lens reflex for a 5×7 or 4×5 press camera. Even the 35-mm now has its place in my camera safe.

The excitement that professional advertising photography promised when I was 21 is still there. Every job was a challenge then, perhaps because of my inexperience. Every job is a challenge now, perhaps because I accept only interesting jobs today. And just try to find another profession so interesting that it's practiced on vacation. Lawyers and doctors leave their briefcases and black bags at home when they travel on vacation. I tote an arsenal of cameras and shoot my head off—and I call it fun.

The World's 10 Greatest Photographers

243 eminent critics, teachers, editors, art directors, consultants, and working photographers express their preferences in an international poll

ANSEL ADAMS RICHARD AVEDON
HENRI CARTIER-BRESSON ALFRED EISENSTAEDT
ERNST HAAS PHILIPPE HALSMAN
YOUSUF KARSH GJON MILI*
IRVING PENN W. EUGENE SMITH

The ten photographers whose names are listed here were voted the "world's greatest" by a panel of 243 outstanding photographers, editors, picture editors, art directors, critics, and teachers in an international poll conducted by *Popular Photography*.

This is the first such poll ever conducted in photography and its results are bound to be controversial. No man nor any group of men can say with finality that any ten photographers are the greatest in the world. Why then did *Popular Photography* ask the question in the first place? Simply because it is a perennial question that comes up wherever photographers get together, and because no one has ever attempted to answer it. This is an attempt.

"Surely," the editors reasoned, "we could get a pretty good idea of how things stand if we asked enough qualified people." And that's what we did. Ballots went out to 465 carefully chosen men and women in all parts of the world. Of these, 243 were returned completed.

We think the results are significant. Eight of the

Gjon Mili declined to participate in the preparation of this feature.

top ten were so far in the lead as to leave no doubt whatever that they are generally regarded as among the world's most outstanding photographers.

If you had been asked to vote, what facts and impressions would have governed your choice? You would be limited to those photographers whose work you know well; you would rule out those whose pictures do not interest you; you would weigh and consider all you have seen, read, and heard of those you like, arriving finally at the required number. Our experts have proceeded in much the same way. Their professional experience has brought them a wider acquaintance with photographers and their pictures, and *Popular Photography* believes their composite judgment is a valid basis for proposing that ten photographers are the greatest in the world. In this section you will find their portraits and biographical sketches, examples of their work, their statements of what photography means to them and details of their working methods, equipment, and facilities.

What can we say about the ten as a group? What have they in common, and how are they different? Only four are native Americans, and the country

of origin placing second highest is perhaps the unlikeliest: Armenia (birthplace of Gjon Mili as well as Karsh). France, Germany, Austria, and Latvia gave us one each. The ten range in age from 34 to 59, for an average of 47. Most of them are difficult to catalog as to specialty, since their work is so diversified. But we might say, roughly, that four are photojournalists, one a fashion photographer, one a portraitist, one a pictorialist in the great tradition, and three defy even the loosest kind of pigeonholing.

Whatever our readers think of this choice of ten great photographers, we know they will learn from it, and broaden their knowledge of pictures and the men who make them. We are confident, too, that this feature will be controversial. We want to hear from all of you, whether or not you like the list, and even if you disapprove the whole idea of such a poll. All photography will gain from an interchange of views. It has been an enriching experience to prepare the feature, and we hand it to you in the hope you will find it the same.

ANSEL ADAMS

Ansel Adams, born 1902 in San Francisco. Was trained as a musician. Became interested in photography through mountain trips and the friendship of Albert Bender, prominent San Francisco patron of the arts. Did his first professional assignment, a story on Mexican cotton-pickers in Fresno, for a now-defunct magazine. Especially noted for his meticulous studies of the natural world, its forms and textures. Turning point in his career was the publication of his first book Taos *Pueblo* (with text by Mary Austin), and his work has since received its widest and most satisfying publication in book form. Titles: *John Muir Trail, Born Free & Equal, Making a Photograph, My Camera in Yosemite Valley, My Camera in the National Parks, Death Valley* (with Nancy Newhall), *Mission San Xavier del Bac* (with Miss Newhall), *Illustrated Guide to Yosemite National Park, Land of Little Rain* (Mary Austin text), *Yosemite and the Sierra Nevada* (John Muir text), *Pageant of History in Northern California* (with Miss Newhall), two portfolios of prints, and a five-part Basic Photo Series: *Camera and Lens, The Negative, The Print, Natural Light Photography* and *Artificial Light Photography.*

Ansel Adams' name is generally associated with large-camera technique, and it is true that a great proportion of his pictures are made with view cameras: the 4×5 Kodak Master View, with lenses of focal length from 4 to 12 inches; and the 8×10 and 7×11 view cameras with lenses up to 26½ inches long. But he also makes extensive use of several other cameras: the Contaflex and Contax with normal 50-mm and long-focus 85-mm Pro-Tessars; the Hasselblad with full complement of lenses; and the Polaroid Land. For black-and-white, he uses various Kodak and Ilford films, and for color, Ektachrome; all are usually employed at manufacturers' recommended speed ratings. Developers are Minicol, D-23, and DK-50. Adams does his own printing on Velour Black, with Beers or Dektol developer, switching to Ansco 130 for quantity prints. He prefers to work under natural light, and has very little lighting equipment, using electronic flash by preference when artificial light is necessary. His exposures are metered by a Weston Master III and an S.E.I., which is a complex exposure photometer.

"An art is definable only in its own terms; it is as difficult to write about photography as it is about music, especially from a personal viewpoint. I feel that as one grows older his credo becomes simpler and more direct. Penetrating the smoke screens of equipment and techniques, glamor, ideology, and simple achievement-motive, the art of photography appears as strong and vital—and purposeful—as any other creative medium, and stands cleanly on its own feet. We are confronted today with a dichotomy; as our equipment

and materials constantly grow in scope and quality the creative and technical standards appear to be diminishing; there is a near-cult of photographers who seem to intentionally avoid the beautiful and precise image, concentrating only on subject and obvious function. My personal reaction to this attitude is a determination to go as far in the opposite direction as possible. I believe in the most beautiful and appropriate prints, and the most clarifying and revealing approach of mind, heart, and craft. I believe that firm objectives in this direction can fulfill the promise of photography as one of the great visual arts. However, we must always be logical in our critical estimates; most of photography is not intended as art and should not be judged as such. But if art is intended, compromise must not be tolerated. As I write this I have word of the passing of my dear friend Edward Weston. I cite the spirit and the body of his work as a shining evidence of the great potentials of photography."

RICHARD AVEDON

Richard Avedon, born 1923 in New York City. Went from high school into the Merchant Marine, where he received some technical training in photography. Friends in his neighborhood had already awakened his interest in taking pictures, and before returning to civilian life he had decided to make photography his career. In 1945, at the age of 19, he joined *Harper's Bazaar.* (Since boyhood, when the three major fashion magazines were always in his home, he had known that he must someday work for *Bazaar.*) He had already apprenticed for a year to art director Alexey Brodovitch, who

HARVEY SHAMAN

found him a likely protegé. For a dozen years almost all his editorial photography has been for *Bazaar,* except for the year 1949 when he left to join the staff of *Theatre Arts,* doing heavy photographic as well as editorial work. He has done advertising work for many major accounts, and his pictures have thus appeared in most mass-circulation magazines. He is currently at work on a book of his photographs.

Richard Avedon works almost exclusively with the Rolleiflex *f* /2.8, using an 8×10 view camera when some color assignments require it. His output is about evenly divided between color and black-and-white, the color mostly for advertising and the black-and-white generally for editorial use in *Harper's Bazaar.* All details connected with shooting and processing are handled by assistants; he devotes himself entirely to the actual making of the picture. Films used are Plus-X and Ektachrome. The 120 black-and-

white is developed in Harvey's 777, the 8×10 in DK-50. He instructs a printer as to the quality he desires in his finished work; the prints are made on Velour Black. Avedon has a skylighted studio, and often uses daylight. There is a welter of artificial lighting, mostly floods, ranging in size from 500 to 5,000 watts, in scoop and pan reflectors. The motion picture *Funny Face* was based on his career, and he was employed as visual consultant during the making of the film.

"I am only stimulated by people, never by ideas, almost never. It is always an emotional response. It is always between myself and another person—this is what it boils down to. I am not interested in the technique of photography or of camera. I am not interested in light. What I want is light in which the subject is free to move in any way without falling into an ugly light. So that I can get to them, to the expressions they make, so that they are free to do or express something which is the way I feel. The camera is most in the way. If I could do what I want with my eyes alone, I would be happy. Then when I get it on paper, on the negative, if there was something in the eyes when I took the picture, then when I look at the print, there are things that I can do to emphasize that. But when I'm used to an approach, it becomes like a person that I have no response to. The approach to the print is like the approach to the sitter. Certain qualities in the print say what I mean. I hate photographs, most photographs. I cannot take a picture of something I have not known and experienced myself, because I do not know what is going on. The photograph is not reportage. I do not believe that something reports itself in a photograph. It is redrawn; it is something I am saying."

93

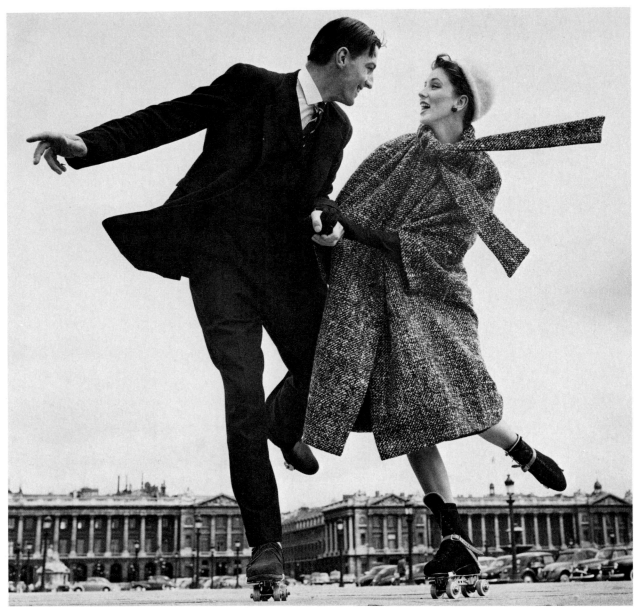

FASHION, PARIS

RICHARD AVEDON

HENRI CARTIER-BRESSON

Henri Cartier-Bresson, born 1908 in France, educated in *lycée* (equivalent to somewhat more than U. S. high schools), studied Latin and other languages, and painting. Became interested in photography because "I am interested in what I see." Did his first professional assignment for the magazine *Vu* in 1933, in Spain. He has no awareness of a time when he turned from "amateur" to professional; his outlook in photography is centered about an "interest in what I'll see next." Cartier-Bresson is a founding member of Magnum, the international picture agency, and his photojournalism has appeared in most of the world's mass-circulation magazines. His books include *The Decisive Moment, The Europeans, The People of Moscow, Danses à Bali, From One China to the Other,* and *The Photographs of Henri Cartier-Bresson* (the last published by the Museum of Modern Art, New York). An exhibition of 400 of his pictures is now touring the U. S. under the sponsorship of the American Federation of Art.

Cartier-Bresson works exclusively with the Leica, together with lenses "of various nationalities." He prefers to use the 50-mm focal length. He has a very low regard for accessories and gadgets of all kinds; he never even uses a filter, and dis-

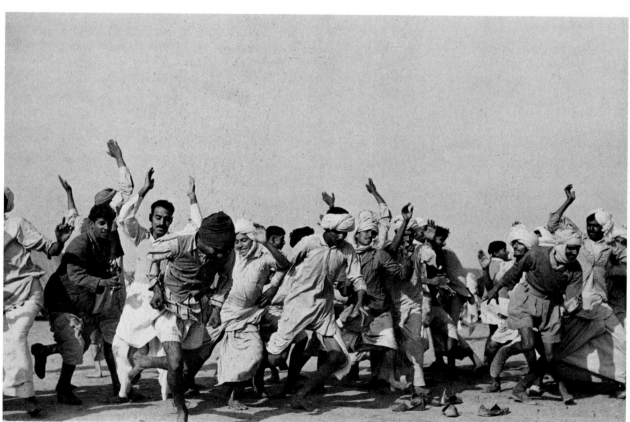

GYMNASTICS, INDIA

HENRI CARTIER-BRESSON

dains exposure meters, preferring to trust his experience and judgment. As to film, when weather and light are good, he chooses Ilford HP-3, rating it at 200 ASA; indoors and when conditions are poor, he uses Du Pont SX Pan, rated at 500 to 1,-000 ASA. Cartier-Bresson trusts all his processing to the lab of Pierre Gassman in Paris, which develops his film in Harvey's 777 (sometimes resorting to D-76 or Promicrol to "push" film speeds). Printing is on Varigam or Ilford Multigrade, with recommended developers. Being free of gadgets, Cartier-Bresson can carry his camera with him at all times, and this habit, together with his unerring skill in capturing "the decisive moment," is the key to his way of working.

"To me, photography is the simultaneous recognition, in a fraction of a second, of the significance of an event as well as of a precise organization of forms which give that event its proper expression. I believe that, through the act of living, the discovery of oneself is made concurrently with the discovery of the world around us which can mold us, but which can also be affected by us. A balance must be established between these two worlds— the one inside us and the one outside us. As the result of a constant reciprocal process, both these worlds come to form a single one. And it is this world that we must communicate. But this takes care only of the content of the picture. For me, content cannot be separated from form. By form, I mean a rigorous organization of the interplay of surfaces, lines, and values. It is in this organization alone that our conceptions and emotions become concrete and communicable. In photography, visual organization can stem only from a developed instinct."

HARVEY SHAMAN

ALFRED EISENSTAEDT

Alfred Eisenstaedt, born 1898 in Dirschau, Germany. On his 12th birthday, received an Eastman No. 3 folding camera from an uncle; was an enthusiastic amateur until drafted into the army at 17. After World War I, took a wholesale button-selling job, and resumed photography as a hobby. Sold his first picture in 1927. Turned pro in 1929, and joined Associated Press. Discovered 35-mm photography in 1930, and has used a Leica ever since. His first AP assignment was covering the ceremonies in Stockholm when Thomas Mann received the Nobel Prize in literature in 1929; for this he used the pioneering, big-eyed Ermanox. Came to the U. S. and joined *Life* in 1935, when it was still in the planning stage. He particularly likes the nature assignments *Life* hands him, like the one about the tropical rain forest in Dutch Guiana. Eisenstaedt takes unceasing pleasure in picture-taking, and his camera is with him even on vacations,

when he experiments endlessly with new ideas and new techniques.

This veteran *Life* photographer uses five Leica M-3s almost exclusively, with a full range of Leitz lenses, plus a Nikkor and a Canon which offer extra-wide apertures. Rarely, he turns to a 4×5 press-type camera. His film choices for black-and-white are Tri-X and Plus-X, depending on whether high speed is necessary. He uses them strictly at the manufacturers' recommended ratings. For color, he will use Kodachrome if light conditions and subject movement permit, otherwise Anscochrome. He is constantly testing new films, willing to try anything that promises to help him do his job better. On about half his assignments he takes artificial lights— usually two or three reflector floods, supplemented for big jobs by a pair of 1000-watt floods. He occasionally uses a portable Mighty Light electronic flash unit. Eisenstaedt has done no processing since coming to *Life* 23 years ago. Its lab personnel are trained to produce the kind of quality desired by both the photographer and the editors. His film is developed generally in D-23, though D-76 is being used now for Plus-X, in a 1-to-1 dilution with seven-minute immersion. Choice of printing paper and developer is left to the judgment of the lab people. Most of Eisenstaedt's work is in the nature of reportage, but like all *Life* staffers, he has access to its huge and completely equipped studio.

"When I took my first picture back in 1912 I had no idea that I would make a career of photography. Today, almost 45 years and at least a million

pictures later, I am certainly much more experienced, but I often wonder whether and how much I have actually improved since that early beginning. Strange to say I started out as a salon-print photographer. Yet through all the changes in style and subjects, I remember almost every picture I have taken and can recall the circumstances surrounding each of them. In the old days, before I came to the United States, I did not have all the conveniences that I enjoy now. As a Life *staff photographer I am spoiled. A plush laboratory processes all my films and does all my printing and helpful reporters assist me in my picture taking. But, as many a veteran photographer will agree, the old days were really better. I was more free, and most important of all, I was thirty years younger. Yet I can honestly say that I get as much enjoyment and excitement out of taking pictures today as I did when I began. If there is any secret to my career, it is that I have managed to keep my original spirit during all these years of professional life. Every assignment I have undertaken, from an essay on Churchill to a story about a day in a dog's life, I have tried to carry out with as much enthusiasm as if it had been my first story. This is why I have such respect for good amateur photographers. Too many professionals think they have learned everything. In actual fact they have already forgotten much. Once the amateur's naive approach and humble willingness to learn fades away, the creative spirit of good photography dies with it. Every professional should remain always in his heart an amateur.''*

ERNST HAAS

Ernst Haas, born 1921 in Vienna. His formal education was directed toward medicine, but

HARVEY SHAMAN

conditions in Europe at that time made such a career impossible for him. He had also studied philosophy, and was strongly attracted to painting. His father had been a professional photographer, but he was not drawn to the camera, feeling it too mechanical and technical. But one day soon after the war, he traded a quantity of black-market butter for a Rolleiflex, and began working seriously with it. His pictures attracted the attention of the editors of *Heute*, a magazine published in Germany by the U. S. State Department: they published his first major story, a powerful reportage on returning prisoners of war in Austria. *Life* quickly reprinted it here, and Haas' fame began to spread. One of his most remarkable achievements was "New York in Color," published in *Life*—a set of pictures which demonstrated his freshness and perception with the camera. Portfolios of his work have appeared in the world's major annuals and photographic magazines including *Popular Photography* and *Photography Annual*.

Ernst Haas works with a battery of three Leica M-3s, and an arsenal of lenses that includes all those designed for them, plus a 28-mm Canon and 25- and 135-mm Nikkors. He now shoots almost no black-and-white, but when he does he chooses Plus-X or Ilford HP3 film, which is processed for him by a lab; he supervises a professional printer when necessary. By far the largest part of his work is in color, for which he uses only Kodachrome. He never uses an exposure meter, and, when asked what sort of artificial light he used, he reflected and realized that he has not used flash for at least five years. These are indications of his prevailing attitude toward the impedimenta of photography. He must work as directly and spontaneously with his subject as he possibly can, and his manner enables him to operate swiftly and unobtrusively. He still pursues his old love, painting, and his color photographs show the working of a trained artist's eye.

"Living in a time of crucial struggle, the mechanization of men, photography for me became nothing but another example of this paradoxical problem: how to overcome, how to humanize the machine on which we are so very dependent—the camera. This mechanical instrument forces and enables us for the first time to learn how to read and write simultaneously visual aspects resulting from a discussion with reality expressed with a language of light called photography. Disinterested in scientific objectivity, I want to transform reality with a poetic conception by relating the unrelated into a vision—forcing the viewer to feel what I felt as well as to think what I thought. I believe photography can be an art and I want to give everything to help achieve it.

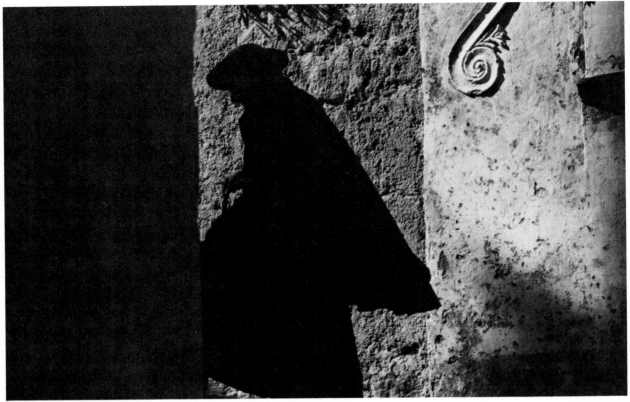

ITALIAN PRIEST ERNST HAAS

HARVEY SHAMAN

There is only you and your camera—the limitations of your photography are in yourself, for what we see is only what we are."

PHILIPPE HALSMAN

Philippe Halsman, born 1906 in Riga, Latvia. Studied engineering in a technical institute in Dresden, Germany. During this time he was an amateur photographer, with a particular interest in people. He began to find engineering too dry and unrewarding, and a year before the end of his course he had decided on a career in photography. He opened a portrait studio in Paris and soon began to make a name for himself, not only among portrait clients but among magazine editors. His first assignments were for the hat-fashion magazine *Voilà* and for the Paris *Vogue*. Halsman came to the U.S. in 1940, and his distinctive style and faultless technique have kept him in demand for magazine editorial and advertising work. Without being a *Life* staff member, he has placed more covers on that magazine than any other photographer—81. Typical of his major picture stories for *Life* was "Beautiful Women of the World" in 1956. He has published two best-selling humorous picture books: *Dali's Mustache* and *The Frenchman,* and a nonphotographic juvenile, *Piccoli.* His goal: "to know that I have created the historic image of a personage."

Philippe Halsman uses a camera of his own design for fully half of his work. It is a 4×5 twin-lens

98

reflex with 210-mm Bausch & Lomb Tessar *f*/4.5 lenses, built for him by the Fairchild Camera and Instrument Co. It is too heavy to be handheld steadily, and is generally used on a tripod. Another third of Halsman's work is done with the Rolleiflex, and the balance divided among a Leica (with full complement of lenses), a Hasselblad (for wide-angle work only), and 5×7 and 8×10 view cameras. His choice among roll films is either Tri-X or Verichrome Pan, and for sheet film Super Panchro Press Type B. For color work he uses 120 Anscochrome, 35-mm Kodachrome and Anscochrome, and 4×5 and larger Ektachrome. Black-and-white film is developed by himself or an assistant, in D-23 for small sizes and DK-50 for sheet film. Whenever light conditions permit, he prefers to overexpose as much as 50 percent and underdevelop 25 or 30 percent, to minimize highlight blocking and too-thin shadow areas in the negative. He does most of his own printing, relying on an assistant when necessary. The usual combination is Varigam and Vividol. Halsman's studio, which is in his home off Central Park West in New York, measures about 25 by 30 feet, with a very high ceiling, and is equipped with numerous large Ascor electronic flash units —his preference for artificial-light shooting.

"The earliest photographic pioneers were painters. Daguerre, Nadar, and Hill began as painters and it was only natural that they—and later the critics—looked upon photography as if it were merely another graphic art. Since it was so suitable for representation of reality, photography caused the disintegration of classical painting and was responsible for the birth

of modern art. It is paradoxical that while painters like Degas and Toulouse-Lautrec tried to break the conventions of pictorial composition, by deliberately imitating the accidents of snapshots, many of our best photographers still try to follow the rules established by painters. It is time to free ourselves from the bonds of this artistic heritage. In my opinion the content of a photograph is at least as important as its graphic beauty, and a profoundly perceptive portrait has more portrait value than a perfectly composed one. This does not mean that I am an advocate of careless technique. With pride in his craft, with utmost professional ability, the photographer should use his sensitivity and perception to capture the depth of an emotion or the quintessence of a human being. The greatest reward for a photographer is to know that his photograph of a person, i.e., his personal interpretation, has become the definitive and potentially historic image of a great man. Since one can photograph only visible things, photography has shunned expressing ideas. It is for this reason that I have lately become more interested in exploring the possibility of translating abstract ideas—directly or through photographic artifice—into visual symbols or ideograms."

YOUSUF KARSH

Yousuf Karsh, born 1908 in Mardin, Armenia. Emigrated to Canada in 1925: wanted to be a surgeon, but took an interest in the profession of an uncle, George Nakash, who was a photographer (and still operates a studio in Montreal). Little formal education; studied photography with the portraitist Garo in Boston, "learning the humanities as much as photographic technique." Opened his

own studio in Ottawa in 1933, subsequently photographed numerous notables, including Canada's Governor General. In 1941, when Churchill visited to address the Canadian Parliament, Karsh arranged a portrait sitting; at a crucial moment he snatched the cigar from the Prime Minister's hand, and captured an expression of defiant courage which has become the classic Churchill image—and which, more than any other single picture, brought fame to Karsh. Other portraits in which Karsh feels he has synthesized many elements of a personality in a single exposure are those of Finnish composer Jan Sibelius, George Bernard Shaw, and Spanish 'cellist Pablo Casals. Book: *Faces of Destiny* (Ziff-Davis Publishing Co., 1946), portraits of the great personalities of our time. Karsh was made a citizen of Canada in 1946 by special act of Parliament, in recognition of his achievement and contribution through photography.

Karsh nearly always uses a white 8×10 view camera for his por-

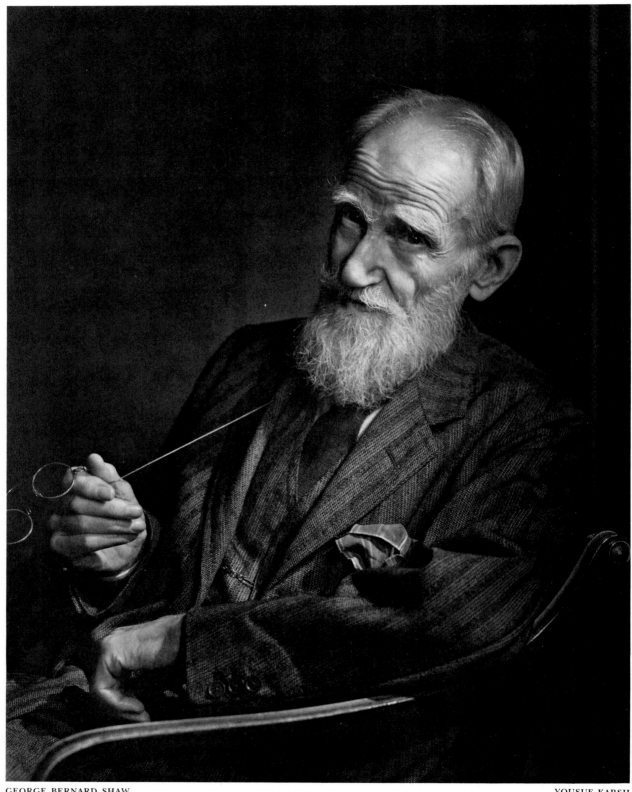

GEORGE BERNARD SHAW YOUSUF KARSH

traits, and employs a full range of Ektar lenses with it. For industrial work he uses a 4×5 view, Rolleiflex, and Leica. Ninety-nine percent of his pictures are made away from his studio. He has not standardized on film, and for portraiture uses Kodak Portrait Pan, Super Panchro-Press Type B, and Super-XX. In the small cameras he uses Panatomic-X. He laments manufacturers' concentration on high speed, and considers films in general "too fast" for his kind of work. He develops his own film, usually in DK-50, and supervises the making of the "master print" from each negative, after which an assistant takes over. Color portraits are made on Ektachrome. Karsh uses electronic flash for all his color work; it is much more consistent in intensity and color temperature than floods and spots. He takes four units with him on a job, sometimes using them in conjunction with available window-light. For black-and-white he uses from two to four spots and floods. Industrial assignments call for speedlight—generally a great many units. Karsh consults exposure meters—both Weston and Norwood—only for color, and heeds their advice "only if it coincides with what I think the exposure should be."

"Photography is, to me, more than a means of expression, more than my particular profession—it is a way of life. And if I were asked to choose one word which holds the key to my work I would select 'light'—for light is my language, and it is international, readily understood by any person of any race. It has been my good fortune to welcome before my camera many great men and women who have made their mark on our generation and will find a place in history. I feel that my

life's work is to interpret to the best of my ability, the inner strength, the true character, of these personalities, through the medium of photographic portraiture. I can think of no elation equal to that when something close to my ideal is achieved, though necessarily there must always be a spark of what I call 'divine discontent'—the constant striving for near-perfection. In this self-appointed task, which also carries, I believe, a great sense of responsibility, the medium of light is all-important. It is the portraitist's chief tool, and he can never learn enough about it."

IRVING PENN

HARVEY SHAMAN

Irving Penn, born 1917 in Plainfield, N. J. Studied art under Alexey Brodovitch in Philadelphia, afterward took a job as office boy at *Harper's Bazaar,* where Brodovitch was art director. In 1940 he left to become art director for Saks Fifth Avenue, but after two years he joined *Vogue* as assistant art director, in charge of covers. He began making the cover photographs himself, and it was not

long before he was doing photography exclusively. He has since remained under contract to the magazine, though he is free to do any advertising work he chooses. His work is remarkably diversified, ranging from fashion (which has evolved since the early days from dry and stylized to tender and human) through portraits, still lifes, action shots, to the semi-abstract technique exemplified by the DeBeers ad reproduced in this issue. Penn attaches great importance to a photographer's consistency and reliability, asserting that there is no room or time in his profession for experiment or uncertainty—"we have to publish our mistakes." Typical of his major efforts are the big color set made in Cuzco, Peru, and the monumental series on man's occupations, made in three groups for magazines in the U.S., Great Britain, and France.

Penn uses an unusually wide range of cameras, suiting each to the job before him. For the Leica he has a full battery of lenses, but is especially partial to the long-focus objectives. He has a Rolleiflex, a Hasselblad, 4×5 and 8×10 Deardorff View cameras, and a rarely used Graflex. His film cabinet is stocked with a dozen varieties, each with its own application depending on subject matter and light conditions: Verichrome Pan, HP3, Tri-X, Plus-X, and Panatomic-X for black-and-white; Kodachrome and Ektachrome for color. Ektachrome is always the choice for color portraits and for all other view-camera uses. A Brockway incident-light meter is used to determine exposures. An assistant does all his black-and-white processing, mostly in

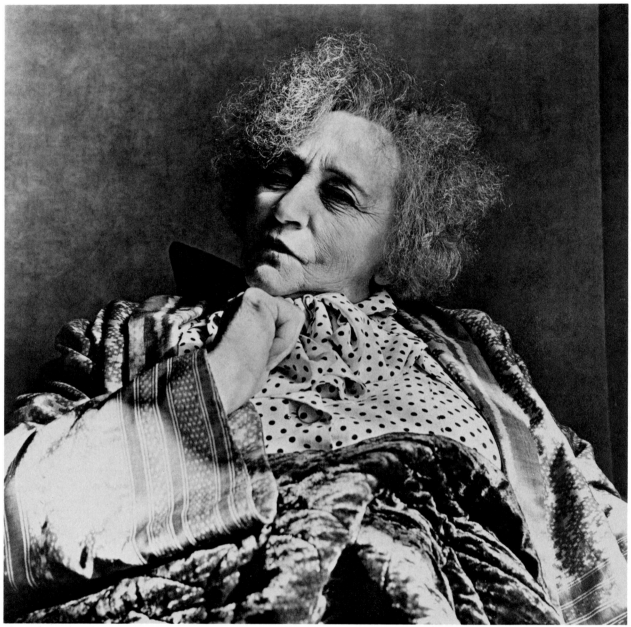

COLETTE

IRVING PENN

Harvey's 777, and makes prints on glossy Velour Black developed in 55-D. Color processing is done by an outside laboratory. He has two studios, one equipped with 24 big 800-watt-second electronic flash units; the other with two banks of 60 reflector floods, one as an "artificial skylight," the other as a wall bank, both fitted with removable glass-cloth diffusing curtains. He has a small portable speedlight for on-location work. Penn believes so strongly in specialization that he has not loaded a camera, cocked a shutter, or turned on a light in years; his function is taking the picture.

"I am a professional photographer because it is the best way I know to earn the money I require to take care of my wife and children. As the side effects of this: I am pleased (through editorial photography) to be able to communicate the essence of events,

102

places, and people to readers whom I could never hope to know. I am grateful that (through photography for advertising) I can be related to important industrial enterprises which to me are inspiring and vital. I feel privileged to be assembling a body of photographs which are a personal record of our time and which provide the illusion of a kind of immortality."

W. EUGENE SMITH

HARVEY SHAMAN

W. Eugene Smith, born 1918 in Wichita, Kansas. At 14 he turned a passion for aircraft into one for photography; made pictures for school and city newspapers. Covered sports, aviation, the dust bowl; the latter gave him the chance for his first real picture story, printed in a national magazine. In 1936 a photographic scholarship was created for him at Notre Dame, but he was dissatisfied with the school's restrictive thinking, and stayed less than a year. Came to New York, joined staff of *Newsweek*, returned to free-lancing after a few months; signed with *Life* in 1939. Soon found himself "in a rut" there, resigned in 1941 to free-lance once more.

War correspondent for *Popular Photography* and other Ziff-Davis magazines in 1942, he won first prize in the black-and-white division of *Popular Photography's* picture contest, then rejoined *Life*. Covered 26 carrier combat missions, 13 invasions; seriously wounded. Returned to work in 1947 for *Life*. Notable photographic essays: Country Doctor, Spanish Village, Nurse Midwife, Chaplin at Work, Dr. Schweitzer in Africa. Ended contract with *Life* in 1955, joined Magnum Photos. Received Guggenheim Fellowships 1956–57, spent three years on a picture essay on Pittsburgh.

Although he uses every type of camera, W. Eugene Smith does most of his work with 35-mm. In a typical shooting situation, he will use "a set of Canons and a set of Leicas with Canon lenses," (a "set" being five or six cameras), the Leicas loaded with one type of film, and Canons with another. They will have the full range of lenses—21-mm, 28-mm, 35-mm (most often used), 50-mm, 85-mm, and 135-mm—so that none need be interchanged while he is working. Other cameras: Miranda and Asahi Pentax single-lens reflexes, Rolleiflex, 2¼×3¼ Linhof, 4×5 Speed Graphic, Graflex (the latter two rarely used) and Sinar, and 5×7 and 8×10 view cameras. Does not believe in "establishing a technique and making the world fit it," uses a variety of films including Plus-X, Tri-X, and Adox. Dislikes color, but has had best results with negative materials: Kodacolor, Ektacolor sheet film. Smith does nearly all his own processing, but permits a skilled friend to make some carefully supervised prints. Negative development

usually in Harvey's 777 by inspection. Does not systematically "push" film speed, but exposes consistently and develops "until I get the negative." Prints are made on Varigam, in Dektol. He is a relentless perfectionist whose "proof prints" are of exhibition quality, and who will spend not hours but days and weeks on a single picture to get the quality he wants. In his grubby, comfortable Manhattan work-place hideaway hangs a punning motto: "C'est Daguerre!"

"I doubt the existence of any perfection, although I am for trying the rise to this the impossible and would take measure from such failure rather than from the convenience of a safe but mundane success. (I do not deplore success.) I would experience ever deeper, and endeavor to give out from this experience. My photographs at best hold only a small strength, but through them I would suggest and criticize and illuminate and try to give compassionate understanding. And through the passion given into my photographs (no matter how quiet) I would call out for a spiritualization that would create strength and healing and purpose, as teacher and surgeon and entertainer, and would give comment upon man's place and preservation within this new age—a terrible and exciting age. And with passion. Passion, yes, as passion is in all great searches and is necessary to all creative endeavors— whether of statesman, or scientist, or artist, or freedom, or devil—and Don Juan may have been without passion, for sex and sentiment and violence can very much be without passion. Question this? Take note of the values around you, everywhere thrust upon you—and wade awhile, with this question in thought, through publications and publications from cover to cover."

One Whom I Admire, Dorothea Lange (1895-1965)

W. Eugene Smith

"I would like to see photographers become responsible and photography realize its potential."
—Dorothea Lange

It was within this challenge of responsibility, with a fitting of her life into that challenge, that Dorothea Lange lived and worked. The photographic statement, the summation that stands solidly in representation of her at the Museum of Modern Art, should convince nearly anyone that this indeed is fact. A fact we can welcome.

Those who know me realize how awkward I am in relating to conditions of praise, whether in the giving, or in receiving. I believe this awkward discomfort to be less from selfishness than from a feeling that such words as we do have for expressing "praise" (and like those for the expressing of "love") have become so terribly scuffed and tarnished, so sodden and chemically changed from our persistence in throwing them outright to the floods of mediocrity that they are nearly irretrievable for worthy and convincing usage.

Several months ago I wrote a few words about Dorothea Lange that were intended for publication, and more, in that they were intended for Dorothea. That she might have one more distinct confirmation of my appreciation for her, even that my words might be a touch of encouragement to her during the trials of her last major work effort —the Museum show.

Being a woman of "incredible will," Dorothea undoubtedly did not need my words. Do not take with less than real appreciation that it has been said that during this past September, in working

out the show, she felt it might be necessary to attempt additional photography. Bravado nothing —it was the simple, direct sense of a problem and the way to rectify it. But being a woman of thoughtful modesty, she probably would have scolded me for an "extravagance" of praise in having mentioned it in this fashion. Being a woman of direct reality, she would not have thought it indelicate of me, I think, that at the time I spoke openly of her impending death from cancer.

And I believe that above all else, Dorothea would have appreciated my comments regarding a project of hers that would benefit others—a dream of hers that, if as a practical suggestion it were realized, would work to the benefit of all photography. All photography, that is, other than that kind which is of pure and deliberate shoddiness, uncorrupted by integrity. The particular project I speak of, this particular project of Dorothea's—is one I will have more to say about at the end of this.

As for now, rather than going through the words I have already written and submitted about Dorothea, rather than any major rewriting of these words that would move the present into the past, rather than any simpler kind of changing that would convert "is" to "was"—rather than these doctoring efforts, let me leave the words that I wrote almost as they stand. And at the end, let me add a few words which underline my concern for that expressed hope of Dorothea's.

Above all, since what I had written was for the living, I wish that it did not now seem to be falling into the "nice thoughts about the recently dead" kind of tradition.

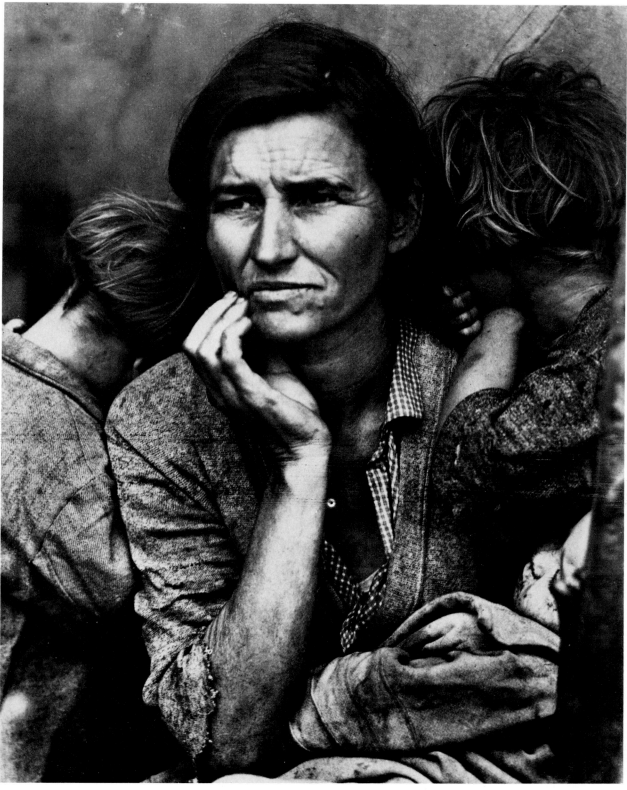

MIGRANT MOTHER DOROTHEA LANGE

Dorothea Lange, that gallant and great woman, is deeply into the preparation of a major show for the Museum of Modern Art. Scheduled to be seen early in 1966, it will draw from the whole of her photographic lifetime. And as she works, editing these experiences of the past, bringing to the show those particular characteristics of graceful passion, that directness of spirited morality which underlines the individuality of her images—as she creates anew, in this new format, she is fully aware that in the physical sense she, herself, is dying. The courage and sense of purpose that directed and sustained—and, yes, inspired her—that belief in the worth of life she has so evidenced in her work and through grievous adversity is directing and carrying her now. Dorothea Lange is a sensitive woman: a "tough" idealist of courage, tenderness, and beauty. She is what many have been called, but few are—a great photographer. And she is much more. . . .

Born in 1895, she early was a student of Clarence H. White, worked briefly for Arnold Genthe, and opened a portrait studio in San Francisco, 1916. I know nothing of the quality of her work in this period between 1916 and the time of the Depression. In 1932 the discrepancy between her studio world and the world of the drifting and jobless men she could see from her studio window was poignantly obvious, and she knew that her compassionate interest in human beings could not be contained solely within the portraits she was doing. Even as it hurt, she went among them, and out of the involvement brought us some of the most searing, utterly human statements of that time. And never were these images rejective of man. Dorothea rejected conditions, and she rejected actions—but man, as such, she did not. None the less, she can criticize with a direct and pertinent sharpness, as I well and thankfully know.

HER SUBJECT WAS MANKIND

In 1935 Dorothea became part of the famed government Farm Security Administration group under Roy Stryker, and in this wonderful group her strength was clearly evident. Without detracting from the others, Dorothea was "the most." In 1941 she became a Guggenheim Fellow, resigning that Fellowship after Pearl Harbor so that she could, exercising the thoughtful freedom of her courage once again, photograph the internment of Japanese-Americans as did Ansel Adams. During the war she worked mostly with government agencies. Photographing the initial United Nations conference, she was struck with a serious illness. She could not continue. Many of us, listening to a garble of indirect reports, wondered if she ever again would photograph.

HER WORK CONTINUED

It was 1951 before Dorothea could and did. In the years that followed she has continued to photograph, the precarious state of her health being overridden in a continuing series of images for the world. Situations, ideas, and places—the human element always. Such essays as "The Public Defender," 1955, and "Death of a Valley," with Pirkle Jones, 1956–57. And in the following years came her images of Asia, Venezuela, Egypt, among others—including those that were right here at home. Dorothea, for reasons enough, has generally remained divorced from the "exigencies" of magazine production. It has been a serious loss to the mass of magazine readers. It is a downright crime, in my opinion, that the largest and most influential publications of our time have made so little use of her reportorial ability, that they have realized so little from her reportorial accomplishments.

A dream that Dorothea Lange has long had (expressed in a 1958 letter to Magnum photo agency) is "to work toward the establishment of the counterpart of Nieman Fellowships . . . designed for practicing photojournalists, who are developing the field of nonverbal communication." Dorothea even dreams "that Henry Luce or Gardner Cowles, or both together (fantastic?) could, or should, underwrite this." And in this last bit, suggesting Luce and Cowles, she is more the optimistic dreamer than am I. But her basic dream of a fellowship through which practicing photojournalists can draw apart from, and into study of their medium—this, which would allow real confrontation with the depressing, deadly confusing state of the profession is a situation mighty important to bring into reality.

Somehow, somewhere there must be a continuing base from which, with practical idealism, real study can be applied—through which growth with the clear view and the steady purpose can be nurtured by those willing to dedicate their lives to bringing into fact the best potentials of photographic journalism. In the meantime, in the immediacy of right now, it is fortunate not only for photographers that Dorothea Lange has so dedi-

cated herself to the humanities through photography.

ACCEPTED RESPONSIBILITY

Now Dorothea Lange works to complete what necessarily must be one of the major photographic shows of our time. A prediction that is hardly a gamble, or far out—although Dorothea quite likely (once again) will chide me for having made it. Dorothea Lange: that Dorothea who in stressing facts, not statistics, has produced art; a free artist who is fully disciplined and in direct engagement with the artist's responsibilities. Her matter-of-fact example chiding us to demand better of ourselves; her example making clear that it is not ill-human to reject the appealing compromises. Dorothea is an Olympian who would claim that she had never reached the mountain—even as she stands astride it. Her example is truly as a beacon light and it is unobscured by the glittering shills of other pathways.

And now Dorothea Lange is dead and this in a way is the farewell after the fact—the very situation I did so much wish to avoid. It has been rather romantically suggested that Dorothea quietly postponed death until she could complete the Museum show. However it was, she at least continued until the show was "90 percent" as she wanted it —she had reached the point of that satisfaction with the work so far accomplished. I doubt that even in full health, with all time before her, she could ever have been more than 90 percent satisfied—and that is as it should be.

TO GIVE MEANING

My romanticism by no means allows me to indulge in the sentimental cliche that the great artist "dead" lives "forever and onward" in the "continuing glory" of his "immortal" works. It is tremendously presumptuous upon my part, but I wager that Dorothea would agree with me—that the one real way, beyond this Museum show, and beyond the book that will follow, beyond the lifetime of her work—beyond these, the one real way she can live on is if her values are realized and are carried on by those individuals capable of carrying them on. And I don't mean just *appreciative* of them. I believe Dorothea would choose, above fame, to live on by having her work infuse its spirit and its meaning into those who will be working today, and those who will be working tomorrow, and for all those who will be working all the tomorrows to come—with her kind of spirit and integrity being carried from one to the other in the kind of tradition that nobility can aspire to.

ESTABLISH A FELLOWSHIP

If I now must use the moment of aroused sentiment that accompanies a death—not a departure, but a death—and which for a few moments seems to bring out the best in man, then let it be unashamed. Grant Dorothea her wish, realize this dream for her. If it will help, I'll beg you to—but do it, selfishly if you will, for its benefits now will be strictly yours. Or let me reason, let my approach be calm and practical: Listen, you who can cause it to happen (whether one person, or a hundred thousand), it would be a very worthwhile accomplishment if the means could be found for establishing a Dorothea Lange Fellowship of photographic journalism. A Fellowship with meaning, and the funds to back it. It is a remembrance that Dorothea deserves. It is desperately needed for ourselves in this age. It is desperately needed.

Cartier-Bresson Today

3 Views: Schwalberg/Vestal/Korda

BOB SCHWALBERG

One of the reasons why there are so few critics of photography may be a middle-aged Frenchman named Henri Cartier-Bresson who claims that he isn't even a photographer. Almost anyone involved with making or using or laying out or doing anything else with photographs will tell you that Cartier-Bresson is one of the world's most important photographers. And some will say more. But they probably won't agree on exactly why or what or how.

Cartier-Bresson is not for pinning down. He uses no tricks, no formulas, no gimmicks. What you find is a kind of completeness, a certain wholeness. He is not a photojournalist; he does not produce classical picture stories with a beginning, a middle, and an end. He does insist on making a complete statement, but only about what has actually happened—and without tampering with either the people or the events.

He practices his own special brand of outside-looking-in photography. He roams his world with a Leica. About 90 percent of his pictures are made with 50-mm normal-focus lenses. He never poses. He never arranges. If observed, he instantly breaks off action. He adds no photographic lighting, but uses light exactly as he finds it. He eschews every specialized optical effect, from limited depth of field to ultra-wide-angle vision. In effect, he is the theoretically ideal photographer who sees without being seen, records without impinging upon his subjects.

Despite his pretense of technical ignorance, Cartier-Bresson actually possesses complete technical mastery of his medium. Every so often he comes to me for technical advice, for which I receive profuse thanks, and which he promptly ignores. One afternoon we sat together in my Wetzlar apartment discussing films and developers. Cartier-Bresson repeatedly referred to the fact that he exposed Ilford HP3 film at 400 ASA. I cut in to ask, since he almost never uses an exposure meter, how could he claim to be exposing at 400 or any other ASA? He insisted, however, that he exposed consistently at 400 ASA.

At this point I picked up a Norwood exposure meter, twisted the bubble toward Cartier-Bresson with the scale facing me, and asked for the exposure at 400 ASA. Without hesitation, he told me exactly what the Norwood did. Slightly taken aback, but not yet defeated, I aimed a flexible desk lamp so as to crosslight my face, and again demanded the 400 ASA exposure. Cartier-Bresson took perhaps 10 seconds before replying: "Well, it depends on whether you mean the right or left side of your face. On the right it's about 1/15 at $f/2$; the left is probably close to $f/2.8$ at 1/30." Both answers were bang-on, and thereafter I accepted his 400 ASA as being at least as reliable as my meter's.

A WALK WITH CARTIER-BRESSON

John Durniak once trailed Cartier-Bresson through New York in the vain hope of witnessing the capture of one of his famous Decisive Moments. Well, I once took a long zig-zagging walk through Paris with Cartier-Bresson. We were both identically armed with black Leicas and 50-mm

lenses. While mine swung obediently from its shoulder strap, his appeared to have a serious nervous affliction causing it to jump to his eye and down again with alarming rapidity. Several times I saw him walk to within three feet of a person, make the picture head-on with his quick up-and-down motion, and sidestep out of their lives without a hint of either recognition or annoyance from any of his "victims." These people must have seen Cartier-Bresson, and maybe even that he was using a camera, but his confident close-in movements blended so perfectly with everything else that they had neither the time nor any reason to react.

As one of photography's great living legends, Cartier-Bresson is much admired, and much discussed; often, as in this completely unauthorized piece, in print. As a result, it is common knowledge that he shoots a tremendous number of pictures, has all of his lab work done for him by Pictorial Services in Paris, and that he prohibits publications from cropping his pictures.

A hapless interviewer once asked him how many pictures he made per day. Cartier-Bresson countered with "How many words do you write in your notebook each day—and do you use all of them?" Like all successful practitioners of the unobtrusive approach, Cartier-Bresson often shoots for the lucky accident. But unlike certain of his confrères, he admits to this without apology. This is why he feels that almost anyone who has done photography long enough must have a few superb pictures. Somebody (probably either Goethe or Frederick the Great) once explained Cartier-Bresson's working methods by saying that luck comes repeatedly only to those who have the courage to exploit it.

MANY SHOTS, FEW PRINTS

If Cartier-Bresson over-shoots, he also under-prints. What he was willing to risk in the viewfinder must convince him again when he examines every frame on the contact sheet. One

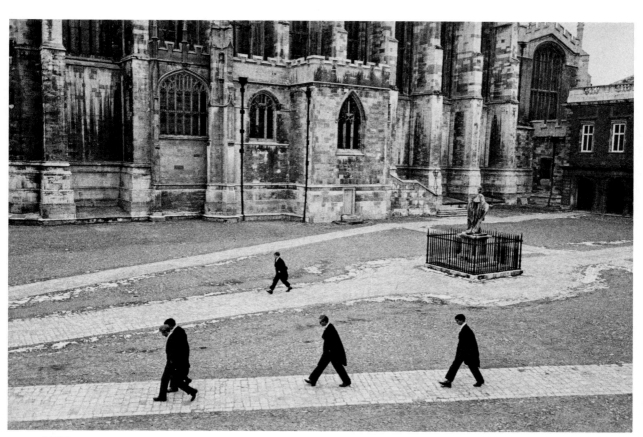

ETON, 1962

thing I've learned through the good fortune of knowing people like Cartier-Bresson, Feingersh, and Haas, is that high batting averages belong to baseball players, and not to good 35-mm men. I once watched Cartier-Bresson go through a stack of contact prints. He showed me only one with two frames X'd for printing. As he finished, he remarked that he was usually very happy to have one frame on a sheet worth printing. He didn't say so, but I suspect that another part of Cartier-Bresson is probably a kind of continuous visual self-education in which the critical study of his own and friends' contact sheets plays a big part. I also suspect that he learns as much from his misses as he does from the frames that end up as famous Cartier-Bresson pictures.

Although it's a common practice today for many —if indeed not most—working professionals to entrust their developing and printing work to outside laboratories, Cartier-Bresson comes in for some criticism on this score, particularly from younger talents who feel that they must see the job through from exposure to finished print. This is the logical, though perhaps unfair, consequence of a certain *noblesse oblige* that Cartier-Bresson carries, whether he likes it or not.

Cartier-Bresson is doubtless the most universally admired and least controversial of all of photography's public figures. The tremendous influence that he has had on the thinking and seeing of at least two generations of young photographers is based partly on his contributions to their vision, and partly on his adherence to an idealistic purity of approach which very few are able to emulate. Thus, for a photographer whose whole way of seeing may have been changed by a Cartier-Bresson picture, the knowledge that the print was actually made by an anonymous laboratory technician is understandably disturbing.

What really counts, however, is not the work but the involvement. Cartier-Bresson, who has many years of active darkroom experience behind him, is deeply involved in every part of the process. His prints are made by people who have worked for him for years, who know what he wants, and who are willing to do remakes whenever his concepts have not been faithfully carried out. But more than this, the whole Cartier-Bresson approach is a negation of effects, and most certainly of darkroom effects. What he really wants is just what is on the negative, with no accentuation of tones in order to add emphasis or to subtract unwanted details. This he gets, with a kind of silvery soft

gradation which photographers devoted to rich jet-blacks recognize as another Cartier-Bresson characteristic.

Unless you don't understand and enjoy Cartier-Bresson's work (and maybe not everybody does), his famous prohibition against cropping is self-explanatory: his pictures are uncroppable. What he does involves cameras and lenses, films, papers, and developers—but only incidentally. His photography is really a process of distillation in which the raw materials that count are knowledge, awareness, and a highly developed recognition of visual interrelationships between objects and shapes. When all of these elements come together as a Cartier-Bresson picture, the product is an uncuttable essence. It's pure Cartier-Bresson.

DAVID VESTAL

Like most photographers, I owe Cartier-Bresson a debt that can never be paid; unless indirectly, by making pictures that are mine the way his photographs are his: totally.

The qualities of his work that have done the most for me are his free yet disciplined vision, his lively and understanding choices of things to photograph, and his unfussed treatment of the pictures once he has them.

He has opened up new territory in seeing and thinking. Somehow he combines spare understatement with visual excitement; and tight-stretched visual tension with really relaxed feeling. The clear accuracy with which he has written about his way of working is a refreshing eye-opener. In seeing and thinking for himself, he has set an example worth following—I mean *emulating*, not parroting. (There's a plague of would-be Cartier-Bressons who try to be him instead of themselves. These are second-rate productions. *Cartier-Bresson Returns; Son of Cartier-Bresson; Cartier-Bresson Meets Frankenstein and Wolf Man.* Don't blame Cartier-Bresson for these: if he weren't handy, they'd imitate someone else.)

The problem of his "let George do it" approach to the print is probably less important than it seems to some critics. Yet I must confess I'm one of those who wish he took a more active part in the printing. This is not a moral issue, not a craft issue; and only partly a matter of interpretation. The problem, as I see it, is not that his printers fail to grasp his interpretation of the picture. They fail to realize that no interpretation is called for, so

they put unwanted interpretation in. This tends to convert strong unconventional pictures into less strong, conventional ones. I gather that Cartier-Bresson makes his final picture decisions at the moment of pressing the button, the way most of us shoot Kodachrome, knowing that we have nothing to do with the processing. There is no reason not to, if that processing, as with Kodachrome, is technically adequate and consistent. I suspect that a really good printing machine, programmed only to make the clearest possible print in terms of tone, and totally *without* interpretation, would be excellent for Cartier-Bresson. (No joke, I mean it.) Such a machine would not dilute his vision by injecting its own mediocre vision into the print.

The printing machine is imaginary, and what follows is guesswork: I'm attributing qualities I try for myself to Cartier-Bresson, without apology. His work tells me I'm very likely right.

THE WORKING ATTITUDE

Cartier-Bresson is not interested in improving on experience: he wants to present it accurately, just as it is. This is practical recognition of a fact often overlooked, but basic to photography. The camera sees more, and the negative remembers more than the photographer. (The negative and the camera don't care; their total unconcern bypasses our emotional blind spots and the deficient attention we bring to picture making.) Cartier-Bresson knows this and accepts it. This is not surprising, and is a major source of his strength: he trusts his vision and his medium. The surprising thing is that so few photographers have noticed this basic factor. In working with this awareness, Cartier-Bresson is a tough-minded realist.

Yet there's a wild side to his work. I think it comes from his trust in what he sees. Fiction writers learn that things can't be told in novels exactly as they are because the literal truth is too often hard to believe. To convince, fiction must be much more orderly than fact. If you look around, you'll see that many people don't really believe their own experience. Part of the function of writers and photographers is to confirm reality for those who don't trust themselves.

The wildness of Cartier-Bresson is that *he accepts what he sees, believes it, and records it unmistakably.* Confronted with sharp, unexpected realities, we get a sense of a wildly active fantasy—the opposite of the truth.

His special awareness of the wildness of everyday reality may be the essence of Cartier-Bresson's photography.

MICHAEL KORDA

Cartier-Bresson's reputation is so great that I am sometimes haunted by the terrible notion that he must be overrated. At such moments I take down *The Decisive Moment* or *The Europeans;* I look through them, and my doubts are instantly dispelled. He *is* a genius. Indeed so great is his genius that *every* photographer admires him. Professional photographers are by and large generous and friendly men, but like all creative people they tend to be critical of each other's work. Yet they agree unanimously about Cartier-Bresson's work.

Why is this? I think the answer lies primarily in the *purity* of Cartier-Bresson's art. Photography

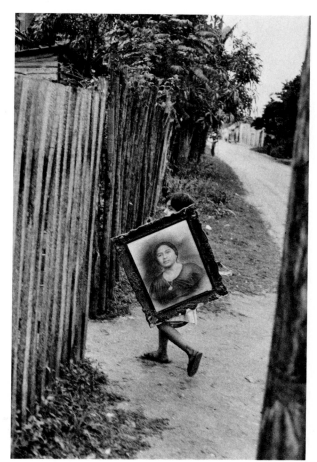

MEXICO, 1964

111

has become a complex and powerful business. It is an art, but an art that touches commerce at a thousand points—and at each point there is a question of compromise. However good a photographer is, he must sell his pictures, and to sell them he must please *somebody*—the client, art director, the sitter, the advertising agency. What is more, photographers are by the very nature of their profession inclined toward experimentation —they must learn to use large cameras, color films, electronic flash, Polaroid Land film—all the tools that industry and science compete with each other in making to place in their hands.

There is nothing wrong with this. But the danger is always there—the business side of photography and the constant lure of technical innovation tend to get in the way of the photographer's expressing himself, tend to emphasize formalism and originality at the expense of a consistent point of view.

The photographer in his studio, looking at his crowded appointment schedule, cannot but envy the man who makes art simply by walking in the streets of any city with a black-taped Leica M. The young man beginning his career in photography, without a studio, having nothing more than talent, ambition and a camera, sees in Cartier-Bresson the ideal of what he *could* be. He cannot emulate the complicated studio setups of the great fashion photographers, he cannot travel to Europe or China, he is unlikely to be sent to a war (at any rate with a camera in his hands). But he *can* walk through the streets to attempt the capture of life. For him, Cartier-Bresson is an idol, *The Decisive Moment* the Bible.

And if he *does* succeed, if magazines do buy his work, if he suddenly finds himself running a studio, flying to Egypt with an assistant, four Ford models, and a hairdresser, Cartier-Bresson will *remain* his idol—for almost every photographer of talent began his career as a disciple of Cartier-Bresson, and looks back upon those early days as on Eden.

For me, Cartier-Bresson's photographs came as a revelation. It was not just that I looked at them and said to myself, "That's what a photograph should be!" More than that, Cartier-Bresson gave me a feeling for humanity, for life, for the transcendent *uniqueness* of ordinary people. At the age of 18, fresh from the stultification of an English public school, beginning my two years of service in the RAF, I discovered Cartier-Bresson and began to look around me, to see things, above all

to see *people.* For Cartier-Bresson is a life-lover. I think that Capa was almost as great a photographer, but I cannot find in his work the immense love of life that shines forth in Cartier-Bresson's. Look at the first photograph in *The Decisive Moment,* for example. A young French groom is watching his bride, in her wedding dress, on a swing. They are both laughing. To describe it is to say nothing, for the strength of the picture lies in the emotion—the bride is not pretty, she is almost ugly; the groom is ordinary, dressed in a cheap rented tail coat. There is a hint that this moment will not last, that it is already almost gone. Yet the photograph is a hymn of joy, an idyll, impossibly moving. There is nothing dramatic about it, I don't even know that it's a "good" photograph in terms of composition (unlike the double-page spreads of the German workers or the Marseilles fisherwomen, in *The Europeans,* which are great pieces of composition, visually stunning, but far less moving). No, the photograph of the bride and groom is an "ordinary" photograph, a "snapshot," but it glows with human feeling. You cannot look at *The Decisive Moment* or *The Europeans* without feeling that Cartier-Bresson loves people, loves life, and has channeled that love, by some miracle of discipline and art, into photography.

DECISIVE EMOTION

"The decisive moment" has become a cliché phrase, used to pigeonhole Cartier-Bresson's elusive and unique quality. But the photographs are far more complex than the phrase suggests. It is not just that Cartier-Bresson catches his subjects at a given moment, one that is somehow exactly right. It is that he seeks and catches the *decisive emotion,* with surgical accuracy. Indeed, I would go so far as to say that his technique can be summarized by a formula:.

DECISIVE MOMENT + DECISIVE EMOTION = PICTURE.

If there is an element lacking in the formula it is the feeling of Cartier-Bresson himself. The primary element of the subject's emotion is subtly changed by the photographer's. For Cartier-Bresson has a point of view, and it comes out strongly in the body of his work. He is humanitarian liberal in the 19th-century sense. The poor, the proletariat, are contrasted to the rich, to those who have property (one senses this strongly in *The Europeans*). The workers, the Italian mothers standing by the fountain, the French peasant, the old, the young

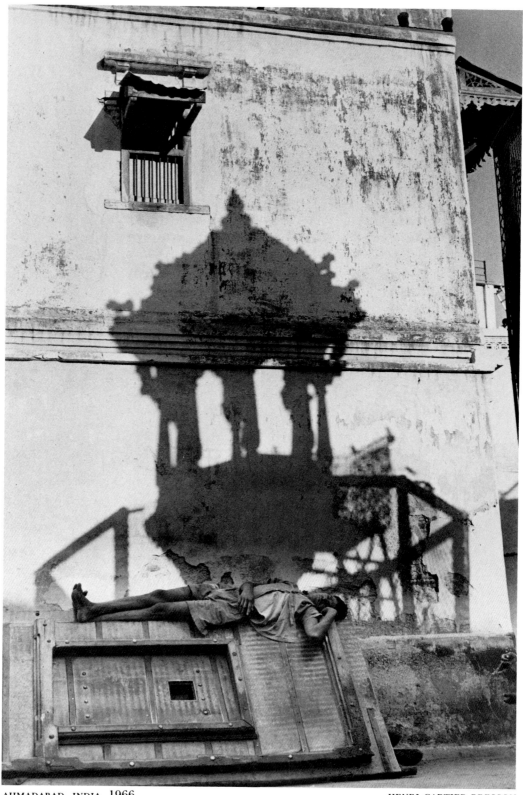

AHMADABAD, INDIA, 1966 HENRI CARTIER-BRESSON

113

—all are set in strong contrast against the Jaipur moneylender, obese and ingratiating, the cold elegance of the rich English couples strolling at Glyndebourne, the arrogance of the politicians on the steps of City Hall. Cartier-Bresson's sympathy illumines a photograph of a crippled German war veteran; his indignation turns his photographs of German industrial tycoons or an Austrian aristocrat into ferocious caricatures, worthy of George Grosz. Nowhere is this more evident than in his photograph of an English couple in mourning dress, on their way to Ascot, passing by a group of English soldiers struggling with their kit on a station platform. Cartier-Bresson is not an observer —he is *involved*.

HE TRANSCENDS NATIONALITY

Like Dickens, like Balzac, like Hugo, like Tolstoi, Cartier-Bresson's genius transcends nationality because it is based on a genuine feeling about people, about life. His eye is the servant of his heart. Thus his photographs of foreign countries never seem like an attempt to capture something strange and unfamiliar. Wherever he goes, he seeks and finds the same thing. European photographers coming to the United States tend to take back *curiosities*, grotesqueries. But Cartier-Bresson's photograph of the old cowboy in the graveyard at Taos, New Mexico, or of the old woman wrapped in the American flag are profoundly *American*, simple, natural photographs that are as American as anything of Walker Evans. The internationalism of Cartier-Bresson is truly remarkable. Look at his pictures of Germany in the early '50's, only a few years after the Germans had ravaged his own country and the rest of Europe— they are deeply moving, inspired by that same sense of sympathy, that same empathy with suffering.

I do not mean that Cartier-Bresson is without faults. The pictures collected here show his strengths, but they also show his weaknesses. I have never felt that he is a naturally gifted portraitist, for example. His photograph of Giacometti is superb, but Giacometti's face was such that it must have been impossible to take a bad photograph of him.

Yet look at the photograph of the two tired, dirty men sitting on the pavement, one of them cradling his head in his hands. Look at the proprietor of the village beauty shop, leaning against the window-pane, side by side with the bewigged dummy. These photographs have a power to move us, a force that is disturbing in its intensity.

What do they have in common? Like all Cartier-Bresson's best photographs, *they ask a question.* Where are the schoolboys going in their black-gowns, hurrying through the Gothic quadrangle? What is the beauty shop proprietor (if he is the proprietor) thinking about? Are the two men on the doorstoop derelicts? But no, one of them has highly polished shoes. Yet the one in the foreground looks defeated, dirty, ragged. What is happening?

These photographs ask a question, many questions; the riddle is part of their strength. Cartier-Bresson is always a good photographer: his picture of the mist-shrouded city island in this collection is worthy of Atget. There are other photographers who can do this sort of thing, as there are others, like Avedon or Halsman, who far surpass him as a portraitist. But the riddle picture, the picture of emotion, is his territory, and in it, he has no rival. Balzac once argued that behind every closed shutter a great drama was taking place, and that his ambition as a novelist was to deduce that drama and reconstruct it. He knew writing and understood life—so he would have understood Cartier-Bresson's genius. For Cartier-Bresson, like a great writer, is a kind of *voyeur*, infinitely curious, infinitely sympathetic, trying to draw— from a commonplace scene, a fleeting expression, an unstudied movement—the drama that is going on in every life.

His is not the mentality of a painter, who sees the world in terms of images and composition. It is the mind of a writer, obsessed with human behavior, human relationships, the fleeting, Proustian moments in which all of us unwittingly reveal ourselves, step out of our carefully constructed shells and show ourselves for what we are, what we want, what we hope to become. It is perhaps for this reason that intellectuals, who are for the most part somewhat indifferent to photography as an art are drawn to Cartier-Bresson. He is not trying to use the camera as a brush, the film as a canvas; he is trying to use the elements of photography as a form of writing, not as poetry, but as a novel. Precisely, thoroughly, he is charting the emotions of his fellow men, recording them, making us aware of them, showing us, like Proust, the infinite complexities of ourselves and our neighbors.

His is the eye of the soul.

Paul Strand:
An Eye for Truth

Jacob Deschin

This article is based largely on two long conversations I had with Paul Strand, five years apart: the first at his home in Orgeval, near Paris, in October, 1966; the second last November, at his temporary residence in New York City. Both are integrated here for the purpose of this piece.

Paul Strand's life as an artist in photography began with his first glimpse of Alfred Stieglitz's little gallery of the Photo Secession, called "291," in 1907. What that life has come to so far, at age 81, was made eloquent in a magnificently displayed 500-print retrospective that opened last November at the Philadelphia Museum of Art in the first leg of a two-year, six-museum tour of the country.

In 1916, Strand was to have his first one-man show at "291" and the honor of having his work fill the entire last issue (49–50) of *Camera Work,* Stieglitz's unique quarterly journal of photography.

As a high-school student of age 17 at the Ethical Culture School in New York in 1907, Strand got into photography through Lewis W. Hine, then an assistant teacher of biology at that school, who had an interest in photography. Hine was a semi-official photographer for the school, covering all its activities, often by flash powder ignited in an open pan, in addition to making those now historic portraits of the immigrants at Ellis Island.

Strand guesses that Hine must have asked the school for permission to start a little class in photography, as an extracurricular activity, and to build him a darkroom for the purpose. When the authorities agreed, Hine went ahead, had the darkroom built, and announced that he was form-ing a class. Strand joined, along with five or six other students.

Once or twice, Hine took his class to the Photo Secession to see the work of such masters as Edward Steichen, Clarence H. White, Frank Eugene, Gertrude Käsebier, David Octavius Hill, Julia Margaret Cameron, Heinrich Kuehn, Demachy, Puyo, and, of course, Stieglitz.

Strand recalls, "That was an extraordinary experience for me. If you could do things like that with a camera, I thought, that's what I wanted to do."

Two years later he graduated, got a job, and devoted weekends to photography. He showed the results to Stieglitz, Käsebier, White, and others for their criticism. Stieglitz was especially helpful, Strand says.

"For example, many photographers at the time were using soft-focus lenses, such as the Smith Semi-Achromatic, which was just a single, spectacle lens—and I was among them. A good deal of the work done then was very soft, like Clarence White's somewhat 'mushy' pictures, mushy according to present standards, however, but this was not the only property of the lens; it could be adjusted to make sharper images. It was soft when used wide open, at f/4.5 or f/5.6, but if you stopped it down to about f/22," Strand recalls, "then you got the quality that I have in *The Blind Woman* or *The White House.* I did this after Stieglitz pointed it out to me. When you had the lens wide open, he told me, you had a kind of unity because of the softness of the image, but you lost the individual character of all the materials in the things that you photographed. Water looked like grass,

and grass looked like the bark on the tree, and so on. Stieglitz was so clear and so convincing that I immediately realized that he was correct."

Strand became a part of the Photo Secession quite late—in 1915; the group was formed in 1904, "I was 25 years old," Strand reminisces, "and I walked in there with some things under my arm and saw Stieglitz. When he saw my photographs, he became unusually excited. He didn't comment, but said he wanted to show them, to hang them, and he would put them in *Camera Work,* and so on. He called to Steichen, who was in the back room somewhere: 'Come here, I want you to look at these,' and Steichen also was very responsive. A whole new world suddenly opened up for me. Stieglitz did show the things the following year, and it was a very great honor to have an exhibition at '291,' I can assure you. They were written about."

Stieglitz was almost embarrassingly cordial. The young man was a find, a real "discovery"; everything must be done to make him welcome. He was ecstatic. He said to Strand, "It's your place, come whenever you like, and you should meet the other people who come here."

"There were painters and photographers," Strand says of those days, "and it was all very informal, rather a place for people interested in the same sort of thing, which, of course, it was. And so I did come very frequently and I became

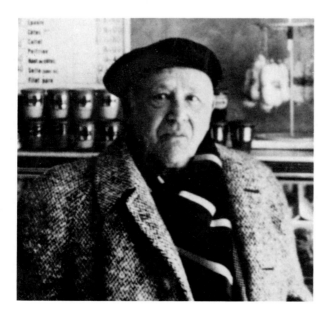

a part of that group. Of course, it didn't last very much longer after that; the war came and he had to move out of those small but beautifully handled rooms. My show was very beautifully hung."

Meanwhile, Steichen was sending over from Europe work by Picasso and Matisse, Braque and Cézanne, "and all of these things were looked upon as evidences of madness at the time." There were angry words, and Stieglitz stood there, defending these things: " He was a very great defender. We were all looking at these things and trying to understand what these fellows were up to." Was he influenced by these painters? "Certainly, because what they were doing was demonstrating the abstract method, which they proposed. They were really showing you how to make pictures, how to build a picture. So when I started to make abstract photographs in 1914–1915, it was with the purpose of trying to understand what this approach was, what it added up to, and I learned a great deal. The picture of the bowls in the show is one result of these experiments."

But abstraction was only a kind of visual training, a preparation for his real work in photography.

"I took what I had learned," he says, "and I began to use it in the real world. *The White Fence* and *Wall Street,* with the repetition of those great big windows and the movement of the people in front of them, were all conscious applications of what I learned from the painters."

In this matter of the abstract as it related to actuality, Strand would not give ground, even when it involved Stieglitz's convictions. Much as he had revered the latter, Strand was no idolator, as he clearly indicated when discussing Stieglitz's *Equivalents,* the famous sky patterns.

"There is no doubt about the beauty of these photographs of the sky," Strand wrote in the July, 1947, issue of *Popular Photography,* following the death of Stieglitz in July, 1946. "However, like all abstract art, the intensity is on a very personal level, their meaning is never quite specific. And the very remoteness of the sky itself seems to carry into the character of this series. One begins to want something as intimate, as tangible as the very simplest and humblest objects of earth, a pebble, a blade of grass, a house."

Nevertheless, abstraction is part of every picture he makes, Strand says, but as an element in the total photograph rather than for its own sake. "When I photographed the machines, if I had not made the bowls, say, or the shadows of the porch

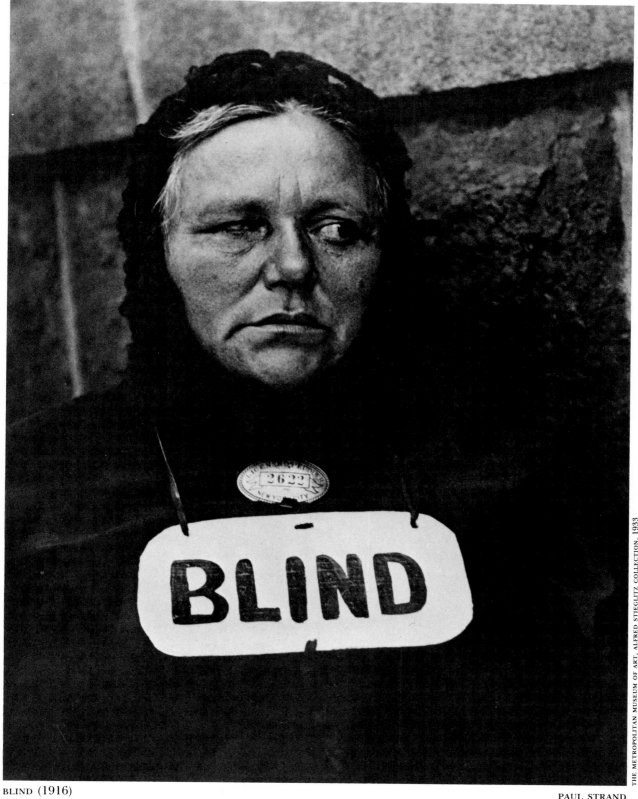

THE METROPOLITAN MUSEUM OF ART, ALFRED STIEGLITZ COLLECTION, 1933

BLIND (1916) PAUL STRAND

fence, I would not have known how to do the other things."

Pictorialism was fairly rampant in those early days, and Strand was part of it for a while, yet eventually he drew away from it, preferring subjects in his life experience, the streets, and the life around him. How did he manage to escape?

"Well," he says, "I lived in the city. And so I took the things that were closest to me. In my very early days I was a pictorialist, but since then I'm not. I am fundamentally a realist, and not a pictorialist."

Strand got into film making in 1921 "to make a living," getting his first job with a small company that made medical films. When it went out of business, he bought an Akeley movie camera and began free-lancing as an Akeley specialist, filming newsreels and production shots for large movie companies. He made such films as *Manahatta*, with Charles Sheeler; *The Plow That Broke the Plains*, with Ralph Steiner and Leo Hurwitz; and *Native Land*, with Leo Hurwitz and others.

After a decade of professional film making, Strand returned to still photography, an event marked by a one-man show at New York's Museum of Modern Art in 1945, and a book of New England photographs, *Time in New England*, with Nancy Newhall.

In the summer of 1949, Strand went to Czechoslovakia to accept a top prize at a Film Festival for *Native Land.* Shortly afterward, his father died, and he returned to the United States. He went back to Paris in 1950, this time with his wife Hazel Kingsbury Strand, who had been secretary and right hand of Louise Dahl-Wolfe, the famous fashion photographer. "Hazel Kingsbury is a very good photographer in her own right," Strand says.

With his wife as a helpful assistant, Strand began a succession of picture-and-text books about places and people that has resulted in a continuing series of beautifully photographed and produced volumes made to the highest standards of photography and quality of reproduction.

For the initial volume, "I had in mind an idea that one really could have carried out in many places," he says. "But evidently, I wasn't ready to tackle it, so I never did it in America, although in a way it was a very American idea," Strand explained in a letter he sent me from Paris May 17, 1955, describing his second European book, *Un Paese*, published in Turin, Italy, with Italian text by Cesare Zavattini, Italy's famous film writer.

"Perhaps by the time you get this," Strand wrote, "you will have received a copy of *Un Paese*, my new book on Italy. I hope you will like it as much as you did *La France de Profil.*

"It is a somewhat different kind of book, for whereas the French book covered almost all of France, this one is based upon a small village on the river Po.

BIRTH OF A PICTURE BOOK

"You may be interested to know some of the facts about it. For perhaps 20 years I have had the idea of doing a book on a village, a sort of *Spoon River Anthology*, but, of course, with living people. Zavattini, who as you no doubt know, is Italy's most famous writer of film stories (*Shoeshine, Bicycle Thief, Miracle in Milan, Umberto D,* etc.), was much interested in the idea. After discussions, we finally chose the small town of Luzzara, where he was born, where he knows everyone and everyone knows him.

"I had met him briefly in 1949 at a film conference but I didn't really get to know him until we met in Rome; and I proposed that we do this book together. His first reaction was, 'What do you need a text for? The photographs are enough.' 'I don't agree with you really,' I said. 'I think that text which is contrapuntal to the photographs but doesn't necessarily say the same thing but something related is much richer as a form. Besides, I personally find that picture books which consist of just one picture after another are rather boring to the eye; there should be another dimension.' "

Finally, he assented, and to Strand's question, "Where shall we start?" Zavattini said, "One could almost take a map of Italy, close one's eyes, put a pin in the map at random, and say, that's it.

"There is a village on the Po where I was born —Luzzara. I know the people; that's already something to our advantage. It's not a very remarkable place visually, but you go and see for yourself." He gave Strand introductions to friends there.

In the next several months, Strand photographed a "sizable amount of material," then came back for two more weeks in the fall. The experience had been "a real journey of discovery for us," Strand says, "as all my books are: to see what you can find. I have a special feeling about that, based on the years of my development as an artist in America, when so-called modern art stressed the idea of self-expression.

"What was important was what the artist felt,

what the artist saw, so he went through life looking for the things that were important to him visually, and there's a certain amount of validity to that, but it's not my basis of work."

He discussed this in the light of his experiences in Luzzara. "If I go to Luzzara, as we did, my feeling is not that I look for what interests me, not at all, but I must look for what is reality: I look for the elements which make up the life of that place, of that community."

All these are diverse aspects of the place and demand the photographer's attention if he is to make a proper report of what the town is all about, Strand feels.

"I say the esthetic problem of the artist about to do what I was trying to do in Luzzara is not a question of self-expression but one of how to paint or photograph those essential elements that make up the life of the place, together with the people: who they are, what they look like, what they do. There is the mayor, the man who runs the pharmacy, the man who works on the river as a dike builder, various others who participate in the town's day-to-day activity. My photographic job as I see it is to translate all this material, put it together into a unity which will result in a book."

On his approach to these people, Strand says, "We did not really have any problem, because

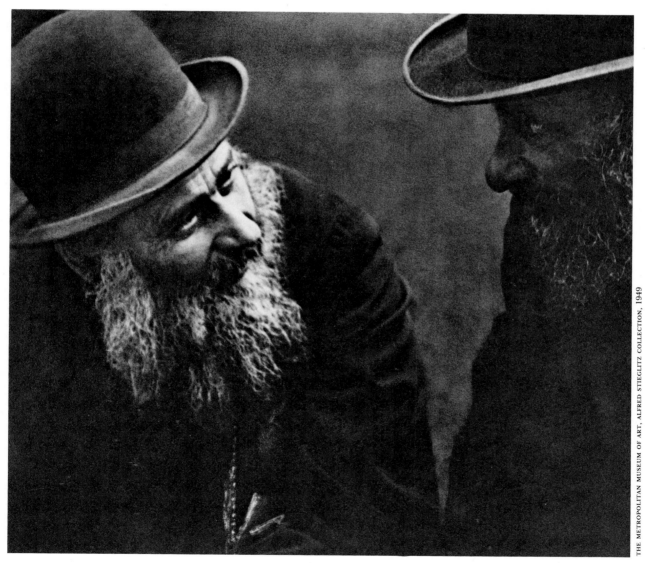

THE METROPOLITAN MUSEUM OF ART, ALFRED STIEGLITZ COLLECTION, 1933

Zavattini is very much loved and respected. He was there at the beginning, and the young interpreter had only to tell these people that I was making a book with Cesare about their town and wanted to make a picture of them, their backyard, or whatever it was."

The point he wanted to make clear about all this, he said, was that as an artist he has the obligation to report the matter for what it is rather than in terms of his personal bias.

"If I found, as I did, that the market is a very important part of the place, I say to myself that I must try to make a photograph of it. I don't say, 'Do I like markets?' No, I must accept the problem that is given to me not by art, but by life, by the life of the people. That is the primary starting point and that has become clearer in each book that I do . . . Life is so complex and so rich when you begin to tackle it this way that you have all sorts of possibilities. You don't do the same thing over and over again, which is one of the dangers that all artists face."

Strand is not a trigger-happy photographer,

and never was, even in his youth. He knows what he wants, so the first exposure does it, but he tries to make two or three negatives as "protection," so that if something happens to one of them, he still has the one or two others.

"I've done a lot of so-called candid photography in the later years with a small camera (the 3¼ ×4¼ Ensign Reflex) held in the hand, and it's invaluable, but I began with a small camera in 1915–1916, and it's just coming around full circle. I made *The Blind Woman* and *The White Fence,* and other street pictures with it."

A few years ago, he found a secondhand 2¼ × 3¼ version of the old Ensign and used it for "very fast, unpremeditated" pictures, in markets, etc. For candids, he has used a prism, for such shots as those he made in the Luzzara poorhouse ("The camera points this way and you photograph that way."), or a fraudulent lens, "a very clumsy technique."

Strand's approach to a subject is in terms of an over-all theme or project, always with a book in mind.

"I'm not the type of photographer who photographs a little here, a little there, whatever he happens to like at the moment; it is much more planned than that. New England, Gaspé, Mexico, France, Italy, the Hebrides—all this work falls very naturally into a chronological sequence of projects. Each of these things is a very definite area that must be investigated. I call it research."

Is actual photography research, too? "Yes, I call it the result of the looking. In other words, I try to find out all the elements that go to make up the life in a certain locale—sometimes it's an island, sometimes a town."

During this preliminary search, does Strand carry a camera with him or go "unarmed?"

GETTING TO KNOW A PLACE

"It's not necessarily preliminary; I very often go to a place and begin photographing almost immediately. This brings to mind some of photography's clichés that I find don't work any more; not for me, anyway. For instance, there is the one that you really can't photograph a place that you don't know; you have to live there a while first; you have to know the place; you have to meet the people, and so on.

"I find that it does not necessarily work that way at all. In fact, I began photographing in the Hebrides almost immediately after I got there, then

120

began to look around very carefully to learn something about the life of the people there . . . It's the way a journalist would act, except that the coverage in this case is not journalistic."

Our discussion turned to the exhibition, which is co-sponsored by the Philadelphia Museum of Art, the City Art Museum of St. Louis, the Boston Museum of Fine Arts, The Metropolitan Museum of Art, the Los Angeles County Museum of Art, and the M. H. DeYoung Memorial Museum in San Francisco, and the monograph, *Paul Strand, A Retrospective Monograph, The Years 1915–1968.* Michael Hoffman, publisher of Aperture, Inc. (which has issued the monograph), designed and hung the Philadelphia show with fabulously handsome results. He has worked closely with Strand since the republication of *The Mexican Portfolio* in 1967.

The monograph, a 380-page volume with more than 300 fine reproductions of photographs from the Strand exhibition, has been published as a one-volume edition at $20 for sale only through the six museums involved in the national project; in a two-volume edition with the same pictures but on slightly heavier paper (100-pound stock compared with 80-pound stock for the popular edition) and selling through regular book channels at $40 the set; and in a special autographed edition at a considerably higher price.

Did Hoffman select the prints that were to hang? "Pretty much, pretty much. The result that you saw in Philadelphia was very much his doing. The actual hanging was his. We came down there, my wife and I, and we were present while he laid it out on the floor, and in general we agreed completely with what he was doing . . .

"In preparation for the show I did an awful lot of printing in Orgeval. I reprinted negatives that I first printed years ago, and I printed negatives that I had never printed before and wanted to really examine again to see why they had been rejected the first time—for good reasons or bad."

Of the negatives that he reprinted, did he find a difference from the first prints? "There's always a difference." In what sense? "It isn't always easy to put it down in words. The difference is there visually; I think very clearly. It's a curious thing that as you change in life, there are differences as you grow older, in the way you feel about things, things that reflect themselves in print quality. You may find that the prints that you're making now are a little more brilliant than those you made 30 or 40 years ago, and that for some reason you want that and you work for it.

"I don't question it much. I simply go ahead and print for the best that I can get." Is there a tendency for more brilliance in his prints now than in the earlier years, when softness was more the vogue among photographers?

"I don't know, but my wife says the prints are a little more brilliant than they used to be. Perhaps they are. I now like a little more contrast than I did many years ago. I imagine you would find the situation also among painters; as they grow older, their color sense varies. I know that in the Matisse show I saw in Paris, I noticed he did a lot of things toward the end of his life in which he used a certain blue that was quite different from the blue he used when he was a young man.

"I don't think you can be very explicit about this. You can have theories, but I don't think they would carry very much weight. There is a tendency in photography to think of the medium in certain respects as mechanical, which once prompted Stieglitz to adopt this motto for his own work: 'No mechanization, but always photography.' It's quite a wise saying of his, because photographers tend to latch onto a way of doing something or a material they get to like very much

THE METROPOLITAN MUSEUM OF ART, ALFRED STIEGLITZ COLLECTION, 1949

and use it over and over again. I think it reduces the scope and interest of a man's work to do that. It is true not only of photography, but of any creative activity—painting, music, writing. They adopt a certain style and repeat and repeat. But in any case, it certainly is true of photography because the latter has certain limitations. For instance, most photography is in black-and-white, so there is not much variation of color. You don't have the variety that the painter has with the myriad of colors he had to work with. Furthermore, photographers tend to select fixed print sizes they like and keep using the size over and over again, and when you put these things on a wall there is a tremendous lack of variety. Even when you have such a very wonderful photographer as Atget, for instance. He used a camera in which the size was fixed, I imagine about 6½×8½ plate camera, and he did not enlarge his pictures. When you hang all these pictures on a wall, it can be very uninteresting; that is, it can work against the actual variety and sense of life in his photographs. The pictures don't help each other necessarily by being put up one after another in a long row.

"In putting on an Atget show, there is a problem: should one have enlargements made from the negatives? One would have to pick somebody to make a print in his spirit. I have an idea it would be possible, but difficult, because you must find somebody who can print in the spirit of Atget's images and not distort his original feeling and original intentions.

"But in my own work, that's my decision, and I have to decide what's the best thing for me to do. Years ago, when I used to go down to the Photo League on occasion to look at the work of the students and talk about it with them, almost invariably the young people would bring in 11×14 prints. I would ask, 'Why do you make them 11×14?' Well, they didn't know why; they just made them. I knew why: because the editors of *Life* and other magazines preferred to have that size to work with. But for anyone who was trying to develop himself in the medium, it was a very unwise and not very useful way to go as a direction.

"Because, I explained to them, something happens to an image when you blow it up. If you have big areas of dark, let's say of shadow, in which there is very little interest, not much interest in the dark at all, the bigger you make it the less interesting it becomes."

Doesn't that depend on the subject matter? "Partly, but not entirely."

How can one judge how far to enlarge a given negative? "The judgment is a problem. The only way to know at what point the photograph is at its maximum impact, from the point of view of size, is to start it very small and enlarge it and enlarge it until it obviously becomes much too big, and begins to lose . . . It's a test by eye; it's not a theoretical question at all. It's a question of what you see."

Would viewing distance from the print be a factor?

"No, I wouldn't think so, not much. I've seen some photographs that were enormous blow-ups, and no matter where you looked at them, whether closely or from across the room, they fell apart. The content of the photograph becomes less and less rewarding. So I told these young people at the Photo League, 'If you really want to know what to do about the size of the image, do it that way, that is, make the necessary experimentation of different sizes and see what happens. You're the ultimate judge.' I don't know whether they ever followed my advice. The fact is, I never did it either, because I wasn't really concerned very much with the question. I made prints as small as 4×5, and when I felt I needed something larger, I got a 5×7 camera, and I had an 8×10 camera, and I felt that that was enough of a gamut at that point, although in my early days I went to 11×14.

"So when my Philadelphia show came up, I felt right away, as did Michael Hoffman, that print size would be a problem. There we were—faced with the problem of showing a very sizable body of work, somewhat larger than one would generally find in photography. I felt also that it was only the scope that justified having so large an exhibition, but that with that scope it was very necessary to show everything. And so the question of size immediately came forward and had to be dealt with. So I did exactly what I told those youngsters to do years ago. I went into the darkroom and I began to work with the negatives to see what would happen. There was a limit to what I could do in my own darkroom, because it's not big enough. I can't make 30×40s and that kind of thing."

Would he never want to go that far? "Maybe I would some day: I'd like to see what would happen. I know that in most cases it is completely unnecessary, but I did go up as high as, say, around 12×15. Michael said the other day, 'You know, those blow-ups of yours, they're the biggest blow-ups I have ever seen.' That is, they have a feeling of bigness, a feeling of size, and they were

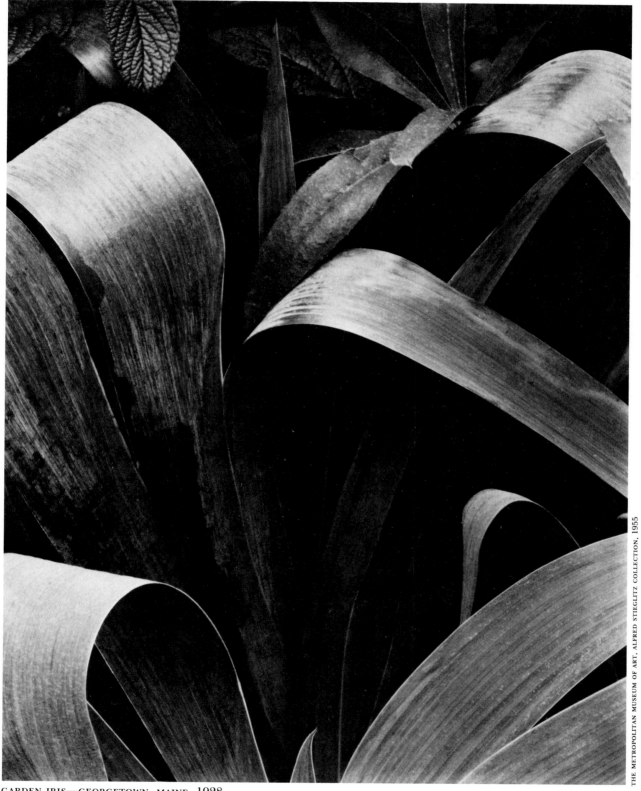

GARDEN IRIS—GEORGETOWN, MAINE, 1928 PAUL STRAND

just the right size to make these walls live, not to be monotonous, not to be mechanical, and that's why I made them."

How long did it take to print the whole show? "I worked on the prints a year to a year and a half."

Did he reprint everything? "Well, almost. I made 150 enlargements. And then there were contact prints or slightly enlarged prints. I must have printed 400 or 500 altogether. I've been enlarging negatives since 1915, and now use a 5×7 Durst. I wish it were an 8×10; I have 8×10 negatives I'd like to blow up. Even going from 8×10 to 10×12 makes a big difference. It's really fascinating to see what happens to the image in terms of visual interest or impact when enlarged. The portraits, *The Blind Woman,* and others were made on $3\frac{1}{4} \times 4\frac{1}{4}$ plates, and then I made a positive from the negative, put it in an enlarger, and enlarged the positive, threw it up on a slow 11×14 plate, and made an 11×14 negative, so I could make contact platinum prints of that size."

The tendency today is to pooh-pooh technique. They say the final print is most often a reproduction anyway, so why worry about technique? What does Strand think?

"Well, the word technique really doesn't cover it. Craft is the word, because it is more comprehensive. The thing I find extraordinary in photography is that so many today think that good craftsmanship is unimportant. There is no art in the world that I ever saw, beginning with the drawings of the cavemen, in which the feeling for the material wasn't present. The artist tries to re-create the material, heighten the beauty of the material, not as a thing in itself, not to make something unique in itself, but in order to increase the expressiveness of whatever it is he is trying to say. However, there are many people who have a sensitivity to material, and who are good decorators, but who don't have any particular content to express. They don't go very deep into the world; they make surface things."

Wouldn't that apply to most photographers? "Not only to photographers. Everything that's true about photography is also true about all the other arts, but there are difficulties in photography which the other arts do not always face. As I said before, the painter has many colors to work with and many different sizes of canvas. But photographers are pretty well restricted to very commercial materials aimed generally at the amateur and a few at the commercial professional. When

these materials no longer sell, they are taken off the market."

Strand was reluctant to discuss his printing techniques except, for the most part, in broad terms. "I can only make generalizations, I think. I can tell you what I like. Supposing you ask Oistrakh to tell you something about the technique that enables him to play the violin and produce a certain quality of tone; would he be able to answer that?"

Could he describe the physical things, the steps he takes, the corrections he makes, changes, technical decisions?

"Well, they are no different from what anybody else does. I have certain personal idiosyncracies, let's say in the choice of materials. First of all, I don't like glossy paper because I think it tends to make the image even more on the surface than it would ordinarily be. The other is that I like a semi-matte paper, in which there is the minimal amount of loss of brilliancy from wet to dry. But I found a paper I like in a sample book of Lumière papers not so long ago in Paris. The question was what happens to that paper when it dries? It may be beautiful when it's wet, but the test is the degree to which the dried paper loses brilliance. If I find there is not a great loss in brilliance, in print quality between wet and dry, then I want to get to work with that paper. I also like to work with a paper that has as many variations, or flexibility in contrast, as possible. I seldom get it."

In graded papers? "Yes. I've used Varigram and that type of paper, which is a good paper but I don't find the range you're able to get with filters long enough."

Isn't the tendency today to use glossy paper but not to ferrotype it?

"Well, I don't like it even unferrotyped. But then that is again an indication of the commercial market. I recently found Lumiere paper in France, and it was a lifesaver for me; it's a beautiful paper called Lumitra. No sooner did I find this paper, which was made in four grades (I think it was a bromide), than it left the market. The maker Lumière first joined Ilford, and then CIBA took over both Lumière and Ilford, and the inevitable happened—the paper I liked went out of existence.

"Then there was a West German paper called Leonar. Agfa bought it out and also took Perutz and a number of other old German manufacturers, and their products ultimately were taken off the market. And now all you have is Agfa-Gevaert and if you don't like it, that's just too bad."

What does he use now? "Several different papers—Lumière's Lumitra, Medalist, Ektalure. Years ago I used Varigram. I bought $100 worth of Leonar before it was removed from the market, and I put it on a shelf."

Without refrigeration? "Well, I don't have a big enough icebox to store paper. But there are prints in the exhibition on Leonar. If the paper begins to fog a little, I just use some antifog. Here is another thing I would mention from the viewpoint of technique. The last thing one ought to do in photography is to mechanize it. That is, to pick one of this and one of that and then use it over and over again. So I'm very glad to have three or four different papers and get the tone I want by a choice of paper plus the effects I can get with different papers through toning with gold (Nelson's formula). I tone all my prints with gold toner for warmth, and because today's archivists say gold toner makes the most permanent image."

Not selenium? "The archivists don't say selenium, they say gold. I use selenium, too, but it's not the same. The result is a different color. I sometimes put selenium on top of gold; I try all sorts of things. Sometimes you get a print with gold that's a little too light and you want it to be a little more full, so I build it up a little with selenium." How does Strand decide which paper to use for, say, a particular landscape? Does he try different papers for the same landscape just to see what would happen?

"Of course, the more, the merrier; you're not always doing the same thing and for certain things you find this paper or that superior."

Strand saw the six-museum sponsorship of his retrospective as "a big step forward for photography. It made the show possible; one museum could not have done it alone."

In this connection, he remarked that "changes are taking place in the world's attitude toward photography, and growing recognition of its value as an art form. It's been a very long struggle, and it isn't completely won, especially in Europe. We are ahead of Europe, although the Bibliothèque Nationale has just built a gallery, and Cartier-Bresson has had an exhibition in the Grand Palais. It's inevitable, you see, because the question of whether photography is an art is one of the stupidest ever raised.

"There is no such thing as an art. It all depends on whether there are artists who decide to use a certain material in order to express what they have to say about life. If the world had not recognized

that paint was of any great importance artistically, nobody would be paying any attention to the artist. When people like Van Gogh and others came along, they couldn't deny it any longer. It's becoming very obvious that photography is a set of materials which attracts the attention of the youth and the life of an artist. If no artist ever wanted to photograph, then you would say, all right, photography is not an art; but the minute an artist accepts it and turns it into an art object, then it becomes an art. Actually, David Octavius Hill did this in 1843, the first artist to work with the medium and prove that a great new thing had come into the world."

Strand touched on a variety of photographic concerns, such as color: "I did some color photographs for Eastman Kodak around 1949–50. They came out with Ektachrome, and I made some things for an advertising campaign and enjoyed it, but I have no permanent interest in color photography . . . From the point of view of certain kinds of information it is very valuable indeed. For instance, a man like Cousteau, who explores the ocean in a very special way, can show wonderfully what the color is like at the bottom of the sea . . . As an art form, however, I think color has very doubtful value."

Strand was very much concerned about archival quality, the matter of permanence that has come increasingly to the fore with acceleration in print collecting and the need for preserving photographs and other record materials, for future historical and informational needs. He was certain that if enough demand were created for such materials, manufacturers could produce them, possibly with governmental help since such institutions are involved as The Library of Congress and the Smithsonian.

Does he approve of the current practice in print-collecting circles of making an edition of a certain number of prints from a negative or negatives, then willfully damaging or destroying the negative to increase the value of the prints?

"I'm against that. The negative is also vulnerable. Besides, it's commercialism, really. Stieglitz wanted his negatives destroyed, but for an entirely different reason. His reason was that nobody could print his negatives except him, and I'm against that, too. I think that's antisocial. Maybe the prints cannot be made the same way, but they can be made, and that could be very important if later these prints are needed for books, for educational purposes, to show what's been done in

photography, for informational purposes, etc."

On histories of photography: "There is not a good history of photography yet. There should be."

What would he call a really good history of photography? "A good history of photography would require very fine reproductions of the key developments of photography, with a text that connected the photographs with the time in which they were made, their significance, and so on. We don't have any historians today. They give a certain amount of information, but they do not critically evaluate."

What's ahead for Strand? More books! One on Ghana has been in preparation for some time. Another on Morocco "that could make a good book if I went back there and did a little more work," is also on his mind.

But, he says, "I can't do some of the things I used to do. I need somebody to drive the car, to pick up equipment and heft it, especially the big cameras; they're too heavy for me to carry now."

EASTMAN KODAK COMPANY

My 50 Years in Photography

Ansel Adams

Fifty years seems quite a time. I'm actually looking for excuses now for what I have not done. Edward Weston once said to me, "You do what you have to to." I am sure many if not all of us have a certain feeling of inevitability. I do not believe in preordination, yet as I look back, event after event, situation after situation seems to fall into place, although at the specific times I held the same doubts, fears, disappointments, ego rufflings and exaltations that I'm quite sure come to all of us. But the world has been very good to me in the main.

My parents were tolerant, and supported, thank goodness, the old puritan work ethic. I had a sporadic education. Today, I'm sure I would be put in some institution for retarded children. When I evidenced interest and talent in music, my father encouraged study but on a no-nonsense term. My first teacher guided me safely to shore with quite infinite patience, and music made my photography possible. That's a very important point—that although the discipline came from another medium it still saved me because I easily could have become a real sloppy Joe.

I must remind you that in the 1920s photography education as we think of it today did not exist in the West. Camera clubs and salons reigned supreme. I learned my basic techniques from working for a photofinisher during some months in the summer and from talking to my good friend Bill Dassonville. I recall Imogen Cunningham, Dorothea Lange, Consuelo Kanaga. But my contacts were few and I cannot remember the years. A few commercial photographs, a few books and magazines, no important exhibits to my knowledge, and

no sources of formal instruction other than the physics department of the high school. I knew nothing of Stieglitz or Strand, I vaguely heard of Käsebier. I was mostly adrift with my own spirit, curiosity, and vision.

In a way I was a real loner. We lived among the sand dunes close to the sea, and would visit Puget Sound, Washington, and the Santa Cruz Mountains south of San Francisco—and hence the natural scene was literally with me from birth. In 1916, the family took me to Yosemite. This, of course, opened a tremendous new world and gave me a program of substance which dominates to the present day.

In 1923 I met Cedric Wright, the violinist and mountain man as well as a rabid photographer and life-long friend. Perhaps you know his Sierra Club book, *Song of the Earth*. It has quite a beautiful poetic concept. A wide circle of friends developed in San Francisco and Berkeley. We lived in a very modest world with an ideal relationship to music, art, and nature. Unrealistic as it sometimes seems today, it was a time of spirit and of love. We all got along in a happy mutual haze of homemade glory and response to the beautiful. But the real world was very far away.

And then, in 1926, I met Albert Bender at Cedric Wright's home. A most extraordinary man, an Irish youth from Dublin who had made his way in the insurance business, he had become a patron of all the arts and a human benefactor—never in large sums because he was not wealthy, but always in terms of generosity of spirit and effort. He liked my photographs. He said, "We must do a portfolio of your Sierra pictures." In less than a week

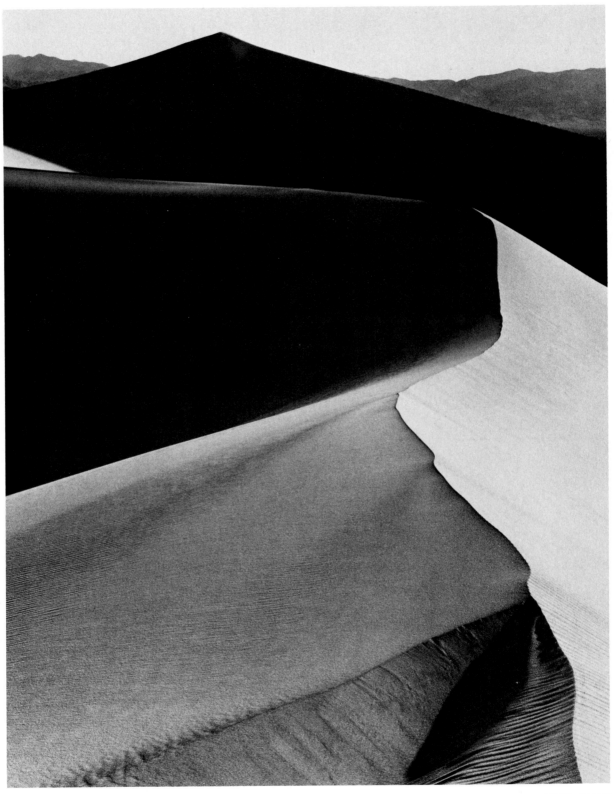

SAND DUNES, SUNRISE ANSEL ADAMS

he arranged a publisher, secured the Grabhorn Press for the typographic inclusions, bought 10 copies himself, and sold 30 more to his friends and associates—enough to finance the project and proceed with the job. Then, through Albert Bender, I touched a much larger world, met a few photographers, and many artists and literary people, and innocently gathered a number of devoted patrons who, with the exception of those who have had prior appointments with the angel of death, remain very dear friends to this day.

Somewhere around 1929 I met Edward Weston and his sons. Edward liked my piano. I did not like his photographs. I was still in the quasi-romantic aura of the times. In 1929 I was working in New Mexico on a book on Taos Pueblo with Mary Austin's text. It was a very elaborate production on specially made paper. Part of it was coated with a silver bromide emulsion by Dassonville for the prints, and the other part went to Grabhorn Press for the text. The book remains, I think, quite beautiful but it reflected the rather romantic and opulent time in which it appeared.

At Taos I met Georgia O'Keeffe, John Marin and Paul Strand at Mabel Luhan's home. Strand was the first truly great photographer I met and talked with. He kindly showed me some negatives. And a great and enduring light was turned on for me which persists until this day. For the first time I could recognize what straight photography was. It was not a matter of imitation, but of revelation. Awareness came upon me like a spring flood. I began to understand and deeply admire the work of Edward Weston. I met and worked with Willard Van Dyke, Imogen Cunningham, and later Dorothea Lange. As an informal association we founded Group f/64. I'm sure you know its history. I think we did its job well, and on the insistence of Edward Weston we gracefully terminated ourselves in less than two years, as we did not wish to create or perpetuate a cult. In this we were not entirely successful.

I went first to New York in 1933 and met Alfred Stieglitz and other people of the time. Standards were now being developed and established. Stieglitz had an impressive effect upon me. But I have never been able to pin down just what it was. Semantics fail and magic cannot be defined. I studiously avoided adhering to the cult which grew up around him, though many of my close friends were and still are close devotees. The man himself was a presence, defining the undefinable, revealing hidden dreams and mysterious perceptions.

He could be precise, contradictory, mind-bending, exasperating, and lovable. I owe Stieglitz a tremendous debt. Perhaps he did more than anyone to bolster confidence in my most personal perceptions and aspirations.

I returned to San Francisco and vigorously pursued the profession: everything from morgue photography to fancy advertisements. When you hang out your shingle, you must take what comes. It was the best possible training for any photographer, young or old, to accept and solve problems involving craft, interpretation and professional relations with the world at large. I admit, some of the assignments were far from inspiring. But I cannot recall one that did not serve to increase, to some degree, my knowledge and craft.

I'm not going to weary you with all the details of my career—or talking about 50 years with the camera. But there were certain highlights—meeting with Beaumont and Nancy Newhall and Dave McAlpin opened up new worlds and priceless, enduring friendships. As many of you may know, Dave McAlpin, Beaumont Newhall and I started the department of photography at New York's Museum of Modern Art. And these indeed were very vibrant and rewarding days. In back of everything stands a very devoted, understanding wife who raised two kids and kept everything together while I was on my many crusades and explorations in the field. I also met the Morgans, and as I look back at all these people, all these contacts, I really can say truthfully I don't know what life would have been without them. And hence at 70 I realize with gratitude what my life has brought me and I appreciate beyond words the affection and help of so many friends and colleagues, without whom most of my work might never have been accomplished.

I do not make as many negatives now as I should, because I feel a very strong obligation to catch up with the printing of hundreds of negatives which have never gone beyond the catalog stage. This delay in keeping up with printing is very serious. Even worse is my failure to properly date and otherwise document my work—to the total despair of the photo-historian and biographer. When I see an old negative almost everything connected with it flashes back into consciousness, everything but the year it was made! This supports my contention that the negative may be compared to a musical score, and the print to its performance. The original concept is immediately recalled but the intervening years have

nurtured a richer sense of meaning, and I think my prints of today are superior to those of earlier decades.

But in retrospect, a lot of teaching has been accomplished, many portfolios and books produced, and many exhibits prepared and executed. I may sometimes miss my music but I accepted in early 1930 that one cannot serve two bosses, two mistresses, or two muses.

I am basically incapable of verbalization of the content of my photographs, or anyone else's, for that matter. If a photograph does not say it, words or explanation cannot help. Definitive titles, technical comment and supporting texts such as Nancy Newhall created in *Time in New England* (with Paul Strand) and *This is the American Earth* for the Sierra Club, are of course, important. Yet, in terms of a single expressive photograph, no words may apply. I'm a total believer in the concept of the equivalent—a concept promoted by Stieglitz. I can paraphrase what he told me, not too inaccurately; he said, "I perceive the world around me as an experience of emotional and spiritual substance. I record this with my camera. I present the photograph as an equivalent of my response to this world which I wish to share with the spectator." But, I might add, only if it means anything to him. I hope it will mean something to him, but not necessarily just what it means to me.

If I need a credo I think this would be it: I believe the function of the artist in all media is a creation of affirmations; the search for and the realization of beauty. The function of art includes an establishment of communication, at the imaginative and constructive level. And placing the emphasis of thought and emotion in relation to an ideal world. The glorification of decay, filth, disease, despair, and evil succeeds only in blunting our necessary awareness of these negative qualities. As a human being the artist cannot be other than involved with the social scene. Not necessarily in the domain of his art. I believe the artist can accomplish most on the agenda for survival by creating beauty, by setting examples of beauty in order, by embracing the concept of the essential dignity of the human mind and spirit.

Not many centuries ago the artist related almost exclusively to the exalted domains of religion. He now has an equally exalted relationship and obligation to the survival of the world, the sublime environment of nature and of man. I think the youth of our time are fully capable of assuming this obligation. It is our inescapable responsibility to assist the young world to make a better abode than that which we have designed and structured. I think this all relates profoundly to photography. I believe, with Alfred Stieglitz, that art is the affirmation of life.

Arnold Newman: The Portrait as Record and Interpretation

Arthur Goldsmith

In the domain of photographic portraiture, few contemporaries have achieved as distinguished and enduring a reputation as Arnold Newman. He is most widely known for his portraits of painters, sculptors, and composers, whom he has been portraying with insight and superb skill since 1941. If anyone deserves the title of court photographer for the world of modern art, it is Newman. But as he himself is concerned to point out, he also has photographed a wide spectrum of notable human beings from industry and show business, from society and politics, from journalism and publishing. And although not our concern here, he also is a master of still-life photography.

Newman is one of those rare portrait photographers who has evolved a distinctive and powerful personal style. This, of course, includes his "environmental" portraits in which the subject is shown in relationship to significant artifacts and surroundings. But Newman's stylistic impact goes beyond these obvious, and frequently imitated, effects even to simple, ultratight head shots, as many of the pictures in the accompanying gravure section bear witness. Newman has been published in most of the world's major magazines, his photographs have been exhibited and acquired by many museums, and, no small feat, he has produced a number of definitive images of famous personalities, portraits so psychologically convincing and so visually arresting that they leave a permanent imprint on the brain of all who see them.

To say that 1973 is a critical or pivotal year for Newman may be an overstatement. But it has been a time for introspection and retrospection, for an evaluation of work done and thought about future directions. A major exhibition of his work opens in October at the Berkeley Art Museum, University of California, Berkeley. He is also in the process of negotiating for one or more books of his portraits, and reevaluating the structure and thrust of his own studio and business operations.

I interviewed him recently at his Manhattan, New York, studio, amid the accustomed ringing of phones, conversations with friends and clients, and interruptions while he checked proof prints for work in progress. The last time I talked to Newman in depth and length about his work was back in 1957 on the occasion of a *Popular Photography* assignment to photograph Alexander Calder in his Connecticut farmhouse. Bob Schwalberg did the photographic coverage of Newman at work, and I had a long tape-recorded interview with him, which Newman feels has held up well over the years as a statement. But for this issue we both wanted an update of that conversation and a re-exploration of his ideas about portrait photography in general and his own work in particular, as it has evolved over the past 30-odd years.

Newman was born March 3, 1918, in New York City, the second of three sons of a clothing manufacturer. When the family business folded after World War I, his father went into the hotel business. The first 20 years of his life were spent in the resort areas of Atlantic City and Miami Beach, and from these early experiences in the family's hotel business he attributes much of his interest in people, one of the important influences on his becoming a portrait photographer. "I'm fascinated by people," he told me. "They are the most exciting thing for me."

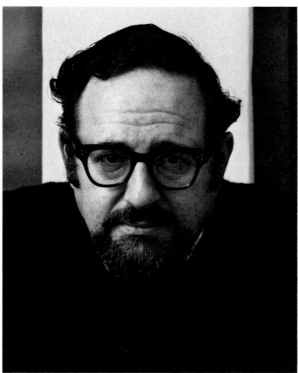

SELF-PORTRAIT ARNOLD NEWMAN

Nobody who knows Newman even casually can doubt the sincerity of that remark. He is a warm and gregarious individual, a man who quickly becomes involved with other human beings. If you get to know Newman at all well, he is going to talk to you, to ply you with beer and chicken soup, to needle you, to charm you, to clown, to complain, to argue, to tell stories, to make you laugh, to make you mad. It is a belly-to-belly, eyeball-to-eyeball style of direct emotional engagement: he responds to you and wants you to respond to him. This quality, adjusted to the ritualistic requirements of a photographic portrait sitting, certainly has helped Newman achieve the results he has obtained. "When it comes to being photographed, everybody is nervous," he said. "Part of being a portrait photographer, a very important part, is handling people. It is my job to put them at ease." Which he does, with a Rabelaisian superabundance of energy, a quick wit, and a sharp mind.

Newman got into photography as a Boy Scout, and met his then patrol leader, Ben Rose, now a well-known New York studio photographer. At about the same time, Newman showed an aptitude for art and began painting. He majored in art at the University of Miami, then a small school with an enrollment of approximately 750. (A fellow student was David Douglas Duncan.) As his interest and involvement with contemporary art increased, he left school because of the depression and moved to Philadelphia where he associated himself with a young, talented group of art students studying at the Philadelphia Museum School of Industrial Art under Alexey Brodovitch, art director of *Harper's Bazaar* and one of that generation's most influential teachers.

Newman took a job as an assistant in a portrait studio where, for $16 per week, he was trained to photograph up to 60 or 70 subjects on a normal working day. He began to photograph in his spare time, and gradually photography replaced painting as his favorite medium. Moving back to Florida to manage a portrait studio in West Palm Beach, Newman continued his personal work on the side. Now earning the relatively magnificent salary of $30 per week, he was able to buy a 4×5 press-type camera of his own and return the borrowed one he had been using until then. Meetings with, and encouragement by, Alfred Stieglitz in New York gave him further impetus to pursue photography as a career. In June, 1941, he was offered the opportunity to participate in a joint show along with his boyhood friend, Ben Rose, by Dr. Robert Leslie of *Art Director's Magazine.* It was this exhibit which launched his career as an important photographer. In the same year he began his experiments in portraiture using artists at first because they were visually interesting and the heroes of his student days.

This art background and involvement with the trends and issues of contemporary art have also exerted a profound influence on his evolution as a portrait photographer. He brings strong painterly and sculptural sensibilities to his work, which is not to imply that his photographs imitate other media. Quite the contrary: Newman has great respect for and mastery of the special qualities of photography. But his way of seeing and his uncommonly powerful and distinctive eye has been strongly conditioned by his art training.

There is an extraordinary feeling for space in many Newman photographs. Not just deep space, but sometimes very compressed, close-in space. Even a tight head shot as in the Picasso portrait has a sculptural quality, a "touch-me" sense of seeing and feeling things in the round. Or he likes

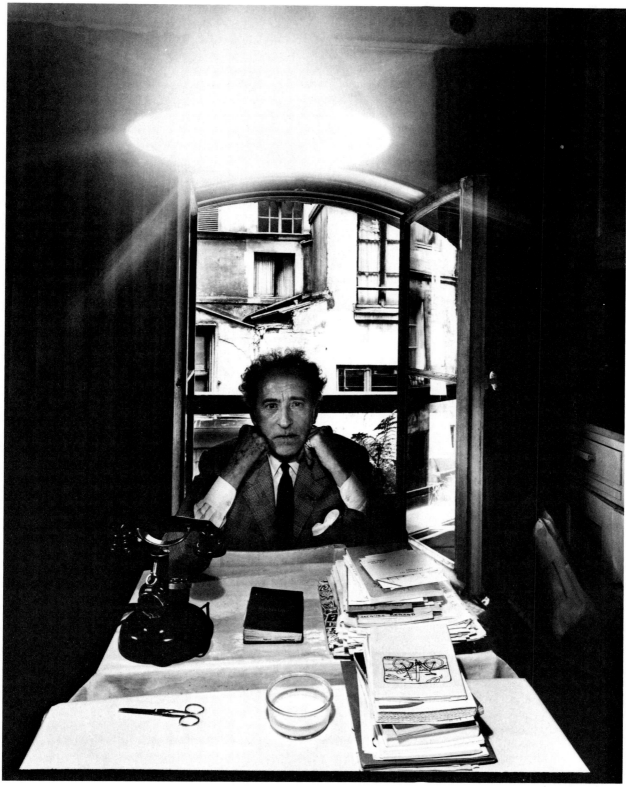

JEAN COCTEAU ARNOLD NEWMAN

to work in depth with the subject relatively small amid an environment which is both an extension and expression of the personality. (The Cocteau portrait is perhaps the best example among those published here.) Or he likes to see space flattened and work with the surprising juxtapositions of shapes and tones and lines which can occur, as with the Dubuffet profile against a patch of moss or the Alfred Stieglitz-Georgia O'Keeffe portrait.

He is keenly aware of graphic elements: shapes and tonality, the sharp edge of a black jacket against a white wall, splashes of light on a polished piano top, the way a Victorian chair twists, or the angle a piece of note paper makes on the wall. In his most successful photographs, he achieves an organization of visual elements which expresses and reinforces his interpretation of the personality portrayed: the fragility and elegance of Madame Koussevitsky, for example, as contrasted to the elemental serenity of Paul Strand. It is a controlled and studied rendition, even though achieved on location and often under great pressure. It is fascinating to watch Newman work under field conditions, to see him scan a cluttered and apparently banal environment and quickly seize upon those elements he feels will best work in the photograph.

That brings up the criticism sometimes raised about his portraits: that they are less records of the subject than they are expressions of Newman's artistry. (For his own rebuttal and thoughts, see below.)

Another essential aspect of Newman's portraiture is his technical skill. He is a meticulous craftsman and a demanding man to work for. A perfectionist, it shows in the results. He likes the sharpness with which a good camera lens can record reality, and if an unsharp Newman picture exists, I haven't seen it. Anything less than a very high standard of technical quality is quickly given the deep six. The prints are rich and full-toned without being melodramatic or cornball. We have been talking about black-and-white: it is a curious paradox that Newman, with his rich background in painting, has never been as successful in his color photography as in his black-and-white. He had done some good portrait work in color, but none, to this viewer at least, has the authority and visual impact, the surprise of things seen in an unexpected but meaningful way, that the most powerful of his black-and-whites do. The greater degree of abstraction provided by black-and-white seems to turn on his powers of creative vision to a higher and more intense degree.

I asked him how he felt his work had changed in direction, if at all, during the years since 1941.

"I don't think I've changed so much as I've progressed," he answered. "I think change for the sake of change is not creativity: it's a matter of activity for the sake of commercialism. In my own case I've become freer in some of my pictures but in others I have gone back to the tightly controlled approach I started off with. If anything, I've simplified, which I think is the natural thing. Most people do. The spontaneity and freshness of youth is one thing. It's important for any creative person whether the medium is writing, photography, painting or sculpture. But then, as you might explain it in baseball terms, you begin to pitch with your head as well as your arm, and that's what I'm doing now: thinking things out more carefully."

I asked Newman what he felt was the function of a photographic portrait today. "There are many," he said. "Somebody becomes the 21st vice president for an advertising agency and needs a one-column cut for *The New York Times*. Or their family would like a picture of them to put on the piano. Another purpose is as a historical record. Another is as an expression of the artist. I've done a great deal of all these things."

"Do you see the portrait as a kind of journalism?" I asked him.

"No," he said. "All my life I've struggled with the concept of what is a portrait, I've been asking it of myself and of students and of people who come to my lectures, and I've gradually come to the conclusion that about the only way you can describe it is as a picture that gives information about somebody. It is a record. But it also can be something more: an expression of the photographer's creativity. You might say a portrait can first be a record and secondly an interpretation, and they are interchangeable. No truly creative person, and this goes throughout history in terms of painters and sculptors as well as photographers, ever lets a straight recording get past him without imposing, unconsciously at least, his own ideas and thoughts. I've been criticized for producing what people have said is not a portrait of the subject so much as it is a portrait by Newman. I can't agree. I feel that you are empty if you can't give of yourself in interpreting. In taking on this responsibility, of course, you must be judged by your track record: are you dependably honest?"

"Even as both a record and an interpretation, how much can a single still photograph reveal about a person?" I asked.

"It can convey only a limited amount of information, of course. We do the perfect photograph of a man at 25, a perfect photograph of him at 35, at 55, at 75. Which is the most meaningful? They all yield information about the subject at various periods of his life, but all are incomplete. Even photographs made at the same time can vary. When I first had an opportunity to photograph Picasso at his villa in the south of France, I shot so much I ran out of film, although I had loaded up with a lot of film that day. There are about four or five portraits made on that same day which I like equally well as the one reproduced here. They're all different, they're all exciting to me, they all give information, but each has a different visual and graphic content and impact. I went back sometime later and photographed Picasso again in a different house. I took a lot more pictures but I don't feel these were as successful. It might have been what I had for breakfast or it might have been the atmosphere, which was quite tense on this occasion. The point is, I saw him differently each time.

"I think of still another example. Once, when John Garfield was in town, three magazines asked me to photograph him. I had already met him, and by this time we both were getting fairly close. He says, 'My God, Arnold, are you the only photographer in town?' I said, 'No, but they figured you would throw the rest of them out on their tails.' I photographed him on three different days, once for each of the three publications, and I saw him three different ways each time even within a short time span, sometimes as John Garfield the man and sometimes as John Garfield the actor. Which were the most valid interpretations? I don't know: it's a complex question."

We got off on technique and his feelings about it. Most of Newman's work is done, not in his studio, but on location: in the subject's own environment. I asked Newman if he preferred working with the light existing in the environment.

"What is natural light or existing light," he said. "I think of Gene Smith's remark when somebody asked him back in the old Photo League days, 'Do you only use available light?' He said, 'Sure: any light that's available—flash, flood, whatever.' I feel the same way. It so happens in an artist's studio that the light often is very beautiful because it's set up to be that way. It delineates clearly but has a softness so that a shadow is a shadow, not

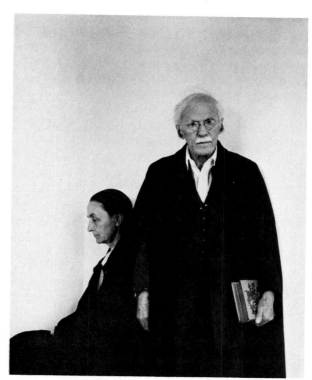

ALFRED STIEGLITZ AND GEORGIA O'KEEFFE

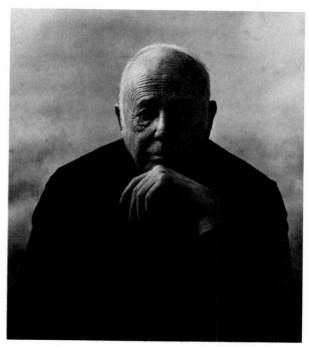

PAUL STRAND

135

just a strong black shape you have to deal with. Other times, other places it may be necessary to augment or alter the light which exists."

Newman started out as a user of big-format cameras; many of his best-known portraits were made with a 4×5 view camera on a tripod. However, in recent years he has been shifting more and more to 35-mm, and now nearly 80 percent of his work is done with the miniature format. He explained how this surprising evolution took place.

"It wasn't that I disliked 35 while I was doing most of my work in 4×5. However, I was thinking in terms of large negatives and the detail, the texture, the quality I could get from that format. I've often carried a 35, but only for personal records, family things, etc. It got pressed into service on one assignment when my 4×5 had been lost by the airlines. I did a very good 4×5 portrait with that 35-mm camera on a tripod. That set me thinking. The rangefinder type wasn't suitable for the

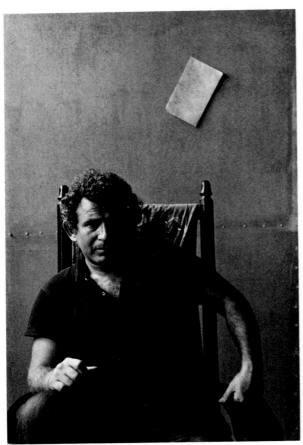

NORMAN MAILER

kind of work I do, but when the single-lens reflex was pretty well perfected, *voilà!*—here was my miniature view camera. A miniature view camera which enabled me to be much more free, more mobile, more adaptable than was possible with 4 ×5. The trap is that you tend to get lazy, and I've made some bad pictures as a result of this. I told myself, 'Well, it's 35-mm, so it should be hand-held' when in truth it should have been used on a tripod.

"Of course, I like the variety of lenses available. I've used wide-angles a good deal because I like to compose in space and depth. But lately I find myself going back to capturing the design of things as I see them on a flatter plane. Don't forget that I get bored.

"Another reason for shifting to 35 was economic. When some major picture magazines started getting into financial trouble, it turned out to be a lot less expensive way to travel and shoot if you used 35-mm rather than 4×5. So all these factors came together at once."

Another relatively little-known aspect of Newman's approach to portrait photography is his interest in experimenting with montage, the tearing of photographic prints and other nonstraight photographic techniques.

His interest in these goes back to very early days. "I was doing cut-outs and tearing in 1939–40," he said. "They were exhibited way back in 1948 at The Museum of Modern Art. This approach kept bugging me all these years. I kept asking myself when I was going back to it, and lately I have begun to work along these lines again. I must say, all the young kids have caught up with experimental ideas in the meantime, and I think it's marvelous what they're doing. Of course, like anything else, there's some bad stuff and some good stuff, but I think the best of what's being done is fabulous."

But isn't the tearing of a photograph something of a gimmick, I asked him. "What's a gimmick," he said. "A gimmick is something you use to get an effect but not to create something. If you work with a technique for awhile and the results look gimmicky, you haven't solved the problem on hand. As for cutting photographs up and assembling them as a collage or a montage, think back to the discoveries of cubism, where line and space imagery were broken up. Who says that God came down to Moses and said, 'Also, come to think about it, Moshe, when you have art, it must go evenly all the way to the edges.' He certainly never

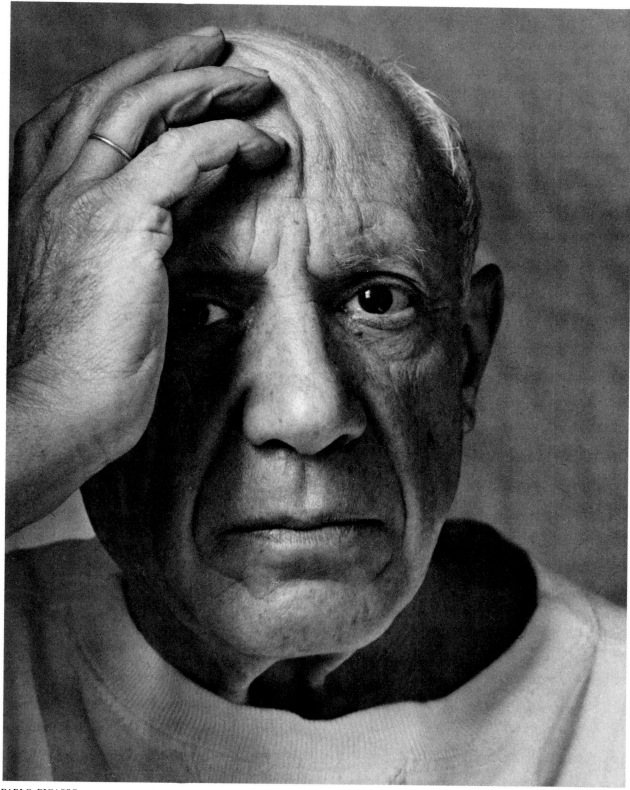

PABLO PICASSO

ARNOLD NEWMAN

said anything about divine shapes or golden proportions or whatever they're called nor did He say all pictures must be rectangles. I've gone back and taken a look at vignetting which used to be done in imitation of etchings. Vignetting, really, is a basic photographic tool. The only thing is, it was used wrongly, to imitate another medium. Young people now are beginning to use it again in a more valid way. You can get the effect with a lens for a 4×5 camera mounted on an 8×10, for example. What difference does it make if the vignetting goes to black or white, if the feeling is there? Why can't a picture go on forever, sort of blending away as the human eye sees? The eye has no specific rectangles within which it encloses things. It sees horizontally and vertically. It sees one big round field of view, and even when we are concentrating on one detail we are aware of an immense amount of surrounding images.

"If anything, even the straight, conventional photograph is a fantasy. Even the most realistic is an interpretation, an abstraction from reality. We've taken from three dimensions and compressed this into two dimensions. We've taken an unlimited image and made it into a sharply confined, specific image in space. We've taken endless time and compressed it into an exact moment. Where is the truth? So there are many exciting possibilities with photography beyond the traditional approaches. Rather than moving further from reality, we might be saying we are going back to reality.

"Now we're coming back to something we discussed earlier. We're not talking about a record picture; we're talking about an artist's interpretation of reality, whether the subject is a human being or whatever. It is the impact of the idea which counts. We have to stand behind what we say. Everybody else is to decide whether our interpretation is true and valid, whether it is worthwhile looking at and something to enjoy."

Where Newman will go in his work from here on is not predictable, he himself being uncertain. "If I knew where I was going, I'd be there," he said with characteristic good sense and honesty. Perhaps more into a realm of visual abstraction, or into multimedia techniques, which fascinate him. But one would expect that Newman will continue to strive to impose his own personal interpretation onto the visual riches of the universe which are chaos unless filtered through the human mind which gives them pattern and meaning.

Notes on the Pictures

Newman photographed *Jean Cocteau* in the latter's Paris apartment. A wide-angle lens emphasized a feeling of deep space while the lighting, from an overhead fixture and window, created a surreal effect that Newman felt appropriate for the subject. The face was dodged to hold detail. Taken with a 4×5 view camera.

The *Stieglitz-O'Keeffe* portrait was made at Stieglitz' famous American Place in New York. "In thinking of both of them and their work I found myself thinking in terms of starkness, linear contrasts, and very definite shapes," Newman says. He posed O'Keeffe with her husband, in dark clothing, standing in front and to one side so that the tones merge and unify the couple. A 4×5 view camera was used.

Norman Mailer posed for Newman at Mailer's Cape Cod workshop early in the morning. Photographed by natural light with a 35-mm single-lens reflex.

Paul Strand was photographed in Newman's New York studio by natural light.

Picasso was photographed at the artist's villa in the south of France; it was one of many portraits made during the shooting session. In this tight composition, only a small portion of the 4×5 negative was used. Natural light came from an open door. "I used my 6″ Anti-Picasso lens," says Newman. "The shutter broke during this shooting, and when I photographed Picasso years later, did it again."

André Kertész at 80 How He Works— What He Feels

Dorothy S. Gelatt

Kertész still loves Paris—the scene of his first photographic triumphs, and the scene of his latest book, *J'Aime Paris,* with 200 dazzling photographs taken in Paris during the happiest creative years of his life: from 1925, when he left his native Hungary, through 1936, when he came to America. It is a book for all photographers—an inspiration, and a timeless treasure.

"This book is my absolute *hommage* to Paris," Kertész said recently in his engaging Hungarian-French-fractured English. "Paris *accepted* me. Paris *made* me. After my first one-man show I felt at home. *This is the biggest thing an artist can have.* But you know what happened when I came to America? It was no more," he said sadly. In 1936, America was apparently not ready for Kertész, and vice versa. But the oncoming war left him somewhat boxed in, so he and his wife Elizabeth stayed.

Kertész' penetrating photographic "reportage" revelations of his world were recognized "early" in his Paris career, but "late" in his American. His swift eye, his deep human insight and his staggering but deceptively simple artistry did not sell when he came to New York. Apparently they made editors uneasy. *Life* magazine told him, "Your pictures *say* too much." And Kertész was too much an individualist to fit himself into the "assignment" role of American journalism. He wanted to photograph what *he* wanted, not what *they* wanted. Nor could he abide the extravagant American tradition of shooting 50 rolls of film so the editor and art directors could pick and choose a few prints to shape a story in their own image. The Kertész instinct has always been: if one picture is worth a thousand words, *take one picture!* He got a little

work here and there, but as he recalls it today, "Not one magazine gave me a real chance. It was not Paris."

In 1936 the Kertész reportage mystique simply did not survive the Atlantic crossing. So for the next 25 years, which he still tragically regrets, Kertész suppressed his creative instincts and supported himself and his wife in the dizzying, competitive world of American glamor, fashion, and interior illustration. Other photographers would have given their eye teeth for his contract at Condé Nast. But it was not his spiritual cup of tea. To this day he considers those years a total loss, an artist's living death—despite the publication of his exquisite small book, *Day of Paris,* in 1945. But the drudgery did not last forever. In 1964, New York's Museum of Modern Art gave him a one-man show, and recognition finally began catching up with him on his own terms.

Now, at 80, André Kertész is what every artist longs to be—a legend in his own time. Even in America. His creative photographs, from the very earliest, are collected, published, exhibited, and revered world-wide. And still he does not stop. His current work is even fresher and younger than springtime. Through wars and peace and professional upheavals, Kertész has never abandoned his inner compassion, his compulsive vision, or his flawless artistry with cameras. He continues to transform the ordinary into the extraordinary with pictures that catch in a glance what many of us overlook in a lifetime.

Since he left Condé Nast in 1962, Kertész has been photographing only what he wishes. And the world now knocks on his door. Museums and gal-

leries and individual collectors treat his work with the respect that used to be largely bestowed on painters. His New York representative, Light Gallery, exhibits and sells his pictures continually. Aspiring young photographers seek him out constantly for advice and guidance. And these days rarely a week goes by that Kertész does not turn up somewhere in the national press—perhaps in art, perhaps in photography, perhaps in the architecture columns of *The New York Times. Life* magazine, where he was a square peg from the start, made its meteoric streak across our culture and disappeared, but Kertész remains. And his influence, which began so long ago in Europe, and created a whole new language of human photographic expression, is, if anything, more persuasive now than it was then. How did the Kertész phenomenon happen?

In 1912, as a boy of 18 in Hungary, Kertész started taking pictures with a small glass-plate

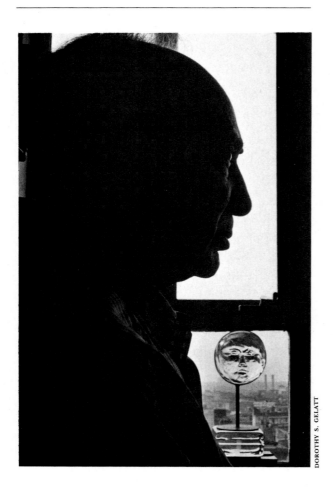

DOROTHY S. GELATT

camera. From the beginning he knew intuitively that, with his camera, he could catch human moments that had a life of their own. He did not know anything about photography or art in the rest of the world, so he largely taught himself. He did not know about the photographic "salon" movement and the photographs that were made to imitate paintings. He just knew what he liked—to show the people and places he knew in a realistic, yet characteristic way that somehow set them off from everything else. For a youngster, his instincts and insights were profound, and his composition strikingly simple and original. He simply *felt* what he was doing, from the first, and loved it. Without knowing it or planning it, in his early years Kertész was busy pioneering, innovating, and ultimately influencing what has become our whole modern era of 35-mm realistic, or "candid" or "reportage" photography. His earliest glass-plate-camera pictures anticipated the instantaneous freedom that other photographers discovered decades later with the first 35-mm still cameras.

"I worked from the start in the Leica spirit, long before the Leica existed," Kertész explained recently. "With my camera, no matter what size, I always looked for the moment that said everything. And when I had that feeling I would make the picture. In 1914 my older brother gave me a 9×12-cm Voigtländer for a present. It had, you know, the triple extension (bellows) and a Voigtländer Collinear 6.8 lens. I was excited with it. We very much loved nature, and we used to go hiking, and climbing you know. But it was so heavy, that camera, with six or 12 glass plates. So you did not take a lot of pictures. You only took what mattered. Always I preferred the smaller cameras, the 4.5×6-cm. So I could move around easier and express myself."

During his World War I service, Kertész photographed "what mattered" on his glass plates, mostly small. Those that were not destroyed have the haunting combination of poignancy, futility, and reality that only a camera in the hands of an artist can convey from war. He found it mostly in the faces and the small details of war. A picture of an overloaded wagon or a family broken by parting can, in Kertész' subdued black-and-white, arouse more emotion than a full-color TV spectacular of today's "automatic" wars, or a split-second TV landing on the moon.

After World War I, Kertész tried to find his place in Hungary, and to follow the life his family hoped for him. His father died when he was

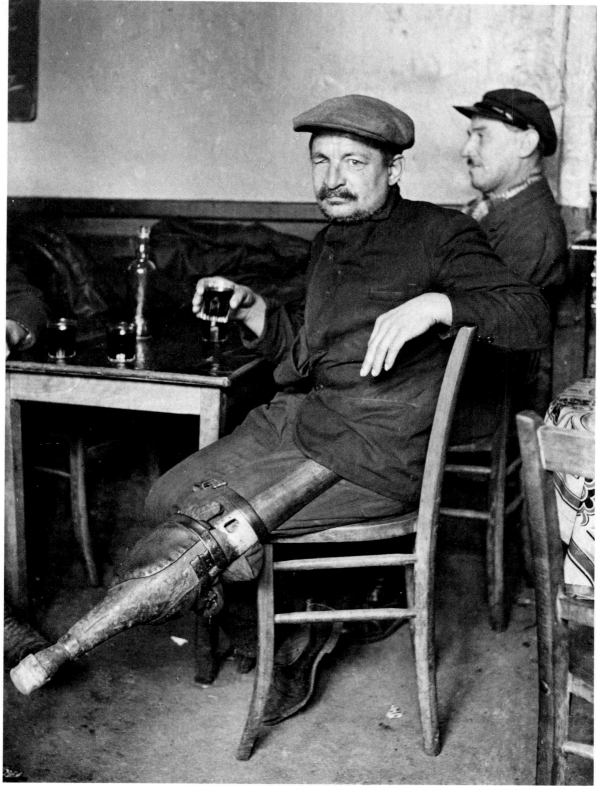

BISTRO, 1927 ANDRÉ KERTÉSZ

141

young, and his uncle tried to interest him in the stock exchange. But it did not take. His mother wanted him to stay on the land and at one time he had plans to be a "gourmet farmer."

"I understand bee-keeping," he explained proudly. "I grew up on the farm and I learned everything in the stable. But after the war, when the Communists came, everything seemed to die. My mother wanted me to stay, but finally she realized I could not. All I wanted was to take pictures, and finally my mother said to me, 'André, you must go. There is nothing for you here.' " It was time to begin.

So, at the unlikely age of 29, André Kertész, untutored and unknown, arrived in Paris in 1925 with a small 4.5×6-cm Goerz Tenax camera, the 9×12-cm Voigtländer, and not much else.

"I went to Paris because I *had* to go," he said. "I did not know why. I had a little money for holding out. I had imagination. And I had dreams."

Reminiscing recently, Kertész described his first sight of Paris. He arrived at night and went to bed in a small room on the top floor of a cheap *pension.* In the morning he opened his shutters and was breathless with emotion at the sight of the windows and shutters across the way. He seized his camera and made his first Paris picture of windows and shutters. Actually he was so carried away that he stretched the point and made *two* pictures of windows and shutters. They have remained among his classics, and he still loves them both.

Once in Paris, Kertész mixed quickly into the artistic community. "Everyone met in the cafes," he explained, "and we talked, and we worked, and we exchanged ideas. In the '20s in Paris we needed little to get along, and if someone needed help, we helped each other. I made enough to eat and live. And help others."

In those days, he took to the streets of Paris, and the studios of *avant-garde* artists, transplanting his home-grown spontaneous techniques, and enlarging his formal artistic vision. He knew Mondrian, Léger, Vlaminck, Chagall, Lurcat, Zadkin, and a host of other artists, writers, film producers and photographers. He photographed them, and he sometimes photographed their studios, producing a picture history of artistic Paris in the '20s and early '30s that has no counterpart.

"My reputation went around even before I was published," Kertész said. "Because all the artists knew each other, and they all talked about each other."

Before long he began to publish in the intellectual *avant-garde* magazine *Bifur,* and other magazines. In 1927 he had the one-man show that "made" him at the Sacré du Printemps gallery. And in 1928, when Lucien Vogel started the remarkable magazine *Vu,* Kertész had an immediate outlet which gave him complete freedom to work in his own way. Although he started late, he was the acknowledged leader of the whole *avant-garde* group of photographers in Paris. "I was on top," Kertész says proudly. It is no wonder he loves Paris so much!

How does Kertész work? He thought a while about what makes his kind of photography. "First you have to be honest with yourself. That lives in you, and it is realized. I have an interest for everything. The bad, and the not bad. I do what I *feel.* But I am not a prima donna. Chiselers I hate. And photographers who are stupid or dilettantes. When the young come to me I try to give them direction. But it is difficult. Not everyone wants to learn really."

Does he go looking for things with his camera? Or does he take what comes? Both. "I work slowly," he said. "But if something happens, you fix what is happening. I catch the moment I feel is the strongest. Then you don't *think.* You *feel.* And you *do.*

"But sometimes I have in my mind an imagination of something. Like the clock at the Académie Française. I asked myself: what is behind that clock? Always we are standing on the outside looking up at it. But what goes on inside? So I asked the *directeur* of *L'Académie,* could I come and photograph inside, and he was *agréable.* I made many pictures inside; the scholars, the rooms, the books. And then, under the *cupole* behind the great glass clock, what did I discover! A treasure. Hidden. A secret tradition of many years. There on the wall, each winner of the music *Prix de Rome* inscribed his name, his music, and the year. Massenet worked there, and made childish designs on the walls when he was bored. I photographed all the inscriptions on the walls. Higher up they were dirty; lower down cleaner. But *monsieur le directeur* was very angry. He did not like that someone had written on his walls, so he ordered them all painted over clean! *C'était tragique.* But I have the photographs. Look!

"And the clock. The face was glass then, and from the *cupole* I made two pictures. For document I showed the whole round clock face." He continued, "But what I really wanted was more depth

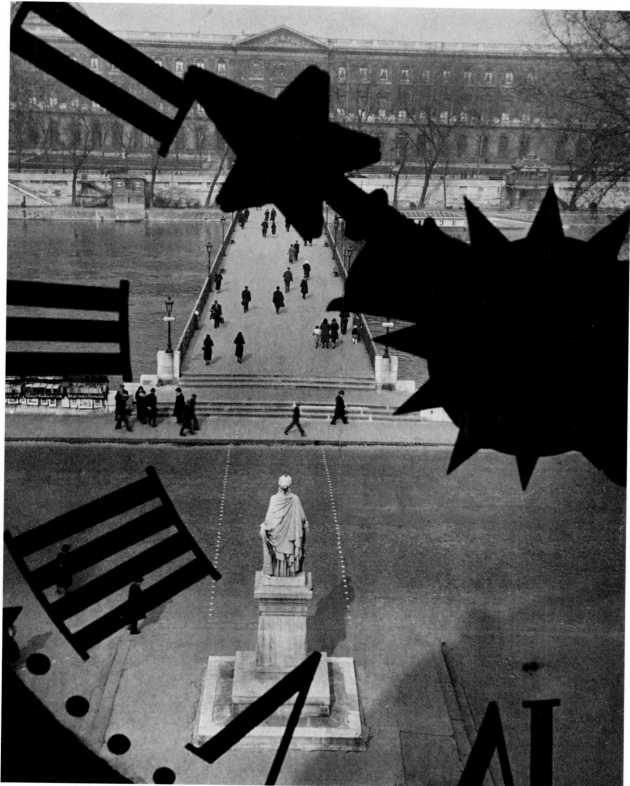

INSIDE THE CUPOLA, ACADÉMIE FRANÇAISE, 1932

ANDRÉ KERTÉSZ

and detail. So I used the wide-angle attachment for my Voigtländer, and I took the other picture so that there is only part of the clock. But see, there is detail in the clock very close—and in the people on the *Pont des Arts,* and the Louvre in the distance.

"But it was strange with those pictures. I could only make with them a small story in a Dutch magazine. Paris was not interested. But years later in New York my friend Rudy Hoffman showed them to the great Arturo Toscanini when he was conductor of the NBC Symphony. And Toscanini went wild for them, so NBC bought him the whole collection for a present."

Looking down from high places, the fresh point of view seems always to have absorbed Kertész. He pointed to a picture plunging down some steps to the bank of the Seine. A bicycle is cast aside momentarily. Shadows of people lean over to see who-knows-what in the river.

"When I started doing this kind of thing it became a rage," he said. "They were all doing it. But I was only doing it because I had an imagination of what it might be. It was what I felt."

Kertész pointed to a print whose viewpoint looks down on a little Paris neighborhood circus-carnival, taken as if from a balloon. How did he do it since there were no helicopters in those days? "Well," he laughed, "you will not believe. There was a building across from it. So I walked to the

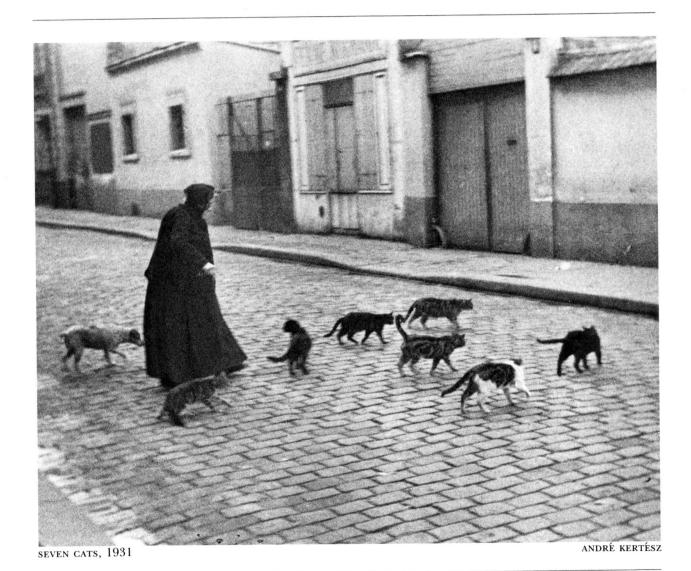

SEVEN CATS, 1931 ANDRÉ KERTÉSZ

top, and I knocked on a door, and I asked the people could I take a picture of the carnival? They said yes, and I took it from a stranger's apartment. That is all. And the picture, it is what I wanted. It is not what you see on the ground."

These days professors of art history write Kertész letters asking, "Did your surrealist pictures influence so-and-so? Did your distortions of nudes influence so-and-so else?" Kertész brushes it all aside. "I guess I influenced a lot of people without meaning to. I never tried to influence anybody. I just did what I felt like." He pointed to a surrealistic picture of a lot of heads stashed around a dinner party. "We were just having fun," he explained, "and I felt like taking the picture. That's Lisette Model's husband in front," he said matter-of-factly.

Equipment means a lot to Kertész, though he doesn't mention it unless you ask him first. He remembers his cameras fondly, almost like children, some of them wayward. A rueful smile escapes when he reminds himself that he fell asleep in the Luxembourg Garden, and somebody stole his 4.5×6-cm Goerz Tenax right out of his pocket. He remarks on the French camera he replaced it with—an imitation of the German Nettel press camera, with a focal-plane shutter that came down with such a bang the pictures were unsharp. He remembers how he loaned his precious triple-extension Voigtländer to a girl, and they both disappeared! Which forced him to buy a cheaply made 9×12-cm Ica, so flimsy that it cracked when it fell on the sand. "I used it anyway," he said, "but it was not very sharp." In 1931 the first-model Linhof came out and he bought that too, but he was never very happy with it. "It was too heavy, and it needed a tripod."

"But the Leica," Kertész says, lighting up, "the Leica was *made* for me. After 1928, with the Leica in my hand, I became crazy. I used it immediately, and even the test roll came out. From then on for me the Leica was the definitive camera. But the Leica did not *change* my work. It just made my life *easier,* not different. My style was from the beginning. Long before there was a Leica."

Over the years Kertész has probably tested or used everything new and improved in photography. Currently he has three Canon bodies, all kinds of lenses, and two Leicas in reserve. He has a Schneider Zoom lens (80→240-mm) that he adores. "I *love* zoom," he will tell you, holding the lens tenderly. "When this one first came out somebody asked me to test it. I liked it, and I bought it immediately. People say to me, 'André, it is so heavy for you.' But I do not care. Zoom was *made* for me. Like the Leica was *made* for me. Maybe a lighter zoom comes out. I will try it."

Kertész is in no mad rush to see his pictures, and he seemed surprised to be asked if he didn't dash the film off to the lab as soon as he took it. "Oh, no," he said in amazement. "Sometimes the film will stay in the camera for many weeks before I finish it. I'm in no hurry. I wait. I don't take a lot of pictures. Unless it is action. Then you would take more to catch expression. For instance," he explained patiently, "yesterday somebody asked me to photograph some jazz musicians. I took a whole roll, but just for *politesse.* I had the wrong lens, and there was not enough possibility to work without disturbing them. Perhaps another time."

Until about 1939, when he suffered an illness, Kertész did all of his own darkroom work and printing. But technique does not concern him overly. "I don't care for perfection," he says. "That is for technicians. I have a printer who knows what I want, and is very great. When there is something special, I tell him. That is all."

There was a quality to the old Ortho plates that appealed to Kertész. "Now," he says, "I use Tri-X. I like grain!"

What does Kertész have up his sleeve now that he is only 80? Well, next year a book about New York that he started working on in 1936, only no one would publish it. Next, to confound everyone who thinks of Kertész purely in black-and-white, a color show is in the plans.

"Yes," says Kertész, dumbfounding a visitor, *"of course I shoot color.* I used to do lots of it at Condé Nast. But so much of that stuff faded."

Do his talents ever end? Apparently not. Last year, in awarding him the Paris *Prix Nadar* for his magnificent 1972 book, *André Kertész—Sixty Years of Photography,* the jury said, "Kertész deserves the prize four times: as a humorist, as a photographer, as a painter, and as a poet." Add to that a superb human being, and you begin to catch the picture.

Weegee's New York

Harvey V. Fondiller

*The self-styled "World's Greatest Photographer"
portrayed the city's violence and compassion in
unforgettable images. Here are his career and
viewpoint, reconstructed from his own words*

As a nonstop talker, Weegee had few rivals.
Though he died in 1968, I can still hear his rasp-
ing voice. I'd listened to him for a quarter-century
—at photo fairs, camera clubs, private parties,
press receptions; in my apartment, my office at
Popular Photography and his cluttered darkroom/
home in the heart of Manhattan's theater district.

What follows is a composite of remarks by a
perpetually enthusiastic, usually disheveled man
with roving eyes. On occasion, he'd even unhinge
the cigar from his mouth while he was talking
. . .

*My name is Weegee. I'm the world's greatest photogra-
pher . . .*

*To me, pictures are like blintzes—ya gotta get 'em while
they're hot. F'r instance, one of my specialties was photo-
graphing the mob. When I was the official photographer
for Murder, Incorporated, there were $5 murders and $10
murders. Life once sent me a pay voucher for "Two Mur-
ders . . . $35." I guess their rate was $5 a bullet, because
there were seven slugs in the two corpses.*

*When I first came to New York, my family lived in two
rooms on the Lower East Side. The rent was $12 a month,
and the heat came up from a bakery on the ground floor.
Later we moved to a fancy place with three rooms, and we
didn't have to pay any rent because my mother was the
janitor. My father was a pushcart peddler, but he didn't
make out so good.*

*I used to play the violin in a movie theater, but I
had the brains to quit when the talkies came in. When
I was around 24, I got a job at Acme News Service. I
learned a lot there. That's where I was first called
Weegee. I used to dry glossy prints on ferrotype tins,
see, and after the darkroom guy made a batch of
prints, he'd yell* squeegee! *It sounded like* Weegee,
and the name stuck to me like glue.

*Back in those days, we'd do anything to beat the compe-
tition. There were a lot of dailies in New York then.
Sometimes we'd go to a fight or a baseball game in an
ambulance that had a darkroom fixed up in it. I almost
got deaf developing negatives while the ambulance siren
was screaming. I processed pictures for a lot of big events
I never saw; I'd go to the newsreels later to find out what
happened.*

*I was making $50 a week when I quit Acme . . . it was
1935 and I decided to free-lance. Ya gotta go on the streets
if ya wanna be a photographer. I put a police radio in my
car, and I'd get to the scene of the crime before the cops.
I told 'em I was psychic and that I used a Ouija board to
find out where the murder was gonna happen.*

In the trunk of my Chevy I had two 4×5 Speed Graph-

146

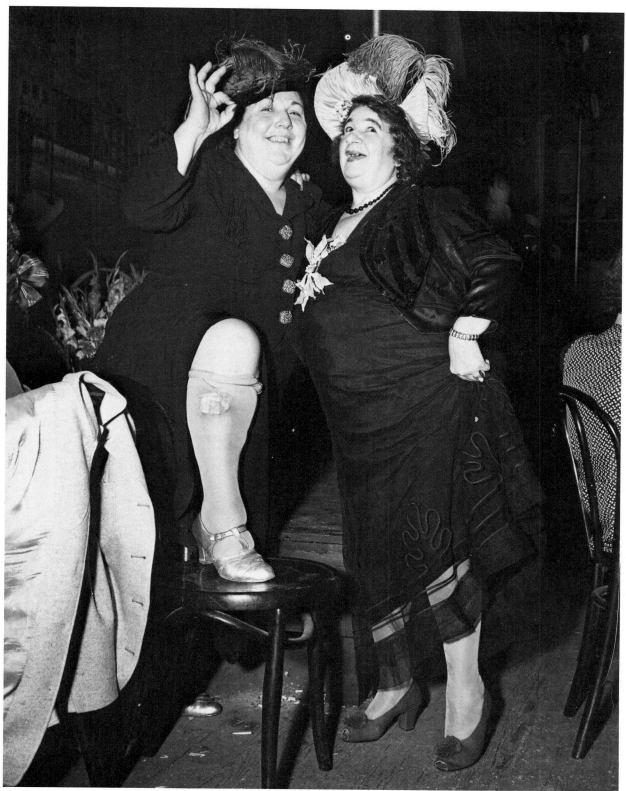

ENTERTAINERS AT SAMMY'S-ON-THE-BOWERY, 1944–45. (TITLED BY WEEGEE: "BOWERY SAVINGS BANK")

ics, a lotta film holders, a typewriter, and plenty of flash-bulbs. Around five in the morning was the best time for the action. That's when people kill themselves or somebody else. I photographed a lot of corpses, but you know what —I'm a very sensitive and artistic guy, and I hate the sight of blood. I sorta circle around the scene and take corpses from an angle that makes 'em look comfortable. By the way —the easiest kind of job to handle is a stiff on the ground. It's good for two hours.

An editor said to me, Weegee, ya got any new corpses? I told him, Wait till tomorrow . . . I'll be around with some more merchandise.

I worked for PM for a while. They printed my pictures with my credit line. After I left, I decided I'd never photograph anybody laying on the ground, waiting for a hearse, with blood all around them.

F'r instance, I'd photograph the body beautiful—alive, I mean. Unless a murder was somethin' special . . .

My reputation was spreading, see, and I was meeting a better class of people. Vogue magazine hired me to do a fashion spread. They wanted something different, and they knew I could give it to 'em. I went to a restaurant on Second Avenue with some gorgeous models. They reminded me of salamis, and that's how I photographed them. I don't know why Vogue didn't use my pictures—they were beautiful.

I've taken pictures all over the world. Ya know what I found out in Hollywood? It's the Land of Zombies and it's full of phonies, but I made out okay. I did a job in Paris, but I didn't like the place—it had only one kosher restaurant.

When I go to Coney Island, I don't take rear-end views of fat ladies. I take pictures of boys and girls holding hands. I like to take pictures of people having a good time. Right now I'm looking for a girl with a healthy body and a sick mind. Tell her to call me . . .

One day I heard that a photographer was giving classes in photographic lighting with a nude model. I went there and found a bunch of guys taking pictures, and maybe some of them even had film in their cameras. I thought

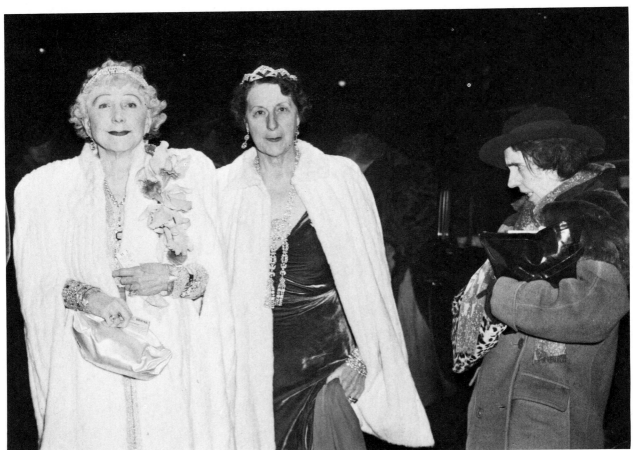

THE CRITIC, 1943 WEEGEE

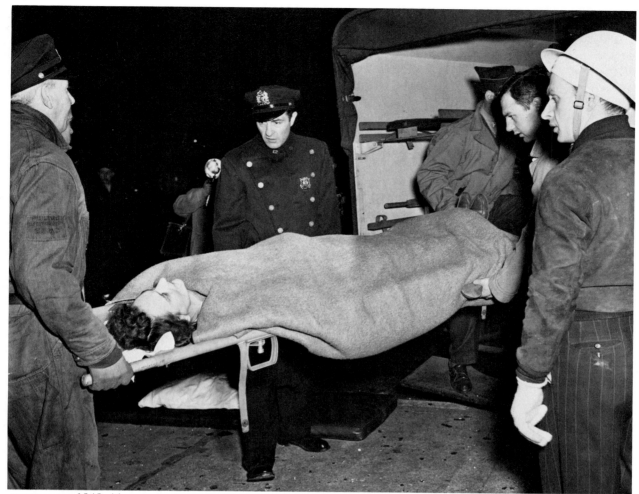

AMBULANCE, 1943–44

they'd be more interested in a lecture on how I make my documentary pictures, so I took over and told them how I operate. After a while even the model got interested.

Manufacturers give me a lot of free equipment. I go to them and say: "I'm going to do you a fantastic favor." Naturally they want to know what it is. I tell them I'm writing an article on how to take good pictures, and I'll put their product in the story. If it has the Weegee name on it, how can it miss?

I made a lot of artistic pictures using my secret techniques and my elastic lens. Ya know something? I'm 5,000 years ahead of my time. Ten years ago, Steichen was 20 years behind the times. The difference between us is that with my elastic lens I can make Mona Lisa yawn.

One time I sent some of my abstract pictures to Kodak to develop. They thought they'd ruined the film when they saw the results, and they sent me a new roll. After I made some other shots, even more abstract, they told me I should have my camera repaired.

When you see a news picture, you've just got time to take it. There's no time to worry about exposure meters, filters, and all that bunk. You catch as catch can. When I take a picture of a guy who's been murdered, there's no one to hold a flash extension for me, no one to move the cops and crowd around for me to get the best composition. You've got 30 seconds in which to work, and you shoot fast. If people laugh in the background of a murder shot, well— that's life. Many photographers live in a dream world of beautiful backgrounds. It wouldn't hurt them to get a taste of reality to wake them up. Anyone who looks for life can find it . . . and they don't need to photograph ashcans. The average camera fan reminds me of Pollyanna, with a lollypop in one hand and a camera in the other. You can't be a Nice Nelly and take news pictures.

So, keep your eyes open. If you see anything, take it. Remember—you're as good as your last picture. One day you're a hero, the next day you're a bum . . .

Hey—whatcha say ya name was? Gimme ya card so I can tear it up. But no kidding, it was a pleasure meeting ya. I gotta go now. I'm working on a big deal and I can't talk about it . . .

Photography is like sex: some do it for love . . . some for money . . . and some for the hell of it. Weegee did it for all these reasons, and more. Taking pictures was his vocation, avocation, and salvation.

Weegee was nobody until he became Weegee The Famous. Considering himself a self-made genius, he overlooked no opportunity to flatter his creator.

In his most productive period—1936–45, when he free-lanced as a news photographer—even the captions of his pictures communicated the humanity of their subjects:

"Ethel, Queen of the Bowery, smiles out of two blackened eyes as she sips beer with her boy friend."

"*Who said people are all alike?* They are all looking at the blood-spattered body of a small-time racketeer who was shot and killed. A woman relative cries, a little girl is bursting with curiosity, a blond-haired boy grins, an older girl looks away in horror."

"*Winterscape.* Snow covers the sidewalks of New York—and also the beard of this old man leading a hardworking horse to shelter."

Weegee's best-known picture shows a shabbily dressed woman watching two ermine-clad society dames entering the Metropolitan Opera: "*The Critic:* She is aghast at the quantity of diamonds in evidence at a war-time opening of the Met, but the bejeweled ladies are aware only of Weegee's clicking camera."

A turning point in Weegee's career came in 1941, when he had his first gallery show, "Murder Is My Business," at the Photo League. After The Museum of Modern Art bought four of his pictures, he began to receive serious critical attention. In 1945, Paul Strand wrote: "Weegee is a specialist in the drama of what most of us neither see nor want to see." The publication of *Naked City* and its sequel, *Weegee's People,* in 1946, confirmed his status as pictorial chronicler of Manhattan from dark until dawn.

Then Weegee went arty. The fast-talking press photographer got culture. If Picasso could be obsessed with sex and multiple bosoms, so too could Weegee. He abandoned his unique brand of primitive photography and expressed himself in abstractionism. His stills and movies added the techniques of distorted, kaleidoscopic, and multiple imagery to his voyeuristic vision.

Weegee became a public figure. He played small roles in motion pictures, led groups in nude-photography sessions. He lectured in camera stores, photo clubs, and private homes, and was available for any stunt anywhere. He did movie stills, travel brochures, and commercial assignments—all with his special brand of ballyhoo.

The penultimate stage of his transformation from hotshot news photographer to *artiste* was exemplified in a series of trick shots he made at the 1965 New York World's Fair. Among the pictures was a Weegee self-portrait: "Behind a black mask he borrowed from Zorro, he brandishes a toy pistol and a big cigar, ready to shoot or smoke out anybody who gives him a hard time. Before him is his trusty kaleidoscope-equipped camera." The caption of another picture in this series—a kaleidoscopic portrait—stated: "Through a number of daring, tricky techniques and offbeat equipment, Weegee has built his reputation as one of the most imaginative photographers in the world . . ."

The photographs for which Weegee will be remembered are those he made in the years when, if he didn't sell, he didn't eat. He shot many of them in the seconds or minutes before the police arrived on the scene. Those pictures are real, true, and strong; they were *life.* Or sometimes, death.

But photographs of murders and fires couldn't support him, so he sought the gentler side of life: couples necking in the park, kids on the streets, holiday bathers at Coney Island. Weegee understood the loneliness and the striving for love of people in the world's greatest—and cruelest—city. Look at his pictures and you'll feel it, too.

There will never be another Weegee. His life was a struggle against poverty, ridicule and deadlines. Nobody tries that hard any more. And no photographer's work better portrays the terror and the pity of Gotham's days and nights in bitter—and sometimes beautiful—moments of truth.

Techniques

Making Silhouettes Is Fun

Ida D. Cone

*A novel variation from the more common
methods of creating photographic images*

Photography is lots of fun, but it very often becomes an expensive hobby. Every enthusiast looks longingly at the latest equipment and strains his budget till it bursts.

Instead, why not spend a portion of your time in experimenting with an old, old form of photography which is very fashionable at present and which, if successful, offers returns great enough to save the strain on the family budget?

Go to the picture department of any large department store, or visit your local art store. You will find one section devoted exclusively to silhouettes. Not those stiff reproductions of George and Martha Washington which are inked on glass by a rapid factory process, but genuine photographic silhouettes.

A visit to the greeting card department will show the same demand for silhouettes. Then, too, aside from the monetary benefits, think of the delightfully clever and distinctive personal greeting cards that can be made from these silhouettes.

Photographic silhouettes can be made in so many ways and under so many conditions that they offer a vast field for experimentation. Once you become interested in this absorbing phase of photography, the extent of your imagination will be the only boundary to the many novel prints you can compose.

These silhouettes may be made indoors or outdoors, in day time or at night. As daylight conditions vary almost from minute to minute, it is far easier and simpler to make silhouettes with artificial light. These also offer many, if not the greatest possibilities for individual expression. The novice would be wise to confine his first attempts to this type of work.

To make night-time silhouettes two rooms are necessary. These must be connected by an open doorway, which becomes the frame of the picture. Stretch a white sheet or tablecloth smoothly and tightly between the doorway. Be sure that it is stretched tight enough so that there are no wrinkles in it. If there are any, they will show in the prints. After you have stretched the sheet, place the light in one room and the subject to be photographed in the other.

The success of the silhouettes depends for a great part on the correct posing of the person to be photographed. The individual should be placed about 2 feet from the sheet at a right angle to the camera. This angle must be so sharp that not even an individual hair or an eyelash can be seen in the finder.

Just as much care must be taken in placing the lamp as in posing the subject. The lamp in the other room should be about 5 feet from the sheet,

and so placed that it will strike the exact center of the subject. One lamp can be used for two figures. When this is done, the light should pass between them. However, in a multiple figure silhouette it is much better to have a light directly behind each major figure.

The accompanying illustrations give some idea of the variety of poses which may be used to create different effects and also suggest uses to which the silhouettes may be put. Accessories can be used to heighten the effect. The birds and the ship were cut out of paper and pinned to the sheet as were the heron and the cattails. A slender cane was used for the fishpole. Even a metal window curtain rod would have answered just as well. An iron attached to the line served as a weight to hold the line taut. The boy was sitting on a wooden frame made to hold the leaves of the dining-room extension table. Such a silhouette makes an excellent picture or mural for a child's room.

Aside from correct posing, proper lighting is the most important factor. One of the nicest things about silhouette photography is that it demands no expensive equipment. I use a Brownie camera and the regular verichrome film. Unshaded house lamps can be used for the light if a short time exposure is used, but a photoflash lamp is more certain as it cuts the time of exposure.

If, however, you do not want to go to the expense of buying photoflash bulbs, three 60-watt house bulbs can be used with an exposure of about 5 seconds. If your camera has a stop, set it at $f/16$ for this work. But any box camera or single-lens camera will give effective results.

If you are using several house lamps, there are two precautions which you must observe. In the first place, they must all be controlled by one light switch, so that the lighting is simultaneous. Second, the lamps should be placed on a line with the figure or figures to be silhouetted. Otherwise, in an exposure of this sort, a spot of light is likely to show on the sheet.

Also be careful that no light is reflected on the subject from white walls, mirrors, or the like. Just before making the exposure see that all other lights have been extinguished in both rooms. A piece of glistening white cardboard or a shiny pot or pot lid placed behind the lamps to act as a reflector will cut the time of the exposure materially.

If you like to do your own developing, there are two methods that should give you successful results and sharp contrasts. Films developed for 15 minutes in a tank containing 2 tank developer powders, the developer at 65 degrees F., will be satisfactorily sharp. Or if you use a tray, use a double strength developer and develop as long as necessary to blacken the background thoroughly.

This kind of picture is appropriate for use as a birthday card or as a party invitation.

Cutouts made from paper or light cardboard can be effective when pinned to a background sheet.

Posing the subject and props to show all details is an essential element in making silhouettes.

When it comes to printing the negatives, you must be careful in the selection of your paper. A paper softer than a No. 4 or No. 5 Velox is not suitable, except under special conditions where the background is extremely dark.

Almost any desired effect can be produced in silhouettes. Full length figures can be reduced to heads or busts by masking the bottom of the negative when you are printing it. The mask can either be laid between the paper and the negative or over the back of the negative. The use of masks will also enable you to vary the shape of your silhouettes.

When silhouettes are mentioned, we invariably think of the black figure on the white background. Just as a change, the white silhouette on the dark background is an interesting experiment. These are made by printing from a positive instead of a negative. To make a positive, use a contrast film, such as the Process Film, and place a negative in a printing frame with a sheet of this film. A short exposure is all that is needed. A 25-watt lamp placed 5 feet away should give desired results in about a quarter of a second.

On a very bright day, satisfactory silhouettes can be made by posing the subject against a window. There should be no other light in the room. All the light must come through the window before which the subject is posed. Consequently any other window should be heavily draped. The window you select should be one which admits plenty of light, one with no obstructions such as bushes, trees, or a neighboring building near it.

As one becomes more expert in silhouette making and consequently more ambitious, outdoor silhouettes tempt one into new fields. These silhouettes are comparatively easy to secure against the sky when the sun is obscured by a cloud. Water also makes a good background. To determine the correct exposure, considerable experimentation is necessary as the time varies according to the strength of the light. However, an exposure of 1/100 second with a stop of $f22$ is frequently satisfactory.

Human Interest in Your Pictures

Clifton C. Edom

The quality in photographs that makes people look—and look again—is easy to attain if you know what it is and where to find it

"Human interest—your photographs must carry a *human interest* wallop!" How often that admonition is doled out to disheartened amateurs and free-lance camera journalists. How often *human interest* is cited as the chief ingredient in the recipes of successful photographers. How often it is spotlighted as the *Open Sesame* to tight-fitting editorial doors.

The pity of it is, no one, it seems, has taken the time to analyze human interest, to give it a concrete form. As a result the amateur may define human interest as a mysterious something one feels in moments of ecstasy—something beyond description. Nothing could be farther from the truth. It is as real as Main Street, as tangible as a K-2 filter. The amateur who cares to do so, may strip it of all mysticism; may reduce it to its simplest terms, after which it becomes an obedient and ever-willing servant.

Human interest simply means that which attracts human beings. It follows, naturally, that what attracts one person may make no impression at all on the next—that a photograph which one person likes will not necessarily be liked by another. That fact adds variety and spice to the picture menu. It explains—if there is any explanation—many editorial idiosyncrasies. The editor,

whether his publication is sensational or a family journal, knows what his readers want, and gives it to them with all the trimmings.

Our problem, then, in making pictures that sell, is to give them eye-appeal, to make them attractive and challenging to human beings.

Fortunately, whether you are an amateur or a free-lance photographer you are not called upon to delve into psychology in your efforts to make human interest pictures. There is a precedent before you, and it is necessary only to make a common-sense application of your observations. For example, examine the reproductions in newspapers and magazines. Make mental note of those scenes which cause *ohs* and *ahs* to arise from feminine throats at the movies. Pay particular attention to the billboards in your neighborhood.

You will find, as many other amateur photographers have, that a picture of a beautiful girl, whether in a bathing suit or gingham gown, will probably lead all other subjects in human interest appeal. The next choice of advertisers—and let us remember they have spent millions of dollars to learn what type of illustrations attract and hold public attention—is children. The successful commercial photographer as well as the successful picture journalist, makes a play for sex instinct and

the maternal instinct in his work. He appeals to the emotions of fear, hate, and love, and whenever possible injects humor into his pictorial message. Humor, as far as the photographer is concerned, is one of the most neglected of all human interest approaches.

Remember *Working on the Levee*—that Associated Press picture taken by John Lindsay during the floods of 1937? Remember the chain-gang Negroes, burdened with sandbags—how they were outlined against the sky? Of course you do, and I venture to say that which is most vivid in your memory is the central figure, who despite his chafing shackles and his heavy load, is able to smile. That display of ivory-white teeth against an ebony background definitely adds human interest, humor, to a dramatic incident in life.

Strictly spot-news pictures, because of their news element, are, generally speaking, assured an audience. Because of this, they need little or no garnishment. This fact notwithstanding, New York City's Arthur Fellig (Weegee), who in playing such a grand game of free-lancing in the big city, increases human interest by posing people at the scene of a wreck or murder. If no one is available, he uses a long cable release, and assumes the role of model as well as that of photographer.

In pursuing human interest, the camera journalist, of course, should stay within the bounds of truthful reporting, although this simple rule is sometimes violated. You may recall the incident when a photographer was sent by a large syndicate to a county in Georgia where armed farmers were reportedly using force to prevent cotton pickers from migrating to greener pastures. Investigation proved that this photographer *posed* a farmer patrolling the county line, a shot gun on his shoulder, and that his prints "did not truthfully represent conditions." The syndicate was placed in an embarrassing predicament, and the cameraman lost his job. With this thought in mind, the amateur photographer in quest of human interest material should not allow his enthusiasm to distort the truth.

The surest and perhaps the easiest way for the embryo camera journalist to cash in on human interest, is to concentrate upon semi-news or feature pictures. This type of work offers a wide opportunity to appeal to human instincts and to play upon human emotions.

This end is accomplished in part by tossing into the discard those head-on studio-type pictures. The wide-awake photographic reporter uses action—posed or otherwise—to lift himself out of the hackneyed snapshooting rut. The present wave of candid photography after all is nothing more than an endorsement of a spontaneous, off-the-cuff picture snatching technique. Candid photography is merely photographing a subject in natural surroundings doing commonplace things. Human interest pictures are story-telling pictures. The story they tell, as well as the manner in which they tell it, are all important.

A fundamental knowledge of human interest and how to achieve it is as much a part of the amateur photographer's working kit today as his knowledge of composition and of lighting. It is even more important if one expects to receive acceptance checks with any degree of regularity.

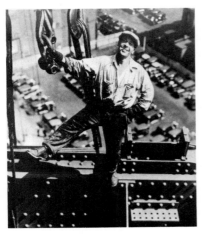

Victor Keppler's photograph for a Chesterfield ad was a photojournalistic breakthrough in 1932.

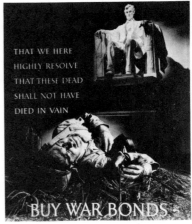

Human interest is paramount in this montage, which Keppler made for a World War II bond drive.

New Process Makes One-Minute Pictures

A camera that turns out a finished picture one minute after the shutter is snapped was demonstrated recently before the Optical Society of America by its inventor, Edwin H. Land, president and director of research of Polaroid Corporation. The new camera is said to accomplish in a single step all the processing operations of ordinary photography. A turn of a knob produces a positive print in permanent form. The camera contains no tanks; the picture comes out of the camera dry and requires no further processing. Snapshots can be seen and enjoyed at once; technical pictures put to immediate use.

Mr. Land disclosed that he had developed a number of photographic processes during the past several years in the Polaroid research laboratories in Cambridge, Massachusetts. He described them as "one-step" processes, to distinguish them from the multi-step processes of conventional photography. The published program of the Optical Society described Mr. Land's work as "a new kind of photography as revolutionary as the transition from wet plates to daylight-loading film."

A camera employing one of his processes is being designed for large-scale production. It will make pictures in a one-step operation carried out automatically when the film is advanced for the next exposure. Commenting on the commercial application of Mr. Land's invention, a Polaroid official said, "it will be several months before we announce when cameras will be available and what they will cost." Land cameras can be manufactured in the same variety of sizes and shapes as conventional cameras, not only for popular snap-shot use, but also for X-ray and other technical applications.

With the new cameras, it will be possible for the amateur to make a snapshot and compare it with the scene before he leaves the spot. He can ask his subject to "hold the pose" until he sees the result. If he is not satisfied with the exposure, the expression on his subject's face, or anything else about the picture, he can retake it immediately and correct the fault. The new cameras will make it possible for anyone to make pictures anywhere, without special equipment for developing and printing and without waiting for his films to be processed. They can be used for making quick snapshots of the family, quick X-ray pictures, quick pictures of horse race finishes, and quick pictures of anything else that can be photographed. Taking and making pictures can be done in broad daylight. No darkroom processing is required. Only a minute elapses between the time a picture is taken and viewed.

One type of camera that the scientist described contains a pair of small rollers, and a place for a roll of special paper in addition to the usual roll of film. Otherwise it is like an ordinary folding rollfilm camera. After a picture is snapped, the turn of a knob on the side of the camera advances the film and paper out of the camera, through the rollers. Film and paper are pressed together into a temporary sandwich by the pressure of the rollers. When they are peeled apart, a minute later, the paper has become the finished picture. In ordinary photography, to make a picture the film must be developed, rinsed, fixed, washed, and dried; then the resulting negative has to be

printed on the positive paper, which goes through a similar process of developing, rinsing, fixing, washing, and drying.

The new camera contains no tanks or other devices for carrying on the usual photographic operations. It forms the picture in a single swift step. When the sandwich passes through the rollers, the pressure breaks a tiny pod or sealed container attached to the special paper. The pod releases a few drops of a viscous chemical mixture which spreads in a moist layer between film and paper. The chemicals instantly start their work. They develop the negative and simultaneously form the positive print during the brief time the film and paper are in contact. One surface is slightly damp when the film is stripped off, but wetness is not apparent and the picture can be used. Each pod has exactly enough chemicals to produce one picture. The opaque outer surfaces of the film and paper prevent the negative from being fogged by light when it is pulled out of the camera.

The two most important materials in the tiny pod on the special paper are the standard photographic developer, hydroquinone, and the conventional fixing chemical, sodium thiosulfate or hypo. These chemicals together form the positive image from the silver in the unexposed areas of the negative, which is fixed out and discarded in ordinary photography.

In his address to the Optical Society, Mr. Land presented charts showing the characteristic curves and other photographic properties of pictures made by his new processes, summarizing measurements made on many thousands of test prints. The Land processes turn out uniform pictures over a wide range of temperatures. Land pictures can be black-and-white, like conventional snapshots, or various shades of sepia, or brown, like rotogravure printing. Mr. Land disclosed that the new processes are also inherently adaptable for making pictures in color and for making motion pictures.

In some of the Land processes, the negative can be used to print additional pictures by the conventional method. All the processes, however, permit additional prints of a scene to be made conveniently by photographing the original print as many times as desired or by re-photographing the scene. The film used with the Land processes can be any of the conventional types. Combinations of different films and different formulas for the chemicals carried by the special paper provide a

Edwin H. Land demonstrates his one-step process by peeling the print from the negative one minute after removing the "sandwich" from the camera.

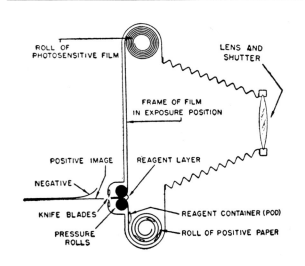

After exposure, a handle is turned to pull film and paper through pressure rolls. A developer pod is broken; contents make an even layer in "sandwich."

wide range of speeds, contrasts, and other photographic characteristics.

In explaining the new kind of photography, Mr. Land outlined four different classes of processes

158

that can be used to produce a positive print in a single operation. A description of one of his "soluble silver complex" processes can be summarized as follows:

When light enters through the lens of a camera and falls on the film, it delivers some of its energy to the silver-bromide crystals with which the film is coated. If a crystal receives enough energy, a few atoms of pure metallic silver form within it. With these atoms already formed, the whole crystal is primed to turn quickly and completely into black metallic silver when it is later treated by the developing solution.

All modern films depend on this formation of a "latent image" by the light that enters the camera. In it, bright objects in the scene are represented by film areas in which many crystals are primed or "exposed" and ready for quick conversion into pure silver. Dark objects are represented by areas in which most of the crystals are not exposed and will resist development.

In the usual photographic process, only the exposed crystals in the latent image are used. A developing agent, usually hydroquinone, turns them into the silver that forms the visible image. Then hypo (sodium thiosulfate), a good solvent for silver bromide, dissolves the unexposed and undeveloped crystals and washes them away. Because the exposed crystals form a negative image, darkest where the scene is lightest, the whole process has to be repeated to get a positive print.

The Land soluble silver complex process, employing standard photographic films, makes the positive print out of the silver that is ordinarily discarded. The few drops of viscous chemical released within the paper and film sandwich when the knob sets the rollers in operation, contain both the developer and the hypo.

Both chemicals go to work promptly, the hydroquinone turning the exposed crystals into silver on the film, the hypo taking into solution the silver of the unexposed crystals. The exposed crystals of the negative image are turned into silver, and kept within the film, out of circulation. The silver from the unexposed crystals, however, is free to move. The hypo takes it into solution within the thin layer or reagent between paper and film. There, the hydroquinone and other chemicals develop it and deposit it on the paper to form the positive image.

In effect, the developer performs the double service of holding silver of the exposed grains out of circulation in the negative, and forming the positive image from the silver carried into solution by the hypo. The hypo performs a shuttle service, carrying the silver in the unexposed crystals from the film to the paper, and returning for more when its load of silver complex has been taken from it by the other chemicals.

In addition to chemicals of the developer and the hypo, a number of other ingredients are used in the viscous mixture contained in the pod, or on the surface of the receiving paper, to control the size of the silver particle which determines the color of the print; to control the rates at which the various reactions occur; to prevent discoloration of the print; and to make the process work over a wide temperature range.

My Lighting Notebook

André de Diènes

I believe that any light any time and any place is suitable for taking photographs. Sometimes this theory is hard to put into practice, but you should learn to master as many different kinds of lighting situations as possible. Success in glamour photography lies in improving your sensitivity to beauty and being able to capture that beauty when you see it. If you have to wait until conditions are just right, or until you arrange a complicated lighting setup, then the perfect moment may be lost forever.

Take advantage of every kind of light, no matter what its quality or direction. Forget that old saw about shooting only when the sun is at 45 degrees, and experiment with light from directly above, the side, the back. Use your camera when the sky is hazy or overcast as well as when it's clear. Every condition evokes its own mood and creates distinctive effects that can make your pictures come alive. Of course you may need some supplementary illumination (provided by a reflector, flashbulb, or floodlamp) to increase shadow detail, but this fill-in light never should overpower your main source. Natural or natural-looking light usually comes from one direction, like the good North light of studio painters.

On these pages are included a few samples of my work under various lighting conditions both indoors and out. Study them carefully—I hope they will encourage you to use natural light with greater freedom.

Diènes says: "I photographed this girl against the light to create a halo in her hair."

"Let's consider outdoor lighting. When shooting at the beach, I prefer a bright, strong sun".

"Inside as well as out, I like simple, natural lighting, and sometimes use one 150-watt bulb."

"Sometimes I pose the girl in the shade of a tree and use a reflector for shadow detail".

"When I use backlighting in the studio, a lamp is placed high behind the subject, with a fill-in light in front."

"The model's pose is especially important when props are used. I make sure it's pleasing before shooting the picture."

162

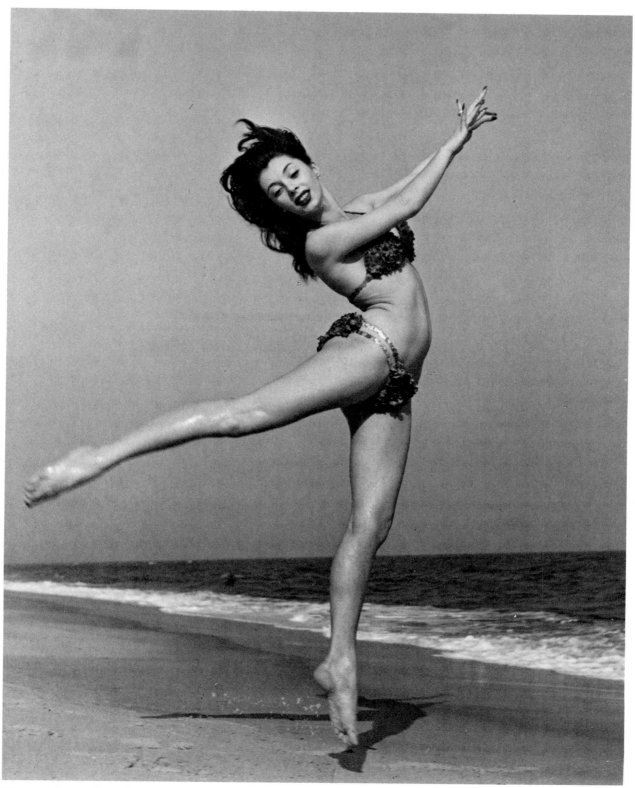

"I'm ready for any kind of action with a shutter speed of $\frac{1}{500}$ sec. The dancer's leap is dramatized by the low angle".

"At the beach, light reflected from the sand and water helps to provide detail in shadow areas".

"Mirror shots have always intrigued me because they reveal two aspects of the subject".

"This backlit picture, utilizing available light from the window, also shows the scene outside".

"Indoor shots are often effective when the available light is supplemented by room lighting."

Tools and Techniques

Norman C. Lipton

The 1954 Chicago Trade Show of the Master Photo Dealers & Finishers Association last March was one of the most lavish and exciting displays of photographic equipment that the industry has ever been invited to witness. Unlike past MPDFA shows, where a particular type of product or trend tended to stand out, this year's event was typified by booming activity throughout the entire field—in domestic as well as imported cameras; in color and in stereo; in sound movies, projectors and screens, darkroom accessories, and lighting gear. A dozen impressions of what we saw and heard there seem worthy of special mention:

1. The influx of attractively priced stereo equipment climaxed by E-K's introduction of their new scale-focusing Kodak Stereo Camera with 35-mm $f/3.5$ lenses—probable price about $85.

2. The speed with which the principle of G.E.'s M-2 Flashbulb with pinless miniature base has been taken up by the industry. All but one of G.E.'s competitors showed tiny 10-cent flash lamps of the same type at Chicago, while a number of equipment manufacturers introduced high-efficiency miniature reflectors for these lamps designed to G.E.'s specifications.

3. The warm response of professional dealers to the Simmon Brothers' first camera—the radically new Omega 120, a civilian version of a U.S. Navy combat camera.

4. The enthusiastic reception accorded the new M-3 Leica by Leica-franchised dealers, who were invited to inspect the camera at private meetings in the E. Leitz suite at the convention hotel.

5. The continuing flow of new, improved equipment from Japan as evidenced by (a) a broad expansion of the Canon 35-mm camera line to include new simplified camera models, new lenses, copying and photomicrographic equipment, and miscellaneous accessories which fill a catalog that is the closest thing yet to the comprehensive Leica catalog issued by E. Leitz, Inc., New York; (b) introduction by Kanematsu New York, Inc., of Minolta cameras in 35-mm, twin-lens reflex, and rollfilm format; (c) addition of a Koniflex twin-lens reflex camera to the Konica camera line; (d) introduction of the new crank-operated fully-automatic Aires Automat twin-lens reflex camera, with 75-mm $f/3.5$ Nikkor lens; (e) announcement by Nikon, Inc., of five new Nikkor lenses for 35-mm cameras, including a 25-mm, $f/4$ which affords an unprecedented wide-angle view—84 degrees of arc. Twenty-eight-mm lenses covering 76 degrees had previously been the shortest focal length available here in the 35-mm still-camera field.

6. The vigorous response of photographic manufacturers in Germany to the challenge of their Japanese and American competitors. Improved models of the Contax IIa, Contax IIIa, and Voigtlander Vitessa; the new Super Ikonta IIIB, the assortment of the new lenses by Rodenstock Schneider, Voigtlander, Zeiss Opton, and Tewe—all these typified this new competitive attitude. We couldn't help but notice Horst Franke, proprietor of Franke & Heidecke, spending many long hours at the Burleigh Brooks booth meeting Rollei camera dealers and finding out first-hand what had to be done to maintain his products' preeminence in the twin-lens reflex camera field.

7. The trend toward dry-battery powered portable speedlight units—to the point where wet-cell units are an all-but-forgotten minority.

8. The continuing boom in low- and medium-priced tape recorders and sound synchronization systems by which commentaries and musical backgrounds can be added to 8- and 16-mm movie showings as well as slide screenings.

9. The short- and long-range planning of the Revere Camera Company—the former represented by their new three-way automatic projector and tape recorder innovations; the latter, by the announced policy of their recently acquired Wollensak Optical Co. affiliate: to market a line of blue-ribbon stereo, movie camera, and projection equipment on which the highest quality standards will be maintained and on which fair-trade pricing will be rigidly enforced.

10. The vigorous competition in the low-cost flash-camera field between Kodak's Duaflex III Kodet model and Ansco's Raymond Loewy-designed Anscoflex and also between the Duaflex III *f*/8 Kodar model and the Argus Super 75—all brand-new cameras.

11. Availability at long last of zoom-type variable-focal length lenses for 8-mm movie cameras: Paillard Products introduced the SOM Berthiot Pan Cinor lens with a focusing range from 12½ to 36-mm (2½ feet, minimum focusing distance) in

"D" mount for all 8-mm cameras; while Zoomar, Inc., demonstrated a domestic product of their own design with precisely the same specifications.

12. Our personal conviction that the MPDFA Trade Show, representing the best photographic manufacturing achievement throughout the world, regardless of the country of origin, is the only World's Fair of Photography deserving of the name, even though the sponsoring Association modestly declines the title.

(July 1954)

Early in June, we witnessed with other representatives of the photographic press, a demonstration by Henry M. Lester of the technique he used to photograph the lightning-fast strike of a rattlesnake at 2,400 fps on 16-mm Kodachrome. The event took place in the upstairs Reptile House laboratory of New York's famous Zoological Park (the Bronx Zoo) with the co-operation of Dr. James A. Oliver, Curator of Reptiles, and other members of the Park's professional staff. In many ways, the equipment and techniques employed were reminiscent of Lester's famed high-speed ciné study in 1947 of the wing beat and vibrating balancer action of the common drone fly which led to the recent perfection of a revolutionary vibratory gyroscope by the Sperry Gyroscope Company. However, the rattlesnake motion-anal-

Zoom lens for 8-mm cine cameras, introduced by Paillard, focuses from 2½ " to infinity.

Kodak stereo camera is for photographers who want to make 3-D pictures, a century-old hobby.

ysis study involved a triggering problem related to the personality and psychological motivations of the subject. It took six months to (1) select a ferocious snake ("Herman," a Western Diamondback rattlesnake) who could be goaded into striking at a target in the picture area; (2) work out a goading technique that would produce a fairly predictable response; and (3) couple the snake's response to an electronic circuit that would trigger Lester's unique high-intensity light source. The Kodak High-Speed ciné camera has to be actuated manually 1 second before the strike, which adds still another complication to the problem of precise timing.

Before the actual demonstration, we witnessed a screening of a successful strike which had been photographed with much sweat and tears on April 7 of this year. Unfortunately, none of the three photographic attempts we saw led to a second clean strike that could be incorporated in the N.Y.

Zoological Society's teaching film on the "defenses of reptiles" which was the reason for the project. We did, however, get an insight into Herman's mercurial temperament, for between the second and third attempts, the rattler calmly slithered off his starting platform, descended to the floor and quickly began making his way toward the assemblage of writers and editors watching the proceedings. A couple of deft restraining strokes from Dr. Oliver's training hook brought Herman to heel, and the demonstration continued.

Incidentally, Lester's continuous Flash Lighting setup provides a very adequate 2,400 fps exposure on Type A Kodachrome at $f/4.5$. The light-triggering device is an extremely sensitive capacitance relay in the form of a screen wire on the work table which actuates the current when the snake's head protrudes two inches into the wire field on its way to the target.

(September 1955)

Rattlesnake strikes at moving target as two banks of No. 31 focal-plane flashbulbs rotate through Lesterlight reflectors, emitting intense illumination during entire 1½-sec, 2400 fps run of camera. (New York Zoological Society Photo)

Ask These 20 Key Questions

1 WHAT IS THE PHOTOGRAPHER'S PURPOSE?

Is it to reveal relationships between people or objects, to create a mood, to report an event, to evoke an emotion, to stimulate you to action, to portray character, to make a social, political, or psychological statement? What is he trying to do—and why?

2 IS THE PICTURE EFFECTIVE BECAUSE OF TREATMENT OR SUBJECT MATTER?

Sometimes a crude snapshot is valuable because the subject matter itself is newsworthy, unusual, or spectacular. On the other hand, a common-place subject can be transformed into a good picture through the photographer's imaginative seeing or original handling. And sometimes both subject and treatment play a role. To what extent does each contribute here?

3 CAN YOU TELL IF THE PICTURE IS SPONTANEOUS OR CONTRIVED?

Some photographs are purely spontaneous, catching life on the wing. Others are carefully planned, with every element arranged to give exactly the effect the photographer wanted. And many pictures are somewhere between— planned to some extent, but designed to look natural and spontaneous. Can you tell which approach was used, and why?

4 HOW IMPORTANT WAS THE ELEMENT OF LUCK IN GETTING THE PICTURE?

Luck plays a decisive but incalculable role in many kinds of photography—especially sports, action, candid, and photojournalistic. However, the good photographer helps make his own luck. He is experienced enough to know what may happen, skilled and alert enough to seize the lucky break when it occurs. Can you evaluate these elements here?

5 HOW EFFECTIVE IS THE COMPOSITION?

Why did the photographer choose the particular angle of view and shooting distance he did? Are the forms, lines, and areas of dark and light organized into a coherent relationship with one another which satisfies our desire for order and design? Does the composition help what the picture is saying? Or hinder it? Why?

6 WHAT IS THE SOURCE, DIRECTION, AND QUALITY OF THE LIGHTING?

What is the direction of the main source of light —front, side, or back? Is it direct and harsh in quality, with sharp shadows, or indirect and soft, with indistinct shadows? Can you tell what light source was used—flash, flood, speedlight, bright sunlight, open shade, or what? Was more than one light source used? If so, where are the secondary lights located, and why? How does

the lighting help or hinder the composition, mood, subject?

7 WAS EXPOSURE USED TO CONTROL THE CONTRAST AND TONALITY OF THE PICTURE, AND WHY?

Does the picture appear to have normal exposure? Was exposure based on the shadow areas, the highlights, or the middle tones, and why? Is deliberate overexposure used to simplify areas by blocking up highlight detail? Or is deliberate underexposure used to create a silhouette effect?

8 WAS DEPTH OF FIELD—EITHER GREAT OR SMALL—USED TO CREATE A SPECIAL EFFECT, AND WHY?

Does sharpness of image range from nearby objects to distant ones? Or is only one plane in sharp focus? If so, where did the photographer focus, and why? Are shallow depth of field and selective focus used to simplify the foreground or background? Are they used to emphasize or isolate the subject? Why did the photographer choose the particular lens aperture (and resulting depth of field) that he did?

9 WAS A FAST OR SLOW SHUTTER SPEED EMPLOYED TO CONTROL MOTION BLUR, AND WHY?

If the picture records motion, is the action stopped and the image sharp? Is some motion blur evident? Or is the action recorded as extreme blur by use of a slow shutter? Was the choice deliberate, and if so, why? How does the amount of motion blur (or lack of it) help the picture? Would the result have been more or less effective had a different shutter speed been used?

10 WAS A WIDE-ANGLE OR TELEPHOTO LENS USED, AND WHY?

Can you tell if the photographer used a normal, shorter-than-normal, or longer-than-normal lens? Why? Did he need a wide-angle lens to include a large scene at close hand? For greater depth of field? Or to "expand" space and magnify the apparent size of close-up objects? Did he use a telephoto lens to get a large

image of a distant or unapproachable subject? To eliminate distortion in a portrait? Or to "flatten" space for visual effect?

11 WAS A FILTER USED TO CONTROL TONALITY OR HUE, AND WHY?

Is there evidence that a corrective filter was used to darken the sky or alter abnormal tonal relationships? Was a contrast filter used to create dramatic, unnatural effects? In color pictures, was a filter used to correct or distort the hues?

12 WAS THE PHOTOGRAPHER'S SENSE OF TIMING PRECISE?

Split-second precision is needed to catch "the decisive moment." Did the photographer trip the shutter at exactly the right time? Was his timing slightly off? Would the picture be improved if the exposure had been made sooner? Later? If so, why?

13 WAS CONTRAST AND TONALITY CONTROLLED IN PRINTING, AND WHY?

Does the print meet the conventional requirements of good technical quality—sharp image, long tonal scale, rich blacks, clean whites, lack of grain, etc.? Or does it violate these standards? If the latter, why? Is it a deliberately dark, low-key print? A deliberately light, high key one? Has over-all contrast been increased or decreased in the printing? Why did the photographer print the picture as he did? Can you find evidence of local control—dodging or burning-in? Can you tell why this was done—to correct a fault or for a creative purpose? Would the picture be improved if printed lighter? Darker? With more contrast? With less?

14 IS THE PICTURE CROPPED IN THE MOST EFFECTIVE WAY?

Obviously, this analysis can only be partial unless you see the full-frame print. Would a different or more severe cropping improve the picture? Would it look better as a horizontal? A vertical? Why, or why not? Has the photographer chosen an unusual cropping, and if so, for what reason?

15 WERE ANY TRICKS OR GIMMICKS USED TO CREATE SPECIAL EFFECTS?

Can you find evidence of any trick techniques in picture-taking or processing? Diffusion lens, vaseline smeared on lens, panning the camera, infrared film and filter, reticulation or solarization of the negative, montage, multiple printing, bas-relief, etc.? Why was it used, and how effective is it?

16 WERE ANY TECHNICAL DIFFICULTIES OVERCOME IN MAKING THE PICTURE?

Was the picture taken under conditions of very poor light, requiring special processing for maximum film speed? Did it require exceptionally great depth of field or fast shutter? Did it involve danger or difficulty for the photographer? Can you tell how the problems were overcome?

17 HOW SIMILAR IS THE PICTURE TO OTHERS YOU'VE SEEN OF SIMILAR SUBJECTS?

Is it a cliche? Does it show signs of trite, superficial seeing and thinking? Does it remind you of the work of any other photographer? Is it related to any school of photography with which you are familiar—the "*f*/64" group, for example, or salon pictorialism, or available-light photojournalism, or the German *Subjektive Foto-grafie* group? Does it remind you of any great photographs made in the past?

18 HOW IS IT DIFFERENT?

Did the photographer contribute fresh, original seeing and thinking? Does he open your eyes, surprise, delight, or startle you with a new way of looking at some commonplace subject? Is he using any of the methods of photographic control covered above in a new and effective way? Is he injecting his own personality into the picture, stamping it with a unique style?

19 IN TERMS OF TOTAL INTEREST, IS THE PICTURE WORTH A SECOND LOOK? IF SO, WHY?

It is not so difficult to find the merely good picture, the competent photograph. But a truly great picture, an image worth remembering, is rare. One of the best clues to a picture's value is to live with it for a time. Does it continue to please and interest you? Do you keep seeing something new in it? Or does it quickly grow stale and uninteresting? Can you discover reasons why?

20 HOW WELL DID THE PHOTOGRAPHER ACCOMPLISH HIS PURPOSE?

The final and perhaps the most important questions of all. The ultimate answer, of course, will be indicated by the answers you get to questions 2 through 19.

Portrait Rapport

Fritz Henle

One of the tests of a competent photographer should be his ability to make a good portrait. Every working pro is called on at some time to take "head-shots"—even the industrial photographer who spends most of his time with machinery should be prepared to take portraits of company executives. And the amateur most of all ought to find continuing inspiration and challenge in photographing the human face.

In my book, *Photography for Everyone,* I titled a chapter, "Portraits that Look Like People." I was objecting to those that *don't* look like people: the stilted poses of many commercial studios; the unmerciful direct-flash "police-line-up" shot; and the hurried, thoughtless picture in which the subject simply looks uncomfortable and out of place.

FEATURES VS. SPIRIT

Much depends on the way you approach portraiture. In some languages there are two words which are both translated in English as "face." One means "the face as an arbitrary arrangement of eyes, nose, mouth, etc." The other means "the face as as a reflection of the personality or the spirit." When you grasp the difference between the two, you will be able to go beyond the passport-and-mugshot product and make portraits that "look like people."

From this you can guess that I think the most important element in portraiture is the relationship between you and your subject. If it isn't right, no amount of technical perfection can make you a good portraitist. This doesn't mean that the better you know a subject, the better your pictures of him will be. That would imply that your portraits of your mother or your wife would always be your best.

Sometimes it is possible to establish a rapport in a few moments that will be as effective *for photographic purposes* as lifelong acquaintance. You must instantly make it clear that you are not an adversary of your subject; that, on the contrary, you are his representative to the world through the portrait you are taking.

CONVEY WHAT YOU FEEL

If the subject is a woman, she should understand that you see her as beautiful (or intelligent, or warm), and that your pictures will show her that way. If it is a man, the quality may be virility, strength of character, alertness. I don't suggest that you say these things to the subject in so many words; the particular method of communication is a highly personal thing. Often an exchange of seemingly irrelevant conversation, or simply an admiring smile, can do much toward establishing rapport.

Paradoxically, it is possible to know someone *too well* to make a good portrait of him—that is, without taking special pains. If a wife or girl friend has a large nose or prominent jaw, we tend to minimize it in our appraisal of her, and neglect the techniques that would flatter her. (In general: don't point large features toward the camera; do bring the camera in closer on features that need emphasis.)

THE RELAXED CAMERA

I find that the twin-lens reflex is less intimidating to portrait subjects than the eye-level camera, especially when the sitter is shy. Perhaps it is because of the indirect communication at the moment of exposure. But there has been plenty of direct communication before that moment. This is again a very personal matter, but I think the twin-lens is a "relaxed" camera; it creates less tension between photographer and subject—except for the desirable kind of tension generated by any serious work.

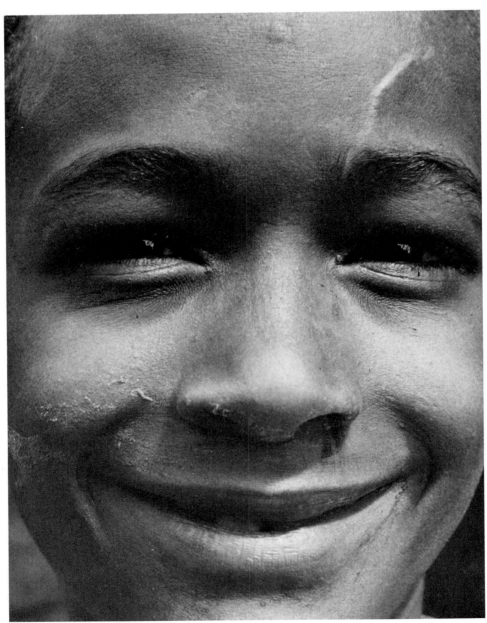

"Scarface" by Harvey V. Fondiller was photographed with a twin-lens reflex and close-up lens.

On Being a Photographer of People

Ken Heyman

Probably the most important influence on my photography is the fact that I like people. I'm not interested in photographing anything else. I don't take pictures of buildings, or flowers, or landscapes—only people. And in the past couple of years I've traveled to 45 countries around the world to photograph people.

I don't work according to any procedure consciously. I doubt if I think numbers when I set a camera's shutter speed or aperture. The following pointers will, if taken seriously, help you improve your photography of people, whether it involves taking a portrait of the boy next door or shooting candids of colorful South Sea natives on your vacation.

Be familiar with your equipment, but don't be preoccupied with it. Nothing is more disconcerting for the subject than a photographer who doesn't seem to know his equipment. Determining exposure should be fast, and focusing should be practically instantaneous. If you're taking a setup shot that requires the use of such accessory equipment as lights or a tripod, have them up and in position before you get the subject ready. Many a good photograph has been lost by the photographer's not being ready when the subject is.

Recently, while working on a *Saturday Evening Post* assignment on the set of 20th Century-Fox's *The Agony and the Ecstasy,* I watched a studio still photographer who was attempting to photograph Rex Harrison. After waiting under the hot studio lights for what must have seemed an interminable amount of time, while the photographer adjusted his 4×5 view camera and rushed back and forth with an exposure meter he kept shoving up to the

actor's face, Harrison finally declared, "When you've finished with your sums, tell me, and I'll come back." And he walked off.

Be self-confident; but don't be self-conscious. You need never be apologetic. Approach the subject with an air of confidence. And forget about the way you look to others. Too many photographers wouldn't for example, lie on the ground, even if that should turn out to be the best shooting angle.

AVOID THE BACK STAGE

You may find yourself going through what I call the "back" stage. Most photographers do when they become interested in candid portraiture. They say they *prefer* photographing people from the rear. I doubt that it's a matter of actual preference. It's just that it's easier to photograph a person from the rear than from the side or front. If you *have* to go through the "back" stage, get out of it as quickly as possible. It won't be long before you're shooting sides, and then the front views that you really want, anyway.

I remember quite clearly that in the beginning I was quite shy about approaching strangers to take their pictures. I tried to compensate by using telephoto lenses, but that didn't satisfy me, because there were times when I wanted the depth of field or, to my way of thinking, the more realistic point of view that you get with a wide-angle lens.

(Most of the time I carry only a Leica with a 35-mm lens and a Pentax with a 180-mm lens. If I don't believe I can move in on the subject, I'll use the 180, but if, while shooting with it, I find that

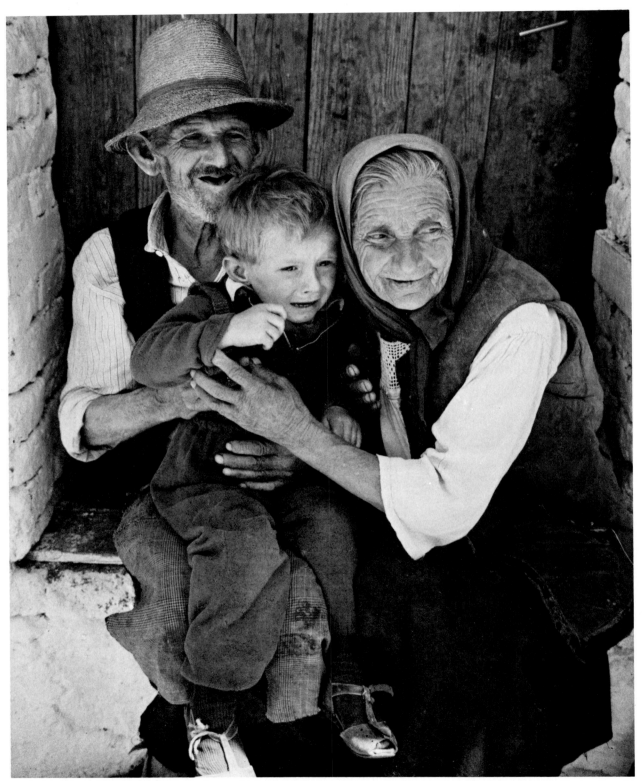

"The boy being held by his grandparents became frightened while I was trying to make a picture of them. But instead of trying to assist or stepping back, I held my ground, hoping to get a better shot."

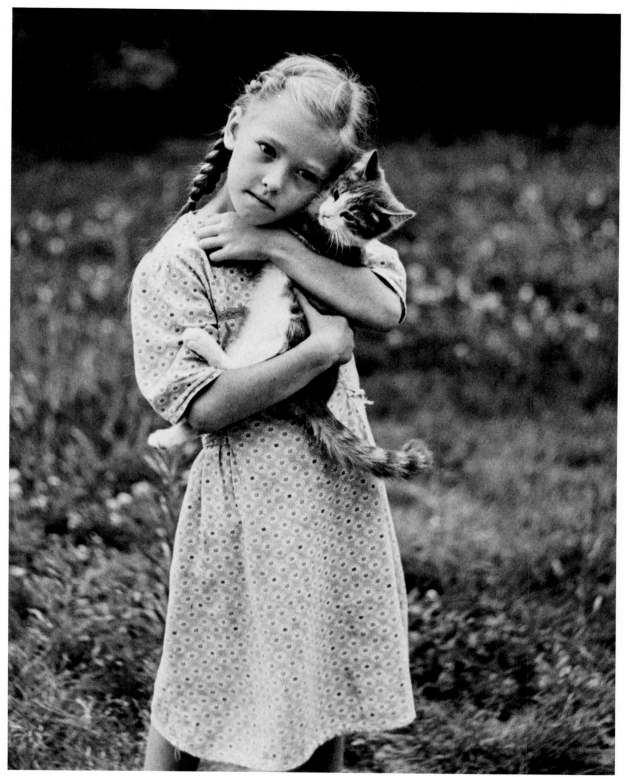

"The little girl was holding the kitten and I made a gesture, as though to hug an imaginary cat. She imitated my gesture. It was at that moment I got the photograph I wanted."

I can move in closer, I almost always switch to the wide-angle.)

And remember that when the subject sees that you have confidence in yourself, he develops confidence in you, and relaxes.

Be the master of the situation, while remaining unobtrusive. Ideally, of course, I would like to be able to make myself invisible. But I can't, and what's more, being 6 feet 1 and weighing somewhere near 240 pounds, I find it practically impossible to blend in with the surroundings. So I act unconcerned, and after a while my presence becomes accepted and the potential subjects lose interest in me and go back to whatever they were doing.

I learned to do this while working with Margaret Mead, the anthropologist, in Mexican and Balinese villages. Usually, she sits down, either on the chair provided for her or cross-legged on the ground; and invariably she folds her hands in front of her and contemplates them or her small notebook. She hardly moves at all. Soon villagers turn back to their activities.

For a photographer, the problem is greater. Not only must he get his subjects bored with him, but with his camera, as well. One way is to sit down and hold your camera with both hands. Or you might look off into space. Often, I just fiddle with the camera dials, making small unimportant movements; and I've noticed that it helps if you hunch your shoulders forward a bit and tilt your head down.

The business of looking off into space relates to a favorite device of mine. I call it "putting your eyes out of focus," which is simply not looking a

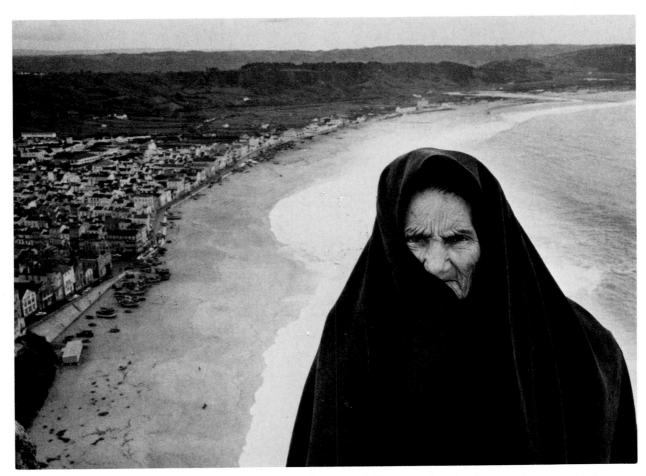

"The old lady was watching me photograph the village behind her. I was looking away from her, but watching her out of the corner of my eye. I was able to take my time, compose, and take five or six pictures, and I don't think she knew I was photographing her."

person in the eye when you don't want him to notice you. You can be facing the subject, but you appear to be looking past him—possibly at some object in the distance. Your subject doesn't know you intend to photograph him, But your peripheral vision will enable you to watch him until his position or expression is exactly right.

Often, the most interesting subjects are the most camera-shy. If they suspect you're zeroing in for a picture, they vanish.

BE PREPARED TO SHOOT

To keep from communicating your intentions any more than is absolutely necessary, try to predetermine your exposure, and have your camera ready. Don't aim your exposure meter directly at the subject, thereby giving him notice of your intentions. Try turning your back while doing "your sums."

Pre-focus whenever possible. You might focus on something that's about the same distance from the camera as your subject, and then swing into position. Or you might set your camera's distance scale by estimating the distance to the subject.

Trick them out of posing. If a person knows you're going to take his picture, he may assume what he considers his best pose, or he may even just stare at the camera with a completely uncharacteristic and undesirable expression. The best way to overcome this obstacle is to take his picture while he's posing. When he relaxes, you can shoot the unposed ones.

Don't be afraid to "play" with your subjects. Make them laugh or enjoy the situation with you.

Pretend disinterest. Pat the dog, or do some other thing that's completely unrelated to taking pictures. If the situation calls for extreme measures, put down the cameras and engage your subject in idle conversation. Eventually, their photoresistance will melt.

Retain your objectivity. No matter how closely you relate to your subjects, or how involved you get in communicating with them, stay alert to the photographic possibilities. When you see what you want, don't hesitate, shoot.

How to Make One Thing Perfectly Clear

Leendert Drukker

It's plain showmanship that the theater goes dark when the curtain is raised. By cutting out extraneous distractions, the viewer's attention is inescapably focused on the presentation. A photograph calls for the same kind of concentration: to be most effective, it should present your point and nothing but your point.

This requires that you crystallize in your own mind, at the time of exposure, just what you are trying to say, to mentally trim the scene down to your subject, and nothing but your subject. Don't include the whole house, if it's the intricate door-knocker you are after.

There are several ways to cut out distractions. The obvious one is to crop down. This can be done in the darkroom, but if you do it on the scene by framing tightly, you'll be way ahead. It isn't merely a matter of taking full advantage of your negative format, to reduce the degree of enlargement required, and to keep grain down. At least as important, the search for the tightest possible composition almost inevitably leads you to a more dramatic, more effective angle.

That brings up another point. By carefully choosing your angle, you can frequently cut down on background interference. Typically, you may find that by kneeling down and aiming up, you can place your subject against a bland sky as background. Still another angle may camouflage some distracting line. The background may also be subdued by opening up your lens, thus more or less limiting its depth of field to your subject. And just as on stage, lighting can direct the viewer's atten-

By choosing a wide-angle lens and closing in, the photographer emphasized graceful lines of the ship's hull in foreground.

Focusing selectively on a white cat, the photographer separated it from trees in rear.

Shooting downward simplified the background of this picture made in a children's play area.

English rock singer Joe Cocker was photographed in his dressing room after a show; note tight framing.

tion. An extreme example of this would be if you illuminated your subject brightly, and exposed for it, letting the background go absolutely black.

Still another way to keep your background under control is by choice of lens, assuming your camera permits you to do so. True, despite all popular misconceptions, a mere change of focal length does not affect perspective. However, by substituting a wide-angle for your normal lens, you can move in on your subject; in fact, you'll have to if you want it to fill the frame as before. And as you do so, you'll find that the background relatively recedes, thus reducing it as a distraction. Alternately, a telephoto lens might require you to back away from your subject, and the background will loom larger than it did with the normal lens. In some cases, this might cause some distracting details in back to fall out of the picture frame, while the telephoto's more restricted depth of field certainly helps to blur others.

Of course, these various techniques can frequently be used most effectively in combination. For example, you may try to "get up tight" on your subject as close as you can with the wide-angle lens, and additionally use its widest aperture to throw the background out of focus. You may find that you get distortion—but then, you may like the effect. If you don't, some judicious cropping may take care of it. Whatever the means, you can't get too close.

Kirlian Imagery: Photographing the Glow of Life

Natalie Canavor and Cheryl Wiesenfeld

"Could you please tell me what filters to use to photograph the human aura?"

K.C.J., Baltimore, Md.

Magazine editors get some strange correspondence, but this one seemed special. Before we stopped laughing, an official invitation arrived to "The First Western Hemisphere Conference on Kirlian Photography. Acupuncture and the Human Aura." Along with an overflow crowd that surprised even the conference sponsors, we attended, found the proceedings fascinating, and decided to find out more about this developing technology-art-science.

The pictures on these pages are examples of Kirlian photographs—that is, images obtained on film without camera or lens by direct recording of an electric charge transmitted by the given object, to which a high-frequency charge has been applied by means of a Kirlian device. This description, amplified later, is the only fact concerning the images that seems incontrovertible at this point. *Why* the images can be recorded on film, what they show, how they can be explained in terms of physics, chemistry, biology, psychology and parapsychology, and what they may mean to future studies in these disciplines are matters of interesting speculation.

The Kirlian device is named for its inventors, the Soviet scientists Semyon and Valentina Kirlian. They are believed to have begun experimenting with contact photography in a high-frequency field as early as 1939, but it was with the publication of articles in Soviet technical journals in 1959 that information became available in this country.

Especially within the last few years, independent groups here variously oriented toward science, psychology, and parapsychology have worked toward reproducing Kirlian experiments and devising new ones, while sometimes modifying the device employed. The conference represented the first official and public interchange of information, and it, along with a forthcoming book on its proceedings, may stimulate interest further.

Kirlian photography has been applied to both inanimate and living objects. A typical nonliving object used is the coin, which, photographed by the Kirlian system, reveals on film topographical structure and a radiant pattern of light around the circumference generally described as the corona. Efforts to change the characteristics of the corona, although it shows up rather differently according to film and exposure time, are unsuccessful: that is, whether the coin is frozen, heated, wet, etc., the image remains basically the same when photographed in the same manner. This is not true when living objects are the subject. The images formed by such things as leaves, insects, or the human body (fingertips are the most convenient and thus most often used part) appear to change according to the physical condition of the subject and even its emotional state. More over, work done so far indicates that the Kirlian recorded image is characteristic of the particular object—a geranium leaf renders a typical image different from that of a bougainvillea leaf: people provide differing specific characteristics typical of the person within a common framework.

One type of common leaf experiment is repetitive photography of the same leaf over a period of

time from freshly picked to, say, five hours "old." Both the inner configuration of colors (when color film is used) and the corona effect change in roughly definable ways as the leaf dies: diminishment of the corona's size and intensity, new color patterns in the interior. A leaf may be deliberately injured, scratched, or cut and the color pattern will change as well as the corona. (An experiment carried out in the U.S.S.R. not yet duplicated here, shows a cut leaf retaining the aura around the outline of the removed area. Referred to as "the lost leaf effect," this reported phenomenon has contributed to speculations about the energy organizational function of the organism's corona.) An essential point of interest is the idea of reversing the procedure: can you examine the photographic image itself to determine the pathological condition of the leaf? It is a possibility currently being investigated with obvious implications for agricultural studies. Could you explore the life processes of the leaf by studying its Kirlian image? Many Kirlian experimenters think so, but considerable further work on the images themselves and plant processes are necessary to really know.

Similar applications are suggested for human beings, which is where the implications become especially interesting. One kind of Kirlian experiment is to photograph successively an individual's fingertip, keeping the photographic method constant but varying other factors. The first set would show the subject's initial condition, judged "normal." Some experimenters have then given the subject alcoholic drinks to the point of increasing intoxication, recording images along the way.

Again, changes show roughly definable developments: a shift in dominant colors on the interior part of the finger image, an increase in size and intensity of the corona, often a shift in color of the corona image. Similar experiments have employed drugs; others have deliberately agitated the subject; one experimenter found accidentally that a change in the person operating the equipment midway in an experiment could drastically affect results, in seeming correspondence with the subject's feeling toward the experimenter. Another idea that has been applied is in the nature of "biofeedback"—a series of images is taken and then the appearance of the images described to the subject: "Your corona is small and tight." Some subjects have shown an ability to control their "emanations," and the next set of pictures could show a larger, brighter corona.

An experiment with black-and-white Kirlian photography was made using a *Popular Photography* editor as subject, in the presence of several other editors. The editor's fingertip images were recorded three times in three intervals of time, a routine Kirlian procedure. The first set was done "straight," to indicate initial state. Our subject was then left quietly sitting in a dark room for about five minutes, and asked to relax consciously while others outside the door also concentrated on "willing" him to relax. Three more images were taken. Then another of us participated by touching the subject's back in a soothing way, still in the dark room, after which the third set of images was made.

As the results were available in negatives in a

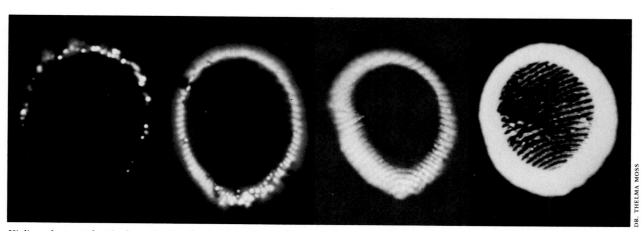

Kirlian photographs of a fingertip give clues to the subject's physical and emotional state, which can be interpreted by biological scientists.

DR. THELMA MOSS

181

few minutes, those conducting the experiment were asked to interpret the results. Jon Skutch, who has conducted a number of similar experiments, noted that our editor showed a certain degree of increasing relaxation (the aura size increased), although relatively little in comparison with other subjects similarly tested. On this admittedly limited basis, our editor might be considered as tending toward the emotionally stable side, as opposed to others who show more volatile characteristics (a view that, coincidentally or not, those of us who work with the subject think is true of his temperament).

Changes in Kirlian images have also been said to correspond to physical changes in the human organism in a pathological sense. In observing Kirlian images shown at the conference mentioned, a British practitioner of Chinese medicine, Dr. J.R. Worsley, noted that a knowledge of classic Chinese medical principles could be applied to interpret particular images. In Chinese medical philosophy, specific colors are associated with specific organs and areas of the body (e.g., yellow connotes a gastric function). Their appearance in a Kirlian image could indicate an imbalance of the body symptomatic of a present or forthcoming malfunction that might not even be pathologically apparent yet. Thus in theory, which will no doubt be subject to concrete experimentation, a doctor could learn to analyze a Kirlian image as a diagnostic aid.

A nonphotographic kind of experiment that Kirlians have done seems to lend support to this concept. A visual rather than photographic observation setup can be employed that substitutes a microscope-type apparatus for the photographic materials. Kirlian researchers have long viewed movement of the color patterns and corona "explosions" by this means. Semyon Kirlian himself reported a disturbing incident some time ago. Accustomed to observing his own finger by the microscope method, he noted one day an extreme change in the appearance of the colors and corona shape. He believed his equipment was malfunctioning, but before solving the·problem became severely ill; when recovered, he found the image was restored to its original appearance.

Kirlian ideas raise some interesting questions in attempting to correlate and analyze results. One of these is the idea of "normalcy"; what is a "normal" Kirlian image for a given person, or in fact, what is pathological or emotional "normalcy?" To

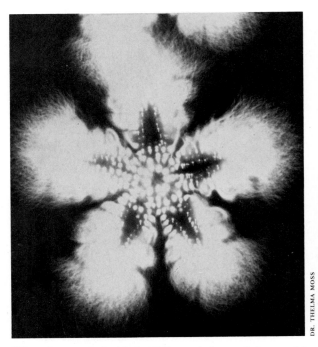

When photographed with the Kirlian technique, a living starfish produces this unusual aura.

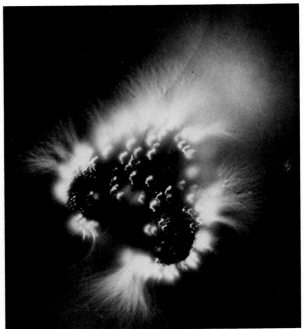

All living objects, such as this African violet, emit invisible biological energy that can be made visible.

observe deviations most accurately would require normalcy to be defined. As each individual seems to have a different Kirlian image, a Kirlian experiment would be most effective if over a period of time the individual's "normal" image could be established. Experimenters have been making this effort.

Another question is the relation of the whole organism to a part. Would every image of different parts of the body—finger, nose, toe, etc.—reflect the same essential image characteristics, and accordingly reflect the entire state of the organism? Does the Kirlian image of one leaf in fact indicate the parent plant's condition? More work needs to be done in this area, and is in progress with at least one group.

Still another implicit question is the relation of emotional, physiological, and psychological condition of the organism. Western approaches have traditionally separated these areas in practice, unlike Eastern medical philosophies, which regard them as integral to the individual's total make-up, and also consider the individual within his environmental context and response to environment. One developing approach to Kirlian photography, in fact, is the concept of its proving a valuable tool for the study of the individual in totality. (A direction in which Western medicine seems to be moving in any case—the idea that schizophrenia is a biochemical phenomenon treatable by drug remedies or nutrition is far from absurd.)

Other areas where Kirlian photography may become of interest are more apparent when theories about why the photographs are produced at all are understood. Most suggestions so far discuss the question of the electrical nature of the effect and draw conclusions on the possible electrical behavior of living things. The Soviet scientist Victor Adamenko talks in terms of "cold electron emission"—an intensive field of electrons without heat emission. Related to this is a natural phenomenon called "St. Elmo's fire," the appearance of an intense halo of light around things like ship's masts and church steeples during thunderstorms. Kirlian photography might be the recording of such a field of free electrons emanating from a living object, a field that is affected by internal changes in the organism, whether chemical, psychological, etc. Adamenko further suggests that the concept of "plasma," defined in physics as the fourth state of matter, is involved. (The other three are solid, liquid, and gas.) In a plasmic state, subatomic particles, mostly electrons, are "free"—that is, not restricted in activity by being part of a molecule. Applied to biology, an electrical charge as imparted by a Kirlian device might artificially produce a plasmic state in a living object.

The idea has been taken further by Victor Iniushin, also of the U.S.S.R. He presumes that plasma is in fact an inherent state of biological tissue, and that "bioplasma," as he calls it, is a structurally organized system that produces the photographable luminescence when stimulated by electromagnetic impulses. Whether this electrical field is inherent in living structures or artificially produced by a Kirlian-type charge, the idea opens doors in areas like psychology and environmental study. As suggested by Dr. Stanley Krippner and his associate, Sally Ann Drucker, Kirlian photography might potentially tell us something about connections between organisms and environments, about the means by which information is exchanged within an organism and between the organism and its world. This would be useful in psychotherapy and developmental psychology, for example.

The electrical field theories also provide the basic link between Kirlian photography and acupuncture, if anyone was wondering about the conference described at the start of this article. Acupuncturists usually presuppose a microscopic system of tubes in the human body, "meridians" along which some sort of energy flows. Adamenko has suggested that the meridians charted by the Chinese long ago are not tubes, but paths of low electrical resistance leading to the skin's surface. An instrument called the tobiscope has been developed that locates acupuncture points on this principle. Such electrical paths would not be discernible by optical means, but would be with the Kirlian system. Preliminary work does indeed show differences in coloration and "flare" at acupuncture points. Work is reportedly under way in the Soviet Union on this kind of charting, with attempts to correlate imagery with specific body malfunctions.

If any of the foregoing seems to verge on the border of science fiction, consider some of the following projects seriously under way right now.

At New Mexico State University, physics students Jim Hickman and Larry Amos are applying Kirlian techniques to the study of artistic and musical activities, toward understanding the mental processes involved and emotional stress situations.

At Roger Williams College in Rhode Island,

Rodney Ross is using Kirlian photography to determine whether people can influence plants by long-distance thought transmission. They are also devising a procedure to film results in motion-picture form. (Motion-picture Kirlian photography has already been done in the U.S.S.R., and shown to visiting Americans.)

At the U.C.L.A. Neuro-Psychiatric Institute, Drs. Thelma Moss and Kendall Johnson are studying the process of psychic healing with a low-frequency adaptation of a Kirlian device (their term is radiation field photography). Douglas Dean at the Newark College of Engineering is also studying psychic healers.

In the U.S.S.R., Kirlian photography is said to be used in cancer research, although little concrete data is available to Western scientists.

Other projects recently proposed include predicting disease and recovery from disease with Kirlian techniques, which is of interest to groups at Harvard and Duke Universities; employment of Kirlian techniques as a tool for measuring human potentials and assessing individual abilities; use of Kirlian techniques to detect and identify objects, such as weapons and to locate mineral deposits; applying Kirlian photography to the study of psychosomatic illness; evaluation of plants with Kirlian imagery for effectiveness in absorbing water pollution, in the wake of investigation of an Israeli plant believed to accomplish this; and a study of the life-death process with Kirlian photography.

What it may all mean and where it may go is for the future, but the imaginative possibilities are terrific.

OCTOBER 1946—BOB HENDERSON

"Mind me watching over your shoulder while you develop that pan film?"

Philippe Halsman's Mini Course in Portrait Lighting

Renee Bruns

*Six challenging assignments that can improve
your skill as a portraitist*

One of the hottest items on the list of courses offered by New York's New School for Social Research is an in-depth photography workshop in psychological portraiture taught by the undisputed master of that medium, Philippe Halsman. Each semester, many hopeful photography enthusiasts apply; only a few (18, to be exact) are accepted for the course.

Students who have passed the initial screening process (by submitting a portfolio to the New School's photography administrators) are then introduced to an intensive learning experience in 10 once-a-week three-hour sessions held at the Halsman studio in Manhattan. Here, they learn about Halsman's celebrated approaches to lighting, posing, camera angles, printing, techniques, and all other areas necessary to creating a psychological portrait worthy of that name.

In the pages that follow, Halsman recreates for our readers six assignments in lighting, with illustrations and diagrams that show how various lighting setups contribute a mood and psychological overtones to portraiture. It is the same approach he uses in class.

What exactly is a successful portrait? Halsman describes it like this:

"Most photographs called portraits don't deserve this name. A photograph of a person is only a portrait if it captures some of the essence of the sitter's character. But, in most of the so-called portraits we see, the subject is posing for the photographer. A picture of a person posing for a photographer is, however, not a portrait because posing is artificial and is one of the least important human activities.

"Consequently, the photographer has to create a situation in which the camera can register a genuine reaction of the subject. He can achieve it by involving the subject in conversation, by helping him to forget that he is being photographed, or by manipulating the subject's reactions with music or with silence and stimulating the subject to reveal himself.

"This kind of photography in which the photographer tries not only to reproduce the features of the subject but capture the character is called 'psychological portraiture.' The portrait then becomes the photographer's statement about the subject. He can make this statement in an underplayed or hidden fashion or with utmost intensity and power.

"If we forget portraiture for a moment, let us compare two photographers whom I admire very much: Henri Cartier-Bresson and W. Eugene Smith. Cartier-Bresson has his film developed and printed on medium-contrast paper by a Parisian lab. Consequently his statement is not reinforced by any technique, and it is up to the onlooker to

discover what Cartier-Bresson is trying to tell in his picture. And this pleasure of discovery is one explanation for the multiple, interesting qualities of his picture—of the success of his pictures. Gene Smith, however, develops the film himself and spends sometimes days printing one negative until he succeeds in getting it to look to his complete satisfaction. He tries to dramatize and reinforce his statement as much as possible. This explains the often incredible force of Gene Smith's pictures.

"By character I am also interested in making my statements with full force. I know that each technical step introduces psychological overtones. And these psychological overtones must support and not weaken my statement. Lighting, camera angle, background composition, cropping, darkroom work, the contrast of the printing and paper are analyzed and used as an arsenal of means to reinforce the psychological statement the photographer wants to make. If we photograph a dramatic person with soft lighting and print in delicate tones, we will understand immediately that the drama of the face will be lost in the finished photograph. And the portrait of the dreamy, delicate young girl will be spoiled if we use a dramatic lighting and print it on high-contrast paper."

Several photographs chosen to illustrate this article were made by former Halsman students, who told *Popular Photography* that the course has helped them immensely in becoming better portrait photographers. They are currently pursuing professional careers in photography, but it should be noted that not all students are "pros." Halsman recalls having taught a subway conductor, surgeon, policeman, bartender, and advertising executive, among others.

ASSIGNMENT 1: ONE LIGHT

Not every kind of lighting generates a mood. Most lighting schemes don't produce psychological overtones, but some of them do. Let us start with exploring lighting with one single light source. Actually, it is the most common of all lighting setups, because the entire world is lighted by one light source—the sun.

The first possibility is to light not the subject but only the background. With this lighting you achieve a silhouette. The extreme economy of information can produce a very effective picture, confirming the saying, "less can be more."

The next position is the light source high above the subject. Outdoors, with the sun shining, we would call it the "high-noon" lighting. It produces a long shadow under the nose. The eye sockets get dark, and the eyes disappear in their shadow. Cheek bones are emphasized; the face takes on a skull-like appearance. This lighting produces a sad or tragic look. (In a tenement a single light bulb high at the ceiling will produce the same effect.)

When you lower your light source, the subject's eyes become visible in the eye sockets, and the shadow under the nose gets shorter until it takes the typical butterfly form. This is the lighting preferred by Hollywood glamor photographers. This lighting usually shows the face at its best without contributing any special mood. It is the most useful lighting when you have only one light at your disposal.

If you lower the light more until it is level with the subject's face, you get a very flat lighting with almost no shadows in the face. This is the lighting that is generally produced with the flash on the camera; this lighting eliminates the wrinkles and lines in the face. It is without character and without depth. You should try to avoid it.

When you lower your light even more so that it strikes the face from below, you get a lighting which you'll register as strange and unusual. It makes the subject look mysterious or monstrous. Hollywood has used this lighting often to characterize the Frankenstein monster and Dracula.

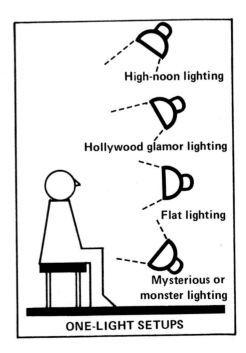

High-noon lighting

Hollywood glamor lighting

Flat lighting

Mysterious or monster lighting

ONE-LIGHT SETUPS

You can also put your light to the side so that it lights only one side of the subject's face, leaving the other side dark. This disparity produces a dramatic effect and gives you the feeling of conflict. It should not be used if your goal is to create a calm and peaceful expression.

We can put the light partly behind the subject, shielding it, however, with aluminum foil or with barndoors to keep it from striking the lens, which might produce a flare. Seen from the camera position only, an edge is lighted, and therefore it is called an edge light. With this edge light you can, for instance, draw the outline of an interesting profile.

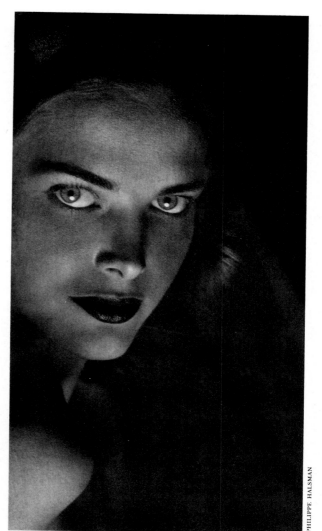

PHILIPPE HALSMAN

The position of a light below the subject's face results in a mysterious or monstrous look. As shown here, the light, diffused by a veil in front of the subject, adds an air of mystery. Portrait at left demonstrates flat lighting.

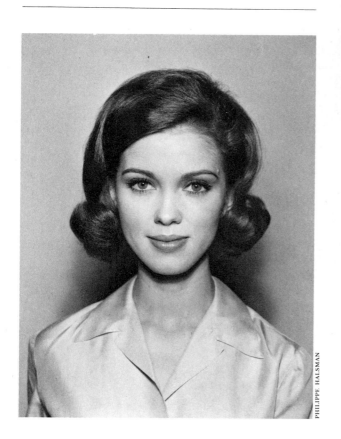

PHILIPPE HALSMAN

187

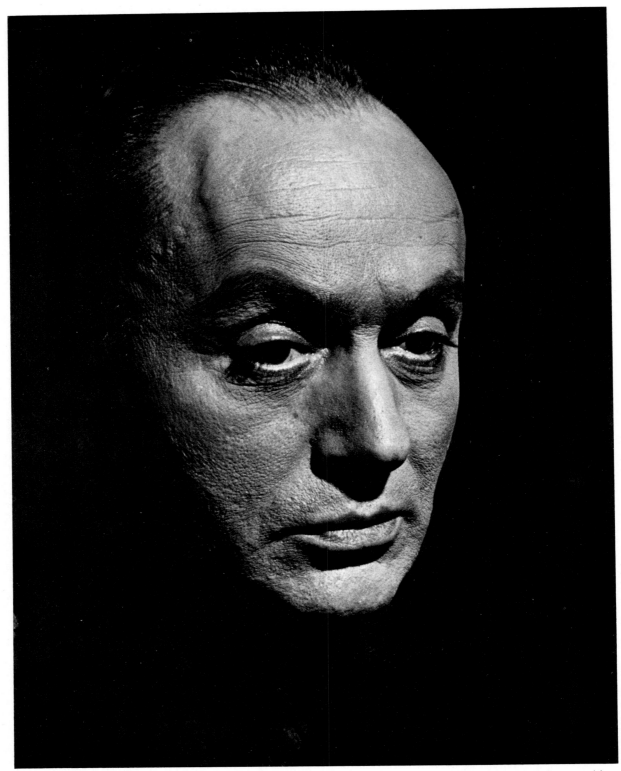

To make a forceful photograph of Charles Boyer, Halsman used only one light source, placing it in Hollywood glamor position.

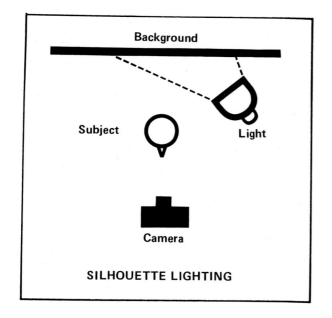

Background

Subject

Light

Camera

SILHOUETTE LIGHTING

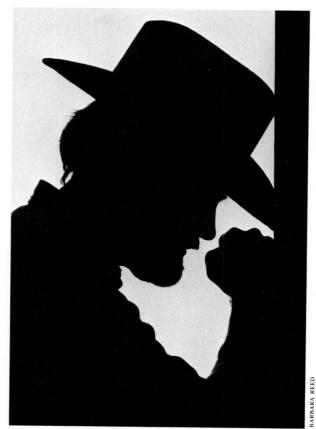

BARBARA REED

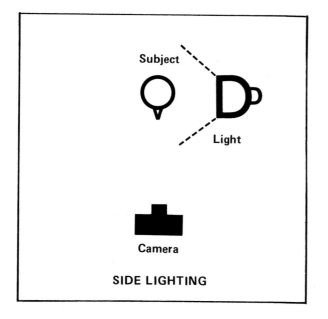

Subject

Light

Camera

SIDE LIGHTING

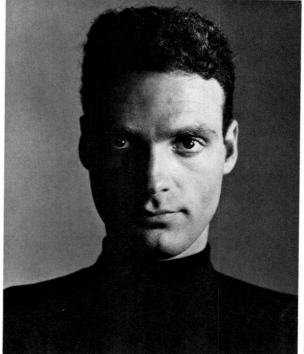

PHILIPPE HALSMAN

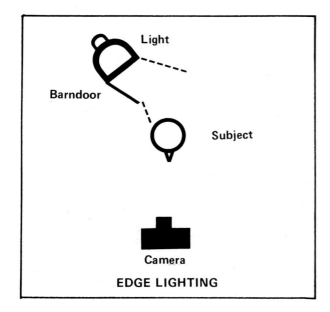

Light

Barndoor

Subject

Camera

EDGE LIGHTING

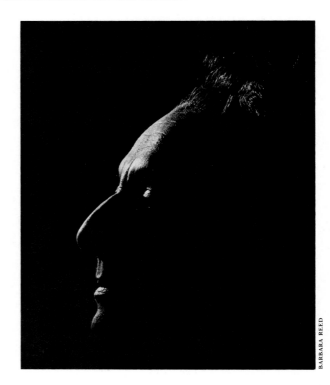

ASSIGNMENT 2: TWO LIGHTS

Portraits taken with one light normally have a great force, but they have the following disadvantage: the shadows are too deep and, although our eye can see details in them, the photographic emulsion cannot. To see details in shadows, you have to introduce a second light. It is called "fill-in" because it fills in the shadows, and where they overlap the shadows of the first light, dark spots appear. To keep these shadows of the fill-in light to a minimum, you should keep the fill-in as close as possible to the lens.

The ratio of strength of the fill-in light compared with the strength of the main light is 1:2 or 1:3. The more overpowering the fill-in is, the softer and flatter the photograph. If you want to emphasize strength of a face, use a weak fill-in; if

you want a delicate, soft portrait, use a strong fill-in. The fill-in light can be used when you want to see details of the face in an edge-lighted portrait, or when you want to see details in the dark side of the side-lighted face.

You can also use the second light as a second *main light* rather than as an *auxiliary light,* for instance as a second side light. We can now use the very spectacular cross lighting. When both lights are in the side-light position, each one lighting only its own side of the face without spilling over, then a black line appears in the middle of the face, running from the forehead to the chin of the sitter. This is a very dramatic lighting, especially successful on thin and lean faces.

The second light can also be used to lighten the background or to edge-light and lighten the hair of the subject.

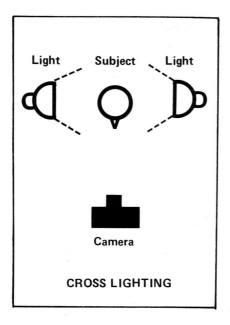

CROSS LIGHTING

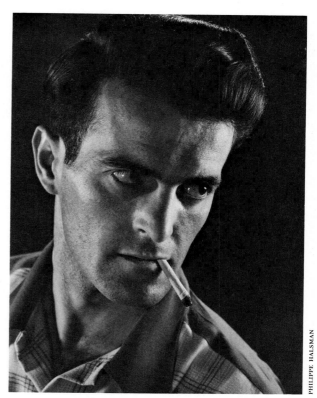

For dramatic cross-lighting, aim one light at the right side and another at left side of face.

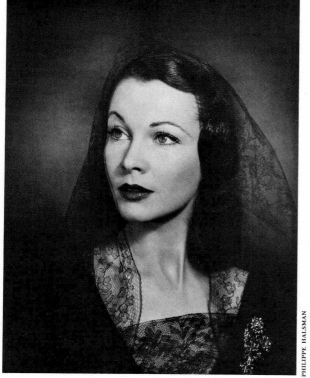

The harshness of a one-light set-up can be avoided by using a fill-in light, positioned next to the camera.

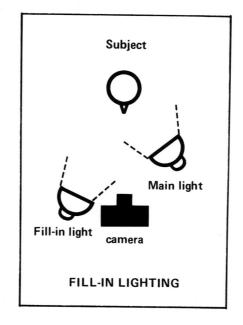

FILL-IN LIGHTING

ASSIGNMENT 3: MULTIPLE LIGHTS

You can add more lights to the lighting setup. If you are a sensitive photographer you might, with the changing mood of your subject, want to swiftly change the lighting arrangement. Halsman usually starts his sittings with the following five-light setup: two lights (the main light and the fill-in) are in front; two spots on each side are behind the sitter, permitting Halsman to edge-light the sitter's hair; and one light, behind the sitter's back, is turned against the background to lighten it, if necessary. With this particular setup you can make very fast changes.

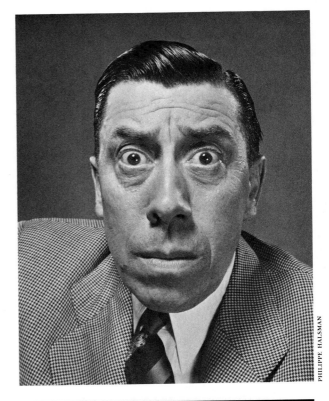

PHILIPPE HALSMAN

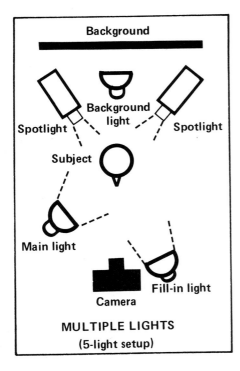

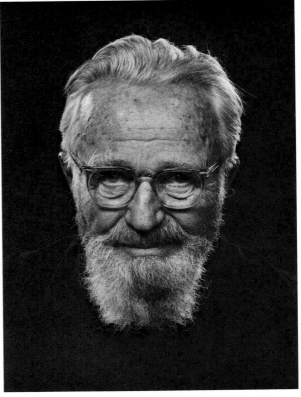

PHILIPPE HALSMAN

The amusing expression of French comedian Fernandel (upper right) was captured with five lights, set up as shown in the diagram. Edward Steichen was photographed in basically the same way, except that the background light was turned off.

ASSIGNMENT 4: BOUNCE LIGHT

Bouncelight, or indirect lighting, is produced when the light or lights are not directed at the sitter but are being bounced off a reflecting surface such as a wall or ceiling.

There are two general misconceptions about this lighting. Many photographers believe that it does not matter where you bounce off the light and that it will continue to bounce around the room and produce an even and soft illumination. Other photographers think that the bouncelight can be aimed like a billiard ball by bouncing it off the wall at a particular angle. (They are right only when the wall happens to be a mirror.)

In reality, the bouncelight works like this: The part of the wall or of the ceiling that is illuminated by the bouncelight becomes a large illumination source itself and lights the subject. By directing the light in such a way that this illuminating source is high above the head of the subject, you achieve a "high-noon" effect; by making the light bounce off a side wall you achieve a side-light effect; by bouncing it off the floor you get the mysterious monster-like effect; and so forth. With one bouncelight you can produce all the single-light effects. However, since the light is coming from a much larger source, the lighting is softer and more diffused; but it is definitely directional. It is also more even than the direct light, but it lacks its dramatic force.

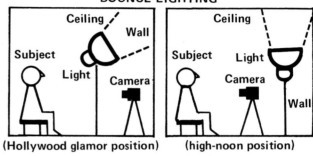

BOUNCE LIGHTING

(Hollywood glamor position) (high-noon position)

The subject and her surroundings were evenly lighted with one bounce light, directed at wall and ceiling.

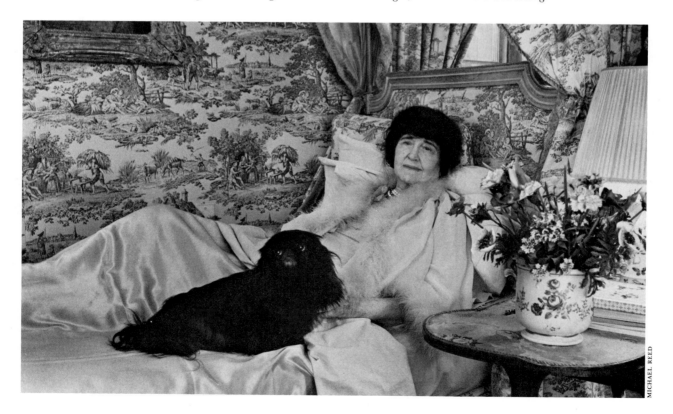

MICHAEL REED

ASSIGNMENT 5: WINDOW LIGHT

Photographing with window lighting is similar to bouncelighting, since in both cases you use a large and, in its effect, a soft light source. The difference is that in bouncelighting you could place the light sources wherever you wanted. In the case of a window, you control the lighting by positioning the subject in a certain way.

WINDOW LIGHTING

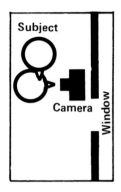

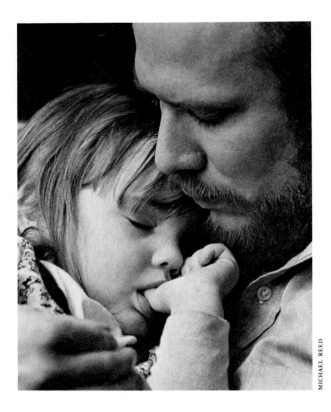

Father and child were facing one window, which was slightly to their right.

ASSIGNMENT 6: OUTDOOR LIGHT

In discussing the single-light setups we considered the single light as a substitute for the sun. Now, in discussing photography outdoors, we can consider the sun as a substitute for a single light. You can duplicate all the single-light setups, including even the mysterious monster lighting (by catching the reflection of the sun in a mirror lying on the ground). The only difference is that, in order to control the light, you move the subject instead of the light.

In sunlight, try not to shoot from 10 A.M. to 2 P.M., because the sun is in the "high-noon" position, and your subject's eyes are hidden in shadows. In the early morning or late afternoon, the sun is in the "glamorous-light" position which is much more favorable for picture taking. The shadows are, however, still heavy and you are often compelled to either use a reflector (a piece of cardboard covered with aluminum foil will do) or a fill-in flash. Do not use a flash that is too strong; it can make the picture look artificial.

To avoid harsh sun shadows, most photographers prefer to shoot either in open shade or on days when the sun is covered by clouds. This produces a diffused and soft overhead lighting which lacks strength but shows a lot of details in the shadows.

When you photograph in the open shade, take into account the direction from which the illumination is coming.

For instance, when you photograph in a narrow street flanked by tall buildings, the person facing the direction of the street will be lighted by a narrow vertical stretch of sky in front and above him. If the person is facing the row of buildings, he is lighted by a horizontal stretch of sky in front and to the right and left of him.

In the first case, his face will appear more modulated and thinner than in the second case where the subject's cheeks are lighted by the long stretches of sky on both sides of him, making his face seem wider.

If you photograph in a doorway, shielded from side lighting and lighted only from the front, you will get a flat lighting. Under a shadowy tree the subject might be lighted from the front and from the back, and you might even get an edge lighting.

194

If you photograph in a deep and narrow air shaft, you are faced with overhead lighting which tends to make your subject appear haggard and sad-looking. Consequently, if you want to take a gay and cheerful photograph you will have to look for another location.

Halsman gives this note of warning: a moody lighting is never a substitute for the subject's genuine expression, but it can either wipe out or strengthen the mood of the portrait.

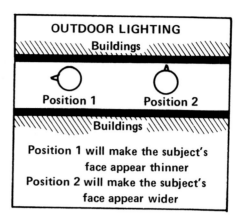

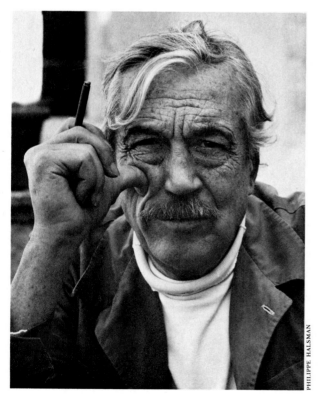

Director John Huston was photographed sitting in a courtyard where the light was diffused.

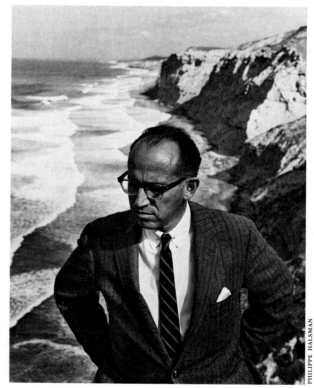

Nobel prizewinner Dr. Jonas Salk directed his eyes toward a shadow area when this picture was made.

A Printing Recipe for Solarization

Cora Wright Kennedy

I'm not clear why so much mystery is made about precise ways for "pseudo-solarization," of prints alias the Sabattier effect. The process causes the black-and-white picture tones to become partially reversed. It's an enormous amount of fun with the right subject matter, allowing you to do weird things. And it's exceedingly easy to get consistently good print results if you know just what to do in the darkroom.

Why, then, is there so much vague, or just partially valid advice around? When I went looking, only the bare generalities of solarization (as it is usually called) came out distinctly. The properly exposed paper should be developed enough for the image to show, but not so much that there won't be enough silver salts to be fogged by the solarizing exposure. This comes next when the partly developed print is flashed with a light that is neither too weak nor too strong. Finally, you redevelop the print for a suitable length of time. Whatever I did, however, results too often were poor. Even using a few recipes I found didn't lead to consistency. So I delved in experimentally, and finally came up with this special way of operating for black-and-white print reversal.

I call it "the test strip approach," because two test strips are made, on No. 6 paper for a strong effect. One is just a conventional *unreversed* test to find normal exposure time. Then this time is used as the basis for making a *reversed* test on the same paper grade, according to specific directions that follow. The payoff is that the fixed, reversed test strip allows you to see which solarization effects were obtained, and which might be most suitable esthetically.

These include the presence of white lines (known as Mackie lines) at the interfaces of some light and dark areas. Of the prints below, for example, the 20-sec exposure is interesting with strong Mackie lines, especially at the cat's back and ear. But the 30-sec print provides a lighter effect with more and differently placed Mackie lines. Note also that the best exposure for reversal is likely not to be far from the best on your unreversed test. (With the white cat as a white cat, for instance, 25 sec was fine.) But there can be greater variations with other subject matter. So go the test-strip route and try these reversal techniques.

First, develop the exposed paper just 40 sec in Dektol developer (diluted 1:1) using continuous agitation. This strength gives me somewhat stronger results than diluting the usual 1:2.

Second, rinse the paper off in a nearby tray of water to bring development to a near halt. Then wipe it off with paper toweling. All this is done to prevent streaks. And the entire step should only take about 20 sec or so.

Third, flash the fairly well-wiped paper with light from a 15-watt bulb affixed about three ft. above your print-flashing position. Flashing time for me is about two sec, by the second hand of a large clock. And this is accurate enough for reasonable consistency.

Fourth, redevelop your test or print in the developer tray for 20 sec with continuous agitation, of course.

Once you get all this down pat, you'll find you can make certain changes. For instance, you can get slightly lighter over-all effects by flashing a fraction of a sec less, and slightly darker ones by

allowing a hair more flashing time. But when you veer in this fashion from your optimum, reversal effects tend to become noticeably softer. Still another variation is to continue development more than 20 sec after flashing. I do this sometimes when I've introduced a weakening variation somewhere along the line, accidentally, and compensate by redeveloping 40, 50, or 60 sec. Just operate by eye, and take the print out when it looks slightly too dark. Then the fixed print should look about right in room light.

As you experiment more, you'll find an interesting alternative is to dilute the developer considerably—say 1:5 or 1:6. Results, naturally, will be more subtle, softer, and less dramatic. But some strange olive-gray or brownish-gray tones can be achieved by using a very dilute developer that is also a bit old or worn out.

So play around a little here. Try to keep the mystery just in the strange or beautiful effects. There's no reason why vagueness or mystery should complicate your ways and means.

An easy approach to pseudo-solarization of prints (for partial reversal of tones) includes a reversal test strip (left), made from negative of a white cat. Times on strip, left to right, were 10, 20, 30, and 40 seconds. The 20-second reversal (center print) is interesting, but more reversal effect occurs in the 30-second print at right, which is lighter and has white lines around the cat.

Fish-eyes vs. Superwides

Norman Rothschild

Focal length's not the whole story

Making straight lines come out straight, even when these lines appear near the edge of the picture is the proud aim of any lens designer who is worth his salt. It's not a simple task, as any maker of extreme wide-angle lenses can tell you. Therefore, even a "cheapie" in the ultrawide-angle field is not necessarily at the bottom of the barrel pricewise.

In contrast, the designer of a frame-filling fish-eye lens would be horrified and look for a malfunction in his computer if lines in the picture that were straight in the subject didn't become increasingly curved the further they were away from the center of the image. In other words the designer purposely introduces barrel distortion into his lenses.

Thus when we speak of a 17-mm fish-eye lens and a 17-mm ultrawide-angle lens, the only thing the same is the focal length on axis. The kind of picture you get from each is different. And that, not optical theory, is what this is all about.

Rectilinear 17-mm lens; angle of view, 110 degrees　　　*Fish-eye 17-mm lens; angle of view, 180 degrees*

Dead-center horizon is straight

Horizon near top has beach-ball curve

Low horizon makes earth a soup bowl

PICK YOUR CURVE WITH A FISH-EYE

This set of pictures of the same scene serves to emphasize that lines at the exact center of the frame (that is, straight lines on the lens axis of a fish-eye lens) are straight, or rectilinear. This is seen in the picture at top left; horizon line appears straight when it is in the center of the frame. At upper right, the horizon line is placed near the top of the frame, resulting in a mountainous upward bulge that emphasizes that the world is a ball. In the shot at the left, the horizon is placed below center. This serves to prove the earth is a hollow ball. These purely functional photos serve to illustrate phenomena that you may find useful in landscape or other expressive areas of your own photography.

Normal 50-mm lens; angle of view, 47 degrees

ANGLE OF VIEW AFFECTS THE LOOK OF THE IMAGE

Even though taken with the same nominal focal length of 17-mm, from the same point of view, the two wide views are quite different. Note that the fish-eye includes more subject matter than does the shot with the rectilinear wide-angle lens. Also note the increasing curvature of lines the further they are from the center of the image. A 17-mm rectilinear lens takes in a diagonal angle of about 110 degrees; a 17-mm, frame-filling fisheye takes in a diagonal angle of about 180 degrees. Comparisons between shorter or longer pairs of wide-angle and fish-eye optics would show roughly similar differences in angle of view seen. The large image of a portion of the scene, made with a 50-mm lens, is included for comparison.

Rectilinear 17-mm lens

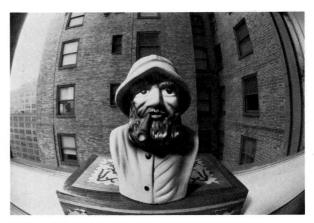

Fish-eye 17-mm lens

BACKGROUNDS IN CLOSE-UPS

Both pictures of the sailor doll were made with camera on tripod and same subject-to-film plane distance. Lenses used were a 17-mm rectilinear and a 17-mm fish-eye. Near the center of the frame, the images appear reasonably similar. In the fish-eye shot, as details recede from the center they come out increasingly smaller. Also, straight lines come out increasingly curved the closer they are to the edge of the frame. Note also that the fish-eye takes in a greater angle of view. Thus, much more background is taken in than when a rectilinear wide-angle lens is used. Close-ups of people, made with a 17-mm fish-eye, often result in frame-filling fun shots.

DISTORTION . . . OR IS IT?

Too often the converging lines in architectural shots, where the camera has been pointed upward, are referred to as distortion. When an extreme wide-angle lens is used, this error is compounded by talking about wide-angle distortion. Actually, unless a fish-eye lens is used (a lens which purposely uses barrel distortion to curve lines) no distortion is involved. Because of a convention introduced by paintings, we expect to see buildings without lines of receding perspective, even though we accept this when straight lines recede in a horizontal plane, as, for example, in a shot of railroad tracks. Thus a shot of columns made with fish-eye seems more acceptable than a rectilinear photo.

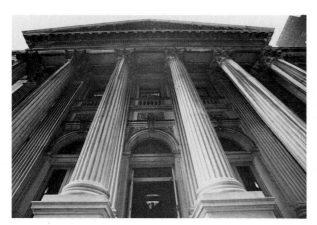

Rectilinear 17-mm lens

Fish-eye 17-mm lens

Basic Printing Controls: Dodging and Burning-in

Cora Wright Kennedy

Did you ever wonder how to make your enlargements better so you could step up to another plateau in printing? It could be that you haven't really explored how to bring out the maximum of tonality through your burning-in and dodging techniques. Yet this is the sort of thing that often separates the real pros and fine printers from the less experienced picture makers. And there are ways of learning it for application to either black-and-white or color printing.

Looking back over years of playing games with tonality, and teaching others to do this, too, it seems to me that it is important first to have a sense of delight in your ability to create print changes. This seems fundamental, just because it is an intangible but real driving force. For creative workers, it should lie behind the use of specific good tools for burning-in and dodging, and behind the art of determining the right exposure particulars for the print. This starts, obviously, with deciding ahead of time how much overall exposure to give, based on test. Then it continues with decisions on how much to dodge (or hold back light from certain areas) during that time, plus how much to burn-in other areas afterwards by giving them additional exposure to light.

Anyone who is less experienced should remember that in *black-and-white* printing, you *dodge* to *lighten* picture areas, and *burn-in* to *darken* them. Ditto for making color prints from color negatives. But just the *opposite* is true when you turn to the fascinating area of making color prints directly from color slides. Then, what applies to making slides also applies to such positive-to-positive printing. But it occurs to me that an easy way of keeping the difference in mind is to call burning-in a double "L" bit, because you give extra *light* to *lighten* areas in pos-to-pos printing. Similarly, dodging becomes a double "D," because *dodging* with pos-to-pos print material leads to *darkening.*

However you remember the differences, keep them straight, use the tools that suit you best, and wield them to best advantage. Writing out of my own experience, I find I can generally save time and avoid aggravating delay just by using my hands for burning-in. I'm not saying I never turn to cardboard. Once in a while I do. What's more, some beginners seem to do better initially with the cardboard routine—either using such opaque sheets intact, or cutting suitable holes in them. However, once you learn to use your hands, you seem to acquire additional burning-in freedom and skill. And there are numerous variations you can choose from, with different pros often favoring different ways.

For instance, I'm very partial to a two-handed approach (used more or less as shown), for burning-in interior print areas (those that don't extend to the edges). This, quite happily, lets me vary the size and shape of the hole quickly before burning, or even during it. And these are no mean advantages. Furthermore, with this two-handed approach, I'm also quite successful in preventing light from reaching areas which need to be held back while burning. In fact, I find the basic approach a lot easier, and more versatile to boot, than mere single-fistedness—a technique that some of my moderately larger-fisted photographer friends turn to for making a small hole under

the lens for burning-in. Though it seems to suit some people, this one-handed approach just isn't my bag.

I do, however, really go for use of just one hand in some other form. One is the extended-thumb approach, sometimes used as shown. I turn to this general idea a lot for burning-in corners to vary tonalities. But I may change the angle formed to suit the corner better. Or I may use the technique to burn-in other areas that extend all the way out to print edges. Occasionally I even alter the shape, so hand and thumb form either a fat or skinny "U," as need be. Another one-handed favorite is to burn-in sides (and sometimes corners) with an all-fingers-together approach. And for sides—especially the longer ones—I may use my forearm for burning purposes. So give all these techniques a whirl to see which ones are for you.

Along about the same time, decide which way to dodge. There's not much doubt that dodging tools are exceedingly useful for holding back light from small (or not so small) interior areas of the picture. Some of my tools are homemade—each constructed from a straight piece of clothes-hanger wire, adorned with a suitably sized piece of taped-on cardboard. However, my collection also includes a manufactured dodging wand for holding pieces of plastic that accompany it, or (if you wish) for use with pieces of cardboard, or a piece of gelatin filter. Then there are my ever-present hands (which never get misplaced) that are used at times for dodging larger areas that go out to the edges of the picture frame.

Whichever way you operate, don't forget to practice turning on the enlarger and getting your hand or other tool into action fast. In burning, first try holding the back of your hand or your cardboard just under the lens (but not touching it), so you will block off all the light when the enlarger goes on. Then turn your enlarger on and slide your hand or cardboard quickly into "burn" position. Practice until you can zero in on the burn area in a second or less. Don't just assume, either, that you can dodge easily without a bit of practice. So put in some time doing dry runs with this technique, too.

As you do all this, remember that beginners are constantly being adjured to move their hand, cardboard, or dodging tool handle enough so the burning-in and dodging will look natural. You are also warned to stop burning in and dodging short of the "overdo" point.

But not enough attention is paid, it seems to me, to the important bit of moving enough so you blend tonalities. In this regard, like most other photographers who have been around a while, I started out in black-and-white a long time ago, and soon found out a number of facts of life. So today one basic approach in my black-and-white printing often is to find an imaginary pivotal point on the print, then pivot around on that point as I burn to create shading and blend tonalities of two adjacent areas—a top and side, for example.

Another rather routine maneuver for me is to burn in the corners of black-and-white prints. But I do it by moving my hand in and out rather rapidly, so the outer parts of the particular corner being treated will get the most light and be darkened most. However, the more central parts that get less light will be lighter. And in between I will have created shading.

Very early in the game, too, I found it was easier for me to burn than to dodge, if I wanted natural black-and-white results. This tends to mean I base my overall exposure on one important area, like a face. Then I note which other areas of the projected negative are darker and will need burning-in. This is the way that usually gives me most control. And I far prefer it to dodging those important, thin-looking areas of the negative image *during* the basic exposure.

Maybe one reason for this is that dodging with black-and-white, in my book, seems to provide less latitude for exposure error. It's not hard at all to wind up with an unnatural faded look when dodging what would otherwise be a very dark area.

On the other hand, the sometimes nice but exceedingly aggravating part of burning-in is that it is possible to burn and burn and burn without getting great tonal changes. In other words, sometimes you have to burn quite a lot (perhaps even after opening up the lens one stop to cut the burn time in half), before you go too far. But when this stage is reached, whammo—suddenly you are over the hill with unnatural looking results.

Any way I consider matters, it's good to have the basic burning and dodging skills under your belt before you turn to color printing. If you do as I did, you may go straight to making prints directly from slides, avoiding the color-negative field completely. When I did this, I was happily surprised. Neither dodging nor burning-in seemed really critical at all with the rather forgiving positive-to-positive approach.

What's more, it was easy to make the transition to a land of opposites, where dodging on pos-to-

pos color-print material is done to darken, and more light is given to lighten. For instance, if you want to darken picture corners with *pos-to-pos color-print material,* just remember to do the opposite of what you would do in black-and-white. You dodge *during* part of the basic exposure to do this darkening. And you move your dodging hand (or large enough piece of cardboard) in and out from near the center, so there is more dodging near the color print corners, and hence more darkening in the outer areas. This is the way, here, to create shading, so the eye will be directed toward the lighter center areas.

To sum up, pos-to-pos color printing is an even happier land for me than black-and-white. But either way—color or black-and-white—burning-in and dodging can be a real delight provided you have acquired good to better-than-good skills. And the payoff is, of course, that these can lead to that desired better print imagery.

Both hands form a small opening for burning-in a small area of the print (shown clear).

Just one hand plus extended thumb is used to burn-in areas like corners (unshaded area).

The Art of Showing Prints

Edward Meyers

Don't learn only from *your* mistakes, learn from other people's.

It's Saturday night. You are visiting a good friend at his or her home. The conversation leads to great times on the latest vacation. Then the friend says, "Wanna see my pictures?" You have a choice—yes or no. Since you are at your friend's home and have been fed a scrumptious dinner (perhaps even with wine), the polite thing to do is to say yes. Then it all begins, the setting up of a slide projector and screen, and/or the opening up of print boxes. Let's just discuss the matter of viewing prints.

Your friend opens the box (boxes) and begins handing you 8 × 10 photographs, shot and printed by the "artist." The prints are emptied out of the box and virtually tossed in your lap. Mistake—your friend has handled the prints as if they were meaningless scraps of paper. Therefore, if he or she doesn't think much of them, why should you? If the prints were carefully handed to you to view, one at a time, taking care not to get fingerprints on the images, you would take the same care handling them, and would, without even seeing the images, have the feeling that they were worthwhile looking at, one at a time.

As your friend hands you the prints, it is explained to you that these are "work" prints; you are told to disregard all the dust spots, blemishes, and stains. "Someday fine prints will get made." Mistake—if this is so, you should not have been shown the pictures. Why waste time looking at inferior prints?

As you are looking at the massive stack of prints, the friend tells you stories about the pictures he missed, or about what was happening outside the image area. Mistake—who cares? The photographs are statements unto themselves. They should be evaluated as such. When you show a picture, it must be complete, unless it is part of a sequence or has a written story or even sound-on-tape that accompanies it. But never think you will help a picture by talking it into being good. Most often it makes things worse.

You are told the camera, lens, aperture, shutter speed, film, filter, meter reading of each picture, and you didn't ask for the information—another mistake. Let the viewer ask before giving this technical information. Some people do not understand f-stops and shutter speeds, etc.; don't "turn them off" by forcing it on them.

Your friend shows you the prints and tells you that he doesn't think they are any good. Mistake—if he doesn't like them, he shouldn't show them.

One or two hundred prints are piled up in front of you to look at. "This is my life's work," you are told. Mistake—don't ever show more than 20 prints to anyone at any one time. And never show your "life's" work. For the first part, the bad pictures dilute the good ones. Also, a viewer will not really want to look at more than about 20 images. Therefore, he'll go through the remainder too quickly. That's bad. He'll never get to really see the pictures. Secondly, after the person is through looking at a "life's" work there is a letdown, a big letdown. You have just spilled your body and soul out on a table, and now what do you do for an encore? Nothing. Psychologically it's a bad thing to do. Sometimes it's best to show only one or two pictures at a time. If they are good photographs,

it indicates that you have many more like them. Show them at a later date, a few at a time.

You are carefully leafing through the prints. You notice that many of them appear to be too dark. Is something wrong with you or with the prints? Possible mistake—insufficient viewing light. In my opinion, there is no perfect print for all viewing conditions. You must print for a particular viewing-light level. If the prints are meant to be viewed under direct flood or spot lights, usually they will appear very dark under normal room light. Conversely, prints made to be viewed in room light will often appear too light in brighter light. Show prints in the proper light, or don't show them at all.

Your friend delicately hands you unmounted prints. They are beautiful. You say so. You hold them, taking care not to fingerprint them. In fact, you balance them on your hands without touching the image sides. Then you are asked to pass them to the next person. You do this and realize, after it is *too late,* that this person is inexperienced. Mistake—a lump forms in your throat as he grabs a print, gets fingerprints on it, and cracks the emulsion while waving it in front of his eyes. Never permit the inexperienced to touch prints until they are educated properly. It is maddening to spend hours in a darkroom making a perfect print, only to have it destroyed in a split second by someone who doesn't know how to handle it.

Now for some ideas about reaction. Verbal viewing, known as criticism, is a very gray area. Unfortunately some people fortify their own egos by attempting to destroy the egos of others. Beware—know that some people do this as a matter of course. Also be aware that constructive criticism can help you and others to improve. A kind word about a picture you think stinks, on the other hand, is not fair to anyone. If you don't like a picture, say so, but also point out good parts of it, or (if asked) give advice on how you think it would be improved. Think how you would feel being on both sides of the picture.

I remember being with two photographers who were showing each other their photographs. At first there was silence, then, as soon as one began saying negative things about the other's pictures, the second photographer attempted to outdo the first. It went back and forth, and got worse and worse. And there I was—watching and listening to two egomaniacs making fools of themselves. I wouldn't show my pictures to either of those guys. I'd just have to let them go elsewhere for help.

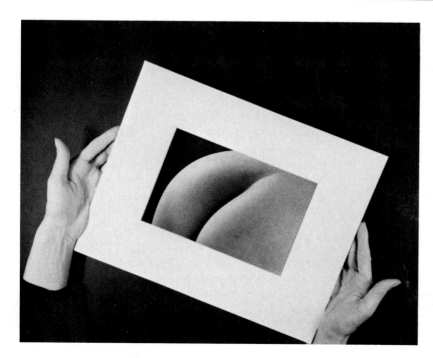

Much of what other people think of your photographs depends on how you present them. If you show respect for your picture, so will your friends. This is one correct way to hold a print.

The Miracle of Modern Lenses

Norman Goldberg

By 1937, a large share of the basic lens designs in use today had already been accomplished. The people who had the genius to do this type of design work may have dreamed of the day when a high-speed computer would trace a light ray through a lens surface in a fraction of a second. But until 1926, when the motorized desk-top calculator was first used by lens designers, ray tracing was a laborious task involving the use of logarithm tables and/or hand-cranked calculators. Either way, it took about seven minutes to trace a ray through each surface.

Even with a single-element box-camera lens, the designer must try a variety of lens shapes to obtain the best one. For each trial of such a simple lens design, he must trace enough rays to have confidence in the nature of the image at the center of the field and the corner of the field, with at least one point in between.

He must also trace the rays that go through the center and edge of the lens, as well as some intermediate zone. Rays of at least three colors must be traced along all the above paths.

When complex lenses containing several elements are designed, the minimum number of rays that must be traced are about the same as for the single-element lens. But the number of surfaces each ray encounters—two for each element—makes the work of computation very tedious.

With the use of the desk-top calculator from 1926 to about the mid-1950s, a ray trace through a single surface took only two minutes—a great improvement from the former seven minutes, but still a snail's pace compared to today's high-speed electronic computers.

In 1962 at a University of Rochester Optics Symposium, Donald P. Feder and his colleagues designed a four-element lens from scratch in one evening session, using two-and-a-half hours of computer time. The same four-element lens could be designed on one of today's computers in about two-and-a-half *minutes*.

The high-speed computer was, at least in part, a war-baby. It was desperately needed to calculate missile and projectile trajectories with ever-increasing speed and accuracy.

Another war-baby, the durable anti-reflection lens coating we now take for granted, was regarded as being so vital to the optimum functioning of military sighting and viewing instruments, it was considered a wartime secret.

The immense significance of antireflection coating was immediately grasped by lens designers. Before the process was available, they were severely restricted to designs that used as few air-glass surfaces as possible because each one of these reflected about five percent of the light. This forced the designer to match the curvatures of adjacent elements whenever possible so they could be cemented together, eliminating two air-glass surfaces.

With antireflection coating, these design restrictions were greatly eased because coated surface reflections were only about one percent. This small amount has been cut down further by the rather recent multilayer coatings pioneered by the U.S. firm, Optical Coating Laboratory, Inc. (OCLI), working with the German firm, Balzers, and with Asahi Pentax of Japan.

The fruit of this joint effort was first seen in a

production photographic lens when Asahi introduced their 50-mm SMC Takumar f/1.4 in 1968. In a relatively short time, the rest of the optical industry followed suit with a variety of multilayer coatings.

A third war-baby, new optical-glass materials made from rare-earth elements had their first use in the aerial camera lenses made by Kodak during World War II. Kodak encouraged the work of George W. Morey, whose investigations into new glass materials date back to 1927. Five years later he had the support of Kodak, whose research laboratories devised such schemes as making the special glasses in gold and platinum crucibles to obtain the highest purity. This exotic-sounding process is now common practice among all optical glass manufacturers who routinely produce rare-earth glasses. These glasses feature high refractive index (light-bending power) and low dispersion (variation of bending power with color).

The coming together of the three war-babies—high-index glass, efficient and durable antireflection coating, and the high-speed computer—created a true revolution in optics.

The triggering mechanism that released a flood of new lens designs was the emergence of the 35-mm SLR as a practical, rapid, and flexible camera during the mid-1950s. Then the Contax S from East Germany introduced eyelevel camera operation by incorporating a pentaprism for the first time, and the Asahiflex II from Japan ushered in the instant-return reflex mirror. Once these two features were combined with the gradually evolved auto-diaphragm, the 35-mm SLR became the vehicle for most of the new and interesting lens designs.

Long denied the wide-angle lenses used in the 35-mm rangefinder cameras because of the mirror swinging behind their lens mounting flange, the SLR's optical horizons were broadened as a first order of priority. The very existence of such familiar optical tools as the reversed-telephoto (also known as "retrofocus") wide-angle lenses that enable rectilinear fields of view up to 110 degrees on our 35-mm SLRs is proof that the optical revolution witnessed since the birth of *Popular Photography* has provided us with substantial gains.

The first still-camera zoom lens, the Voigtländer Zoomar 36→82-mm f/2.8 of 1959 ushered in the present era, where the attempt seems to be directed at providing one lens that answers (almost) every need. Today's wide-angle-to-telephoto zooms with so-called macro-focusing ability come close to being "do-all" lenses. And they appear to be getting better all the time, as do the rest of our modern lenses.

One big reason for the improvement in modern lenses is the way they are now being tested. In 1951, Otto H. Schade of RCA described a system of evaluating image quality that made it possible to predict accurately the final result by knowing the characteristics of each link in the image chain. Schade showed how these characteristics could be specified in terms of information-theory techniques.

To greatly simplify, the process involves the measurement of the fidelity with which a signal (light) is transferred from the input to the output of any component in the imaging system.

Known as Modulation Transfer Function (MTF) testing, it is the basis for the lens tests performed in most optical labs today. The importance of MTF testing is that it taught lens designers what properties to optimize in various lenses.

For example, a recently designed 58-mm f/1.2 lens from Nikon is optimized for use at full aperture and a target fineness of between 5–10 linepairs per mm (5–10 LP/mm). These optimizations were programmed into the design commands given to the computer, according to Nikon.

Such apparently coarse detail as 5–10 LP/mm would amount to a mere 0.5–1.0 LP/mm on a 10X enlargement, and our eyes can easily resolve detail almost ten times as fine. But Nikon's experiments showed that for the poor-light photography for which this lens is intended, the 5–10 LP/mm optimization gave the best results. This same lens employs another feature being found in more lenses all the time—one or more of its surfaces is aspherical (nonspherical).

Plastic lenses, first attempted in the 1930s with disappointing results, showed up as viewfinder optics in simple cameras made by Kodak in 1952, and as the picture-taking simple lens in the same class of camera by 1957. Two years later saw Kodak making triplet (three-element) lenses from plastic with quite good results.

Plastic optics really came into their own in Polaroid's SX-70, whose viewfinder system is a tour de force of innovative design and manufacturing in plastic optics. Several high-grade glass-plastic hybrid lenses have been made in recent years, and the results have been excellent. Further work in this area is certain in the coming years, thanks to the encouraging recent optical history.

Traveler's Camera

Carl Purcell

Roaming free or in captivity, animals are difficult to photograph . . . here's how

Photographing animals is not a simple matter. These contrary creatures just don't understand why they should cooperate with photographers. I have stalked numerous felines including my own domesticated cat Gulliver as well as his larger carnivorous cousins in East Africa. For some reasons these beasts, and I include Gulliver under that general heading, yawn, blink, or turn their backs just as I get ready to press the shutter release. Coaxing, pleading, or cajoling are of no avail for "He is the cat who walks alone and all places are the same to him."

Actually there are a number of things you can do to get better pictures of animals and birds, but they have little or nothing to do with cooperation and everything to do with ingenuity and patience.

Let's start out with easy animal photography at the zoo. I've spent many pleasant afternoons at zoos throughout the world in places like London, Zurich, Tokyo, New York, Washington, and Santiago, Chile. You can be assured that these wild animals will not gallop or fly off at the sight of an alien creature with three eyes. In fact, they will probably sit or stand rather placidly and let you take pictures to your heart's content. But, if possible, you should compose to avoid fences, wire mesh, or other details that clearly say the picture was taken in a zoo. Sometimes you can't avoid a zoo background, but if this is so, accept it and concentrate on getting a good picture of the animal.

In some zoos the animals are housed in a very natural and open habitat such as an island with a moat around it or a large open pit with natural vegetation. Other zoos, however, use the more traditional cages, and these can present problems for the photographer. Who wants to see a lion or a leopard through the ugly bars of a cage? There are ways to see through bars or wire cages. The most obvious is to stick your lens through an opening in the cage, but in most instances there is a barrier to prevent you from getting that close, and usually for good reasons. One would not choose to have his new Nikon carried away by an avaricious orangutan.

So in most instances it will be necessary to stand back from the cage, and the wire mesh will be between your camera and your subject. If you have a moderate zoom lens up to 200-mm or a comparable telephoto you can often make the wire cage disappear with a little optical magic. With your zoom in the telephoto position, set your aperture to the widest opening and focus on the animal inside the cage. You will be surprised and pleased to note that the cage is so far out of focus that it cannot be seen through the viewfinder and will not record on the film. Your furry friend appears to be out in the wild!

There is little doubt that the real challenge of animal and bird photography is in the wild, but it is far better to let the wildlife come to you than to attempt to stalk it with your camera.

One of the best examples of this is the seagulls which will follow the stern of a ship. If you happen to have some bread crusts they will hover within three or four feet of the goodies. Of course, this gives the photographer the chance for some very effective bird shots.

I was recently doing an assignment on Cape Hatteras and took the Ocracoke Ferry from Ocracoke Island over to Hatteras Inlet. The stern of the ferryboat was besieged by an aggressive flock of seagulls. They were so close that I was even able to use a 35-mm wide-angle lens.

Probably my best seagull shot was made from the stern of a ship in the Aegean. I captured it with an 80→200-mm zoom lens extended to the 200-mm position at a fast shutter speed.

I hasten to point out that this type of shooting is not easy, and for every outstanding bird shot there will be five or six rejects. It is difficult to catch the focus on a moving bird and trip the shutter at precisely the right moment.

Novaflex makes a special follow-focus telephoto lens that makes it considerably easier to focus on a moving, elusive subject such as a bird in flight. Many years ago I owned the 240-mm version of the Novaflex, but have not yet tried their new lenses that include a 280-mm, 400-mm, and 600-mm.

The principle is simple. The main body of the lens is mounted on a spring activated pistol grip. You focus simply by squeezing the pistol grip until the subject becomes sharp in your viewfinder.

The ultimate in wildlife photography is in East Africa. This incredible area is a gigantic outdoor zoo with a cast of thousands! It is a deeply moving experience to stand on the Serengeti Plain during the annual migration, herds of zebra and wildebeeste stretching as far as the eye can see. Most camera safaris use the VW mini-buses with open tops for more convenient photography.

A long telephoto lens is helpful, but not always necessary. It is surprising how close you can get to some of the animals and how often they ignore the presence of the vehicle. My favorite lens for shooting game is the 80→200-mm zoom, because it allows you to crop and compose your picture from a fixed vantage point. That's important, because you *must* stay in the bus.

I have also used a 300-mm telephoto and the 500- and 600-mm mirror reflex lenses. The two latter lenses require a steady hand when shooting color film such as Kodachrome 64. Some ingenious game photographers take along a sandbag or a bean bag to act as a solid support for their lens. Such a bag can be laid over the window sill or on the roof of the bus; the car motor should be turned off to eliminate all vibration.

Some people have expressed concern about going to East Africa because of the political unrest that has flared up from time to time, but with the exception of Uganda it does not affect the major game areas. It is important, however, to know that the border between Kenya and Tanzania is closed, and it can be time consuming and expensive getting from one country to the other. It is my general advice to select a package tour to East Africa offered by an airline or tour company. This can save you both money and time and make your trip much more enjoyable than if you try to wing it on your own.

Tanzania and Kenya are the two countries in East Africa that comprise the heart of the big game belt. Tanzania has more animals, and the game parks are much less crowded, but Kenya has a fine selection of game and better hotels and tourist facilities. In either country you'll be comfortable and see plenty of animals.

On my last trip to Kenya I went to Lake Nakuru, a bird photographer's paradise. This placid lake nestled in a green valley is home to countless thousands of flamingos and pelicans. There are blinds and vantage points where it is possible to get quite close to these extraordinary and colorful birds. This is an ideal place for a motion-picture photographer, because the flight of these graceful birds is greatly enhanced by recording it in the added dimension of time and motion.

Whether you use a still or a motion-picture camera, it is worth getting up before dawn to photograph this natural aviary in the light of the rising sun.

There are many places throughout the world where the traveling photographer can focus his camera on birds and animals. In this country, try the Everglades National Park on the southern tip of Florida or the Outer Banks at Cape Hatteras in North Carolina. Walt Disney did a feature-length film on "The Living Desert" in the Southwest. Try the wilds of Canada or Alaska, the Great Barrier Reef in Australia, or Darwin's amazing Galapagos Islands off the coast of Ecuador. Best of all, you won't need to get any signed model releases!

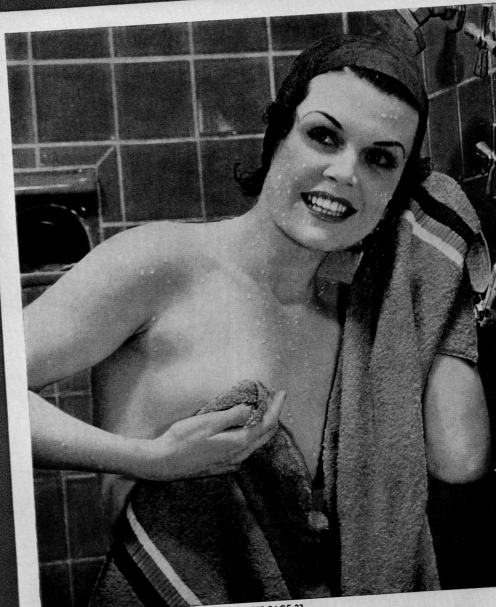

1st Issue

Popular Photography

- PHOTO KINKS
- CANDID SHOTS
- HOME MOVIES
- COMMON ERRORS
- TRICKS EXPOSED
- PHOTO MARKETS
- EXPOSURE CHARTS
- COLOR PHOTOGRAPHY

Answers All Questions About Photography

SEE PAGE 23

MAY 25¢

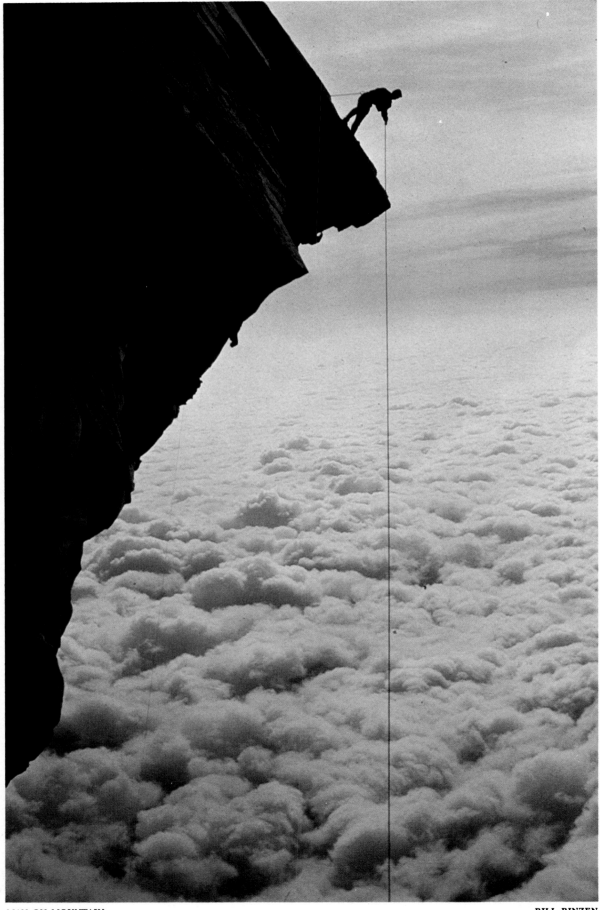

BILL BINZEN

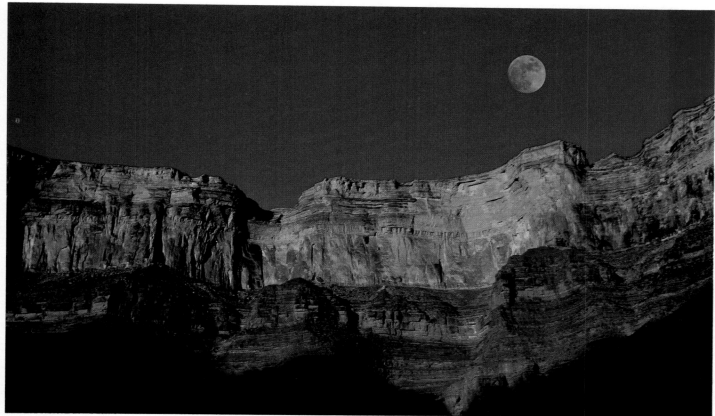

MOONRISE **JOHN BLAUSTEIN**

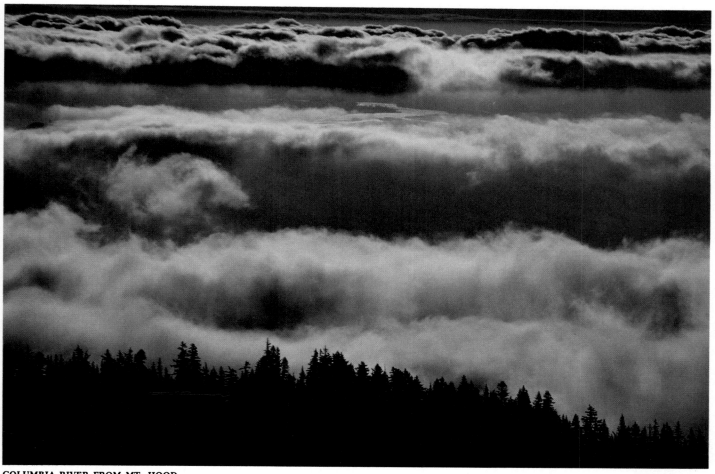

COLUMBIA RIVER FROM MT. HOOD **GARY BRAASCH**

POND SHOTARO AKIYAMA

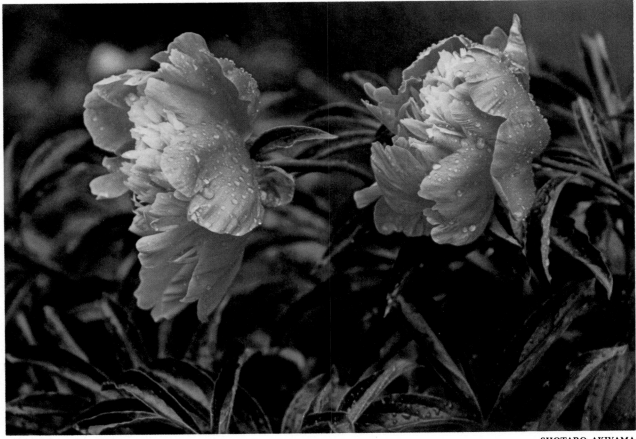

FLOWERS SHOTARO AKIYAMA

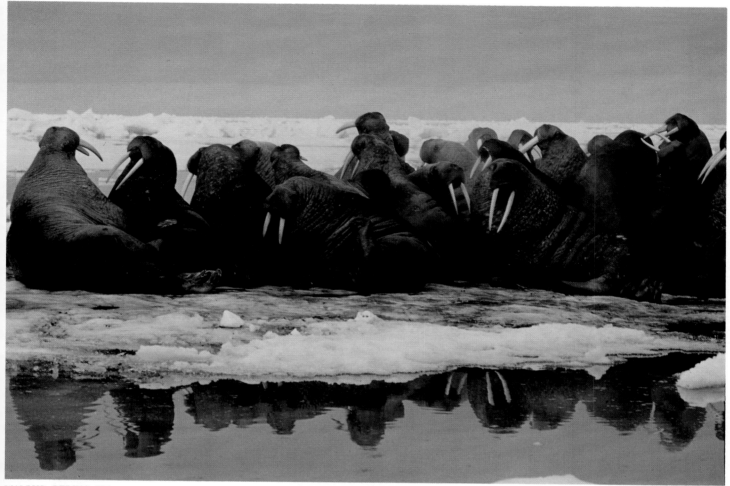

WALRUS, BERING SEA

ROBERT BELOUS

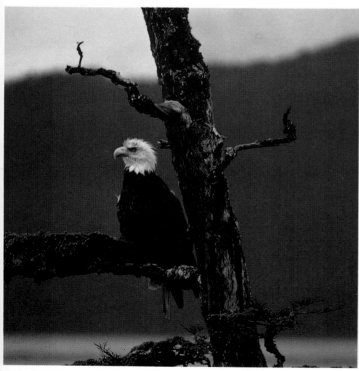

BALD EAGLE

M. WOODBRIDGE WILLIAMS

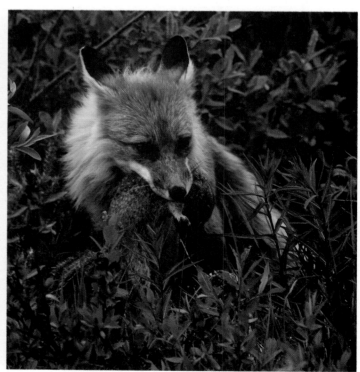

RED FOX, MCKINLEY NATIONAL PARK

ROBERT BELOUS

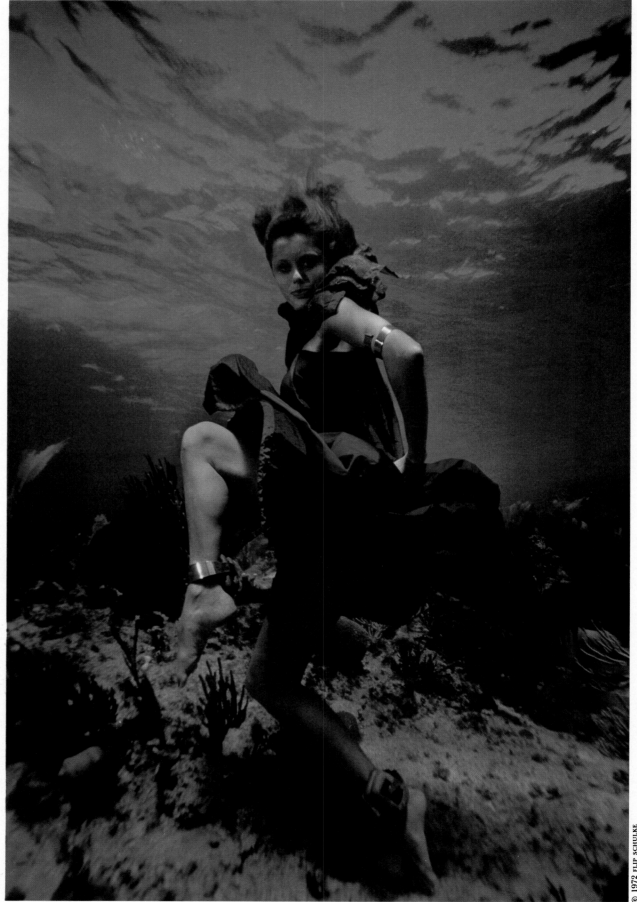

UNDERWATER FASHIONS

FLIP SCHULKE

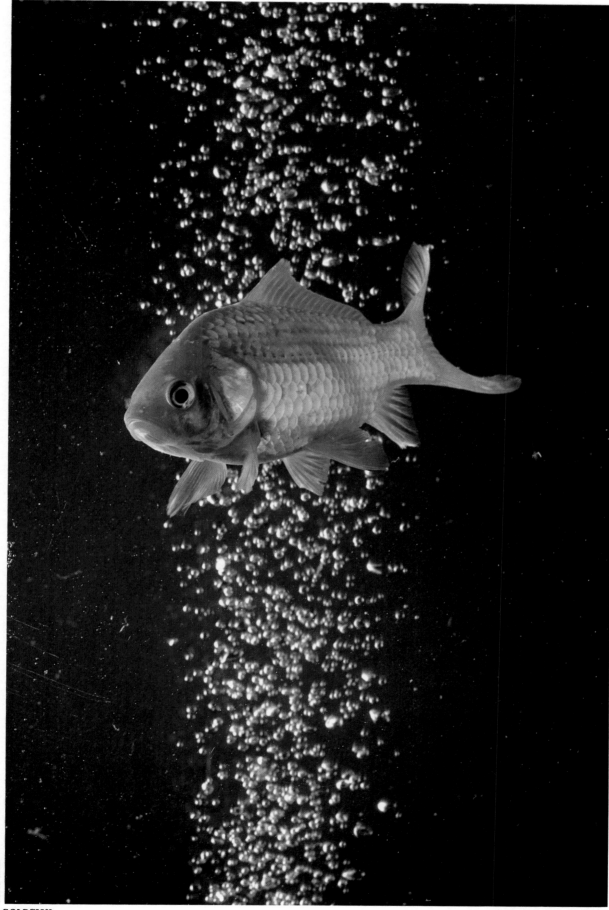

GOLDFISH

MICHEL TSCHEREKOF

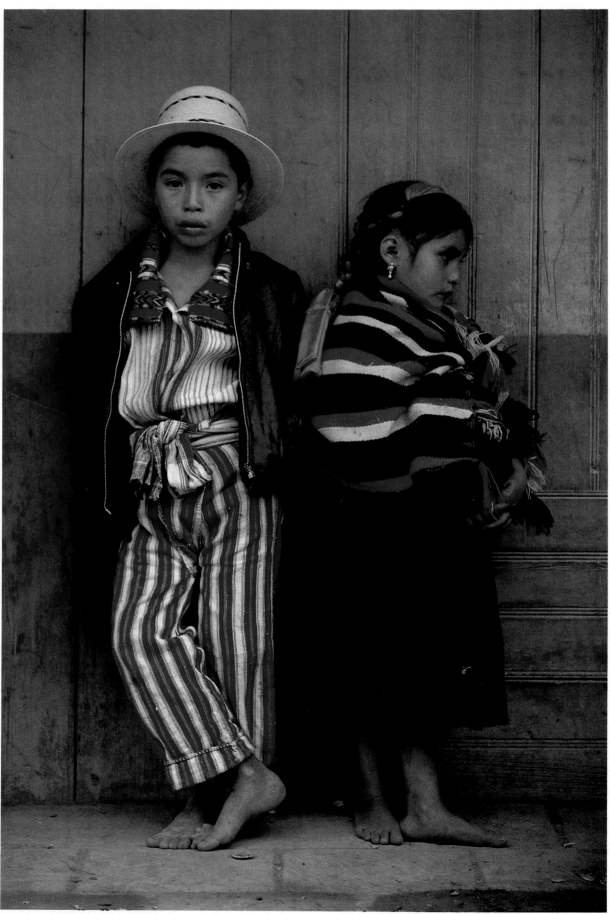

INDIAN CHILDREN, GUATEMALA

GEORGE HOLTON

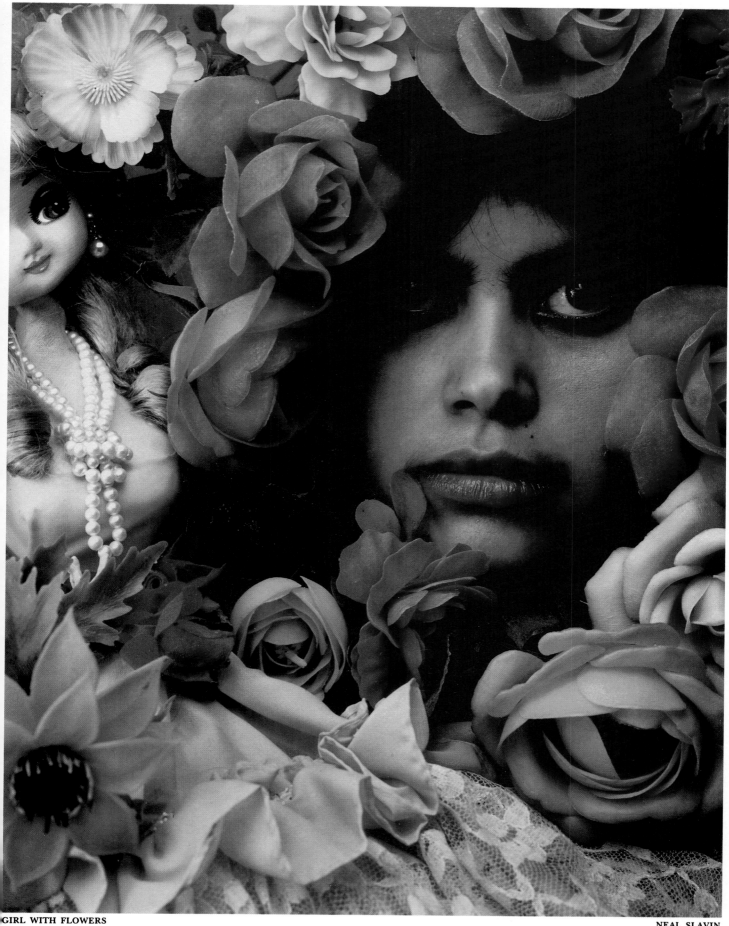

GIRL WITH FLOWERS

NEAL SLAVIN

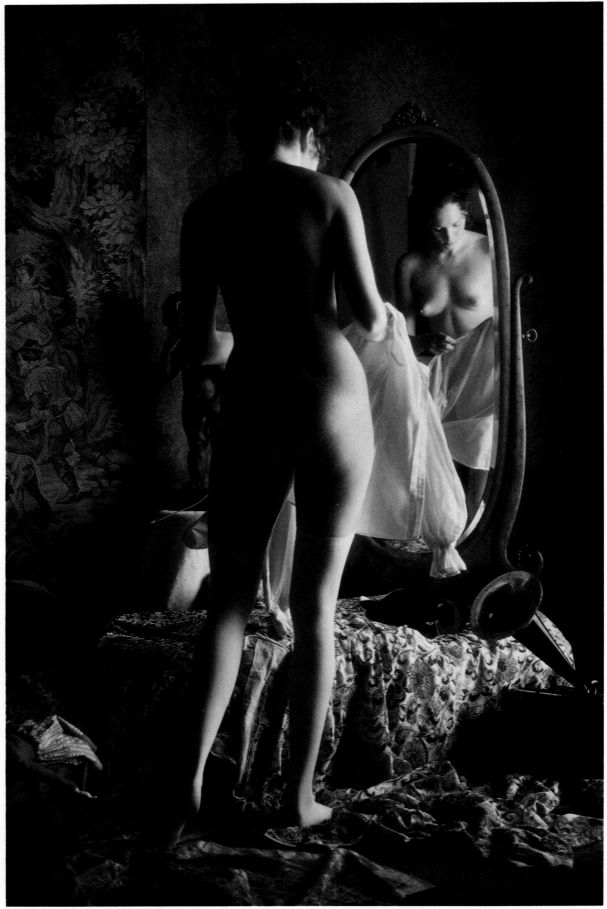

MIRROR IMAGE

GEORGE ADAMS

STILL LIFE PETE TURNER

FERRIS-WHEEL FANTASY

NORMAN ROTHSCHILD

FLUORESCENCE LEONARD A. ASKOWITZ

ANCERS

FIRE EATER, JAMAICA

JAMES V. ELMORE

Photojournalism

Giving Wings to News Pictures

Frank J. Hughes

*Carrier pigeons are the latest innovation in speeding
news photographs to the press*

A great transatlantic liner docks at New York. Off the boat steps a society big shot, a political mogul, and a movie star.

One of the first things they see, is their own picture in the newspaper. Under the picture is the caption. "So-and-so arrived today from a sojourn in Europe."

Naturally, they wonder what sort of journalistic necromancy made such a thing possible. "Why, the paper was on the street two hours before the boat left Quarantine," they say.

There was no miracle performed. The instance only serves to show what can be accomplished by the use of carrier pigeons in conveying pictures and news to various newspapers.

In the case of the notables returning from Europe, photographers boarded the boat at Quarantine and shot their pictures. The birds then carried off the film and the photographs were in the paper before the boat docked, three or four hours later.

The carrier pigeon air service has established not only a new beat of time on boat assignments, but has also developed an almost infallible method of swiftly transferring films of great news import. Although there are but few agencies utilizing the bird express, results are sufficiently significant to warrant a general employment of pigeon transport by newspapers and news agencies.

Efforts at forming a carrier pigeon express service have been started from time to time. But it remained for Amster Spiro, city editor of the New York *Evening Journal,* to work out a practical bird transport system. Aided by Bob Keogh, manager of the *Journal's* photographic department, Mr. Spiro bought sixty pedigreed birds, all bred from carrier pigeons with a World War record.

A pigeon loft was constructed on the roof of the *Journal* building. The birds were turned over to Harry Meyers, whose services had been obtained from the headquarters of the carrier pigeon division of the United States Army Signal Corps, at Fort Monmouth, N.J. Mr. Meyers and his pigeon crew trained the birds for over a year.

Last fall during the football season, when the rivalry between evening newspapers was intense, Mr. Spiro put his pigeons into active service, and succeeded in beating his competitors to the presses with action photographs of the game.

The manner of operation was this. After an exciting play at a football game had been shot by the photographer, he unloaded the exposed film in a changing bag, and placed it in an aluminum tube which was then strapped by a little harness to a pigeon's back. The bird was released and within approximately twenty minutes, since the distance

was not more than fifteen miles from the newspaper office, the films were landed and rushed to the darkroom.

These birds average a speed of approximately fifty miles an hour from the time they get their bearings. Naturally, they lose a little time getting on their course. Sometimes, because of head winds, their flying speed may be reduced, but again, with a tail wind of thirty to forty miles an hour, they have been known to make record flights as high as eighty or ninety miles an hour.

Pigeons can be used to transport both copy and film, and they are utilized for all spot news. Harnesses are no longer employed for the carrying of film or copy. The negatives or copy are now placed in a leg band of aluminum. A strip of adhesive tape is fastened around the band to prevent the pigeon's leg from becoming chafed.

These bands come in three sizes. The one-inch band is employed for one sheet of copy. For two or three sheets, a 2¼-inch band is used. If four or five films are to be sent at one time, a little wider band is used.

Not only have pigeons been the means of thrilling newspaper readers with pictures of the early action in football games, but the birds are now used in carrying fight pictures and negatives covering other sports events, as well as spot news, within a radius of thirty miles of the *Journal* office.

In order to prevent the overloading of pigeons, Keogh had the Big Bertha cameras, used by *Journal* photographers, reconstructed to make 3¼ × 4¼ film negatives instead of 5 × 7 plates. The cameraman is cautioned against carelessness in loading his negative into the leg band. Since it is necessary to roll the film quite small, there is danger of cracking or scratching it. Stories typed on flimsy paper are also attached to the birds' legs.

It takes a carrier pigeon about fifteen minutes to fly from Baker Field to a metropolitan newspaper office—a distance of twelve miles. It may require more or less time, according to the wind. The time saved in transportation from the steamers at Quarantine is approximately two hours. If the ship is held up by fog or tide, a greater saving of time is obtained.

Not long ago when a former mayor of New York arrived at Quarantine from a European trip, a rival paper tried to compete with the *Journal* on pictures of the politician. The opposing paper rented some pigeons, gave them a brief course of training over the route they were to fly, and when the day arrived, carried the birds to Quarantine. Photographs were made of the incoming "Biggie," the

The photographer places his negatives in a small cylinder attached to harness on the pigeon's back.

These pigeons, released from an incoming ship, will carry films to the New York Evening Journal.

213

film was loaded on the rented birds, and they were shooed off. But the plan didn't work.

In the first place, they were too heavily loaded, and secondly, the birds were not familiar with the route. Flying back to the ship where the *Journal* birds were just taking off, they attempted to follow but with disastrous results. One bird was lost and the others got back to the office hours after the last edition of the paper was on the street.

The *Journal* now has 120 carrier pigeons in service. In addition to two mobile units, the paper maintains a travelling squadron which cruises about the suburban territory in an automobile. This latter consists of a reporter, a photographer, and a bird trainer with a crate of twenty pigeons.

The motorized unit recently demonstrated its efficiency in the coverage of a bank robbery at Paterson, New Jersey. While cruising in that vicinity the unit, which reports by phone every half hour, was ordered to cover the theft. Story and pictures were procured in record time and sent to the office by pigeon express. The *Journal* thus scored a news beat of several hours over its competitors.

The effectiveness of pigeons in covering spot news in remote areas where the use of telephone and telegraph is not possible, was shown by the Salt Lake *Tribune-Telegram* in covering the discovery of a wrecked Western Air Express transport plane which crashed near Lone Peak, high in the Wasatch Mountains.

The ledge between Lone Peak and Chuipman Peak, on which the tragedy occurred, is nearly eighteen flying miles from Salt Lake City. On the ground the distance is forty miles and the telephone nearest to the wrecked plane was fifteen miles away.

The first accurate news and the first photographs of the plane's discovery were brought from the scene by pigeons, scoring a scoop of more than an hour over messengers who fought through the rugged country on foot and horseback to reach a telephone.

The Salt Lake *Tribune-Telegram* maintains a loft atop its building where pigeons are kept. They were loaded into baskets and sent to the site with reporters who were equipped with ordinary cameras, rice paper, and aluminum capsules, made so they could be strapped to the leg of the pigeons. Fresh pigeons were sent each morning, from Alpine, about fifteen miles from the rescue camp, to carry on the messenger work.

The dispatches were written on rice paper, in what is termed *cablese* by the reporters, and sent out at intervals by pigeon express. Pictures were taken, films unloaded in changing bags, rolled into small cylinders, and capped inside the bag. The cylinders were then attached to the birds and the birds released.

Each of these dispatches was timed on leaving the site. The longest elapsed period for a pigeon flight from the crash to the newspaper office was an hour and fifteen minutes. The flight was made during a heavy storm, during which rain, sleet, and snow fell. The fastest record for any bird was twenty-five minutes.

It is interesting to learn how the pigeons make their landings at the newspaper office. When they arrive at the loft, an automatic switch lights a large electric bulb and sounds a buzzer in the editorial room. It is only ten minutes from the time the pigeon lands until the story is ready to set in type.

There are, in many parts of the country, equally impressive and successful experiments with carrier pigeons as airway express agents in the transportation of important news events. The development of this service seems phenomenal, considering the short time it has been used. Experts declare that this method will soon be adopted almost universally by papers and news agencies, becoming an important factor in news transmission under certain conditions.

The Assignment I'll Never Forget

Arthur Rothstein

Back in 1936 during my first year as a professional photographer I received the assignment which produced some of the most memorable pictures I've ever taken. Early in the spring of that year I was one of the photographers working for the Resettlement Administration (an early New Deal agency later called the Farm Security Administration).

Roy Stryker, head of the agency's photographic section, sent me on my first trip west of the Mississippi River to make pictures of the drought-parched lands. I headed immediately for the Dust Bowl, where nature had caused the greatest havoc. Driving north from Amarillo, Tex., I passed through a desert of abandoned farms and sand dunes. With my camera I documented the devastation caused by the winds and drought.

It was in Cimarron County, in the middle of the Oklahoma Panhandle, that I found one of the few farmers still on his land. A single cow stood forlornly facing away from the wind in a dusty field. The buildings, barns, and sheds were almost buried by drifts and in some places only the tops of fenceposts could be seen. I decided to photograph this scene.

DUST FILLS THE AIR

While making my pictures I could hardly breathe because the dust was everywhere. It was so heavy in the air that the land and the sky seemed to merge until there was no horizon. Strong winds raced along the flat land, picking up the sandy soil and making my hands and face sting.

Just as I was about to finish shooting, I saw the farmer and his two sons walk across the fields. As they pressed into the wind, the smallest child walked a few steps behind, his hands covering his eyes to protect them from the dust. I caught the three of them as they neared a shed.

This photograph was later printed everywhere, and it helped arouse sympathy for the farmers of this desolate area. People across the nation began to understand why the "Okies" were arriving in California in masses and why black blizzards darkened the sky in the East. It dramatized the need for prompt action and the importance of a soil conservation program.

But aside from becoming a famous documentary photograph for the Resettlement Administration, the picture was later exhibited in many museums and printed in many photographic books. It is now in the permanent collection of New York's Museum of Modern Art and appeared in the museum's show in 1959. It also was shown in the Metropolitan Museum's exhibit that year as well as that of the Unione Fotografica in Milan.

MAKES HIS SKULL SHOTS

After leaving the Dust Bowl I went north to the Dakotas where I took the picture that was to figure in the election campaign of 1936. It was dry there too, for there had been little snow and even less rain. The Federal Government was buying the Bad Lands for a national park. There was no water for livestock, and the bones and skulls of many animals could be seen around dried-up water holes on the parched pasture lands.

I found a sun-bleached skull and photographed

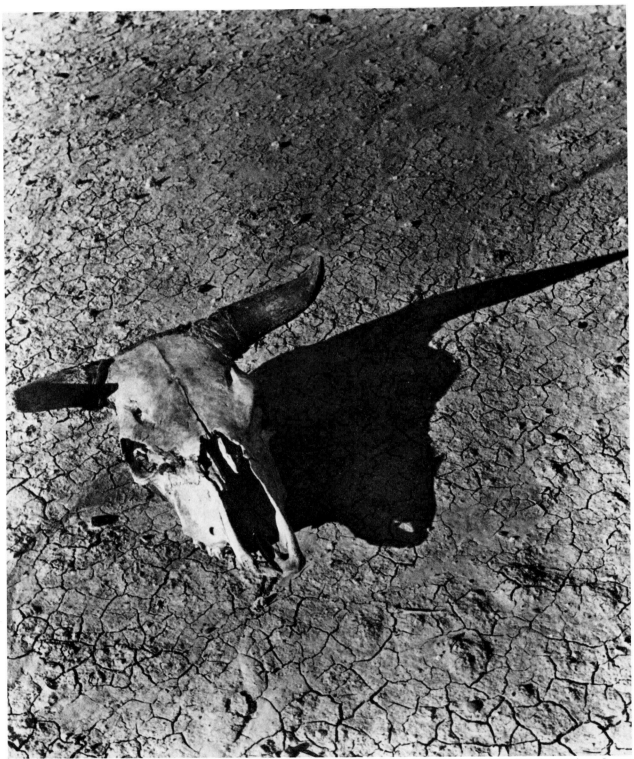

This sun-bleached skull appeared in pictures made by Rothstein that became an issue in the 1936 national political campaigns. It was photographed on the parched earth of Pennington County, South Dakota.

it against the cracked earth in Pennington County, S. Dakota. Experimenting with textures and shadows, I took many pictures and then moved the skull about 10 feet to a grassy spot near some cactus where I could get another effect.

Later during the summer of 1936 when the drought became worse, many cattle were dying because of the serious water shortage. The R.A. had released my pictures to the newspapers, and many of them printed the picture of the skull as a symbol of the drought's effect. President Roosevelt appointed a committee of agricultural experts to visit the affected areas of the Great Plains and to plan a relief program. I was assigned to accompany them on their hot and dusty tour. They were to report to F.D.R. when his election campaign train passed through Bismarck, N. Dakota.

PAPER CALLS PICTURES FAKE

But the day before the meeting, the campaign train was flooded with copies of the *Fargo* (N. Dakota) *Forum* featuring a front-page story and one of my skull pictures under the caption "A Wooden Nickel." The paper was strongly anti-administration and state pride had been wounded. The story branded this and other pictures sent out by the R.A. as fakes and accused me of using this skull as a stage property by placing it in several pictures taken in different parts of the state. The *Forum* ominously warned members of the President's party not to be taken in by "unreliable stories" of the drought in that state.

Since the nation's newspapers were almost solidly opposed to Roosevelt in 1936, they magnified the issue with enthusiasm. The *New York Herald Tribune* and *Chicago Tribune* Washington reporters went to the R.A.'s files and found two other pictures with the same skull but on what they considered different terrain. They also disclosed that I had taken the pictures and was receiving the princely salary of $2,600 a year and $5 per diem plus traveling expenses. The R.A.'s assistant photo chief, Edwin Locke, explained that I had made one view on the cracked, alkali ground and then moved the skull about 10 feet away for the others. But both papers played the story big, and the small-town *Fargo Forum* felt vindicated.

I then became the subject of political cartoonists and columnists. The inimitable Westbrook Pegler came to my defense even though he accepted the idea that I was transporting the skull around the country for pictures. In a column he wrote: "It

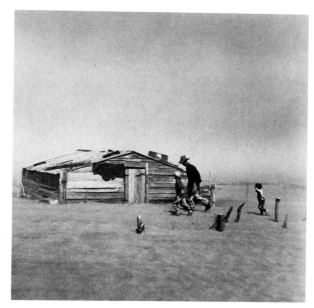

Rothstein's famous documentary photograph of the Dust Bowl was made during a raging storm. It has been published hundreds of times throughout the world.

wasn't the photographer's fault that we demand hokum in our pictures as well as in our oratory and politics and it probably was no fun to go clattering around the country lugging a cow skull along with his suitcase and all the gadgets and traps which a photographer has to carry in his line of work."

It took weeks for the furor to die down. But then 15 years later, in 1951, the issue was revived on the Senate floor by Bourke Hickenlooper, an Iowa Republican, who charged that the Democratic administration deliberately mislead the nation's leading publications to bolster its election campaigns. Comparing my skull picture with the composite of Sen. Tydings and Earl Browder used by the McCarthy forces during the 1950 senatorial race in Maryland, Hickenlooper hauled up all the old charges and some of the newspapers repeated them again along with my skull pictures.

It's not often that a photographer has a chance to make pictures like these in his first year as a professional. I'll also remember that trip west for two other reasons. My camera, a Zeiss Super Ikonta B, was made useless by the dust. And an operation was required on my right eye, with the result that I've been a left-eyed photographer ever since. In so many ways this was an assignment I could never forget.

The Darkroom That Went 600 MPH

Herbert Orth

Life converted a jet to meet its color deadline

As soon as the "no smoking" sign went off we dashed into the darkroom. By the time we reached 33,000 feet, our cruising altitude, the first batch of film was in the first developer. And some 4,000 miles later, at the completion of the eight-hour jet flight from London to Chicago, the 70 rolls of 35-mm color film (from 17 photographers) had been edited into layouts for 21 pages of color illustrations of Winston Churchill's funeral—complete with captions and text, and ready for *Life's* printers.

The story of that dramatic flight began with *Life's* decision to cover the historic event in color. Normally our color deadline is Wednesday, but the funeral was going to be on a Saturday. We were able to postpone the deadline, with the provision that the color for that issue "closed" no later than Saturday night in Chicago. This meant that the plant had to have all material in its final form by that time, so that the eight hours en route between London and Chicago had to be used for processing and to complete all of the editorial functions.

Immediately after this decision was made plans got underway to charter an airliner in which a photography lab and editorial office could be set up.

Dick Billings, associate editor, George Karas, chief of *Life's* photo lab, Herb Schwartz, assistant maintenance supervisor, and I met with officials of Seaboard World Airlines. They, having held preliminary discussions with Billings, were fully prepared for us.

Their engineers were equipped with wiring charts and layouts of the DC-8F jet we planned to use. We found that the only problems were water and electricity. The plane's electricity was 100 cycles, incompatible with the heaters used in our film-drying cabinets, as well as electric typewriters. The flying lab was going to need plenty of water to wash properly the large quantity of film we anticipated.

The airline shrugged off the problem of electricity by arranging to fly in a special converter from Chicago. They assured us, also, that they could provide the water we would require.

Meanwhile, with the help of technicians at Eastman Kodak, a formula was worked out that would allow us to process 30 rolls of 35-mm Ektachrome with only 10½ gallons of wash water, instead of about 75 gallons that would normally be required.

About two days before departure, our carpenter shop built six special crates, each of which held four 3½-gallon processing tanks. Each crate was equipped with a special hold-down lid that forced the tank covers into place very tightly, so there would be no leaks or spilling of chemicals—especially during take-offs and landings. Two drying cabinets also were constructed.

We and all our equipment arrived at the Sea-

Chartered airliner became a flying photo lab and editorial office. (All photographs by Herbert Orth).

Enlarger and other equipment are inspected in hangar a few hours before departure time.

Water drums are loaded on the plane, along with crates containing complete darkroom layout.

Setup for developing color film was thoroughly tested prior to use in flight. Entire darkroom area was 150 sq. ft.

Herbert Orth checks processed color films on airborne light table during airliner's return trip.

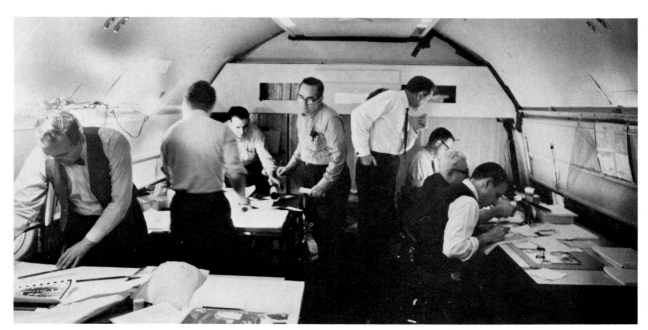

Members of the editorial department lay out pages while plane flies westward across the Atlantic Ocean.

board hangar at Kennedy airport on Friday afternoon. On the hangar floor was a full-size chalk layout of the interior of the plane. (The plane itself was expected to arrive at about 7 p.m.) This gave us an opportunity to set up all the furniture and darkroom equipment in proper place on the hangar floor, so that no time would be lost later on when loading actually began. Meanwhile, color chemicals were being mixed on the floor of the hangar.

As soon as the plane arrived, its interior was ripped apart. Two bulkheads were installed directly over the wings for the darkroom space.

Our entire darkroom area was a space of about 10 by 15 feet. This was divided into three rooms. Two were for color processing and the other was for black-and-white printing. This area was equipped with a 4x5 enlarger.

Because we knew, from the floor layout, exactly where everything belonged, we were able to load quickly. (Two 50-gallon drums of water and two empty drums for waste were strapped inside the plane.) Shortly after midnight we were in the air, heading for London.

On the plane were 34 members of the *Life* staff, headed by George Hunt, managing editor. The lab crew was too busy to sleep on the way over. First of all, the plane's electrical facilities had to be checked out. There hadn't been time for that while we were on the ground. Then there were curtains to be hung to subdivide the darkroom area into three separate rooms. We soon discovered that there were many light leaks that needed to be blocked up.

About five hours (and eight rolls of black tape) later we landed in London, satisfied that our flying lab was ready.

We remained on the ground for about three-and-a-half hours. During that time all the exposed film arrived from the photographers. As soon as each batch was received it was taken into the darkroom and loaded onto reels which were placed in light-tight tanks. We didn't want to start any processing before the plane was in flight, because of

the possibility of splashing chemicals out of their containers during take-off.

Because the temperature of the big jet's interior was controlled and maintained at close to 73 F, there was no great problem in holding the required temperatures for our solutions. Actually, only the first and color developers required special attention.

The driers were located in the forward section of the plane. Each was equipped with a heater fan that dried the film in about 20 minutes.

As soon as the film was dry it was carried, uncut, to the rear section, where the editors made their selections. The lab was given the dimensions of the space the individual shots were to occupy in the magazine. Each selected frame was cut from the roll, placed in the enlarger, and a paper negative was printed directly to size.

We had anticipated all sorts of problems in this step of the operation, because of the plane's vibration. In fact, we had experimented with an electronic flash head as an enlarger light source, to be used if the paper negatives were too unsharp. We had hoped to avoid using this method, because it would have been necessary to add a step to the process—focusing with the incandescent light and then replacing it with the electronic flash for the exposure.

The regular setup worked quite well, however, and I can safely say that our biggest surprise of the entire trip was seeing *sharp* enlargements from exposures of five to ten seconds. The explanation for this is, of course, that the entire enlarging setup vibrated together.

Probably our greatest problem of the trip was the plane's electrical supply. Because of the amount of power our equipment (photofloods, heaters, driers, electric typewriter, and light tables) drew, we taxed the electrical output to its maximum capacity. It was necessary for a Seaboard engineer, who was on the flight with us, to check constantly and let us know if we could turn on a light table without having to turn off something else, such as one of the driers.

The New War Photographers

Les Barry

Photographs by the author

Saigon, Vietnam

In the dining room of the Hotel Caravelle, Associated Press photographer Eddie Adams excused himself to go to the men's room. He got up from the table and slung a Nikon F over his shoulder. . . .

At Minh's Tailoring Shop on Tu Do Street, Charles Moore of Black Star, in Vietnam on a *Life* assignment, was being measured for a shirt. The tailor had to remind him to remove the Olympus Pen W that was hanging under his arm. . . .

At an infantry outpost somewhere near Phuoc Vinh, Kyoichi Sawada of United Press International put down his field pack and canteen belt to get into the chow line with the troops he'd been covering on patrol. A Leica M-3, suspended from his neck, dangled above the tray of food. . . .

In the back seat of an Army jeep, riding at night through ambush country on the highway between Bien Hoa and Saigon, Tom McHenry, Columbia Broadcasting System cameraman, cradled the driver's rifle in his arms. On his lap was a loaded Bolex H-16 Rex. . . .

This is the nature of war photography in Vietnam today. The only thing sure is that you'd better have a camera handy at all times, because you never know if the action is going to explode right beside you, or if you're going to have to hightail it for the hinterlands—50 or 150 or 350 miles away. It's the hottest extended news story of the decade, but it's probably the strangest war in history. There are no front lines. The action keeps popping up all over the country, like bubbles in a cauldron of boiling water—rising to the surface, bursting, and vanishing.

Danger? It's all around you. On the day before I arrived in Saigon, Bernard Kolenberg, a photographer on leave from the Albany (N.Y.) *Times-Union* to work for AP in Vietnam, died in an airplane accident. A few days later, Huynh Thanh My, an AP staffer, was killed when a Viet Cong bullet caught him during a battle in the Mekong Delta area. Several weeks after that, Dickey Chapelle, on assignment for *The National Observer* and WOR Radio, was fatally wounded by a land mine, while covering a large scale U.S. Marine operation near Chulai.

"Sure it's dangerous," Eddie Adams agreed. "But you don't try to hide from the shooting; you try to find it."

Dirck Halstead, head of UPI's photo operation in Vietnam, put it this way: "There's no specific area of operation, and the Viet Cong is a very elusive enemy, so we work the way the military works—as a reaction force. When you hear something's happened, you try to get there in time to go in with the first wave of troops, because by the second wave the V.C. probably will be gone."

Adams added: "Once you get to the battleground you seem to forget about the danger. You concentrate on making pictures. The problem is finding out what's going on and where it's happening, and then figuring out how to get yourself there."

The problem is a constant one. The U.S. Military Assistance Command, Vietnam (known as MacVee), holds daily briefing sessions for the press, but these are aftermaths of the action, and although valuable to the correspondents, they're of little use to the photographers.

"We have to build up our own unofficial sources of information," Adams told me. "We make our own contacts. Usually they're friends; we've met them on previous operations or around the bases."

Sawada said: "We learn to recognize the signs. I know that if a big group is going out it's going to be a big operation, or at least more than just a routine patrol. I try to make contact to go along.

"A good thing to watch is the medical evacuation helicopters. If a bunch of them are ready to take off, there's a big operation going on somewhere. You have to find out where, and try to tag along."

In chasing a war that explodes anywhere, from one end of the country to the other, the new war photographers spend much of their time arranging for transportation. Each has to arrange his own. There is a commercial airline, Air Viet Nam, but its destinations are limited, and, as far as I'm concerned, it's not entirely reliable. (I wanted to get from Saigon to Danang, and I bought a ticket and made a reservation for that day's only flight there. After a five-hour wait at the airport, I was advised that the flight had been cancelled. The reason: the pilot hadn't shown up. A fellow potential passenger told me that the airline's pilots were actually members of the Vietnamese Air Force who flew commercial on a moonlighting basis. I never got that fact confirmed officially, but the incident is indicative of what commercial travel is like within the country.) Most members of the press get around by military aircraft. This, of course, has to be on a sort of standby, space-available basis, but at least the military fly to where the action is. The photographer has to find out for himself where that is, by information or according to hunch, but once he knows where he wants to go, MacVee or the Army or the Air Force will help him get there, as long as his transportation doesn't

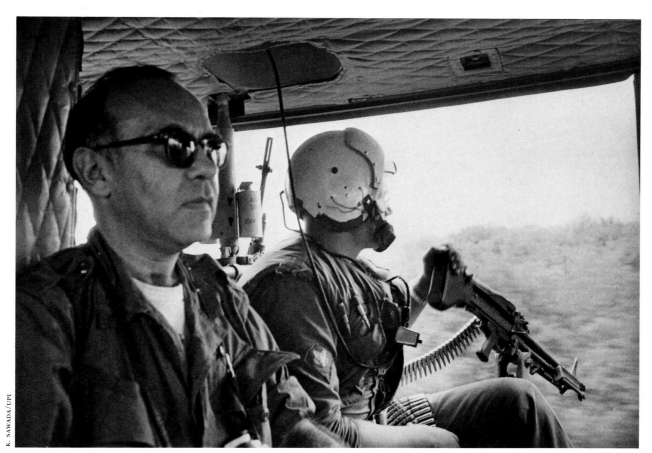

Helicopter hitchhiker is Popular Photography's Les Barry, looking for combat action in Vietnam.

Waiting for a flight to Danang.

Moving up with troops toward the battle area.

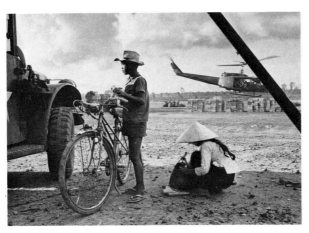

Supply helicopter arrives from Saigon.

Armed trucks advance toward forward outpost.

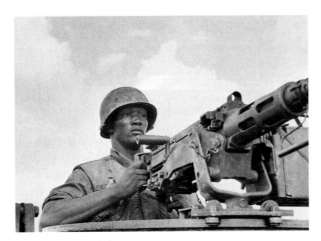

Machine-gunner helps to protect convoy.

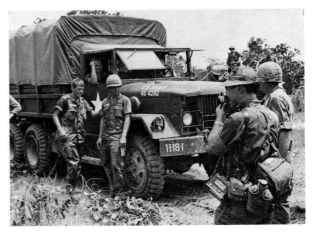

UPI photographer Kyoichi Sawada at work

interfere with their normal course of business.

CHECKING OUT A HUNCH

For example, Sawada, who'd just come back from six relatively unexciting days in the field near An Khe, had a hunch that something might be going on with the 1st Infantry Division's 2nd Brigade, near Phuoc Vinh, about 60 miles north of Saigon. They'd moved their advance headquarters to that area a few days earlier, and Sawada had the feeling they were building up for a major move. He invited me to join him in checking it out.

Early the following morning, we checked with MacVee, where a very cooperative major telephoned the Brigade's rear headquarters to find out the exact location of the group in the field and whether they were involved in any important action. We found out where the troops could be found, but got a noncommittal answer about their activities and plans. Sawada thought we ought to go anyway, if only to give me an idea of what's behind getting a war picture.

Getting to Phuoc Vinh meant picking up a helicopter ride out of Bien Hoa, about 30 miles north of Saigon. There were no flights to Bien Hoa available, so we hired a car and driver for that leg of the trip. About 10 miles out of Saigon, the driver suddenly speeded up to better than 80 miles an hour. I asked Sawada if we were in some sort of hurry. He laughed, indicated the tall grass on both sides of the road, and explained that we were in "ambush country." He said he thought that the driver was being unusually cautious, because the real danger came from driving through there after dark. (I didn't know, at the time, that our return along the same route would be well after the sun had set.)

OFF TO BRIGADE FORWARD

At Bien Hoa, we found the Public Relations tent, where the soldier in charge (I couldn't tell his rank, because he'd taken off his shirt in the late morning heat) handed us a couple of tepid soft drinks (this war is being fought by the Pepsi generation), and made the necessary telephone calls to find out how and when we could get a "chopper" to "Brigade Forward." He learned that a load of C ration was going to be carried into the jungle in a few minutes, and he arranged for the resupply helicopter to stop for us. Soon after he hung up, the helicopter descended, in a cloud of dust, onto the little pad nearby. Apparently, it had been just about to take off from some other part of the base when our call had come through. While its rotors still turned, kicking sand and dust into our teeth and hair, we scrambled aboard and found seats between the two grim machine gunners at the hatches, and up and away we went. It took about 15 minutes to fly to Brigade Forward, where we were met by the public relations officer, Lt. Phillip Aigner, who told us that a motor convoy had just made contact with the V. C. in the jungle about 12 miles away. A medical evacuation helicopter was going in that direction, and the lieutenant arranged for the three of us (he, being one of the Army's multitude of amateur photographers, wanted to go along and see how we "pros" worked) to ride it out to the point of operation. The "medivac chopper" was a foot off the ground when we fought the wash of its rotors to climb aboard. Our take-off and, in fact, the entire flight, was one big swoop. We sort of leaped into the air, with the feeling you get once you dive from a springboard; whipped in low, just above the dense treetop foliage; and fell (for want of a better word) through a hole in the jungle. The helicopter never touched the ground. The pilot turned to us and waved us off the aircraft. We jumped, and he left, as abruptly as he had arrived. Suddenly, I realized we were surrounded by U. S. troops, many of whom were admiring or examining a pea-green truck that was poking its hood out from the under-

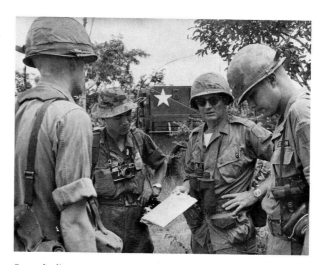

Sawada listens to a briefing before action.

225

growth. We found the colonel in charge of the convoy (you couldn't tell his rank, because he wasn't wearing any insignia, but you could tell he was a high officer by his binoculars). He told us that we had missed the action. The convoy had come across a Viet Cong truck, carrying 101 bags of rice (about 5½ tons), six bicycles, and six or seven V. C. soldiers. There had been a brief exchange of shots before the outnumbered V. C. had vanished into the jungle. A patrol had gone off in pursuit of them, but we'd missed their departure.

A TRUCK IS RECAPTURED

The truck, it turned out, had been originally captured or stolen from our side. The bicycles, considered strategic military vehicles in Vietnam, were destroyed by hand grenades. The rice was to be taken to one of the villages for distribution by local officials.

Having missed the action and, from Sawada's standpoint, the opportunity to take any usable pictures, we decided to ride back to Brigade Forward with the convoy. We proceeded along a jungle road, which had been invisible from the air, until we came out on the major (dirt) highway. About half the 35- to 40-vehicle convoy had turned onto the highway, when we heard rifle shots, and then half a dozen bursts of machine-gun fire, coming from the vicinity of the lead vehicles. The convoy stopped. Lt. Aigner said, "Ambush, I guess," and I, through some instinct, glanced down at my camera to check on the film counter. I had my only real twinge of emotion when I noticed it read "34." I grabbed another camera out of my gadget bag and was loading it frantically, while keeping an eye on Sawada, who was standing up, looking as though he was about to leap from the back of the truck and head for the sounds, when the shooting stopped, almost as suddenly as it had started, and

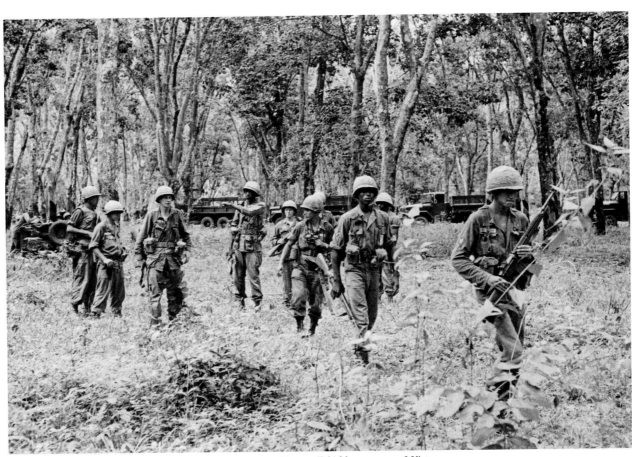

Sawada takes off with patrol for hike through jungle, seeking well-hidden groups of Vietcong.

the convoy started moving again. Sawada slumped back down onto his seat and said, "No use running up there now. They'll be gone. (Afterwards, I read in a newspaper article that two days later a 2nd Brigade convoy had ridden into the biggest Viet Cong ambush of the war up to that time, suffering "moderate" casualties.)

Back at Brigade Forward, I was conversing with several soldiers who were carrying cameras, when Sawada rushed up to announce that a "search and destroy" patrol was going out.

We joined them.

TWO DANGERS

Going out on patrol means hiking. We hiked through a rubber plantation, and then through an hour of jungle. I remembered some words of advice I had received from Eddie Adams: "There are two big dangers in the field—land mines and the possibility of getting lost. Stay behind the G.I.s, but don't let them get out of sight, whatever you do. Even if you see an opportunity to take a great picture, forget it if it means getting separated from the troops. They can't worry about stragglers; and you'd be amazed at how fast and how completely you can get lost in those jungles."

I thought, also, of what Dirck Halstead had said at dinner the previous evening: "Remember these two words: *bao chi* (pronounced: bow chee). They mean 'press' in Vietnamese. If you get caught by the V.C., shout '*bao chi,*' and maybe they won't shoot you."

Meanwhile, we hiked. We came out of the jungle, into an area of tall grass. There were some shots from the trees behind us. The sergeant in charge of the patrol threw down a smoke grenade, and the soldiers moved toward the source of the sound, their weapons ready for action. Sawada, I noticed, was already taking pictures. He ex-

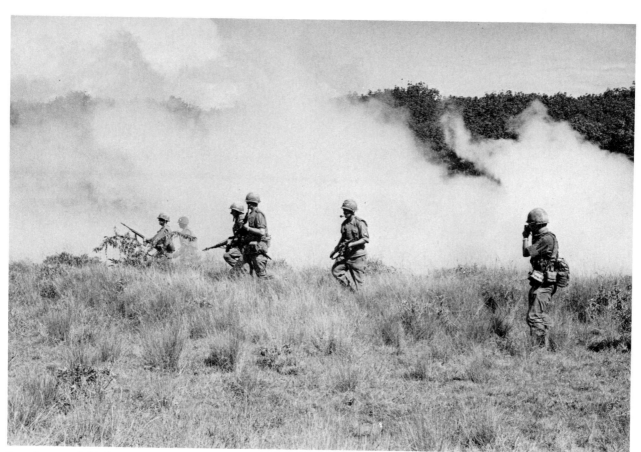

Sweeping area behind cover of smoke grenade, U.S. infantrymen are photographed by Sawada.

plained, afterward, that you start taking pictures as soon as there's a possibility of action, so that if anything happens you might catch a shot of it taking place. Nothing happened, except that he got a set of pictures of a squad moving forward, under cover of smoke, and I got some pictures of him taking them.

BACK TO BIEN HOA

A few minutes later, we were back at the camp. It was getting late in the afternoon (too late for any more patrols to be going out), and there was a resupply helicopter unloading, prior to heading back to Bien Hoa. We decided to take it. While we were waiting, Tom McHenry and a Vietnamese sound engineer came in from a patrol. The four of us flew back to Bien Hoa, where we hitched a ride on an Army jeep going to Saigon. It was after dark, although a bright moon and a succession of artillery tracers lit the night, but both McHenry and Sawada checked to see that their cameras were loaded.

When we reached the section of highway that ran through so-called ambush country, McHenry set his Bolex carefully onto his lap, and picked up the driver's rifle from the floor of the jeep. He flipped off the safety catch.

Sawada and I had dinner that night with Eddie Adams and Sam Jones, AP's chief of photography

for Southeast Asia. I related the events of the day.

"No use complaining," Jones said. "You can't get a usable picture every time you go out. This is a tough war, but one of the toughest things is finding it."

You come to think of the photographers as fighters. They're civilians, but they take more risks than any of the troops, if only because of the frequency with which they enter combat situations. The troops are in plenty of danger a good deal of the time, as they go about the business of war; but the photographers work at getting themselves into danger *most* of the time, because that's where the pictures are, and that's where they can do their type of fighting. Their enemy is made up of the hundreds of publications all over the world that swallow up the products of their cameras day after day, and modern high-speed, sophisticated communications methods that feed their insatiable appetites.

WHERE'RE THE PICTURES?

Halstead told me: "Communications are so good, and we're so sensitive to communications, that when our news-side sends out a bulletin on a big story, we'll get a query back from New York within ten minutes, asking when the photographs can be expected.

"In previous wars, if you got a picture, everyone said, 'Fine, and how about that!' But now, they expect a constant flow.

"So here's what's happened. In order to make sure we have transmission time available on the radio circuits when we get pictures, we reserve time in advance. As a result, we have six or eight hours of time scheduled and paid for every day, and we have to get pictures to fill this paid time. Normally, it takes about 20 pictures a day to make our reserving the time economical. Usually, we can get extra time when we need it. There have been days when we (UPI) have transmitted as many as 50 good to sensational war pictures.

"Filling the basic time with good usable material—that's the nut. And when you've paid for this much broadcast time, you're not looking for only combat pictures. We're looking for good features, too. We try to come up with a well-rounded picture coverage, but frankly, we're so busy running after the hot news story, a lot of the good feature stuff gets away. Maybe an unfair picture of the situation here emerges, because of our concentration on combat, but as a news service we have to

Competitors AP and UPI have radiophoto transmitters side by side at headquarters of Radio Saigon.

concentrate on the hottest, most urgent news.

"What we really need is more photographers."

Both AP and UPI are looking for more free-lance photography.

Jones said: "The war covers such a wide area, such a great amount of territory, that we can't station staff photographers all over the country. We pick a few strategic locations and keep them covered. A free-lancer could just about pick his location, start taking pictures, and sell to either service and a lot of publications that are looking for exclusive coverage. There are so many things to shoot, even our newsmen carry cameras. ("And," Adams interjected, "most of the photographers wind up writing—occasional dispatches or little features they happen to come across.") The reporters aren't photographers by any stretch of the imagination, but we show them how to operate their cameras, and they come back with a lot of good pictures—usable pictures."

SOURCE OF 'INSTANT SUCCESS'?

Halstead called Vietnam a possible source of "instant success" in photojournalism. He explained: "There's a tendency in the States for a young guy who wants to break into editorial photography to feel there's a closed shop against him—until somehow he gets a reputation. He can get an instant reputation here. He has to provide his own means of getting here, but if he can take pictures, we'll help him get his accreditations; we'll give him film; we'll take care of all his processing; we'll pay him 15 bucks cash for each picture we send out; and we'll send it with his credit line.

"There's no premium—right now, anyway—on length of service, background, experience, or whatever you want to call it. There's no background for combat photography, anyway. It's different. In this war, it takes initiative and guts—and mostly initiative."

Jones said: "Good photographers in Vietnam are not necessarily good photographers in the U.S. But this is the best place in the world to become a photojournalist, if you have any aptitude for it at all."

"And if you don't want to be a combat photographer," Halstead added, "there's an unlimited number of non-combat photo features that can be shot here."

Both services expect free-lance contributors to supply their own cameras. Both recommend and use 35-mm.

"The ease and mobility of 35-mm, and the extended firing power of a 36-exposure roll of film, mean you can take more good pictures, because you can take more pictures faster than were ever taken in any war," said Adams.

With occasional individual variations, each wire service photographer working in Vietnam carries two Nikon F's, a Leica M-2 or M-3, and a Nikonos. (Horst Faas, AP's Pulitzer Prize winner, who's the subject of a special article elsewhere in this issue, carries only Leicas—two or three, according to Jones—and his Nikonos.) For lenses, each AP staffer gets a 35-mm (usually for the Leica), a 90-mm, a 105-mm, and a 200-mm. (Adams also keeps a 2x TelXtender with him. "You'd be surprised," he said, "at how often you find yourself doubling the focal length of the 200-mm lens with the TelXtender to move in on a shot that you wouldn't otherwise be able to get close to.") The UPI photographers, who often use wide-angle lenses on their Nikons, also get 135-mm and 200-mm lenses for their basic outfits.

WORKHORSE OF THE WAR

The Nikonos, Nikon's underwater camera, is the "sleeper" of the war. Being waterproof, it's the camera you use in rain, mud, flying dust, or when the humidity is so high "other cameras sweat."

"It's the workhorse of the war," Sawada said. "If they ever develop it to the point where you can load it fast, and use longer (than 35-mm) lenses with it, it will become the basic camera of photojournalism."

All the wire service photographers use Kodak Tri-X, exclusively, for black-and-white. They use Ektacolor-X and High Speed Ektachrome when color is required. At UPI, they rate the Tri-X at E.I. 400, and develop it in HC-110, at one-to-three. At AP, they rate it at 250, and develop it in Microdol-X.

Each service feels it has the best combination for combating the problem of contrast. Each works for flat negatives and shadow detail.

Our casual conversation about cameras and photography was taking place over lunch in the ninth-floor dining room on top of the Hotel Caravelle in Saigon. In the background, we could hear big artillery and mortars firing, from positions no more than five miles from where we sat; and it occurred to me that the one thing really required of a war photographer is a sense of fantasy, in order to make sense out of the unreal world in

which they function. I found something ludicrous about being able just to buy a ticket on a regularly scheduled Thai International flight from Bangkok to Saigon, with no more frills and fuss than booking a flight between New York and Boston. I couldn't help admiring the objectivity with which the photographers go about their jobs, day after day, going off to war, with nothing more exotic about their behavior than the fact that they put on Army fatigues and jungle boots, and carry canteens full of water and steel helmets on their belts, in order to be dressed conventionally for their line of work. Each of them has a close familiarity with death and danger and violence; and when I asked about their political attitudes about the war they parried my questions with cliché answers about having to do a job of covering the news.

In reflecting, it reminds me a lot of my childhood when, as an aspiring journalist in the Hildy Johnson tradition, I used to be the foreign correspondent when the kids in the neighborhood played war.

Requiem for a Giant

Arthur Goldsmith

Life was gone but its influence on photography and photojournalism would long endure in book publishing as well as in magazines

They began telephoning *Life* staff members at home before 8 A.M. on a gray Friday morning early in December. There was to be a meeting of the magazine's employees later that day in the Ponti Room, the big auditorium at Time-Life's Manhattan headquarters. Purpose? Couldn't be revealed ahead of time. "When I heard that," one *Life* photographer told me, "I knew it was the end."

So did practically everybody else. The world's greatest picture magazine had been faltering for years, afflicted by severe financial problems and an editorial identity crisis. Rumors of its forthcoming demise had been with us for a long time, and the real question was not would it really happen, but how soon. Therefore, it came as no surprise when Andrew Heiskell, Time Inc.'s chairman of the board, with tears welling in his eyes, announced that *Life* would cease publication after its year-end issue of December 29, 1972.

No surprise, but that didn't ease the pain and shock. It was like a death in the family for many of the people at that grim, emotion-charged meeting, and for many on the outside, too: readers, photographers, contributors, members of the publishing and photographic community. A magazine, more than most human enterprises, ac-

quires a living personality, deeply involving the emotions both of its creators and consumers. *Life,* during 36 years as our leading words-and-pictures mass magazine, had become a window through which America looked out on the world and a mirror in which it saw itself reflected. Many of us grew up with *Life,* its visual images having helped shape our view of human events and the nature of the universe. In particular, for any of us who love photography, its total influence has been enormous. Gone now, incredibly gone, as if you looked up one morning and saw that the Empire State Building or the Golden Gate Bridge had vanished overnight.

Popular Photography began just six months after *Life's* first issue reached the newsstand. During the years, we have published the work of many *Life* photographers, described their working methods to our readers, shared in the developing of photographic techniques, and occasionally provided *Life* picture people with a forum for opinions and ideas. We deeply regret that this dialog has come to an end. As a tribute to the outstanding photography and the distinguished photographers that made *Life* such an exciting publication for nearly four decades, we have devoted the following section to some of *Life's* great images: a small sample

from a vast, rich storehouse; a token of remembrance for past achievements.

"It's the end of an era." Many people were saying that when they first heard the news. And it is true: for the first time since the 1930s, the U.S. is without a major picture-oriented magazine, without a great general-interest publication (with the possible exception of *Reader's Digest*). A casualty of the electronic revolution and an age of splintering special interests, it has gone the way of those other fallen giants: *Collier's, The Saturday Evening Post,* and *Look.*

As former *Life* film critic Richard Schickel commented in *The New York Times:* "Alone of all the printed matter we turn out in this country, *Life* was, to borrow a phrase, trying to bring us all together again, asking us to be still for a minute, contemplate a picture or a string of words and suggest—but not insist on—an interpretation of

them . . . We are now, I believe, a nation of small audiences—truly a lonely crowd, at last, because that's the way we seem to want it. And the fear must be that, with the passing of the last of the national magazines, there is no force powerful enough to reassemble us, except in moments of high national tragedy."

But although *Life* is gone, its influence on American life, on visual communications, on photographers and photography is very much alive and will persist, I believe, for a long time to come.

It is easy to forget today, with a glut of television images and live satellite transmission from Peking and the moon, what an exciting novelty *Life* was when it first appeared, how it opened up a new world of visual wonder and excitement. How it brought strange corners of the world and the great leaders and celebrities closer to Main Street than ever before.

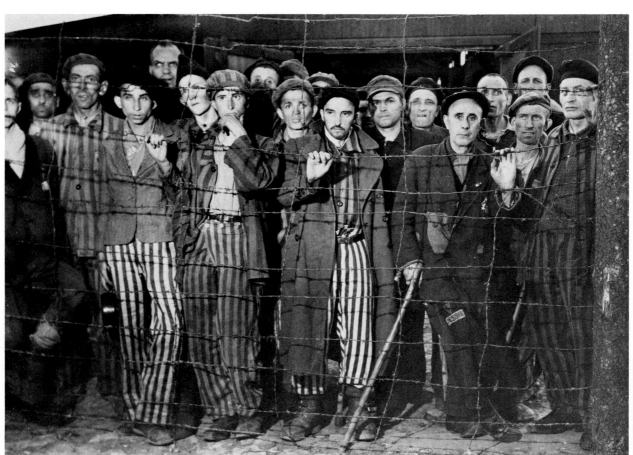

SURVIVORS OF BUCHENWALD

MARGARET BOURKE-WHITE

Long before the age of Marshall McLuhan, Henry Luce and his editorial advisors sensed the latent power of visual communication; that the American public was ready to become an eyewitness. "Thus to see, and to be shown, is now the will and new expectancy of half mankind," he wrote in his famous prospectus for *Life* magazine in 1936. Magazine X, as the new publication was code-named during its formative months, was designed to fill that need: to show the world in pictures. When the first issue appeared November 23, 1936, it was a rapid sellout with 235,000 copies going to charter subscribers and another 200,-000 grabbed off the newsstands. Within four months, circulation had soared close to a million, and it seemed as if at least half of mankind, indeed, was trying to get its hands on a copy. During the first year, and often enough later, you had to hurry to the newsstand on publication day to grab a copy before they were all gobbled up.

Ironically enough, *Life*'s instant popularity nearly did it in. Circulation and production costs soared far beyond advertising revenue, which had been pegged at what turned out to be an unrealistically modest level. Eventually, it cost Luce about $5 million to keep the magazine from "dying of success," as *Time* dryly commented, and it wasn't until 1939 that it went solidly into the black. From then on, until the end of the '60s, it remained one of the most popular and lucrative magazines in the history of American publishing. At its peak year, it boasted a circulation of more than 8 million readers and an advertising revenue of $127 million. All told, during *Life*'s lifetime it earned a fabulous $3.5 *billion* dollars in advertising income alone.

Although the magazine's format and formula was a daring mass-media innovation, *Life* was not the first picture publication. The techniques of modern photojournalism have their roots in Weimar, Germany and England in the post-World-War I era. Years before *Life,* publications like the *Illustrated London News, The Münchner Illustrierte Presse,* and several of the Ullstein magazines were experimenting with new forms of picture-and-text layouts, and encouraging a new breed of press photographers: men like Martin Munkacsi, Dr. Erich Salomon, and Alfred Eisenstaedt, pioneers in candid-style photojournalism by available light.

What *Life* did was adapt these concepts to the American market and to hire many of the new photojournalists including Eisenstaedt. There followed a remarkably fertile period of exploration and experimentation in which the techniques of photojournalism were developed to sometimes brilliant and stunning heights: the use of multipicture spreads to reveal the subject in depth, the story-telling photographic sequence, the emphasis on photographs that interpret as well as document, the smashing of important pictures big on a full page or across a spread, the realism and spontaneity of available-light reportage, the sophisticated integration of captions and photographs, an increasing use of color to tell the story, the refinement of the photographic essay into a form of visual poetry. We take these techniques so much for granted now, and they have been adapted to so many uses from annual reports to educational filmstrips, we tend to forget they once were exciting experiments.

There used to be a saying around *Life* that "There isn't anything wrong with the magazine that a few good pictures won't fix." Even if only partly true, it expressed an attitude. For many years, during its most creative and successful days, the emphasis was on pictures, and the photographer was king. *Life* gave prestige and resources to its staff photographers as no other publication has done before or since, creating its superstars and acting as a training ground for new talent over a time span of nearly four decades. A list of *Life* staffers, stringers, and free lances whose major works have appeared on its pages would read like a Who's Who of contemporary photography.

There was an esprit about *Life* that many felt strongly, especially in its early days. In *More Than Meets the Eye,* Carl Mydans, who joined the staff as the first issue went to press, recalls the excitement at its birth. "We expanded with the magic and speed of protoplasmic cells: young men and women appeared, formed departments, and these grew, divided and multiplied until they filled the top floors of the Chrysler Building with throbbing, growing tissue, crammed into offices and overflowing into passageways, all vibrating with brilliance and temper, with ego and expression, with ideas and idiosyncrasies." Before long, *Life* was top banana, and there was a sense of pride in being associated with it. "You worked a little harder when you were on assignment for *Life,*" recalls Philippe Halsman, the only photographer with 101 *Life* covers to his credit, a record that will never be challenged now. "One had a sense of power," he continued. "On assignment for *Life* I always felt I could walk up to any door in the middle of the night, ring the bell, introduce myself

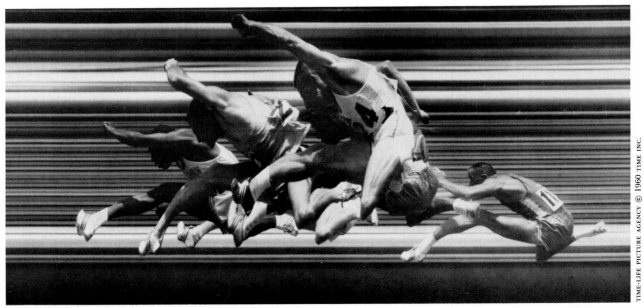

U.S. OLYMPIC HURDLES TEAM

GEORGE SILK

to the husband and say 'I want to photograph your wife taking a bath,' and I would get complete cooperation."

Not that it was all a picnic. Over the years, *Life* has had its share of sadists, ogres and egomaniacs aboard. There tended to be a chronic state of cold war between the word people and the picture people with tensions that sometimes were productive, but other times destructive. There were confrontations and fights, most notably the battle between W. Eugene Smith and *Life.* Angered by what he felt to be lack of a rightful say in the selection and layout of photographs, he forsook *Life* for the more hospitable pages of *Popular Photography's Annual* for the first publications of his famous Pittsburgh essay. To outsiders, the *Life* crew often seemed arrogant and clannish, members of a snobbish, incestuous clique who were admittedly good, but nobody was that damn good. As one cynical free lance once remarked to me, no staff photographer at *Life* was capable of walking across water, let alone their stringers.

There were many years of fabulous assignments and magnificent photographic essays, the equal to which we are not likely to see again in American magazine publishing: Leonard McCombe's "Career Girl" and "Cowboy," W. Eugene Smith's "Midwife," "Country Doctor," and "Spanish Village," Gordon Parks' "Flavio," George Silk's

"America's Cup Race," Brian Brake's "Monsoon," Lennart Nilsson's "Inside the Womb," and John Dominis' "Great Cats of Africa," to name just a few which have burned themselves into the retina and visual memory of millions.

To score its big scoops, to cover its big stories, to create its memorable images, the magazine sometimes spent fabulous sums and marshalled awesome resources. An expedition was mounted to get Eliot Elisofon to Africa's Mountains of the Moon, the U.S. Air Force was enlisted to land George Silk on a North Polar ice floe, task forces of up to 100 or more people were deployed to cover major sports events, coronations, national conventions, and other spectacles. Carrying photographic overkill to extravagant limits, *Life* staffers at one time were shooting about half a million pictures a year with 10,000 being published, for a wastage of 50-to-1!

The publication played an important role in developing the techniques and technology of photography, too. On the one hand, it was one of the earliest American picture publications to explore the authenticity and immediacy possible with available light reportage. (Leonard McCombe's contract once specifically forbade him from photographing with a flash!) On the other hand, it exploited all the elaborate equipment it could find or devise for creating spectacular images.

234

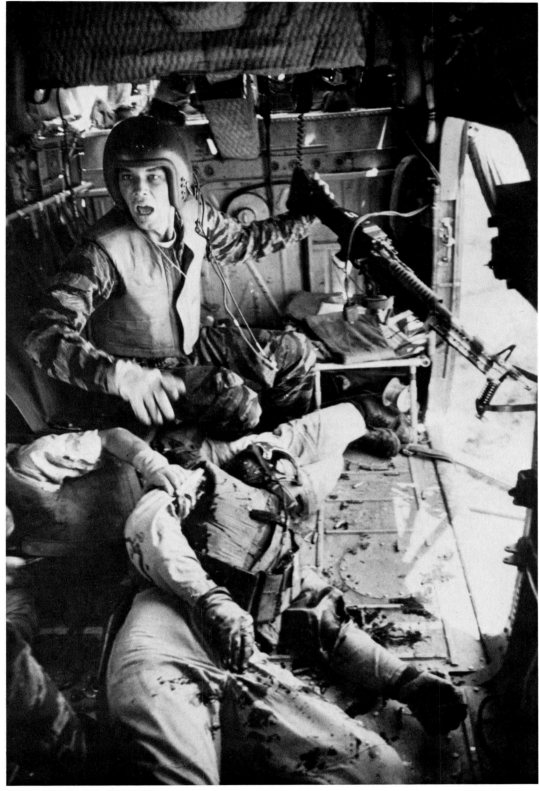

DEATH IN THE AIR, VIETNAM

LARRY BURROWS

Staffer Gjon Mili was a pioneer in the use of electronic flash for stroboscopic effects. Fritz Goro and Andreas Feininger were endlessly resourceful in finding new ways to portray nature and scientific subjects. George Silk attached a wide-angle camera to his skis for a notable winter sports story. Ralph Morse earned the reputation of being the Cecil B. DeMille of photojournalism with his skill at setting up complex camera coverage of major events. (On one of *Life*'s last published assignments, he covered the Apollo 7 moon launching.)

Born and grown to maturity in a Time of Troubles, *Life* has had a shooting war to cover during most of its existence, and the skill and courage of its combat photographers is legendary. Robert Capa's classic image of the death of a Spanish soldier—possibly the most frequently published war picture of all time—appeared in *Life* in 1937. During World War II, Capa landed with the first wave at Normandy, recording that moment in a picture which vibrates with the shock and terror of combat. (He later was to die from a land mine in Indo-China.) W. Eugene Smith was severely wounded covering the Pacific War for *Life*. David Douglas Duncan did some of his finest work under fire with his beloved Marines in Korea, and later during the siege of Khesanh in Vietnam. Paul Schutzer was killed in action during the six-day Arab-Israeli War. Larry Burrows was turning out some of the best still-picture coverage of Vietnam when his helicopter was reported missing in Laos. As Henry Luce once commented: "Though we did not plan *Life* as a war magazine, it turned out that way."

But, of course, *Life* had its frivolous aspects, too: it was show biz and entertainment, as well as hard news, and its critics accused it of being sensational, superficial, and silly. For many years, *Life* went to a party, until that editorial gimmick was worn utterly threadbare. *Life* always loved a fad: the Big Apple, Conga Lines, piano smashing, panty raids, college kids cramming themselves into telephone booths. Through the years, it held up a mirror to Americans, showing our foibles and absurdities. The cornball and the kooky appeared in "Speaking of Pictures" and "Parting Shots." In truth, even as the magazine grew in its sophistication and intellectual ambitions, it always retained something of the flavor of the brash old newspaper rotogravure picture section. It knew the power of sex and the gruesome as circulation builders, and often exploited both. The sexy images seem tame enough to run in a Sunday school bulletin by today's *Playboy* and *Penthouse* standards, but the horror of its "grue" pictures still can inspire nightmares: the shriveled skull of the Japanese soldier on a tank, for instance, or the motorist hanging from telephone wires, where he was flung by a crash.

In one of its major contributions as a communication medium, *Life* turned towards education with spectacular results. Its major, lavishly illustrated special features on nature, science, history and religion were milestones in magazine publishing; and copies containing "The World We Live In" or "The Story of Man" were saved, thumbed over, worn out by teachers, students, and just curious people who found this visual level of learning to be fun, as well as informative. Out of this eventually grew Time-Life's huge and successful book division. It was a powerful word medium too, publishing Churchill's memoirs, Hemingway's *Old Man and The Sea,* and many other notable authors.

So now that it's over, and *Life* will never go to another party, what was the magazine? So enormous and complex an institution, and one we all have been, one way or another, so close to, is difficult to sum up. Before television, it was, among other things, mass communication incarnate. It attempted, sometimes with arrogance and sometimes with an understanding which evoked the most responsive vibrations, to be the eyes of America. Not the voice, but the eyes. To show us, through the skill and daring of its wide-ranging photographers, an eyewitness vision of what was Out There, of the events, the personalities, the wonders, the ceremonies, and the disasters. And to show us ourselves, our fads and foolishness, our greatness and our tragedies. Although such an ambitious goal could never be fully achieved, and contained the hubris leading to its own failures, *Life* did indeed, in its greatest days, provide a commonality of shared visual experience for millions of Americans. It was our tribal house organ, the showcase of our culture, the expression of our concerns, the vehicle by which to reach fame and success.

It was, of course, a distorted and sometimes pernicious image which *Life* showed us, both in its role of mirror and window. The publication was, after all, the Super Establishment and part of the Luce empire with all the chauvinism, personal prejudices, and hobby horses this involved. But no lens is flawless, and the wonder of *Life* is, not that it so often failed, but that, as a mass-circulation magazine, it so often achieved the excellence

and beauty it did. It talked down the least, it attracted the best, and it aspired to the most.

Toward the end, it became an obviously sick publication. I used to have a group of white birch trees outside my house, but the ravages of blight and age have destroyed them. I could always tell when another tree was going by the fungus which sprang out of its side. Magazines, too, show the stigmata of disease and decay, and in its last years, *Life* was no exception. It had lost its sense of mission both as a news media and a vehicle for fine visual images. The moment of truth came, it seems to me, when men first landed on the moon. We all saw that event and participated in it live, on television in our own living room or wherever, and when the printed images reached us so many days later, the edge was off and it was old, cold news.

At one time, *Life* spent great sums of money to rush its pictures into print. For the coronation of Queen Elizabeth II, the editors proudly boasted of their remarkable feat in bringing four-color coverage to their readers after the event. But with satellite TV coverage, all this became irrelevant and obsolete. As *Time* magazine bitterly commented in its obit for its sister publication: "Ten days to bring back the coronation in color? Ten nanoseconds for the next one, beamed to TV sets anywhere on earth."

So *Life* gave up on news, and rather gave up on pictures too. The staff was cut and photographic assignments were sharply reduced. The lab only printed up 8×10s instead of unlimited 11×14s. There also were fewer pages and more material bought from stock or from the outside rather than being created from within. The arrogance was gone, and with it the style and conviction too. No longer was the image of *Life* a handsome young Leonard McCombe or David Douglas Duncan setting off for dangerous far corners of the world, but of middle-aged guys with ulcers worrying about their retirement benefits.

Then, toward the very end, the magazine underwent a curious and lovely transfiguration: it discovered pictures again. It began to run exciting photographs full-page and across double-trucks. It began to run extensive picture features. But like a drowning human being whose life flashes through his mind during the instant before the end, *Life* too began reliving its own past: page after page of the great old *Life* photographs, as if it were, unconsciously at least, celebrating its own forthcoming demise.

Maybe judgments on *Life*'s editorial perform-ance were overly harsh and critical as observers sensed its problems. In America, everybody hates a loser, and during the last few years, the publication certainly was not coming on as a winner. But I think of the comments of Carl Mydans, a wise and sensitive man who was with the magazine from the very beginning. "People would complain that the pictures today aren't as good as they used to be," he told me. "I don't believe that was so. The magazine was using better pictures than ever. But what happened is that we raised the expectation for good pictures in the reader. In our 36 years we created and educated a mass audience to what pictures can do, and they went along with us, sometimes unwittingly."

We raised the expectation for good pictures.

It is perhaps as fitting an epitaph for *Life* magazine as one can think of.

So Time-Life had its Black Friday December 8, 1972. (When magazines fold, it's often just before Christmas, not because publishers are sadistic, but because that's the time that projections for next year and chances for survival are in.) And people inside and out reacted in their various ways: with tears, with bitterness, with gallows humor and desperate laughter, with stoicism or despair, with a grim turning to other jobs and alternate futures.

Could *Life* have been saved? Is it possible to revive it? Who will fill the gap? What does it mean for photographers, for the publishing industry, for human communications? What is the future of the still photo image? Questions that will be haunting us for a long time to come.

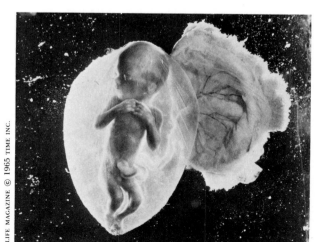

18-WEEK-OLD FETUS LENNART NILSSON

LIFE MAGAZINE © 1965 TIME INC.

237

AP to Wire Laser Photos

Leendert Drukker

A high-speed photo transmission system for wiring high-quality prints to its member newspapers is slated to be introduced by the Associated Press in 1974.

The new development uses 1/1,200-watt helium-neon lasers at both the transmission and receiving ends. The original print is scanned by the laser, using an oscillating mirror system. The reflected light is "read" by photocells, and converted by them into electrical form for transmission. At the receiving end, the system works somewhat in reverse: the electrical current modulates a laser beam that scans, again with a mirror system, light-sensitive dry-silver paper. This paper, manufactured by 3M Co., is then heat processed, avoiding the need for chemical solutions and drying.

The new system is expected to replace two others presently in use. The most common one of these is the decades-old low-cost electrolytic process, which works with solution-soaked paper. Its drawbacks are limited tone scale and poor definition. The other present process, which was introduced only a few years ago, gives possibly slightly better quality prints than the forthcoming Laserphoto. It depends, however, on stabilization processing, and AP says it has found its reliability to be low, and its maintenance costs high.

Probably the most significant aspect of the Laserphoto system is that it anticipates a worsening transmission problem, overcomes it, and promises *consistently* high quality. The growing problem is that of increasingly noisy telephone circuits. At present photos are sent over these wires in the same way as sound or music; minute variations in

Laserphoto opens possibility of an electronic "darkroom," permitting cropping, dodging, and burning-in while watching results on TV screen.

electrical amplitude are translated into variations in black-and-white tones in the print at the receiving end.

As these phone lines are becoming more and more crowded with traffic, they are introducing more and more distortions in photo transmission. However, A.T.&T. expects to replace the voice lines with digital ones in the '70s. The tonal scale of prints would be translated into numbers, not electrical amplitude. The "coding" process is somewhat reminiscent of painting-by-numbers. Laserphoto anticipates this development, which would greatly increase the faithfulness of photo transmission. Moreover, printing time would be speeded up to four times, allowing an 8×10 print to be received in two minutes instead of eight.

Even before the realization of the digital transmission, Laserphoto promises more faithful prints, as it has a built-in quality control system. It will automatically transmit a small step-wedge before each picture. This will show the range of tones from white to black that the receiver can produce at that moment. If the picture that follows does not have those tones, it means it is not the receiver's fault.

The receiver loads with 500-ft. rolls of paper. As the pictures come in over the wire, they are automatically cut off and individually stacked in a tray. Processed by heat and perfectly dry, they have a somewhat shiny finish. As true photographs AP points out, they should be a special boon for papers printed by photo offset.

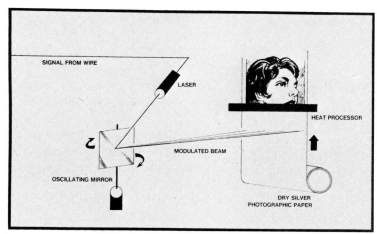

To print Laserphoto, signal from wire modulates helium-neon laser's beam. Its output, reflected by oscillating mirror, scans dry-silver paper, which is processed by heat. Same-size segment of actual print (bottom) indicates quality. (AP Photos).

Viva, Aultman

Wayne McClintock

*Meet a 5-ft 1-in. Texan who was the Robert Capa
of the Mexican Revolution in 1910*

Photographic coverage of the Vietnam War helped to keep the public abreast of a conflict that varied from moment to moment, and viewers gave no thought to the tremendous work it represented —but the first photo coverage of a war that was "almost" immediate was the picturing of the Mexican Revolution in 1910.

The man most responsible for that coverage today is almost unknown except to a handful of people who are continually harking back to his faded photos of bandoliered Mexican revolutionaries. His name may be forgotten and his exploits faded in memory, but his photos live on and people around the world have viewed them as first-hand accounts of the fighting that took place in the searing desert of Chihuahua on the border with the U.S. and were printed in newspapers just days later.

He was Otis Aultman, a wiry five-foot one-inch man born in Holden, Mo., who took that state's famous "show me" philosophy to heart and showed the world what was happening as the famous Pancho Villa led his "dorados" or golden ones on their way to sweep a dictator from oppression of the Mexican people.

And he did it under some of the worst circumstances known to newsmen. He trudged behind foreign troops in hanging clouds of dust, lugging his view cameras and tripods. He pulled the focusing cloth over his head while bullets whizzed all around him and calmly set his image on the groundglass, stopped down his aperture to get his exposure—there were, of course, no exposure meters in his day—put the lens cap on, inserted his holder, and removed the lens cap for a "guess" exposure.

All around him, Mexicans were killing Mexicans, but Aultman was concerned only about his photos, oblivious to danger.

Unlike today's generation that has loyalty to a special camera and film size, Aultman used them all. At various times, he used 8×10 view cameras, a 5×7 Graflex, and folding Kodak cameras.

When the revolution broke out, Aultman was a photographer in El Paso, Tx., with the firm of Scott Photo Co. Scott was later to go to Hollywood where he would be the favorite cameraman of movie stars Mabel Normand and Annette Kellerman.

Aultman wasted no time after word came that hostilities had begun in Mexico. He dashed from El Paso to Casas Grandes, a small village about 100 miles southwest of El Paso, and pictured the dead in Mexico's first big revolutionary battle. He met Pancho Villa for the first time. A friend at first, Aultman was later to photograph the carnage of a

Villa force at Columbus, N.M., and document the $8 million Gen. John Pershing "punitive expedition" into northern Mexico chasing after Villa.

When the Francisco Madero forces marched on Juarez just across the Rio Grande river from El Paso, Aultman was with them. The street fighting was grist for his camera as adobe walls were pockmarked by the Mauser bullets.

Aultman once was traveling with three American soldiers of fortune who had contracted to fight with the Madero forces for $10 a day, but had received only three pairs of socks worth 10 cents, when they happened upon an abandoned bank. The three men, all explosives experts, blew the bank door with a charge of dynamite and opened the vault doors with another. Aultman watched Mexican pesos settle from the air, and the three

Aultman is shown cooking over a campfire during one of the many desert treks he made in search of scenic photographs.

Americans scooped up the money which was worth 60 American cents for each peso. The three revolutionaries returned to El Paso and purchased silk socks and silk pajamas and "lit out" for parts unknown, Aultman said.

Aultman was on hand when the Juarez garrison surrendered and famed world-soldier Jose Garibaldi accepted the commander's sword.

Traveling with Pancho Villa in later battles, Aultman found some of the fighting a luxury, because Villa had a railroad car set up for foreign correspondents—complete with a darkroom.

He shot glass negatives. Development was by inspection. Later he was to use film in holders with film rated an amazing ASA 10! In his early photos he sensitized his own plates and paper.

Lenses were Zeiss, Cook, Goertz, and rapid rectilinear. Contact prints were made because there were no enlargers in the Southwest then.

More than just a photographer, Aultman was an adventurer. He hobnobbed with soldiers of fortune such as Tracy Richardson who campaigned in South and Central America. He was later to play host to a convalescing Richardson, an expert machine gunner who had been shot through the lungs. The two later made an archaeological safari into the wilds of Honduras.

Not only a still photographer, Aultman was one of the first movie men, shooting film for Pathe News Co.

A partner with him during 1911–1914 revolutionary days was Robert P. Dorman, who went on to become head of Acme News Pictures of NEA. Dorman flew during the Villa violence to get to the scenes of intense fighting.

Cartoonist Bud Fisher of "Mutt & Jeff" fame also traveled with Aultman to the front to see the revolution.

Along with several other foolhardy men, Aultman formed the Adventurers Club in El Paso. It was during one of their drinking sessions in Aultman's darkroom in 1916 that word came of the raid on Columbus, N.M. Aultman had a teletype machine in his darkroom, and the notice came clacking over at 5 a.m. He left immediately for the scene, about 60 miles west of El Paso. He arrived at 10 a.m. while the fires were still burning. His pictures gave the U.S. the first view of an atrocity that was to culminate in action sending Pershing into Mexico at the head of the troops. The last cavalry charge in Army history would be made during the expedition. But, like many newsmen, Aultman missed the historical moment, but did

241

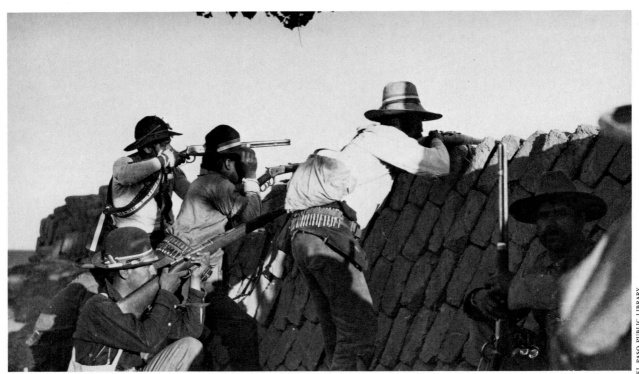

"Soldados" take cover behind adobe bricks while firing on "Federales" during a skirmish.

A Columbus, N.M. resident is documented in death by Aultman the morning after Pancho Villa's raid.

manage to bump across the Chihuahuan desert in Packard automobiles to document Pershing's futile chase that prepared American soldiers for the First World War.

Once the fires of revolution died down, Aultman settled into routine photography—routine for him. He was official photographer for the Juarez, Mexico, (across from El Paso) Race Track and did photography for the Secret Service—no one knows what secret documents he photographed. He did the photographic printing for the El Paso Police Department.

Despite his early predilection for violent photography, Aultman is remembered also for his scenic shots in and around El Paso. He had a regular page in the El Paso *Times* on Sunday where his favorite shots of nearby historic forts, stage trails, and mountains were published.

Aultman began photography in Trinidad, Co., taught by his older brother, Ollie Aultman. Indeed, Ollie's son, Glenn, still has the Aultman Studio there.

An early marriage turned bad in 1907, and Aultman barely made it over the Colorado state line ahead of the sheriff. He came to El Paso and an exciting destiny.

His daughter, Lela May Aultman, of Denver, stayed with her mother, but visited her father and remembers the gentle side of Otis:

"The day I spent with my father in El Paso was mostly going around to meet his good friends. He did tell me about his interest in photographing desert flowers, and that he would dash out to the desert at an instant's notice when he got word that some rare cactus or other flower was about to bloom," she recalls.

"He was, of course, known best for his photography in connection with Mexican-Texas border history, and I heard him speak often of his friendship with Villa."

Noting his versatility, she said, "I remember that much earlier, when Pathe motion pictures pioneered news pictures from the air, he was a photographer for them."

Aultman's only son, William, is chairman of the board of James Montgomery Water Engineers of Pasadena, Ca. He was in Saigon for his company two summers ago—perhaps a flicker of his father's adventurousness.

The end came for Otis Aultman March 6, 1943, when he fell from a seven-foot platform near his darkroom. He was 67 years old.

Local citizens mourned him, and the Chamber of Commerce president and now banker Chris

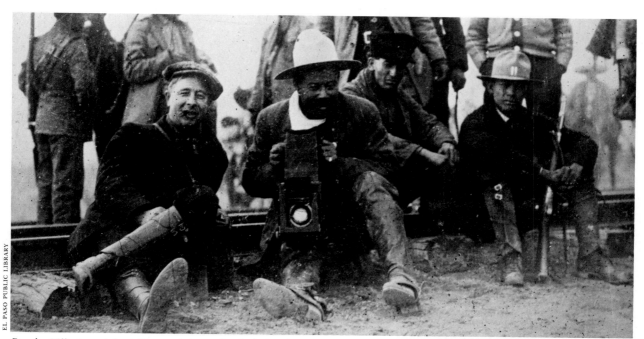

Pancho Villa turned the tables on Aultman by displaying his own "battlefield" Graflex camera.

Fox proposed to save his pictures for posterity. The Chamber bought the entire file for $600. They were later given to the El Paso Public Library.

History buffs and writers have sifted through them time and again. Several important photographs have disappeared. Many books about the revolution, Villa, and the Pershing expedition are illustrated with Aultman photos. Some are credited with the Aultman byline, others carry the library credit.

Mrs. Elizabeth Davis is in charge of the Aultman collection and deals with those wanting copies. She deplores that no true index of the photos has been made, nor have all the subjects and scenes been positively identified.

Chris Fox spoke about the historic photography soon after Aultman's death. He said, "His pictures recite a graphic story of the days when a wild and woolly Southwest was battling for recognition as a modern spot on the map."

In a greater sense, Aultman's pictures tell a graphic story of mankind and in the telling, illustrate the drive that all photographic pioneers had to take technique far beyond its capabilities—and make it perform for all future generations.

One Day in Life's "One Day in the Life of America"

John G. Morris

It was old home week in the haunted halls of the Time & Life building in New York's Rockefeller Center. The 29th floor corridors, which had once connected the world's most modern and luxurious magazine offices, only to lose their pulse when *Life* died in December, 1972, were humming again.

It was September 5, 1974, and across the country 92 photographers were furiously at work recording "one day in the life of America" for a *Special Report* that would go on sale six weeks later in an edition of 1,100,000 copies priced at $1.50.

Life's Philip B. Kunhardt, Jr., an assistant managing editor of the old magazine and now in charge, had dreamed for several years of making a "sweeping wide-angle survey of one 24-hour period in the life of the country"; originally it was to have been the world. "Like Everyman, this would be Anyday." The Thursday after Labor Day was chosen because it was calculated to be a normal day of work, school, business, politics, and sport, following the summer's vacations.

The first photographer to come in with film that day, dropping off his early-morning take on David Rockefeller before going to *The New York Times* to shoot the editorial board, was the 76-year-old veteran Alfred Eisenstaedt. Later he would cover the U.S. Tennis Open in Forest Hills.

Next came John Loengard, the former *Life* staff photographer who now, as picture editor of the issue, had had the enviable but delicate job of choosing the 92 photographers who would end up with $200-day-rate assignments. From Aarons, Slim, to Zimmerman, John, everyone wanted in. Almost everyone. Gordon Parks apologized that

he would be too busy working on his new movie on Leadbelly. Leonard McCombe was reluctant for personal reasons.

Former *Life* staffer John Bryson was so anxious to participate that he returned from a movie location in Switzerland. Cornell Capa, busy preparing the opening of his International Center of Photography on Fifth Avenue, agreed to put in a 20-hour day photographing five literary celebrities in New England—a chartered plane would make the connections. John Dominis, another *Life* alumnus and now picture editor of *People,* was delighted to spend a day on a chartered boat in New York harbor. For Bruce Davidson (as for Loengard) it was a birthday, and furthermore his wife was expecting another child momentarily (it waited a day). Bill Ray's mother had just died, and Bill wound up making color pictures of her funeral.

So it went through the roster—doubtlessly the most talented collection of photographers ever to work on a single assignment. Ansel Adams agreed to send in a few Polaroid SX-70 color shots—one, his favorite, was used. Bill Eppridge made an early-morning aerial run with a traffic spotter over Los Angeles, then flew to San Francisco to photograph Randolph Hearst. Ralph Morse flew with WACS who parachuted into Fort Bragg, N.C. (their efforts did not make the magazine); he had shot pictures of the same division 30 years before. Elliott Erwitt got two assignments suitable for his pixieish humor: an animal park where he met a most interested ostrich and the Miss America warmup, where he uncannily picked only one girl for close-ups—Miss Texas. She was chosen Miss America two days later. His Magnum colleague

Burt Glinn had an even sexier assignment: a stripper joint in Dallas, where he shot an amusing picture *Life* wouldn't find room to publish.

Not all the chosen photographers were celebrated. Loengard kept the door open to all comers with interesting ideas. In addition, almost 200 photographers shot on their own. From the 200 takes thus submitted "on approval," 12 pictures made the magazine. One of these, by Jerry Gay of *The Seattle Times,* showing two Mexican migrants who were about to hop a freight for home, is one of the most memorable pictures in the issue.

Washington coverage posed a special problem. Fortunately the new Ford administration had brought David Hume Kennerly into the White House as the President's personal photographer, and the President agreed to let Kennerly shoot him from breakfast to bedtime. In theory, all these pictures were nonexclusive, and *Life*'s editors feared that some might be requested by the wire services. However, the White House cleverly admitted the press to the breakfast session, giving the wires the "informals" they wanted that day and also giving Kennerly a chance to contribute an amusing picture to the *Life* story—of the press photographers working over the President as he toasted his English muffin.

Congress was not very active that day, but *Life* assigned Harry Benson to cover the Kissingers throughout the day—resulting in an offbeat picture of the couple holding hands in the back seat of a State Department limousine. Further *Life* prearrangements resulted in several other nice Washington touches: Fred Maroon's picture of Chief Justice Burger lunching alone in his chambers and Stan Tretick's of Judge Sirica breakfasting in his back yard over *The Washington Post.* Senator Ted Kennedy was photographed but left out.

No photographer shot as many celebrities during the day as did New York free lance Jill Krementz, who was invited to make her own list and then line them up. She began at 5:20 A.M. with Barbara Walters, then in quick succession caught Beverly Sills, Margaret Mead, Gloria Steinem, dress designer Halston fitting actress Carol Channing, Kurt Vonnegut, Irving Berlin, Alvin Ailey, Betty Furness, Robert Rauschenberg, and Robert Gottlieb, the Alfred A. Knopf editor. Seven of the twelve made the issue—along with a Schnauzer named Bozo, whom Jill shot as he ate a $1.40 lunch at the Animal Gourmet.

One of editor Kunhardt's serious purposes was to document the "social history" of America in the mid-1970s, as reflected in changing patterns of family life, manners and morals. Three photographers were assigned to spend the day with families: Ken Heyman with a Wisconsin family of 10 children, Roy de Carava with a black family in Brooklyn, Suzanne Szasz with a Massachusetts mother—resulting in a lovely color picture of mother and children skinny-dipping after school. In New York, Evelyn Hofer shot simple but eloquent wedding portraits in color of 11 couples who were married that day at City Hall.

Changing patterns of sexual mores were reflected in several assignments: Milton Greene was sent to Chicago to shoot a routine day in the *Playboy* studios, as veteran Playmate photographer Pompeo Posar shot a male-female nude scene. Photographer Bud Lee said a lot with one simple picture—of a New York career girl casually dressing in front of her date, and a spontaneous picture from Rick Smolan of a boy and girl student sharing a shower off-campus at Dickinson College enlivened the "America Awakes" lead section.

Perhaps the greatest technical challenge was faced, in totally different ways, by Co Rentmeester, the former *Life* staffer from Holland, and by New York photographer Max Waldman, who had the only studio assignment of the day. His job was frantic; he had to schedule into 16 hours some 17 different performers and groups who were entertaining that night in New York, ranging from Jason Robards with Colleen Dewhurst to musicals, singers, and dance groups. A tour de force, he pulled it off brilliantly in a four-page layout of 11 pictures.

Rentmeester's job was equally difficult but more dangerous. With reporter Linda Witt, he spent 24 hours roaming the Chicago streets with police in squad cars, photographing in color the victims of robbery, rape, burglary, and "possible homicide," for the most unusual color layout.

The American scene, landscape division, posed one of the toughest problems for Kunhardt and the other editors. How would September 5 differ from other days in such beauty spots as the national parks, the coasts, and forests? It wouldn't, but no portrait of an American day would be complete without this heritage. George Silk was dispatched to Yellowstone and the Tetons. Using four motor-drive SLRs, he shot 50 rolls of color, catching wild buffalo, herons, moose, mountain

sheep, and even trout in one exhausting day of long-lens shooting. Silk was erroneously credited with one picture he did *not* shoot—of a convict in Kansas: it was by George Tice.

Aerial specialist William Garnett, encountering in the Southwest almost the only bad weather in the country that day, nevertheless got the expected vista of Arizona's Monument Valley. In Maine, Henry Groskinsky shot a sunrise with a fisherman; all the way West, Robert Goodman wound up the day (actually making the elapsed time span 29 hours in total) with Hawaiian fishermen pulling up anchor.

Following scenic "color postcard" pages, *Life* used color (Barbara Pfeffer's) with deliberate ugliness to show the scarred earth of the vast, new, open-pit mines of Colstrip, Mt. Accompanying black-and-white, also by Ms. Pfeffer, showed the bleak lives faced by the women whose men work the mines. In the sharpest editorial comment of the issue, *Life* said: "Big energy companies, it now seems certain, are about to ruin the whole Big Sky country of Montana, South Dakota, and Wyoming."

In the old days *Life* was often stronger on spectacle than on sympathy, often sophomorically treating people cynically in "gimmick" pictures, with notable exceptions such as the great Eugene Smith essays. Kunhardt says that his one, most serious regret is that the reader "doesn't really get to know" any of the families presented by Ken Heyman, Szasz, and de Carava. Nevertheless, theirs include some images rich in human insight, as well as others, such as Abigail Heyman's old lady clutching her doll in a nursing home, Brian Lanker's Buffalo (Ks.) barbershop and lunch counter, Ted Polumbaum's confused two-year-old on moving day, Susan Greenwood's young lovers, and Heinz Kluetmeir's Wisconsin students at a bar.

In fact, there were just too many fine pictures for a mere 80 pages of editorial matter. As it was, 17 of the 92 assigned photographers were left out entirely, and while Associated Press and a number of newspapers were asked to submit their complete file for the day, not a single press picture made it.

The issue's one news scoop came from David Kennerly, submitted with his day's White House take. It showed President Ford conferring at his desk with lawyer Philip Buchen, General Haig, and an unfamiliar man who turned out to be Benton Becker, the lawyer who later that day carried a draft of the Presidential pardon to Richard Nixon. On the editors' first runthrough it was a reject, but Sunday, September 8, it took on sudden meaning as the pardon was announced. It then became a black-and-white "double truck."

Thanks to the long and thorough preparations, the issue closed with amazing smoothness. The Time & Life labs, color and b&w, stood by with full crews from Thursday through the weekend to process 1,278 rolls of film, making 2,150 contact sheets and 1,300 prints. Kodak kept its Fair Lawn, N.J., plant open Saturday and Sunday to process 567 rolls of color.

All photographers were encouraged to make their own initial selections, but in some cases they simply could not be around. Loengard managed somehow to look at all the black-and-white. Kuhnhardt, Loengard, art director Elton Robinson, assisted by photographer Gjon Mili and Ernst Haas, former *Life* picture editor Ron Bailey and associate editor Jan Mason, plowed through the color. They were determined to see all the "selects" before making even the first layouts, so that the issue could be properly organized into the three major sections: America Awakes, All Day Long, After Dark.

Then the material, spread out on the floor for black-and-white, and on six or eight light boxes for color, was pulled together in the familiar, informal *Life* manner of group journalism, with Kunhardt asking the questions: "What's your opener? . . . Doesn't that one work better? . . . No, he shot his wad over there . . . You'd better go back to the contacts . . . Ah, this looks like it . . . okay, *here* we go!"

However, as opposed to the endless *Life* edit conferences of the 1950s and '60s, this effort was simple and sweet: Kunhardt firmly calling the final shots, Robinson organizing all the layouts himself. Old *Life* hand Loudon Wainwright wrote the lyrical section intros, and David Scherman, sole survivor of *Life*'s first issue in 1936, wrote some fascinating footnotes on the day. Ron Bailey read all the copy, with a final reading by Otto Fuerbringer, the former *Time* managing editor who now heads Time, Inc. Magazine Development. The total editorial staff, most of them "temporary," numbered only 33.

How would it all work out? Would the public buy *Life* at a buck and a half a throw? Were subscriptions *really* unnecessary? Would this issue live up to the 90-percent sale of the previous "report"

on the year 1973 (Would *People* get off the ground so that *Life* could proceed with tests for resumption as a monthly? Didn't the sensational success of the book *The Best of Life* (1,100,000 copies sold) indicate that the public appetite for photojournalism was still there? Wasn't there another *Day Book* right here in the overflow of good pictures?

"It's really an absurd idea," Kunhardt says of *One Day* in modest self-deprecation, but he knows better: *Life* has undertaken a notable journalistic experiment, and the country is richer for this visual perspective of itself.

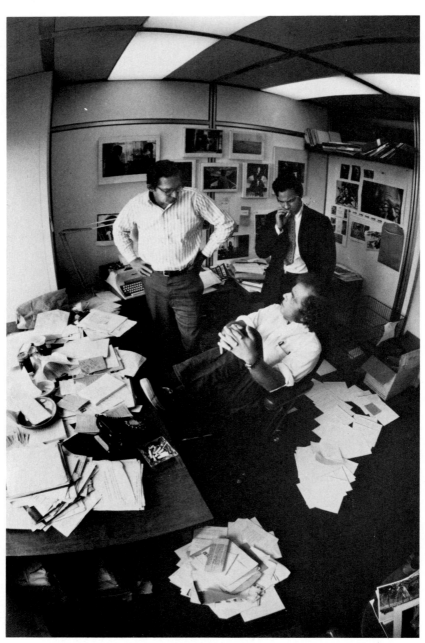

Facing a tight time schedule are managing editor Philip Kunhardt (l.), picture editor John Loengard (seated), and editorial associate Edward Kern (r.). Contributing photographer Alfred Eisenstaedt caught the tension.

Moving Images

Common Errors in Home Movies

E. A. Reeve

Eight simple rules to improve your technique and raise your results several notches closer to professional work

The faults which mark the work of many, if not most, beginners in personal movie making are fortunately few in number and easy to overcome.

But they are serious faults—so serious that until they *are* overcome one's films are unsatisfactory to everyone. Improvement will come with experience. But experience is a dear teacher and it is in the hope of saving beginners much loss of film, time and respect for their ability and equipment that this article is written.

What are the errors most frequently made by beginners? First, and perhaps most serious, is failure to hold the camera steadily. In movie making it is the subject and not the camera which should move. If the camera is held unsteadily, the motion of the subject is obscured, on the projection screen, by the swaying and jiggling of the entire picture. It is as though you held up a snapshot for someone to see and jerked and wiggled it continuously. The picture simply couldn't be seen clearly, and your friend would soon stop trying to see it.

Watch some fixed object—a house, a tree, a fence—in each scene as your films are projected. That object should remain stationary on the screen. If it moves in relation to the edges of the picture, you have broken Rule No. 1—you have failed to hold the camera steadily.

What can you do about it? Nothing in regard to films already made. Plenty in your future filming. First, see that you are grasping the camera as the manufacturer suggests. If it is used at the eye level, as most movie cameras are, give it firm, three-point support. Let it rest against your forehead. Hold it with two hands, and keep your elbows close against your body. Place your feet apart to obtain a firm stance.

Practice, without operating the camera, by sighting through the finder at some stationary object. Soon you will find the grasp and the stance and the depth of breathing that will let you keep your target steadily centered in the finder for the ten or more seconds required to take a movie scene. Then do as well while actually taking movies, and when you see the film projected you'll be pleased at the improvement.

Some people simply can't hold a camera absolutely steady. Some think they can, but can't. But there's a solution for these people, too. It is—use a tripod. In fact, it is safe to say that no matter how steadily you can hold a movie camera, the use of a tripod will make a definite improvement in your movies.

There are times, of course, when the motion picture camera should be moved while in opera-

tion—to record a broad expanse of landscape, to follow a moving subject such as a car, a boat, a group of people, or the family dog at play. But swinging the camera during operation should be the exception, and Common Error No. 2 is excessive use of this motion.

Swinging the camera in a horizontal plane is called panoraming, which is commonly abbreviated to panning or pamming. Swinging the camera vertically is called tilting. In all too many amateur films, almost every foot is exposed with one or the other or a combination of these two camera motions. The effect is monotonous and tiring, and the constant camera motion causes true subject motion to suffer in comparison, besides making it difficult fully to see the subject.

Take most of your scenes with an absolutely stationary camera. Avoid the inclination to play your lens over a group of people or the facade of a building as though the lens were a hose and your subject a lawn needing water. Step back until the viewfinder tells you that you can take in the desired area with a stationary camera. Save your panning and tilting for the occasions when they are necessary and appropriate.

Common Error No. 3 is the fast and jerky pan or tilt. If the motion is very fast, the pictures will be blurred. A less speedy but still too fast pan will give that annoying effect of vertical objects jump-

ing sidewise across the screen. When it *is* desirable to pan or tilt, be sure that the motion is very slow and uniform. And any but a very slow, steady pan will be useless, because the eye can't enjoy the scene as it whizzes by.

A *series* of scenes from a fixed viewpoint will usually be more satisfactory than a scene taken by swinging the camera through an arc. But if you want to show the juxtaposition of various scenes, shoot the first with a stationary camera, then pan *slowly* to the next and film it with the camera held still, and so on.

Remember that the speed of panning will always seem greater on the screen than it appears through the camera viewfinder. When you think you are panning slowly enough, cut your speed in half and you'll get better results.

If your reason for panning is to follow a moving object—a child running, a car moving along a street, the action in an athletic event, then and only then should you disregard the rule of panning slowly. For in this case the problem is to keep the moving object constantly in the picture, and if the background becomes blurred in the process no one will criticize you.

Fourth in our list of common errors is inadequate length of scenes. When the camera is humming away, time seems to fly and many beginners stop shooting after a few seconds, thinking that

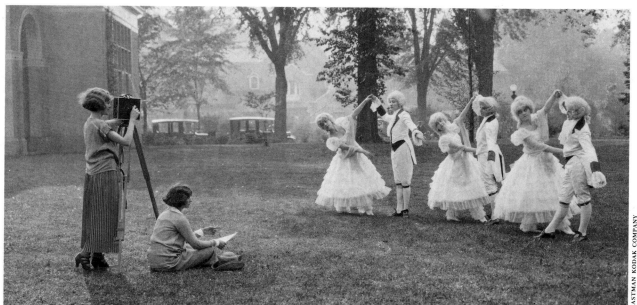

Home movie cameras had to be tripod-mounted when they were first marketed in the 1920s.

they've used enough film on that particular camera run. But that scene will flash on and off the screen before the audience has had time to see it, and what was intended to be commendable regard for the cost of film turns out to be waste.

A good general rule is that no scene should appear on the screen for less than 10 seconds. Ten seconds is your minimum. It is enough for any scene in which the action or the interest is continuous, but not changing in nature, such as scenic shots and pictures of people doing nothing in particular. Of course, many scenes will require a much longer camera running time. Scenes involving a flow of action will necessarily be continued until the end of the desired action.

Counting while filming is the generally used way of avoiding too-short scenes. A little practice with your watch before will make you accurate at counting off the seconds.

If your camera is used on a tripod and you are not peering through the viewfinder, you can regulate scene length by watching the footage dial.

At normal operating speed, 16 frames per second, a 16 mm. camera exposes a foot of film (40 frames) in 2½ seconds; four feet in the minimum scene length time—10 seconds.

At normal speed an 8 mm. camera exposes a foot of film (80 frames) in 5 seconds; never stop the 8 mm. camera until the footage dial has clicked off at least two feet. The film size has no effect, of course, on the minimum desirable scene length *as expressed in time.*

Error No. 5 is failure to take closeups. People—family and friends—appear in most personal movie films, yet all too often they are recognizable only with difficulty, if at all. Not because the pictures are not clear and bright but because one's face is small in a picture which takes in the full length of the figure and perhaps a lot of foreground and background, too.

Get up close. Intersperse your long shots with scenes in which a single head fills the entire height of your picture area. Walk up until you just get the chin in at the bottom of the viewfinder without scalping the subject with the top of the viewfinder, and shoot. Then you'll have family record pictures which are really likenesses.

Your camera may have a universal focus (fixed focus) lens, and that will limit you somewhat in taking real close closeups. Consult the instruction book to see just how close you can work and still get sharp focus.

The stronger the light the smaller a lens setting you can use, and the smaller the lens setting the closer you can get without losing sharp focus. If yours is an 8 mm. camera with the usual 12½ mm. lens, you'll find that good sharp close-ups can be taken when the light is good enough so that you're using a lens setting of *f*/8 or *f*/11. But with a 16 mm. camera with the usual 1-inch lens, the taking of real close-ups really demands a focusing mount lens.

There are so many worthwhile things which, if you are equipped for taking close-ups, you can inject into your films, that a focusing mount lens is an excellent investment. Watch the professionally made films for camera technique, and you'll be surprised at the relative footage devoted to close-ups.

Incidentally, the amateur can learn much through study of the professional's camera technique. So skillfully is the professional film produced, however, that we are often unconscious of the medium of portrayal. To study technique it is sometimes necessary to see a good film twice, as only upon second viewing can we give full attention to the cameraman's methods.

Errors in exposure are not nearly so common as they were formerly, due to today's improved films and to the increasing use of exposure meters. But errors in this class are still common, and are one of the faults that the beginner should strive to avoid. A scene which appears too light has suffered from over-exposure; too large a lens opening was used. Dark scenes are the result of under exposure—the use of too small a lens opening for the subject and the prevailing light.

More care in using the exposure chart built into or supplied with the camera may be the correct recommendation for those who have exposure troubles. But the chart can't possibly cover every possible combination of subject and light condition, and at best must leave a lot to the cameraman's judgment. And judgment, to be good, must be based upon far more constant use than the average amateur makes of his cameras.

The best way to avoid exposure trouble is to use, and use correctly, a good exposure meter. Good ones aren't cheap, but neither is film and it doesn't take long for one to waste enough film through incorrect exposure to have paid for a high-quality, dependable exposure meter.

If you are taking movies in natural color, correct exposure is even more important. Black-and-white film has considerable latitude—will give acceptable results even though not quite correctly

exposed. But color film is far more exacting. To get good color, you must hit your exposures *right.* The results are certainly worth the effort.

Failure to get natural action is a common fault among amateur movie makers. Those who have taken up movies after successful experience in still photography know the interest value of unposed story-telling pictures, and their movies reflect their ability to select or to arrange pleasing subjects. But there are others who habitually line their subjects up as before a firing squad, and blaze away with the movie camera.

The resulting pictures show the fallacy of this method. The victims stand stiffly, look self-conscious, fail to move a muscle or animate a feature, or perhaps resort to horseplay which is bound to fall flat when it appears on the screen.

How much better it is to give your subjects something to do, some familiar, natural bit of action in keeping with their characters, and then take your movies while they are busy. Catch the children while they are playing. Take the adults while they are conversing, or admiring your roses, or lighting a cigar, or paying for a tank of gasoline.

But don't simply line everyone up and shoot!

The eighth common error, and the last to be aired here, is lack of editing. We're not going to tell you that every personal movie must be edited to the perfection of Hollywood's best. After all, personal movie making is a diversion, not a duty. But we do believe that the bad spots should be cut from every personal film. It's easy, with a simple film splicer. And the mere cutting out of say the worst 10 percent of a reel will make the balance seem 100 percent better.

Cut out those scenes that are too short, the ones where the camera wiggled or was panned too fast, those which flash bright with over-exposure, those which are dark because of under-exposure, and those which you wish you hadn't taken because the expected interesting action didn't occur. Do away with them, and the rest will look far better. Go as much farther in editing as the spirit moves, but don't inflict the really bad spots upon your friends.

Eight common errors! Eliminate them and you'll have films which will do you credit. It's not hard—thousands have done it.

TV's Greatest Show Ever— The Moon Walk

Harvey V. Fondiller

Photographs by the author

In the lifetime of men still living, dot-and-dash wireless became broadcasting and radio evolved into TV. On July 20, 1969, A.D., the greatest show off earth had 350 million TV witnesses around the globe. It was the biggest television spectacular in history because it covered the biggest news event since history began. The networks set aside 31 hours of time for space and spent $6.5 million to televise a drama in five acts: launching, lunar landing, moon walk, rendezvous with the Apollo capsule, and—for a grand finale—the splashdown.

Nothing in centuries to come would ever surpass this show because it had *everything*—except sex. It was a science-fiction documentary, shot on location at Cape Kennedy, the command module of a spaceship, Mission Control in Houston, the White House and Smithsonian Institution in Washington, Wapakoneta, New York, London, Paris, Tokyo and—to cap the climax—the moon.

The action was out of this world. It was so socko that it ran straight through prime time and into the next day . . . a semi-scripted program with a boffo climax that just possibly might not have happened. The only sure thing was the cast: three fantastically costumed astronauts who were performing the riskiest stunt in show-biz history.

The TV transmission was a triumph of communications. The world received the telecast via an intricate interconnection of satellites, microwave relays, cables, and broadcasts. The signal streaked through space, was picked up by a ground station at Parke, Australia, then relayed by a Pacific satellite to another station at Jamesburg, Calif. It was transmitted by land line to NASA's Mission Control in Houston, thence to the network pool, and finally to the ABC, CBS, and NBC

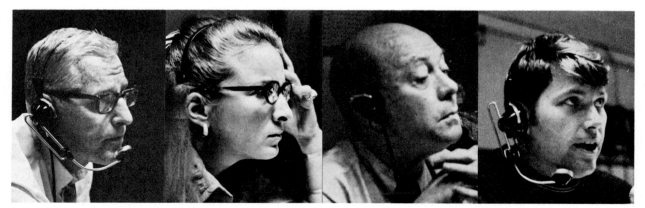

Lighting director, program logger, advertising executive, and executive producer concentrate on TV monitors.

networks in Houston and New York. Elapsed time: 1.3 seconds.

The world has been communicating a lot faster —though hardly better—since May 24, 1844, when the first telegraph message moved the 40 miles between Baltimore and Washington. The clicks spelled out that prophetic biblical phrase: *What hath God wrought.*

By 1910, the world was communicating so well that the Kansas City *Times* announced: "Television On The Way," and added: "We hope soon to transmit the colors as well."

In 1928, outdoor scenes were televised at Bell Telephone Laboratories and in 1937, NBC operated a mobile TV station on the streets of New York. A couple of years later, anybody could buy a television set with an 8 by 10-in. screen, and millions saw TV at the New York Worlds Fair.

In 1940, after Manhattan was telecast from an airplane, people were saying, "What next?" On December 7, 1941, they got an answer on the radio: Pearl Harbor.

Soon after, Japanese soldiers grabbed a newscaster in mid-syllable at a Manila radio station. When he returned from captivity, three years later, his first words into the studio microphone were: "As I was saying when I was so rudely interrupted . . ."

By war's end, nine TV stations were operating in the U.S. In 1946 there was a telecast via coaxial cable from Washington to New York, and another of the opening sessions of the United Nations Security Council at Hunter College. By 1947 there were 44,100 TV sets in the nation. In 1948 there were 600,000. By 1949, the total was 2,150,000, and in 1950 there were four million sets, 107 TV stations, and—believe it or not—a total of 4,146,-602 TV sets were manufactured during the year.

Advertisers began to cut their print budgets and started to buy TV time instead. When *that* happened, the Age of Television had arrived.

People could sit in their living rooms and see beyond the horizon; they watched wrestling matches, Dagmar, Senator Joseph McCarthy, Jerry Lewis—and the kids simply loved Howdy Doody. Some critics said that TV neither extended man's vision nor showed him very much that he couldn't see at his neighborhood movie house. The main difference between TV and the movies seemed to be that on TV you could see it sooner—and with a beer.

In 1961, John F. Kennedy set a goal: a man on

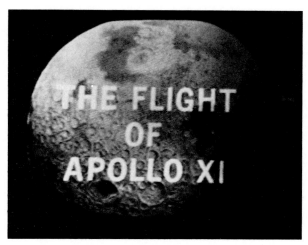

Telecast of space trip to the moon was seen by viewers in countries throughout the world.

Program director (pointing) calls a shot as he sees it on one of the 27 monitors facing him.

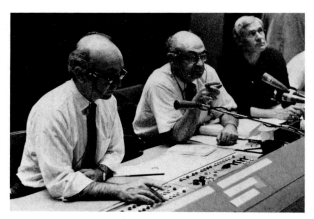

Technical director plays on his console like an organist, switching from Houston to outer space.

the moon by 1970. (The President was goal-oriented, so he aimed at the moon.)

Eight years later Kennedy was dead, but his idea lived on. Its name now was Apollo 11, and on July 16, 1969, at Cape Kennedy, Fla., it lifted from the launch pad—all 3,242 tons of it—precisely 724 milliseconds behind schedule, which was 9:32 A.M., EDT, and needled heavenward, lancing at the moon. The leader of a poor people's protest march said he was so stunned by the sight of the take-off that he forgot about hunger.

Apollo 11 cost $24 billion; plenty of money-oriented people had to be paid for making its 15 million parts. (But Americans are result-oriented, too; they don't care what things cost—*just get the job done*.) So three astronauts hustled through space on the most expensive excursion of all time —$8 billion per roundtrip.

When the spacefarers—weightless and floating in their cramped cabin—were 148,000 miles from home, they gave viewers a view of the bluish-gray globe that was formerly man's only world, From

their perspective of sullen earth, Vietnam, riots in the streets, Appalachia, and Black Power seemed to pale—and even shots fired in anger would not have been heard in the airless void.

Four days and nights after lift-off, the spaceship shot into orbit around the moon at 3,660 miles per hour. The brilliance of a rising sun flooded the landing site on the Sea of Tranquility when the people in a crowded control room at NBC Studios in New York heard a voice from Houston:

"Eagle, you are go for powered descent. Over."

The earthbound observers stare at their TV monitors; the room becomes a three-dimensional study in concentration. Jim Kitchell, the program's executive producer, sits on the backdeck, flanked by a producer, associate producer, production assistant, unit manager, program logger, the NBC News vice-president, a vice-president of the sponsor's advertising agency, and an NBC-TV sales rep.

Below and in front of him, seated at a long table that houses an intricate switching console, are

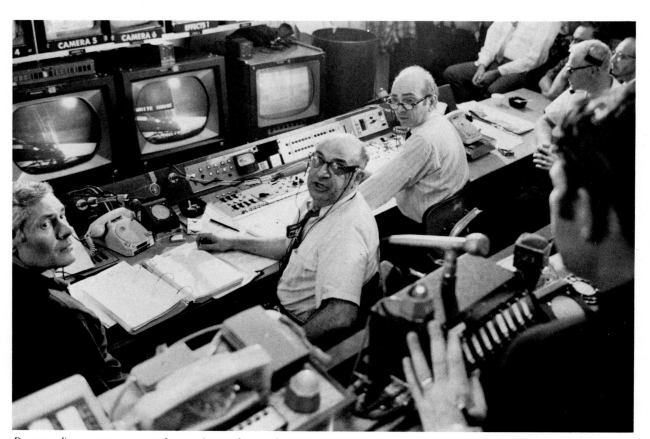

Program director turns to consult executive producer, who masterminded the historic telecast.

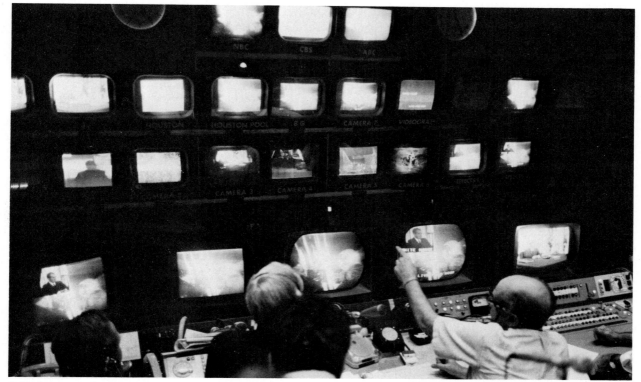

Behind the control room's front deck, technical staff see monitors showing many images.

Tony Messuri, the director; the technical director; two associate directors (one handles remote pick-ups and the other supervises titles and superimpositions); a broadcast operations coordinator; lighting director, and scenic designer.

Facing them are 27 television monitors, arranged in four rows. Suspended from the ceiling are sets marked NBC, CBS, and ABC. Under them are monitors labelled 4J Preview, 4J, Houston, Houston Pool, 8G, Camera 7, Videograph, Countdown, Superlock, and Sunscope. Below these are: VG, Camera 1, Camera 2, Camera 3, Camera 4, Camera 5, Camera 6, Effects 1, and Effects 2. The bottom row includes two program monitors—black-and-white and color—Preview, Pre-set, and B&W Preview.

In a glass-enclosed booth at one side of the control room is an audio engineer, taping the voices from Mission Control; in another booth are six video engineers, each scrutinizing a green oscilloscope pattern formed by the image of a color camera.

Kitchell runs the show but Messuri, as director, does the talking:

Keep an eye on the Houston Pool . . . If the crowd at Time-Life starts cheering, I want it on tape . . .

From Apollo Control: "Seven minutes 30 seconds into the burn. Altitude, 16,300 feet."

Time-Life—wide shot . . . hurry up!

One of the associate directors is on the line to Washington: "We know you're there, Smithsonian—we'll be right with you."

Coming out of film to Six . . . Take!

Apollo Control: "We're now in the approach phase. Everything looking good. Altitude 5,200 feet."

Get a mike out there—we want to hear him if we can . . .

Houston: "You are go for landing."

Eagle: "Roger go for landing, 3,000 feet. We're go. We're go. Two thousand feet. Two thousand feet . . ."

The top row of monitors show identical images; all three networks are transmitting the feed from Mission Control.

Apollo Control: "Altitude 1,600 . . . 1,400 feet, still looking very good."

The technical director leans back, but his eyes scan the monitors.

Houston: "Sixty seconds."

Eagle: "Lights on; down 2½. Forward, forward 40 feet down 2½ picking up some dust; 30 feet 2½ down shadow, four forward, four forward, drifting to the right a little."

Houston: "Thirty seconds."

Eagle: "Contact light. Okay, engines stop. Engine arm off."

Then from the surface of the moon come the electrifying words:

"The Eagle has landed."

Applause ripples through the crowded control room. The time is 4:17:40 p.m., EDT.

Mission control . . . Take it! Standby . . . go back to our stuff. Standby, videograph . . . change it on the air. Standby to back to Armstrong again. If you can undercut, do it. Standby to dissolve to the other one . . .

A minute has passed since the landing. Somebody comments: "It's about time to do a commercial!" A phone rings and an engineer answers as he scrutinizes the rows of monitors. New scenes are flipping into many of them.

Kitchell asks: "Do we have audio from Wapakoneta?" The broadcast operations coordinator answers: "Not yet." A moment later he adds: "We're getting bars out of there."

Two—let me see it, top to bottom . . . Get back on McGee . . . Standby to use videograph over this. Houston pool . . . take it! Standby to go back to Six. Six . . . take! Four—get me a shot of the globe under McGee. Six—are you in trouble?

The Preview monitor shows Frank McGee in the adjoining studio.

Open McGee's mike. Six . . . take! Put in videograph.

At 4:56 p.m. the scene switches to Wapakoneta, Ohio (pop. 7,500), home of Neil Armstrong's parents.

Lose the super—let's see people.

The parents thank God that their boy is all right. "We just hope and pray it will all go well."

Kitchell decides: "Light up Chet and let's do a commercial."

Standby, One. The director holds up his hand, then punches a finger at the screen. *One!* The commercial is coming up. *Take Six and roll it, please. Standby, Announce. Cue Announce.*

Announcer: "NBC News will continue with its color coverage of Apollo 11 in a few moments,

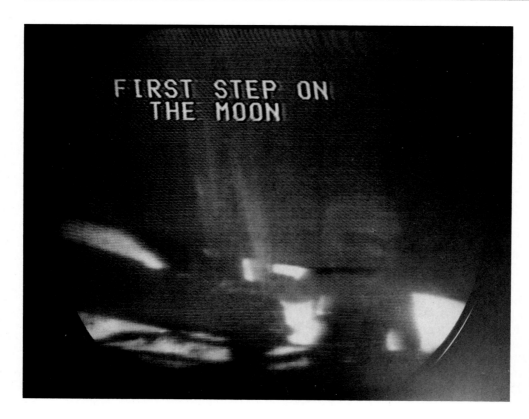

Man on the moon—a miracle of technological achievement witnessed by history's largest TV audience.

258

after this pause for station identification."

Just before 10:55 p.m., when the black-and-white telecast from the moon began, the control room was a montage of sound: the commentators, Kitchell, the spacemen, Mission Control, ringing telephones . . . but the director dominated the scene like the conductor of an orchestra and the technical director was as silent at his console as a master organist.

Billy—lose the door on Four . . . thank you. That's it, okay. Now come up to the right . . .

The time is near. An associate director snaps: "Get rid of Atlanta!"

Neil Armstrong reaches the ladder on the landing craft. "I'm going to pull it down," says his voice.

Start coming in very slowly to the flag . . . then, when he gets down—

An eerie image, transmitted by a 7.25-lb TV camera on the moon, flashes on the monitors.

Take it! Standby to insert videograph . . . as soon as we see picture I'll yell . . .

Voices continue to speak from Mission Control and the lunar module as vague shadows move on the screens. Suddenly there are shouts:

"Here they come! We got 'em!"

Cheers and handclapping. Someone points to the monitors and exclaims: "The foot . . . the foot . . . look at *that!*"

Set me up on videograph.

From space, a calm voice announces: "I'm at the foot of the ladder . . ."

On the monitors, a shadow creeps toward the unknown. The spectators stare silently. Then: "Here he comes!"

FIRST STEP ON THE MOON!

For centuries, man dreamed the impossible dream of conquering the virgin moon. For centuries, men waited for this moment. *This is the moment.* The longest journey now ends with a single step. *What hath Man wrought?*

The image of an astronaut quivers. From outer space, a quarter of a million miles away, comes his voice:

"That's one small step for man, one giant leap for mankind."

POSTSCRIPT: THE TV VERSIONS DIFFER

CBS goofed and ABC didn't tell when; only NBC communicated the exact moment when man first stepped on the moon.

More than a minute before Neil Armstrong placed his boot on the lunar surface, CBS's Walter Cronkite—speaking as the television image showed the astronaut descending the LM ladder —conjectured: "If he's testing that first step, he must be stepping on the moon now." He erred again when he stated, "He's on the surface of the moon," a moment before Armstrong said, "I'm going to step off the LM now." Compounding the inaccuracy, CBS superimposed the words *Armstrong on Moon* seconds before the astronaut said he was about to step from the lunar module.

Viewers of ABC's telecast never knew exactly when Armstrong set foot on the moon. It was signified neither by superimposed words nor by a commentator's voice.

The only accurate television reporting of the most historic event of all time was by NBC. At almost exactly the instant Armstrong placed his foot on the moon (10:56:15 p.m., EDT, according to NASA's official log), *First Step on the Moon* was superimposed on NBC's picture. Five seconds later, viewers heard the astronaut say: "That's one small step for man . . ."

A quarter of a million miles away, in an NBC control room, executive producer Jim Kitchell made the split-second decision to flash the words on the image.

Intensive study had familiarized him with probable movements of the first astronaut to touch the moon, and with the construction and dimensions of the ladder down which the spacefarer would clamber. Kitchell knew that radio-frequency waves bearing video and audio information through space travel at the speed of light—186,000 miles per second—and that it would take the signal 1.3 seconds to go from the moon to the earth.

His eyes followed the vague shadows on the monitors as the astronaut slowly descended . . . then he heard Neil Armstrong's voice: "I'm going to step off the LM now." Two seconds later he shouted:

"First step on the moon!"

Tony Messuri, the director, echoed the words a fraction of a second later. O. Tamburri, the technical director, pushed a button on the switching console (the videograph had been visible on the pre-set monitor) and the phrase was instantly superimposed.

How did Kitchell arrive at his decision? "We knew—just as all the networks did—that we were going to put in the label," he explains. "We planned our coverage carefully and tried to react a little faster."

259

Making Better Travel Films

Leendert Drukker

Photographs by the author

Build up your background, cut down on baggage

You, too, must have heard it: How can you possibly see anything when you always have that camera in front of your face? Well, the proof is in the footage: filming forces you to make it a more profound experience—when traveling, an unforgettable one. In a way, it's like asking yourself constantly: *"Now* what am I seeing?" It actually sensitizes the traveler and makes the trip all the more rewarding. Here's a smorgasbord of suggestions: help yourself as you see fit.

• To make a film of some depth, you have to bring some depth to it. Immerse yourself beforehand in the background of the area you're to visit: its history, economy, industry, politics, customs. Brush up at the library, request literature from the Chamber of Commerce, tourist commission, or information office. New Yorkers can help themselves to a big break: local newspapers at Hotalings' in the midtown area.

• Form a plan of action—where you are going, what you're going to see, specific subjects you're going to shoot. Avoid spreading yourself too thin. Try to keep down on the mileage, so that your film will have some cohesion. If you intend to shoot a mere record of your travels, string it together by giving it a viewpoint—for example, that of someone in your party, or perhaps of your bicycle or car. A Volkswagen "bug" almost asks to be personalized: stick eyes and mount, cut from Contact

Paper, to its hood. You can make it surprised, happy, or sad to suit the scene.

• Don't expect to "cover" a country on one trip. Instead, pick a single subject: the major industry that makes a country go, a local handicraft, a festival, a way of life. Your background studies are bound to suggest any number of topics. It's astonishing where and how you pick them up. Example: flying to Chicago for last month's PMA report, I noticed a "natural" in the plane's "American Way" publication: New York's proliferating street musicians. Certainly beats the usual skyscraper stuff.

• Don't take any new, untried equipment. Vacationers often shop for a camera just prior to departure—too late for a thorough shakedown. I know one filmmaker whose footage was ruined by a new filter: it turned out to be slightly clouded by a fungus!

• Take along lens-cleaning fluid, lens tissue, and a brush to get rid of travel dust. Also a chest- or belt-pod: they beat a tripod left behind. For old-time's sake, also pack a set of jeweler's screwdrivers—including the Philips type—though today's super 8 cameras hardly leave you anything to fix yourself.

• Before departure switch to all-fresh batteries—and take along at least one extra set. And if your

camera's electric eye uses a separate "button" cell, replace it too.

• Unless you have a case specifically designed for your camera, carry it grip up. That way you're able to grab it instantly, ready to operate. Above all, never let the camera rest against its lens so that the mount acts as a lever for all that weight.

• Protect your lens with a rubber hood: it's great for absorbing shocks. A haze or skylight filter will shield it from spray, dust, fingerprints.

• Pack a spare camera, just in case: a simple lightweight one will do in an emergency—or else carry enough to buy a replacement, if need be.

• Film import restrictions are rarely enforced. Try to stock up on all the film—no, more than you need: you'll find it very expensive abroad. Look for the same emulsion number to avoid needless color shifts. However, take along a second high-speed batch, strictly for indoor shots. If need be, unbox silent-film cartridges to prove they are not for sale. With the sound type, this might invite jamming: the loop needs protection.

• If you are going abroad, register your equipment at the U.S. Customs office—either at the border or, if you are flying, at the airport before departure. This avoids haggling about paying an import tax on return.

• At airport security checkpoints, have your bag with film inspected visually. There's no point inviting needless X-ray exposure.

• When filming while traveling—by car, plane, or rail—avoid transmitting vibrations: don't lean on rails or armrests for support, and don't press the lens against window or porthole. Aim forward as much as possible to minimize blurring. When shooting from a plane, set the lens to infinity, trim the exposure—if your camera permits—to compensate for haze.

• Get away from the point of arrival as fast as possible. Usually it is a big, cosmopolitan city, much like any other in this homogenized world, and too complex to grasp. You can't get the essence of a culture in a setting like that. A village, or the countryside, is more digestible; it's off the beaten track, offers more, demands less. You can always film the big city afterwards—and with better perspective.

• Don't tie yourself down with hotel reservations: be ready to switch plans and grab filming oppor-

To catch the action as it is, blend in—don't distract. Here is market day in Goes, Holland.

Traveling isn't all sightseeing. Sometimes it's the mood that makes a place memorable.

tunities elsewhere. You will probably be able to find lodging overnight—in a neighboring town if need be.

• Baggage can weigh you down like a ball and chain. Travel light, and you won't be subject to the vagaries of taxicabs, porters, etc. Makes it easier to scout for promising locations, and settle right in their midst.

• Don't take along all you need to cope with any assortment of emergencies. You can't predict which one—if any—may actually materialize. Instead, take along travelers' checks to cover reasonable eventualities—they are less of a load.

261

• Soap, a basin-stopper, and a string as laundry line are light and compact substitutes for lots of spare clothing.

• Unlike the photographer, you can't get along on "grab" shots. Travel leisurely, stay long enough to develop a "feel" for the place.

• Shoot those first impressions. They may turn out to be superficial "postcard" stuff, but then again, they may have a freshness you'll never be able to capture again. You can decide what's what when you edit.

• A plan is just a plan. If the location suggests a different theme—go ahead and develop it.

• To feel the "pulse" of a country, go down to the port. It's usually a beehive of activity.

• Don't shoot by the numbers. Usually, it isn't the tourist's "must" attractions that make a place tick.

• Show people doing things; look beyond the obvious for the best angle.

• To keep travel companions from getting impatient, enlist them in your project. One may be your "star" as suggested earlier; another might record your sound track; a third might concentrate on filming cutaway or reaction shots, or unusual angles, such as from way above—this does assume a second camera. You can't be everywhere at the same time.

• Sound-filming is not really a oneman job. Handling the mike for the best audio is a full-time occupation.

• To film at the beach, start with clean hands, devoid of a single grain of sand. Keep camera in a plastic bag sealed with an elastic band, and take it out only long enough to shoot. Careful, though: even after you've left the beach, camera may be exposed to sand—it may be lurking in your bag. Happened to me once.

• When sending film to the lab for processing, don't let it bake in a mailbox out on the street: for utmost safety, bring it to the post office.

• If there is a dependable film lab, have your footage processed locally and forwarded to your home. That avoids the hassle of another trip through inspection. However, don't mail your unprocessed film across the border: you never can tell whether or not it will be X-rayed.

These are my field-tested tips; serve yourself.

Because of the dim ambiance, camera's electric eye tends to overexpose cathedral's stained glass.

Posed companions don't make a travel film interesting—what they do, unhampered, does.

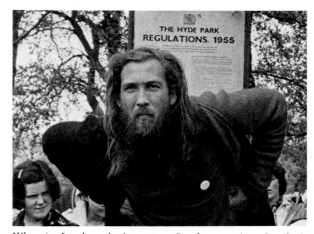

When in London, don't nap on Sunday morning; Speaker's Corner in Hyde Park is full of life.

Viewpoints

"I Don't Like the Photographic Press!"

Anton Bruehl

One of the nation's foremost photographers deplores the sensationalism of the photographic press and contemporary photography

I don't like the photographic press.

And when I say I don't like the photographic press, that holds for the big picture magazines and the tabloid papers, as well as for the technical camera publications.*

My distaste for the tabloid papers is not because they produce terrible pictures. You can't expect a news photograph usually taken under difficult circumstances and reproduced on cheap stock to be a work of art. I object to the tabloids because they beget a bad reaction in the minds of millions of people.

A publisher should not deliberately play up the sordid. But publishers do. They feed our people a vulgar, commonplace, sensual picture diet. And even the news-photo magazines are not above reproach. They don't print photographs. They manufacture news for the multitude and then pictorialize it to suit themselves.

I stress the picture publications and the tabloids because they are influencing the camera press adversely. The very elements I dislike in photographic magazines and tabloid papers I see gradually seeping into the technical periodicals; naked

*We assume that Mr. Bruehl refers to *Life, Look,* the metropolitan daily and Sunday newspapers, the photographic trade publications, and maybe even our own *Popular Photography.* —ED.

or half-naked women on the covers; lurid, badly-reproduced pictures in the body of the book; and boring photographs of cute children and dogs in the rotogravure sections.

Twenty years ago when you were asked out to dinner, for politeness' sake you had to sit down and look at the family photograph album; Uncle Ezra's wedding; Aunt Mame's birthday party; Tommy's first tooth showing through an infantile grin; and, of course, grandpa sitting out on the back porch with his spectacles halfway down his nose, reading the county gazette.

You looked at them for the sake of friendship. But today you pay out good money for camera magazines containing pictures no better technically or pictorially than those you saw two decades ago in the "fotygraph" album.

Magazines have lost their quest for sincerity—if they ever had it. Everybody now is out to make money. And I deplore the fact that this high-pressure trait is allowed to affect the art of photography in which I am seriously interested and for which I have set up a high standard of ideals.

There doesn't seem to be a market any more for serious work or good craftsmanship. The miniature camera is partly responsible for bringing this situation about. It has introduced the vogue for

taking people in informal, unexpected poses. And that seems to connote news—and art! Many pictures are soft and out-of-focus, with nothing to recommend them technically for publication.

The average cameraman today is less skilful than he was a decade ago, so far as technique is concerned. What with photo-electric meters to measure light and improvements of all kinds in the camera itself, almost anybody can go out and click his shutter and come home with a record picture. What I quarrel with in present-day cameramen is that they have little sincere feeling or sensibility for photography.

No matter what kind of pictures they take, a place can usually be found for them in the inevitable volumes of photographs which are published in large numbers each year.

Too many such books are being published just to bring out something in volume form. An individual starts in and gathers together a lot of pictures without any regard for subject matter, artistry or technical perfection, and puts them on the press. Any camera Tom, Dick, or Harry will find his work acceptable. Anything is used—just to get a picture tome on the market.

Frankly, there hasn't been a really good collection of photographs published since Stieglitz's *Camera Work*. He formerly brought out two or three a year, as I recall. They were printed beautifully—as photographs have never been printed since—and contained the really serious, superb pictures of the day. I am not sure but I think Mr. Stieglitz had the plates made in Germany.

With the Stieglitz collection of photographs were included interesting articles written by well-known writers of the day; in sad contrast to the magazines now that publish story after story by people with no photographic background at all.

Today the collections of photographs contain merely a lot of little snapshots which anybody could take by aiming a lens. With a world full of good pictures, the editors, with unerring instinct, select the second-rate, the boring, the commonplace, and the sensational.

Every photographic publication should have a governing board, composed of men and women with a serious appreciation of the camera art. This committee should spend its entire time looking for pictures—prints to illustrate the articles adequately and photographs technically and artistically worthy of space in the rotogravure sections.

When an adequate amount of camera material has been gathered, the editor should select only the cream of the crop—outstanding pictures which would perhaps provide a substitute for a world seemingly never weary of sex-abnormalities and bloodshed.

After the pictures had been meticulously chosen, the *method of reproduction* should receive careful consideration.

A camera magazine should never go in for tricky lay-outs. Nor should one print be permitted to cut into another. If a photographer's work is worthy of reproduction at all, an entire page should be assigned to it. This should be a "must." No photographic patchwork quilts should be allowed: one picture—one page.

In this connection a photographic publication has no right to take liberties with a man's work. There should be no type in the actual picture itself. That is like hanging a painting in a museum and sticking a poster on it. If a magazine reproduces fine pictures and then cuts into them with other prints, the photographer has a legitimate right to raise hell.

Something should really be done, too, about the childish, asinine titles which are assigned to pictures.

Another pet aversion of mine is the way the technical articles are written in the camera press. They are turned out, oh, so brightly and gaily by people with no photographic sensitivity. All technical stories should be prepared by technical men.

What if they do write dull stuff? You don't read camera magazines for amusement but for information. People want facts and should receive data which will help them improve their picture standards. If you could get an article full of meaty value written in lucid fashion—that would be capital!

Another shameful smear on the photographic name is the pornography which is edited and sold under the false banner of art. You have got to do more than set a camera up in front of a naked woman and click the shutter to get a nude. A nude is only worthy of the appellation if it is achieved with imagination, sensitivity, respect, and technical and artistic competency.

One of the worst features of magazines today is the advertising photographs with which they are crammed. Despite the fact that I earn my living by making pictures for advertisements, I must speak out about them. The majority are bad, trashy, worthless, technically and artistically inferior. And I include my own work in this condemnation.

I don't know what to do about it. I am not set-

ting myself up to remedy the situation. But I can deplore it. Very rarely does a photographer get a chance to make even a fair picture for an advertiser. When I look through the advertising pages of the national publications, I feel ashamed that I am a photographer.

I cannot help admitting that the average drawing or painting for advertising is far superior to the photographs used for the same purpose. And that again includes my own. Only a few days ago I was speaking with the art director of a large agency. He told me that within the past six months the demand for art work, in comparison with the orders for photographs, had increased more than at any time during the last seven years.

This statement should speak for itself. But I will annotate it by saying that anything goes in advertising photography today. That is—anything but good work. Even if a photographer made a really fine picture, I don't know who in the current market would buy it.

The great photographers to my way of thinking are such men as Edward Weston, Steichen, Stieglitz, Willard Van Dyke, Charles Sheeler, and of course, Clarence White, who unfortunately died in 1925.

When any camera magazine can reproduce photographs made by men of this calibre—then and then only will I put my "John Hancock" on a check for a year's subscription.

Camerawocky

by John R. Whiting

Lewis Carroll, as many of our readers know, was an amateur photographer as well as the author of "Alice in Wonderland." And since he himself made parodies (one was on "Hiawatha"), we have turned around and parodied the famous Jabberwocky:

'Twas gamma, and the hypo part
 Did fix and harden in the trays;
All Steichen was the Modern Art,
 And the finegrain out-grays.

"Beware the Camerawock, my son!
 The Minny Blur, the focus trick!
Beware the contact bird, and shun
 The red-green stirring-stick!"

He took his flashgun sword in hand:
 Long time the picture tale he sought,—
So rested he by the tripod tree,
 And shuttered, which he ought.

And as in panchromat he stood,
 The Brodovitch, with focus fuzz,

Came reflex through the ballet wood,
 And Weegee'd as he does!

Life, Look! Life, Look! And Argoflex
 His tripod blade went clicker-clack!
He left it red, and pictures bled
 And went a-Pixing back.

"And hast thou Karshed the Graphic House
 Come to my arms, my Kodak boy!
Oh, Eugene Smith! Oh, Feininger!"
 He Black-Starred in his joy.

'Twas gamma, and the hypo part
 Did fix and harden in the trays;
All Steichen was the Modern Art,
 And the finegrain out-grays.

266

Do You Take Snapshots or Pictures?

Karl A. Barleben, Jr.

Very few amateur photographers give sufficient thought to the pictures they produce. By this I mean that they do not devote sufficient time and attention to each exposure. Possibly this carelessness in modern amateur photography is due to the fact that our picturetaking has been made too easy for us.

Years ago, when a big, heavy 8 × 10 camera was about the only thing available, photographers seem to have turned out better pictures. The reason for this undoubtedly was that a lot of work and expense were involved in the process of making a single photograph. You couldn't be careless, or your effort and money were totally wasted. So the photographer saw to it that both effort and money were well spent.

There's no need to go into the details of how the old time photographer had to painstakingly coat his own plates, expose them in the camera for comparatively long periods of time, then develop them almost immediately, one at a time. The point is that these laborious methods produced truly great pictures, which any of us could be proud of today.

Contrast those old methods with our modern procedure. Now we have tiny cameras built with the precision of expensive watches. Lenses are faster than the photographers of other days ever dreamed possible. Our emulsions are served to us on a platter, as it were, fully corrected and incredibly sensitive.

Manufacturers maintain costly research departments, where the finest formulas are created for us. In short, the difference between photography in 1900 and 1938 is as great as that between day and night. But what do we do with all this marvelous material at our disposal?

We seem to have degenerated into a race of snapshooters, despite our tremendous advantages. It's a fact worth thinking about if you are seriously interested in photography.

Perhaps we may blame our shortcomings upon our modern mode of living. The demand for speed and efficiency is reflected even in our photography. And everything must be done on a grand scale. No longer are we satisfied to make one or two exposures—we shoot in terms of rolls.

Instead of getting away from the rush and bustle of our workaday lives by taking our photography in a leisurely fashion, we keep the stiff pace even in our recreation. It doesn't make sense, but we are apparently helpless to stop it.

Most of us could learn much from the European amateur photographer. He is not so well stocked with available funds as we. And therein lies an important factor. Because he must limit himself to one roll of film every week or two, he makes certain that he derives the maximum pleasure and value from it. Each exposure must count; and, as in the case of the pioneer photographer, his limitations tend to make him produce superior results. He goes after quality, not quantity. It's the old story: come easy, go easy.

Since we have such excellent equipment at our disposal, why not make better use of it and thus get results which justify the expenditure?

The finest and most elaborate camera, by itself, is incapable of producing good pictures. It requires human intelligence to guide it. On the other hand, even the simplest box camera can be

made to produce salon prints when used by a skilled photographer. It is human nature to blame failures upon equipment, but facts prove that equipment is perhaps the least important item in the creation of a good photograph. That it does much to help, especially under adverse conditions, cannot be denied; but we must look to ourselves first of all when it comes to photography as we understand it.

Miniature camera enthusiasts undoubtedly are the worst offenders with regard to quantity shooting, due to the economy of using their small film. They fail to realize that this very economy may prove detrimental to their achieving reputations as first class photographers. Certainly, if we go out and shoot a hundred negatives we're apt to get at least one or two which merit a great deal of admiration. But these will be accidents for which the maker deserves no credit. The man who deliberately strives for good results and achieves them through skill and persistence rates higher praise, obviously.

The real photographer makes his exposure only after he has satisfied himself that the angle, lighting, composition, and subject matter are arranged as well as is possible under the circumstances. In addition, he has a clear conception of what the final print will look like. It then becomes relatively simple for him to build the exposure of the negative around this idea. It's entirely different from merely coming upon an "interesting" scene or subject, hauling out the camera and shooting without any great consideration for the result.

Another matter which deserves our attention is the quality of our prints. The average amateur slaps a negative into the enlarger, focuses it upon the easel, shoves a sheet of bromide paper under the masking bands, and makes the exposure. In all probability the result is not just right—but it will do! And so it goes, throughout the entire roll of film. With from sixteen to forty negatives on a roll, the photographer must work fast in order to see most of the negatives in print form. Hence he has no time for careful work with one or two of his better negatives.

And what about our European colleague? Making comparatively few negatives as he does, he can afford to spend one or more entire evenings, if necessary, in experimenting with a single negative. He tries paper of various grades and surfaces. He varies his exposures, his developing time, even his formulas. We may consider that he is wasting his time; but he winds up with a superb print which not only gives him a lot of satisfaction, but also wins prizes.

And he has really enjoyed the work involved, since in performing it he has carried an artistic process through to completion to the best of his (and the medium's) ability.

While this article may sound like a sermon, it is intended to carry a message of nothing more than common sense and logic. We all enjoy photography; but unfortunately too few of us give to our hobby the thought and time which it requires. And it is surprising how much a little care can do for your pictures. Five minutes' extra consideration can make the difference between a snapshot and a print you'll be proud to show people.

Picture Analysis

Nicholas Ház

Toy towns, little heaps of sand, and tubs full of water might suggest cities, deserts, lakes, and the sea more convincingly than the real things, if the "props" are photographed well and the real things not so well. There can be more glamour, mood, and pointed meaning in pictures shot in the corner of a movie shed, than those taken of the great city of Los Angeles, if the set designer and photographer of the miniature are first raters, but the one who snapped Los Angeles is mediocre.

Some people capture more "outdoors" in a few blades of grass photographed *indoors* than others can get in six months of snapshooting over the prairie country and the redwood forests of the West.

The picture shown here, taken by Yousuf Karsh of Ottawa, Canada, represents a humble box of soda fountain straws that have never left the box. Yet they pack more glamour of the big city than there is in reams of snapshots brought back by trippers to New York, Chicago, and other metropolitan centers.

The explanation of this seeming paradox is that the glamour is not in the buildings but the photographer's head. He embodies the glamour not necessarily by shooting tall buildings but by the proper management of *line composition*.

Line composition is a two-legged proposition. The first leg is the sum of the axes of the images which, in relation to each other and to the edges of the picture, are commonly known as the line composition of the picture. But the second leg, the sum of *outlines* of the images, often called "contour," contributes so much to the general effect of a picture that it must be counted part of the line composition. The two together are great factors of the mood and meaning of the picture.

Vertical lines carry the mood of dignity, importance, strength, honor, and pride; sloping lines stand for action, motion, work in process. The two together show proud yet active dignity, lively strength, important elements of glamour.

We arrive at these statements by *abstraction*. To abstract means first: to remove, to take away, to separate; second: to generalize, to make universal or all-inclusive. The process of abstraction in this case could have been as follows: one man photographs a tall building with sloping roof lines. He identifies the building, gives the data about the photographer, time and place of making the picture in a caption which is added to the photograph. This makes a *concrete* picture, because he defines a given thing, pictured by a certain person, at a specified place, and at a certain time. Newspapers like concrete pictures.

Then someone sees the picture and feels that it is glamorous. That is, he abstracted the emotion of glamour from the concrete picture. This is the first part of abstracting; he distills an emotion from the concrete representation. So he proceeds to rename the picture and calls it *Pride*, or *Strength*, or *Glamour*. This device is quite well known to pictorialists who love to rename pictures of little girls *Innocence*, particularly if they have forgotten the child's name.

A third person might feel the glamour and try to find out how it got into the picture. If he is a good analyst he will soon find that glamour is not in the buildings but in the axes and outlines of the images. He then proceeds to make a picture of

CITY OF STRAWS YOUSUF KARSH

lines that do not represent a building, but are simply lines. Yet this line picture will show as much glamour as any picture of tall buildings. The abstraction is now complete. The distilled emotion, which is abstract, is now expressed by ordinary lines, which also are abstract. The two together make an abstract picture.

A fourth person, being a witty photographer, such as Yousuf Karsh, re-embodies the glamour of the abstract lines by covering them with concrete likenesses of some trivial objects, such as soda fountain straws. By this device the straws become dignified, strong, important, and fully suggestive of a skyscraper city of our day or of the future.

Karsh, official photographer to the Governor General of Canada, is an A.R.P.S. He so loves photography that he puts all his free time into it.

Outside of its wit and clever suggestion of the beauties of the skyscraper city made through humble objects, this picture has many virtues. It has good proportion; that is, the number, size, and position of the straws is neatly managed. There aren't too many nor too few, they are neither too big nor too small, neither equal in size nor too different. They aren't quite in the center, in the corners, or too near to the edges of the picture.

Their shape is so managed as to resemble the shape of skyscrapers normally seen.

The tone values are rich. Plenty of nice greys between the black and the white. Nothing needed correction for color. The edges are sharp all over, as they should be. Printed on glossy paper to cash in on as many of the greys as it was possible to capture in the negative and to show the texture of the straws. There is fine depth, that is volume, near and far, although Karsh has put the brightest spot on the far side of the scene. He counteracted this unexpected move with adroit handling of his linear perspective. There is just enough quiet dignity and sufficient movement to serve the purpose of the picture.

There is good balance. The picture hangs well together and is quite clear. Anyone can tell what the subject is, although some spectators won't recognize the wit of imitating the skyscraper city. The picture carries beautifully. The emphasis is on the taller group on the right. Next in importance and almost overwhelming the former is the bright spot below on the left. But both places being important, the emphasis is correct. The rhythm is free, and because parts of this whole fit well together this is a good picture in my opinion.

What Makes a Good Picture?

Experts' answers reveal an extraordinary diversity of approaches to one of the most important questions in the world of photography

ANSEL ADAMS, *photographer*—To me, a good photograph is one which shows expressive and interpretative integrity; in which the subject is approached and photographed with taste and comprehension. The good photograph must have an appropriate craft quality and sensitivity of "seeing." The obligation of clarity is paramount—although this clarity is more of mind and heart than of the optical and material perfections of the medium. Photographers often tell fibs, but photography never lies!

ALEXEY BRODOVITCH, *art director, Harper's Bazaar*—A picture which affects you emotionally, which stimulates thought; a picture which you can never forget, which you love for some reason or which irritates you; a picture which gives you the impact of intrigue, novelty, originality, or shock . . . These very personal reactions are usually achieved by subject matter, composition, quality of print—but sometimes the very opposite is the key, when these orthodox principles are absent, whether by intention or error . . . This (I guess) makes a picture good.

ANTON BRUEHL, *photographer*—I believe that subject matter is of first importance in a great photo-

graph, but I also believe in photographic quality. I believe a good photograph must make use of this inherent quality that no other medium has, of recording accurately and beautifully the subject matter chosen by the photographer . . . I do not believe it is necessary to throw a photograph out of focus, move the camera during exposure, use trick printing or developing to inject "mood" into the picture.

HENRI CARTIER-BRESSON, *photographer*—You are asking me what makes a good picture. For me, it is the harmony between subject and form that leads each one of these elements to its maximum of expression and vigor.

SEY CHASSLER, *managing editor, Pageant*—Impact makes a good picture; not action—impact, a visual impression which hits something in the viewer. It can hit anything from anger and tenderness to the yen for knowledge and the desire for information. It must be clear, though. It cannot contain symbols known only to the photographer. It cannot reach that level of subtlety at which the photographer is forced to explain it. It can be abstract as a circle or detailed as a dictionary, but it must give something all by itself. A good picture doesn't

272

need critics, artists, journalists, philosophers, or the photographer himself to explain it. It must carry its own weight and deliver its own impact.

JOSEPH COSTA, *photo supervisor, King Features—Sunday Mirror*—The question is as boundless as asking, "How high is up?". Good pictures in photography and the preferences of people are as varied as paintings and the tastes of connoisseurs in art galleries . . . The one indispensable ingredient is that a picture must be an eye-stopper. Whatever the subject matter, composition, lighting, camera angle, or general presentation must be such as to catch and hold the interest.

ANDRÉ DE DIÈNES, *photographer*—If a photograph so dominates the viewer by surprising, startling, horrifying, amusing, or exalting him, it must be a good picture. But there is such a wide scale of human intelligence and sensitivity that what impresses one may leave another unmoved. The best photographers seek to communicate great human emotions like sorrow and joy, horror and love, beauty and perfection, as well as sensuality and wit, and they hope that their photographs will be seen by people who understand them.

JACOB DESCHIN, *camera editor, The New York Times*—A good picture has content, meaningfully expressed (the photographer has a point to make, and makes it), and effectively communicated (the photographer is sufficiently a master of his craft to make his point stick). Generally, a good picture is felt rather than merely understood (intellectually). Because it describes an experience in visual terms, words are inadequate as a measure of its value. The observer responds to a "good" picture, remains untouched by a "bad" one. Only a "good" picture itself can tell us what makes a good picture. Let's see the picture, I say.

ALFRED EISENSTAEDT, *photographer*—A good picture to my mind is a relative thing, depending on the observer. A good picture is what pleases me, though it may not and often does not please others. What I look for in a picture is great simplicity. It does not have to be a still-life picture but it should present one idea with clarity and should not be a confusion of so many elements that the observer cannot tell in a quick glance the meaning of the picture.

ADOLPH FASSBENDER, *photographic teacher*—A good

picture is a replica of a visual image conceived by an artist who has the imagination, artistic and technical ability to transform his conception into a vivid representation. If his interpretation, coming from within his heart, is understood and admired by more and more people, success is assured.

ED FEINGERSH, *photographer*—There is no formula for a good photograph. Mediocre pictures may follow a formula, good ones seldom do: When the visual tools are used just right, the design, lighting, mood, and emotion come together to just the right point, and that point hits you and you know what the photographer meant—that's a good picture.

ANDREAS FEININGER, *photographer, author*—Good photographs enrich the experience of the observer by showing him *more* than he would have seen if confronted with the subject, because *good* photographs clarify, emphasize, dramatize, capture the "decisive moment," or offer a revealing close-up view—in short, depict the very essence of the respective subject or event.

PHILIPPE HALSMAN, *photographer*—A photographer worries about composition, timing, lighting, texture, design, unusual angles, print quality, etc.—but all this is not enough if the photographer has no depth and perception. A portrait is not a portrait if the very essence of the subject is not captured; a picture of a scene is just a snapshot if its meaning and emotion are not caught. But even then, everything is futile if the onlooker has no sensitivity and imagination.

NORRIS HARKNESS, *syndicated camera columnist*—The elements that make a good picture must be unobtrusive. The arrangement of the material, the action, the lighting, the balancing of the processing factors that constitutes good photographic quality—all must make their contribution without being obvious about it. And, with all the mechanical and artistic elements suited to the subject, a good picture must first be a good photograph expressing something worth expressing.

YOUSUF KARSH, *photographer*—Obviously, the first essential can lie only in the perceptivity of the photographer—his sensitivity, training, craftsmanship, and experience. A good picture is an intensely personal thing—it rests first in the mind

273

and eye of the artist. His apparatus is secondary but technique is not. Brady worked with comparatively primitive equipment but few photographers have yet arisen to excel him. Why? For one reason —his superb technical command of his medium plus those other factors already noted. To-day the general tendency is toward technical sloppiness . . . toward a complete indifference to technique. Human interest is not enough. It must be accompanied by excellent craftsmanship. A good picture is never an accident—it may appear so. It is always a product of the artistic mind and eye, and back of that is years of study, thought, training, and experience.

BEAUMONT NEWHALL, *historian, curator George Eastman House*—A good photograph says something so well that it cannot be said better any other way. It may be factual or poetic, but always it will be so true that from it we can learn of life. A good photograph is made by one who knows and respects his medium.

IRVING PENN, *photographer*—A good photograph is one that communicates a fact, touches the heart, leaves the viewer a changed person for having seen it. It is, in a word, *effective.*

JOHN RAWLINGS, *photographer*—There are basically two kinds of pictures; those where the photographer has some measure of control (over backgrounds, lighting, movement), and those in which the photographer is in the right place at the right moment, when something vital is happening, and has the ability to capture it. In this second group we find "great" pictures. In the first group, with which I am identified (fashion, beauty, travel, theatre), perhaps the secret is that the good picture arouses intense interest in the viewer, so that he identifies himself with the situation. Perhaps this kind of good picture helps us to measure ourselves, to increase our knowledge and understanding of one another. Certainly, a good picture must be eloquent enough to get at the emotions of people.

SANFORD H. ROTH, *photographer*—The culmination of the photographer's life experience together with its impact and effect on him is a great and constantly present influence. Through his use of line, form, texture, light, contrast, composition, and subject matter we finally see the emergence of a portrait of the photographer himself with his hopes, fears, truths, and indulgences actually imposed on the photograph. Subject matter? Cézanne approached the apple and the hillside and was rewarded with immortality. A hundred photographers can approach a given objective and come away with the sum total of themselves. The photographer, the man or woman, is the major contributing element—the conclusive element. Only after him can we go on with the speculations having to do with optics, chemistry, and fine machine-tooled instruments related to photography.

ARTHUR ROTHSTEIN, *technical director, Look magazine* —Anybody can take a good picture. Technical progress in photography has reached the point where the means for producing good photographs is available to all. Good pictures contain those characteristics which recognize and emphasize the photographic process. These are: 1. The reproduction of fine detail and texture. 2. The accurate rendition or willful distortion of perspective through proper choice of lens and viewpoint. 3. A range of tonal values from light to dark, which may be compressed or extended at will. 4. The ability to stop motion, to capture the exact instant or the decisive moment. . . . But more important is a recognition of what makes a great picture. In a great picture the camera discovers significance in things which seem unimportant. It reveals a new way of observing the commonplace and enriches the visible world of infinite detail. It opens up new vistas and bares the aspects of people and their environment with unequalled revelation.

We Asked the Pros–

DO YOU THINK PHOTOGRAPHY IS GETTING EASIER OR HARDER?

LOUIS STETTNER—'Easier and harder,' to me, depend on enthusiasm for meaning. With enthusiasm the hardest job becomes easy. Technically, photography is easier since better cameras and films are available. Also, a stimulating photographic climate—typical of today with more fine photographers around and good work more readily acceptable—makes work easier. But young photographers find it confusing and therefore harder, because of a harmful current trend placing emphasis on subject matter instead of photographer's vision. For photography is going somewhere when current flows from the human being behind the camera, *not* the camera.

ARTHUR ROTHSTEIN—It is becoming easier to obtain a visual record. However, with the progress in photography, the techniques that must be mastered for exceptional success have become increasingly complex. The public's more perceptive visual mindedness means that the creative aspects of photography require increasingly higher standards making outstanding photography difficult. Museum exhibitions and magazines have made the viewer of photographs more conscious of quality. Today, in order for the photographer to practice his art, he has to be more selective, sensitive, and skillful.

JOE COSTA—Photography is getting harder both technically and imaginatively. There are so many new cameras and films—each designed to make

things technically easier—that the photographer needs a greater overall technical knowledge than in the past. In addition, each new tool taxes his imagination to put that advance to an original and interesting use. Consequently, people who buy photographs have become used to, and continue to expect, a great deal more from photographers than they did in the past.

(April 1958)

WHAT DO YOU FEEL IS THE DIFFERENCE BETWEEN THE AMATEUR AND THE PROFESSIONAL?

BENN MITCHELL—The difference is in their attitudes toward photography. Any good professional is devoted to his craft, so he gives up much of his personal life because of its demands. Few amateurs do. To survive, the professional must be good, so he experiments constantly to add to his skill and knowledge. Most amateurs are too easily satisfied with their pictures and therefore are unwilling to experiment at all. Amateurs usually are impatient. They don't want to take the time or care to do a good job. A professional works first, then watches television.

TOSH MATSUMOTO—The professional must approach photography as a job. He is under constant pressure to complete assignments before a deadline and to produce work acceptable to his client. As a hired worker, he is faced always with certain restrictions. At the same time, he must experiment constantly to keep up with competition. The ama-

teur is free to select his subjects and to search for the approach or techniques which best satisfy him. He is free to approach photography as a hobby.

NORMAN ROTHSCHILD—The professional must consistently produce the kind of pictures demanded of him, with no room for alibis. The amateur can succeed sometimes, fail badly at others, and there is no skin off his nose. While both may be equally creative, the professional usually can't experiment on the job. He must use known techniques. His experimenting must be done on his own time, and the experience gained added to his resourcefulness in carrying out assignments. The amateur has the greatest opportunity to explore. Unfortunately, he doesn't always do this, but often imitates contemporary pictures he sees.

(January 1959)

IS THE PHOTOGRAPHER THE BEST JUDGE OF HIS OWN PICTURES?

FRITZ HENLE—He is not! To me, being a photographer is a process of steady development. In order to develop, any creative person must accept criticism and advice. I think that is a part of the growing pains of being an artist. Naturally, as a person grows older and more mature, they become better able to evaluate what they have done.

I don't think, however, that they ever reach the point where they can't learn from the comments of people whose judgment they respect.

JOHN MORRIS—I feel a photographer is the best judge of his own work. But when his work is used in a medium such as a picture magazine, the standards of that medium must prevail. From this it follows that in photo journalism, the editor must ultimately judge the photographer's work. The only exception to this would be a case where the photographer's work is presented as a personal portrait or possibly a case where the photographer himself combines words and even layouts with his pictures to form a photographic essay. Such cases are extremely rare at the moment.

ARNOLD NEWMAN—Generally speaking, yes, for only he knows exactly what he is trying to achieve in his pictures. Naturally, the photographer is emotionally involved with his work, but he must be able to stand back and be objective. This ability to judge his own work as well as the work of others in relation to it, is a pre-requisite for any photographer if he is to continuously improve and grow. Without judgment, not only is growth stifled, but a beginning would be impossible. Criticism and the judgment of others is simply a by-product of creativity—not the beginning or its aim.

What They Said About Photography

"Photographers have more competition than anyone else—*everyone* has a Brownie!"—*Steve Heiser.*

"If Velasquez were born today, he would be a photographer and not a painter."—*George Bernard Shaw.*

"The artistic temperament is a disease that afflicts amateurs . . . the great tragedy of the artistic temperament is that it cannot produce any art."—*G. K. Chesterton.*

"All the arts are brothers. Each one is a light to the others."—*Voltaire.*

"Indifferent pictures, like dull people, must absolutely be moral."—*Thomas Hardy.*

"But the Devil whoops, as he whooped of old: 'It's clever, but is it art?' "—*Rudyard Kipling.*

"Art is the demonstration that the ordinary is extraordinary."—*Ozenfant.*

"All good work looks perfectly modern."—*Oscar Wilde.*

"Ideas, like children, always have fathers."—*Moholy-Nagy.*

"An artist is either a plagiarist or a revolutionist."—*Paul Gauguin.*

"I always work on paintings that miscarry. They pose exciting problems. It's good to fail."—*Pierre Bonyard.*

"There are no amateurs, but only those who paint bad pictures."—*Edward Manet.*

"Each artist writes his own autobiography."—*Havelock Ellis.*

"Advice to photographers: learn technique, then forget it."—*John R. Whiting.*

From the Editor's Desk...

Bruce Downes

NEEDED: PHOTOGRAPHIC CRITICS

Is mechanics the curse of photography? Child of a technological age, the camera is a mechanical invention, the first instrument of modern times to have resulted in a new art. But is it art? The controversy aroused by this foolish question has been going on for decades, but an eighth art has not been officially added to the classic seven. Why?

That is a pertinent question and one which I posed in just these words in *Popular Photography* some years ago. Judging by the widespread response, the subject was of great importance at the time. Little has occurred in the intervening years to alter the critical situation referred to. Now in 1951 I repeat what I wrote then:

Why has not an eighth lively art been officially added to the classic seven?

For one thing, photography is still too conscious of itself as a technical process. Discussion is endless concerning the instrument. The hypo pundits—and Roget calls them wranglers—pour forth millions of words annually about optics, chemistry, and all the minor rigamarole of technical procedure. This pontifical palaver doubtless girdles the globe like radio impulses. Of pictures the MQ maharajahs write or utter little or nothing beyond the way in which they were taken, the exposure, *f*-stop, film and developing process.

It is, you see, almost always the machine—not the marvelous things the machine can be made to do by the artists. Aside from an occasional—and frequently specious—reference to composition it is extremely difficult to find anything in photographic literature even suggestive of sound criticism without which—and this is the point—no art can flourish.

Great art, said Walt Whitman, demands great critics. True criticism is the salt of aesthetics. In photography, however, there are not only no great critics, but even moderately competent critics are as rare as the doodle-bird. There are plenty of carpers and darkroom lawyers, technicians, mechanical and chemical experts passing in the guise of critics. But these are not critics in the civilized sense of that word. Their stuff is mere shop talk, some of it of textbook calibre, designed for the edification of photographers and, as they say at the horse tracks, for the improvement of the breed. O.K., it has improved the breed. The graph of print quality over the past ten years has shown a sharp rise. But it isn't criticism, the sort of criticism that has accompanied, enlivened and enriched the fine arts from the beginning of cultural history.

True criticism addresses the public, acts as liaison officer, interprets, stimulates, challenges, arouses, awakens, blazes trails, and opens the somnolent people's eyes to the wonders that lie hidden in works of art. But so far in photography the alleged critics have been unable to see the pictures for the trees—the trees of Birnam Wood that moved like ghosts to Dunsinane. The trees are emulsions and developers and lenses and shutters and a handful of half-digested dynamic symmetry. The picture, in a word, is a mere by-product of this strange orchestration.

Such critics belong in the schoolroom and the laboratory. They may be masters of the tools of

art, but of art itself, its magic and beauty, its profound eloquence, the deep and wondrous things it is capable of whispering, or singing or saying, these gentlemen of the juries and photographic pulpits appear to know almost nothing.

True criticism is, I say, a *rara avis* so far as photography is concerned. With one or two exceptions, the camera columns in the nation's newspapers, where criticism should flourish like the green bay tree, are spawning grounds for technical chit-chat, gossip, and sporadic back-biting. The camera columnists have been too feeble to throw off the shackles of mechanics with the result that 90 percent of their output is concerned with the abracadabra of technical procedure. The big news is: How was the picture taken? What aperture, what speed, what lens, what camera?

Do civilized people care what canvas, what brush or what pigment Van Gogh or Degas used? Do the neighboring art critics say in reviewing a Picasso show that the artist used Winsor & Newton brushes or Schmincke colors? Of Matisse's design do they observe that the artist mixed pigment with one part linseed oil and two parts turpentine? Indeed they do not. Critics are concerned with *what* the artist has created, not *how* he created it. Too much of photographic writing is just technical double-talk.

We have many salons at which pictures are hung, judged by the technical experts, much as horses at auction are judged, looked at by other photographers and a few intrepid laymen, given stickers of merit and for the most part forgotten. The criticism to which these exhibitions are subjected amounts merely to a measure of grumbling about judges' senility and incompetence, some caustic generalities anent the feebleness of pictorialists.

Denunciation is not necessarily true criticism. The blue smoke of a documentarian, for instance, sounding off in the presence of pictorialists, is usually mere spontaneous combustion ignited in a vacuum. Likewise a pictorialist criticizing documentarianism is a case of the blind berating the blind. This is mere feuding. The fretful sparks of irritation are not criticism. Adherents of schools disqualify themselves by reason of circumscribed horizons. True criticism springs from breadth of vision and insight, not from either isms or the rules of optics, chemistry or composition.

Can it be that this absence of an important critical literature means that photography is not an art? Certainly not. It probably means that the real critics—the hydroquinone Hazlitts, rodinal Ruskins and pyro Paters—have not yet emerged to proclaim it.

Genuine criticism, please remember, is written for and interests the public. Art criticism is the public's guide to art. It stimulates interest in art, and as a result the public buys pictures. Ergo, if photographs are pictures photography needs critics more than it needs anything else.

It is easy to say, as any number of cynical kibitzers do say, that people won't buy photographs because there are too many photographs. If this is true then the art museums and galleries of the world are sheer humbugs based on nothing but a scarcity economy.

Nothing could be more ridiculous. It is true that the *monetary* value of a painting is enhanced by the fact that there are no duplicates, but the *intrinsic* value lies in the painting itself, and that value is not altered even if ten thousand perfect reproductions are made and sold to the public. It remains essentially the same picture. The rarity of a painting is merely its incentive factor to collectors who, quite often, are either speculators or snobs.

But the world is changing, its values falling apart in a cataclysmic upheaval, which is something our cynical kibitzer forgets. And in the new order I venture the prophecy that photography will take its place as the true art of democracy!

Painting has never been the art of the people. Only the wealthy can own great paintings. Great photographs are within the reach of everybody, and people will begin buying them when the great critics arrive to open their eyes to an art that is definitely a product of the new world.

Too many photographs? Nonsense. The same may be said of painting. The walls of art galleries and museums are covered with paintings, and artists turn them out by the hundreds annually. But only a few of these are great pictures, the rest are no better nor worse than most of the stuff hung on our salon walls. It may be more difficult, in terms of time and energy, to turn out a bad painting than an equally bad photograph, but a great photograph calls for as much creative genius to produce as a great painting.

Too many photographs, too many cameras? Cameras are in the hands of a large part of the population. The camera is the people's medium of creative expression. The more cameras there are the more geniuses will be uncovered. The more cameras, the more photographs; the more photo-

graphs the more pictures; the more pictures, the more great pictures. . . .

When the great critics arrive they will open our eyes to the great photographs, show us the magnificent vistas, the quick, transcendent insights, the transforming vision of the creative artist in work that we may have overlooked in our intense preoccupation with technical procedures. The great pictures will prove by turns embarrassing to pictorialist and documentarian alike, for the greatness lies in the vision and the insight of the man who made the pictures and who was able to get these intangible qualities into his print, not in the technical method used.

Photography needs no apologists to counteract its detractors. Photography is a living, vital, modern art on the threshold of a glorious future. What it needs more than anything else at this moment are mature men to sound the critical clarions.

them quite young in chronological age—to support a few teachers who still teach photography as if they were painters! Photographers who strive to build pictures as painters do, primarily concerned with composition and technique and ignoring the vast and turbulent panorama of life, miss the boat and the point.

What is the point? The point is that the inventors and designers of cameras have put instruments in our hands that are capable of doing what painters cannot do—of catching life instantaneously, revealing and interpreting it as no painter can. It is a swift, responsive medium ideally suited to the highly developed reflexes of modern man. Photography is the true image maker of our time. It is as contemporary as the rising sun and the pictures it makes are as vital and exciting as the life it reflects. No, indeed, contemporary photography ain't what it used to be, thanks be!

PITY THE OLD-TIMERS

It is characteristic of human nature that people in general resist change, and photographers seem more resistant than most. At least I have that impression from my mail which carries complaints that pictures published by the photographic magazines and the annuals aren't what they used to be. The truth, of course, is that nothing that grows is what it used to be, and these letter writers are simply those who got left behind in the great forward march of photography.

Too many photographers are living in the past, forgetful that every art changes as time passes. Photography certainly has not escaped the incredibly swift currents of change that have swept over the world in the last 30 years. Today's photography reflects the image and spirit of our time—not, as these complaining old-timers would have it, the image and spirit of the Victorian age. Most of the salon pictorialists practicing today are as modern as Victorian spinsters embroidering antimacassars for the parlor furniture. That age is dead and buried and so should be the pictures the old-timers yearn to perpetuate.

Anyone with the slightest discernment of what is happening in the world knows that photography today is not a Victorian parlor game and is not concerned with the fussy business of contriving pretty pictures exemplifying compositional rules that have been cliches at least 50 years. Yet there are enough of these old-timers around—some of

FREEDOM THROUGH AUTOMATION

The growth of automation in photography has been so rapid that manufacturers as well as photographers have been unable or reluctant to keep pace with it. The photoelectric cell has taken over control of the shutter and aperture on so many cameras that manufacturers who have resisted the trend are getting harder to find. Manually controlled exposure mechanisms are on the way to becoming as uncommon as the stick shift in automobiles, and as time goes on automated exposure mechanisms will keep on improving. Whether or not the strictly manual shutter will survive electronic coupling remains to be seen.

Objections to automatic exposure control on the part of pros as well as some advanced amateurs are based on the contention that it usurps *their* control of the picture-taking process. Professionals in any field, of course, are basically conservative and tend to resist new techniques, nearly always giving good reasons for doing so. In this case they are right so long as they have in mind the camera that can function only automatically. Such cameras are for snapshooters who have no interest in the controls afforded by manual aperture and speed adjustments. But to turn one's back on shutters and diaphragms that can be operated manually as well as automatically is simply to refuse the liberation that such mechanisms offer. When the situation permits, the automatic camera, continually adjusting itself to the fluctuating

light, frees the photographer to concentrate on the action before him; when it doesn't he simply bypasses the automation and proceeds to make his exposure adjustments manually. Indeed, exposure automation does not deprive the photographer of his control but actually takes him another step toward freedom from the tyranny of his equipment.

APRIL 1952

Thoughts on Photography

Simply look with perceptive eyes at the world about you, and trust to your own reactions and convictions. Ask yourself: "Does this subject move me to feel, think and dream? Can I visualize a print —my own personal statement of what I feel and want to convey—from the subject before me? Are my ideas communicative?

—*Ansel Adams*

Just living in a place is not enough. You can live in a community and not understand it. Just looking at it won't do. I almost believe we don't see anything until we understand it. Look into the history of the area—why it started, how it developed. The more research you can do on the place, the more you may realize that you don't know it as well as you thought you did.

Let the subject speak for itself. Be true to the subject. Pretty pictures are only an escape from the subject. Don't photograph a good-looking branch just because it looks nice; the branch should mean something about the community. Photography is a statement; it has to tell us things about a place.

—*Berenice Abbott*

All sizes of negatives and printing papers are arbitrary, and determined by the manufacturer. The real shape is the circular image given by the lens. I have to compose within that circle. Therefore, the problem of square versus rectangle does not disturb me. It is easy to compose a horizontal or vertical image within a circle. It is possible to compose this either when taking the picture or later in the darkroom. Many times my final pictures are square. I do not allow the proportions of the paper to dictate my composition. I change the proportions if they do not fit my idea of what the picture should be.

—*Philippe Halsman*

The documentary photographer aims his camera at the real world to record truthfulness. At the same time, he must strive for form, to devise effective ways of organizing and using the material. For content and form are interrelated. The problems presented by content and form must be so developed that the result is fundamentally true to the realities of life as we know it. The chief problem is to find a form that adequately represents the reality.

—*Paul Strand*

One does not think during creative work, any more than one thinks when driving a car. But one has a background of years—learning, unlearning; success, failure, dreaming, thinking, experience, all this—then the moment of creation, the focusing of all into the moment. So I can make "without thought," fifteen carefully considered negatives, one every fifteen minutes, given material with as many possibilities. But there is all the eyes have seen in this life to influence me.

—*Edward Weston*

Photographic Style

Charles Reynolds

What is it? How can it be developed? Who has it? How much is it worth?

Style is that quality which sets apart the work of one photographer from all others in the field. It is the stamp of personality which distinguishes the artist from the snapshooter and, in the commercial world, the successful pro from the run of the mill picture-maker. If you have developed a style, *a distinctive or characteristic visual quality that is recognizable in all the pictures you make,* you will possess an important key to both artistic and commercial success in photography.

To see a picture is not enough. Your reaction to what you see must also appear in the final photograph. The style of any good photographer is produced by the degree to which he can introduce this unique personal element into his pictures.

Style is more of a problem in photography than in almost any other form of expression. The beginning painter, sculptor, or writer, unless he starts out deliberately to copy, is certain to create a work which is, to some degree, his own. This work may not be of high quality but at least the artist has automatically imposed his personality on the raw material he is using. He has created an image out of the resources of his mind and this image is, by its very nature, subjective. The fact that a photograph is an objective machine-made image of what is in front of the lens of the camera makes it easy to produce (far easier than any painting or sculpture) but at the same time it becomes

very difficult to infuse this image with the personality of its maker. This problem of making his pictures show visual evidence of his own personality becomes a central consideration for every creative photographer.

In spite of the inherent objectivity of the medium there have been many photographers who have developed personal photographic styles. Pictures by Weston, Smith, Karsh, Avedon, and dozens of others are identifiable to people familiar with their work. Their styles are unique and organic. They start with the original decision of what to shoot and follow through the complete photographic process to the making of the final print. Such a personal style cannot be successfully imitated because it fits only the person who originated it.

INGREDIENTS OF STYLE

What are the components of a photographer's personal style? There are three major decisions a photographer makes which determine this:

First, the photographer decides what to photograph. He takes pictures of what is important to him and his decision is necessarily a reflection of his personality and unique outlook on life. Different photographers walking down the same city street would train their cameras on very different things.

One might see a particular person who interested him and ask the person to pose for a picture, another might concentrate on the abstract patterns formed by the buildings with their windows and fire escapes, still another might try to catch fleeting moments which emphasize the human relationships between people on the street. In terms of this approach to subject matter we can break down photographers into three general types: the *director,* the *discoverer,* and the *capturer.* While in many good photographers these distinctions overlap, a consideration of them helps to clarify the way in which most photographers work.

The *director* directs what is in front of his camera. He *makes* the picture and then he captures it on film. Irving Penn, Bert Stern, and Richard Avedon might be roughly categorized as this type of photographer.

The *discoverer* finds things with his camera and preserves these images which he considers to be significant. Edward Weston, a great photographer who clearly fits into this category, once said: "I get a greater joy from finding things in nature, already composed, than I do from my finest personal arrangements. . . ." Other photographers who would fit into this general category are Ansel Adams, Paul Strand, and such discoverers of abstractions in nature as Walter Chappell, Aaron Siskind, and Nathan Lyons.

The *capturer* uses his camera to catch moments of his life on the wing. Perhaps the most famous photographer to fit in this category is Henri Cartier-Bresson with his concept of "the decisive moment." Bresson personally defined his approach to photography in his much-quoted statement that "To me, photography is the simultaneous recognition, in a fraction of a second, of the significance of an event as well as of a precise organization of forms which will give that event its proper expression." An important factor in the *capturer's* approach (as well as the *discoverer*) is that he does not arrange what is in front of the camera to suit the picture he wishes to take. Dorothea Lange, one of the greatest photographers of this genre, has a quote from Francis Bacon pinned to her darkroom door. It says: "The contemplation of things as they are, without error or confusion, without substitution or imposture, is in itself a nobler thing than the whole harvest of invention." This attitude is a key to the style. Almost all of the photojournalists fit into this category of the photographer as *capturer.*

On a more obvious commercial level, many photographers are identified with the type of subject matter which they handle best. Thus we have sports photographers, fashion photographers, portrait photographers and so on.

Second, the photographer must decide how to shoot his subject. Different photographers shooting the same subject would shoot it in many different ways, each attempting to use the resources of the camera to express his particular point of view. His decision on the camera to use, the focal length of the lens, the type of film, the lighting, the angle of view and all the other aspects of shooting a picture contribute to the style of that particular photograph. After a photographer has become proficient in his work, he makes these myriad decisions on the basis of what he wants.

As photographers develop a style they often become identified with the equipment which is best suited to their particular approach and point of view. For example, Cartier-Bresson is commonly identified with the Leica. This 35-mm camera with its speed of operation, unobtrusiveness, and flexibility is consistent with his approach of capturing the "decisive moment" in a particular situation. Weston, on the other hand, is identified with the 8×10 view camera, perfectly suited for photographing the extreme detail and superb tonal ranges for which his pictures are famous. Other photographers, such as Bill Brandt or Fritz Henle, are particularly identified with the Rolleiflex. The many photographers who shoot with several different kinds of cameras usually have a style which resides in other aspects of the photographic process, such as their sense of composition or use of light.

Because the photographer is inextricably wedded to the machine which produces his picture, the technological changes in that machine and in the film that goes through it will always be reflected in changes in photographic style. For example, the recent rise in popularity of the single-lens reflex camera (usually used with long-focal-length lenses) has produced a style of photography virtually unknown a few years ago. The stylistic influences of technological advances such as color printing are also just beginning to be seen.

The third component of personal style is how a photographer makes his prints. Different photographers shooting the same subject in the same way would probably come up with very different final prints. A W. Eugene Smith print is very different from a William Klein print and each printing style is an

integral part of the vision of the photographer who employs it. Most fine photographers recognize this relationship between the quality of the final print and what they are attempting to express. Richard Avedon has said, "To get a satisfactory print, one that contains all that you intended, is very often more difficult and dangerous than the sitting itself. When I'm photographing I immediately know when I've got the image I really want. But to get the image out of the camera and into the open is another matter. I make as many as 60 prints of a picture, would make 100 if it would make a fraction's improvement, help show the invisible visible, the inside outside." In his concern and respect for this final step of the photographic process, Mr. Avedon is not alone. Most good photographers share his opinion.

CULTURE INFLUENCES STYLE

There are many outside factors which act upon the photographer to influence how he makes his basic stylistic decisions.

One of these is the style required by the audience for which the pictures are intended. Ideally, this perhaps should not matter, but no photographer exists in a vacuum and the influence is undeniably there. If a professional photographer wants to sell his pictures to a particular magazine he will, within limits, modify his personal style to fit the requirements of that publication. Even the amateur preparing pictures for the contest at his photo club will tend to conform to the style that is popular in that club. On every level the photographer takes not only the kind of picture that he likes but also those which gain him the recognition he desires.

There are other, far subtler, cultural influences on the style of a photographer. Every country and area of the world has a predominant photographic style. When viewing quantities of pictures, one soon learns that there is a difference between northern or southern European styles of photography or between the pictures taken in Japan or the United States. These differentiations obviously do not apply to each and every picture but the general trends are obvious. Cecil Beaton commented on this in a discussion of the camera in his book *The Face of the World:* "The extent to which this passive mechanical instrument can be the medium for the subjective element is nowhere so apparent as in national styles of photography. English and American photographers produce very

different work. In England, we are inclined to be softer and more sentimental in our approach to a subject; American photographers are more direct, more realistic, and at times brutal. Yet there is an infectious vitality in American work. The photographs taken of the late King George VI and his Queen, during their American visit before the Second World War, were so very American that they looked like part of the American scene itself. When in Rome, even the camera does as the Romans do."

A further stylistic influence is the general cultural climate of the times in which the photograph was taken. There is almost nothing else as contemporary as a photograph. If one doubts this, he has only to look at the pictures published 10, 20, or 30 years ago. The times have changed and the photographic styles like the fashions in dress have changed with them.

PHOTOGRAPHY AND PAINTING

One of the most interesting influences on general photographic style is the constantly shifting relationship of the medium to painting and the other graphic arts. In the early days of photography, its principle appeal lay in the fact that the camera could reproduce literally and objectively what was before it. Up to that time, this recording function was filled none too successfully by painting and the other graphic arts. After a preliminary moment of panic, when some of the more pessimistic artists thought the new invention marked the end of traditional art, the situation began to balance out. Photography began taking over the areas of literal representation which it could handle best and modern art began moving in the direction of the abstraction which characterizes it today. Some representational fields of art, such as portraiture, were almost completely absorbed by the new medium of photography. Edward Steichen wrote: "Certainly modern art has dumped the business of literal representation, dumped it lock, stock and barrel, for better or for worse, into the lap of the photographer, giving the painter a freedom he is now beginning to use." As photography grew a little older, it began to compete with the traditional arts for recognition as a legitimate means of expression. Creative photographers, while protesting loudly that they should be recognized in their own right, began producing pictures that were practically indistinguishable from the late 19th century paintings which preceded them. At

the same time, some major painters such as Degas were being strongly influenced in their work by photography. Over the years photography has continued its evolution toward a style which is purely photographic, while the old pictorialist tradition of photographs which look like paintings have persisted feebly in the stagnant backwaters of some of the salons. Even today, the interaction between the painting and the photograph continues and the influence of nonobjective modern art is visible in many of the abstract images being produced by contemporary photographers.

In an attempt to supplement my own ideas about photographic style, I took an informal survey of the editors of *Popular Photography*. The first question I posed was, "How can a valid style be developed?" Mike Kinzer commented, "Real style can be good only if organic, unlearned. Style resides in the EYE which never stops looking at the image, from the viewfinder to the mounted print." Bruce Downes felt that "a conscious striving to achieve style can do nothing but achieve mannerism." Jim Zanutto agreed that style can evolve naturally only through shooting many pictures. "Sometimes, when shooting pictures, I unconsciously imitate. By imitating enough people, it's possible to get a style of your own. You also learn by imitation," he said. John Durniak commented: "Style takes years to develop and thousands of pictures. I don't think anyone who shoots as casually as I do can have a style. To have a style and be versatile within this style—that is the crowning achievement."

ITS COMMERCIAL VALUE

Most of the editors recognized the commercial value of style. Lee Drukker felt that, "a definite, recognizable style can be an economic advantage to the working photographer, a trademark. By consistently turning out work that is just a little different, always in the same direction, the photographer builds a reputation." Jim Zanutto's terse comment was "Style sells. Do you want to sell?"

Several editors commented upon the problems of working within a particular style. John Durniak observed that "there are a few men (Penn, Avedon, Shaw, Stern) who have developed a definite style and are bought for it in the commercial area. I feel, however, that they are always fighting themselves, trying their hardest to be versatile within their styles. The fear of turning out something that looks like yesterday's assignment is constantly over them. To have this fight within a style is healthy." Les Barry warned that "a photographer who recognizes that he has a style and tries to stay within it is doing himself a terrible disservice. As the history of any successful painter proves, style must undergo change in order to remain dynamic." At about that time Ken Heyman came into the office and I decided to ask a working photojournalist for his comment on style. Heyman said, "I have consciously tried to steer away from developing a style. When I see myself taking a certain kind of photograph over and over I make a conscious effort to stop it. I think that for a young photographer it is a mistake to have a personal style too early." The danger that a photographer will consciously try to develop a style that is merely a gimmick was commented upon by almost everyone.

Whatever the commercial value of a style and its danger as a limit to creativity, all the editors agreed that as a photographer shoots many pictures and becomes complete master of his tools, a consistent visual approach often emerges. Ideally, this remains flexible and allows him to develop. All of the editors felt that certain photographers could usually be recognized by their distinctive styles, although Bruce Downes emphasized that the degree to which a style is recognizable is directly related to the control the photographer is able to exercise over what he is shooting. "The closer a photographer comes to candid spontaneous work, the less likely he is to develop a recognizable style," he said.

EXPERIENCE PRODUCES STYLE

The fact that only by shooting many pictures and becoming completely experienced in his medium can a photographer evolve a style has been illustrated to me many times in my job. When you see, as I do, a considerable number of photographers' portfolios in the course of a day's work, it becomes possible to predict, with considerable success, how long a photographer has been shooting by the consistency of his stylistic point of view. The beginning photographer may show you 20 photographs, some of them good pictures, but each of the 20 might have been shot by a different person. With an experienced photographer this is almost never the case.

In photography, style seems to become most apparent when you view many pictures by one

photographer. In painting, where the image is shaped more completely by the personality of the artist, it is comparatively simple to look at *one* painting by Van Gogh or *one* painting by Cézanne and identify who made it. In photography it is practically impossible, even for an expert, to positively identify the work of a photographer from one picture. The only really fair way to distinguish between the work of a photographer with a personal organic style and the work of one of his imitators is to look at several pictures by each.

No one, if shown an unfamiliar example of the work of Henri Cartier-Bresson and a successful photograph by one of his many imitators, would be able positively to distinguish between them. In terms of large numbers of photographs by each photographer, however, the qualitative difference between Cartier-Bresson's work and the work of the imitator who has adopted a style not really his own, would soon become apparent. Ralph Evans in his book, *Eye, Film, and Camera in Color Photography,* makes a similar observation when he writes: "Because styles are, by definition, idiomatic, it is necessary for the observer to see more than one picture to interpret the results. The answer could be in the production of groups of pictures of similar subject matter and the same style. There is much evidence that in photography the group plays the part of the single picture by an artist whose style is known."

It is this implied versatility within an honest and organically developed style which gives the work of a good photographer both its vitality and its personal touch. Without it style becomes a rigidly imposed limitation to creativity and must ultimately degenerate into commercial gimmick or merely empty mannerism.

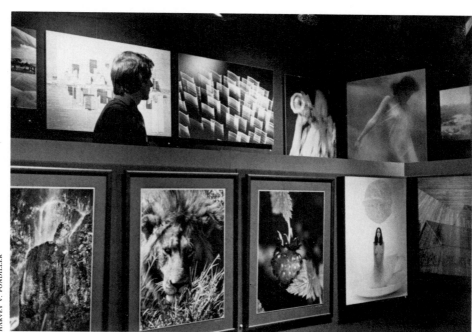

HARVEY V. FONDILLER

285

Hearing's Believing?

Tony Schwartz

The other day, Harvey Fondiller of this magazine remarked, "Most people are more likely to believe something if they read it than if they hear it." Later in our conversation, when we were discussing a transcript of one my tape recordings, I said: "You have to *hear* this to really understand it."

In a way, he was saying, "Seeing is believing," and I was saying, "Hearing is believing." Actually we're both right and both wrong.

Today we live in a world of many media and we receive messages by many means. Each of the media has its own characteristics . . . its own areas of power and of inadequacy. This applies to TV, movies, newspapers, books, magazines, records, letters, telephone, telegraph—and it even applies to such things as baby bottles and lace.

Note the effect on people of different media:

• On a line with five other people I waited to ask a store clerk for information about a new product. The phone rang. The clerk immediately answered the call. The person on the other end of the telephone line received the information; *we* waited.

• A mother gave her child a shopping list. Another mother told her child what she wanted from the store. Need I say more?

• Have you ever heard someone say, after coming out of a movie, "The book was much better!"

• The director of a school for boys sought a way to make his students tuck in their shirttails. Talk was ineffective. Lace, sewn onto the shirttails, produced results.

• In a jail, many prisoners tried to prove their toughness by misbehavior that led to solitary confinement. Talk by the warden was ineffective. Bread and water (in baby bottles) produced results.

• A New York policeman told me: "If you're ever attacked in a building, don't yell *Help*—yell *Fire!*"

These examples indicate how various media convey different messages, as well as the same message in different ways. They suggest why the creative tape recordist should ask himself, "What can this medium do that others can't?"

If you want to show how someone has grown taller over the years, you can't beat photography. But if your intention is to show the changes in their thinking and feelings, writing or recordings would undoubtedly be more effective media for this specific purpose.

Some people become so involved in one medium that they become "blind" to messages in other media. For example, in a commercial for a children's candy, I recorded a child telling how much he liked the candy, while chewing on it. The copywriter (who was accustomed to writing words for everything in his ads) heard the tape and remarked: "You didn't say it was chewy." He was wrong—I *did* say it, but *he* didn't *hear* it. In this case, the sound of the chewing said "chewy" and conveyed the message.

If you get an enthusiastic response to one of your recordings, consider it a good indication that you have made the right choice of medium for your message.

Truth, Myth, Fallacy, Humbug, Etcetera...

Arthur Goldsmith

Every branch of human knowledge has its body of commonplace beliefs and truisms—what John Kenneth Galbraith has called the "conventional wisdom." Photography is no exception. In any photographic conversation today you are likely to hear one or more of the following statements—or even make them yourself. They are part of the contemporary folklore of photography: statements whose truth is widely accepted by the in-group of sophisticated photographers as self-evident.

But are they really true? Or are many of them half-truths—a misleading mixture of fact and fiction? Are some of them even completely false—the new myths of photography's automated age? Let's take a look at some of the most popular of these truisms and see.

• *Available-light pictures are realistic.* Ever since the phrase "available light" was popularized in the early 50's it has carried the connotation of "realistic." In one sense, available-light pictures frequently are. Shooting by the light that exists often enables a photographer to capture real human emotions and uncontrived situations. But however natural-looking the action, available-light pictures just as often are highly *un*realistic in terms of reproducing the illumination in a scene the way the eye sees it. As any available-light photographer knows, the common problem is to record satisfactory detail both in highlights and shadows. Vigorous development for high exposure index tends to build up the contrast in the negative.

Shadows often go black, highlights become harsh and glaring, or both distortions may occur. As a result, the typical available-light print tends to make a subject look more dramatic (and gloomy) than the original.

Some photographers have been exploiting this effect with great success for years, turning a handicap into an asset. By producing a dark, heavily ferricyanided print from a contrasty available-light negative, they can turn a gay party into a gathering of ghouls or a cozy living room into a gloomy cavern. The result may have visual impact, but realistic it certainly is not.

PHOTOGRAPHERS CAN'T WRITE

The opinion is widely held by writers and editors, but is shared by a number of photographers, too. Actually, the statement makes no more sense than claiming that "plumbers can't write." Some can: some can't.

Admittedly, visual and verbal ability don't necessarily come wrapped in the same package. However, many photographers today not only are literate but also are at home expressing themselves with words.

To name just a few examples, consider the following well-known contemporary photographers who also are successful writers: Gordon Parks (a novelist as well as a photographer): Philippe Halsman (author of several books including a children's fantasy), David Douglas Duncan (among other items he wrote a lengthy historical text for his *Masterpieces of the Kremlin*): Carl Mydans (widely considered as fine a reporter with words as he is with pictures); Henri Cartier-Bresson (his intro-

duction to *The Decisive Moment* is an eloquent essay on photographic esthetics); Andreas Feininger (author of many books on photography); and Robert Riger (a triple-threat artist-photographer-writer). When you stop to think about it, the notable exceptions to "photographers can't write" are so numerous they just about abolish its validity.

PHOTOGRAPHY IS EASIER THAN EVER

Most of us have made this comment at one time or another, meaning it is easier in the mechanical, physical sense to produce a technically acceptable picture today than it used to be. However, the truth of the statement depends on which yesterday you are referring to.

If you mean that photography is easier now than it was in 1865, for example, there's no question about it. When the pioneer combat photographer Roger Fenton covered the Crimean War he carried with him 36 cases of equipment in a horse-drawn van, and had to coat his wet plates on the battlefield itself before he could make a picture.

On the other hand, if you compare photography today with 1888, the statement may not be entirely accurate. That was the year the first Kodak snapshot camera was introduced, and the slogan "You Push the Button, We Do the Rest" meant exactly what it said. Your camera came preloaded with a roll of film that produced 100 circular pictures. After using up the 100 exposures, you sent both film and camera to the factory and got back mounted prints and the camera loaded with a fresh roll of film. For amateur photographers, things never have been quite so easy since.

FLASH PICTURES LOOK CONTRIVED

Often they do, but they don't need to. A contrived, artificial flash picture is the fault of an inept photographer, not of the technique. In reacting against the stilted, elaborate, multiple-flash lighting of the 30's and 40's, and the crude, flash-on-camera techniques of Neanderthal press photography, they have thrown out the good with the bad. Flash—especially bounce flash—can be used in such a subtle, unobtrusive way that even an expert photographer or picture editor can scarcely detect its presence. Many published pictures that pass for available-light shots in their spontaneity and naturalness actually were helped by a touch of discreet bounce-flash illumination.

THE PICTURE STORY IS DEAD

This lament has been heard more or less continuously for the past 15 years whenever photojournalists and their friends congregate. Whether it is true or not is largely a matter of semantics and how narrowly you define picture story. The conventional "day-in-the-life-of" type of picture story, once so popular, does seem to have worn itself out; magazines that used to run picture stories have folded, and others have curtailed or eliminated them.

On the other hand, new markets have risen. The picture story, in one form or another, is thriving in a host of smaller publications—house organs, trade journals, university publications, specialized magazines, etc. To name just a few that come to mind: *International Harvester World*, *The Camp*, *American Cyanamid Magazine*, *The Texas Quarterly*, and *Ford Times*.

The simple picture story has evolved, too, into the more complex and subtle form of the photographic essay, which finds its most effective expression, not on the pages of a magazine, but in a book. Martin Dain's *Faulkner's County* is a good example of the picture story writ large, and so are Magnum's *First Hundred Days*, Shirley Burden's *Behold Thy Mother*, Robert Frank's *The Americans*, Wayne Miller's *The World is Young*, and any of the "continent" books of Emil Schulthess.

The picture story sometimes appears in a new guise, too, as still photographs used for television (with or without accompanying motion picture footage). Gordon Parks' *Flavio* and Marvin Lichtner's *A Child's Christmas in Wales* are two examples of how a picture story can be transformed into a television film.

From a broad perspective, then, it would seem that any reports of the picture story's death are highly exaggerated, this bit of folklore belonging more to the realm of myth than reality.

PRINTING IS A LOST ART

Anyone who has observed the general level of black-and-white prints by American amateurs in recent years will tend to agree. Also, few professionals today find the time to do their own printing, usually preferring to turn this task over to a custom lab or a darkroom assistant. Good printers are hard to find, professionally speaking, and automation is filling the gap. But if printing is neglected as an art, it certainly is far from lost.

For a minority of serious contemporary photographers, printing is an essential aspect of their craft. To name just a few. Paul Caponigro and David Heath among younger photographers, and Ansel Adams and W. Eugene Smith among older ones, have set contemporary standards of the highest quality. Who can say that the print quality obtained by the most skilled practitioners today, however small that minority may be, is not on a par with great printers of the past?

There are signs, too, that darkroom activity may be making something of a comeback on a wide scale. In a recent survey, photo dealers noted a substantial increase in the sale of darkroom products. Some enlarger lines and the Kodak drum processor have been selling well. The Metropolitan Camera Club Council, with about 70 clubs in the New York area, has reported to *The New York Times* a large increase in the number of color prints (which must be processed by the photographer) entered in its interclub competitions. Between color and black-and-white, the "lost" art of printing may be on the verge of a renaissance, in which case another piece of photographic folklore will have to be revised.

YOU CAN'T SELL ART PHOTOGRAPHS

For many photographers, this truism has been uncomfortably true. Although there has been a small but steady increase in the number of print sales to private collectors and museums, the photographic print market still is minuscule by comparison with the booming (and highly inflated) art market. However, the situation is not entirely bleak: photographic prints, as works of art, sometimes are worth much more than is generally realized. Prints from contemporary photographers have been sold at prices ranging from about $25 to $75 for black-and-white, and up to about $200 for color. Pictures by well-known photographers of the past often have considerable market value, as do good examples of obsolete, historically important techniques—calotypes, daguerreotypes, etc. According to Nathan Lyons of George Eastman House, original Atget prints may sell for $50 to $60 or more on the U.S. market today. Platinum prints may bring about $200. A Julia Margaret Cameron portrait was sold at auction for $700 a few years ago in Switzerland. And speaking of auctions, the Parke Bernet Gallery auction of the Will Weisberg collection brought some surprisingly high prices —$350 for a Cameron portrait of Alfred Lord Tennyson, $260 for a single daguerreotype, $1,850 for a collection of 31 calotypes by David Octavius Hill. Although way below the million dollars paid for Rembrandt's "Aristotle Contemplating the Bust of Homer," these prices aren't peanuts, either.

PHOTOG OUTRANKS EQUIPMENT

To question this truism is rank heresy. But to be honest, it doesn't always apply. There are situations in contemporary photojournalism where the equipment (and the picture editor) usurp some of the functions usually left to the photographer. I refer to using rapid-sequence cameras to give massive, "total" coverage of an event, rather than relying on the selective eye of the photographer to choose the decisive moments.

Life, for example, used a battery of heavy, rapid-fire, super-telephoto equipment to cover the Olympic games in Tokyo. Specialized equipment like this enables the editors to obtain dozens, scores, or even hundreds of 70-mm frames of key events. Once the camera angle is selected and the equipment properly set up, the photographer's role is less critical than the judgment of the picture editor who selects the best frames.

Some interesting examples of photography without photographers were shown at the Museum of Modern Art's recent "Once Invisible" exhibition. Beautiful patterns and images were displayed in color and black-and-white—and many were captured by automatic equipment. Art untouched by human hands!

Personally, I don't believe there's any substitute for the photographer's individual seeing and thinking. But things are happening amid the fantastic technology of our age that make one stop and think. The truism about photographer versus equipment needs to be qualified. In some limited situations, it *is* the equipment that makes the picture, disturbing as the idea may seem.

You may feel there is a good deal more truth than I have indicated—or considerably less—in the statements given above. But whether you agree with me or not. I'll be pleased if I've stimulated you to think. In any field of human knowledge or activity, commonplace truisms tend to become established and so taken for granted they are never challenged or questioned. It's healthy to stand them on their head and shake them once in awhile to see if a few coins of truth fall out of the pockets.

What Kind of Photographer Are You?

Edward Meyers

A friend of mine once asked a famous sculptor-potter if he considered himself to be an artist. He replied by explaining that he was not an artist. Everyone who paints pictures on Sundays is an artist. He would rather call himself a ceramist.

Anyone who owns a camera can call himself or herself a photographer—that's one of the nice things about photography. The only qualification is, what kind of photographer are you? Where do you fit into the photographic scene? Read on and perhaps find your niche. If you're not satisfied with where you fit, aim yourself in a new direction.

Let's first eliminate two categories simply because they are so obvious. The first one is the three-roll-a-year snapshooter who shoots six frames at Christmastime and finishes the roll during his summer vacation. You don't fit into this category, because if you did, you would not be reading this column. Number two is the professional photographer who shows up at his job, makes the pictures he must make, then at 5 p.m. goes home, and only *thinks* about shooting his personal pictures at Christmas- or vacationtime (see category number one). This worker is not really a photographer, although by definition, since he makes his living shooting pictures, he is called one. I call him a picture mechanic. He wouldn't be reading this column either.

Then there is the pro who not only makes his living from selling his picture-making talents, but who also cares about his pictures. He tries to make great images for money and for pleasure because he finds pleasure in what he is doing and often wants to tell the world about it. I admire this guy. You may not agree or understand what he's trying

to communicate, but you respect him for his enthusiasm and drive.

This photographer could also be an amateur making his living at some other profession. In fact, many amateur photographers are as good as or better than professional image makers. Because you make a living at photography doesn't mean you are automatically better than someone not shooting for pay. Within this category of professional and amateur, you find many variations. There's the picture taker who only carries his camera when he has a specific picture to make. He's a rare but dogmatic shooter. His pictures are often preconceived, classic in composition, and crying to be accepted and praised by others. Another *always* carries his camera. I suspect he even sleeps with it. And within the group of people whom you never see without a camera, there are those who (unfortunately) keep them inside leather cases or gadget bags. When a picture presents itself, they remove the camera and shoot—most often too late to make the picture they saw with their eyes, because it takes time to remove a camera from a bag or open a case, make the necessary settings and shoot. The guy with the caseless camera is the one who has the best chance to make the split-second decisions, and therefore make the better pictures. (The so-called ever-ready camera case is a photographic accessory of much dispute. It is commonly called the never-ready case, for obvious reasons. Sure, protect your camera with a case, but do it when you don't want to make pictures.)

Carry the works, or simplify your shooting equipment? I've made mention of this subject in

290

the past. Should you hang three cameras around your neck containing different films, all with similar focal-length lenses, or with the same film in all, plus varying focal-length optics? Or, use one camera, film, and lens at a time? I choose any of these techniques. It all depends on my mood at the time.

Enough of gadgetry. Let's get back to the shooter who lives with his loaded, quick-draw camera. He's a gut image maker. He doesn't worship his cameras and lenses. This is evidenced by their dented prism housings, scratched surfaces (including lenses). It's also shown by his or her lack of regard for precision, observed when he or she is seen plopping cameras and lenses on a table, chair, or the floor of a car. When these highly prolific shooters carry two or three cameras in ready position, you'll see and hear the clunks and cracks of their meeting as they swing strapped in a cluster on a shoulder or around a neck. I'd hate to know how much money goes for repairs.

Still another photographer-type is the equip-ment collector nonshooter. I don't refer to the collector of old cameras. That's another bag. The guy I do point my finger at buys cameras and lenses with intentions of using them, but does not. He may own one each of four *different* SLR cameras plus a couple of rangefinder ones. He may even carry three or four of these cameras with intentions of making pictures. Rarely does he finish rolls of film in any camera before expiration dates pass him by. There's no sin in owning many cameras and lenses. The sensible buyer chooses them, however, for specific purposes, and *interchangeability.* This means interchangeable lenses from one camera body will fit one or more of the other cameras.

I know that I've hit on sore spots or weaknesses common to many picture takers, maybe even yours truly. The idea here is to rap about them and bring them out into the open. You must re-evaluate goals once in a while and perhaps change direction, if you find yourself wandering or going the wrong way. Who doesn't?

291

How to Be a Photographic Snob

David Vestal

WHY BE A PHOTO SNOB?

The overriding reason to become a photographic snob is that being "in" is an easy way to impress oneself and feel important. In its purest form, photographic snobbery is almost totally efficient. It requires no work, intelligence, expense, or achievement beyond the constant assertion of a sweeping redefinition of everything photographic. This redefinition makes it clear that whatever the snob does or thinks is right, whereas all contrary thoughts and actions by others are inferior and wrong. Thus, the snob is World Leader.

A nice thing about the status of World Leader is that anyone can attain it, but *nobody else can*. Exclusiveness is the key. The photo snob is an in-group of one. When others agree, they prove he is right; when they disagree with him, it only shows how wrong they are.

It's great to be *Numero Uno*. If you are not already a photographic snob, think of the fun and profit you're missing. Get with it by following these instructions:

PHOTO SNOBBERY AS ART

Art is a green pasture for the photo snob. Even if you are totally incompetent, you can go far in the art world. Simply declare that you are a genius and that your work, although misunderstood by clods, is uniquely marvelous.

Call your work your *oeuvre* and point out that it's over the heads of peasants. Dismiss other photog-raphers, especially those with reputations, as envious second-raters.

Delightfully, art is a subjective field, so no one can prove you are wrong, even if you obviously are.

THE LIMITED-EDITION PLOY

Ignore the plain fact that few photographs exist in more than 10 prints. Breathlessly announce a limited edition of 100 prints. Add that their scarcity forces you, reluctantly, to raise your prices.

If the prospect of making 100 good prints appalls you, relax. You really make 10 prints and number them from 91 to 100. You only say there are 100, so you can use the magic word "edition." The prints do not have to be good, and you don't have to make them. Any lab can knock them out quickly. You just tell people how hard you worked and how great the prints are.

For collectors: buy limited-edition prints and talk about them. Avoid moderate prices. Pay extravagantly (impressive), or drive a hard bargain (you can't be fooled). Either ploy, delivered with well-chosen gossip in which at least two great names are dropped, will show that you are "in" and move in awesome circles. If you can be off-hand in all this, so much the better.

DESTROY THE NEGATIVE

Your price can be multiplied by 10 if you destroy the negative or say you did. Not only are destructive tantrums a universally respected sign of genius, but also the scarcity value of a limited edition

is thereby so enhanced that destroying the negative makes even a hopelessly mediocre picture extremely valuable. (I have secret plans to destroy a negative *before* printing a super-limited edition of zero. This will lend the picture even more inestimable value.)

SIGN YOUR PRINTS

Like checks, prints take on cash value when signed. In art traditions, the signature is the artist's seal of self-approval, a socially acceptable way to claim that the work is good. Your signature also shows that you can write your name. Together, these factors make a signed print much better than an unsigned one, except in rare cases like the one that follows.

MAKE A PRODUCTION OUT OF NOT SIGNING YOUR PRINTS

The following quotation from Alfred Stieglitz can hardly be improved upon as an example of modest name-dropping and virtue-by-association: "When people ask me why I do not sign my prints, I ask them, 'Does God sign the sky?'"

This ploy can be used to turn any omission into a profoundly significant gesture.

The difficulty is getting people to ask.

PROCESS ARCHIVALLY

Even a miserable smudge of a print seems to take on intangible cash value if you process it archivally so it will retain its smudginess unchanged for thousands of years. Or if you say you did. Nobody checks.

For excellent photographs to last for a long time is clearly a good thing. How much better for masterpieces to be immortal, then, even if the pictures aren't much good.

Remember the principle of assertion. A rubber stamp that says "Archivally Processed Print" is a convenient substitute for washing the prints.

THE EPHEMERAL PRINT (CONCEPTUAL ARCHIVAL PROCESSING)

If, after much fuss about archival processing, the prints quickly turn yellow and fade, the true photographic snob is not embarrassed. He merely points out the equation Scarcity = Value, and the fact that the *ephemeral print* enjoys enhanced scarcity: in time as well as in space. If there is a problem, he says his assistant got the rubber stamps mixed up ("He's a bit of a genius, you know, but not methodical.").

At this point we should consider scarcity value in depth. Just as the only seabiscuit in the lifeboat expands in food value to feed a whole crew, so does the unique print take on incomparable beauty and strength. When there is even less than one print—as in the case of one that is half faded away—its value multiplies.

The ephemeral print, the one that fades most rapidly, is the most precious of all. You can watch the beauty fade.

The spiritual virtue of ephemeral processing, or conceptual archival processing, is that it shares the purity of conceptual art. You talk about it, but you don't actually do anything about it. The photo snob will appreciate the beauty of this approach.

CLAIM THE IMPOSSIBLE

The snob art photographer is not content merely to shoot and print superb pictures. He *creates.* His art transcends reality, or so he tells us. "My images are far more real than the world of surface facts: they lift the veil and pierce the unknown." And no one can prove they don't. There are none so blind as those who will not see, see?

BE INCOMPREHENSIBLE

Clarity in showing the obvious is beneath the true snob's notice. He is concerned with manifesting the inner isness of the whatness, often with accompanying poetry: "Whales' feet trampling cosmic grapes produce soft drinks, hamburgers, Styrofoam. Ah, the eyes." The way to appreciate this sort of thing fully—and to enter the in-group—is by prayer and fasting. Or you go around quoting it reverently, which will do as well.

BE ABRUPT

This is a tested countersnob technique. When other photographers try to compete with you, the easy answer is to shut them out of your in-group. No matter what they say, you answer with one word. Almost any insulting word will do, but stick to the same one. (All together, now, "Baloney.") You automatically come out on top. See how easy?

BE INNOCENT

Realize, please, that it's dangerous to know what you are doing. Your purity might be compromised, your inspired naiveté corrupted: you would no longer be above it all. So talk, do not listen. Show your pictures, but do not look at pictures by others or notice the world around you. Then information will not confuse you, and competence will not limit the freedom of your flights of pure expression.

TRY MACHISMO

The macho photo snob is carefully scruffy, like those Cossacks in *Taras Bulba* who wore silks and velvets to show that they weren't cheap, and smeared them with tar to show that they didn't care.

To be a macho snob, you must carry the regulation outfit of two badly dented late-model cameras of an expensive "in" brand (see *The equipment snob*). Brass must shine through holes worn and gouged in the black enamel.

To achieve full macho-snob status, study method actors and learn to grunt, mumble, and scratch.

When someone praises your pictures, look at him with contempt and snarl, "You like that crud?" Show him that you think he's an idiot.

When other photographers are mentioned,

shrug or grunt. Your reputation for character and integrity will shine like a bloodshot beacon. A diamond in the rough, that's you. A little hard to take, but what a guy!

BE AN OBSOLETE-PROCESS SNOB

Be the first kid on your block to coat glass with collodion and make genuine ambrotypes. Whomp up a batch of platinum paper, or buff some silvered-copper plates and make daguerreotypes.

The quality, with luck, can sometimes equal that of the prints you can make on store-bought paper with one-twentieth the labor and at one-tenth the cost of these great old processes; besides, you can charge extra for quaintness. If the pictures look peculiar enough, they've got to be art whether they're any good or not.

THE EQUIPMENT SNOB

Cameras are extraordinary toys, so equipment snobbery is multiform and rife. To avoid confusion, we oversimplify here. Remember that the key principle here is assertion, and you'll be okay.

The in-camera snob (amateur) typically carries the latest Leica, Nikon, Canon, or Hasselblad—sometimes all four. The brands vary with the seasons. The cameras are equipped with either the showiest or the most highly specialized lenses. They are to show off and to talk about, more than to take pictures with. This snob talks about what really matters to him in photography—prices, deals, and discounts, which he knows the way baseball fans know batting averages.

The in-camera snob (old pro) collects battered expensive cameras: the more battered and the more expensive, the better. He is never seen with fewer than two cameras, arranged so they bang together alarmingly when he walks ("Hell, they're only tools.").

These cameras are laden with ritual gadgets and excrescences. Black tape peels off chrome, mushroom-shaped "soft releases" tower over shutter buttons, little extra levers are fastened on focusing rings to make old pro a little faster on the draw, and surgical ringlights dangle from lens barrels. The cameras are motorized so as to be extra heavy; they hang on badly frayed four-in.-wide webbing straps bought at surplus stores and left in the sun to ripen. The photographer walks hunched over to express suffering. Everyone

knows at a glance that he's an old pro. He takes pride in being inconspicuous.

Rough and tough as he is, old pro defends one area of childlike innocence. He has never learned to read a meter, a sissy skill that would shame him. Instead he makes vague guesses and tells the lab, "Shot these at four thou." In actual fact they are only slightly underexposed.

The classic-camera snob is like the classic-car fiend. He fondles his equipment instead of taking pictures with it. He is full of esoteric lore, and knows when each of 10 unannounced changes in the design of the 54-mm Gloppar f/1.3 took place, the designer's name and Tokyo phone number, and the reason for each change (higher resolution at the edges of the image at the small apertures).

He's also a historian: "They only made 27 of these babies with the lens put on backward, but the old pros swear by them."

The classic-camera snob's pictures usually have low resolution at the edges and elsewhere—unsharp at any aperture—but his talk is razor-sharp: authoritative, technical, and endless.

The inverse equipment snob prefers cheap, poor-quality cameras and materials after all, the photographer makes the picture. It pleases him to use a camera that is held together with string and chewing gum, and he is delighted when the lens falls off. The poorer the quality of his pictures, the prouder the inverse equipment snob is of his talent and his faithful old Super-Wretchflex.

BE A GRIZZLED OLD FOLK-PHOTOGRAPHER SNOB

The grizzled folk-artist or Douanier Rousseau-type photo snob also enjoys inverse equipment snobbery. To become one, you quit shaving and carry one of the following three cameras: an early Instamatic, a roll-film Polaroid, or a 3A Autographic Kodak Folding Camera. With it, you devote your efforts to showing up the fumbling efforts of them danged dudes with them fancy cameras. Gabby Hayes is the model.

You don't buy your camera new. You either find it in a phone booth or win it in a breakfast-cereal contest. When the first jumbo prints come back from the store, you find you are an undiscovered folk-genius—Grampa Moses with a camera.

Someone always has to load the Instamatic for you because you never could get the hang of all that technical stuff (see *Be innocent*).

Your pictures are consistently fuzzy tilted,

fogged, smeared, and scratched. The deckled edges give them finish.

The funny thing is, they all come out just great. You say so yourself, all the time.

You specialize in homely subjects—bums in doorways, crying babies with dirty faces, and so on. Aged morons with wrinkles furnish you with character studies, always profound and full of deep human feeling. You say so yourself, all the time.

BE A HIP YOUNG RELEVANCY-AND-SUFFERING PHOTO SNOB

This is very "in" right now. To succeed fully as a relevancy-and-suffering snob, is helpful to say "man" and "like, you know" and other meaningful things like that all the time.

But the main thing is to go into ghetto neighborhoods and annoy the people who live there so they will look at you resentfully, with anguished or angry (and therefore real and deeply meaningful and relevant) expressions in your pictures. The pictures will then be relevant, too, so they will bring about social justice right away.

Relevancy is so well understood today that a whole generation of photographers have been able to express it mathematically by the following equation: Ghetto child + snot or tears + garbage \times camera + Tri-X \times underexposure \times overdevelopment \times contrasty printing = Relevancy.

For a higher level of relevancy and suffering, add rats (living or dead) and established hard-drug symbols such as hypodermic needles (bent), scars, and sores on arms and legs of sweet children.

The more relevancy-and-suffering photographers go forth daily into our slums, the sooner that earthly paradise of universal joy and justice for which they strive will arrive. Order your camera today and hasten the millennium.

BE A COMFORTABLE MIDDLE-AGED RIBBON-AND-MEDAL PHOTO SNOB

Ribbon-and-medal snobs are simply transposed relevancy-and-suffering snobs of a different age group. They, too, operate in fixed ritual patterns and compete ruthlessly for points. Instead of relevancy, however, the aim is a certain hard mechanical finish in sentimental pictures of several preestablished types; and instead of taking place in the ghetto, the action takes place in the camera club.

Most of the pictures are as follows: pattern shots, solarizations, moment-of-truth bullfight pictures shot with long lenses (extra points for gored matadors), weeping or laughing children, pollution over Manhattan (extra points for blob-shaped sunsets or sunrises), fuzzy kittens, Connecticut barns (extra points for hex signs), depressing picture series on homes for the aged, and unsharp color close-ups of the inner plumbing of flowers. Other pictures are also seen occasionally. High-contrast prints of lobster pots and of picket fences in snow are regarded highly.

Points are awarded for thoroughness, fanaticism, sentimentality, and conformity. To carry away a blue ribbon or a gold medal is a source of deep and solemn pride.

Like relevancy-and-suffering photography, ribbon-and-medal photography has a vital social purpose. It is intended to beautify the world, to establish human dignity, and to be cute.

THE SUBJECT SNOB

To be a subject snob, you must *know* that certain subjects are "in" and the rest are "out." (To find your own "in" subjects, look for anything that is either avant-garde, or camp, or both.)

Subject snobs have been with us for a long time, and some of their subjects readily come to mind. Any of them can be reestablished by a firmly assertive photo snob: spotlighted cogwheels, arrangements of eggs, old men draped in dark velvet, girls draped in white cheesecloth, milkweeds against red-filter sky, factory chimneys, and nudes standing in pools. The reflections in the water in Venice and in Provincetown harbor are popular, as are blood streaks on the faces of fuzzy young men with spectacles, and bald young girls.

Currently, transvestites in their underwear, the porpoises at Marineland, toilets, and hunters with dead deer are all among the popular "in" subjects.

But bear in mind that just shooting "in" subjects does not make you a full-fledged subject snob. You're missing half the fun unless you remember to feel superior to everybody who photographs other things.

THE TOTAL-CONTROL SNOB

One kind of photo snobbery that gives great satisfaction is the belief that one's own photographs are totally under control; and that all photographs are bad that are not controlled from start to finish, with no iota of chance or accident.

To make a totally controlled picture, start with atoms and build yourself according to a prearranged plan. Then construct your subjects, their environments, and photography. Otherwise, all these components introduce random qualities that inevitably introduce a large quota of accident. It must be difficult, although rewarding, to be a total-control photo snob.

THE ANTISNOB PHOTO SNOB

Worst of all, and enjoying it most, are those who look down on other snobs and write snide articles about them.

You, Your Ego, and Success

Norman Rothschild

In watching the behavior of those who go through the process of having their pictures screened by editors, I've noticed certain conflicts, contradictions, and misunderstandings. These are generally in the areas of love, artistic attitudes, and commercial values. Confusion among these three can often lead to psychological conflicts, as well as practical conflicts that stand between the artist and success in life.

Let us first take up the subject of love. The confusion here is that individuals who are unable to establish satisfying relationships leading to love with their friends turn elsewhere in hopes of being loved. After questioning quite a few artists who have had their work rejected by editors here and other places, I have found that they develop a feeling of not being loved and appreciated. The problem is expecting love and appreciation from the wrong people. Having one's pictures rejected does cause a great deal of disappointment. But blaming the editors for love rejection is a bit unfair, especially since the editor's relationships with clients generally is not one of playing mother, father, sister, brother, or even "Dutch Uncle."

The same error is made by people who work for a boss. I've often heard someone say that his boss doesn't appreciate him. It would, of course, be nice to always work for, or submit pictures to, someone who appreciates you as a person. But this appreciation, which can be a part of love, must not go so far as to break the business relationship. It is this reality with which the photographer has to learn to deal. Once it is clearly understood that editors, art directors, and bosses are conducting a business, and are not required to engage in therapy sessions, it will be possible for the photographer to make contact with such professionals on better terms commercially, artistically, and emotionally.

Now let's discuss those who say that they do not relish being rejected as artists. Here, still another confusion is encountered. Too often, the artist assumes that someone's judgment about his work is a personal assault on him or her. Admittedly, a work of art can reflect the feelings of the artist. But the work of art is not the artist, except in a purely symbolic sense. Thus, judgment about a work of art is very often a reflection of the character, needs, and prejudices of the viewer. In an artistic situation, this can have many ramifications. But in a commercial situation the feelings of the artist must take second place to that of the customer: an art director, manufacturer, editor, picture agent, and the like. It should be clearly understood that a competent buyer of photographs and photographic services does so not for his own ego gratification, but for the purpose of earning money. Of course, there can be ego-satisfying situations in which the work of the photographer is really loved by the buyer. And the photographer and client who have many things in common may actually become friends. But these are not the primary purposes of a client-photographer relationship.

Perhaps the most emotionally tinged problem is that of the photographer who does not want to "compromise" his art by shooting and selling pictures that do not truly represent what he stands for. The situation is particularly painful for those whose specialties are esoteric, avant-garde images that are seldom used in a commercial situation.

Insistence that one can somehow make a living with such imagery is quite unrealistic. With the increase in interest and in sales of photographs by galleries, this situation might change somewhat. But to make a living in photography you have to take a hard look at the millions of photographs in use today to come to the realization that a client wants his product to look like his product, only better. Here and there, you do find an unusual image being used. But that is a rare exception. I can assure you that even those photographers who are well known for their unusual imagery make the bulk of their income from straight photography.

This should not discourage you from experimenting with technical tricks. But it does mean that you should have a rich knowledge of photography in *both* technical and esthetic terms, so you can bring home the bacon.

Finally, there is the problem of those photographers who sit on the sidelines and snipe at commercialism, Madison Avenue, and the "sell-out" of photography as art. Quite a few of the paintings that are on display in major art museums were originally made for purely commercial or propaganda purposes. No shouts about dirty commercialism here, right? True, some of the advertising seen today is not for the most moral or useful purposes. It's up to you and your own ethical codes whether you want to handle such accounts or not. But it is just as immoral and illogical to lump all commercial uses of photography together. Rather than take a narrow doctrinaire view of things, rational human beings leave themselves open to new approaches and are able to see the exceptions and the exceptional. As for art, many of the finest works of photographic art have been and are being produced by professional photographers and illustrators in their line of duty.

Holography–Is It Art?

Kenneth Poli

The handsome matron with the prematurely blue hair said to her companion, "It's so complicated already, and this makes it even more complicated." And she was right.

She had been viewing what looked like 3-D photographs, and was reading a simplified rundown on the nature of the images at *Holography '75, The First Decade,* an exhibition held last July at the International Center for Photography, New York City's chic, young photography museum. The show featured holograms by 35 scientist/artists, and the images ran from abstractions to pornography.

Holography is the science, or craft, of making three-dimensional images (called *holograms*) of both animate and inanimate subject matter on relatively conventional film material. These can be made as stills (the vast majority) or motion pictures of limited length. Several of the latter were displayed at the show, and those dealing with people as subjects had an eerie reality—as if tiny beings had been put into transparent cages to perform for the museum-goers.

The exhibition was made up of some 50 holograms, both still and motion picture. The images were chosen, mounted, and illuminated by the show's joint sponsor, The Museum of Holography, another New York City institution. Since holography is such a young process, many "firsts" and early works were a part of the show—the incunabula of 3-D. And, since much early work used chessmen, toy trains, and other small, inanimate subjects, the esthetic breadth of the material was, shall we say, restricted.

The show's title, *Holography '75, The First Decade,*

should have taken the responsibility for content off the shoulders of both the cosponsors. It signaled, after all, only a survey of a short, formative period. And most critics' reviews of the show were uncharacteristically tolerant of the esthetic shortcomings of the works on exhibit.

But the elegant ambience of the Center, its prestige as New York City's only photography museum, and its previous displays (the works of W. Eugene Smith, Henri Cartier-Bresson, and other masters) were too powerful an influence to be erased entirely by the shock value of the holography. Outraged prose flowed from the typewriters of several publications.

In *The New York Times* for Sunday, July 20, Hilton Kramer's column "Art Views" stated: "The esthetic naiveté of this show must really be seen to be believed. No mere description could begin to do it justice. Images of a stupefying innocuousness, ranging from peep-show porn and low-grade beer commercials to the even more ludicrous parodies of so-called 'serious' art, are unrelieved by the slightest trace of esthetic intelligence. A more dismal demonstration of the distance that still obtains between advanced technological invention and the serious artistic mind could scarcely be imagined."

The New Yorker's anonymous reviewer wrote, in what could have been an entry in that magazine's own Non-Stop-Sentence Derby, "The show here called 'Holography '75' *(sic)* exhibits the work of thirty-five holographers who use a laser process, based on a 1947 invention by Dr. Dennis Gabor, to make three-dimensional-looking images reminiscent of those vulgar 42nd Street novelty-store

Visitor views a hologram at the International Center of Photography

items like the plastic-coated postcards of Christ with a crown of thorns and eyes that eerily open as you move the card one way and close as you move it another way."

Whether or not one shares the views of these two reviewers is beside the point—which both seem to have missed. The point of the show seemed to be that, what started out to be (and still largely remains) a scientific tool, has at least potential as an artistic medium. On the walls of the ICP were the gleanings of the short childhood of holography. The show was presumably saying that, along with their experiments, testing, and probing with a new scientific tool, the technicians and scientists in holography were *also* attempting to make images that were *fun* to look at, not just necessary as working tools. As a bonus, along the way, some artists had also discovered the fascination of the new medium and were trying to learn its grammar—with varying degrees of success.

And why isn't this reason enough for such a show?

Reaction was far from all bad, however. Most critics, as a matter of fact, viewed the show with the same "gee-whiz" reaction that the general public displayed.

Martin Levine, in the suburban Long Island newspaper *Newsday,* called it the "most interesting photo show in the New York area . . . An exciting and, I suspect, historically important show . . . What the show does best is simply stir the imagination, and it does that so well that it should give the technique an important boost. By the end of the *second* decade, holography is clearly going to be a major force in art, science and amusement."

The respected weekly *The Village Voice,* in its art column by David Bourdon, said, "At this early stage, it's hard to tell what, if anything, distinguishes the artists from the scientists . . . So far the medium is more entertaining than artistically expressive. But, while holography has yet to find its Stieglitz or Steichen, it's plain to see that the medium will continue to lure new and talented devotees."

And John Gruen's "On Art" in *The Soho Weekly News* said, ". . . only a very few [of the holograms] are worthy of being called works of art. Indeed, the makers of holograms seem far more interested in noodling and tinkering with their newfound toy, leaving its esthetic possibilities alarmingly at bay. So enamored are they of the science involved, that the final products look, for the most part, like

unimaginative samplers for a new photographic line . . . The absence of fertile imagery is the exhibit's fatal flaw, although it must be admitted that even at its most banal, holography is never less than arresting . . .

"Standing midway between the still photograph and the movies, holography seems destined to become a major art form. It can only progress, however, by true artistry—by holographers who will have the vision to transcend the medium's already marvelously transcendant attributes."

In reply to the slings and arrows of outrageous critics, Cornell Capa, the tousled doyen of the International Center, said in *The New York Sunday Times* of August 3, "Since the beginning [of the Center], we have been aware of our obligation to present photography of all persuasions, not limiting our view, but expanding it through our lectures, discussions, and experimentations. As an expression of this wider role, the Center decided to show holography in its 'largest and most comprehensive survey to date' (and not as a 'first' as the [Kramer] review reported). This decision was not based on the present esthetic and technical qualifications of this new vision, but rather on the belief that this is a significant new dimension with unlimited artistic and scientific possibilities that need to be fostered and developed."

What, then, is this technique, this process, this "significant new dimension" whose images elicit what might be described as contemptuous excitement in so many critics? (The public, by the way, seemed not to have such reservations; they came out in record-breaking numbers to the show.)

Holography is among the youngest—perhaps the very youngest—of the visual sciences. It is a method for capturing photographically and without camera lenses, the information content of wavefronts transmitted or reflected from objects. Most commonly, these are light waves of the visible spectrum. But they can also be from other areas of the electromagnetic spectrum or even acoustic waves.

Properly processed, the wave interference patterns can be reconstructed to "start up" the wavefronts that would originally have continued to our eyes from the subject. These reconstructed wavefronts, when our eyes see them, show us an extraordinarily solid-seeming three-dimensional image of the original object, as detailed and "real" as the original, even to displaying parallax when viewed from different angles.

The possibility of making such wavefront rec-

ords was dubbed *holography* but its inventor, Dr. Dennis Gabor, in 1947. He then conceived the idea of using "coherent" light to improve the sharpness of images in an electron microscope. In the course of experiments, in 1948 he produced the first "in-line" transmission hologram (one method of lighting the subject for holography), using a filtered, mercury arc lamp—the nearest thing Dr. Gabor could rig up at the time to substitute for coherent light.

Such light is a special kind whose waves have equal frequencies and whose phases are related to each other at a given time or at a given place in space. (I took this definition from *Holography*, a NASA publication [SP-5118] by David D. Dudley.)

Faced with holographic theory and the physics of holograms, your average camera person is likely to pale slightly. For it is a world teeming with mathematical symbols and arcane equations.

But no skills are needed to enjoy the holograms themselves. All they need from the observer is stereo vision and a sense of wonder. The effect of solidity is so real that your eyes seem to be playing tricks when you have a chance to look behind the hologram and see that there *is* nothing there! Holograms have the age-old fascination of magic.

The process was first postulated, as noted, by Dr. Dennis Gabor in 1947. But it was 1960 before the first ruby "laser" was made, providing a source of the coherent light called for by Gabor's theory. It was only then that the infant process could really begin.

In 1962, Emmet Leith and Juris Upatnieks made the first holograms using the new light source. One of these, called "Train and Bird" (and its history makes it, roughly, the holographic equivalent of the Gutenberg Bible) was displayed at the exhibition at ICP.

From its primitive beginnings, the science began to expand. Reflection holograms were soon produced in both the U.S. and the U.S.S.R. And 360-degree holograms (in which the viewer can see all sides of the subject) were made. The first of these, an incredibly real-seeming image of a ceramic horse by Dr. Tung Jeong, was also on display at the show.

By 1967, the first holographic motion pictures had appeared, and the following year holograms that can be viewed by transmitted (as opposed to reflected) white light were developed, and the first of these were on display.

Dichromate (silverless) holograms, which can be printed on irregular surfaces, can now be made

without the need for photographic films. Other techniques, only about a year old, produce holograms embossed on any plastic surface, and capable of mass reproduction.

But what *use* is this Space-Age, gee-whiz process that makes such real-seeming images? Aside from their obvious entertainment and "grabber" value, can you do anything worth doing with holograms? Indeed. Holography has, in its short lifetime, developed into a most useful and accurate tool in dozens of fields, with applications in law enforcement, crime prevention, banking, food production, clothing, household furnishings, communications, education and welfare, data storage, building and construction, materials testing, medicine and health, chemistry, aerospace, national defense, and many more. NASA, incidentally, is supposedly the largest consumer in the country of holographic film—an indication of the importance of this new science to aerospace activity and research.

In another area, holographic data storage techniques offer 200 times the capacity of microfilm and microfiche in a given space with a bonus of higher readout speed. This promises faster-acting computers in the future and perhaps some hope for libraries trying to keep up with the flood of printed information that swirls around us today.

The old photographer's gag about sharpening up an already-processed negative is now out of the ha-ha category, thanks to holographic "image-deblurring" techniques that can actually improve the readability of unsharp images.

Holograms of sprayed material, such as dust or water droplets, can be used to analyze atmospheric samples, carburetor-jet and aerosol spray-head pattern efficiency, and so on. Individual drops and particles, in depth, are visible and countable in the holograms, and from such information design improvements can be made.

Holographic microscopes have been developed; glaucoma can be detected, even when cataracts are present, by holography of the retina of the eye; acoustic (soundwave) holograms are used to examine soft tissues for medical research.

Weld joints, rocket propellants, microcrack information, turbine-blade resonance, and contamination by space particles are a few of the areas in which holograms are used for inspection and testing in America's space program.

And the craft is still young.

Holography is deep into your daily existence already, obviously. But in silent, backstage ways,

in medical and scientific laboratories, in secret government installations, in the research and development departments of major manufacturers.

But in the future you'll see holography's products more and more—in stores, in theaters, and even right in your own home. Right this minute, if you have the money, you can have a holographic portrait made of yourself complete with movement and three dimensions. Several holographers offer the service.

What's that? You'd rather wait until they're making X-rated movies in holographic 3-D? You may not have long to wait. At the *Holography '75* show there was a brief holographic movie sequence that showed a no-one-under-18-admitted encounter between two handsome young ladies. Artistically, it was easily outdistanced by others; but it was an arresting demonstration of the new medium's potential. Stopped every visitor in his/her tracks.

But such film loops are limited to brief displays and small, close-in audiences. Still in the future, but being well researched, are holographic movies for the theater audience. Dr. Gabor, who fathered the whole process to begin with, is actively investigating the development of commercially oriented, three-dimensional holographic motion pictures that can be projected in a theater and be viewed without special glasses. He patented his system in 1970.

Although no special viewing glasses are needed, a special screen with lenticular surfaces *is* needed. Two lasers are used for projection, but the pictures themselves can be made with conventional stereo cameras using conventional lighting, rather than the lasers normally used for holography.

Several other holographic motion-picture systems are also under development. And commercial movies—notably "Logan's Run"—are starting to use holograms or holographic effects as important plot elements.

The producer of "Logan's Run" is quoted as saying, "With the many future refinements of holography which are inevitable, audiences may soon watch complete movies being shown in mid-air without the use of screens. It is possible that, in the future, giant filmed pageants will be created with holograms to be projected at midfield in a stadium seating 100,000 spectators. The practical application of holography to movies seems boundless; it boggles the mind," he said.

And so it goes, from the commercial laser's birth in a factual 1961, to a fictional 23rd century

on a movie lot. So far, probably because of the exacting setups needed to make them, holograms haven't had the enthusiastic reception from amateurs that M. Daguerre's new process got 136 years ago. Although, come to think of it, the technical problems of early photography (not to mention the poisonous fumes involved) were pretty formidable, too.

An irony of the technological age in which we live is the speed with which developments such as holography improve, increase and race on, leaving their history almost forgotten even by specialists.

Perhaps this is the reason behind a course, "Holography: History and Applications," offered by a New York City school of holography. Short as that history is, the school feels it should teach students the background of this new science.

They're probably right. To illustrate how fleeting the fame of pioneers can be in the Space Age,

let me leave you with this footnote on the *Holography '75* show.

A set-piece of the exhibition was a really large (about life-size) image of Dr. Gabor. Head and shoulders, bathed in eerie green light with somewhat the aspect of a fly preserved in amber, Dr. Gabor's ultrarealistic portrait drew startled murmurs from all comers.

No doubt about it, this hologram was historic—for its size, for its technical excellence, and for its subject matter. (Dr. Gabor had just received a Nobel Prize for his discovery.)

The image, in other words, is early and important in hologram history. A bit like the relationships of a 14th-century wooden religious statue to the history of art—generally admired and respected, but with the artist's name lost to history.

The Gabor hologram, an example of early space-age art, is also labeled "artist unknown." Its date is 1971.

Viewing a hologram is very much like seeing the original subject. This hologram and the one at right were shot from slightly varying angles, revealing different details of the subject.

In this high-angle view of the same hologram shown at left, the top view of the cars is visible. These examples were not in the show at International Center of Photography.

The Photo Scene

Harvey V. Fondiller

Irving Penn—Recent Works, The Museum of Modern Art, New York City (May 23–Aug. 3, 1975). For all I know, a brave new world of photographic imagery may be heralded by this exhibit—but I doubt it. Infinite care was lavished on the subject —cigarette butts, which were rendered in 14 king-size (25×22-in.) platinum prints. Transfigured and elevated from the ashtray level, they are seen vertical in virtuoso solo, duet, trio, and quartet appearances. Their posture is predominantly erect, though some lean slightly askew. The brands include—in alphabetical order—Camel, Chesterfield, Dunhill, Kent, Lucky Strike, Marlboro, Philip Morris, Rothman, and Winston.

Irving Penn, whose photographs rank with the world's best, has worked for *Vogue* magazine since 1943. Now, however, it would seem necessary for someone to take Penn in hand and criticize his compositions, for their dullness is exceeded only by their pretentiousness.

Ever since The Emperor's New Clothes were admired by sycophants and other servile or dim-witted individuals, the public has been befuddled by the notion that any piece by a master is a masterpiece, especially if it's in a museum. In this case, the exhibit is simply banality apotheosized. Besides, nothing in the Winston pictures looks good like a cigarette should.

(October 1975)

Women of Photography: An Historical Survey, Sidney Janis Gallery, New York City (Nov. 29–Jan. 3, 1976). Never underestimate the power—earning or otherwise—of a woman photographer. I ought to know; I used to work for one. She knew what she wanted and worked like hell to get it. Now she's remarried and retired, with a bigger swimming pool than anyone of my personal acquaintance. She earned it with her camera.

In photography, as in other fields, talent and hard work separate the men from the boys, but not males from females. For more than a century, the distaff sex has compiled a commendable record behind the camera; evidently, the ladies didn't choose to stick to their knitting.

Among the well-known names in the roster of 50 exhibitors are: Julia Margaret Cameron (born 1815), Gertrude Käsebier (1852), Frances Benjamin Johnston (1864), Alice Austen (1866), Imogen Cunningham (1883), Doris Ulmann (1884), Laura Gilpin (1891), Dorothea Lange (1895), Louise Dahl-Wolfe (1895), Lotte Jacobi (1896), Berenice Abbott (1898), Barbara Morgan (1900), and Margaret Bourke-White (1904). Of special interest is the work of some lesser-known photographers and the wide divergence of styles espoused by the younger generation.

Although fem photogs often choose their own sex and children as subjects, the exhibit reveals a broad range of visual interpretation. Some of the women show unusual versatility—for example, Modotti. Her 1924 "Wires," a stark semi-abstraction, contrasts with her portraits and a high-key close-up of flowers. Among many interesting pictures are the social documentation of Jessie Tarbox Beals, circa 1916; strong statements in line and form of Florence Henri, circa 1930; and Carlotta M. Corpron's experiments with light in the 1940s.

But our enthusiasm wanes on being exposed to

the effluvia produced by numerous contemporaries. Various abortions in the form of splotched cyanotypes, hand-colored (but garishly!) montages, and stitched images on cloth indicate that much effort has been misdirected.

Granted that the new generation is searching and that in the span of a decade women have graduated from "training bras" to burning them. Meanwhile, whatever happened to maidenly modesty? (A rhetorical question, to be sure; we know, we *know!*) But focusing below the belt has its limitations. And some of the sexually oriented pictures are as mysterious as a sphinx without a secret. Others, produced by self-styled sexperts of mixed media, subvert the photographic medium by changing lens-formed images into photo-chromolithos—triumphs of unimagination.

One of the cutesy-craftsy "photographs" includes a hand-stitched rainbow. Sort of what you'd expect (a male chauvinist might snicker) from a woman. Just possibly the photographer would be better at her craft if, like her sister camera people a century ago, she didn't stick to her knitting.

(April 1976)

Image Before My Eyes: A Photographic History of Jewish Life in Poland (1864–1939), The Jewish Museum, New York City (Mar. 17–Sept. 5, 1976). A dwindling number of survivors still recall the civilization of the Polish Jews, which was destroyed by World War II. For other people, the camera has provided graphic testimony, in this exhibition's 400 photographs, about an extinct community.

Men whose names are unknown to photographic history recorded scenes of the life in cities and villages of prewar Poland. Among them were Matthias Berson (1823–1908) and Szymon Zajczyk (1900–1943), who photographed wooden synagogues. Jewish photojournalists of the 1920s and 1930s included Alter Kacyzne, Menakhem Kipnis, and Avrom Rotenberg, who were assigned by the *Jewish Daily Forward* to make pictures for that New York newspaper. (At the time, the *Forward*'s policy was not only to provide pictures of interest to its readers but to encourage them to assist their co-religionists who remained in Eastern Europe).

Roman Vishniac, the noted scientific photographer, made numerous pictures that now have historical significance. The Jewish newspapers in Poland printed many photographs, some of which are preserved in the archives of YIVO *(Yidisher visnshaftlekher institut).* Established in Vilna in 1925 as a research center for East European Jewry, the organization was transferred to New York in 1940. Part of its archives, confiscated by the Germans in 1941, was eventually returned.

A few years ago, in a "mama-and-papa" stationery store in New York, I noticed a tattooed concentration-camp number on the forearm of the aged proprietor. It was an indelible reminder to him—and to me—of the holocaust that destroyed 6,000,000 Jews. It was evidence, in living flesh, of the most terrifying period in modern history.

In photography, as in life, there are survivors. The photos in this exhibition are surviving histori-

KATE MATTHEWS, FROM "WOMEN OF PHOTOGRAPHY"

SIDNEY JANIS GALLERY

cal documents. They must be assessed not by esthetic criteria, but by conscience.

(August 1976)

William Eggleston—Color Photographs, The Museum of Modern Art, New York City (May 25–Aug. 1, 1976). Some believe that a critic's opinion may be influenced by his state of mind or digestion. Could be. Possibly he (or she) was cranky after a bad night's sleep, had a fight with a friend, boss, or lover, or simply was suffering from unassuaged ego. Since my initial reaction (literally within five seconds) to William Eggleston's show was negative, I felt that in all fairness I should return for another look. Which I did. Now I'm *positive* that my opinion is negative.

It's not just that the pictures are mediocre. It's that they're presented with such fulsome flattery.

Is Eggleston really "one of the most accomplished photographers now working in color"? (That's how the museum described him.) Can we believe that "his photographs comprise a remarkable and surprising commentary on contemporary American life"? John Szarkowski, who directed the show, states that these pictures are "perfect." And the exhibition is accompanied by the museum's first book on color photography.

Eggleston (born 1939) was a 1974 Guggenheim Fellow and held a National Endowment for the Arts fellowship last year. He has been a lecturer at Carpenter Center, Harvard College. Most of his photographs were made in Tennessee and northern Mississippi before 1971.

In his simplistic misinterpretation of what he saw, he features the lowest, most common denominator, signs: *Coca-Cola, 7-Up, Pabst Blue Ribbon, Wonder Bread;* also *STOP, Elect Hutchison Sheriff, Just-Rite Cafe, Bozo's Cafe;* and *Father* (in a cemetery). This approach was okay when Walker Evans did it, back in the Burma-Shave era, but Eggleston makes it tiresomely repetitive.

A glorified snapshooter, Eggleston is described as having "discovered the work of Cartier-Bresson" in 1962. But his indecisive moments are omnipresent: a man standing and staring in a cemetery; somebody touching a blimpy U.S. Air Force thing; a swimming pool minus swimmers, or even good color; people in a car looking toward someone (off-frame) whose legs are unaccountably on the car door.

These photos embody little thought and less feeling. Many are dull in color and concept. The execrably rendered "Candlesticks on table" would be unacceptable if submitted by one of my

SCHOOL OF NURSING, JEWISH HOSPITAL IN WARSAW, FROM "IMAGE BEFORE MY EYES"

basic photography students. The exhibit even includes the ultimate cop-out—an image of an image (close-up of a football scene on TV).

You may have guessed by now that I don't like the photographs of William Eggleston. *Somebody* did, though; the exhibition and book were supported by grants from Vivitar, Inc., and the National Endowment for the Arts. But differences of opinion are the reason for horse races . . . and possibly for photography exhibits at The Museum of Modern Art.

(October 1976)

Nadar, Photographer, Metropolitan Museum of Art, New York City (Feb. 2–Mar. 27, 1977). A few years ago, in the stacks of the Bibliothèque Nationale in Paris, time seemed to reverse itself by a century as I studied hundreds of photographs by Gaspard Félix Tournachon (1820–1910), otherwise known as Nadar. For Nadar was a Leonardo of the lens; he made the first aerial photographs (from a balloon, 1856), the first electric-light photographs of the Paris catacombs (1860), and a host of remarkable portraits of celebrities. In the words of Daumier, he "raised photography to the height of art."

Nadar's achievement is especially impressive because he used the cumbersome wet-plate process, which had been introduced in 1851. In a darkroom, the collodion solution was poured over a glass plate, which was placed in a solution of silver nitrate. The plate had to be exposed before it dried, then developed immediately. The negative was printed on albumen paper, by sunlight.

This first major American exhibition of Nadar's work includes portraits of many noted personalities, including Sarah Bernhardt, Daudet, Doré, Manet, Millet, Meissonier, Meyerbeer, Rossini, and George Sand. I viewed the show with a noted photographer, a fellow countryman of Nadar. Looking at the portrait of Bernhardt, age 22, he marveled at its mood and feeling.

"My impression is that Nadar knew her very well indeed," he remarked, with Gallic innuendo. "This isn't the sort of picture you take cold."

With all his subjects, Nadar seems to have had marvelous rapport. In 1856, he wrote:

"The theory of photography can be learned in an hour and the elements of practising it in a day. . . . What cannot be learned is the sense of light, an artistic feeling for the effects of varying luminosity . . . What can be learned even less is . . . that instant understanding which puts you in

touch with the model, helps you to sum him up, guides you to his habits, his ideas and his character and enables you to produce, not an indifferent reproduction, a matter of routine or accident such as any laboratory assistant could achieve, but a really convincing and sympathetic likeness, an intimate portrait."

Has anyone ever given a better description of psychological portraiture?

(May 1977)

The Russian War: 1941–1945, International Center of Photography, New York City (Sept. 16–Nov. 6, 1977). A generation ago, our fathers (and some of *us*) were engaged in a war that covered the globe with fighting men and machines. They clashed on battlefields that became, for many of them, a final resting place. It is fitting and proper that we, the living, should not forget.

War is a sporadic continuum that elicits ex-

MEMPHIS, CA. 1969 WILLIAM EGGLESTON

tremes of courage, cowardice, sacrifice, and shame. Thus it was during World War II, when every disputed barricade was part of a titanic cataclysm to which none but eyewitnesses can truly attest . . .

Came the dawn, one frosty morn in November, 1944, on the Alsatian front. Thunder and lightning: a battery of 105-mm guns hurled white phosphorous and high-explosive shells into Saulcy-sur-Meurthe. We marched through the village an hour later. Nothing stood higher than a man. The most vivid image I can recall from those smouldering ruins is the outstretched legs of a dead horse. I wished I had a camera.

Later, remembering this and other ruined villages, I wrote: "Not a sound or light or breath/- Lingers in the wake of death . . ." These words came to mind when I saw the photographs in "The Russian War: 1941–1945."

A lexicon of war: *air raid, artillery, attack, banners, babies (crying, dead), barbed wire, bombardment, casualties, cavalry, chow, civilians (grieving, dead), coffins, concentration camp, desolation, destruction, direct hit, farewells, fighting (cold-weather, house-to-house), flamethrower, furlough, grave (solitary, mass), guns (angry, silent), homecoming, infantry, lovers, mothers, near-miss, parade, partisans, prisoners, reconnaissance, reinforcements, retreat, rubble, soldiers (fighting, dead), sons, sorrow, survivors, tanks, trenches, wounded . . .*

P.S. Add: *horses.*
P.P.S. Add: *Victory!*
Words try to tell it. These pictures show it.

(January 1978)

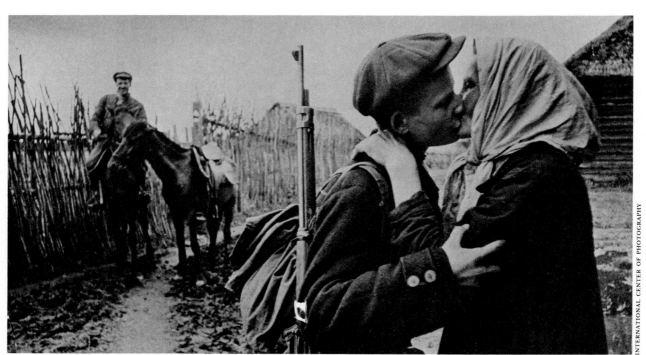

SOLDIER'S FAREWELL

MIKHAIL TRAKMAN—FROM "THE RUSSIAN WAR: 1941–1945"

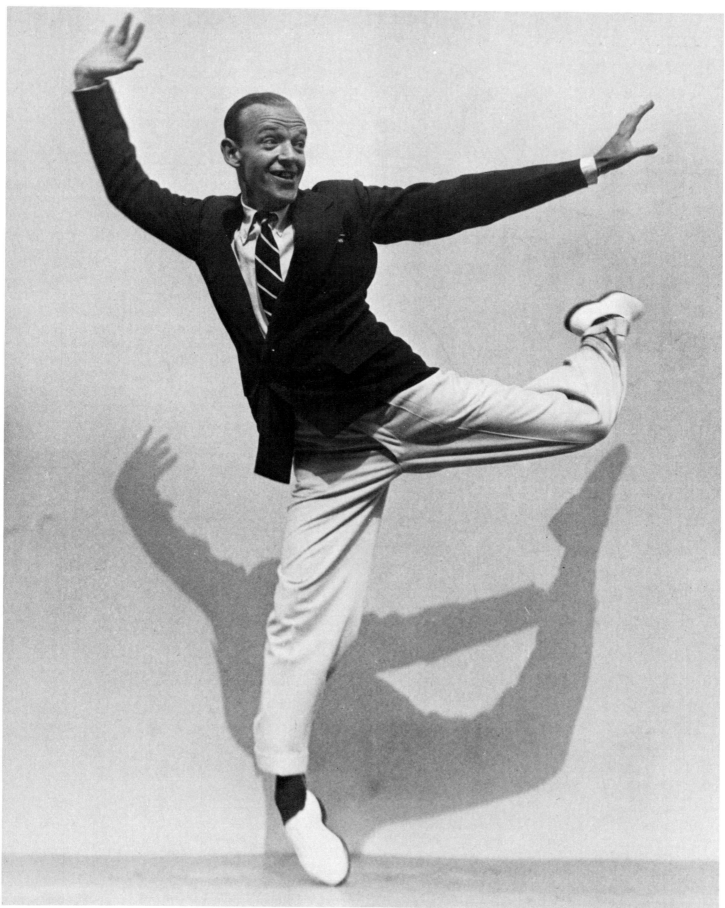

FRED ASTAIRE MARTIN MUNKÁCSI

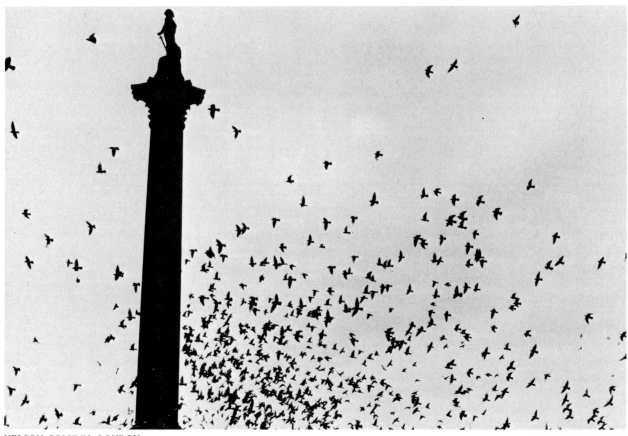

NELSON COLUMN, LONDON ARTHUR GOLDSMITH

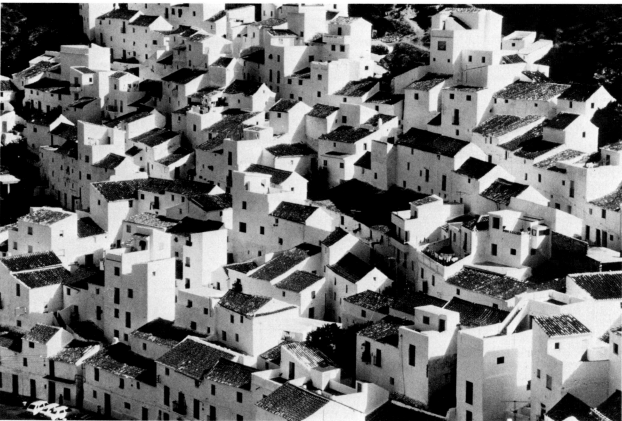

CASARES, SPAIN CARL PURCELL

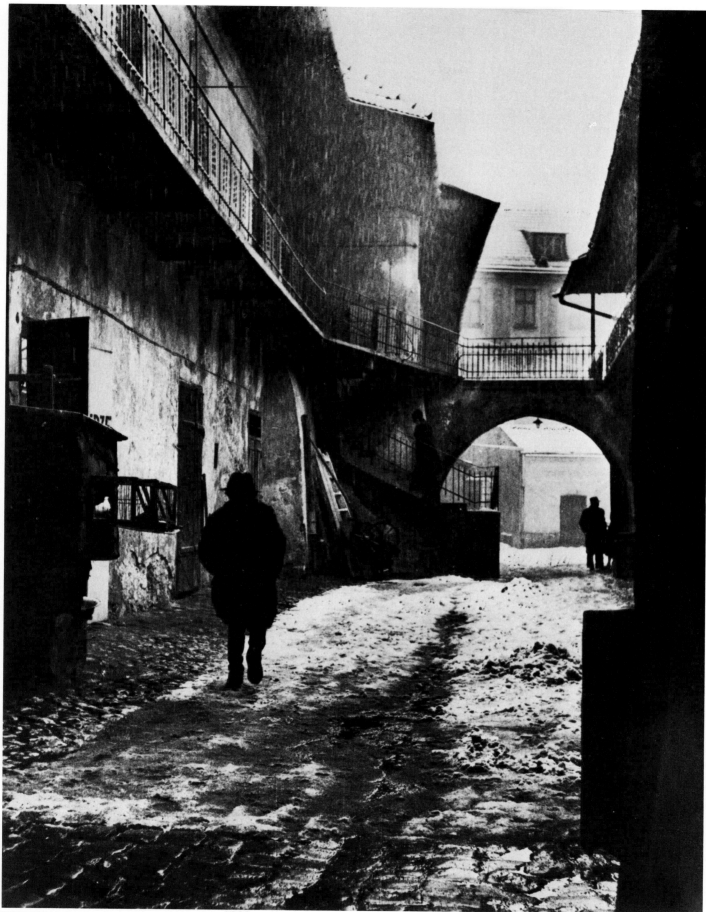

ENTRANCE TO THE OLD GHETTO, CRACOW, 1938

ROMAN VISHNIAC

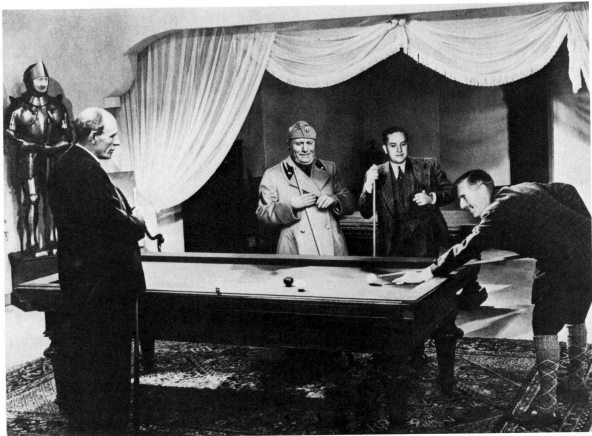

THE AXIS PLAYING POOL JOHN HEARTFIELD

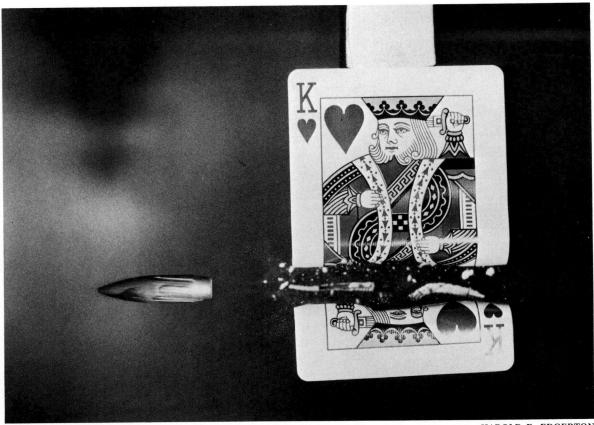

HIGH-SPEED PHOTOGRAPH HAROLD E. EDGERTON

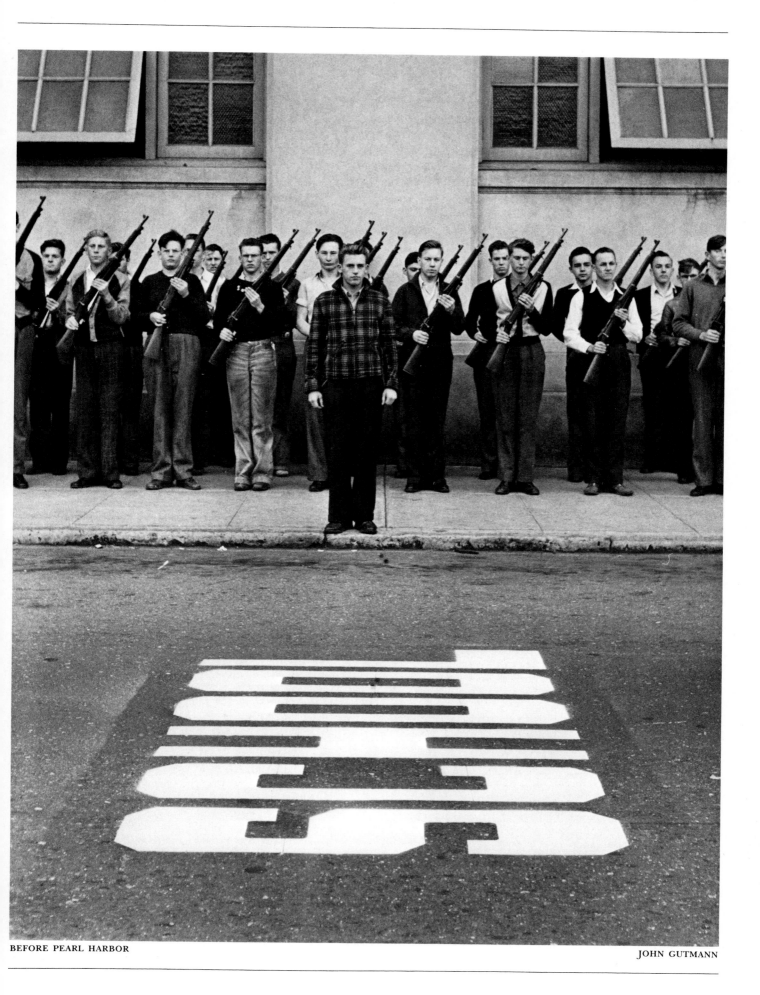

BEFORE PEARL HARBOR

JOHN GUTMANN

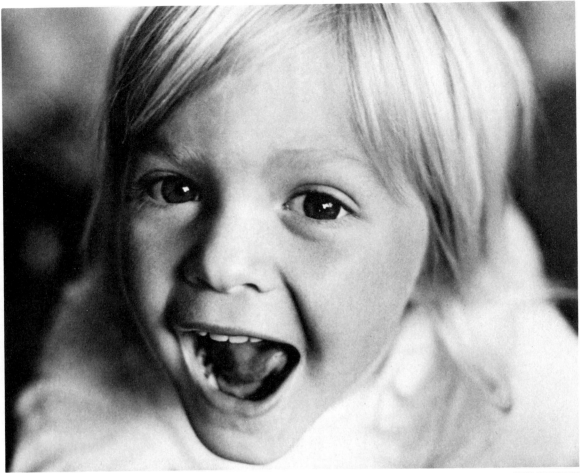

CHILD KEN HEYMAN

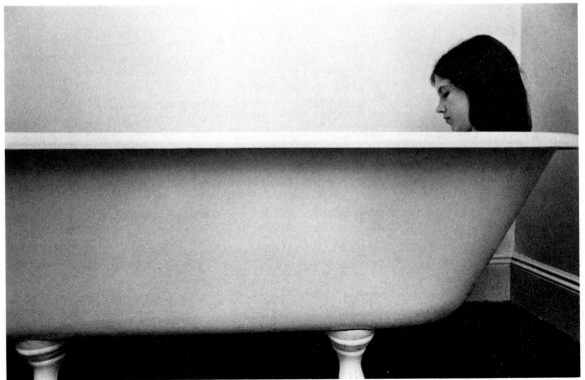

GIRL IN BATHTUB KERRY DOLCH

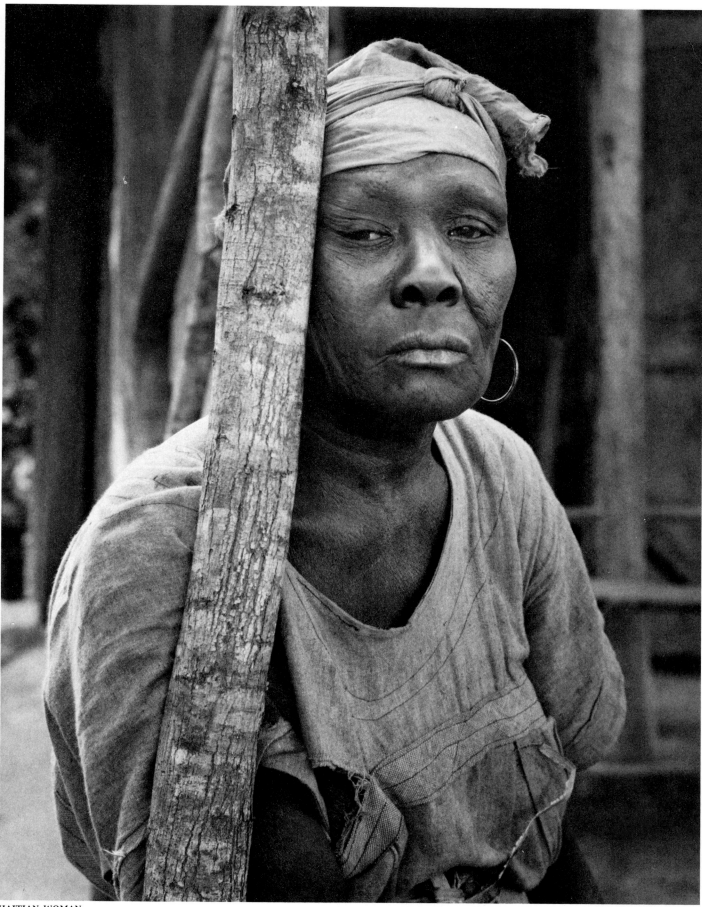

HAITIAN WOMAN

WALTER ROSENBLUM

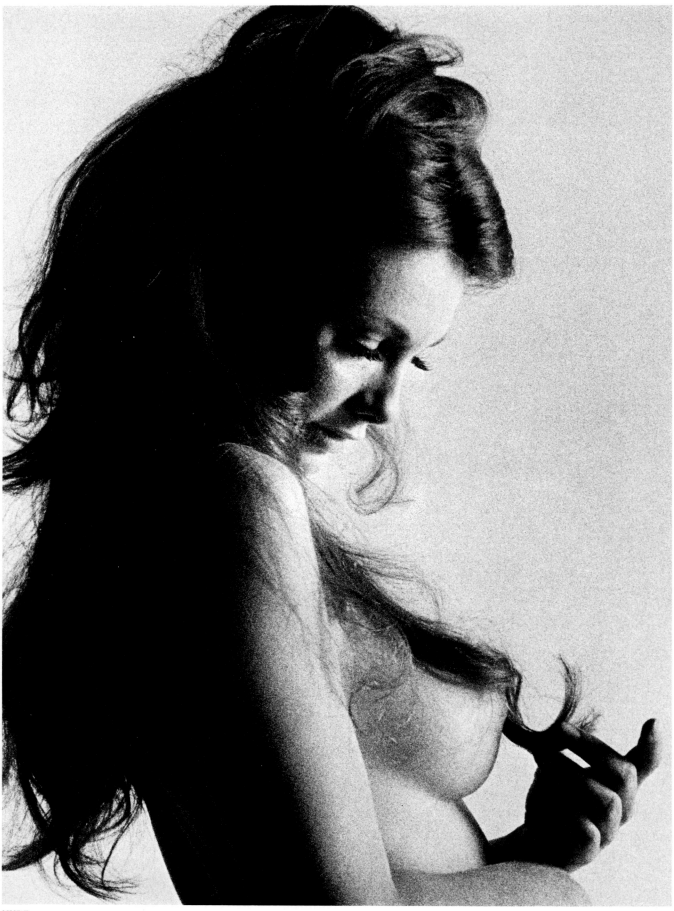

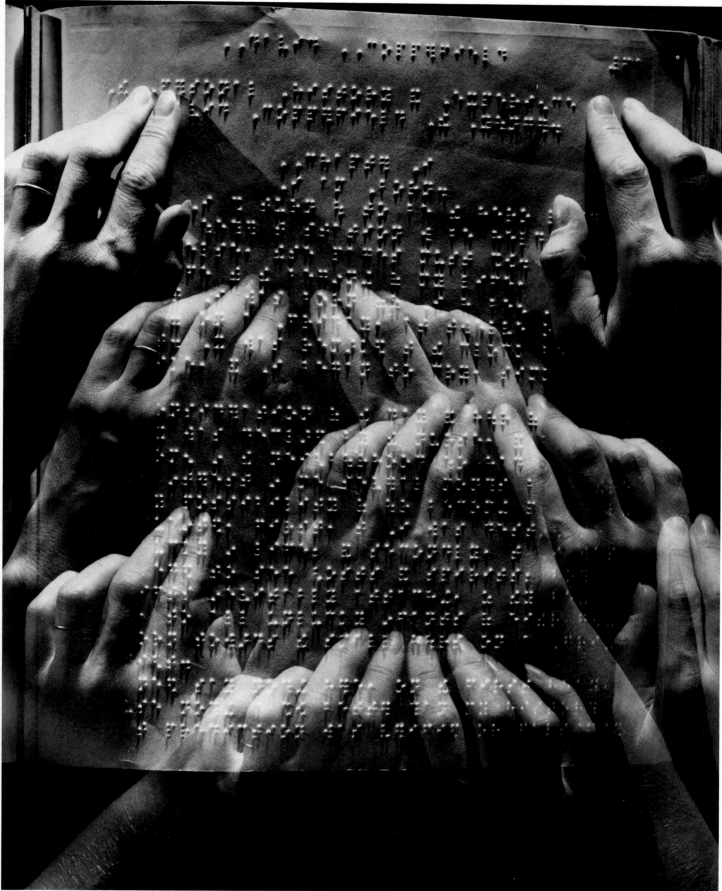

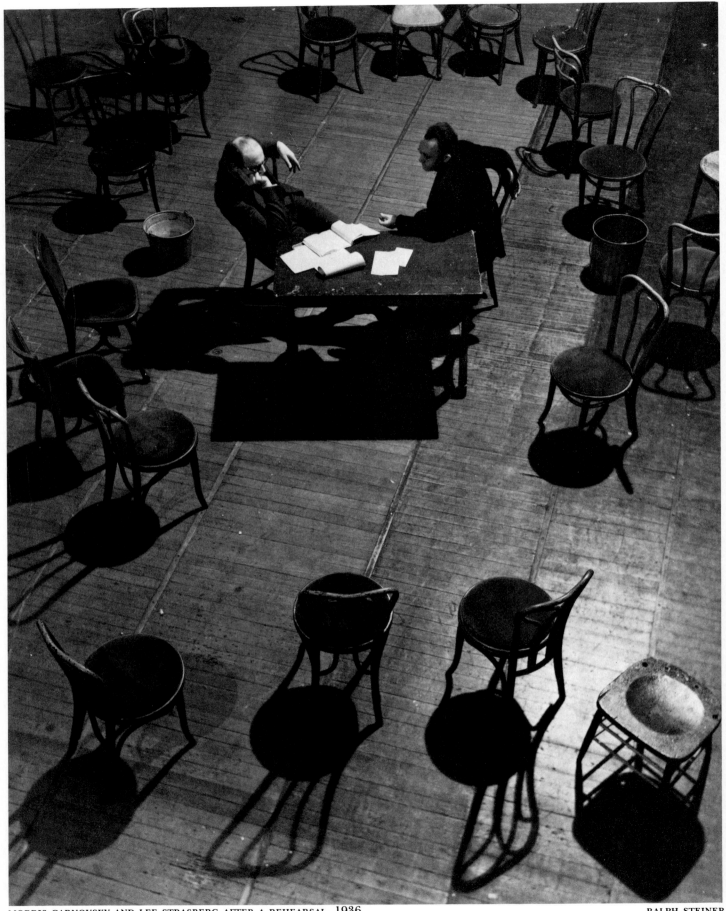

MORRIS CARNOVSKY AND LEE STRASBERG AFTER A REHEARSAL, 1936 RALPH STEINER

Careers

Pictures That Will Sell

Max Peter Haas

*Some sound advice on the kind of pictures that can
be sold, from a man who has bought and sold
thousands of photographs throughout the world*

A professional photographer is one who sells his pictures for money. An amateur is a person, who, ninety-nine times out of a hundred, would like to get dollar value for his prints but doesn't know how to go about it. If you're in the latter position, cheer up!

I was in that same fix myself eight years ago. Then, if I'd had somebody to give me a few good kicks in the pants, photographically speaking, I might be a better photographer today and I might have been started on the road to prosperity at an earlier stage. Though I'm not complaining about that. But when I started out I didn't have anyone to tell me the facts of camera life.

Consequently when *Popular Photography* asked me to write a word of advice on marketing—selling pictures—I was only too glad to do it. For I remembered my past, when I was a kid with a fine camera in my hands and didn't know what to do with it. That was literally true of me. And I suspect it about states the case of eighty per cent. of the amateur photographers in the world today.

This matter of marketing pictures! Well, I believe I can make it clearer to you if I tell you my own experience.

About 17 years ago someone gave me a very fine camera. I took a few pictures with it—then stopped, as my results were not so good. In fact, they were awful! A few years later, however, I suddenly decided to buy a snapshot camera—a very inexpensive one.

I started visiting sports events—tennis tournaments, prize fights, and had fine results. But I realized my little instrument had very definite limitations.

By a series of accidents, I became the proud possessor of a Leica. And the picture changed!

I got down to the serious business of being a photographer. I have Dr. Paul Wolff to thank for that. My admiration for his work inspired me to try to do something real with photography.

This inspiration should prove very valuable. For last fall one of my pictures showing Max Schmeling looking out of the window of the Zeppelin Hindenburg over Philadelphia won first prize in the International Leica exhibit over pictures taken by the world's outstanding miniature photographers. The 500-to-1 shot had won the exhibit!

Perhaps your own experience resembles mine.

Did you start out taking pictures full of enthusiasm? Were the results far from what you hoped? You didn't know what to do about it? You thought because you had bought a fine camera it *must* automatically take fine pictures?

Yes, I made that mistake, too. But I shouldn't have. I wouldn't buy a Stradivarius and try to play a concerto on it before I had learned how to finger a scale.

A fine camera is just as fine a piece of mechanism as a Strad. Any day it is!

And this reminds me of the big industrialist of my acquaintance who recently bought a Leica, preliminary to making a tour of North and South America. He was to be gone some months and decided to have his developing and printing done when he returned.

In all—on his journey—he took three thousand pictures. When he came back not one negative was any good.

He had forgotten to pull out the lens!

In order to avoid the disappointment that arises when you try your utmost to take pictures and pull a blank—I would suggest this:

Buy a dozen rolls of film and start experimenting. Then take notes of your experience—good and bad. And *learn* by your experience. Don't make the same mistakes twice. Then when you have made the advanced amateur grade—when you can really take good pictures—it is time enough to consider the question of marketing them.

Now what is a good picture? A salable picture?

The picture should tell a story. Or—It should be artistic. Or—The picture should have some relation to a story which goes away beyond the limits of a village of five hundred inhabitants.

No, I don't necessarily mean that it must be intelligent. But it must interest the average person who reads a newspaper or magazine.

The main consideration in a photograph is that it must contain human interest.

What is human interest? Let me explain it this way. You've taken a picture of your little sister winning the beauty contest at the church bazaar. That photograph is vitally interesting to you because you love your little sister. She is sweet and charming. She's standing there in front of the church—holding in her chubby hand the prize she won.

You think the picture is a knock-out! Colossal! You think, because you like it, everybody will. You try to sell it—and can't.

Why?

Because that picture belongs in your own private family album. Not in a newspaper or magazine. It doesn't appeal to enough people. A salable picture must appeal to a large audience.

Familiarize yourself with the work in every good magazine or newspaper you can put your hands on. Study the various forms of camera illustration.

Life, the new picture magazine, or *Look,* or *News-Week,* state a definite policy as to the pictures they use. But they will always be keen on new ideas in which they feel their readers will be sufficiently interested.

Then you must consider sports or scientific magazines. They will be less choosy and a much better market if you have the pictures which are suitable. Don't try to make magazines of the type of *Harper's Bazaar* or *The Ladies' Home Journal;* their tastes run in directions which are beyond the average amateur or even beyond many professional photographers.

But here's another shot of your sister that would make space. Take a beautiful action picture of your young lady sister—a marvelous looking girl, of eighteen years, say. She is skating on a lake. She is wearing a short, full-skirted skating costume. Her lovely legs make an entrancing pattern of grace. Her body is poised like a bird ready to fly. She smiles as she looks at you over one slightly tip-tilted shoulder.

That's a picture! A salable picture! In Ceylon, Cheyenne, Wyoming, or China.

And more so if it shows action!

In other words, your photographic theme song from here on should be GIRLS! GIRLS! GIRLS! You can snap the handsomest Adonis that ever lived. But that will not alter the matter of business statistics. The demand for pictures of girls outnumbers the requests for male photographs one hundred to one.

To illustrate it in another way, suppose you took a picture of the Empire State Building. There wouldn't be a market for that. But suppose you snapped a couple of little colored children cutting the pigeon wing in front of the Empire State Building—doing good swing steps—forgetful of the building and the world—then you'd have a *picture* with real human interest.

Life in a picture is what is salable. Vitality. Action! And don't forget the beautiful girl!

Another good type of picture is the provocative one. I have included one of Helen Wills at an exhibition of her own paintings. She has her hand over her eyes.

Why?

Can't she bear the sight of her own art?

Of course she can. It just happened that a man was setting up a strong light. It shone directly in

Helen's eyes. She put up her hand to shield them —and my little candid camera caught the scene.

Once you have taken a good shot, what next? Naturally you can send it direct to a magazine yourself. But it is not advisable. Much better to turn it over to a reliable agent, specializing in the sale and distribution of pictures.

In one half-hour, your agent could get in touch with a half-dozen magazines by phone—magazines which would be in the market for your type of pictures. If one publication couldn't use it, another might. And it is your agent's business to know these facts. To know just where he can place a certain kind of picture at a given moment.

With regard to photographic agency fees, the standard price all over the world is fifty per cent. In other words, you get half for taking the picture; the agent gets the other half for selling it.

The agent's fee does seem a lot. But you must take into consideration that the agency business is the most complicated commercial venture there is. An agent needs the suavity of a diplomat, the showmanship of a Barnum, the patience of a virtuous woman, and the ears of an ox. (I've almost had my telephone ear talked off.)

Every now and then, with much hue and cry, a new agency sets up business. It promises photographers everything: high prices, instantaneous placing, consistent markets. But beware of a company which promises too much. Agencies are human—just as people are. They can accomplish only a certain amount of service.

Another caution to be remembered! When reading a photo-marketing magazine, look out for misleading statements. Many firms advertise which have been inactive for years. Also, if you see a listing: "Have had bad reports from contributors here," back off. Without ceremony. There must be something wrong.

There is one way in which photographers can help each other immeasurably. When you have had a bad experience with an agency, report it for the protection of your fellow craftsmen. Of course, accidents will happen and your photographs may have been lost in transit, etc. But if you have an experience that is downright crooked, shout it to the world. A photographer is an artist, a creator. He sweats to get a tangible idea on paper. He has a right to dollar value for his creative effort. And if he doesn't get it—he should howl!

Some agencies have the lovely little habit of selling your picture once—and then forgetting to inform you when they sell it again to—say the *Plumbers' Gazette* in Squeemilch, Michigan. Only chance allows you to discover such tricks. So deal with reliable people.

The size of prints submitted for commercial markets should be 5×7 or 8×10 inches. They should be glossy also.

Don't be discouraged if you are an amateur and your friends tell you it is impossible to go professional. Work! Experiment! Try new equipment— new technique! Don't listen to the talk that the professional market is cornered by a few big names; that there is no place for the beginner, the little fellow.

Remember the big names of today were amateurs yesterday: Bourke-White, McAvoy, Terry, Leavitt, Nichols, Stackpole, Vandivert, McKay, Rogers. If you've got a yen to take pictures, take them. And if they're good enough—they'll sell.

Are You Afraid of Being a Photographer?

John Durniak

Does your camera intimidate you? Do the dials give you an unsure feeling, a feeling of inferiority? Do you sometimes think your camera is better than you are, that it's really too much machine to master? Has this fear carried over into your shooting? Are you afraid of moving up to the front of the auditorium to make a shot because everyone will look at you? Are you afraid to shoot a full roll on a single situation because you may be wasting money? Are you afraid to ask someone to pose for you because you feel you're imposing on them? Do you keep from entering your pictures in competitions or contests because you are afraid you will lose?

Fear is a vicious emotion in photography. It keeps thousands of pictures from passing through a lens. It lets exciting, colorful, and dramatic events go by unrecorded. It keeps beginners from developing into fine photographers.

Worst of all, fear grows in a photographer's mind. Before he knows it, he has quit shooting pictures of people that are anything but snapshots, and has found peace in landscapes. He has quit the all-important experiments and limits himself to shooting between noon and three when the sun is bright.

Probably the most important step in eliminating fear is recognizing it. Each photographer must do this for himself.

Think back. Was there an embarrassing moment surrounding a picture session that caused you to swear, "I'll never take another picture again"? Is there a lapse in a picture story of your vacation, one caused when you suddenly became timid about shooting? We all have our scaredy-cat moments, but in some of us the scars are deeper and affect us every time we pick up a camera.

I don't pretend to be a psychiatrist, but I don't feel this is a matter for psychiatry. Just plain horse sense is the answer to most photographic fears.

There are two basic fears that are most common in photographers: first, the fear of making a technical mistake; and second, the fear of social embarrassment.

The fear of making a mistake can be remedied in a number of ways. Probably the best way is by gaining confidence in yourself as a technician. You can do this by using your camera. The man who shoots one roll a month can't hope to feel "right" with his camera. The cliché, "Practice makes perfect" can be applied in this case. Anyone who drives one day a month might find himself ill at ease and clumsy behind the wheel of a car. The same thing happens in photography. When you find yourself hunting for an f-stop, or spending too much time focusing, you're leaving yourself open for that unsure feeling which usually builds up into a fear. Therefore, become proficient in the use of your equipment, and practice to keep this proficiency. If there are long periods where you do not shoot, take out your camera and put it through a few dry runs. Get the feel of the focusing, and the controls. When you're out shooting for keeps, this familiarity will pay off.

Mistakes should not cause you to quit photography: they should help you become a better photographer. I can cite case after case of professionals I know who have made mistakes—big mistakes—that would make almost anyone quit photography, but they didn't.

313

The amateur is constantly faced with situations in which his reputation is at stake. It is hard work to shoot when your imagination pictures you standing red-faced, trying to explain why the photograph you are about to make did not come out. Fear is not giving you a chance, or better said, you are not giving yourself a chance.

The second fear—social embarrassment—is more involved and can be approached from several angles.

The biggest problem: shooting a stranger in the eye. If a poll were to be conducted on what is the number one fear in photography I believe it would read something like this: "I'm afraid of going up to a stranger and taking his picture. I feel I'm doing something I shouldn't be doing, and that I'd be embarrassed if the person said anything."

The photographer who says he has never had this fear—amateur or professional—is either a liar or a poor photographer. Sensitivity is an important trait in photographers. Often this element makes the difference between a good technician and a great photographer. However, this sensitivity must be channeled in the right direction. I'm sure Cartier-Bresson and Leonard McCombe have as much respect for people's right of privacy as anyone and I'm sure they are both sensitive men. But, their sensitivity helps to get good pictures, and not hinder them.

Also, let me point out a case history of a man who wanted to photograph people. This man wanted to collect people with his camera, but like most amateurs, he was afraid of people when he held a camera in his hand. In fact he once made the statement. "I feel that I'm taking something away from strangers when I take pictures, something I have no right to do."

On advice of a friend, this photographer began carrying his camera to work with him and around on lunch hour. The first few days he took pictures of people who were some distance away, or looking away from him. In time, he began getting closer, and began taking pictures of people who were involved with looking in stores, or working at a job. Before a month was over, this photographer felt at home carrying a camera and shooting in public. By exposing himself, little by little, to common everyday situations, he had grown confident. He stopped feeling sneaky, and moved around boldly. The timid amateur who whips out his camera and nervously makes one quick exposure looks like a spy. The amateur who takes his time, is obvious, and has an air of confidence looks like a professional photographer. And, let's face it, most people like to have their pictures taken.

If you make yourself go out and shoot, you will conquer this problem. Remember, the first time is the hardest, but once you've had your first time all the rest will be easy.

Let's face other facets of this problem.

Learn to be polite but forceful with people. There are times when you are expected to take pictures. It could be a family reunion or an assignment you've picked up. In such situations, you must act the part of the official photographer. The best way to do this is to think of yourself as a general. If you don't give commands, nothing will come of the situation. Take command, give orders, give them with strength and vigor. Don't let anyone else interfere with your control of the situation.

Refuse to take NO for an answer. Before you go out shooting, promise yourself you will come back with pictures. Refuse to allow people or conditions to keep you from getting what you want. Determination means so much.

If you are in a situation where the answer might be "No" to shooting, shoot first and ask questions later. Instead of saying, "May I take your picture?" say "Please, hold it." then shoot. If you don't give a subject a chance to say "No," you should get your shot.

Become unobtrusive. A photographer who works quickly, smoothly, and quietly never attracts attention. Don't drop things. Don't fumble. If shooting in front of an audience, always keep low out of the way. There are also a few superficial things like dressing conservatively which helps keep you from sticking out like a sore thumb.

Conquering a fear of photography has many rewards. Your pictures will improve, and you will live with yourself in a new kind of peace. You will learn to take time to see more clearly. The confidence you develop in yourself will spread, and people will have confidence in you as a photographer.

No doubt you have found yourself sitting at the edge of your chair in the movie theater completely involved with what's going on before your eyes. Your imagination, your thinking, was so involved with the situation that you forgot yourself. The same thing can happen in taking pictures, you can get so involved in searching for the picture that you forget yourself and forget fear. In fact, let's make a rule out of this: Forget yourself: it is the picture, not you, that's important.

The Turning Point

Harvey Shaman

Top pros tell why they chose photography

ARTHUR D'ARAZIEN

During the late 1930's I became fascinated with the drama of little people doing big things. I began to visualize the possibilities of taking an ordinary industrial situation and by doing things to it—using lighting, motion, color, and exciting composition—making a dramatic photograph. However, before I could put my ideas into practice, the war came along and I went into service. Just after the war, I went to see the advertising manager of a plant that produced bombsights and navigational equipment. He needed good color photographs for the company's historical files before the plant was dismantled. This gave me the opportunity to try my ideas. The resulting pictures were instrumental in establishing my reputation as an industrial photographer.

JOSEPH BREITENBACH

The turning point in my career came when the director of the *Kammerspiele,* a Munich theater, asked me to make portraits of the actors and actresses associated with it. The pictures were quite unlike anything that had ever been done before in the theater. Instead of over-all shots of the stage and full-length photographs, I did close-ups and big heads of the actors. In essence, I did candid portraits, something commonplace today, but

very unusual in the early 1930's. These photographs took first prize in a show in Czechoslovakia. As a result of this, *Berliner Illustrierte* and *Die Dame,* the 1930 German equivalents of *Life* and *Vogue,* began buying my photographs, giving me my start as a pro.

ANDREAS FEININGER

There were actually several important factors in my career as a photographer. Although I was trained as an architect, I always used the camera as a form of sketch book. During the late 1920's, economic conditions in Germany were such that I couldn't find work in my chosen field. Consequently, I went to France where I spent a year without pay working under Le Corbusier. I was unable to continue doing this, so I left for Sweden. Again, there were no jobs in architecture. I turned fulltime to my camera, doing architectural photography for Swedish art and architectural magazines. When World War II broke out, foreigners were not permitted to have cameras in Sweden. Again I was out of work, so I came to the United States in 1939. In 1940 I became a member of the staff of Black Star picture agency. My work came to the attention of Wilson Hicks, then picture editor of *Life.* He gave me a chance to work for him, and I joined the magazine's staff the following year.

DAVE HEATH

It was about one month before my 16th birthday when I decided to become a photographer. The catalytic agent that brought about this decision was the May 12, 1947, issue of *Life* containing Ralph Crane's essay, "A Bad Boy's Story." In Mr. Crane's unique visual interpretations, I found portrayed conditions similar to my own life: broken home, foster families, social withdrawal, and life in an orphanage like the one in which I was then living. In that moment of self-awareness, I discovered photography as a direct and moving form of expression.

MELVIN SOKOLSKY

I have always been involved with the way things looked. About eight years ago, I met a big-name photographer who was handling top accounts. Though his pictures were extremely well done—the best I had ever seen—I felt they had an artificial quality. The over-all vision didn't feel right to me. I had strong definite opinions of what was right and wrong with them, although at the time I didn't know anything about photography. As a result of seeing his pictures, I started looking at things more closely. I soon realized that when I looked at things, I saw them one way, but when I closed my eyes I saw other things. I wondered if it was possible to put these other things on film. Finally I bought a camera and started to work. I soon found it was easier to close your eyes and see than to make the camera see for you.

SUZANNE SZASZ

The turning point in my career came when I discovered I could photograph people as they really are, rather than as is usually done by making pictures of them as they appear to be. I had an assignment to photograph two children. The mother said she didn't think I would get successful photographs because, "Adam is so jealous of the baby." In thinking about how to handle the story, I decided to show the jealousy rather than avoid it. As a result, in less than two hours, I did one of the best picture stories I have ever done. This is what got me started in my specialty doing picture stories of children and their problems as they really are, rather than the way people think they are or would like to think.

JOHN VACHON

In 1936, by pure chance, I got a job in Washington as a file clerk with Roy Stryker. At the time I had no interest in photography. The first things that hit me were Walker Evans' pictures of America itself—the barns and store fronts and posters. I suddenly realized that photography could capture the essence of how a filling station in the South really looked. Shortly thereafter, I took a train trip to New York. The country was all new to me, and I was tremendously impressed with what I saw. Every place I looked were things of the type that had impressed me in Evans' photographs. When I mentioned this to Stryker, he suggested I start using a camera to record those things that impressed or moved me. By 1941, I was working full-time for him as a photographer.

Are You Ready to Turn Pro?

Arthur Goldsmith

Here's what you need to know about getting started in photography as a full-time career

The dream, secret or expressed, of many amateur photographers is to make the switch to pro: someday, somehow, to be able to chuck the old 9-to-5 routine, tell the boss what they really think of him, and make a living as a free entrepreneur, taking and selling pictures.

As dreams go, this is a reasonably viable one. There probably are upwards of 100,000 professional photographers in the United States, including free lances and those employed by studios, publications, industry, etc.—and that number is likely to keep growing. More than 13,000 industrial and business firms have photo departments employing one or more full-time photographers.

The rapidly expanding audio-visual field has created many new jobs and provided many new assignments. (More than one billion dollars a year are spent in the audio-visual field now: this figure is expected to double or triple during the next decade.) The use of photography in medicine, research, and the graphic arts is growing explosively, too.

No statistics are available for the number of photographs (often in color) needed by catalogs, house organs, specialized magazines, annual reports, college fund-raising booklets, promotional brochures, etc., but it obviously must be astronomical, as anybody with a mailbox can very easily attest.

The picture isn't all roses, of course. Mass-circulation publications—hard pressed both on the editorial and advertising side by TV—are having their troubles. *The Saturday Evening Post* has folded, and people in the field are worried about who may be next. An increasing proportion of advertising dollars is spent on television commercials, which has made things tougher for advertising still photographers and studios.

The "glamor" types of photography—photojournalism, advertising, and fashion—are overcrowded. Everybody seems to want to get into the act, especially after seeing *Blow-up.* But these fields always have been overcrowded and highly competitive in the nearly 20 years I've been involved with photography; yet there remains a dearth of fresh new talent here. So, photography is, indeed, a "generally bright and growing field," as *Changing Times*, the Kiplinger magazine, called it during a recent survey of career opportunities.

For some, the dream of becoming a professional, full or part-time, will remain a dream. But others will make it a reality. One thing that strikes me in my conversations with those who are about to take the plunge is the lack of information on the specific little nitty-gritty details of getting started.

Things like who do you see? What pictures do you show them? How many pictures? How big? How do you set up an interview? Where do you

find names and addresses of picture buyers? Will these people look at the work of an unknown photographer? What do you say in an interview? Should you start out alone or work through an agent?

Nobody's ever *told* them. Those of us in the field have acquired the answers by osmosis or personal experience, and we sometimes forget that things that seem self-evident to us aren't that way at all to a newcomer to the ranks.

So I'll cover some of these fundamentals of getting started as a professional photographer—what picture researcher Sam Holmes calls the "household hints" of photography—as if you were sitting across the desk from me or we were having a drink together at a quiet bar and I was leveling with you about your chances of breaking in.

I'm assuming you have talent, taste, energy, stamina, drive, knowledge of your equipment, good ideas, and are more than a little nuts about photography. Otherwise I'd say, well maybe you ought to try another way to make a living in some other type of work.

First, let's take the importance of personal contact. The only way I know for a beginning professional to find his markets and get assignments and clients is the hard way—by making lots of appointments and showing samples of his work to lots of potential buyers. That goes for Crow's Foot, Minn., as well as for Manhattan. Occasionally, an assignment may come to you "over the transom" as a result of published work or word-of-mouth recommendation, but if you rely on this alone you're going to have trouble paying the rent, much less getting rich and famous.

Nor, as a beginner, can you expect a picture agent to take you on and do the hustling for you. Later, maybe, when you've established yourself as a reliable producer, you can make a mutually profitable arrangement with an agent; but when getting started, you're on your own, as were most successful professionals before you.

Obviously, the key people for you to meet are those responsible for buying photographs and giving assignments. Let's see who they are. At a large advertising agency, there probably is a chief art buyer who should be your first contact. He may look at your work himself or turn you over to one of the agency's art directors upon whom he relies.

At smaller agencies, the responsible person is probably one or more art directors. (Advertising agencies are listed in your local phone book, but for a comprehensive U.S. listing, see the most recent edition of the *Standard Directory of Advertising Agencies,* available in most library reference departments.) If you don't know the name of the person to see, call the agency and ask the switchboard operator for this information.

Another avenue of approach is directly with an industry or business itself. There may be a number of larger or smaller firms in your area that use photography and assign photographers directly. Although more and more corporations have established their own photo departments, they may supplement the work of in-plant people with outside studios and free lances, depending on special needs and the internal work load.

Try the firm's public relations director for openers. He should be interested in your portfolio for his own purposes and can steer you to other key people—the advertising manager, for example, the editor of the company house organ, or the head of the audio-visual department, etc.

Also get to know the picture buyers on your local newspapers and other publications. On a small paper, this might be the managing editor himself; larger papers usually have a picture editor or chief of photography who would be your best contact.

Even though the newspaper has its own staff photographers, it probably also uses free lances and buys individual pictures from outside sources. Local Sunday supplements (there are hundreds of them printed) are excellent markets for photography, and many of them use color today.

On smaller magazines, the editor may do the buying, or perhaps the art director is the man to see. Larger publications usually have a picture editor whose prime responsibility is buying photographs and making photographic assignments. Check the magazine's masthead and/or the switchboard once more.

Another market to try while you're at it, is any college, university, or private school in your area. Fund-raising is a big business today, and photographs often play a vital role in brochures, pamphlets, and related campaign material. Contact the development director or the director of public relations, one of whom usually handles photography for fund-raising.

The strategies and techniques of your interview come next. If you have a personal contact with a potential picture buyer, or can get someone to put in a word of introduction, fine. That's always a bit pleasanter than going in cold, and everybody in the business values his personal connections.

But you don't need an introduction: it's a picture buyer's business to see photographers. He's hungry for new talent and good pictures. Who knows, maybe you've got just what he's looking for, and if he doesn't see you, a competitor might grab you first. Think about it that way, and don't be shy or hesitant.

Always set up an appointment first, and be on time. If you arrive late and mess up a busy individual's schedule, you aren't likely to endear yourself or have your pictures looked at with the most favorable eye. A phone call, for local clients and contacts, is quickest and easiest. If you don't know the name of the appropriate individual to see, ask at the switchboard, as I've mentioned.

For out-of-town appointments, send a letter, allowing ample lead time. Maybe the person you want to see is booked solid or is going to be out of town the days you want to see him, but could make it on an alternate date, etc. (Enclosing a self-addressed, stamped envelope will increase your chance of a fast reply.) If you have to break an appointment—and try to avoid it—be sure to let the person or his secretary know, and set up an alternate date if possible.

AVOID THOSE FRANTIC FRIDAYS

The logical strategy is to set aside a morning, an afternoon, a full day (or perhaps several days for an out-of-town trip) in which you see as many people as possible. Don't pack your schedule too tight, though. Allow time for waiting, traveling between one office and another, unexpected delays, etc. Two, or at the most, three, interviews are probably enough for a busy, and hopefully productive, morning or afternoon.

Whenever possible, avoid late afternoon appointments, at which time your man may be anxious to break away and go home. Friday afternoons are particularly hazardous: If you've worked in an office you know how the worst crises always seem to break on a Friday afternoon. The best client-hunting seasons are fall, winter, and spring, simply because in the summer many of the people you want to see may be away on vacation.

During the interview, relax and be yourself. The first few times you show your photographs you may feel self-conscious, but you'll soon get over that. Salesmanship is important, but that simply means good ideas and strong pictures presented by someone who believes in himself; no fancy pitch or suede-shoe routine here.

Let the person you're talking to lead the interview. If he or she feels like chatting, fine. Otherwise, don't force the small talk. The person you're confronting is probably busy, sees many photographers and pictures in the course of a working week, and is accustomed to quick decisions.

You may very well get some constructive criticism, useful tips, or additional contacts during the interview, but don't demand them. In particular, avoid long-winded accounts of how terribly difficult it was to make the pictures. Don't be a boor, a bore, or a pest. Leave the door open for a return visit.

In times not long past, I would suggest to the more casual young photographers I knew that they ought to shave and wear a tie and jacket during interviews. But the cultural climate changes, and I guess this advice isn't necessarily valid anymore.

The other day I was talking to a conservatively dressed advertising photographer when we happened to pass a hippie type with a camera, somebody right out of the road company of *Hair*. "See him?" my friend said. "A couple of years ago he couldn't have got past the reception desk of any agency in New York. Now if you don't look like that they think you aren't creative."

DON'T SHOW A MUSEUM EXHIBIT

An effective portfolio of your work is actually your most valuable sales aid. It's worth the best thought and greatest care you can give it. The first thing a potential picture buyer will ask is to see your portfolio, and maybe he'll remember a picture or two in it long after he's forgotten your face. (Always leave a business card too.)

A portfolio can have many physical formats, and I'll talk about some of these in a moment, but first a point about over-all strategy. Don't think of your portfolio as a static, never-to-be changed museum exhibit of your work. It should be a dynamic, flexible, adaptable presentation.

Plan to change its contents, as necessary, so you can *slant* it to the needs of a particular buyer. Do you want to show a representative cross-section of your work? To emphasize a particular specialty of yours, such as fashion, still life, or architectural photography? To sell a specific advertising campaign or story idea? Decide what you want the portfolio to do for you and each time you show it, select its contents accordingly.

A second basic point is: stress quality not quan-

tity. Whatever selection you make or format you use, include only your very best work. In the final analysis, good pictures make a good portfolio, and it's a mistake to include weak or marginal pictures to pad things out, as I've seen some inexperienced photographers do. If you have any doubts about a picture, by all means leave it out.

How many pictures should you include? Well, you won't find unanimous agreement here, from successful photographers or from picture buyers either. You need enough to give a fair example of your abilities, but not so many as to overwhelm.

I'd say at least a dozen. Anything less doesn't give a potential buyer much to evaluate. Two dozen or even three dozen (if you really have that many strong pictures) is a good solid sample, but I wouldn't go very far beyond that or you risk leaving the viewer confused rather than impressed with your work.

Garry Burdick, a successful freelance, has a good method for handling big portfolios. "Split them up," he advises. "Go back a second or third time with a different selection. This gives you a good excuse for repeat visits to a client or picture buyer, and at the same time helps keep your name alive."

Most portfolios I look at include 11×14 prints. Size does lend impact, and an 11×14 tends to be more impressive than an 8×10 from the same negative. Some photographers like to go up to 16×20 for their "show" work (or else they may mount an 11×14 print on a 16×20 board).

That's about the maximum limit of practicality, though, in terms of portability and convenience in showing to a picture editor or art director in his office. (Have you ever tried carrying 16×20 prints on the subway or in and out of a Volkswagen?)

Do mount your prints: it gives your presentation a more finished, professional look, and the photographs will hold up better under repeated handling. I'm assuming, of course, that the prints themselves are the best you can make, and have been carefully trimmed, spotted, and mounted.

What about color transparencies? One way is to bring a loaded tray or trays and your own projector. This can be a very effective way to make a presentation, but only if arranged and approved ahead of time, with a screen, darkened room, etc., available. Most picture buyers I know don't want to bother with projection as a routine thing.

Far more convenient for the viewer is for you to mount your transparencies in 8×10 acetate sheets (available from a number of manufacturers with slip-in compartments for mounted 2¼ or 35-mm transparencies). These can be placed on any light box or merely held up to a window or light fixture for viewing.

An experienced picture viewer can tell all he needs to know without projecting the slide. If he wants to see one blown up, it can easily be removed from its compartment.

Include a few clips of good published work, if you have them. (For protection, place them in clear acetate sheets of the type sold as notebook fillers by any stationery store.) It's good psychology to establish the fact you *have* been published, especially when making a first contact.

NO ELEPHANT HIDE NEEDED

A wide variety of sample cases are available for carrying your portfolio, and you can go as fancy or as austere as your taste and budget dictate. You could get a custom-made case of elephant hide with your name stamped in gold, and perhaps this would impress some people.

However, I've never heard of a buyer turning down a good picture because he didn't like the carrying case it came in. Fiberboard cases, sold by most large art supply houses, are neat, durable, and relatively inexpensive; many pros use them.

Another method is to carry your pictures in an 11×14 salesman's sample or presentation binder, the kind that closes with a zipper. You can insert your pictures in the acetate leaves, or if you prefer, remove the leaves and store individual mounted prints in the resulting space.

All the little details I've been talking about aren't very glamorous, but they are important, and they are as much a part of a free-lance's life as testing lenses or booking models or catching a jet to Tahiti. Making personal contacts, seeing picture buyers, showing your portfolio, presenting ideas, selling yourself and your work—all this is indispensable in getting started as a professional and in continuing to succeed.

Sounds like hard work? You better believe it. But out of it can come the personal satisfactions and financial rewards that make photography such an exciting and varied career.

How Photographers Learn

Wallace Hanson

*On the value of schools, ways to study on your own,
and the importance of learning by doing.*

The education of the photographer is a process that continues throughout his life. It begins with the learning of certain fundamentals of how a camera works, how to load and point it in the right direction, and so on. And then it grows and expands into a process of exploring the intricacies of photography, toward a more sophisticated knowledge and understanding of things like optics and the effects of various lenses, the subtleties and limitations of film, the infinite complexities of lighting, darkroom technique, the psychological aspects of confronting the subject with a camera, and countless others.

As in all fields of human interest, there are basically two approaches to learning photography—by going to school, and on your own. Although school is one of the best ways to learn the fundamentals, as well as to pursue more comprehensive knowledge of specific areas of photography, the fact remains that most photographers are self-taught.

There are many ways for you to master what you want to know about photography even if you, like Winston Churchill, "love to learn, but hate to be taught." Let us first discuss the various ways of studying photography on your own, and then go into a discussion of formal education.

To begin at the beginning, nothing is more basic than the instruction sheet that comes with the film and the booklet that comes with the camera. All too often, these important documents are discarded because of laziness or ignorance. Yet, I've noticed that a lot of real experts in photography veritably pore over them.

For example, Pat Caulfield, the superb nature photographer whose book, *The Everglades,* was published by the Sierra Club, says that she is frequently asked how she manages to get such perfect exposures when she often has just one chance to photograph a swiftly moving animal she has stalked for weeks. Her answer is so simple that people sometimes find it incredible. "I just follow the directions that come on that little slip of paper with the film," she says.

The same is true for the famous Canadian portraitist Yousuf Karsh when asked once by an eminent photoscientist how he achieves the heights of technical perfection. He explained that he has just one rule. He, too, follows the manufacturers instructions to the letter.

Not only can you learn a lot of basics about exposure of film and how to use a specific camera by studying the instruction sheet, but it can also save you money by sparing you repair bills. As one camera repairman stated: "The (name withheld) camera becomes a product in need of repair when the owner does not read the instruction book. The manual clearly states that when the camera is set

on "auto," no speed slower than one second can be used. When the speed ring is forced to "B" a post is sheared which results in a loose lens housing and possible damage to light meter wires." It goes without saying that he recommends studying the booklet.

Research, however, has shown that most people do not respond very well merely to a stream of information. When they want to learn something new it is often far more productive for them to try to find out for themselves by doing, and then, after they have had some hands-on experience, to hear or read the theory regarding their own discoveries.

The technical director of a large Hollywood motion picture laboratory, a man with an engineering degree from a leading university, told me that he learned more about photography by developing film in his mother's kitchen than at any other time. I believe him. Even though research shows that we may not have an accurate perception of when our learning is slow or swift, the evidence is all but overwhelming that actually doing something is of immense benefit in learning.

It is for this reason that I do not believe any tuition is a better bargain than $100 worth of film put to work in an attempt to make each picture, each roll, better than the last. Of course, if you really do that, you will soon find yourself digging into all the instructions and data available to you.

I am reminded of one of the best photo printers I ever knew. He would take a whole box of 16× 20 paper and make 25 slightly different prints of a single negative—experimenting, trying different approaches, trying for different moods or for different ways to solve a hard dodging problem, attempting to see more deeply into the picture and into his craft. (If you experiment like this, by the way, use smaller paper and be sure to dry, mount, and hang the results. You may be surprised what an effect that "drying down" or the ambient lighting conditions can have on photographs.)

There are, of course, countless other ways to learn through exploring. I am sold on the virtues of the Polaroid Land system for this purpose. Many professionals make a Polaroid picture as a test before each "for real" picture that will be used for reproduction. Believe me, they learn substantially from these tests.

Failure to experiment stymies development. What one needs is plenty of supplies including film, ample time, and a patient subject. And the photographer should keep at it until he solves some artistic or technical problems he sets up for himself. Because you do not have to wait for results, I think you can do this more easily with Polaroid Land photography than with any other format, but the basic technique is valid, of course, for all types of cameras.

But mere exercises are not enough. All too often amateur work is characterized by its lack of evident meaning to the photographer, by its being some empty derivation of an in-vogue subject or composition, a hollow imitation of another pho-

tographer's form, but without his substance. It is much healthier to express or to record something meaningful or valuable to you than to pretend to be an artiste. Your girl, your child, your rock collection, your house or anything else familiar and close to home will make a far better picture than a colonaded portico framing Elysian fields. Renoir was once asked how he achieved the marvelous flesh tones of which he was a master. He explained that he continued painting until he felt the urge to reach out and pinch—and then he was sure the tones were right.

How do you learn these things? Without really much to go on, I am a believer in the discovery method. I believe that you must discover for yourself, and perhaps within yourself, what is worth doing with photography. I do not believe you can do this without going out and making pictures, without trying ideas, proving them, improving them, and without struggling to develop an art for yourself.

This is hard to do, and perhaps one can never do it alone, without some critic, teacher or colleague to help, but I have never seen worthwhile photographs made by anyone who was not somehow expressing his own unique self. Far better for an amateur to photograph a nude in a salacious pose, if that really turns him on, or to capture on

film the new Simonize job on his car than to make this year's 39th Pre-Raphaelite pose of the three graces at the camera club—better artistically and more rewarding psychologically.

Speaking of camera clubs, what place do they have in a photographer's lifelong education? Well, one proven stimulus for learning is a peer group which is also eager to learn. Conversely, a peer group that puts learning down, or that puts you down, is devastating. A group can be a powerful influence on you, and some experts in learning think that a motivated group can learn to master any subject. What this boils down to is that camera clubs can be very good or they can be horrid, depending on how well their aims mesh with yours, and depending upon how stimulating they are. If you can't find one to suit, you might be able to start one. You'll probably be better off with other like-minded photographers to share experience and information with, than by trying to go it alone.

Of course, camera clubs are never the extent of human resources available to the photographer. In almost any community there is a camera dealer accessible to you. Most are flattered when you ask them for advice and diagnosis of your problems, so try to establish a friendly relationship with him. And when you need equipment, buy it from him.

His advice and knowledge is worth a lot more than what you'll save by buying from a discount store. Also in your community there probably are photography and art teachers, artists, art directors, professional photographers, museum curators, librarians, chemists, physicists and other amateurs who will be willing to talk with you about photography and share your interest and enthusiasm.

For sheer raw efficiency in learning nothing beats reading, especially if you are a skilled and analytical reader and if you have a background of picture-taking experience to invest your reading with meaning. Early on, the most valuable book to me was Kodak's *How To Make Good Pictures* which assumes no knowledge at all on the reader's part. I think the clearest, most comprehensive guide is the *Ilford Manual of Photography.* It ducks no issues of importance to a practical photographer, and some people to whom I've recommended it say that it takes study, but is worth it. The *Leica Manual* is another good one. John Whiting and Jacob Deschin have changed the whole meaning of photography to a generation of photographers with their books on the nature of photography as art and communication. The one great work of technical and scientific scholarship on photography is C.E.K. Mees and T.H. James' *The Theory of the Photographic Process,* but I must warn you it is not light reading.

What else should you read? Read only so much as gives you pleasure, solves your problems or stimulates your photography. There is an inexhaustible literature in photography, even though your local library may only offer a sparse collection. There are hundreds of periodicals, devoted to every subject from aerial photography to biological photography, and including, of course, the more general consumer magazines like *Popular Photography.* I think one of the best and most educational features of this magazine is the Hattersley Class which I recommend strongly.

Another important input for you is the work of other photographers. I do not believe that any photographer can possibly be the same after seeing a book or an exhibit of Paul Caponigro, Paul Strand, Edward Weston, or Henri Cartier-Bresson. Many photographers make a regular practice of visiting the galleries to keep up with what other photographers are doing, and this is an excellent idea. Perhaps even more enlightening than an exhibit is to own a fine photograph—so long as it is stimulating and not overwhelming.

If you live in a large American city, you'll proba-

bly have ample opportunity to take in evening courses, workshops, lecture series, and demonstration courses such as the Nikon school. Any of these can help you, especially if you know what you are looking for, have some background, and are eager to develop some specific skill or ability, some insight or outlook possessed by the teacher. And you need not concern yourself much about whether the course is too difficult or too easy. If the subject really means something to you, you'll extract some value from it in any case.

Learning, good as it is, is a means and not an end. The same might be said of photography. Unless you use your photographs in some self-gratifying or fulfilling way, I seriously doubt that you will continue growing for long. On the other hand, there are plenty of outlets available to anyone. You can use your photographs to decorate your home, to remind you of your loved ones, to present as gifts to your friends, to exhibit publicly, to publish, to use as communication for your community, church or political party, and dozens of other ways. If it is hard to learn photography, it is nearly impossible to learn it for no purpose. Finding a way to get some satisfaction, some joy from the results of your photography, is perhaps the most important aspect of your development.

Young people contemplating a career in photography would like to know whether formal education is necessary and, if so, which kind is best. Of course, there are no simple answers to that question. Certainly there is a lot that can be learned by taking courses, but which ones, and where, are questions that must be decided by each individual based on his needs and desires. A Kodak pamphlet, *A Survey of Motion Picture, Still Photography and Graphic Arts Instruction,* is the most comprehensive compilation of available courses listed alphabetically by state.

If you are interested in becoming a professional photographer, formal education probably helps. But if the history of photography makes anything clear, it proves that you do not need to go to some fancy school to learn how to take excellent pictures. Many famous and successful photographers and technicians had but the slightest brush with formal education during their careers.

Perhaps even more important than formal training in photography as a route toward a career, is the practical experience that can be had by taking a part-time job such as a photographer's assistant during summer vacations before graduation. Not only does this provide you with first-hand experi-

ence to supplement your formal learning, but it also helps greatly when looking for a job. Employers usually give greater weight to practical experience than they give to formal learning. In fact, I feel so strongly about this that I would like to urge youngsters thinking about photography as a career to do *anything* they can within reason to get some job experience in photography before finishing school.

However, this is not intended to belittle photo schools and courses. They serve an increasingly more important service as they continue to get better and more practical in their scope and technique. When choosing a school with a career in mind, one thing you will want to know is what kind of assistance the college can give you in finding a job once you graduate. You could investigate by looking into the placement office to find out the kinds of jobs obtained by recent graduates.

At some time in the future it may be possible for the individual to place himself in the hands of an institution that will virtually overnight make him a success as a photographer, and as a person. Meanwhile, however, the burden of an education in photography still depends almost entirely upon you, and what you do about yourself—now.

Assignments on "Spec"

Al Francekevich

. . .or, robbery in the art department

Most sources of advice to young photographers—A.S.M.P.; books on selling pictures; older, experienced hands—tell you never to speculate. Yet every beginner seems to dismiss this as pious, goody-goody advice. He does speculate and inevitably gets burned.

I was no exception. In my earlier career, I'd be exploited by practiced con-men art directors on the average of once a year. Some of these felons are still around and operating, and I'd like to tell you about them.

One art director approached me through my rep to do a cover for a magazine he was redesigning. No money. Just do a cover of a beautiful girl in a simple hairdo that he would use as the first cover of his regime at a long-existing but floundering women's magazine. It didn't sound too tangible even then, but this well-known, award-winning art director had a manner so low-key and so convincing that it seemed as if he were doing me a favor instead of vice versa. I rounded up my favorite model, a real beauty with gorgeous strawberry-blonde hair, and did some shots. The model called me a week later to say another photographer had asked her to work on the same project. A few days after that, a third photographer talked to her about the same cover, the same art director.

The realization hit me that if one girl had been asked by three photographers to speculate on the same cover, that there were probably a few dozen photographers involved in this art director's secret photo contest.

Why did this guy go to these lengths to string along so many photographers and waste their time? Insecurity. Instead of getting his own idea, he tapped the talents of many young men trying for a break. He probably went into a meeting,

The author examines color transparencies after shooting an advertising assignment.

displayed the varied results, and said to his bosses, "Look at all the work I've done on your problem!"

The tragedy of this secret photo contest is that probably no one won. I'd bet that all of these photos were treated as roughs, and the assignment went to one of the magazine's regulars.

Another example of the same weakness was an art director at one of the world's largest ad agencies. He was more direct. Holding in his hand three layouts for a paper-products company, he said, "You've got these three jobs. But first could you do me a favor?"

The favor was a free presentation on a beauty soap. When this was completed, he first asked, "How large is your studio?" Knowing that a beginning photographer would be unlikely to have a large studio, he went on to say that he wanted a set to be built showing a series of checkout counters at a supermarket. This was his out. My suggestion to use a real supermarket was ignored, because I was not destined to do these three national ads in the first place. He had conned me into doing some free soap pictures.

One year later, the same art director approached a friend of mine to do speculative shooting on the same paper-product account. What he didn't know was that my friend was the former assistant of the photographer who usually handled these ads. By coincidence he visited his old boss the next day. In their conversation, it came out that the boss was so busy that the agency had gotten "some kid" to do "roughs" to stall the client. The "kid" immediately realized he was being had and saved himself some useless work.

I'd like to be able to say this unscrupulous art director was found out and fired, but, alas, life is not like fiction. He's currently vice president involved in producing TV commercials.

Another kind of deception that was more difficult to detect was the case of an art director of a women's service magazine who thinks of himself as a photographer. He has gained a great deal of confidence and some photographic skill in the eight years or so since I knew him, but he is still basically a professional art director and amateur photographer. (Many art directors have made the switch to being full-time photographers. I welcome them as competitors and colleagues. However, I can't compete with, and I actually feel embarrassed for, art directors who publish their inept, below-standard, unprofessional photos to satisfy their egos and/or pick up a few bucks in the process.)

On several occasions, he gave me or a good friend an assignment and also worked on it himself. If his pictures didn't "come out" he had the pro's work to fall back on. If his were even passable, he'd make up a cock-and-bull story on why the photographer's pictures weren't being used. The photographer would get a partial payment. This practice gave him security while he was learning to operate a 35-mm camera.

Another security stunt this man pulled (he was very insecure) was told to me by another commercial photographer. They had booked a model for a full day to shoot a cover. After two hours in the photographer's studio, the art director said, "I think we've got it." Puzzled, the photographer protested. The A.D. (who is the boss on a job, after all) prevailed. Only later did the photographer learn that the A.D. had spent the rest of the day shooting pictures of this model in Central Park. The pictures were bad, so one of the morning's exposures by the professional were used.

Why did he do this? The all-day fee for the model was $360. The A.D. was too timid to actually book a model himself, for fear that his results would be poor: he didn't want his editor and publisher to see a bill for $360 with no tangible result. By pulling the maneuver he did, he made it look as if the photographer was shooting all day—and the magazine had a cover to show for it!

As you might have concluded, photographers talk among themselves, and quickly learn who the bad guys are. Unfortunately, there is no professional group strong enough to do anything about it. I'm certainly going to stay away from the thieves and con men, but it is not me they are looking for any more. There's always some talented, hungry young photographer they can victimize and nobody will do anything about it.

To protect yourself, as an individual, there is a concrete test of a potential client's sincerity. It's called *money*. If a client wants to try an idea, let him pay at least part (let me suggest half) of the fee for the finished job. No agency or magazine gets printing, engraving, rent, pencils, paper, or typewriter ribbon for nothing. They shouldn't be able to get photography for nothing, either.

In bull sessions we've had about this subject in my studio, an interesting point crystallized. In all of the schemes in which I naively participated—all of which seemed somehow exceptions to the rule of not speculating—did anything, ever, in 14 years, work out as promised? I must humbly answer: *No*!

Photos and Captions

Howard Chapnick

*Words tell the reader what pictures can't; they make
a photographer a photojournalist*

*"What is a good caption? I know that it is 'who, what,
when, where, why,' but various sources lead one to believe
that this can be anything from two or three words to a
complete accompanying manuscript. I also know that diff-
erent markets will have different requirements—but this
leads me to the original question—What is a living,
breathing example of a good caption?"*

Bill Shuman

Let's start by saying that the photographic cap-
tion is the least understood, most abused and neg-
lected segment of photojournalism. It is least un-
derstood because few take the trouble to evaluate
the role of the caption in the total picture story. It
is most abused and neglected because—more
often than not—captioning is delegated to the
least experienced writers on the staff.

There are really two distinct areas for explora-
tion of this subject. Bill Shuman is asking about
the role of the photographer in the development
of captioning expertise. From a total journalistic
viewpoint, the concern should be about how the
information provided by the photographer is ulti-
mately used by the editors in preparing final copy.

I have yet to see a caption of "two to three
words" that will satisfactorily amplify the informa-
tion in the photographs. Nor have I ever encoun-
tered a photographic assignment that required "a
complete accompanying manuscript" as a caption.

What I *have* seen over the years are visually articu-
late but verbally inarticulate photographers whose
pictures arrive devoid of even simple, basic infor-
mation that is needed for intelligent captioning.
One cannot err on the side of providing too much
caption information. The editor who finds a pho-
tographer who understands the importance of de-
tailed captioning will figuratively embrace him
bodily and professionally.

The professional photographer is the eyes and
ears of the assigning magazine. The photogra-
pher's mind and eye (assisted by an intricate ma-
chine) create visual images. But the job doesn't
end there. The true professional in communica-
tion also records revealing comments or dialogue,
observes and collects nuances of the situation
being photographed. He should be trained in the
reportorial techniques in garnering information
that separate the photo*journalists* from the photog-
raphers.

In supplying information, the photographer
must intelligently key roll and frame numbers to
the captions. I have yet to see an improvement
over the *National Geographic's* caption books which
photographers get before going on assignment
for the magazine. The photographer who uses
these caption books efficiently makes the editor's
job easier and provides himself with permanent
identifications that will add immeasurable value to

his photographic file. Since everybody doesn't work on assignment for *National Geographic,* they might do well to develop their own little captioning books like the one shown in this article.

Few individual pictures stand alone without words. Few exist without the framework of an event. Freezing a particular moment in time freezes only *that* moment. It tells nothing of the moments and events that preceded that image or what followed. Only the photographer can place that picture in perspective by providing the necessary background information.

That's where the photographer becomes more than a photographer—he becomes a journalist. He may misinterpret the event or suffer from lack of perception. But he has an obligation to himself, to the editor and to the reader to present his photographs with all the delicate shadings and nuances and depth reporting that traditionally distinguish the professional observer from the dilettante.

A classic example of such an event can be found in the pilot issue of the new *Look* scheduled to be published early in 1979. A six-page, five-picture layout depicts the heinous brutalization of Delbert Africa, a member of "Move," a black squatters commune in Philadelphia. The braided long hair of Delbert Africa is pulled by an arresting officer, he is smashed over the head with a helmet and finally unceremoniously kicked as he lies on the ground defensively holding his face. Shades of Nazi atrocities! The knee-jerk humanistic response to evidence of such brutality is to react with equal measures of compassion, and disgust, to feel the pain as if it were your own.

But then one reads the captions that accompany those photographs and evaluates the event with new perspectives and new attitudes predicated on the total event. One becomes aware that this is a vengeful retaliation for the death of one policeman and six firemen.

The caption reads "When the smoke cleared, a policeman lay dead and rage turned to revenge. Enraged by the killing of a fellow officer, a patrolman brutally kicks Move member Delbert Africa as another policeman drags him by the hair."

That is an example of a living, breathing, concise, honest, descriptive caption. It ameliorates what would otherwise be an example of the worst kind of human behavior and man's inhumanity to man. Even then, we perhaps wonder at the excesses being committed. But it gives us the opportunity to understand the motivations that impelled these policemen to commit acts that violate the precepts of a civilized society.

It has been pointed out that pictures often lie. Captions are equally suspect. The reader must constantly be alert to evidences of editorial liberties based on inadequate information or conscious efforts to influence him or her with editorial bias.

I recall a series of photographs that was published in a national magazine many years ago that showed life behind the Iron Curtain. There was one innocent picture of a silhouetted dog howling against the fading late afternoon light. It was a time of great confrontation between the Western Democracies and the collectivist countries dominated by the Soviet Union.

The picture was innocuous and could have been taken anywhere in the world. If it had been taken in Michigan, it might have been captioned "A dog greets signs of nightfall with anticipation of nocturnal dalliance with the opposite sex." But, because it was behind the Iron Curtain, the caption read something like "A dog bays dismally . . ." In their bias, the editors were trying to tell us something. American dogs bay happily at thoughts of the benefits that accrue to participants in the American way of life. But, once the dogs get behind the Iron Curtain, the lives of dogs and humans suffer equally under the heel of the oppressors.

Photojournalism, in my opinion, is comprised of three basic elements. The text block gives the background of the story and sets the stage for understanding the photographs. The photographs depict the event, and the captions specifically amplify information about the individual photographs.

Too often the captions are extracted and refined from the basic text block. Captions should not repeat either what's in the text or what the photograph has already told us visually. Properly used, the caption gives us solid information that *adds* to what we already know about the subject from the basic text block. The *National Geographic* is probably the most sophisticated practitioner of the captioning art. There are no one-liners. One gets the feeling that the editors have worked as hard on the caption material as they have on any other part of the story.

During the administration of President Gerald Ford, I was involved with the publication of a combined picture-and-text book titled *Portrait of a President* (photography by Fred Ward, text by *Time* Washington Bureau Chief Hugh Sidey).

Although it was not one of the most successful publishing ventures of our time, I am particularly proud of how the book was put together—and particularly the depth and dimension of the Sidey captions that accompanied the photographs.

I have chosen one caption to illustrate my point. "Left: The President gets his soul into a backhand on the White House tennis court. Many people are unaware that there is a court here because it is well hidden by planting. The court is only a few yards from the Oval Office on the South Lawn and it stands ready at all times for Presidential action. Other staff members can sign up to play when the court is not set aside for the President. Ford wears an elastic support on his weakened right knee. Though left-handed, the President plays tennis with his right hand."

This caption goes beyond the ordinary caption, which might have been something like, "President Ford plays tennis on the White House tennis court." In the expanded Sidey caption, we learn the location of the court, to whom it is available when not being used by the President, why the President wears an elastic knee support, and the fact that the President plays tennis with his right hand though ordinarily left-handed.

Other captions in this book are replete not only with additional tidbits of information, but quotes provided by the photographer. These give greater insight into the personalities and minds of the people represented in the photographs. A skilled caption writer can underline the key points of the photograph and provide the reader with a greater understanding of what is happening in the photo.

As in all aspects of photography, there are no categorical rules to be followed for captioning. Newspapers have different needs than magazines; the audio-visual market has its own special requirements. What they all have in common is the need for professionalism, for photographers who do not provide them with question marks but instead with solid information that can be used to enhance the impact and communication of the photographs.

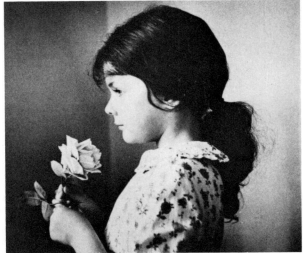

CAROL CARLISLE

History:
The Photographic
Tradition

Japan's Cameras

Irving R. Lorwin

Manufacturers begin production of copies of American and German equipment in an effort to meet a boom demand

Photography is undergoing a boom period in Occupied Japan today. The manufacturers of "Sakura" (Cherry Blossom) and "Fuji" (Peerless) films sell their products as rapidly as they can turn them out in their chemical-scarce plants. It is practically impossible to find a Japanese camera selling for less than 350 yen ($23) and German Leicas get 18,000 yen ($1,200).

Largely responsible for the inflated prices and the tremendous demand are the GI's of our Occupation Force, who almost without exception want to record photographically their stay in Japan and bid frantically against each other for the limited equipment available. Also Japanese amateurs— and there are many—long deprived of materials during the war years, are eager to get a share of the goods now on the market.

Now that several Japanese camera manufacturers are in production again with the permission of our military government, the shortage shows promise of easing. But the demand is so great that it will take years to satisfy it. For the most equitable distribution among our soldiers, all Japanese cameras being manufactured now are bought from the factories by the Tokyo Central Post Exchange and sold at near-cost to American and Allied troops.

First to get into postwar camera production was the Tokyo Optical Company, which manufactured binoculars, telescopes, lenses, and microscopes during the war. Like several other optical plants in the Tokyo area, this group of large gray buildings was spared in the fire bomb raids which devastated huge sections of the Capital. At present Tokyo Optical is turning out some 400 cameras a month which sell for $25 each. This camera, pictured on these pages, is known as the Minion and has a Toko lens with a 6 centimeter (slightly less than 3 inches) focal length. This *f*/3.5 Toko lens is not one of the better Japanese lenses, but the company expects, when reconversion is completed in several months, to manufacture a more expensive model of the Minion with a Simlar lens, copied from the English Cooke lens.

It is not at all unusual to find that Japanese cameras have been copied from designs of American, German, or English origin. In fact, that is the rule rather than the exception. Lack of originality is a mark of Japanese cameras. Scarcely an original feature has been incorporated in any camera of Japanese manufacture. Almost all of their lenses are copies of foreign formulas. The design of the overwhelming majority of their cameras is so strikingly like well-known American or German cam-

eras that it is difficult to distinguish them at a first glance as Japanese cameras. In operation they are inferior.

The Minion looks like any one of half a dozen popular American cameras. It takes 127 film, has an eye-level viewfinder, and an automatic exposure counting device that works so seldom that a window is provided in the back for making sure that the film has moved on to the next number. Made by Seikosha, a Tokyo watch manufacturer, the shutter has a self-timer, and speeds of 1/25, 1/50, 1/100, bulb and time exposures. Like almost all Japanese cameras the writing and numbers on the lens and camera are in English, but the distance scale is graduated in meters.

Japan's largest photographic firm, Konishi Rocu, Ltd., is at present manufacturing three cameras called the Pearl, Semi-Pearl, and Pearlette, ranging in price from $40 to $12. The Pearlette is a dead-ringer in appearance for the Jiffy Kodak; the others are closely modeled after larger American folding models.

Sometime this year Konishi Rocu expects to start assembling some of its pre-war models. Popular among Japanese amateurs and some newsmen is Konishi's prewar rather crude imitation of our Speed Graphic type press camera. The Japanese version uses film 4½ × 6¼ inches in size. By American standards the camera is extremely unversatile. It has no flash attachments and no built-in synchronizer. Its bellows are single, fixed extension and focusing is accomplished by the focusing mount in which the $f/4.5$ 18 cm. (7-in.) Hexar lens is mounted. To change lenses requires removing four screws which hold the lens board in place, an operation that would take a fast man with a screw driver a full five minutes—not to mention the time required to put on the new lens. If a longer lens is used, some type of barrel extension is necessary since the camera bellows is of fixed length.

Holders, designed for glass plates, are placed on the camera by removing the groundglass back after focusing—another time-consuming operation. There is no rangefinder.

Only redeeming features of this box-like camera are its light weight of five pounds, and its rubberized focal plane shutter which is designed to permit winding the shutter to the selected speed without danger of fogging the film, since the shutter curtain remains closed until the shutter is tripped. Besides "time" and "bulb," the shutter has eight speeds from 1/10 to 1/100 second which are selected by two knobs on the camera's side as on a Speed Graphic.

The Hexar lens used is one of the most widely sold in Japan. It is designed from a Zeiss formula and manufactured by Konishi Rocu.

Another pre-war model in demand by amateurs and professionals in Japan before and during the war and today is the view camera made in a variety

 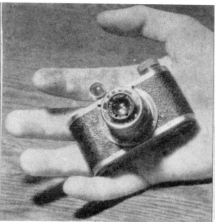

Model 99 aerial camera is unusual. Spring tension automatically transports roll of 120-size film for 10 exposures.

Small enough to be held in a man's hand, this midget uses 35-mm film. Lens is unsharp, precludes big enlargements.

Here are four lenses of Japanese manufacture. Largest is 50-cm Hexar for aerial cameras. Only 50 were ever made.

of sizes by several photographic firms. Japanese genius for delicate and detailed woodworking finds expression in the sturdy and finely finished wooden framework of these cameras. However, most Japanese view cameras lack the tilts and swings of those of American manufacture. Like the one shown with this article, Japanese view cameras generally have triple extension bellows, an easily removed lensboard, and a rising and falling front.

Principal users of the view camera in Japan these days are the itinerant photographers who now are making a better living than usual taking pictures of GIs near shrines and other Japanese landmarks. There are at least six such photographers with view cameras taking pictures every day at the outer grounds of the Emperor's Palace—of American soldiers and sailors with the bridges and moat of the Palace grounds as backdrop.

A craze for midget cameras seems to have struck Japanese camera fans, judging by the number of small models around the country. Some are even smaller than the one shown in the palm of a man's hand. This particular pint-sized model takes a negative slightly less than one inch square on 35-mm film. Other miniature Japanese cameras take two exposures on a normal 35 mm frame. The lens of the one pictured is a 40 mm $f/4.5$ Picner Anastigmat and the shutter speeds are 1/25, 1/50, and 1/100 second and bulb exposure. Like most Japanese midget models, the lens used is not sharp enough for the small negative to permit the necessary enlarging without extreme loss of detail.

In production before and during the war were several imitations of the German Leica and Contax called the Leotax, the Cannon, and several other names. Principal manufacturer was Seiki Kogaku (kogaku is the Japanese word for Optical Company). Except for the lenses used, the cameras were ingenious imitations. Best lens used in these cameras was modeled after the Elmar lens and called the Nikkor. Rated at $f/2.5$, this lens was manufactured by Nippon Kogaku in Tokyo where most camera and optical plants are located. In pre-war days these Japanese imitations sold for about 150 American dollars. When produced again the price will probably be higher in Japan's inflated economy.

At least one Japanese photographic firm plans

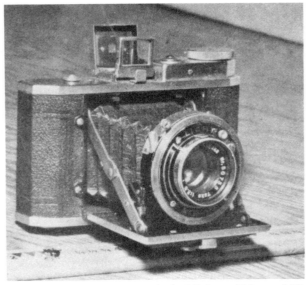

First postwar Japanese camera is the Minion, which uses 127 rollfilm. Its automatic exposure shutter seldom works. The camera sells for $25 and is inferior in quality to American-made products that sell in this price bracket.

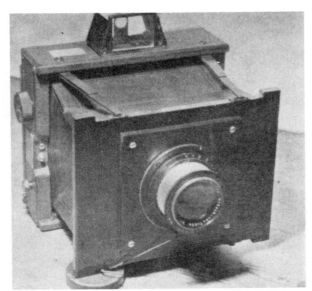

Crude imitation of the American Speed Graphic is this widely-used Japanese camera made before and during the war. Four screws must be removed to change lensboards; bellows is fixed; if longer lens is used, barrel extension is necessary.

334

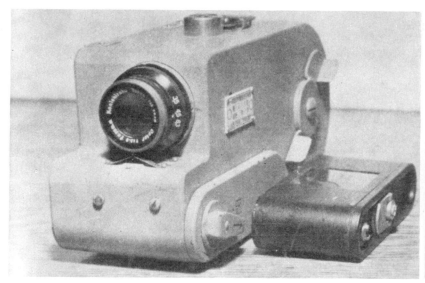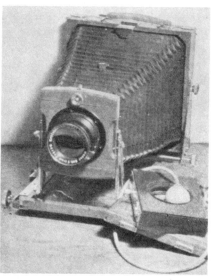

Japanese gun camera is synchronized with plane's machine gun. Leica-type cartridge allows 50 pictures to be made on a 35-mm roll. In the Japanese armed forces, only the air corps had a variety of equipment.

Excellent woodworking is a feature of this unversatile view camera which has no swings or tilts but has a rising front.

to manufacture a camera in which the film plane rather than the lens moves in focusing. Several pre-war reflex type cameras, modeled closely after German reflex cameras but vastly inferior, including the popular-in-Japan Shinkoflex, will be in production again before the end of the year.

But as has always been the case, most serious Japanese photographers prefer cameras of foreign manufacture to the imitations of their own country. It is a conservative estimate that fully 85 per cent of Japan's professional photographers, particularly press photographers, use American or German cameras. The market for cameras and other photographic material in Japan when exporting to that country again becomes feasible, will surely be enormous.

In many respects, Japanese photographic growth is some 10 years behind times. Although lenses of binoculars and telescopes were coated during the war, not a single Japanese camera or lens manufacturer has yet started coating camera lenses. Glass plates are still widely used in press and view cameras of Japanese make. Almost no high-speed films have been developed. Gaslight paper is manufactured and sold in large quantities, and all Japanese photographic papers lack the

tones and latitude of American papers. No exposure meters have been produced in the country. Flash powder is still used by many photographers there. Development in use and processing of color film has been equally behind time.

Reason for this backwardness is not only the expected civilian shortages of photographic material during the war which retarded civilian progress, but is largely due to the fact that the Japanese Army, with few exceptions, did nothing to encourage development in the photographic field until very late in the war. As a result photography in Japan has been at a near standstill. Not until the closing months of the war did the Japanese Army fully realize the importance of photography in warfare. Until then all photographic manufacture, with the exception of aerial cameras, and all photographic experimentation and activity, was relegated to a place of secondary importance.

Four months before the atomic bomb brought the war to a sudden close, the 9th Japanese Technical Laboratory was established high in the Japanese "Alps" near unbombed Matsumoto; one of the purposes of the lab was to design photographic equipment to meet the needs of the Army ground forces.

335

Work of the lab never advanced beyond the paper stage. Major Bon, head of the photographic section, had detailed plans for proposed cameras and equipment. Among the projected cameras was an underwater model designed to record the results of the efforts of a "Kamikaze" Corps then in training to repel the expected American landings. This suicide group dressed in diving garb and placed at strategic underwater points at the time of the invasion were to blow up the invaders and most likely, themselves. How they intended to save the cameras and pictures from being blown up with the underwater photographers was an unsolved enigma when the war ended.

There was no counterpart in the Japanese Army to the Photographic Section of our Army's Signal Corps. When a Japanese army unit wanted pictures taken of a captured piece of equipment, of a visiting general, or of the boys enjoying a "saki" party, it was up to the unit to find a soldier in the outfit with a camera to take the pictures. Compact field darkroom sets were provided higher echelons for processing film, but cameras and photographers were each unit's responsibility. The soldier-photographer chosen was usually a non-commissioned officer with civilian photographic experience. His job as unit photographer was secondary to whatever his original job in the outfit might be. The camera he used would be one that he had brought along with him from civilian life.

Combat photography was left to Japanese newspaper and newsreel photographers who more or less successfully covered the war for the home front. Several Japanese war photographers were killed recording the war. At least one crew of Japanese combat cameramen made sure they were not killed. They took the precaution of shooting pictures from such a distance from their subject that a bullet would have had a hard time reaching them. To make doubly sure that bullets could not reach them, they only took pictures when there was no shooting.

Sent out by the Asahi (Rising Sun) Newspapers of Japan's second largest city, Osaka, this fearless crew was armed with a specially designed, wholly impractical, "combat" camera. The camera's focal length was 42 inches, or well over three feet. A cow 500 feet away would almost fill a 4×5 negative using a lens of this focal length.

Bulky, awkward to handle, and weighing 130 pounds, the camera requires a three man crew to operate effectively. It uses 9×12 cm. film. Length of the camera from its lens to its "Graflex" type back is just under four feet. Ground specially for this camera by Nippon Kogaku, the lens has a speed of $f/4.5$.

Any American newspaper would have fired cameramen who brought back "combat" pictures like the Asahi photographers took in Burma and Yunnan Province in China early in 1943. Setting up their mammoth camera on a hill overlooking a likely bit of terrain, these Japanese photographers took unexciting pictures of bridges, railroad trestles, and cows grazing. Abandoned trucks on the Burma road were the closest to combat pictures that the crew attempted.

The bulky combat camera was designed for the newspaper for war photography in 1941 by Sentario Uno, Japanese camera engineer, who accompanied it on its first and only combat mission. Except for the Burma-China trip the camera was not again used during the war. Asahi photographers explained that the terrain was unsuitable for use of an extremely long lens camera.

Now the newspaper is considering it to photograph sports events. But no one on the staff seems eager to be among the crew that lugs this oversize camera anywhere.

Two exceptions to the lethargy of the Japanese Army regarding photography were the Field Artillery and the Air Corps. Considerable infrared work was done by the Japanese Field Artillery Corps. But only the Air Corps had a rather impressive variety of cameras and equipment.

Smallest and most unusual Japanese aerial camera was their Model 99 Miniature Aerial Camera which takes 10 exposures on an ordinary roll of 120 film. "Model 99" weighs just over three pounds, its longest dimension is less than eight inches, and, as shown in the picture, is easily held by handles on either side. Most remarkable feature of the camera is its automatic film transport. A small crank on the bottom winds a metal spring inside. Pressing a release with the forefinger of the right hand trips the shutter and immediately advances the film automatically for the next exposure. Ten exposures can be made as quickly as the photographer can trip the shutter ten times. A single winding of the spring is sufficient for a roll of film.

There are three shutter speeds: 1/100, 1/200, and 1/400 second. A variety of Japanese lenses were used on the camera, all of three inch focal length and fixed focus. Extra backs were provided which, loaded with film ahead of time, could be quickly placed on the camera as they were needed.

This camera would be useful for peacetime ground photography as well as aerial photography if it were equipped with a focusing mount for the lens. Its double-exposure-proof, quick operating automatic features, and light compactness would be valuable for photographing fast-breaking action. For instance, a series of pictures of a fullback bucking the line for a touchdown could be snapped off from the start of the play to the time the fullback dived over for the score. Even the fastest photographers with the usual press cameras would have difficulty getting two pictures in sequence of quick action such as that.

Most widely used of the hand held aerial cameras was a model studiously copied from a Fairchild design used by our Army Air Corps. The camera takes 20 exposures $2\frac{3}{4} \times 3\frac{3}{4}$ inches on a special roll of film. Focal plane shutter speeds are from $1/75$ to $1/400$ second. The shutter is cocked and the film transported for the next exposure by twisting the right handle, pressing a release with the thumb, and the shutter with the forefinger. Most of these cameras were equipped with an $f/4.5$ Hexar, but in some instance a lens of German manufacture was used. One of the best performing of Japanese aerial cameras, its focal length is 15 centimeters (about six inches).

For larger planes, the Japanese used mounted aerial cameras with lenses up to 75 centimeters (30 inches) in focal length, and complete with electric heating units for high-altitude flying, electric motors for automatically advancing the film at set intervals, and other refinements. Wide use was made in fighter planes of machine gun spotting cameras which recorded the hits and misses of the fighter pilot's guns. Synchronized with the machine guns' firing, most of these cameras used ordinary 35-mm film cartridges and took 50 pictures on a roll.

When the Japanese surrendered, most photographers hid their cameras, fearing that the American troops would steal them. Contrary to the Japanese propaganda, the Americans, rather than stealing their cameras, offered them fabulous prices for them.

Press photographers are enjoying new-found freedom of movement under the American Occupation. Never before permitted to take pictures of the Emperor except by special arrangement, hordes of Japanese photographers now follow Hirohito around on his every excursion. One group of photographers from Japan's largest picture agency, Sun Photo, even spent a Sunday in the Imperial Palace photographing the Emperor's day—a previously unheard-of privilege.

Japanese amateurs are anxiously awaiting larger supplies of film and equipment after the lean war years. Amateurs and professionals alike, long deprived of free exchange of photographic information, are eager to learn of the latest developments. One English-speaking Japanese amateur naively asked a Signal Corps photographer if he would please relate to him "all the advancements in photography in the United States in the past 10 years," as if expecting that such an account could be given in full in about an hour.

When the time comes that defeated Japan is again permitted to enjoy the benefits of world trade, a vast market for photographic goods of all sorts will be open to American exporters. Japanese photographers recognize the superiority of our photographic products over theirs and are anxiously awaiting the opportunity to purchase American cameras and equipment.

Nadar

H.M. Kinzer

This two-thousandth birthday of the City of Light is a good time for photographers everywhere to salute Paris, home town of Daguerre and Niepce, inventors of photography, and of one Gaspard Felix Tournachon, medical student, novelist, artist, journalist, and balloonist, who, midway in the 19th century, changed his name to Nadar and thereafter wrote it indelibly upon the scrolls of photographic history as one of the great portrait photographers of all time.

The wonderful portraits reproduced from original prints on the following pages will leave no doubts on that score. He was a genuine master of the camera, who revealed the character of his famous sitters with unerring insight. The men and women who came before his slow lens were completely relaxed and at ease.

"Nadar has never been surpassed," says Horst, from whose private collection these portraits were selected. "He understood the medium of photography better than anyone ever has. His approach was amazingly direct. He resorted to no tricks, and his concentration on the subject was fantastic. You never notice the background of a Nadar portrait. What you do notice is the living presence of the person who is presented to you with the utmost realism."

Nadar was a pioneer of the first water. A true trail blazer, he not only excelled in portraiture with cumbersome camera and collodion wet-plate paraphernalia a dozen years after Daguerre published his invention, but took to the air with all that stuff and became the world's first aerial photographer ten years later. This was, indeed, no timid man. As the winds blew over the chimney

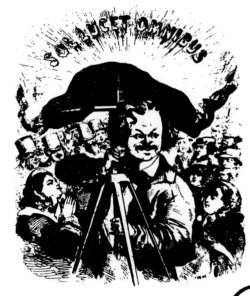

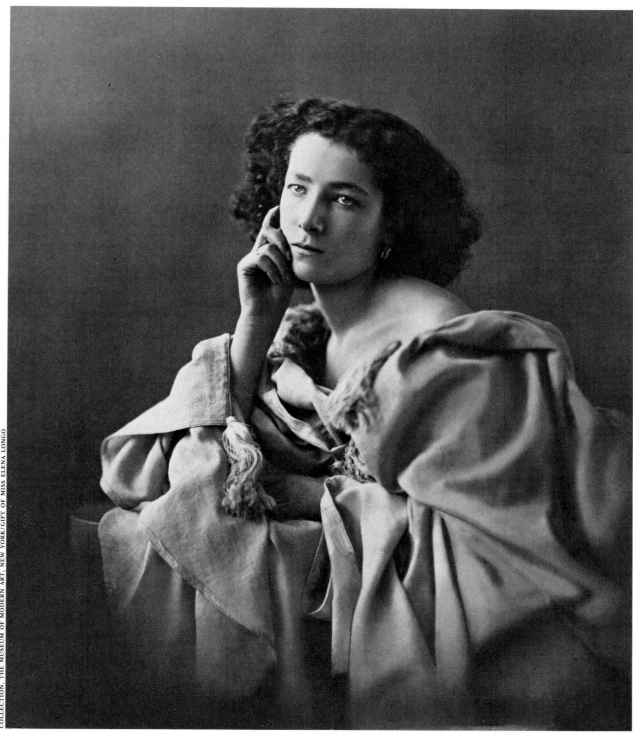

SARAH BERNHARDT

NADAR

pots of Paris, Nadar struggled to prepare his plates. And although adversity pursued him relentlessly, he succeeded in photographing the Arc de Triomphe for the first time as the birds saw it.

This master of portraiture, who held that a good portrait study could not be made unless the photographer was closely acquainted with his subject, was a pioneer also in the use of artificial light. His pictures of the bonestrewn, skull-haunted Paris catacombs, made with primitive galvanic arc lights—the first electric illumination ever used in photography—remain macabre monuments to Nadar's rare originality and fruitful imagination.

He began his career as a medical student, but quit, as so many others have had to do, when the money ran out. Then he went into journalism, and adopted the pen-name of Nadar for his articles and drawings. It stayed with him, and he passed it on to his son. One day a friend mentioned photography to him; there was good money to be made in it, and the friend knew just where Nadar could get a complete outfit cheap. After days of debate with himself, he bought it, but for many months he was tortured by the idea that he was betraying art.

By the time he opened his Rue St. Lazare studio in Paris in 1853, Nadar had already been training himself in portraiture for three years. He was one of the earliest established professional photographers; before him, the only way to make a career out of Daguerre's invention had been to travel about the country with camera and darkroom in a wagon or in a hiker's pack, astonishing the peasants at rural fairs with the magic of photography.

Since Nadar held the conviction that a good portrait can only grow out of close friendship and understanding between photographer and model, it is fortunate for posterity that his circle of friends was broad, and drawn from the cream of European intellectual and political society. He knew the writers Balzac, Baudelaire, Gautier, George Sand, Hugo, Murger, Lamartine; the composers Wagner, Rossini, Meyerbeer; the artists Delacroix, Daumier, Courbet, Corôt, Doré; and political leaders like Kropotkin, Bakunin, and Leopold I of Belgium. The portraits he made of them proclaim the truth of his photographic philosophy and its importance to his work.

But Nadar did not work only with such notables. The quality of these portraits of writers and artists and politicians had attracted the attention of the aristocracy and the upper classes returned to power by the ferment in French society. They now began to clamor for sittings with this acknowledged master of the camera and it was they who made a financial success of Nadar's enterprise. His studies of them almost without exception, testify that he never abandoned his integrity, never permitted himself to do bad work. Because of its penetrating, thoroughly honest portrayal of its time, Nadar's work has been likened to Balzac's in the *Human Comedy.*

A tribute like this is even more meaningful in view of the technical difficulties under which Nadar had to labor. His wet collodion plates had to be painstakingly coated in the darkroom, one by one, carried to the camera for the exposure—sometimes several minutes long—and whisked back to the darkroom for processing. The modern photographer reflecting on all this is surprised that Nadar had time to think of anything but the mechanics of his craft.

Most fascinating and dramatic of his contributions to photography was his work with captive and free balloons. It was daring enough, ninety years ago, to leave the ground in one of the big gas-bags, but Nadar thought so little of the danger that he could devote all his attention to his photographic equipment—which, heaven knows, demanded plenty of attention in that day of collodion plates and albumen prints!

For a magazine published by his son in 1893, Nadar wrote a series of memoirs of his first experiments with aerial photography. Both balloonists and photographers were skeptical of his efforts to combine the camera and the gas-bag. But Nadar answered them repeatedly with "Nothing is so easy as what was done yesterday; nothing is so difficult as what will be done tomorrow."

His balloon basket was quickly convertible into a flying darkroom. A big orange-and-black tent, impermeable to light, was suspended from the rigging above, and a smoky safelight was mounted inside. "It was warm inside," recalled Nadar, "but our collodion plates didn't mind, submerged in their cool baths."

He had designed his own "guillotine" shutter, and used it with a big Dallmeyer lens mounted vertically on the side of the basket. To give the rig as much stability as possible, the anchor lines were made fast to the bag itself rather than to the basket. Nadar worked only on calm days, for his long exposures would have been ruined by the least motion.

Those early efforts would have tried the patience of a saint. Nadar made more than 20 ascensions and never got any more on his plates than a

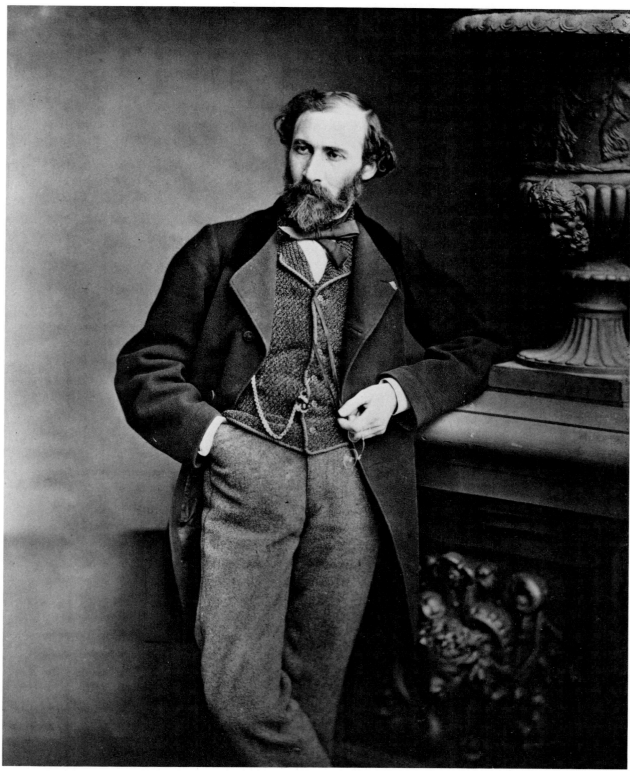

OCTAVE FEUILLET

hazy smudge—not even the suggestion of a photographic image. He felt, understandably, that he had a right to at least a dim blur, but—nothing!

Then one day, in the suburb of Petit Bicêtre, he had trouble with the balloon itself. He had filled it with hydrogen the night before, anticipating an early start in the morning. But overnight the temperature dropped sharply, contracting the gas and leaving the bag pitifully shriveled. Nadar, however, was determined to go aloft; he threw out of the basket all the ballast and everything else he could do without. The cumbersome tent was left behind: he would do his processing later on the ground. This done, the balloon struggled to rise, bounded up once or twice, and settled sadly back to earth. Only a few more pounds would do the trick. Modesty was sacrificed to science—Nadar removed all his clothes and jettisoned them. Success! The balloon rose, slowly but steadily, to a height of almost a hundred yards.

Nadar made his exposures as usual, and developed the plates in his room at the village hotel. It was a great day for photography. On the plates, at last, was a feeble, blurry image of the suburb! Now all that remained was to repeat the operation, correcting his technique as this first experiment dictated.

But wait—why had he been successful this time and not before? Feverishly he went back over his preparations to find the key, the secret. What he discovered was something so simple, so elementary, that Nadar almost refused to believe it could have made all the difference. In normal balloon operation, a small exhaust valve at the bottom of the bag is left open to allow for expansion of the gas at high altitudes under a warm sun. On that particular chilly morning, of course, there had been no question of letting any gas escape; Nadar had closed the valve. And for the first time his plates were free of the mischievous action of hydrogen! "Silver iodide and hydrogen sulfide," he reminded himself, "make a bad marriage which can bring forth no offspring." And so aerial photography was born.

Only a few years after these pioneer exploits, Nadar began looking for new worlds to conquer. He became interested in the theory of heavier-than-air flight, and before long he had written a book on the subject called *The Right to Fly.* It had a preface by another far-sighted author of the period, George Sand.

Convinced that the balloon's days were numbered by the theoretical advance of rigid aircraft, he devoted himself to the new cause. To raise money for the "Society for the Advancement of Heavier-than-Air Flight," he built a monster balloon, the *Giant,* with which he expected to tour Europe and draw attention to his views. It was to be a "balloon to end all balloons"—and here Nadar didn't know how close he came to speaking prophetically!

On its first ascension, Nadar flouted superstition by taking 13 passengers aloft. The second ascension, with nine people aboard including the balloon pioneer Montgolfier, ended in disaster. The *Giant* traveled from Paris, over Belgium and Holland, to a town near Hanover, Germany, in about 27 hours. There it ran into difficulties, complicated by disagreement among crew members. It descended, but winds bounced it along the Prussian countryside for more than 20 miles. Everyone aboard was injured, and Nadar himself broke a leg. He tells the whole story graphically in his book, *Memoirs of the Giant.*

Nadar lived long enough for the early experimental flying machines to justify the confidence he had had in them a generation earlier. Though firmly convinced by 1870 that the balloon was a thing of the past, he offered his services as commandant of the balloon corps which kept Paris in contact with the outside world during the Prussians' siege of that year.

Honoré Daumier, the celebrated caricaturist, was a close friend of Nadar, and his attitude toward both photography and aeronautics was probably typical of the average French citizen. He thought photography was dangerously encroaching on the artist's territory, and as for ballooning—it was just one more way to break one's neck! He made numerous lithographs ridiculing both activities, and the most famous is the one titled by Daumier, "Nadar Raising Photography to the Height of Art."

In 1880, at the age of 60, Nadar decided to retire from active commercial photography. He turned his studio over to his 24-year-old son Paul, who was even more enterprising than the old man. In short order, he established himself as a leading theatrical photographer, director of France's outstanding photographic magazine, and head of a large establishment for manufacturing and distributing photographic supplies for professionals and the rapidly-growing band of amateurs.

The pictures illustrating this article, unless otherwise credited, are from the collection purchased from Paul Nadar's widow by the well-known fash-

ion photographer Horst. The old lady still lives in Paul's studio, listed in the most recent Paris telephone directory as "Nadar P. photo portr. 48 r. Bassano (8e)," but no one carries on the tradition of the illustrious father and son.

Nadar *père* lived for thirty years after abandoning his career, long enough to watch a procession of lesser men try to match his genius at portraiture. But not long enough to see anyone succeed.

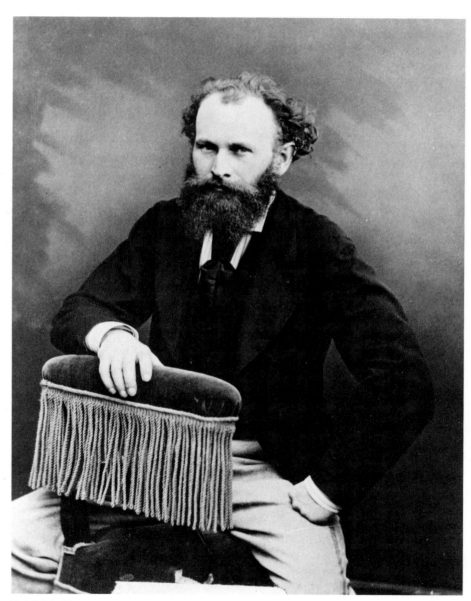

EDOUARD MANET NADAR

When Grandpa Had His Picture Taken

Don Nibbelink

*It was a brave man who faced the portrait
photographer and his paraphernalia without flinching*

Contemporary portrait photographers may think they have problems when faced with a wriggling moppet or an unphotogenic matron, but their trials are molehills compared with the mountainous difficulties besetting the shutterclickers of Grandpa's time. Not only did exposures run to nerve-wracking lengths—15 seconds to more than a minute for wet plates, 4 to 8 seconds for "high-speed" dry plates, introduced in 1880—but dark-room work involved a smelly kerosene-lantern safelight and deadly potassium cyanide in the fixer. Surviving the perils of fire, fumes, and poison, the photographer then had to sensitize his own printing paper and wait for a sunny day before he could produce the final picture.

But despite technical difficulties which would floor the coddled contemporary photographer, Grandpa did have his picture taken—and the results sometimes were as truthful, revealing, and sensitive as anything we get today. The masterpieces of Victorian photography already have been given due recognition; we devote these four pages to some of the lesser-known efforts of little-known men. Let's take a look at the portrait methods of photography's Dark Ages, and the story behind those faded, yellow pictures in the old family album.

The typical "picture-taking parlor" of the 80's bore slight resemblance to streamlined modern studios. The walls of the grand reception room

Group-posing stools were used in studios a century ago

Magnesium flash lamp made indoor snapshots possible

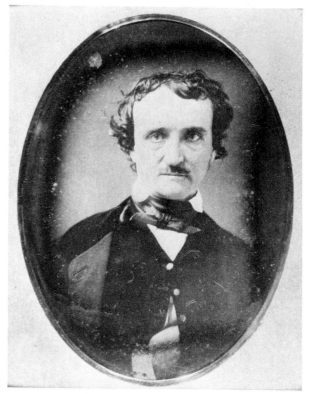

EDGAR ALLAN POE

STANDING MAN

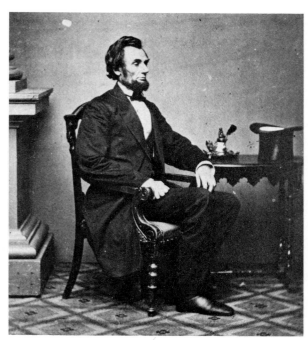

ABRAHAM LINCOLN

THEODORE ROOSEVELT AND SON

were thickly hung with elegant portraits in ornate frames, and the studio was crowded with an assortment of painted backgrounds, like a theater prop room. Overhead was the skylight, the only source of illumination in most studios before 1900.

Offhand, skylight pictures sound rather easy to make. Just seat the subject, focus the camera, and shoot. Actually, though, the skylight and its manipulation were fairly complicated. Some photographers built an extra shade on the roof to obscure the sun's rays. There were numerous and expensive side curtains operated by strings, pulleys, and screens that slid back and forth on wires. Sometimes the light was filtered through a ground-glass, sometimes through blue glass. Customers scolded because the light hurt their eyes or because there was a "white spot on top of the head" in the resulting picture. Of course, if it rained, shooting schedules were cancelled for the day. Articles telling how to predict the weather were popular, and the almanac was the photographer's best friend.

In Grandpa's time, emulsions were slow and cameras cumbersome. Action photography was a hobby for only a specialized few. Shutters were practically unheard of before the 1880's, because the lengthy wet-plate exposures were made simply by uncapping and recapping the lens.

These time exposures gave contemporary photographs a pronounced artificial appearance by smoothing out ripples in a lake or stream, by being taken when the foliage wasn't moving in the wind, and by necessitating a rock-steady pose for all animate subjects. In fact, early portrait photography was even harder for the sitter than for the photographer. People leaned against studio props such as imitation-marble columns, not because the photographer thought it improved the composition, but because it helped to keep the subject steady during the long exposures. Besides the inevitable pillar, one popular "piece" was an imitation piano costing $10.00 and weighing 10 pounds. "Immobilizers" (iron head rests) were another important item of studio equipment. Two schools of thought existed concerning them: one believed it best to place the head in position and then adapt the immobilizer to the head; the other placed the head rest in position and then forced the head into the rest. In either case, Grandpa probably preferred a trip to the dentist.

Most prints were contacts but a few were enlargements made on an enlarger known as a solar camera. The direct rays of the sun were needed as the light source. Consequently, the enlargers could be operated only under the most favorable weather conditions, which meant about six months a year. However, by 1876, solar cameras were improved so that twelve prints could be turned out daily. On a clear, long day and with an early start, a good operator might squeeze out as many as fifteen enlargements. These solar cameras were large and unwieldy, features which often were an advantage. The prints frequently were made outdoors on the studio rooftop, and the solidarity of the camera construction aided in preventing the machine from swaying in the wind. On a February visit to the large New York studio of Mora, a visitor observed "on the top of the roof the poor printers were flopping their arms about their bodies in order to keep their fingers warm."

Considering the value of money at that time, a rather high price was charged Grandpa for the privilege of squeezing his head into an iron rest and "bracing" for half a minute to have his features recorded. A dozen 8×10's cost about $20.00 while the 4×5½ cabinet size cost $3.50 for the first print and about $9.00 a dozen. Hand-colored 14×17's were priced as high as $100.00 apiece.

Today the iron head rests, the painted pastoral backgrounds, and the teakwood cameras are museum curiosities or dust collectors in some forgotten corner of the attic. To modern eyes they seem as quaint and outmoded as the moustache cup or the crossbow. But for all of photography's amazing technical advance since Grandpa's day, the basic ingredients of a good portrait remain unchanged. It is a tribute to those bygone photographers that they were able to make such good portraits with such limited equipment—and to Grandpa that he could survive the ordeal.

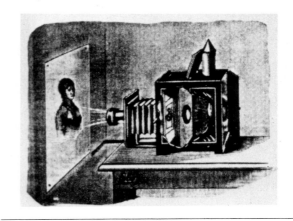

Landmark Cameras

Beaumont Newhall

During the past 125 years immense ingenuity has gone into the design of the photographer's indispensable tool—the camera. At first nothing more than two sliding boxes with a detachable plateholder, the camera gradually became more compact and flexible. Bellows replaced the boxes so that the camera could be folded up. As the speed of sensitive materials increased, shutters were needed which would slice seconds into exact fractions. Tighter construction was required to prevent light leaks. And with the introduction of fine-grain film and enlarging equipment, cameras had to be built with all the precision of a fine watch.

In addition to these technical demands, cameras had to keep pace with the vision of photographers. For quick operation, finders replaced the groundglass, or mirrors were fitted inside the camera to enable the photographer to see the exact image up to the instant of shooting. A mechanism to change glass plates in rapid succession or to transport film was required. Powerful lenses of large relative aperture but shallow depth of field made rapid yet precise focusing essential; the rangefinder was coupled to the lens.

From the camera collection of the George Eastman House, we have selected a few landmarks in this remarkable development. These cameras were all mass-produced—by the hundreds and by the thousands. In all of them are innovations which quickly became assimilated and imitated. Our survey begins in 1839 and ends with the outbreak of World War II, which marked the end of what may be called the classical era and the beginning of another—that of the automatic camera.

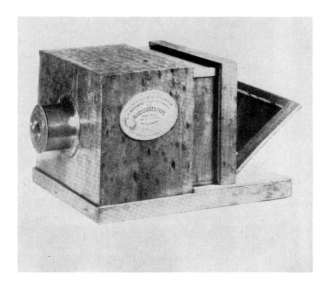

LANDMARK CAMERAS

Daguerreotype, 1839. The daguerreotype process was published on August 19, 1839; two days later cameras built to Daguerre's design by Alphonse Giroux were on sale in Paris, each with the label "No Apparatus Guaranteed If It Does Not Bear the Signature of M. Daguerre and the Seal of M. Giroux." The two telescoping boxes are bird's-eye mahogany veneer. Attached to groundglass at 45 degrees is a mirror, so image can be seen right side up. After focusing, the groundglass was replaced with a holder containing a 6½×8½-inch silvered copper plate, made light-sensitive with iodine fumes. The lens is an achromatic telescopic objective of 40-cm focal length with external diaphragm, working at effective aperture of f/17. There is no shutter, as exposures were minutes long. Development was with fumes of mercury.

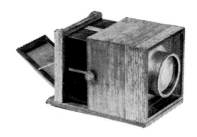

Plumbe, 1841. The daguerreotype process was introduced to America in September, 1840. At first photographers built their own cameras or used imported ones. In 1841 John Plumbe put on sale at his American Photographic Institute in Boston cameras patterned after Daguerre's original. This model is for quarter plates—3¼ × 4¼. Owner added focusing scale.

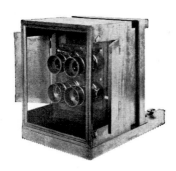

Lewis Daguerreotype, 1851. To make cameras compact, "for packing in transit or for traveling operators," W. & W.H. Lewis of New York invented the bellows in 1851. This model, for quarter plates, is fitted with a C.C. Harrison doublet lens of 15-cm length.

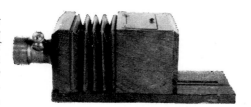

Carte-de-Visite, 1854. The French court photographer Adolphe André Eugène Disdéri patented in 1854 a new camera with four lenses and a double plate holder. With it he could take eight poses on one negative. The print was cut up and mounted on cards the size of visiting cards. This invention made portraits cheaper.

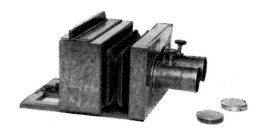

Pistolgraph, 1858. Pioneer miniature camera invented by T. Skaife, London. Lens, *f*/2.2. Shutter operated by rubber band. One-inch square plates were sensitized, developed in tank at left.

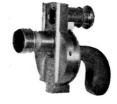

Scovill Stereo, about 1861. Stereoscopic photography became immensely popular just at the time of the Civil War. This camera, given to the George Eastman House by Graflex, Inc., was once owned by Mathew B. Brady. It was manufactured for the American Optical Co. by the Scovill Manufacturing Co. of New York. It takes wet plates 4 × 8 inches, and is fitted with C. C. Harrison lenses.

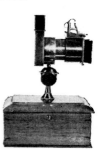

Revolver Photographique, 1862. Four exposures on one glass plate, 2⅞ in. diameter. Groundglass focusing by sliding lens to finder position. Remarkable forerunner of hand camera. Made by A. Briois, Paris.

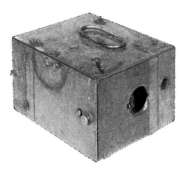

Schmid Detective, 1883. The invention of the dry plate in 1871 made hand cameras popular. The earliest American box, or "detective" camera was designed by a musician, William Schmid and manufactured by E.& H. T. Anthony & Co., who boasted: "it is only necessary to touch the button on the right side of the camera and the exposure of the plate is instantly made, its development being afterwards accomplished in the usual manner. Price complete, including camera, instantaneous lens and one double dry-plate holder for 3¼ × 4¼ plate, $55.

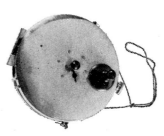

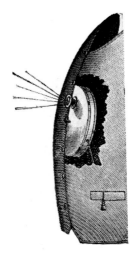

Concealed Vest, 1886. The rage to take photographs unawares led to the design of this camera to be worn under a vest, its 40-mm, *f*/11 lens poked through a buttonhole. Six exposures could be made on a glass plate of 5½ in. diameter by pulling string in pocket. The manufacturer claimed to have sold 15,-000 in three years.

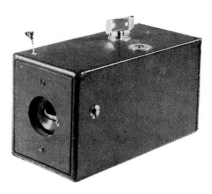

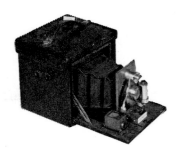

Kodak, 1888. George Eastman's first roll-film camera was factory loaded for 100 exposures, each of 2½-in. diameter. Fixed focus 57-mm. *f*/11 lens. Barrel shutter, fixed speed (about 1/20 sec); cocked by pulling string, released by pressing button. When film was used up, entire camera was sent to Rochester, where the American Film was developed, stripped from its paper base, and printed. Eastman's simplification of picture-taking and his photofinishing service brought photography to everyone. Cost, including processing, was $25. Fresh film, $10.

No. 4 Folding Kodak, 1890. "Advanced amateurs" found the original Kodak camera too simple; they wanted a camera with professional controls. George Eastman gave them what they wanted with the "Folding Kodak" cameras: the swings and tilts of a view camera combined with the convenience of a roll-film camera plus an ever-ready case. The No. 4 refers to the 4-by-5 inch picture format.

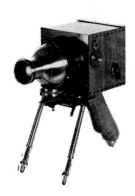

L'Escopette, 1889. A camera in which Eastman's Kodak roll film could be used was designed in Switzerland just one year after the Kodak camera was introduced. The new camera had a pistol grip plus two brass legs to hold it steady for time exposures. L'Escopette was manufactured by Boissanas of Geneva.

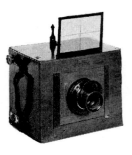

Goerz Anschütz, 1889. High-speed action can only be photographed with shutters that slice seconds into thousandths. Ottomar Anschutz of Poland designed such a shutter by putting inside the camera a slotted curtain. On pressing a button the slot passed the plate to make an exposure. In 1889 Goerz, famous for its lenses, marketed a hand camera fitted with this focal-plane shutter. For decades it was standard for European press cameramen.

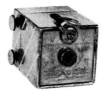

Kombi, 1893. A subminiature camera introduced at the 1893 World's Columbian Exposition, for 25 negatives, 28×28-mm, in interchangeable film magazines.

Bull's Eye, 1892. The prototype of all box cameras of fond memory, the Bull's Eye, invented by Samuel N. Turner of the Boston Camera Co., introduced the familiar red window in the back and film rolled up in black paper. George Eastman paid royalties for using these innovations in his Pocket Kodak until August 21, 1895, when he wrote his mother: "We bought Turner of the Bullseye Camera out last night for 35,000 payable 7,000 per yr for 5 yrs. This is less than his royalties . . . and we get control. . . ."

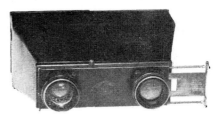

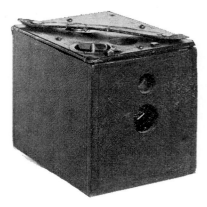

Photo Jumelle, 1892. "Jumelle" in French means binocular, and this camera is held like one. The left lens takes the picture; the right finds it. Inside are stacked 18 dry plates, which are changed by pulling and pushing a lever. Manufactured by Jules Carpentier in Paris to a precision unknown in the camera industry until then, the Photo Jumelle was designed to make negatives for subsequent enlargement, and thereby opened a new field.

349

Photorette, 1893. Loaded with a 2-inch circle of sheet film, the camera could be tucked in a watch pocket, ready for shooting six pictures, each 15-mm square. The Photorette was invented by W. K. L. Dickson, who invented for Edison his pioneer motion picture camera. It was patented by another motion picture inventor, Herman Casler of Syracuse, N.Y.

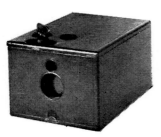

Pocket Kodak, 1895. The first small Kodak camera: size, 3⅞ ×2⅞ ×2¼ in. Eastman wrote his partner, H. A. Strong, in April, 1895: "We are making as a starter five batches of 5,000 each. . . . It is a daisy, and ought to be in every home." Designed by F. A. Brownell, it was fitted with a fixed-focus 65-mm, *f*/10 lens and a shutter cocked and released with the same button. Cost was a mere $5.

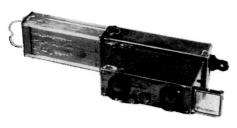

Verascope, 1896. Metal stereo cameras were introduced by the French. Typical is J. Richard's Verascope for 12 45×107-mm glass plates in a magazine. Richard exhibited 30×40-inch enlargements from single negatives.

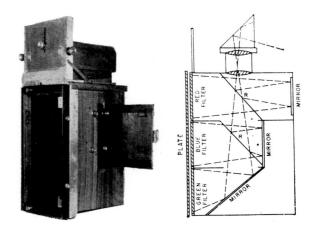

Chromographoscope, 1897. One of the earliest "one-shot" color cameras, built by Mackenstein from the designs of Louis Ducos du Hauron, who predicted both additive and subtractive color photography in 1869 and made successful color photographs in 1877. By an arrangement of thin transparent films (pellicles) and mirrors, three identical images were obtained. Against the focal plane were placed red, green and blue filters. With one exposure records of these primary colors were obtained on one negative. Ducos du Hauron made a glass positive from the negative; when he placed it in the focal plane with the color filters in place and the back open, he could see a brilliant color photograph by looking through the lens. Alternatively, he could make color prints from the three filtered color records by one of a variety of techniques.

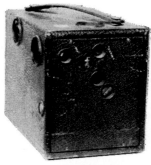

Cyclone, 1898. Before film became universal, great ingenuity was shown by camera makers in the design of mechanism to change plates rapidly. One of the most popular magazine cameras was the Cyclone. In the darkroom 12 4 ×5-inch glass plates were stacked in the back of the camera, against a spring. After exposure, a key was turned. The plate fell to the bottom, while a fresh plate was pushed into the focal plane. "Twelve Pictures in Twelve Seconds" was the motto of manufacturer, the Western Camera Mfg. Co., Chicago.

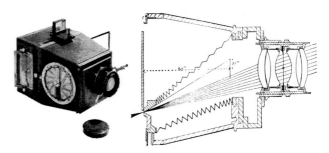

Sigriste, 1898. Specially designed for sport photography, the French-made Sigriste had a focal-plane shutter of unique design: an adjustable machined slot at the end of an internal bellows was driven past the focal plane: 100 combinations of tension and slot-width gave exposure speeds from 1/40 to 1/2,500 second. A table recommends minimum speeds for stopping such various subjects as grazing cows 36 ft distant, 1/25 sec; automobiles 18 ft away, 1/1,200 sec. For 9×12-cm plates in magazine, Krauss-Zeiss Planar 110-mm, *f*/3.6 lens in helical focusing mount. Eye-level finder with parallax adjustment.

Folding Pocket Kodak, 1898. Made of leather-covered aluminum for lightness, with a bellows for compactness, this camera took 12 3¼×2¼-inch negatives on roll film. To stand upright, collapsible strut was pulled out. The catalog pointed out: "It can readily be carried on the bicycle."

Twin-Lens Artist's Camera; 1899. A pioneer twin-lens reflex camera, built by the London Stereoscopic Co., who boasted that it was "not a toy but an instrument of precision." The upper lens formed a full-size image on a groundglass shielded by a hood; the lower lens took the picture. Both were *f*/6.3 "Black Band" Euryscopes of identical focal length. A magazine held 24 3×4-inch sheet films or 12 glass plates. The shutter was focal-plane.

Premoette, 1903. The Rochester Optical Company introduced the film pack in 1903 for use in its Premoette. Compact (1⅜×3¼× 4⅝ in.), it took a 40-cent pack of 12 2¼×3¼-inch films. Camera shown is Premoette Junior, almost same as first model.

Graflex, 1902. The single-lens reflex, allowing the photographer to see the exact image up to the instant of exposure, was well known when William F. Folmer designed a greatly improved model, the Graflex, which became a classic. He improved the focal-plane shutter and linked the mechanism for moving the mirror to the shutter release, so that pressing one button was all that was required to make an exposure. The fast, 1/1,200-sec shutter made it ideal for sport photography. It was also favored

by pictorial photographers. Alfred Stieglitz wrote Folmer in 1905: "It is against my principles to give testimonials except on rare occasions—and this is to be one of those occasions, for I believe you have fully earned that distinction. Ever since the Graflex has been on the market I have used it for many purposes. At present I own a 5×7, 4×5, and a 3¼×4¼. . . . It is beyond my understanding how any serious photographer can get along without at least one."

Expo, 1904. Almost everybody used to carry a pocket watch, so handling a camera looking like one attracted little attention. Magnus Neil put the 25-mm *f*/16 lens in the stem of his Expo, and made its cap look like the winding knob. Film for 25 negatives was factory-loaded.

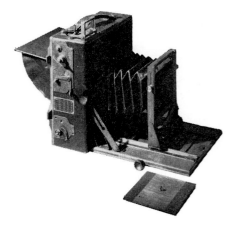

Vest Pocket Kodak, 1912. One of the most popular amateur cameras, the Vest Pocket Kodak was manufactured with slight variations up to 1936. All models used roll film for eight 1⅝×2-inch negatives. The original model was fitted with a 3-inch lens in an Autotime shutter, marked with light conditions instead of *f*-numbers to simplify exposure calculation. Cost of camera: $6: leather case, 75 cents. A fixed-focus enlarger for making postcard-size prints cost only $1.75.

Speed Graphic, 1912. For years the standard work horse of the press photographer, the Speed Graphic has remained almost unchanged since the first model, William F. Folmer's prototype of which, shown above, George Eastman House is proud to exhibit. The camera, sturdily built of mahogany covered with morocco leather, incorporated the already famous Graflex shutter. The Speed Graphic was supplied in three sizes: 4×5, 3½× 5 (postcard), and 5×7, with a choice of 15 lens focal lengths.

Tourist, 1913. First still 35-mm camera produced 750 negatives 18×24-mm on one loading of standard motion picture film. Designed and manufactured by Herbert & Huesgen, New York. Fitted with a 50-mm Bausch & Lomb Zeiss Tessar *f/3.5* lens and focal-plane shutter for speeds 1/40 to 1/1,200 sec. Almost unique to 35-mm cameras is the Tourist's rising front.

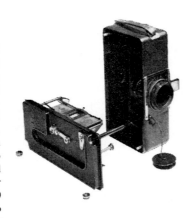

3-A Autographic Kodak, Special, 1917. Two features made this postcard-size camera special: a coupled rangefinder and the Autographic back, which enabled the photographer to write the title on the negative at time of exposure.

Sept, 1922. Spring-motor-powered hand camera for taking either motion pictures or 250 still pictures on standard 35-mm film. Berthiot *f/3.5* lens. Manufactured by André Debrie, Paris. The camera could be used for making prints.

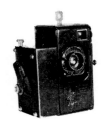

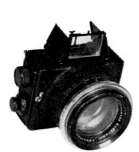

Ermanox, 1924. Designed for the remarkable *f/2* Erno-star 10-cm lens, the Ermanox made available-light photography possible on 6×9½-cm glass plates. This camera was made famous by pioneer Erich Salomon.

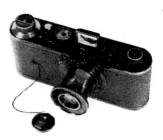

Leica, 1923. Of the many cameras designed specially to take still pictures on standard 35-mm motion picture film, the Leica, invented in 1912 by Oskar Barnack of the optical house of E. Leitz, Wetzlar, Germany, was the first to gain widespread acceptance. Although production models were not put on the market until 1925, thirty handmade prototypes were released for trial in 1923; they were numbered 100 to 130; this is No. 109. The basic Leica design is already evident in the body shape, lens (50-mm, *f/3.5* Leitz Anastigmat), focal-plane shutter, double-frame (24×36-mm) format, and metal film cassette.

Rolleiflex, 1929. The twin-lens reflex camera was revived by Franke and Heidecke of Brunswick, Germany, in their Rolleiflex, an adaptation of their roll-film stereo camera. At first No. 117 roll film for six 2¼ × 2¼-inch negatives was used, but the camera was soon adapted for 12-exposure No. 120 rolls. This model has *f/3.8* lens.

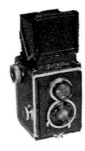

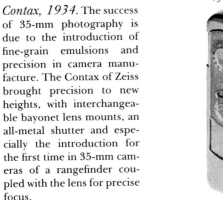

Minox, 1937. A precision-built subminiature camera, originally made in Riga, Latvia, for 50 8×11-mm negatives on 9.5-mm film in cassettes. The lens is 15-mm, *f/3.5*.

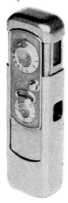

Contax, 1934. The success of 35-mm photography is due to the introduction of fine-grain emulsions and precision in camera manufacture. The Contax of Zeiss brought precision to new heights, with interchangeable bayonet lens mounts, an all-metal shutter and especially the introduction for the first time in 35-mm cameras of a rangefinder coupled with the lens for precise focus.

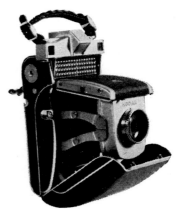

Super Kodak Six-20, 1938. The first commercially produced automatic camera and herald of a new age in camera design. A built-in photoelectric cell generated power from the light shining on it to actuate an indexing mechanism to select the aperture for a proper exposure at any preselected shutter speed from 1/25 to 1/1,200 sec. For speeds longer than 1/25 sec diaphragm was manual.

A Photographer's Corner of "America's Attic"

Kenneth Poli

*The Smithsonian Institution's Hall of Photography—
an 8000-square-foot showcase*

The scene is an exact reconstruction of the first Kodak printing room, the time the 1880s. The 'ladies' are mannequins and the exhibit is a part of the Smithsonian Institution's new 8,000-sq.-ft. Hall of Photography, open to the public on April 6, 1973.

"America's Attic," as the Institution has on occasion been called, has long provided major exhibit space for many areas of American culture and technology. But photography, housed in the Smithsonian's National Museum of History and Technology, has, prior to the opening of the new space, been limited to a fourth or a fifth of what it will enjoy after April.

The expanded space will make the new Hall of Photography, along with the International Museum of Photography at George Eastman House, one of the two largest photo museums in the country. And I would speculate that, because of its location in the nation's capitol, it will draw more visitors than any other photo museum. (The National Museum of History and Technology, which houses the Hall of Photography, has some seven million visitors a year. A percentage of them will visit the Hall of Photography. But only the photographic faithful make the pilgrimage to Rochester, in upstate New York).

According to Eugene Ostroff, Curator of Photography at the Smithsonian, the new hall will pre-sent an appropriately broad view of its vast subject.

There will be a print gallery with shows that change about three times a year. In keeping with its plans to show not only historical but contemporary aspects of photography, the Hall's opening print exhibit, "New Images, 1839–1973," will show prints made by several basic processes, including daguerreotypy, with examples of work contemporary with the invention of the process alongside images made by photographers currently using the old processes.

The print gallery will have about the same format as the former area allotted for that purpose. But the remainder of the space is arranged around a number of "visual centers," as Ostroff calls them. These will include units, in period settings, devoted to the tintype photographer, the pioneer-explorer photographer, the parlor stereoscope, the wet-plate photographer, the early Broadway studio, the first photojournalistic photography, the handling of pictures from the earliest Kodak, and many others.

Also included will be a reconstruction of a *nickelodeon* (early movie theater) where the visitors will be able to see clips from movies that made grandma's eyes pop. Especially interesting is a representation of the first photographic laboratory—that of William Henry Fox Talbot, who pio-

neered successful negative/positive photography and laid the base for the process as we know it today.

At both the tintype setting and the Fox Talbot laboratory there will be live demonstrations so that visitors get a feeling of "how it was." An "itinerant" tintype photographer with a (stuffed) pony, standing in front of a setting of the period, will allow visitors to put their children in the pony's saddle and will make a picture of the child for on-the-spot delivery. Nominal charges are planned merely to cover costs.

To encourage visitor participation and understanding, there is an arcade with devices visitors can operate. Among these will be one of the take-your-own-photo booths that delivers a group of do-it-yourself portraits a couple of minutes after you have grimaced in front of a mirror within its curtained posing booth.

There's also to be a *mutoscope,* (an early movie device) that once flourished in penny arcades and amusement centers. It displayed, at the hand-turn of a crank (and the insertion of a penny) a brief sequence of rapidly flipped prints made from sequential motion-picture frames. These illustrated many simple types of human activity that, in the early days of cinematography, had the gee-whiz quotient of moonshot TV pictures in the 70s. The sequence I saw at the Smithsonian merely showed a mail truck being loaded. But no one felt gypped

when he paid a penny to see relatively unsizzling action like this when mutoscopes were young. *Any* action was an eye-bulger. Current-day descendants of these machines still find a home in proliferating, pornographic "peep shows" that infest many cities—their coin-op requirements increased on the order of 25 times or more, and the stimulation quotient of the on-screen activity increased accordingly.

One of the period settings that will not include live participants or demonstrations will depict a corner of an old-fashioned photo studio with painted-wall back-drop, posing chair, headrest, and all. Visitors will be able to use this area to take pictures of one another in a really authentic old-timey setting.

Signs will provide exposure information slanted for users of simple camera gear, both in this installation and others throughout the Hall. Flash exposures will be permitted.

Ostroff has been nothing if not assiduous in his pursuit of authenticity in checking and planning the appearance of the exhibits. For instance, the Fox Talbot "bottle room" (his laboratory ca. 1835, so called by his family because of its glassware contents) involved a personal visit by Ostroff to Lacock Abbey. He took photos of the original room, made measurements and, with a contour gauge, even profiled the molding around walls and ceiling so that it might be authentically du-

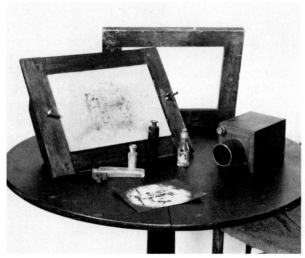

Relics from a reconstruction of Talbot's photo lab include printing frame, chemical bottles, and calotype.

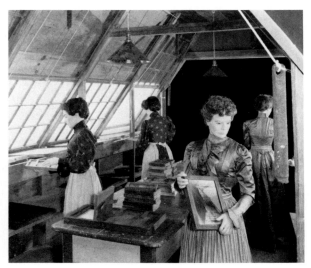

Women lab technicians, working in an early printing room, exposed sensitized paper to sunlight.

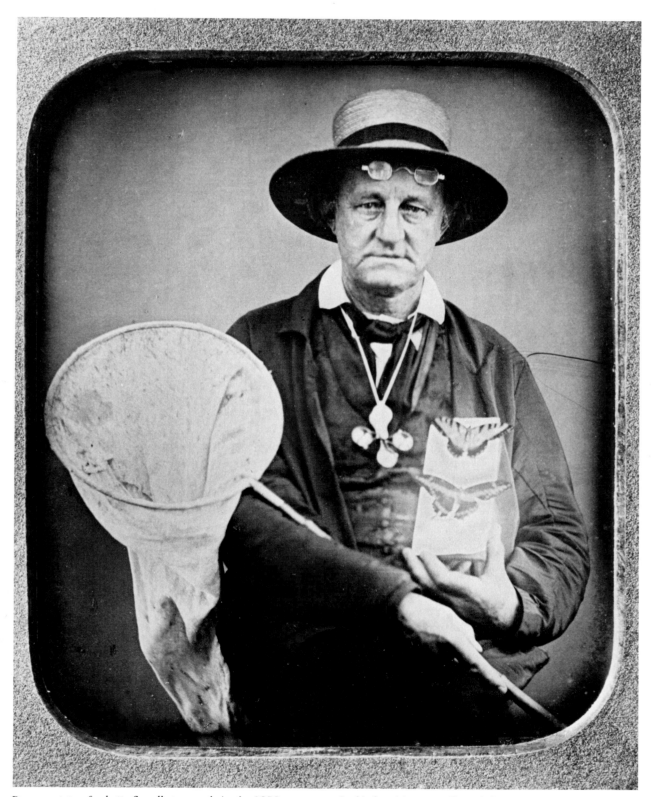

Daguerreotype of a butterfly collector, made in the 1850s, was one-of-a-kind positive on a silver-clad copper plate.

plicated. A final touch of verisimilitude will be provided by a painting of the scene that Fox Talbot actually saw and photographed from his laboratory window. It will be positioned "outside" the window in the room and seen through it.

One of the more eye-catching individual equipment pieces to be displayed elsewhere in the Hall is a large *solar camera*—actually one of the first photographic enlargers. It used the sun as a light source, since the camera (enlarger) predated sources of intense artificial light. Its lens was pointed at the sun, the negative image was projected onto paper pinned to an easel inside the camera, and the exposure was made by lifting trap door which permitted the light from the lens to reach the paper. The exposure was made on printing-out paper, and the photographer watched the progress of the print through a little peep-hole in the side of the apparatus. When the image was "done," he capped the lens (or closed the trap door), removed the print and took it downstairs to the darkroom to fix, tone, and wash the image.

Another major exhibit unit in the new Hall of Photography shows Roger Fenton, a British pioneer war photographer who "covered" the Crimean War. Fenton developed his own photo wagon from which to produce his pictures, and the Smithsonian's craftspersons have reproduced it with great fidelity, backed by the research of Ostroff and other of the museum's experts in various areas of history.

Fenton's van was reconstructed from a photograph of its exterior and the photographer's own description of its interior. And when it came to costuming the soldiers whom Fenton will be seen photographing next to his wagon, other museum experts had to be called in to point out what was or was not authentic to the time, place, and milieu.

Photography is a wildly versatile medium—used in more and more ways each year. It will be impossible, even for the Smithsonian to cover all of its many applications. But that won't prohibit their giving it the old Institution try.

Planned are exhibit units, whether major or minor, in such areas as the history of sensitized materials (both films and papers), history of exposure calculation, history of enlarging, panoramic photography, microphotography, documentary photography—and dozens more—60 different units in all.

Most of these displays will be permanent, but several are designed to be changeable so that they can be kept up with innovations in photography.

Will there be rivalry between the Smithsonian's new Hall of Photography and the International Museum at George Eastman House? Ostroff foresees none. As a matter of fact, he says, "Eastman House and other museums have been very cooperative in helping us get the information and material together however necessary. And I think a . . . very firm spirit of cooperation exists between museums in trying to do the same or similar presentations, or presentations in the same field. I don't feel we're duplicating what Eastman House has already presented. I feel that our approach is really quite different from their approach. They have their own philosophy on museumology, if you want to term it that. I don't feel that there is any conflict.

"I feel there can't be, at this time, too many exhibits devoted to photography, whether it be a gallery presentation or contemporary print displays, or three-dimensional exhibits, or the history of photography, or a combination of them.

"The recent proliferation of photograph collections throughout the United States augurs well for the field. If another museum were getting started on the history of photography, I'd be only too delighted to lend our cooperation to assist such a facility."

Because the print show installations at the Smithsonian's new Hall are rather elaborate and geared for long-term (around three months) exhibitions, such shows are not expected to be circulated to museums in other cities. Nor will the Institution offer to sell prints from the work of an individual photographer whose work may be on exhibit.

"But if anyone wants to know where a particular photographer can be contacted for purchase of his material, we would furnish him information," says Ostroff.

In preparation, but not yet in print during my visit to the new premises, was an impressive catalog that is planned as something of an expansion rather than a recapitulation of what the visitor will see in the galleries.

"Our catalog is not going to be a two-dimensional walk-through of the exhibit area. It will be a treatment of the history of photography. It will be illustrated by our period settings as well as by our key objects from our collection . . . it will be a publication that someone who doesn't know anything about the history of photography can acquire and have documentation of this and some

reference to the area surrounding it," Ostroff said.

Visitors whose curiosity is piqued by what they experience in the exhibits will find a reading list in the catalog that can refer them to books that can tell them more about general and specific areas of photography. What's more, a letter or telephone call to the museum, Ostroff promised, will bring additional information and suggestions for further research.

And for serious research, in the mysterious, quiet corridors and storage rooms of the cellar of the National Museum of History and Technology are stored many of the Hall of Photography's treasures that are as yet not able to be displayed. These include many one-of-a-kind U. S. Patent

Office models of photographic devices going back just about as far as photography itself. Also there are many individual pieces of photo equipment purchased by or given to the Museum for eventual use, display, and research work.

Of the latter, Eugene Ostroff says, "Indeed, that's the purpose of our collection. . . . It will be worked over by students and writers and technical people in the field of photography. We want the collection to be used."

Bona fide students and researchers can have access to the items of the collection by appointment. And for a nominal charge a researcher can have items of interest to him in the collection photographed, and prints supplied.

An important part of the Smithsonian's (or, at

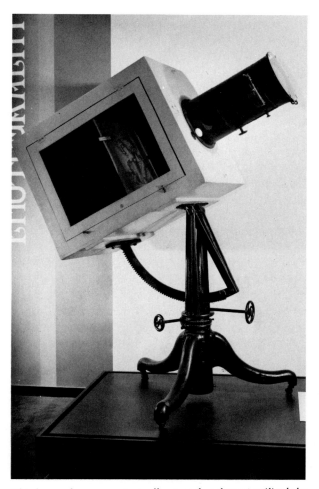

This huge solar camera (actually an early enlarger) utilized the sun as a light source.

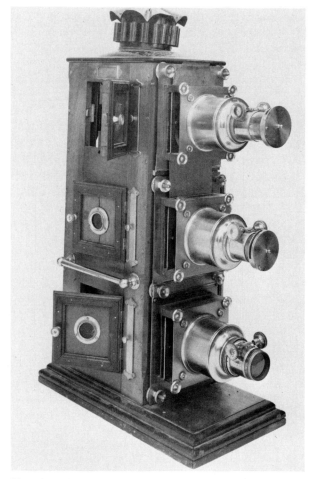

Three-lensed magic lantern, or "dissolving" stereopticon, was used for presenting slide shows in the 1890s.

least, its Curator of Photography's) philosophy is the involvement of the casual visitor in the exhibits and collections.

"The interest here is in visitor participation," says Ostroff, about his new area. "We're trying to reach visitors who basically don't have an understanding of what goes on in the camera, or what goes on between the time they click the shutter and they get the transparency or print." So, in this bright, big new corner of the august Smithsonian Institution there is something for all photographers—from casual snapshooter to scholarly antiquarian. Demonstration, participation, reference material, scarce equipment to see and study: they're all there and waiting for you in "America's Attic."

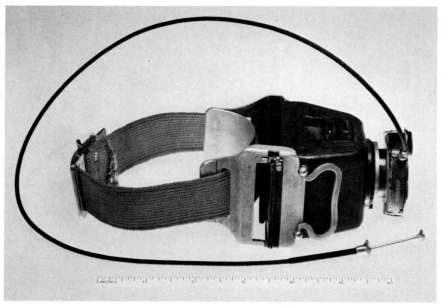

A German plate camera was used by New York Daily News photographer to make a picture of the 1928 execution of Ruth Snyder in the electric chair at Sing Sing Prison. Camera was strapped to the photographer's ankle.

ILLUSTRATIONS FROM SMITHSONIAN'S HISTORY OF PHOTOGRAPHY COLLECTION

Those Oldtime "Traveling Artists"

Eaton S. Lothrop, Jr.

From the 1850's on, almost every community of any consequence had its resident photographer. In the early days he was called "daguerreotypist", "ambrotypist", or "ferrotypist", depending upon the process he used to photograph the residents.

While the more prosperous establishments advertised locally (or even nationally) and had their photographic mats, cases, and/or mounts marked with their names, many of the more marginal operators could not afford such indulgences. So, it is more difficult for researchers and historians to learn anything of this latter group.

Even more ephemeral are traces of the itinerant photographers of the 1800's, people who toured the towns and villages too small to support a resident "photographist" and who visited these locations only long enough to exhaust the supply of potential customers, then moved on to the next likely place.

These "traveling artists" operated in varying ways. Some would travel by train, coach, or their own buggy and, upon reaching a prospective town, would seek out rooms to rent which had suitable illumination and in which they would set up their equipment.

Others (still using public transportation or their own wagon) also had a tent, or some other sort of portable studio. This they would set up in a likely location to carry on their profession. A third category of itinerant photographer included those who outfitted a large wagon, or even railroad car, with windows and usually a skylight, and used that vehicle itself as their studio (and usually living quarters, too).

The first type of traveling photographer, whatever process he used, is the most difficult to find information about. There are, though, some sources of documentation on them. One fairly early tintype, in the collection of America Hurrah, a New York City antique shop, shows a building in the background in one part of which is apparently housed the itinerant's studio. Out front of the rooms are a framed display of the photographer's work and a sign, laterally reversed as in most tintypes, stating that it is the photographer's last week in town.

Some years ago I was fortunate enough to acquire an almost complete daguerreotypist's outfit. I found it in a small New England town, still in the trunk where the photographer must have put it in 1853, since some of the equipment was still intertwined with pieces of 1853 newspapers. Prominent among the items was a heavy cloth (almost canvas) sign, the letters painted on it, which measures 29×54 in. and which reads B. F. JOHNSON'S DAGUERRIAN ROOMS. In the corners of this sign are holes, which must have been produced when the photographer nailed it up outside his temporary quarters.

Most informative about this type of itinerant operation, though, are the words of such a photographer, himself. In his early career, James F. Ryder, a prominent professional of the late 1800's, was a traveling daguerreotypist. In his autobiography, *Voigtlander and I*, he describes his visit to one place. "There was no hotel in the village. There was a main street and a cross street, a store and post office, a grist mill and sawmill, driven by a passing stream. . . . The prominent lady of the place, whose husband was merchant

and postmaster, welcomed me to her home and permitted me to use her parlor, the finest in the village, in which to make my sittings, rent free. My sleeping room, the best in the house, and board, cost me two dollars per week. My little frame of specimen pictures was hung upon the picket fence beside the gate. When my camera was set up, the clip headrest screwed to the back of a chair, and background and reflecting screens tacked upon frames, I was ready for business. I used the open front door for my light. I could ask for nothing better."

Of the portable, temporary studio or tent, carried in a buggy or wagon and set up for business at a suitable location, we have a bit more information at hand. In his autobiography, *The Life and Travels of John W. Bear, "The Buckeye Blacksmith"*, Bear writes of his daguerreotyping in 1848, "The greatest difficulty I had to encounter . . . was the want of a suitable room with the right kind of light to make good pictures with . . . I knew what kind of light I required to do good work with, and this light I could not get in country towns. There being a little Yankee in me, I set to work to build me a house adapted exactly to the business, with a large, splendid sky-light, made so that I could, by taking off a few screws, take it all apart in small compartments and load it on a car or big wagon and move it to any place I might wish to, where, with the aid of two men, in three hours I could put it up, ready for work." Bear, incidentally, operated with this portable studio through the beginning of 1854.

Most photographic operators looking for collapsibility/portability in their studios, though, seem to have chosen tents over the years. Among the card or paper-envelope mounted tintypes in my collection are some marked "Boston Picture Tent", "Boston Tent Gallery", and "The Algonquin Bon Ton Tent". (A "bon-ton" tintype ranged in size from about 2¼ × 3¼ in. to 2½ × 2½ in.) Two paper tintype envelopes illustrate "The Algonquin Bon Ton Tent" and the "Excelsior Bon-Ton Tin-Type Tent", each of these illustrations showing display frames out front of the tent, exhibiting samples of the photographer's work.

Of the third type of itinerant's studio, the movable studio/wagon or railroad car, we know even more. Advertising material and card mounts have survived in moderate quantity and there are more literary references in existence, including advertisements of traveling "saloons" (wagons) for

sale. (As late as 1890, the *American Amateur Photographer,* for August, carries the notice, "For Sale— Photo Car, first class. Good chance for beginner. E.O. Tuttle, Brookfield, Mass.")

Some photographs of such wagons are still to be found. Indeed, one actual wagon even survived in New Hampshire from around the 1870's to the present day. In 1970 the wagon was bought and moved to Rochester, New York, where it is now on display in restored condition in the International Museum of Photography at George Eastman House. An article by Richard Fullerton in Vol. II, No. 3 of *The Photographic Collectors' Newsletter* (November, 1970) assembled considerable information on such studios.

Card mounts and labels tell us of "Shields' Photograph Car", E.A. Bonine's "Portable Photographic Gallery", J.K. Bottorf's "Mammoth Car," and J.H. Robbins & Co.'s "Mammoth Traveling Daguerrean Saloon", and some, such as the "Portable Picture Palace, Keene, N.H." and W.T. & J.S. McEwen's "Excelsior Photographic Car, Lewiston, Pa." show us that some of the photographers had temporary roots. Early photographs of Gray, Me. (a postcard and a stereo card) show the traveling wagon of Mr. Gooding, who apparently had an annual "route" which included many towns too small to support a resident photographer. Gooding's wagon and those, shown in other photographs, of "Fletcher's Art Studio", the "Portable Art Gallery", etc. have the common elements of a long wagon on wheels, a skylight, steps leading up to the studio, and the all-important samples displayed outside in frames.

The December 16, 1871 issue of *Harper's Weekly* carried a sketch by Thomas Worth titled "The Traveling Photographer in the Country" which, though probably a fictitious composite, shows all the salient features of its factual counterparts.

Last, and largest, were the photographic railroad cars—some specially built and others merely modified—"Lehigh Valley Railroad Photograph Car No. 52", "Hutchings & Crum Photograph Car", "Union Pacific Railroad Photograph Car", and "Parson's Palace Car Photograph Company" railroad car, for example. Some of the photographers operated these for the railroad, while others owned them and had arrangements with the railroad, wherein they would take whatever "company" pictures the railroad desired, in exchange for the railroad's towing the car from location to location and the loan of an unused siding while the photographer was in town.

The February, 1898 issue of *The Photogram* reported, "A studio on wheels is not by any means a novelty, but a novel and improved form of such studio has recently been manufactured by the car-making shops of the Baltimore and Ohio Railroad. The car is sixty feet long by ten feet wide . . ." This particular car, however, wasn't really a studio, merely a darkroom/living facility, though I suppose one could also consider the whole thing a form of camera stand, as a trap door in the roof permitted carrying a big camera to the top of the car, for the purpose of taking views.

As things turned out, the increasing popularity of photography and improvements in transportation led to the decline of the traveling photographer and his studio. The public turned more and more to taking their own pictures and those who didn't live in a community which had a photographer found trains and trolleys could take them to one.

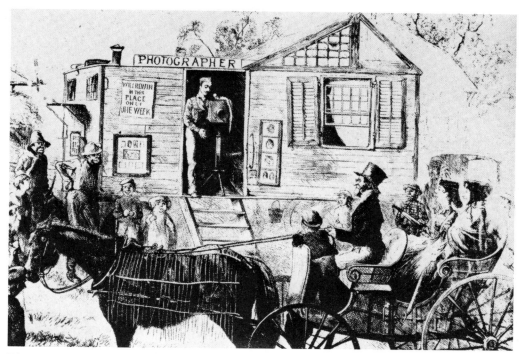

Thomas Worth's sketch "The Traveling Photographer in The Country," from *Harper's Weekly* for Dec. 16, 1871, shows a traveling photographic "saloon" with samples hung outside.

ICP: Photography's Fabulous New Center

Harvey V. Fondiller

*It's a home for multifaceted activities and a dream
come true for Cornell Capa*

At an opening preview of New York's International Center of Photography, November 14, 1974, a giant arc searchlight beamed at the imposing facade of a Fifth Avenue mansion. Celebrities poured into the marble halls—an elite assemblage of photographers, critics, and personalities renowned in society and finance. An event of the first magnitude in the world of photography, it was Cornell Capa's moment of triumph—for his "impossible dream," dimly perceived a generation before, had become a reality.

Visitors saw two exhibitions that emphasized the photojournalistic approach and a third exhibition by masters of color photography:

Apropos USSR (1954 and 1973)—the world premiere of an exhibit of photographs of the Soviet Union by Henri Cartier-Bresson. The 60 black-and-white photographs, ranging in size from 16×20 to 40×60, were printed in Paris under the personal supervision of Cartier-Bresson.

Classics of Documentary Photography: Werner Bischof, Robert Capa, David Seymour ("Chim"), Lewis W. Hine, Roman Vishniac, and Dan Weiner—80 black-and-white prints, from 11×14 to 20×30, printed under the supervision of Cornell Capa.

The Eye of the Beholder—a group exhibition of 25 large color prints by 21 photographers.

The Center's opening also marked the publication of the first six titles in the ICP Library of Photography (Grossman/Viking Press)—monographs on the six photographers in "Classics of Documentary Photography."

Educational programs at the Center began October 2. A "Directions and Perspectives" lecture series included two 10-week courses: "Photographers," moderated by Capa, and "As Others See Us: Designers, Editors, Publishers, Critics," moderated by Arthur Goldsmith, Editorial Director of *Popular Photography.* Five "Vision and Craft" workshops (for students of photography and related disciplines) included courses on subjects ranging from design to editorial layout. A series of weekend classes, each of which convened for 16 hours on two weekends, offered students an opportunity to learn by first-hand contact with distinguished photographers.

The new center is located in the former Audubon House, built in 1914 as the residence of Willard Straight. Situated at 1130 Fifth Ave., on the northeast corner of 94th St., it is in one of Manhattan's prime residential areas. The red-brick building, designed by Delano & Aldrich, cost $200,000 to construct. Sixty years later, an equal sum was required for renovations.

With 20,000 sq. ft. of floor space, the building has two elevators, two dumbwaiters, two massive safes, and all the accoutrements required by gra-

cious living with servants in the pre-World War I period. Its refined elegance and the 14-ft. ceilings of the first and second floors provide an impressive ambience for exhibitions.

In the basement (below which is a sub-basement) are a black-and-white darkroom, color lab, print-finishing room, and a space that will eventually serve as a lounge. The rest of the building has been remodeled to include the following:

First floor—20×40-ft. exhibition gallery, bookshop;

Second floor—two galleries (20×30 ft. and 20×40 ft.) and library/lecture room;

Third floor—two seminar rooms, accommodating 15 and 20 students, workrooms;

Fourth floor—Director's office, administrative offices, workrooms;

Fifth floor—workrooms, storage;

Penthouse—interior space and two patios, with serving pantry, for special events.

We asked Capa: *What does it take to establish a center of photography?* He answered: *Three things: A conviction that there is a need. A group of people who believe in you. Twenty years' effort.*

A personal tragedy marked the beginning of Capa's two-decade effort. In May, 1954, two great photographers died at opposite sides of the globe: his brother, Robert Capa, stepped on a mine in Indochina; and a close friend, Werner Bischof, plunged to his death in the Peruvian Andes. Two years later, another friend and colleague, David Seymour ("Chim") was killed while on assignment at Suez.

In 1958—as a memorial to his brother and to "Chim"—Cornell Capa, his mother, and Chim's sister, Mrs. Eileen Shneiderman, established the Robert Capa-David Seymour Photographic Foundation in Israel. Its objectives were "to promote the understanding and appreciation of photography as a medium for revealing the human condition," and to foster international cooperation by means of photography.

In the years that followed, two other friends and colleagues of Cornell Capa died while on assignment: Dan Weiner in 1959, and Vytas Valaitis in 1966. In that year, Capa established the Capa-Bischof-Seymour Photographic Memorial Fund in New York. Co-founded with Rosellina Bischof Burri (Bischof's widow), the Fund was established to encourage and assist photographers of all ages and nationalities who were vitally concerned with their world and times. The Fund sponsored a book and exhibit on Valaitis, traveling exhibits of

Cornell Capa, founder of the International Center of Photography, is a noted photojournalist.

The Center occupies a neo-Georgian mansion at 94th Street and Fifth Avenue in New York City.

363

Robert Capa and David Seymour; and three English-language monographs (on Capa, Seymour, and André Kertész) that were published in Czechoslovakia and distributed by Grossman Publishers in New York.

On the 10th anniversary of Chim's death, Capa prepared an exhibition of his friend's work—but could find no gallery in New York that would hang it. (In 1966, only The Museum of Modern Art and two small galleries presented photography shows.) But Capa received an offer from the Israel Museum in Jerusalem, and on November 8, 1966 —two days before the prints were to be shipped there—a memorial evening was scheduled in a back room at Compo, the firm that printed and mounted the exhibition. Many friends and acquaintances came—among them a man whom Capa had met six months before.

At that time, while on jury duty, he made the acquaintance of Frank Horch, a former photographer. After discussing the state of free-lance photography, Capa mentioned that he was looking for a gallery in which to mount a show. Horch said that his sister, Oriole Farb, director of the Riverside Museum, might be interested.

At the memorial evening for Chim, Horch came with his wife, photographer Nancy Sirkis. The next day, Ms. Farb came to see the show. She was impressed but dubious about the suitability of the show for her gallery.

"We haven't had a photography show for 30 years," she said. (The last one had been a retrospective of Lewis W. Hine.) "But," she added, "we might be interested if the show were thematic rather than a one-man exhibition."

Capa pondered that statement for a month, then went with his wife to their perennial vacation spot, Yelapa, a fishing village near Puerto Vallarta, Mexico. The only approach is by boat. Halfway there, Capa suddenly yelled, "Eureka—I've got it!" He explained to his wife: "We've talked about the tradition of documentary photographers and their humanistic approach, but we've never defined the tradition. To me, it's their concern for mankind." Thus was born the phrase, *Concerned Photography*.

Which photographers should be included in the exhibition? Robert Capa, Chim, Bischof . . . and also Dan Weiner . . . an old master, André Kertész . . . and a young photographer named Leonard Freed, who would represent the unrecognized generation. Here was a thematic show; it would be called "The Concerned Photographer."

When Capa returned to New York, his concept

HARVEY V. FONDILLER

ICP's opening was a gala event that drew overflow crowds for two evenings. Guests included Jacqueline Onassis (center).

was approved by the Riverside Museum, and he began to plan the exhibition. "There were only six problems," he remembers. "I didn't realize what it took to make a show."

When not involved in the intricate details of mounting a major exhibition, Capa did photographic assignments. He flew to Israel—his first visit—for *Life,* photographed a Jordanian refugee camp, and did various other picture-taking jobs. And he made a fateful decision: he changed the name of the foundation to The International Fund for Concerned Photography.

The opening of "The Concerned Photographer" October 1, 1967, was a major milestone in the history of photographic exhibitions. Under the headline, "Six Witnesses to History," Richard F. Shepard wrote in *The New York Times:* "History is hanging on the walls of the Riverside Museum, where more than 400 photographs exhibit the concern of six photographers with the imperfect world they were called upon to chronicle."

The exhibit was seen by 30,000 people in three months. Expenses, however, far exceeded the budget, and Capa decided to offer original prints for sale. Evidently it was an idea whose time had come; visitors purchased $5,000 in prints, and paid up to $165 for a signed Kertész.

There was another significant offshoot of the "Concerned Photographer" show. One of the participants, Leonard Freed, had commented: "Suddenly I feel I belong to a tradition." The remark seemed to exemplify a recognition of the tradition of photographers going to the world's lonely, or dangerous, or far-off places and recording with their cameras—for today, tomorrow, and forever—what they saw and what their cameras recorded. Many photographers have lived in this tradition, and some have died for it—those who were not afraid to look at life without a rose-colored filter, nor use their eyes and hearts and lenses to show clearly the way things were.

Capa produced five more shows for the Riverside Museum before it closed in 1969. Meanwhile, another link was forged in the chain of events that eventually led to the establishment of his "impossible dream"—an international center of photography. In 1968, Karl Katz, newly appointed director of the Jewish Museum, decided to mount a show dealing with the social and political development of Israel. Realizing that photography excelled as a medium for communicating this type of change, he contacted Capa and asked him to direct an exhibit on the subject. Capa decided on a novel approach to a thematic show; it consisted

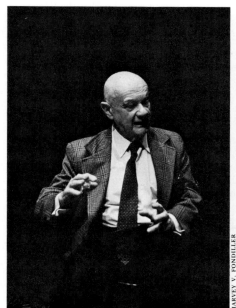

Dr. Roman Vishniac, microbiologist / photographer, presents an evening lecture.

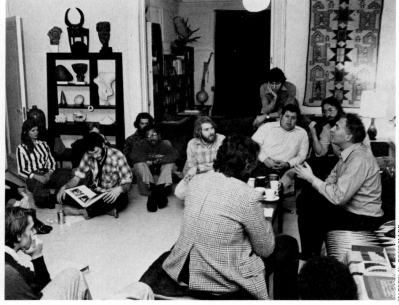

Ernst Haas, world-famed photographer, conducts workshop in his home for a group of ICP students. Weekend workshops have become very popular.

mainly of self-contained photo essays by individual photographers as well as general collections on specific themes and events. The exhibition, "Israel/The Reality," opened in 1969, went on a nationwide tour the following year, and was reinstalled at the Jewish Museum in 1971.

As a result, Katz became a believer in Capa's cause. With his aid, W. Eugene Smith received a grant through the Jewish Museum to make prints for a year. The grant led to a mammoth Smith retrospective, "Let Truth Be The Prejudice," which was shown at the Jewish Museum.

In 1971, at Katz' urging, Capa began a fund-

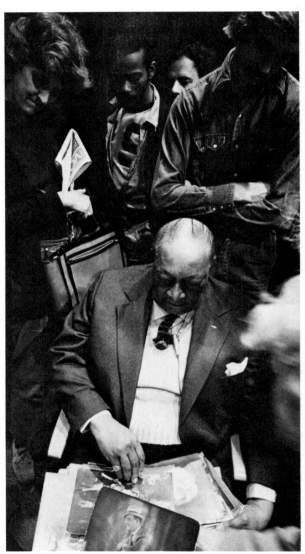

James Van Der Zee is among the scores of noted photographers who give guest lectures at ICP.

raising campaign for a permanent home for the Fund. "By this time," Capa recalls, I had a museum without walls, with exhibits, lectures, books, and slides. I never had to worry about paying any overhead—but there was just one problem: no money came in, except marginal royalties." Katz told him: "Cornell—you fracture yourself. Without a central place that everything emanates from, the Fund has no future."

All of Capa's fund-raising proposals had focused on renting the then-vacant Riverside Museum, but eventually it became evident that the museum's location was not favorable for night classes. By this time, additional people had joined the Fund's board of trustees, and Capa was authorized to find a new site.

In its solicitation of funds for a home of its own, the Fund could point to its achievements in the following areas:

Photographic education. The Concerned Photographer Lecture Series, presented in cooperation with the New York University School of Continuing Education; visiting photographers from 1969 to 1973 included Ansel Adams, Diane Arbus, Walker Evans, Robert Frank, Ernst Haas, Ken Heyman, and W. Eugene Smith. Also at N.Y.U. was a Seminar Critique Series, with guest speakers and discussion of student portfolios (1971–72); Master Classes, with Arthur Rothstein, Roman Vishniac, and Ruth Bernhard (1971–72); and Advanced Seminars with Arnold Skolnick, Herb Goro, and Bill Pierce (1972). The Fund also sponsored "The Concerns of Photography," a month-long workshop in cooperation with the Center of the Eye, in Aspen, Colorodo. (1970), and "Contemporary Trends in Photography," in collaboration with Columbia College, Chicago (lectures and special weekend workshops, 1972–73).

Publications. The Fund had published *The Concerned Photographer* (1968), *The Concerned Photographer 2* (1972), *Margin of Life,* a sociological/photographic study of poverty and population in Central America (1974), and *Images of Man,* the ICP-Scholastic Concerned Photographer program—an audio-visual series of filmstrips and cassettes utilizing the photographs and narration of William Albert Allard, Cornell Capa, Henri Cartier-Bresson, Bruce Davidson, Brian Lanker, Donald McCullin, Eliot Porter, W. Eugene Smith, and Roman Vishniac.

Exhibitions. The ICP Traveling Exhibitions Program had circulated many shows within the United States and in Canada, Europe, and Japan.

They included: "The Concerned Photographer," "Eyewitness: Czechoslovakia," "America in Crisis," "Israel/The Reality," "Let Truth Be the Prejudice," "Images of Concern," "The Concerns of Roman Vishniac," "Jerusalem: City of Mankind," and "The Concerned Photographer 2." Also circulated by ICP was "Behind the Great Wall of China," which had been originally exhibited at the Metropolitan Museum of Art.

Then came two years of what Capa recalls as "incredible disappointments and problems" as he searched for a suitable location, from SoHo to the upper east side of Manhattan. Finally he contacted a real estate agent, who told him: "Meet me at 94th and Fifth."

There, Capa inspected the neo-Georgian mansion that was known as Audubon House (it had been the headquarters of the National Audubon Society). He couldn't help but notice that the interior was a shambles and that pigeons were commuting through the open windows.

As Capa remembers it, his discussion with the agent went like this:

Capa: "What kind of white elephant is this? How does one get it?"

Agent: $1,400,000.

End of conversation.

In the months that followed, Capa became expert in the many factors involved in choosing a building—things like fire exits, floor loads, the advantages of a building being open (or not open) on weekends; sign-in/sign-out procedures, and all the reasons why a building is feasible for use as a museum, or not.

In January, 1974, Katz talked Capa into hiring an administrator for the museum that didn't exist. She was Ann Doherty, who had held a similar post at the Jewish Museum. Her office in the International Fund for Concerned Photography, Inc., was located at 275 Fifth Ave., New York, in the third-floor walk-up apartment of its executive director, Cornell Capa.

Fund-raising was stepped up after it was learned that the asking price of Audubon House had been reduced to the $400,000–$600,000 range. Meanwhile, Capa produced another exhibit, "Jerusalem: City of Mankind," which opened April 10, 1974—his birthday—at the Jewish Museum. Among those present was a representative of the owner of Audubon House. In due time, the latter, Ann Doherty, Henry Margolis (board chairman of the Center), and Howard Squadron (board secretary) met in an upstairs room. When they came down, half an hour later, Squadron told Capa: "I guess you have a birthday gift." The present was Audubon House.

What followed may well be a world record for the creation of a museum. (Granted, of course, that preparation is the secret of success, and that 20 years of preparation preceded these culminating events):

April 15—Contract for Audubon House is signed.

July 15—ICP takes possession of the building.

Arthur Rothstein—editor, author, and former FSA photographer—conducts class at the Center.

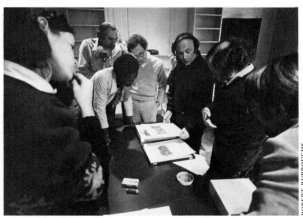

Bruce Davidson, winner of two Guggenheim fellowships, discusses book layout with his students.

Sept. 4—Building alterations commence.
Oct. 2—Educational programs begin.
Nov. 16—Public opening of ICP.

When the International Fund for Concerned Photography was incorporated in 1966, it had one full-time salaried employee and an annual budget of $25,000. Individual contributions totaled about $5,000 per year, and the New York Foundation made three annual grants of $5,000 each. In contrast, the International Center of Photography is a massive operation. Operating budget for the first year is $600,000, half of which is expected to come from self-generated income—i.e., admissions, publications, royalties, bookshop operations, and fees from commissioned exhibits. Seed grants have come from six foundations: Rockefeller Brothers, New York, Billy Rose, American Philanthropic, Matz, and Joe and Emily Lowe. Programs have been funded by the New York State Council on the Arts and the National Endowment for the Arts. The trustees have made gifts averaging $5,000 each. Two processing laboratories—Berkey/K&L and Modernage—have donated a demonstration color lab and a black-and-white instructional darkroom, respectively. Among camera manufacturers, Minolta has

pledged a $10,000 grant and Nikon has pledged $10,000 to partially support the current spring session of lectures. *Popular Photography* has established a Scholarship Fund for talented students in the workshop programs.

Thus far, five trustees of the International Fund for Concerned Photography have joined the board of trustees of The International Center of Photography, Inc., a nonprofit educational organization dedicated "to the appreciation of photography as the most important art/communication form of the 20th century with the capacity to provide images of man and his world that are both works of art and moments of history." The five are: Karl Katz, chairman of exhibitions and loans at the Metropolitan Museum of Art; Gyorgy Kepes, Professor of Visual Design at the Massachusetts Institute of Technology; Ellen Liman, painter and collector; Henry M. Margolis, industrialist; and attorney Howard Squadron. The other trustees are: David Finn, board chairman of Ruder & Finn, a public-relations firm; Thomas Hess, art critic of *New York* magazine; Rita Hillman; Beverly Karp; Jerry Mason, president of Ridge Press; Bess Myerson; advertising executive Frederic S. Papert; Nina Rosenwald; Lewis Salton;

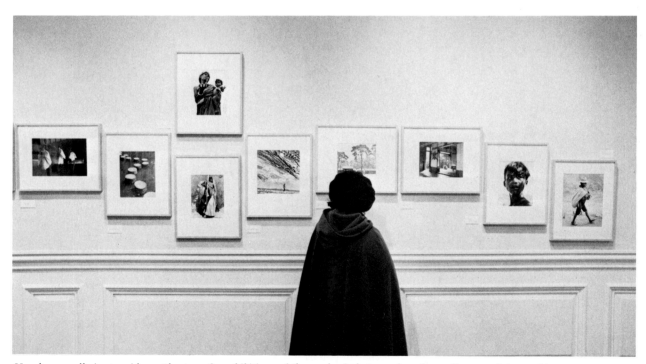

Handsome galleries provide ample space for exhibitions of the work of photographers from all parts of the world.

Susan Tepper; Edward M. M. Warburg, financier; and Lester Wunderman, advertising executive.

Membership ranges from General ($25) and Family ($40) to Supporting ($100), Sustaining ($500), and Contributing ($1,000). The rate for students and senior citizens is $15. General members are entitled to free admission, one free publication yearly, invitations to special Member Previews, and 15-percent discount on most of the merchandise in the bookshop. (The Center is open daily, except Monday, 11 A.M.–5 P.M.)

General admission to the Center is by voluntary contribution. These have ranged from pennies from children to $5 bills. Actually, memberships are not much of a profit-maker; it's only in the higher categories that the revenue mounts. In the first month, 300 charter members contributed $14,000; 31 for $100 or more, with four at $500 and two at $1,000 each.

The Center's staff includes Bhupendra Karia, associate director; Ann Doherty, administrator; Enid Winslow, coordinator of the traveling-exhibit program; and Pat Schoenfeld, bookshop manager. Assisting are 25 regular volunteers who help four or five hours per week, and 10 or 15 more who give less time. Also helping are six in-terns (from Finch College, Barnard, Staten Island Community College, and Marymount), who work four to six weeks full-time at the Center and receive academic credit from their colleges. Each student has rotating assignments in the bookshop, membership, and education departments, and—if needed—in curatorial capacities. Three interns are photography students who were recommended by their teachers.

About 10 groups of 10 to 40 visitors make special arrangements to visit the Center each week. Among the visitors in a recent week were groups from a suburban adult-education program, the School of Visual Arts, a parochial school, Rutgers University, Kingsborough Community College, Phoenix House, Photographic Federation of Long Island, Smithsonian Associates from Washington, and a class from the Rochester Institute of Technology.

For the Center's educational activities (in which 160 students enrolled during the opening semester), Capa assembled a teaching staff—all working professionals—that includes scores of famed names in the world of photography. They include the editorial director of the world's foremost photographic magazine; a two-time Guggenheim

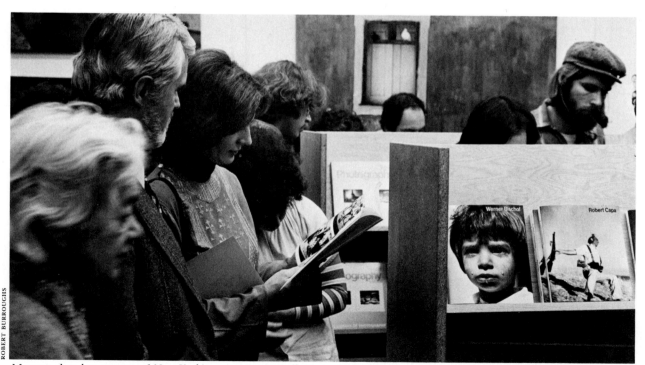

ROBERT BURROUGHS

Museum shop has one one of New York's most extensive collections of photographic books, prints, and posters.

369

award-winner; a world-famed innovator of micro-photographic techniques; the chairman of a university photography department; and experts on nature, underwater, multimedia, audio-visual, documentary, and color photography. The Center's photographic faculty is unmatched by any university in the world.

A "Photographers Advisory Council" includes Henri Cartier-Bresson, Carl Chiarenza, Bruce Davidson, Benedict J. Fernandez, Karl Gullers, Ernst Haas, Hiroshi Hamaya, Ken Heyman, Gordon Parks, Eliot Porter, George Rodger, Arthur Rothstein, W. Eugene Smith, Howard Sochurek, and Roman Vishniac.

Opening of the Center was greeted enthusiastically by the public, by photographers, and by the photographic industry. More than 10,000 visitors flocked to the Center during the first 10 days after its opening. Following are some reactions:

• Lawrence Fried, president of ASMP—The Society of Photographers in Communications: "Photographers will no longer be stepchildren of museums, for we now have a home of our own."

• Howard Chapnick, president of Black Star (picture agency): "It's an important contribution to the world of photography, as a center of education, and a place where people can exhibit. It adds tremendously to the prestige of photography, especially of journalistic photography."

• Norman C. Lipton, executive secretary, Photographic Manufacturers & Distributors Association: "This is one of the great developments that confirms the maturity of photography."

But of all the encomiums, Cornell Capa is proudest of the comment he received in a personal note from Henri Cartier-Bresson shortly after the Center opened: "The tremendous work you did reaches a huge and important public . . . the house on 94th Street is a sort of lighthouse."

The Leica's First 50 Years

Bob Schwalberg

Inanimate objects seldom engender revolutions. Some fundamental discoveries and inventions, like gravity and the wheel, were in themselves revolutionary. And so, all too frequently, are military weapons. But not cameras.

Inventions almost never appear as surprises. Aviation, atomic energy and, yes, photography were all widely anticipated. The only wager worth the game was who would get them first. And the Leica was neither the first miniature camera, nor even the first still-picture camera to use 35-mm motion-picture film for its images.

The Leica was the first truly successful miniature camera, the first to achieve widespread international popularity, the first to introduce technical concepts that revolutionized photography, from lens design to photochemistry. But one might as easily say that the strap watch revolutionized time by taking it out of the pocket and placing it on the wrist. The Leica did much more than this.

To reemploy two old and semiretired clichés, the Leica successfully pioneered the "small negative, big picture" concept, and offered the adventurous a handily compact "extension of the eye." The first altered and accelerated the whole course of phototechnical development; the second changed almost everything that was changeable in picture-making and the esthetics of photography. After the Leica, nothing was quite as it was before.

The Leica redefined the photographic experience by elevating the snapshot, that unplanned, instantaneous, sometimes "candid" exposure to an art form, perhaps photography's only art form. Of course, people like Eugene Atget produced remarkably revealing snapshots long before the Leica, and others, like August Sander, mirrored the magic of human personality long afterward, using basically similar large-format cameras.

But this little Leica, and the great school of small cameras that swam in the wake of its success, first made obvious the real uniqueness of photography. Not its incredibly detailed optical tracery, not the beautiful miracle of its silvery photochemical image, but the moment—this thin slice of frozen time, this irreversible, irretrievable moment of exposure.

It is this, and only this that can make a photograph different from any other picture made by any other means. It may show truth or falsehood, beauty or banality, it may be good or bad, but it is uniquely photographic. The moment is photography, and combined with its secondary technical attributes of brilliance, gradation, and sharpness, it provides the most powerfully compelling image of reality that man has ever possessed.

Thus, the Leica and the many miniatures that followed did something more than merely freeing photographers from the burdensome inconvenience of larger cameras. The generous film capacity—first 40, then 36 exposures—and the rapid working of a winding knob to retension the shutter, advance the film, and actuate the frame counter in but a single turning, encouraged the "photo notebook" concept of shooting around a subject, working and hoping for the best possible moment, composition or situation. Yes, and taking chances, playing for luck. Goethe wrote that luck comes only to those who have the courage to exploit it. Had he belonged to our times he might have added—and a Leica to record it.

This year, Leica is not celebrating its 50th birthday, but the semicentennial of its first public appearance, at the 1925 Leipzig Fair. Like any debutante, however, the lady was born considerably prior to her coming-out party.

This needs emphasis because it is most doubtful that many other inventions have ever enjoyed such a long period of fruitful gestation as the Leica camera. Most books and eminent Leicologists agree that Oskar Barnack produced his first prototype in either 1912 or 1914. Certainly, the inventor of the Leica had one or more prototypes in these years—working models with which he made many fine photographs—but the experts are wrong. As we shall see, Barnack had a 35-mm camera even earlier than this.

It is also almost universally stated that Barnack's invention of the Leica came as a kind of spin-off from his (largely unsuccessful) development of a professional motion-picture camera. More ex-

treme manifestations of this mythology hold that his camera was intended initially as a mechanism for testing the qualities of 35-mm movie films, and even that it was invented as a kind of exposure meter for use by motion-picture cameramen.

To this one can reply with the words of the Duke of Wellington, when greeted as "Mr. Smith, I believe!" Fixing his victim in the glare that was the despair of his age, that Iron Duke who never lost a battle (including his last, at Waterloo), said: "Sir, if you believe that, you'll believe anything."

The truth is a lot less complicated, and a lot more credible. Quite simply, Oskar Barnack was an ardent amateur photographer, and he invented the Leica because he wanted exactly what it was, a very compact, lightweight, precision camera.

Throughout his life, Oskar Barnack suffered from the painfully debilitating effects of bronchial asthma. Both from his love of nature and the outdoors, and always hoping to achieve good health,

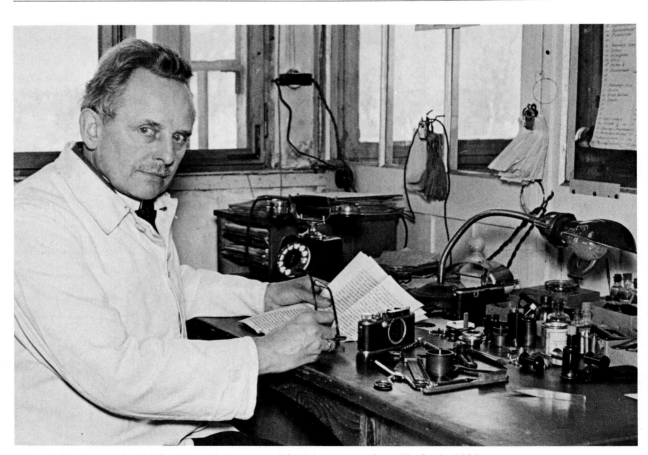

Julius Huisgen's portrait of Oskar Barnack, inventor of the Leica, was made at Wetzlar in 1935.

A Leitz family outing was photographed by Barnack in 1912 with a "Ur-Leica," an early prototype.

he was addicted to roaming the German forests and countryside, on foot. He desperately needed a lightweight camera.

Barnack was born on November 1, 1879, in Linow, Mark Brandenburg, but his family moved to Berlin/Lichterfelde soon thereafter. He graduated from the local technical high school, where he showed considerable mechanical and mathematical talent, and apprenticed himself to a Lichterfelde manufacturer of astronomical instruments. After some years as a journeyman precision machinist (Feinmechaniker), in three different locations, and some painful periods of illness, he joined the firm of Carl Zeiss, in Jena, where he was employed from 1902 well into 1910. Willi Erb, in his history of Leitz, states that he went to the Zeiss-owned Ica camera factory in Dresden in July, 1910, where he stayed two months as a design engineer.

Oskar Barnack joined Ernst Leitz, Wetzlar, on January 2, 1911, as a master machinist (Mechanikermeister), and head of a new experimental department. He died on January 16, 1936, in Bad Nauheim, a nearby Hessian spa. Throughout his 25 years of service to Leitz, everything possible was done to protect his health and to prolong his creativity. He enjoyed the special friendship and kindness of both Dr. Ernst Leitz I (1843–1920), and Dr. Ernst Leitz II (1871–1956), the grandfather and the father respectively, of the present Dr. Ernst Leitz III.

And now to the Zeiss connection. The following is a carefully translated passage from Friedrich Schomerus' history of the Carl Zeiss company:

"The appearance of the miniature camera 'Leica,' of the firm Ernst Leitz, Wetzlar, in 1925, was a specially important event in the recent history of photography. Normal perforated cine film

with a picture width of 24 mm is used in the 'Leica,' but not so that the picture has the normal, but instead double the cine format, that is, not 24 ×18, but 24×36 mm. The inventor is Oskar Barnack (born November 1, 1879, in Linow, Kreis Jüterbog, employed by Zeiss as a machinist from 1902 to 1910, later to Leitz, deceased January 1936). Barnack had offered a model of such a camera already before the war to General Director Mengel of Ica, who, however, didn't think much of it, and rejected it. The Leitz firm, on the contrary, recognized the future implications of the camera, which can be assumed to have been improved in the intervening time, and developed the type very intensively and happily, achieving a very great success.''

So much for poor old Mengel, and so much for the kino-evolutionary theory of Leica development. These very generous lines from Schomerus

show clearly that Oskar Barnack was working on a miniature still-picture camera for 35-mm motion-picture film, and indeed had such a camera ere he saw Wetzlar. His work on the famous aluminum movie camera began as an assigned task only after he joined Leitz, at the start of 1911.

We also know that in about 1905 Barnack modified a wooden 13×18-cm (5×7-in.) camera so as to make some 20 exposures, in several rows, on the same film. Thus, he didn't yet have the movie-film idea, but because working with any such repeating-back camera is an unmitigated nuisance, and because its small individual frames were not much different from the format dimensions he later made famous, the penny may have dropped rather soon after this construction was completed.

True Believers must consider that every bit of written material evidence shows that Barnack used

August 1914: Germany mobilizes for World War I. Barnack made this picture—possibly history's first 35-mm reportage.

the double cine frame for *all* of his 35-mm proto-types, right from the beginning. It is just this undisputed fact that makes the orthodox kino-evolutionary interpretation so untenable, even in the absence of other evidence.

If Oskar Barnack, that most practical of engineers, a man who always sought, and usually found the simplest solutions, wanted to study the characteristics of 18×24-mm (silent) movie film frames, why expand to 24×36 mm?

The Leica began as an idea whose time had missed the bus. Although providing twice the format area of its several 35-mm single-frame predecessors—most notably, the Minnigraph, of Levy-Roth, in Berlin—24×36-mm negatives caused more future shock than today's women's liberation movement.

Suddenly, photographers discovered the granular structure of film negatives. Developers appeared to do more than just blacken exposed parts of the picture. Some caused a migration of silver particles called clumping. Most produced a lot more contrast than these little negatives appeared to want. None seemed satisfactory.

Now that every picture needed enlargement, every photographer received an education in film defects from dust on the outside to halation inside. Film manufacturers moved molecules to produce sharper, finer-grained 35-mm films. By the mid-1930s, there were as many fine-grain film developers as superheterodyne radio receivers.

A 1928 advertisement by E. Leitz, Inc., New York, featured a portrait of Marjorie Le Voe, winner of the "Apple of Gold," in the Radio Beauty Contest conducted by KYA, San Francisco, under the brave headline: "Any Leica Negative can be Enlarged to 12×18 inches."

Back at the ranch, Leitz founded the "Leica-Schule," a school of 35-mm technique, in Wetzlar, to train qualified missionaries. Its leader, Heinrich Stöckler, was soon embroiled in one of 35-mm photography's longest-lived, and most productive controversies, taking issue with such giants as Dr. Paul Wolff, the first professional to adopt the Leica as a way of life.

Dr. Wolff maintained that, to obtain 24×36-mm negatives capable of great enlargement, one should overexpose and underdevelop, using a fine-grain formula of the paraphenylenediamine type. But this, argued Stöckler, merely disguises the grain in fuzziness. To preserve the sharpness of the Leica lenses, he advised the minimum exposure needed for developing fully in a dilute (com-pensating) developer free of any silver solvents.

Now that the grain has settled, it's apparent that both were right, for different reasons: Wolff because he could work only with the films then available, and the printed page is more tolerant of small sharpness losses than of visible graininess; Stöckler because as the films were steadily improved with tighter, finer grain, there was progressively less need to sacrifice valuable emulsion speed and image sharpness on this altar.

The Leica experienced its most exciting spurt of rapid evolution between 1925 and the outbreak of World War II. With a speed of Leitz almost unimaginable today, these 15 years saw the introduction of no less than a dozen different Leica models, with perhaps twice as many major, minor, and nit-picking variations.

These model differences, and the vast accumulation of lenses and accessories that accompanied them are, of course, the delight of today's Leica collectors. To ensure that no change of knurling or screw-head diameter will go unrecorded, two Leica Historical Societies have been founded (but not by Leitz), the first in Britain, and the second right here.

The earliest Leica models lacked two of the features most responsible for the camera's later success: interchangeable lenses, and a coupled rangefinder. The famous threaded lens mount of what is now called the "classic" Leica appeared in 1930, but it wasn't until 1932 that the "Autofocal Leica" introduced coupled-rangefinder (CRF) focusing. This was the Leica II, also called the "Model D" in the U.S.

Leica II was the world's first CRF camera, but before 1932 faded into the sad history of the Third Reich, the Leica received something else: a first-class competitor of equally high quality, Contax I, Zeiss Ikon's first 35, also with a built-in rangefinder.

By 1932, the Leica had experienced more than 20 years of experimental evolution, and seven years of commercial production. The need for an accurate distance-measuring instrument had been recognized at least from 1925, when an accessory pocket and clip-on rangefinder was supplied for the Model I. Why, then, did it take so long to put it where it obviously belonged, inside the camera, working in concert with the lens' focusing travel?

There are two basically different approaches to technical instrument design. One starts by deciding all of the necessary functions, and then determines the size and shape required. The other be-

gins by fixing a set of maximum dimensions, and then decides how many desirable functions can be contained. And this was Barnack's way.

The rangefinder was valuable, but the camera's comfortable shape was vital. Nothing must destroy that indefinable "feel" that was the classic Leica's most famous, and most universally admired feature. Calling his team of engineers together, Barnack laid a metal rule across the flat tops of the winding and rewinding knobs at either end of the Leica I, and told his team: "Gentlemen, if we are going to have a built-in rangefinder, it must fit within this space."

This made the job a lot more difficult, but those early knobs were fortunately generously dimensioned, and a rangefinder with a 39-mm base (amplified by a 1.5× telescope, to give an effective measuring base of 58 mm) was squeezed into the camera without enlarging its external dimensions. This basic design served in all of the thread-

mount CRF Leicas, including the last of the line, Model IIIg, manufactured from 1957 to 1960.

Barnack's last camera was the Leica IV, a supersecret project that occupied his final years. An accompanying photograph shows the only existing prototype, which was built and rebuilt in 1934 and 1935. Note the long-base combined range-viewfinder system which provided a modified Albada-type frame with interchangeable parallax-compensated finder inserts for the principal Leica focal lengths, from 35- to 135-mm.

This was, of course, a first step toward the redoubtable M-series Leicas brought to being by two of "Barnack's boys," Willi Stein and Hugo Wehrenfennig. Willi Stein invented the nonspinning speed dial of the Leica IV, which didn't appear until the Leica M3, of 1954. Herr Stein, who was Barnack's successor, retired after completing his last camera design, the Leica CL.

The Leica M-series, which began in 1954 with

When the river Lahn flooded Wetzlar in 1920, Barnack's reportorial skill presaged the coming era of photojournalism.

Leica M3 No. 700,000 is represented today by the models M4 and M5. And they are direct descendents of that little camera that shook the world in the spring of 1925.

Richard Weiss, the Rollei company's chief engineer, and therefore a neutral, once handed a borrowed Leica back to this writer saying, "Without a doubt, Leitz has carried the rangefinder camera farther, and done more with it, than any other company." What is debatable is only the rangefinder, and whether it any longer has a place in the photographic scheme.

Once the Leica was rivaled by magnificent opposition: Zeiss Ikon's beautiful Contax, Nippon Kogaku's great "S" to "SP" series of Nikon CRF models, the wonderful Canon models IV to VII, America's own sadly short-lived Kodak Ektra, and many, many more. Now, all have passed into history and only the Leica remains to offer a comprehensive 35-mm rangefinder system with an extensive range of optics and accessories.

When it was young and still developing, the Leica thought it could do everything. Now that it possesses the maturity of its M4-M5-CL models, the Leica knows that it can do nearly everything, but not always with the optical ease and versatility of a single-lens reflex that sees through its own camera eye.

You can say this with numbers: lenses shorter than 35- or longer than about 90-mm are far more efficiently served by the SLR. And the SLR is always superior in the close-up ranges because it can focus there, and has no parallax.

The interesting range of lenses are the solid, reliable workhorses between 35 and 100-or-so mm, the lenses that most photographers use most of the time, for most of their pictures. This focal range includes most of the really high-aperture optics, and is well, but not equally served by both focusing and viewing systems.

The case for CRF, and for the Leica, can be stated in two ways. Technically, the rangefinder focuses faster and more accurately, especially in dingy, flat lighting and with moving subjects. Because it has no moving mirror or auto-aperture mechanisms, the CRF camera introduces far less time-parallax. This delay between pushing the button and beginning the actual film exposure is about 1/125 sec for a Leica, and an average of perhaps 1/20 sec with a typical SLR, a factor of six. And it is so much less noisy!

Photographically, the Leica puts no optical barrier between the photographer and his subject.

Looking through an SLR is sort of like looking into a tunnel, the effect one gets by peering through reversed fieldglasses. The CRF viewfinder image, for all its close-in parallax (for which, incidentally, automatic sliding-frame parallax compensation has been provided in all Leica models introduced since 1954) is never interrupted; you see your subject throughout the exposure. With any SLR there's a blind interval, while the mirror goes up, the aperture blades down, and the shutter across, in which you see nothing.

Today, the "system camera" with 20 or 30 interchangeable lenses and more accessories than most people can comfortably house, dominates the quality-camera market. In this respect, the Leica is probably over-accessorized, so that it can do with difficulty what an SLR accomplishes with no accessories at all. And it undoubtedly includes a lot more lenses than are really needed.

The little Leica CL, with its "minisystem" of

Talent for posing is evident in a pre-1920 portrait by Barnack that is reminiscent of August Sander's work.

only two focal lengths, 40- and 90-mm, is much more realistically representative of modern photographic practice. The technically dependent "gee-whiz" based on optical oddity now belongs to the SLR. All that remains for the Leica is the photographer's eye, and his intellect.

What will happen to the Leica in the next 50 years? Frankly told, I don't know. And I'm not sure that the wizards of Wetzlar know either. But I'm very sure that if the Leica were ever to disappear, some other Barnack would have to invent it again.

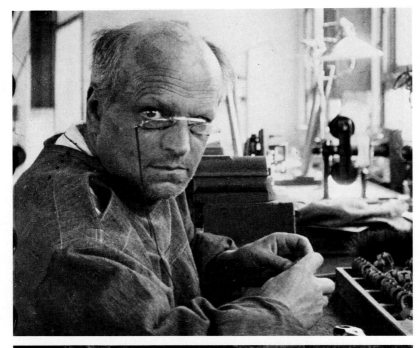

There's a Caligari-like feeling in this picture of a Leitz worker by the inventor of the Leica.

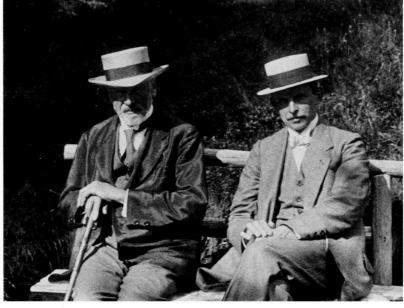

Barnack (r.) and his sponsor, Dr. Ernst Leitz, were photographed in Black Forest, 1914.

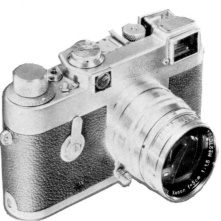

SOME FAMOUS LEICA FAMILY MEMBERS

Leica cameras have kept their family resemblance for many generations, unlike other equipment lines. Here are a few notable members. Over the years there appeared an elegant, gold-plated model, another with the first lens-coupled rangefinder, a 250-exposure model, a multiframe finder model with bayonet mount to replace threaded types and, finally, a compact model that, despite dimension and proportion changes, kept on looking like a Leica.

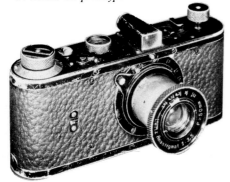

Ur-Leica: the prototype

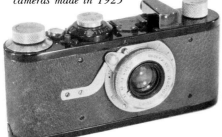

One of 31 preproduction cameras made in 1923

Model A, 1925: earlier ones had Leitz Anastigmat lenses

Model C, 1930: basically, a Model A with interchangeable lenses

Model D, 1932: first to have built-in rangefinder

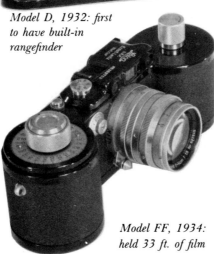

Model FF, 1934: held 33 ft. of film

Compur model (B), 1926–1929; for exposure to 1 sec

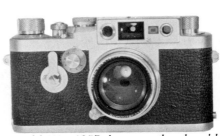

Luxus model, 1929; gold plate & snakeskin

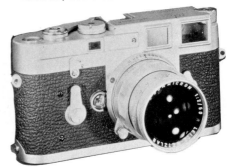

Leica IV, 1934–35: looks like an M3

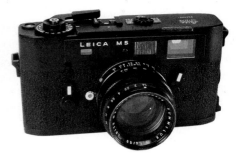

M3, 1954: first bayonet-mount model

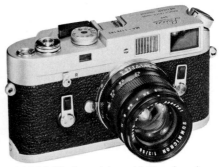

M4, 1967: first with rapid-film changing

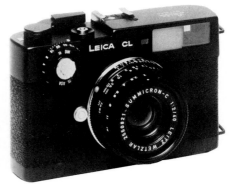

M5, 1971; first with behind-lens meter

Model IIIg, 1957; last screw-thread model

CL, 1973: the compact Leica

Will "Holy" Photo Relics Become Collector's Items?

Kenneth Poli

After Julia Margaret Cameron, what?

The tumult and the shouting about collecting photographic prints, far from having died, are in a crescendo. The days of the $38,000 daguerreotype and the $150,000 album of prints and the $4,500 gravure reproduction are upon us. And the race has barely begun.

But with the profit motive so solidly at work, there would seem to be a question as to whether the supply of prints—particularly 19th-century material—will continue to be available to meet the demand.

Of late, interest seems to have shifted to 20th-century work. But will contemporary photographers die fast enough to drive up the prices of their prints?

After all, in his lifetime, Atget barely made enough money to survive. Only the good taste and belief of Berenice Abbott kept his images from oblivion. Yet, today, Atget prints (at $1,500 each!) have been stolen in broad daylight from the relatively busy premises of a New York gallery. Diane Arbus' prints that went unsold during her lifetime now bring four figures from "collectors" who confidently expect that their price will rise much, much higher. (When their market value reaches a certain point, presumably collector "A" will be prevailed upon by an optimistic collector "B" to part with his photographic art, in the hope that the price will go up even more.)

There will, of course, always be contemporary photographers whose work will be eagerly snapped up by "connoisseurs." Reports are that the prices of the Avedon pictures shown at the Marlboro Gallery in New York City have tripled since the show hit the road to other cities and other exhibitions. Gallery owner Harry Lunn some months ago announced less-than-quantum, but nevertheless substantial, jumps in the price of the already high-priced prints of Ansel Adams.

But, sooner or later, like the Ph.D. candidate in English Literature, the collector who buys for investment value will find himself faced with a fixed body of work from which he will be searching in vain for untapped or unused areas.

I have given much thought as to what areas photographic collectors might venture into when the supply of vintage prints (or cameras) runs out —and I think I have struck an unmined vein of gold.

"Holy" relics. Photographically holy, at any rate. I'm nobody's fool, though. You don't think I'm going to let you in on an idea like this before having grabbed a few biggies for myself, do you?

I'm going to tell you what I've put into my own collection of rare and treasured relics, and you can jolly well search out your own. I'll suggest a couple of ideas, though. Some of the best pieces from my own collection illustrate this column.

The prize of them all, I think, is something I came across in a little shop on a back street in London. I can't tell you exactly where. After all, you never can tell when another priceless item will turn up there. But anyway, I have the only genuine lock of Julia Margaret Cameron's hair known to exist today. No one is going to produce any more of *these* from an unsuspected negative or find an undiscovered album full of specimens to dilute the value of those already in collections! My lock of hair excels a vintage print as a collector's item.

There's another remarkable bit of photographica in my possession—something truly unique—the kind of memento that can only increase in value with the years. I'll have to admit that this took some real—er—digging to acquire. But any collector would agree that the effort it took was worthwhile. Once more, I'd rather not give you the details of how I got hold (figuratively) of a finger-bone of Nicéphore Niépce. But it's in my collection, and I've never seen anything to match it in all the Sotheby-Parke-Bernet auctions I've been to. This is the kind of quality investment collectors will be turning to when the vintage prints run out.

A somewhat more available relic in my collection is a symbolic rather than actual representation of photography's very beginnings. Whole units of this revered instrument exist in certain museums and in a very limited number of distinguished collections. However, few were made and fewer still have survived intact.

But legend has it that, during *la daguerreotypomanie* in 1840s France, after the introduction of photography, an inspired and fanatical devotee of the new art acquired seven early cameras and crudely carved them up into small bits—splinters of the true Giroux Daguerreotype Camera. These he sold to other less well-to-do but equally reverent collectors. And it was from the descendent of one of these early enthusiasts that I acquired my specimen of these priceless incunabula.

Still other scarce and costly items I have are mementoes, gathered either personally or through assigned agents, of outstanding contemporary photographers—the immortals of tomorrow, as it were. Some thought, discernment and a fine sense of marketing can bring rare treasures to the collector in this way. An outstanding example of these is a small glass phial in my collection. It contains some of the tears shed during TV talk-show interviews by an outstanding and emotional photojournalist when discussing certain of his assignments. Such moments of high emotion in public are not easily anticipated. And being on the spot at the right time (and with a collection phial!) is a rare achievement indeed. Money in the bank, right?

This kind of relic—available with sufficient enterprises to anyone—is a prime investment, both spiritual and economic, in photographica. (Just be sure to keep tear samples archival by preserving them in airtight containers.)

Other current and collectible items of interest for the forward-looking connoisseur are quite plentiful. For example, who knows the potential worth of an *unopened* pack of Mike Mandel's Baseball/Photographer Cards, *complete with enclosed bubble gum?* There will be many complete sets of cards available, but who will have had the restraint and foresight to have preserved a virgin package for posterity? Another area of interest should be the earliest-dated snapshot produced by such landmark instruments as cameras that image the date of exposure right on the negative or transparency. Not only will early dates be scarce in the future, but it will be easy, given equal print or image quality, to assign value chronologically.

So, collecting photographica will *not* die when the supply of vintage prints dries up. No one need buy a print today or even in the future *simply because he likes the image,* God forbid! By aggressive, imaginative buying you can select commonplace items of today that will be photography's holy relics tomorrow, and maybe make a bundle. Why not resolve, beginning April 1st, this bicentennial year, to acquire tricentennial treasures now?

Rare items from author's collection include splinter of true Giroux daguerreotype camera (lower l.), locket containing lock of Julia Margaret Cameron's hair (upper l.), unopened pack (with bubble gum) of baseball photographer cards (center), and phial of photographer's tears.

Men of the Revolution

Harvey V. Fondiller

*In 1864 the last surviving veterans recalled their
experiences in the War for Independence. Their words
and portraits were the world's first photo-interviews*

"Every American desires to know all that can be
known of the surviving soldiers of the Revolution.
It was in this desire that the following work origi-
nated, and with a view to its gratification that it has
been prepared." With these words, Rev. E. B. Hil-
lard introduced *The Last Men of the Revolution,* a
64-page book containing six mounted photo-
graphs of the last surviving veterans of the Ameri-
can Revolution. Published in 1864 at Hartford,
Ct., by N.A. and R.A. Moore, the book includes
biographical sketches of the men and hand-col-
ored lithographs of their homes.

Hillard wrote: "Of these venerable and now sa-
cred men but seven remain." Four lived in New
York State, one each in Maine and Ohio, and one
veteran could not be located. One of the men was
100 years old, another was 101, two were 102, and
two reached the age of 104.

"Their extreme age . . . forbids the hope that
they can continue much longer among the living,"
stated Hillard. "Soon they too must answer the
final challenge and go to join the full ranks of
those who have preceded them to the invisible
world. The present is the last generation that will
be connected by a living link with the great period
in which our national independence was achieved.

"Our own are the last eyes that will look on men

who looked on Washington; our ears the last that
will hear the living voices of those who heard his
words. Henceforth the American Revolution will
be known among men by the silent record of his-
tory alone. It was thus a happy thought of the
artists who projected this work to secure such
memorials as they might of these last survivors of
our great national conflict, before they should
forever have passed away."

The author noted: "Possible now, it will soon be
impossible forever, and now neglected it would be
forever regretted. What would not the modern
student of history give for the privilege of looking
on the faces of the men who fought for Grecian
liberty at Marathon, or stood with Leonidas at
Thermopylae . . . How precious a collection to
every true American . . . would be the portraits of
the seven men who fell, on the morning of the
nineteenth of April, 1775, on Lexington Green!
. . .

"In the memorials of such men . . . the past
seems still to live. The connection with it of their
personal history gives it reality. Ever, it is only
through association with the men who were actors
in them that the periods of history seem real.

"History lives only in the persons who created
it. The vital words in its record are the names of

men. Thus everything of personal narrative gives reality to the past. This these memorials of the last living men of the Revolution will do for that great period of our history. As we look upon their faces, as we learn the story of their lives, it will live again before us, and we shall stand as witnesses of its great actions.''

The author, Elias Brewster Hillard, was a Congregational clergyman, the grandfather of Archibald MacLeish, noted poet and former Librarian of Congress. He was apparently approached by the Hartford publishers with the suggestion that he interview the surviving veterans of '76. In July, 1864—toward the end of the Civil War—Hillard embarked on a pilgrimage to their homes. The first was that of Samuel Downing in Edinburgh, Saratoga County, N.Y.

"It was about noon when I reached there," he wrote. "As I drove up I observed . . . seated between two beehives, bending over, leaning upon his cane and looking at the ground, an old man . . . On entering the yard I at once recognized him from his photograph . . . On telling him that I had come a long way to see an old soldier of the Revolution, he invited me to walk into the house . . . Seated (there), he soon entered upon the story of his life . . .''

Hillard recognized that "the chief interest of this work lies, of course, in the pictorial representations of the men." Unknowingly, he made photographic history, for the portraits and reminiscences in his book are the world's first photo-interviews.

The six photographs are 2 $\frac{1}{16}$ × 3¼ albumen prints, slightly smaller than a carte-de-visite image. Each print is mounted within a printed gilt border topped by an eagle and shield.

All of the subjects are seated, as might be expected of centenarians. The photographers are unidentified; possibly some were itinerant "sun artists" who set up temporary studios or visited the subjects at home. One of the old men—Adam Link—refused to be photographed, and his portrait was "secured without his knowledge; the family fearing the proposal would provoke him, and thus defeat the attempt.''

The negatives were made on wet collodion plates; exposure was probably about two seconds. To prepare the emulsion, the photographer mixed collodion with a soluble iodide and poured it over the plate, which was then sensitized by a solution of silver nitrate. After development in a solution of iron sulfate, acetic acid, and alcohol, the negative was fixed in a dilute solution of potassium cyanide or hypo. The albumen contact prints were made by exposure to sunlight.

Fourscore and seven years before Hillard's book was published, our nation was engaged in a conflict to which these six men were eyewitnesses. As the author foresaw, seeing their faces makes the Spirit of '76 "live again before us." Thus has photography spanned two centuries of American history.

When Samuel Downing was a boy, he ran away from home and apprenticed himself to a spinning-wheel maker. For six years, he lived with his master, Thomas Aiken, in Antrim, Ma., "working at wheels during the day and splitting out spokes at night.''

According to Downing, Aiken "didn't do by me as he agreed to. He agreed to give me so much education, and at the end of my time an outfit of clothes, or the like, and a kit of tools. So I tells aunt (I used to call Mr. Aiken 'uncle' and his wife 'aunt',) 'Aunty, Uncle don't do by me as he agreed to. He agreed to send me to school, and he hasn't sent me a day'; and I threatened to run away. She told me if I did they'd handcuff me and give me a whipping. 'But', said I, 'you'll catch me first, won't you, Aunty?' 'O', she said, 'they'd advertise me.'

"Well, the war broke out. Mr. Aiken was a militia captain; and they used to be in his shop talking about it. I had ears, and I had *eyes* in them days. They was enlisting three years men and for-the-war men. I heard say that Hopkinton was the enlisting place . . .

"The recruiting officer, when I told him what I'd come for, said I was too small. I told him just what I'd done. 'Well,' said he, 'you stay here and I'll give you a letter to Col. Fifield over in Charlestown and perhaps he'll take you.'

"So I staid with him; and when uncle and aunt came home that night they had no Sam. The next day I went and carried the letter to Col. Fifield, and he accepted me. But he wasn't quite ready to go: he had his haying to do; so I staid with him and helped him through it, and then I started for the war.

"The first duty I ever did was to guard wagons

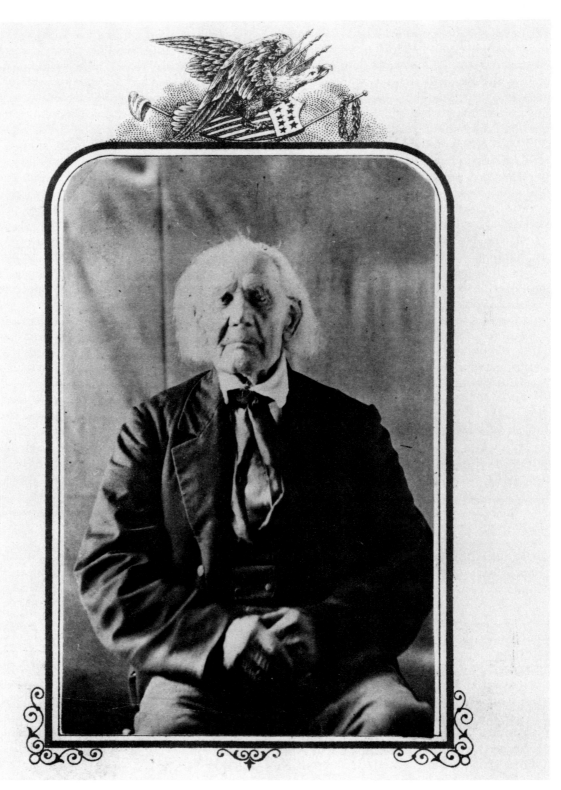

SAMUEL DOWNING
Born November 30, 1761, in Newburyport, Massachusetts

from Exeter to Springfield. We played the British a trick; I can remember what I said as well as can be. We all started off on a run, and as I couldn't see anything, I said, 'I don't see what the devil we're running after or running away from; for I can't see anything.' One of the officers behind me said, 'Run, you little dog, or I'll spontoon you.' 'Well,' I answered, 'I guess I can run as fast as you can and as far.'

"Pretty soon I found they were going to surprise a British train. We captured it; and among the stores were some hogsheads of rum. So when we got back to camp that night the officers had a great time drinking and gambling; but none for the poor soldiers. Says one of the sergeants to me, 'We'll have some of that rum.' It fell to my lot to be on sentry that night; so I couldn't let 'em in at the door. But they waited till the officers got boozy; then they went in at the windows and drew a pailful, and brought it out and we filled our canteens, and then they went in and drew another. So we had some of the rum; all we wanted was to live with the officers, not any better.

"Afterwards we were stationed in the Mohawk valley. (Gen. Benedict) Arnold was our fighting general, and a bloody fellow he was. He didn't care for nothing; he'd ride right in. It was 'come on, boys!' 'twasn't 'Go, boys!'. He was as brave a man as ever lived. He was dark-skinned, with black hair, of middling height. There wasn't any waste timber in him. He was a stern looking man, but kind to his soldiers. They didn't treat him right: he ought to have had Burgoyne's sword. But he ought to have been true. We had true men then; 'twasn't as it is now . . .

"We heard Burgoyne was coming. The tories began to feel triumphant. One of them came in one morning and said to his wife, 'Ty (Ticonderoga) is taken, my dear.' But they soon changed their tune. The first day at Bemis Heights both claimed the victory. But by and by we got Burgoyne where we wanted him, and he gave up. He saw there was no use in fighting it out. There's where I call 'em *gentlemen.* Bless your body, we had *gentlemen* to fight with in those days. When they was whipped they gave up. It isn't so now.

"Gates was an 'old granny' looking fellow. When Burgoyne came up to surrender his sword, he said to Gates, 'Are you a general? You look more like a granny than you do like a general.' 'I be a granny,' said Gates, 'and I delivered you of ten thousand men to-day.'

"By and by they began to talk about going to take New York. There's always policy, you know, in war. We made the British think we were coming to take the city. We drew up in line of battle: the British drew up . . . They looked very handsome. But Washington went south to Yorktown. La Fayette laid down the white sticks, and we threw up entrenchments by them. We were right opposite Washington's headquarters. I saw him every day."

Washington was a fine-looking man, Downing remembered, "but you never got a smile out of him. He was a nice man. We loved him."

How would Washington treat traitors if he caught them? "Hang 'em to the first tree!"

"When peace was declared," said Downing, "we burnt thirteen candles in every hut, one for each State."

At the close of the war, "too big for Aunty to whip," Downing returned to Antrim. He married and had 13 children, three of whom were still living on his 100th birthday. On that occasion, 1,000 people gathered on his son's farm in Saratoga County, N.Y.; a hundred guns were fired, and the old man cut down a hemlock tree five feet in circumference.

At the age of 102, Downing was "the most vigorous in body and mind of the survivors", according to Hillard, who noted that he "hoes corn and potatoes, and works just as well as anybody."

A distant relation of Presidents John and John Quincy Adams, Daniel Waldo was drafted for a month's military service at New London, Ct., when he was 16. He subsequently enlisted for eight months and in March 1779 was taken prisoner.

The circumstances of his capture were related by him to the "artist who took his photograph," as follows:

"One of the guards, on leaving his beat one stormy night, failed to give him warning, and thus the tories surprised him. One of them snapped a musket at him, but it only flashed in the pan; whereupon he laid down his own musket and made signs of surrender. But one of the enemy, on pretense that he was about to pick it up again, made a thrust at him with his bayonet, which failed to pierce him. He thereupon demanded to be treated as a prisoner of war; and lying down, the attacking party passed over him into the house which he was guarding, capturing the whole company (thirty-seven in number) which it contained."

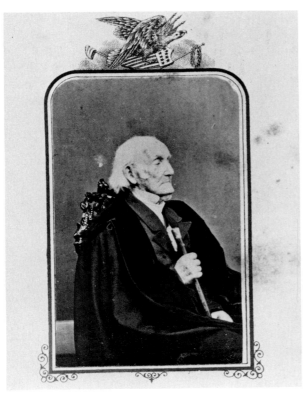

DANIEL WALDO
Born September 10, 1762, in Windham, Connecticut

With his fellow prisoners, Waldo was taken to New York, where he was confined for two months; he received short rations but was otherwise well treated.

At 20, he entered Yale and graduated with honors in 1788. After studying theology for a year with a minister, as was then the custom, he was licensed to preach. Ordained in 1792 as pastor of the church at West Suffield, Ct., Waldo remained there 18 years. He married and had five children, but in 1805 his wife became insane. "I lived 50 years with a crazy wife," he recalled.

Employed by the Missionary Society of Connecticut, he made tours to the states of New York and Pennsylvania, then the "Far West." Later he went to live with his son's family in Syracuse, N.Y.

Waldo died July 30, 1864. A friend wrote of him: "His spirit was eminently kind and genial . . . Though he experienced many severe afflictions, and had always (been burdened by) domestic sorrow . . . his calm confidence in God never forsook him . . . At the close of a life of more than a hundred years, there is no passage in his history which those who loved him would wish to have erased."

Lemuel Cook enlisted at the age of 16 at Cheshire, Ct., and was mustered in at Northampton, Ma., in the 2nd Regiment, Light Dragoons. He served until his discharge in Danbury, Ct., June 12, 1784.

"When I applied to enlist, Captain Hallibud told me I was so small he couldn't take me unless I would enlist for the war. The first time I smelt gunpowder was at Valentine's Hill (West Chester, New York). A troop of British horse were coming. 'Mount your horses in a minute,' cried the colonel. I was on mine as quick as a squirrel. There were two fires—crash! Up came Darrow, good old soul! and said, 'Lem, what do you think of gunpowder? Smell good to you?'

"The first time I was ordered on sentry was at Dobbs' Ferry. A man came out of a barn and leveled his piece and fired. I felt the wind of the ball. A soldier near me said, 'Lem, they mean you' go on the other side of the road.' So I went over; and pretty soon another man came out of the barn and aimed and fired. He didn't come near me. Soon another came out and fired. His ball lodged in my hat. By this time the firing had roused the camp; and a company of our troops came on one side, and a party of the French on the other; and they took the men in the barn prisoners, and brought them in. They were Cow Boys. This was the first time I saw the French in operation. They stepped as though on edge. They were a dreadful proud nation.

"When they brought the men in, one of them had the impudence to ask, 'Is the man here we fired at just now?' 'Yes,' said Major Tallmadge, 'there he is, that boy.' Then he told how they had each laid out a crown, and agreed that the one who brought me down should have the three. When he got through with his story, I stepped to my holster and took out my pistol, and walked up to him and said, 'If I've been a mark to you for money, I'll take my turn now. So, deliver your money, or your life!' He handed over four crowns, and I got three more from the other two."

Cook gave the following account of the events leading to the surrender of General Cornwallis:

"It was reported Washington was going to storm New York. We had made a bylaw in our regiment that every man should stick to his horse: if his horse went, he should go with him. I was waiter for the quarter-master; and so had a chance

to keep my horse in good condition. Baron Steuben was mustermaster. He had us called out to select men and horses fit for service. When he came to me, he said, 'Young man, how old are you?' I told him. 'Be on the ground to-morrow morning at nine o'clock,' said he.

"My colonel didn't like to have me go. 'You'll see,' said he, 'they'll call for him to-morrow morning.' But they said if we had a law, we must abide by it. Next morning, old Steuben had got my name. There were eighteen out of the regiment, 'Be on the ground,' said he, 'to-morrow morning with two days' provisions.' 'You're a fool,' said the rest; 'they're going to storm New York.' No more idea of it than of going to Flanders. My horse was a bay, and pretty.

"Next morning I was the second on parade. We marched off toward White Plains. Then 'left wheel,' and struck right north. Got to King's Ferry, below Tarrytown. There were boats, scows, etc. We went right across into the Jerseys. That night I stood with my back to a tree. Then we went on to the head of Elk. There the French were. It was dusty; 'peared to me I should have choked to death. One of 'em handed me his canteen; Said he, 'take a good horn—we're going to march all night.' I didn't know what it was, so I took a full drink. It liked to have strangled me.

Then we were in Virginia. There wasn't much fighting. Cornwallis tried to force his way north to New York; but fell into the arms of La Fayette, and he drove him back. Old Rochambeau told 'em, 'I'll land five hundred from the fleet, against your eight hundred.' But they darsn't. We were on a kind of side hill. We had plaguey little to eat and nothing to drink under heaven. We hove up some brush to keep the flies off. Washington ordered that there should be no laughing at the British; said it was bad enough to have to surrender without being insulted.

"The army came out with guns clubbed on their backs. They were paraded on a great smooth lot, and there they stacked their arms. Then came the devil—old women, and all (camp followers). One said, 'I wonder if the d—d Yankees will give me any bread.' The horses were starved out. Washington turned out with his horses and helped 'em up the hill. When they see the artillery, they said, 'There, them's the very artillery that belonged to Burgoyne.' Greene come from the southard: the awfullest set you ever see. Some, I should presume, had a pint of lice on 'em. No boots nor shoes."

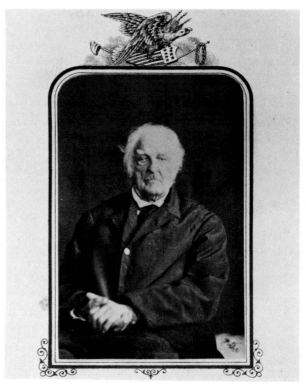

LEMUEL COOK
Born September 10, 1759, in Northbury, Connecticut

After the war, Cook married and lived near Cheshire, Ct., then moved to Utica, N.Y., where he had frequent encounters with the Indians that still occupied the region. At 104, he was described as follows: "His frame is large, his presence commanding; and in his prime he must have possessed prodigious strength. He has evidently been a man of most resolute spirit; the old determination still manifesting itself in his look and words. His voice, the full power of which he still retains, is marvellous for its volume and strength . . .

"The old man's health is comfortably good; and he enjoys life as much as could be expected at his great age . . . Altogether, he is a noble old man . . ."

His father, an Englishman who served in the British army, died at the Battle of Quebec in 1759. Alexander Milliner was born the following spring, and later his mother moved to New York State.

Too young in 1776 for service in the ranks, he was enlisted at Lake George, N.Y., as a drummer

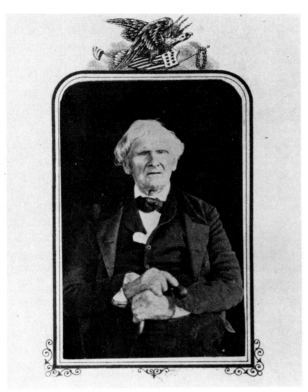

ALEXANDER MILLINER
Born March 14, 1760, in Quebec, Canada

boy. He served four years in Washington's Life Guard, and by his own account was a favorite of the commander-in-chief. Washington often patted him on the head after the drum-beating at reveille, and on one occasion—"a bitter cold morning," Milliner recalled—gave him a drink from his flask.

He remembered Washington as "a good man, a beautiful man. He was always pleasant; never changed countenance, but wore the same in defeat and retreat as in victory."

Martha Washington was "a short, thick woman; very pleasant and kind. She used to visit the hospitals, was kind-hearted, and had a motherly care."

"One day the General had been out some time. When he came in, his wife asked him where he had been. He answered, laughing, 'To look at my boys.' 'Well,' said she, 'I will go and see *my* children.' When she returned, the General inquired, 'What do you think of them?' 'I think,' answered she, 'that there are a good many.'

"They took a great notion to me. One day the General sent for me to come up to headquarters.

'Tell him,' he sent word, 'that he needn't fetch his drum with him.' I was glad of that.

"The Life Guard came out and paraded, and the roll was called. There was one Englishman, Bill Dorchester; the General said to him, 'Come, Bill, play up this 'ere Yorkshire tune.' When he got through, the General told me to play. So I took the drum, overhauled her, braced her up, and played a tune. The General put his hand in his pocket and gave me three dollars; then one and another gave me more—so I made out well; in all, I got fifteen dollars. I was glad of it: my mother wanted some tea, and I got the poor woman some." (Milliner's mother accompanied the army as a washerwoman so that she could be near her son).

Milliner was at the battles of White Plains, Brandywine, Saratoga, Monmouth, and Yorktown. The first of these he describes as "a nasty battle." At Monmouth he received a flesh wound in his thigh.

"One of the officers came along, and, looking at me, said, 'What's the matter with you, boy?' 'Nothing,' I answered. 'Poor fellow,' exclaimed he, 'you are bleeding to death.' I looked down; the blood was gushing out of me."

At General Burgoyne's surrender: "The British soldiers looked down-hearted. When the order came to 'ground arms,' one of them exclaimed with an oath, 'You are not going to have my gun! and threw it violently on the ground, and smashed it."

The encampment at Valley Forge: "Lady Washington visited the army. She used thorns instead of pins on her clothes. The poor soldiers had bloody feet."

Milliner served 6½ years in the army, then 5½ years in the U.S. Navy. At 39, he married and settled in Cortlandt County, New York. He and his wife lived together 62 years; they had nine children, 43 grandchildren, 17 great-grandchildren, and three great-great-grandchildren. Milliner had a jovial, carefree temperament. Hillard relates: "At the time his photograph was taken he could still handle his drum, playing for the artist, with excellent time and flourishes which showed him to have been a master of the art."

On his 104th birthday a veterans organization, the Pioneers of Monroe County, marched to his house and greeted him with cheers. Then the procession marched to the church, where "after the singing of Washington's Funeral Hymn by the Pioneers and a short historical address, Mr. Milliner stood up on a seat where all could see him, and

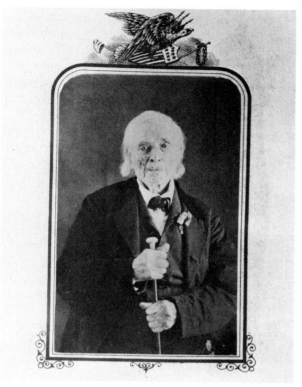

WILLIAM HITCHINGS

Born 1764 in York County, Maine (then Massachusetts)

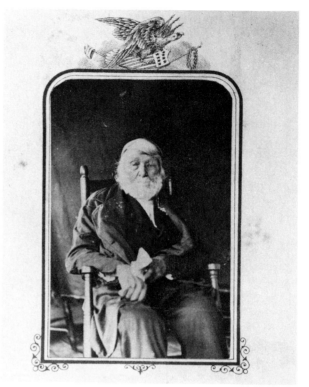

ADAM LINK

Born November 14, 1761, in Crawford County, Ohio

thanking them for their kind attention, appealed to them all to be true to their country . . ."

William Hitching's father, who had fought in the French and Indian War, used to say that he had served under George II, George III, and also under George Washington, and was ready to serve under Madison. In 1768 he moved with his family from New York to Penobscot, Me., when William was just four years old.

The region was a wilderness, Hitchings Sr. being one of the earliest settlers. He cleared a farm and established a home under the harsh conditions of pioneer life. His son recalled those childhood experiences; at times, he said, they were scarcely able to get enough food. The family was finally beginning to live comfortably when the British drove his father from his home. He fled with his family to Newcastle and lived there until the war ended, while his son remained to fight the enemy.

Soon after the war ended, Hitchings married. He had 15 children, all but one of whom lived to be married. Throughout his life he was an early riser and hard worker.

"He is deeply interested in the present conflict," wrote Hillard, "his whole soul being enlisted in the cause of his country. Speaking of General Grant and his prospects of success in his campaign against Richmond, he concluded by saying, 'Well, I know two old folks up here in Maine who are praying for him.' He had lost four or five grandchildren in the war. On the subject of slavery, he declared: 'God will never suffer it to exist in this country.'"

At 16, Adam Link enlisted in Wheeling, Va., for frontier service. During his five years as a soldier, his father was killed by Indians in his own house.

Link participated in no important battles during the war. Seven years after being mustered out, he married a distant relative, age 17. He lived in a

number of places and, at 60, walked from his home in Pennsylvania to Ohio—a distance of 141 miles—in three days.

At 70, he cleared land for a farm, while living in a house the main wall of which was formed by the flat roots of an upturned tree. "Although always a hard worker, he was always poor," wrote Hillard.

"Part may be set down to the score of that ill luck which seems to dog the steps of some men through life."

The old soldier finally moved to the home of his son-in-law in Sulphur Springs, Crawford County, Oh., where he lived until his death on August 15, 1864.

EASTMAN KODAK COMPANY